·THE IDEA OF·
THE LABYRINTH

· THE IDEA OF · THE LABYRINTH

from Classical Antiquity through the Middle Ages

Penelope Reed Doob

CORNELL UNIVERSITY PRESS

ITHACA AND LONDON

Open access edition funded by the National Endowment for the Humanities/Andrew W. Mellon Foundation Humanities Open Book Program.

First printing, Cornell Paperbacks, 1992
Second paperback printing 2019

ISBN 978-0-8014-2393-2 (cloth: alk. paper)
ISBN 978-1-5017-3845-6 (pbk.: alk. paper)
ISBN 978-1-5017-3846-3 (pdf)
ISBN 978-1-5017-3847-0 (epub/mobi)

Librarians: A CIP catalog record for this book is available from the Library of Congress

· For Graham Eric Parker ·
worthy companion
in multiplicitous mazes

·

and in memory of
Judson Boyce Allen
and
Constantin Patsalas

Contents

List of Plates ix

Acknowledgments: Four Labyrinths xi

Abbreviations xvii

Introduction: Charting the Maze 1

The Cretan Labyrinth Myth 11

PART ONE
THE LABYRINTH IN THE CLASSICAL
AND EARLY CHRISTIAN PERIODS

1. The Literary Witness: Labyrinths in Pliny, Virgil, and Ovid 17

2. The Labyrinth as Significant Form: Two Paradigms 39
 A clash of paradigms 40
 The multicursal model 46
 The unicursal model 48
 The essence of the maze 51

3. A Taxonomy of Metaphorical Labyrinths 64
 The labyrinth as a sign of complex artistry 66
 The labyrinth as a sign of inextricability or impenetrability 72
 The labyrinth as a sign of difficult process 82

PART TWO
THE LABYRINTH IN THE MIDDLE AGES

4. Etymologies and Verbal Implications 95

5. Mazes in Medieval Art and Architecture 101
 The three-dimensional labyrinth (buildings and gardens) 103
 Diagrammatic labyrinths 112
 Turf and stone mazes 113
 Labyrinths in churches 117
 Labyrinths in manuscripts 133

6. Moral Labyrinths in Medieval Literature 145
 The mythographers 148
 Moral labyrinths in other literature 155
 Readings of selected texts 165
 The *Gesta Romanorum* 165
 Il Corbaccio 167
 The Assembly of Ladies 171
 La Queste del Saint Graal 175

7. Textual Labyrinths: Toward a Labyrinthine Aesthetic 192
 Labyrinthine *Inventio* 198
 Labyrinthine *Dispositio* 201
 Labyrinthine *Elocutio* 211
 Difficult process 213

PART THREE
LABYRINTHS OF WORDS:
CENTRAL TEXTS AND INTERTEXTUALITIES

8. Virgil's *Aeneid* 227

9. Boethius's *Consolation of Philosophy* 254

10. Dante's *Divine Comedy* 271
 The labyrinthine landscape 281
 The labyrinthine journey 287
 The myth transformed and reenacted 294

11. Chaucer's *House of Fame* 307

Appendix: Labyrinths in Manuscripts 341
Index 343

List of Plates

1. Prehistoric Cretan-style labyrinth rock carving from Rocky
 Valley, near Tintagel, Cornwall 19
2. Labyrinth from the Tragliatella wine-pitcher (Etruscan,
 seventh century B.C.) 28
3. Roman mosaic labyrinth, Via Cadolini, Cremona 42
4. Early multicursal labyrinth, adapted from Claude Paradin's
 Dévises héroïques (1551) 47
5. Circular unicursal diagrammatic labyrinth (ninth or
 eleventh century) 49
6. The Greek key pattern or meander 51
7. Eye-brain diagram (1350–1400) 84
8. Diagram of the brain, from Jehan Yperman's *Cyrurgie*
 (1328) 85
9. Labyrinth and amphitheater, from Raban Maur's *De rerum
 naturis* (late fourteenth century) 105
10. Illustration of a three-dimensional labyrinth (ca. 1460) 108
11. Garden maze, attributed to Pozzoserrato (ca. 1550) 111
12. Turf-maze at Wing, Rutland 114
13. Diagram of Julian's Bower, turf labyrinth, Alkborough,
 Lincolnshire 115
14. Labyrinth roof boss, Saint Mary Redcliffe, Bristol
 (fourteenth–fifteenth century) 119
15. Labyrinth on baptismal font, Saint Martin's, Lewannick,
 Cornwall 120
16. Drawing of labyrinth with figures of architects (ca. 1240) in
 the nave of Reims Cathedral 122
17. Diagram of the labyrinth (ca. 1194–1220) in the nave of
 Chartres Cathedral 132

18. Architectural depiction of the Cretan labyrinth, from a
manuscript of the *Histoire ancienne jusqu'à César* (1250–
1275) 136
19. Labyrinth from a manuscript of the *Histoire ancienne jusqu'à
César* (thirteenth century) 137
20. The Cretan labyrinth, from a manuscript of the *Libellum de
septem miraculis mundi* (late twelfth century) 140
21. The city of Jericho as a labyrinth (late twelfth century) 141
22. Labyrinth in a fourteenth-century manuscript of Boethius's
Consolation of Philosophy 143
23. Labyrinth in a fourteenth-century manuscript of
Boethius's *Consolation of Philosophy* 256
24. Illumination (1419) from Dante's *Inferno* 275
25. Labyrinth in a manuscript (1419) of Dante's *Divine Comedy* 276

Acknowledgments: Four Labyrinths

P EOPLE who wander in mazes for twenty years need a lot of help along the way. But if labyrinths are icons of difficult process, by the same token they are occasions for generosity, and I have encountered more than my fair share of gracious guides. Pliny tells us that four labyrinths existed in ancient times. Taking up his clue, I thank those who have eased my passage through the four mazes I have experienced while imagining and then writing *The Idea of the Labyrinth.*

First came the magnificent, many-folded labyrinth of medieval studies, endlessly attractive precisely because of its multitudinous difficulties. It was probably Geoffrey Chaucer, English Daedalus "with his playes slye," who enticed me into this maze, but he had wily accomplices, not least the late R. W. Ackerman of Stanford University, who persuaded me to become a medievalist even though I had no interest in Old Norse. Classical and medieval mazes typically begin where they end and end where they began, as Boethius told Lady Philosophy; hence, appropriately, my point of entry into medieval studies, the origin of this book, and the final chapter all coincide in that brilliantly eclectic poem Chaucer's *House of Fame,* which is not only a beginning and ending but also an eccentric thread of Ariadne to the labyrinth of medieval literature. B. J. Whiting introduced me to the poem at Harvard University, where English 115 began with his wry line-by-line commentary. Although our approaches to Chaucer are fundamentally different, it was he who first revealed to me the charm of a work that has captivated me ever since and who inspired me to begin my own Chaucer courses with that poem. (It was while teaching *The House of Fame* to a group of baffled undergraduates in 1970 that I hit upon the idea that the poem was itself a maze, only to realize how much was yet to be discovered about medieval

labyrinths.) At Stanford, A. G. Rigg fed my addiction with impromptu soirées where a group of us read the poem aloud, stopping every few lines to explore one or another of the many paths branching out into other medieval texts and traditions. I never studied *The House of Fame* with V. A. Kolve, but his astonishing Chaucer seminars at Stanford persuaded me of the fruitfulness of looking for controlling metaphors—what he would later call "narrative images"—in Chaucer's poetry. And while I never worked with the late E. Talbot Donaldson, his enthusiasm for my research on Chaucer and labyrinths alike often gave me confidence to forge ahead when I was weary.

All writers are necessarily implicated in three additional labyrinths. First, they are maze-treaders: as the English historian Ralph Higden complained, would-be scholars have to make their way through the labyrinths of invention—their material, their sources—before they can even begin to write. Second, they are maze-makers: as the rhetorician Geoffrey of Vinsauf reminds us, writers are architects, aspiring to design a well-crafted Daedalian *domus*. This is the labyrinth of disposition, of conceptual order. Third, the text itself is a labyrinth through which readers wander at will, comprehending all or nothing according to the mental fit between text and reader: as the preacher Robert of Basevorn warned, one man's artistry is another man's inexplicable maze. This is the labyrinth of words and of the reception of texts. Writers need help as they tread, create, and entangle others in mazes.

In the labyrinth of invention I encountered many tutelary spirits who directed me along unexplored pathways. Régine Astier, Christopher Baswell, Harry Bober, John Leyerle, Guy Lobrichon, Kathryn Kerby-Fulton, V. A. Kolve, Ruth Mellinkoff, Brian Stock, David Wallace, and Francis Woodman suggested references, answered questions, or found possible illustrations. Ann and Nollaig MacKenzie traveled to Cornwall to trace a labyrinth of whose existence I was uncertain. Colin Burrow, Terry Hoad, and Charlotte Morse retraced my steps for me when I was unable to do so myself and provided last-minute reference-checking in British libraries. Eleanor Silk, Yvon LePage, and Margaret F. Nims gave me liberal access to unpublished material. Ross Arthur, Christina Hawkes, A. G. Rigg, and Brian Stock helped interpret what I saw darkly in untranslated texts.

Readers of Umberto Eco's *The Name of the Rose* know that libraries, like texts, are labyrinths in their own right, and I am grateful to the guardians of such mazes for letting me explore hidden treasures at the British, Bodleian, and Cambridge University libraries and at many Oxford and Cambridge college libraries. The Library of the Pontifical Institute of Medieval Studies in Toronto continues to be the friendliest of labyrinths, and staff at York University Libraries were tireless in satisfying my Minotaurian gluttony for exotic interlibrary loans.

Many people have played Saint Julian, patron of travelers and maze-treaders alike, on my behalf: I thank Ann Kussmaul, Paul and Elaine Hyams, Harriet Kirkley, and Mahmoud Manzalaoui for their hospitality in England on my various research trips. To Wendon Dobbs and Clive Evans, who generously let me and my labyrinthine obsessions invade their London home for many summers, I owe the deepest gratitude and affection.

One can neither explore nor build labyrinths without material support, and that I have had in abundance from the John Simon Guggenheim Foundation, the Social Sciences and Humanities Research Council of Canada, the Glendon College Research Grant Fund, and York University. Pliny thought the ancient labyrinths were a tremendous waste of resources, and I hope those who have invested enormously in this book feel their money has been somewhat better spent. Maze-walkers also need help in the exhausting tasks of searching bibliographies, checking dates and quotations, writing for permissions, photocopying articles, and so on. In this regard, I have been lucky in my talented and painstaking research assistants: Sheila Barry, Jinnean Bernard, Lucia Cino, Colleen Cowman, Nirmal Dass, Brandi Dickman, Patrick Johnson, Tom Klubi, Birgit Langwisch, and especially Dyan Elliott.

Would-be architects of a book like this one need special help in designing its complex groundplan, and I've been blessed with friends who helped me see the labyrinth whole. Judson Allen, John Leyerle, and Brian Stock played the roles of Ariadne and Daedalus, helping me chart the ground. Still more important, they believed in what I was doing even when I despaired of ever reaching the end. That this book exists at all is in large part due to their persistent encouragement over two decades.

If one needs an overview of the maze, one also needs distraction from its labors now and again. In this respect, I record my gratitude to my dear friend, the late Constantin Patsalas, who granted me the privilege of intense involvement in his own Daedalian artistry as a choreographer. His imagination sparked mine, and I often returned from rehearsals and excited discussions of his ballets with far greater energy to attack my own work. We had planned some day to collaborate on a ballet about the Cretan myth; his early death ended that hope.

People who create labyrinths need to gain perspective by stepping back and describing what they have designed so far. For letting me give papers and lectures on parts of this research over the years and for valuable feedback, I want to acknowledge Nicholas Mann (Oxford, 1975), Raymond St. Jacques and Douglas Wuertele (Universities of Ottawa and Carleton, 1981), John Leyerle (University of Toronto, 1982), Diana Theodores Taplin (University of Waterloo, 1982), Otto Gründler (International Congress of Medieval Studies, 1982, 1983, 1985, 1989), Patricia Brückmann ("Discovering in Wide Landscape," 1983), Thomas

Hahn and Marjorie Woods (University of Rochester, 1984), the Dance History Scholars Association (1985), George Brown and Donald Howard (Stanford, 1985), and V. A. Kolve (Medieval Academy, 1988). A special award for patience in adversity must go to the generations of York University graduate and undergraduate students who, since 1970, have had versions of the chapters on *The House of Fame* and *The Consolation of Philosophy* inflicted on them, often at trying hours in the early morning.

Ancient labyrinths were lavishly decorated with works of art, and while my labyrinth of words is not as extensively ornamented as the mazes of Egypt or Etruria, I have been able to draw upon some supplemental visual artistry. Permission to reproduce photographs was graciously provided by the Bayerische Staatsbibliothek, Munich; the Biblioteca Apostolica Vaticana; the Bibliothèque Municipale, Dijon; the Bibliothèque Nationale, Paris; the Bodleian Library; the British Library; Her Majesty Queen Elizabeth II; Edwin H. Gardner; the Ghent University Library; the Laurentian Library, Florence; the Royal Commission on the Historical Monuments of England; the Soprintendenza Archeologica, Milan; and the Staatsbibliothek Preussicher Kulturbesitz, Berlin. Michel Baridon, William C. Irvine, and Leonard Boyle generously helped me obtain certain photographs, and Alison and Robert Ouellette provided expert assistance with other photographs and drawings. For dealing skillfully with the impact of the computer age on the generation and regeneration of textual mazes, I am grateful to Deirdre Maclean and Chris Monteith.

Once a verbal maze exists, its architect needs readers and listeners willing to venture inside and report on what they have seen. Many friends and colleagues have cheerfully traced various versions and segments of my labyrinthine text, and the book's present form owes a great deal to their comments; if those comments sometimes contradicted one another, that's what labyrinthine paradox is all about, and my task as architect has been to try to find some comprehensive if not transcendent resolution. I thank these courageous readers: Judson Allen, Ross Arthur, John Brückmann, Jane Couchman, Talbot Donaldson, Rachel Jacoff, Christopher Kleinhenz, Charlotte Morse, Glending Olson, Thomas L. Reed, Jr., David Staines, Brian Stock, Janet Warner, and Marjorie Woods. For suggesting unexplored by-ways and better paths after I thought my work completed, I am grateful to the readers so ably chosen by Bernhard Kendler of Cornell University Press: Christopher Baswell, James Miller, Hope Weissman, and Winthrop Wetherbee. Roger Haydon of the Press suggested appropriate finishing touches. While the manuscript has been much improved by the advice of all these fellow travelers, the academic enterprise remains an irrevocably multicursal maze in which I have sometimes insisted on my own way despite the wisdom of my guides. If errors remain, as they surely do, they go with

the territory. Indeed, errors *define* the territory—without *errores*, there's no labyrinth.

My greatest debt is to my husband, Graham Parker, who accompanied me to countless labyrinth sites, tolerated recurrent crises of confidence, and lugged innumerable books back and forth from libraries during the years I was embroiled in the impenetrable labyrinths of administrative office. More important, he read one draft after another, providing the judicious perspective that only a highly literate nonspecialist can give. Having endured the countless labors, errors, false turnings, and blind alleys I have brought upon him in the course of writing this book, he has staunchly remained my center and my path.

<div align="right">PENELOPE REED DOOB</div>

Toronto, Canada

Abbreviations

AJP	*American Journal of Philology*
ArchJ	*Archeological Journal*
Batschelet- Massini	Werner Batschelet-Massini, "Labyrinthzeichnungen in Handschriften," *Codices Manuscripti* 2 (1978), 33–65
CCSL	*Corpus Christianorum, Series Latina*
Charland	Th.-M. Charland, *Artes praedicandi,* Publications de l'Institut d'Études Mediévales d'Ottawa, 7 (Paris and Ottawa: Librairie Philosophique J. Vrin / Institut d'Études Mediévales, 1936)
Chaucer	Geoffrey Chaucer, *The Riverside Chaucer,* 3d ed., gen. ed. Larry D. Benson (Boston: Houghton Mifflin, 1987)
CSEL	*Corpus Scriptorum Ecclesiasticorum Latinorum*
CJ	*Classical Journal*
CR	*Classical Review*
EETS	Early English Text Society
e.s.	extra series
o.s.	original series
Etymologiae	Isidore of Seville, *Etymologiarum sive originum,* ed. Wallace M. Lindsay, 2 vols. (Oxford: Clarendon Press, 1911)
Faral	Edmond Faral, *Les arts poétiques du XIIe et du XIIIe siècles,* Bibliothèque de l'École des Hautes Études, fasc. 238 (Paris, 1924)
HF	*The House of Fame*
Inf.	*Inferno*
JMRS	*Journal of Medieval and Renaissance Studies*
Kern	Hermann Kern, *Labirinti: Forme e interpretazioni: 5000 anni di presenza di un archetipo,* trans. Libero Sosio (Milan: Feltrinelli, 1981)
Lewis and Short	Charlton T. Lewis and Charles Short, *A Latin Dictionary* (Oxford: Clarendon Press, 1879)
LCL	Loeb Classical Library

Matthews	W. H. Matthews, *Mazes and Labyrinths: Their History and Development* (1922; rpt. New York: Dover Books, 1970)
MED	*Middle English Dictionary*
MGH	*Monumenta Germaniae Historica*
M&H	*Medievalia et Humanistica*
MLN	*Modern Language Notes*
MLR	*Modern Language Review*
MP	*Modern Philology*
MS	*Medieval Studies*
NLH	*New Literary History*
Oxford Latin Dictionary	*Oxford Latin Dictionary*, ed. P. Glare (Oxford: Clarendon Press, 1968–82; consolidated ed., 1983)
Para.	*Paradiso*
PL	*Patrologia Latina*
Plato	*Plato: Collected Dialogues*, ed. Edith Hamilton and Huntington Cairns (New York: Pantheon Books, 1961)
PMLA	*Publications of the Modern Language Association*
PQ	*Philological Quarterly*
Pseudo-Bernard Silvester:	*The Commentary on the First Six Books of the* Aeneid *of Vergil Commonly Attributed to Bernardus Silvestris*, ed. Julian Ward
J&J	Jones and Elizabeth Frances Jones (Lincoln: University of Nebraska Press, 1977)
S&M	Bernardus Silvestris, *Commentary on the First Six Books of Virgil's* Aeneid, trans. Earl G. Schreiber and Thomas E. Maresca (Lincoln: University of Nebraska Press, 1979)
Purg.	*Purgatorio*
RES	*Review of English Studies*
SAC	*Studies in the Age of Chaucer*
Santarcangeli	Paolo Santarcangeli, *Le livre des labyrinthes: Histoire d'un mythe et d'un symbole*, trans. Monique Lacau (Paris: Gallimard, 1974; orig. publ. as *Il libro dei labirinti* [Florence: Vallecchi, 1967])
SP	*Studies in Philology*
StIR	*Stanford Italian Review*
UTQ	*University of Toronto Quarterly*

· THE IDEA OF ·
THE LABYRINTH

Charting the Maze

It may be good, like it who list,
But I do doubt. Who can me blame?
.
Alas, I tread an endless maze
That seek to accord two contraries;
And hope still, and nothing haze,
Imprisoned in liberties. . . .
—Sir Thomas Wyatt, Ballade 85

NCIENT and medieval labyrinths or mazes (the words have different etymologies but mean the same thing) are characteristically double. They are full of ambiguity, their circuitous design prescribes a constant doubling back, and they fall into two distinct but related structural categories. They presume a double perspective: maze-treaders, whose vision ahead and behind is severely constricted and fragmented, suffer confusion, whereas maze-viewers who see the pattern whole, from above or in a diagram, are dazzled by its complex artistry. What you see depends on where you stand, and thus, at one and the same time, labyrinths are single (there is one physical structure) and double: they simultaneously incorporate order and disorder, clarity and confusion, unity and multiplicity, artistry and chaos. They may be perceived as path (a linear but circuitous passage to a goal) or as pattern (a complete symmetrical design). They are dynamic from a maze-walker's perspective and static from a privileged onlooker's point of view. Their paths are linear, but—since many ancient and medieval labyrinths are round—their pattern may be circular, cyclical; they describe both the linearity and the architecture of space and time. They may be inextricable (if no one can find the exit) or impenetrable (if no one can find the center). Our perception of labyrinths is thus intrinsically unstable: change your perspective and the labyrinth seems to change. As images, then, labyrinths are convertible and relative: what you see and feel and understand one moment can shift completely the

1

next like a reversible figure, an optical illusion. Thus mazes encode the very principle of doubleness, contrariety, paradox, *concordia discors*, as Wyatt knew.[1]

Accordingly, the aims of this book are dual: to reconstruct the idea of the labyrinth in the western Middle Ages by extrapolation from a wide variety of sources, both literary and visual, and to see how that idea informs an array of important literary texts. I use the word *idea* to mean the general governing concept of the labyrinth as a visual or verbal sign, its ruling principles, the theoretical set of characteristics abstracted from and manifested in the specific labyrinths of art or literature. The idea of the labyrinth thus encompasses both formal principles (e.g., circuitousness, complexity) and habitual, culturally shared and transmitted significances of labyrinths (e.g., artistry, imprisonment). Unlike a Platonic idea, the kind of idea I'm talking about is not "true," universal, or immutable; like other human ideas, the idea of the labyrinth is subject to temporal change, the most marked change occurring in postmedieval times, when the presence of false turnings and repeated choice became the labyrinth's dominant characteristic. But because there is considerable constancy in the idea of the labyrinth over many centuries, including those spanned by this book, I speak of *an* idea (albeit one with permissible variations), not of *many* ideas. Since it allows for certain variations, this idea is not monolithic, a fixed and perfect template; rather, it includes a small repertory of attributes and associations among which a maze-maker can select, emphasizing these as opposed to those to shape the precise significance of this particular maze, which will in turn be interpreted by readers or viewers in accordance with their familiarity with the received idea of the labyrinth.

The word *idea* is also appropriate because I am interested not only in "real" labyrinths—mazes one can see and touch, things that are labeled labyrinths—but also in metaphorical labyrinths and in the very concept of the labyrinth. Thus I am also concerned with the labyrinth*ine*: with identifying certain features closely associated with labyrinths (for instance, enforced circuitousness; disorientation; the idea of planned chaos;[2] the *bivium* or critical choice between two paths; inextricability; intricacy; complexity), and with examining how constellations of these features operate in things, metaphors, and texts that function like labyrinths even though they may not be identified as such. In this context, I have coined the term "labyrinthicity," by which I mean the condition of possessing significant features habitually associated with labyrinths.

1. See epigraph to this chapter and Ballade 85 in *Sir Thomas Wyatt: The Complete Poems*, ed. R. A. Rebholz (New Haven: Yale University Press, 1978), pp. 120-121.

2. I first encountered this phrase in Alfred David's "Literary Satire in *The House of Fame*," *PMLA*, 75 (1960), 333-339, where it struck me as the perfect definition of a maze.

I speak of *reconstructing* the medieval idea of the labyrinth because I want to avoid imposing modern definitions and canons of interpretation on medieval mazes. The modern idea of a labyrinth is curiously limited. It holds that mazes must contain many points of choice between two or more paths (they are *multicursal*, to use a word that will recur throughout this study—see plate 4) with dead ends leading nowhere, and that they are intended to confuse and frustrate. This idea is not foreign to the Middle Ages: many literary texts assume a multicursal model, and some see confusion as the maze's primary function where others present bewilderment as merely a byproduct of brilliantly complex structure. But the modern concept of the maze excludes virtually all medieval labyrinths in the visual arts, which show a single winding path leading inevitably to the center and then back out again (they are thus *unicursal*—see plate 5). The medieval idea of the labyrinth allows both patterns, so modern readers must discard their mental image of the maze if they are to approach medieval examples and see what is actually there. Previous studies of medieval labyrinths have been seriously handicapped by their failure to appreciate, let alone to examine carefully, the implications of the coexistence of these radically different paradigms of the maze. Similarly, most modern studies of labyrinths manifest an interest in determining anthropological origins or archetypal significance.[3] This search for the Ur-labyrinth may tell us something about twentieth-century ways of thinking about signs in general and the labyrinth in particular, and it can provide cross-cultural insights and suggestive speculation about the maze's prehistory, but it tells us next to nothing about how *medieval* people saw and used the sign and hence has no place in my discussion. Instead, I want to recover what medieval people actually thought about mazes, what their "horizon of expectations" might have been when they heard the word *laborintus* or saw a maze in a cathedral nave, what they meant by the sign in their own works; I want to describe an appropriate code for deciphering medieval visual or literary works involving literal or metaphorical labyrinths, to define the "literary competence" required

3. See, e.g., Janet Bord, *Mazes and Labyrinths of the World* (London: Latimer New Dimensions, 1976); Philippe Borgeaud, "The Open Entrance to the Closed Palace of the King: The Greek Labyrinth in Context," *History of Religions*, 14 (1974), 1-27; Gaetano Cipolla, *Labyrinth: Studies on an Archetype* (New York: Legas, 1987); Raymond J. Clark, *Catabasis: Vergil and the Wisdom-Tradition* (Amsterdam: B. R. Grüner, 1979); C. N. Deedes, "The Labyrinth," in S. H. Hooke, ed., *The Labyrinth: Further Studies in the Relation of Myth and Ritual in the Ancient World* (London: SPCK, 1935), pp. 3-42; Kern, *Labirinti*; W. F. Jackson Knight, *Cumaean Gates: A Relation of the Sixth Aeneid to the Initiation Pattern* (Oxford: Blackwell, 1936); Matthews, *Mazes and Labyrinths*; Jill Purce, *The Mystic Spiral: Journey of the Soul* (London: Thames & Hudson, 1974); and Santarcangeli, *Livre des Labyrinthes*. My short study "The Labyrinth in Medieval Culture: Explorations of an Image," *University of Ottawa Quarterly*, 52 (1982), 207-218, based on papers given at Oxford in 1975 and at Ottawa in 1981, is very sketchy in comparison to the present book.

to appreciate labyrinth references and intertextualities.[4] The kinds of questions I want to answer are these: What was the documentable medieval reception and development of the form, concept, and meaning of the labyrinth, as witnessed by the broadest possible range of texts and visual images from both official and unofficial cultures? What were characteristic and atypical medieval ways of seeing the labyrinth? How did the idea of the labyrinth, both literary and visual, generate metaphor, and what are the consequent metaphorical uses of the sign?[5] How does the idea of the labyrinth function as a heuristic tool for understanding labyrinthine literary texts that may or may not explicitly identify themselves as labyrinths? This general focus on the medieval, the metaphorical, and the literary distinguishes my work from most recent studies of labyrinths.

Readers familiar with W. H. Matthews's seminal *Mazes and Labyrinths*, Paolo Santarcangeli's *Livre des labyrinthes*, and Hermann Kern's *Labirinti* may wonder why another book is necessary. First, these previous studies concentrate on the visual arts, not on literature, and certainly not on labyrinthine texts. Second, they treat the labyrinth from prehistory to the present, and the medieval idea of the labyrinth merits far more attention than they have given it. Third, despite their visual orientation, they give little or no attention to the formal implications of the two medieval paradigms of the maze and the tensions between literary and visual traditions. Fourth, my work deals more with metaphorical labyrinths than with real ones.[6]

The best way to suggest the scope, rationale, and methods of this book is through a brief overview of its contents. Part One lays the groundwork for the study of medieval labyrinths by examining several facets of the classical and early Christian background. Focusing on the written witness, Chapter 1 identifies, analyzes, and compares two major classical traditions associated with different kinds of literature and well-known to

4. See Hans Robert Jauss, "Literary History as a Challenge to Literary Theory," pp. 9-45 in *Toward an Aesthetic of Reception*, trans. Timothy Bahti, introd. Paul de Man (Minneapolis: University of Minnesota Press, 1982), and Jonathan Culler, "Literary Competence," pp. 101-117 in *Reader-Response Criticism: From Formalism to Post-Structuralism*, ed. Jane P. Tompkins (Baltimore: Johns Hopkins University Press, 1980). Culler's essay is excerpted from his *Structuralist Poetics* (Ithaca: Cornell University Press, 1975).

5. We encounter a chicken-or-egg question in regard to whether the visual image of the labyrinth generated myth and metaphor or vice versa. Given the great antiquity of the typical round, unicursal design, the visual image may have come first, begetting (or attaching to itself) myth and metaphor, but the question is really unanswerable.

6. I remain deeply indebted to Matthews's pioneering work and appreciative of the valuable studies of Santarcangeli, Kern, and Batschelet-Massini; these works have not significantly influenced my own approach or conclusions, but they have made this book shorter than I expected when I began my research in 1970, for they cover some ground so ably that, to paraphrase a medieval commonplace, if in some ways I can see farther and more accurately, it is because I am standing on the shoulders of giants I can cite in footnotes.

the Middle Ages—the historical-geographical, quasi-factual description of four ancient labyrinths as real buildings, discussed by Pliny the Elder, Strabo, and others, and the purely literary tradition established by Virgil and Ovid, the classical poets who most influenced medieval thought. Here I explore characteristically labyrinthine dualities—artistry vs. chaos, order vs. confusion, admirable complexity vs. moral duplicity—in these traditions and texts; I discuss the physical facts and narrative implications of the labyrinth and its associated myth; and I show how the written tradition presupposes the multicursal model of the maze, transmitting that model to the Middle Ages.

Chapter 2 focuses on the surprising conflict between written tradition and the visual arts, which endorse not the multicursal model but rather the unicursal model that persists in art throughout the Middle Ages. It is almost impossible to overestimate how remarkable this paradigmatic incompatibility is: as an analogy, imagine that literary descriptions of circles defined them as having four sides joined by right angles, whereas visual illustrations showed the figure we recognize as a circle. Other studies of the labyrinth at best mention the extraordinary discrepancy between medieval unicursal and modern multicursal visual models. But I will argue that it is precisely the peaceful coexistence of ancient and medieval *literary* multicursal models and *visual* unicursal models that is the key to understanding what medieval people meant by the word *laborintus*. Analysis of the two paradigms, then, constitutes the substance of Chapter 2. First I examine the formal implications of each model, showing how its characteristic features imply metaphorical potential; for instance, the presence of true and false paths in the multicursal maze may suggest the importance of correct moral or intellectual choice within a confusing world, whereas the single circuitous passage of the unicursal type argues that persistence in the difficult path prescribed by God— or in the devious path designed by the devil, or in the philosopher's complex argument—leads ineluctably to the appropriate destination, be it heaven, hell, or knowledge. Since the single word *laborintus* denotes both unicursal and multicursal models, and since the name and the visual image often appear together, classical and medieval people must have assumed that the paradigms, so contradictory from our point of view, shared enough common features to comprise a single category; therefore I deduce the classical-medieval definition of this category, *laborintus*, by identifying the two models' most important shared characteristics. The formal features that both models share broadly outline the general idea or the essence of the labyrinth; they reveal the most important criteria for labyrinthicity and shape the major aspects of the maze's metaphorical potential. Formal features specific to one model or the other fill in the picture and allow considerable flexibility in individual instances: medieval authors can pick the model that best suits the meta-

phor in mind, or (occasionally) they can select features from both models, or (very rarely) they can describe a transformation of one model into the other.

Chapter 3 shows how three shared formal characteristics generate a taxonomy of labyrinth metaphors: because of certain physical attributes, the labyrinth may be a sign of complex artistry, of impenetrability or inextricability, and of difficult intellectual, epistemological, and verbal process. These categories are illustrated and developed by a wide range of classical and early Christian texts, most of them known in the Middle Ages.[7] In a general sense, then, Chapter 3 is a case history in how properties of structural models generate, or at least support, literary metaphor; more particularly, the chapter documents the specific metaphorical heritage of the maze on which medieval writers and artists could, and did, draw in creating their own labyrinthine works and metaphors.

Part One thus describes the literary, conceptual, and metaphorical backgrounds of the medieval idea of the labyrinth. Part Two tackles that idea directly. A brief introduction, Chapter 4, considers Latin etymology and vernacular terms for mazes and condenses the various ambiguities of *labor intus* and *domus daedali* into three general categories of meaning roughly corresponding to those outlined in Chapter 3: artistry, morality, and difficult process. Each of these categories is then explored. Chapter 5 examines the witness of the medieval visual arts (architecture, gardens, turf and stone mazes, cathedral labyrinths, mazes in manuscripts) to see how it informs written texts by exemplifying, developing, and popularizing certain aspects of the medieval idea of the labyrinth; in return, the literary tradition casts light on some puzzling aspects of visual labyrinths, including the hotly debated function of cathedral mazes. The visual arts are the major medieval locus of the classical and early Christian concept of the labyrinth as magnificent artistry, whether human or divine; they also provide evidence for a purely secular view of labyrinths in a culture that moralized most things, including mazes, and give some insight into the mazes of popular and aristocratic cultures. Thus the interaction of literature and art enhances our understanding of each and enriches our perception of the medieval idea of the labyrinth.

Chapter 5 stresses Daedalian artistry, the visual arts, and the labyrinth *in bono*; Chapter 6 turns to morality, literature, and the deceitful, nearly

7. In most of this book (Part Three is an exception), I am not concerned with establishing the direct influence of one author on another. Most authors cited would have known both the unicursal visual design and the multicursal literary tradition, and I hypothesize that the idea of the labyrinth and its metaphorical potential are defined theoretically by the structural features, contrasts, and commonalities of the two models. If that is correct, then although many writers probably borrowed labyrinth metaphors from other writers, *any* writer could visualize a labyrinth and *independently* deduce appropriate metaphors without the mediating influence of a text.

inextricable mazes of the world and sin. Most of the texts considered here draw as heavily on the story of the Cretan labyrinth as on the ambiguous building itself, and that narrative context tends to equate the structural windings or *errores* of the maze with moral error. Three sets of texts are considered. First, several elaborate fourteenth-century mythographical readings of the Cretan legend illustrate the rich and comprehensive metaphorical potential of labyrinthine characters, plot, and structure within the allegorical tradition. Next, fairly casual references to the labyrinth in selected nonmythographical texts document the maze's commonplace metaphorical associations as background for more substantial discussion and fuller appreciation of particularly innovative works. The chapter concludes with four unrelated texts that draw more creatively on the plot and cast of the Cretan legend: the story of Gardinus in the *Gesta Romanorum*, Boccaccio's *Corbaccio*, the anonymous *Assembly of Ladies*, and the *Queste del Saint Graal*. Each text reflects the medieval idea of the labyrinth and presents the world as a perilous maze in which one learns how to function only with great difficulty, and in each the idea of labyrinth serves as a revealing interpretive tool.

Chapter 7 concludes Part Two with the most interesting group of metaphorical mazes: intellectual and textual labyrinths. Here the maze becomes a model for the complex processes of creating and receiving texts as well as for the object of these activities, the text itself as a work of elaborate art. The chapter addresses the question of a labyrinthine aesthetic and shows how labyrinthine qualities are privileged in literary theory and practice even though the term "labyrinth" is most commonly applied pejoratively to *failed* art, art that is too complex for its intended audience and purpose.

Part Three, "Labyrinths of Words," consists of four essays in practical criticism. Here I apply concepts developed in Parts One and Two to labyrinthine readings of four interrelated literary texts: Virgil's *Aeneid*, Boethius's *Consolation of Philosophy*, Dante's *Divine Comedy*, and Chaucer's *House of Fame*. Each of these texts plays with received ideas of the labyrinth, its plot, its characters; and each text reflects not only the idea of the labyrinth in its own age but also labyrinthine aspects of the texts that precede it in this remarkable series. Boethius uses and corrects Virgil's idea of the labyrinth; Dante uses and corrects Virgil and Boethius; and Chaucer makes extraordinarily innovative use of all three masters. These four works constitute a complex study in labyrinthine intertextuality and an appropriate conclusion to my explorations of the idea of the labyrinth. Thus these chapters illuminate the texts they discuss and serve as models for readings of other labyrinthine literature.[8]

8. I intend to pursue some such readings, most notably of several great English Ricardian poems, at a later date. Those who have heard my talks on the labyrinths of *Sir Gawain and the Green Knight* will have to wait for the appearance of that discussion in print.

Obviously my methodology is eclectic. By nature and training a literary historian with some interest in modern theory, I share Paul Zumthor's insistence on the need to respect the historicity of a text "and, simultaneously, to redefine, adapt, and sometimes reject modern critical concepts, so as to render them appropriate in seizing this historicity."[9] At the same time, I share many medievalists' conviction that a good deal of modern thought has medieval ancestry.[10] Thus I take a somewhat semiotic approach in considering the labyrinth as a sign with important formal attributes, but I don't see this as ahistorical or anachronistic: medieval philosophers were interested in sign theory and believed that the meaning of any conventional sign (*signum ad placitum*) derived not only from traditional usage but also from qualities inherent in the sign—its etymology, if the sign is a word; its natural attributes, if the sign is a thing—that make it an appropriate symbol of the thing signified.[11] Thus, for Isidore of Seville, *amicus* (friend) is derived from *animi custos* (guardian of the spirit), and the triangle, its three angles united in one geometrical figure, is an appropriate sign for the Trinity.[12] Since the labyrinth is both a word and a thing, its etymologies and physical structure help delineate its significance.

Similarly, reader response and reception theories of literature inform my interest in the reception of the labyrinth in the Middle Ages, my speculations on the labyrinth as process, and my assumption that neither the sign's meaning nor its significance in medieval texts is ever strictly determinate. But once again such concerns are not alien to medieval thought: rhetoricians and preachers were acutely sensitive to reader (or listener) response, and the labyrinth *topos* figures in such ruminations. Augustine discusses the polysemous nature of signs, and the validity of biblical interpretations never intended by the author, as long as these novel interpretations accord with the prevailing code, "the truth taught in other passages of the Holy Scriptures."[13] Ambiguity is as central to medieval hermeneutic practice as it is to the labyrinth itself. Deconstruc-

9. Paul Zumthor, "Comments on H. R. Jauss's Article," *NLH*, 10 (1978), 367-390.

10. For example, the labyrinthicity of texts, almost an *idée fixe* for J. Hillis Miller and a recurrent image in modern critical theory, has considerable medieval precedent, as we shall see. For Miller, see, e.g., "Stevens' Rock and Criticism as Cure, II," *Georgia Review*, 30 (1976), 330-348, where critical theory and texts are both seen as labyrinths. I hope to publish separately a short study of how medieval labyrinth theory anticipates modern critical theory.

11. On medieval sign theory and related issues, see Ross G. Arthur, *Medieval Sign Theory and Sir Gawain and the Green Knight* (Toronto: University of Toronto Press, 1987); Marcia L. Colish, *The Mirror of Language: A Study in the Medieval Theory of Knowledge* (New Haven: Yale University Press, 1968); and *Archéologie du signe*, ed. Lucie Brind'Amour and Eugene Vance, *Papers in Mediaeval Studies*, 3 (Toronto: Pontifical Institute of Mediaeval Studies, 1983).

12. Isidore of Seville, *Etymologiae* 10.4.

13. Augustine, *On Christian Doctrine* 3.27, trans. D. W. Robertson, Jr. (Indianapolis: Bobbs-Merrill, 1958), p. 102. As far as I know, Augustine does not consider what happens to the stability of a text if any part of it can be destabilized in the manner he describes. On

tionist ideas are also illuminating: the concept of *aporia* (the "unpassable path," self-contradiction, paradox) sheds light on the labyrinth's embodiment of paradox, its simultaneous affirmation of antinomies: order/ chaos, imprisonment/liberation, linearity/circularity, clarity/complexity, stability/instability. The view that what one sees in a text, however perverse by traditional critical standards, is worth writing about has encouraged me to be mildly speculative in discussing what a text expresses even if that expression may be remote from the writer's probable intention. But what medieval exegete ever acted differently?

In some ways my discussion of the medieval idea of the labyrinth may even illuminate some contentious issues in contemporary theory. For instance, since the labyrinth is a model simultaneously for artistic intention (the architect's plan), the integrity of a text (the labyrinth as artifact), and the experience of the reader (the well- or ill-informed choices of the maze-treader within the parameters set by the builder), it suggests some possible ways of dealing with the often conflicting claims of authorial intention versus reception in critical discourse.

Naturally, this study has limitations. It is not—nor does it aim to be—a catalogue of literary labyrinths comparable to Kern's catalogue of mazes in the visual arts; but I am reasonably sure that I have covered all *categories* of labyrinthine metaphor as well as a representative selection of classical and medieval works in which the idea of the labyrinth plays a major part. Much as I would have liked to locate certain ways of seeing mazes on the vast map of intellectual history by linking this interpretation with Platonists and that with Aristotelians, say, I have been unable to do so: there seem to be no systematic linkages between labyrinthine metaphors and particular schools of thought, although in a very gradual temporal change the word *labyrinth*, though not the visual image or the idea, acquired predominately moral and pejorative connotations, as we shall see.

Another unavoidable limitation is suggested by Hans Robert Jauss's comment that "modern scholarship still does not sufficiently differentiate between various levels of reception."[14] For Jauss, high-level reception

reader response approaches to medieval texts, see Chauncey Wood, "Affective Stylistics and the Study of Chaucer," *SAC*, 6 (1984), 21-40, which also discusses the citation from Augustine. Other discussions of modern critical theory in the study of medieval texts include Judson Boyce Allen, "Contemporary Literary Theory and Chaucer," *Chaucer Newsletter*, 3 (1981), 1-2; Morton W. Bloomfield, "Contemporary Literary Theory and Chaucer," in *New Perspectives in Chaucer Criticism*, ed. Donald M. Rose (Norman, Okla.: Pilgrim Books, 1981), pp. 23-36; Florence Ridley, "A Response to 'Contemporary Literary Theory and Chaucer,'" ibid., pp. 37-51; and, taking a conservative but constructive stance, A. J. Minnis, *Medieval Theory of Authorship: Scholastic Literary Attitudes in the Later Middle Ages* (London: Scolar Press, 1984).

14. Hans Robert Jauss, "Theses on the Transition from the Aesthetics of Literary Works to a Theory of Aesthetic Experience," in *Interpretation of Narrative*, ed. Mario J. Valdés and Owen J. Miller (Toronto: University of Toronto Press, 1976), pp. 137-147.

is the "dialogue of great authors," which creates truly innovative (and quite unpredictable) readings—Pascal reading Montaigne, for instance. Part Three of this book grapples with high-level readings in the labyrinthine tradition and by its very nature is not susceptible to "proof," if proof is ever possible in literary criticism. We know how commentators like Servius and pseudo-Bernard Silvester read the *Aeneid*, and we know how Benvenuto da Imola and Guido of Pisa read Dante's reading of the *Aeneid* in the *Divine Comedy*, but neither kind of evidence tells us how Dante read Virgil and his labyrinths. Middle-level reception involves "institutionalized reading," interpretations of texts and visual images by skilled readers whose comments reflect competence but not the idiosyncrasies of genius and result in "traditionalized and authorized meaning." Much of the material presented in Chapters 3 through 7 reflects middle-level reception and development of the idea of the labyrinth: commentaries on and uses of real and metaphorical labyrinths by men literate in Latin, schooled in the *trivium* (grammar, rhetoric, and dialectic), familiar with such standard curriculum authors as Virgil and Ovid and their commentators, and trained to read and interpret in predictable ways. Here I have drawn on as many kinds of primary written and visual sources as possible: letters, commentaries, poetry, historical and geographical treatises, theology, biblical exegesis, encyclopedias, arts of preaching and rhetoric, sermons, formularies, philosophical works, manuscript illuminations, and so on—material that defined and transmitted official institutional culture. The idea of the labyrinth that evolves in the first two parts of this book, then, is primarily the idea shaped and accepted in middle-level readings, for this is the idea that can most easily be reconstructed and documented. At the lowest level is "pre-reflective" reading, the personal responses of a relatively inexperienced reader encountering a work for the first time. There is little classical or medieval evidence for low-level reading of the maze for the simple reason that the medieval equivalents of modern low-level "readers" were illiterate and their responses to the labyrinth went unrecorded. We may detect traces of low-level readings in the names of turf-mazes or labyrinthine stone circles, or in preaching manuals and sermon collections whose content might have been transmitted to unlettered parishioners. But what is transmitted is not necessarily what is received, so we can only guess at low-level reception of the labyrinth in the Middle Ages. Thus much of this book recreates a middle-level horizon of expectations regarding labyrinths, and its conclusions about the medieval idea of the labyrinth are neither comprehensive nor a handy interpretive template to be applied mechanically to all medieval uses of the image.

There is yet another limitation to be acknowledged. I began studying medieval labyrinths almost twenty years ago while lecturing on Chaucer's *House of Fame* as a labyrinthine poem, and though I have worked on the

topic ever since, I have certainly not read everything published or in manuscript that might be relevant. Moreover, I am not a classicist or a specialist in Italian and French literature, and I have not read all the secondary material on the *Aeneid* or the *Divine Comedy* or the *Queste del Saint Graal*, to name but three works I treat at some length. Rather than refrain from discussing obviously pertinent texts, I have forged ahead in the hope that by looking at old material with fresh eyes, much-appreciated guidance from willing experts, and a different perspective—the view from the labyrinth—I can suggest new threads to follow through these textual mazes. I acknowledge these problems with regret but also with a lively awareness that treaders of multicursal labyrinths inevitably leave some paths untraced and forget what they learned in others. I sometimes think it is a miracle that I have extricated myself from this endless labyrinth of contraries at all: nineteenth-century discussions of church mazes are dotted with references to one M. Bonnin, who had collected more than two hundred maze designs that he intended to publish as soon as he had completed the accompanying text.[15] So far as I can tell, nothing ever appeared in print, and the cautionary figure of M. Bonnin stalks my nightmares.

Before this errand into the maze begins in earnest, two small points: first, in dealing with some examples of labyrinth metaphors, I address meanings that emerge from the immediate context of the image rather than from its place in the whole work, lest a long study grow completely out of bounds. Second, since I want this book to be useful not only to medievalists but also to nonspecialists interested in labyrinths, I quote most texts in translation, either a published version or my own.[16]

Finally, for readers who may not have details of the Cretan legend at their fingertips, I provide a summary based on Ovid but including a few details and variants from other classical and medieval retellings.

· The Cretan Labyrinth Myth ·

Outraged by the death of his son Androgeos in Athens, King Minos of Crete besieged that Greek city. Meanwhile, his wayward wife Pasiphae fell passionately in love with a handsome bull. To satisfy her lust, she enlisted the help of the Athenian Daedalus, master inventor of antiquity,

15. See Matthews, p. 201.

16. I have crosschecked published translations against the original and usually cite both versions—or easily available, facing-page Loeb editions—in notes. For my own translations, I have had generous assistance from Brian Stock and A. G. Rigg (Latin), Ross G. Arthur (Greek), and Christina Hawkes (German). When shades of meaning in the original language are important, I include the original in brackets.

who built her a wooden cow covered with hides. Pasiphae climbed into the cow, mated with the bull, and conceived the Minotaur, a monster with the body of a man and the head of a bull. When Minos returned triumphantly to Crete, he was shamed by this visible proof of his wife's lechery, and he bade Daedalus construct the confusing and inextricable labyrinth in which to emprison and conceal the Minotaur. So bewildering were the maze's paths that even Daedalus could scarcely find his way back to the entrance.

Every nine years (or, some say, every year), Minos fed the Minotaur with Athenian youths sent as tribute in atonement for the death of Androgeos. At the time of the third tribute, one of the fatal lots fell to Theseus, King Aegeus's son, who, with his companions, was brought to Crete. But Ariadne, Minos's daughter, fell in love with the young prince and determined to save him from labyrinth and Minotaur alike. To this end—and, some say, on the advice of the crafty Daedalus—she gave Theseus a clue of thread, which he tied to the entrance of the labyrinth and unwound as he followed the twisting paths to the center. There, some say, he took Ariadne's second gift, a ball of pitch, and threw it into the Minotaur's gaping mouth. Choking on the ball and unable to attack the man who should have been his prey, the Minotaur fell victim to Theseus's sword (or, in other accounts, his club). The young Athenian rewound the clue of thread, retraced his steps, and emerged safely from the hitherto inextricable labyrinth. Taking Ariadne and her young sister Phaedra with him, Theseus set sail for Naxos, where he abandoned Ariadne. Moved by her plight, the god Dionysus consoled her, transforming her crown into a constellation. Theseus and his companions sailed on to Delos, where they performed a labyrinthine dance in celebration of their escape from Crete. But Theseus's triumphant homecoming to Athens turned to tragedy. He had promised his father Aegeus that if by some miracle he escaped the labyrinth, he would replace the black sails on his ship with white ones. Having already forgotten Ariadne, Theseus was equally forgetful of his promise to his father: the black sails remained aloft, and the distraught Aegeus hurled himself into the sea.

Meanwhile Daedalus, inventor of the labyrinth, was himself made prisoner. Some say that Minos cast him and his son Icarus into the labyrinth as punishment for assisting Pasiphae or for having helped Ariadne save Theseus; others claim that Minos refused to let so ingenious an inventor return home to Athens. Whatever the truth may be, Daedalus made wings so he and Icarus might escape the maze by flight. Daedalus warned his son to take a middle course—the sun would melt the wax that held the feathers in place, the waves would drench them. But Icarus ignored his father's advice, soared sunward, and plummeted into the sea.

As Daedalus mourned, he was taunted by a partridge who had once

been his own nephew, Talos (or Perdix). This precocious lad had been apprenticed to his uncle, but when the child proved his brilliance by inventing the saw and the compass at the tender age of twelve, Daedalus grew jealous, threw him off the Acropolis, and fled to Crete. Athena, pitying the child, turned him into a partridge, a bird that still shuns heights because it remembers Talos's terrible fall.

After the death of Icarus, Daedalus flew to Italian Cumae, where he built a temple to Apollo, sculpting on its doors the story of the Cretan labyrinth. Some say that Daedalus then flew to Sicily, where he was welcomed by King Cocalus. Still seeking vengeance, Minos offered a reward to anyone who could thread a tightly spiraled shell. Daedalus, as crafty as ever, drilled a tiny hole in one end, inserted an ant with a thread attached to its body, induced it to enter by smearing honey on the shell's mouth, and thus traced the windings of the shell. Sure that no one but Daedalus could have accomplished such a task, Minos came to claim him, but the Sicilians, reluctant to give Daedalus up, murdered Minos.

The Labyrinth in the Classical and Early Christian Periods

The Literary Witness: Labyrinths in Pliny, Virgil, and Ovid

Dicamus et labyrinthos, vel portentosissimum humani inpendii opus, sed non, ut existimari potest, falsum.

We must speak also of the labyrinths, the most astonishing work of human riches, but not, as one might think, fictitious.

Pliny, Natural History 36.19.84

B Y THE time of Juvenal (ca. 60–131 A.D.), "that thingummy in the Labyrinth" and "the flying carpenter" who built it were the stock in trade of hack poets, and references to the labyrinth and its associated myth abound in classical literature. Of the many writers who treated the subject, three are particularly important, not merely because of their stature in their own age but also because they defined the labyrinth for early Christian and medieval writers, establishing a rich storehouse of labyrinthine characteristics and associations and laying the groundwork for the literal and metaphorical mazes of later literature. These three classical authors are Virgil (70–19 B.C.), Ovid (43 B.C.–17 A.D.), and Pliny the Elder (23–79 A.D.), whom I discuss in conjunction with other historical-geographical writers.[1] Each in his own way

1. For Juvenal, see Satire 1.53–54 (the Latin reads, "aut mugitum labyrinthi et mare percussum puero fabrumque volantem"). I quote Peter Green's racy translation in the *Sixteen Satires* (Harmondsworth: Penguin, 1967), p. 67; see also *Juvenal and Persius*, ed. G. G. Ramsay, LCL (London: Heinemann, 1940). For the three major texts, I follow Pliny, *Natural History*, trans. D. E. Eichholz, LCL, vol. 10 (London: Heinemann, 1962), 36.19; Virgil, *The Aeneid*, trans. H. Rushton Fairclough, LCL, 2 vols. (Cambridge: Harvard University Press, 1916; rev. ed. 1935), 5.553–603 and 6.1–105; Ovid, *Metamorphoses*, trans. Frank Justus Miller, LCL (Cambridge: Harvard University Press, 1956), 8.1–262.

Other historical-geographical writers include Herodotus, *The History*, trans. David Grene (Chicago: University of Chicago Press, 1987), 2.148; Diodorus of Sicily, *Bibliotheca historica*, trans. C. H. Oldfather, LCL, 10 vols. (Cambridge: Harvard University Press, 1960), 1.66; Strabo (called "The Geographer" in the Middle Ages), *The Geography*, trans. Horace Leonard Jones, LCL, 8 vols. (Cambridge: Harvard University Press, 1959), 17.1.37; and

expressed one major paradox inherent in the labyrinth image: its status as simultaneously a great and complex work of art and a frightening and confusing place of interminable wandering—the labyrinth as order and as chaos, depending on the observer's knowledge and perspective. But there is an important distinction among these seminal describers of the labyrinth: Pliny and other historical-geographical writers were interested chiefly in the *facts* of the ancient labyrinths, their status as buildings, their design and purpose, the skill of their architects; Ovid, ingenious author of entertaining fiction, was concerned chiefly with the *myth* (and to some extent the morality) of the Cretan maze, with the labyrinth's story rather than its structure; but Virgil, grand predecessor of both, writing fiction freighted with quasi-historical authority, was fascinated with story *and* structure, the path through the maze as well as its elaborate pattern. In this chapter we will see some of the literary effects of these various preoccupations.

Later writers, like their classical prototypes, also tend to emphasize either fact or fiction, building or legend, in their variations on the theme of the labyrinth. Writers emphasizing objective fact often follow Pliny by stressing magnificence of design, the maze as artistic building; those more concerned with myth or fiction follow Ovid and typically explore the subjective experience of being within a maze and suffering its intellectual confusions and moral delusions; and some rare authors, such as Dante and Chaucer, share Virgil's comprehensive vision and arrive at the richest developments of the idea of the labyrinth by blending labyrinthine fact and fiction, structure and story, objective pattern and subjective path. Metaphorical uses of the labyrinth to connote brilliant artistry often depend ultimately on the historical-geographical tradition of the labyrinth as a real building of dazzling complexity, viewed from a privileged perspective or with the sophistication of an architectural connoisseur, whereas metaphors involving confusion, error, and entrapment often rely more on the fictional-mythical tradition and an identification with those trapped in the maze.

The myth of the many-pathed ("multicursal") Cretan labyrinth existed in some form as early as Homer, who describes on Achilles' great shield the dancing-floor that Daedalus made in Crete for Ariadne, a passage often interpreted as alluding to the labyrinth.[2] The labyrinth design in

Pomponius Mela, *De chorographia*, ed. Carl Frick (Stuttgart: B. G. Teubner, 1968), 1.8.9 (56).

2. *Iliad* 18.590–592. Kern cites this passage as evidence that the first labyrinth was an intricate dance. See also Lillian B. Lawler, *The Dance in Ancient Greece* (Middletown: Wesleyan University Press, 1964), pp. 44–46, and James Miller, *Measures of Wisdom: The Cosmic Dance in Classical and Christian Antiquity* (Toronto: University of Toronto Press, 1986), pp. 24–25.

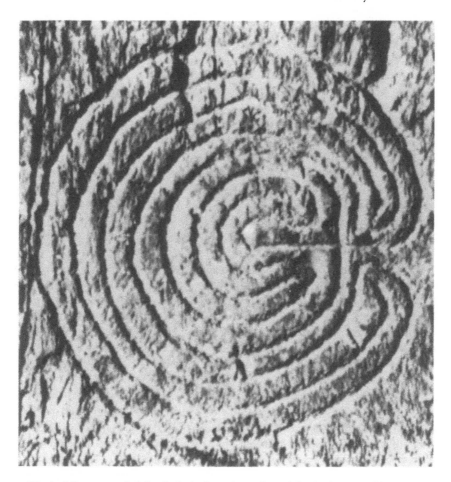

1. Typical Cretan-style labyrinth design. One of two labyrinths carved in stone at Rocky Valley, near Tintagel, Cornwall (ca. 1800–1400 B.C.). Photograph courtesy of Edwin H. Gardner.

the visual arts—a square or circular diagram in which a single un-branched ("unicursal") circuitous route leads inevitably, if at great length, to the center—is older still, dating back to prehistoric times (see plate 1).[3] Since this book must recognize some limits, I focus on the classical works most influential in early Christian and medieval times. Thus the origins and early transmission of myth and visual image alike—subjects of speculation rather than of knowledge—lie beyond my scope, and I regretfully exclude some classical treatments of the story as

3. See Kern, chaps. 1 and 4.

well.[4] The conflict between literary and visual models of the labyrinth, to which I have just alluded, is touched on here and there in this chapter when the subject naturally arises from the texts; it becomes the major theme of Chapter 2.

Here I address the most significant classical literary witnesses, and because labyrinthine "facts" in some sense underlie poetic fiction, I begin with the historical-geographical tradition, which describes not only the Cretan maze familiar to modern readers but also other ancient labyrinths, telling us what they looked like, how and why they were built, and what they were used for. This tradition, highlighting labyrinthine artistry, is at least as old as Herodotus (fifth century B.C.) and encompasses a number of authorities. Although Pliny's description of ancient labyrinths is comparatively late, among historical-geographical accounts it is fullest and best-known in the Middle Ages, and thus it provides a good framework for further discussion.[5]

Pliny considers the four labyrinths of the ancient world in the context of great architectural achievements, among which the labyrinths (in Egypt, Crete, Lemnos, and Etruria) were the most extraordinary (*portentosissimi*), incredibly complex in construction and inordinately expensive to build; the Etruscan labyrinth, the tomb of Lars Porsenna, in particular was an "insane folly" that "exhausted . . . the resources of a kingdom." Pliny assures his readers (perhaps those skeptical of the Cretan myth?) that these magnificent creations are "by no means fictitious." His emphasis on the labyrinths' architectural splendor is anticipated by Herodotus, who visited the Egyptian maze and found it even more splendid than the pyramids: "If one were to collect together all the buildings of the Greeks and their most striking works of architecture, they would all clearly be shown to have cost less labor and money than this labyrinth." Diodorus Siculus (fl. 49 B.C.) concurs, stressing the magnificence and magnitude of the Egyptian maze, whose artistic carvings, ceiling paintings, relics, and murals would have made it insurpassable in execution, had it ever been finished.

4. For classical sources and variants of the myth, see A. S. Hollis's edition of *Metamorphoses* Book VIII (Oxford: Clarendon Press, 1970), notes on 152–259; Howard Jacobson, *Ovid's Heroides* (Princeton: Princeton University Press, 1974), pp. 213–216; Plutarch's *Theseus*, which preserves material from now-lost sources; and Johannes Meursius, *Creta, Cyprus, Rhodus* (Amsterdam: Abraham Wolfgang, 1675), pp. 67–70. Robert Graves, *The Greek Myths*, 2 vols., rev. ed. (Harmondsworth: Penguin, 1960), sections 88, 90, 91, 92, 95, 96, 97, 98, is provocative, but Graves's interpretations (as opposed to retellings) must be taken with a large grain of salt. So too with Raymond J. Clark, *Catabasis*, chap. 5.

The most intriguing classical version of the myth—omitted here as irrelevant to the medieval tradition—is Catullus's Carmen 64:50–266.

5. Were the *Antiquitates* of Varro (116–27 B.C.) excerpted at length by Pliny extant, Pliny's importance for this study might pale in comparison. Although Pliny wrote after Virgil and Ovid, much of the material he codifies might have been known to these poets through Herodotus, Varro, and others.

The artistic preeminence of these labyrinths derives partly from the excellent artwork they contain but chiefly from their immensely complicated structure. Oldest and most illustrious of all was the Egyptian maze, which Pliny describes as still extant. This impressive monument inspired Daedalus, whose Cretan labyrinth, a markedly inferior copy, included only a hundredth of the "passages that wind, advance and retreat in a bewilderingly intricate manner [*quae itinerum ambages occursusque ac recursus inexplicabiles*]" in the Egyptian exemplar.[6] Not surprisingly, Pliny finds it impossible to describe precisely the groundplan of this complex building with its winding passages, vast halls, and temples.[7] The "bewildering maze of passages [*viarum illum inexplicabilem errorem*]" consists of several storeys above and below ground crammed full of columns, galleries, porches, and statues of gods, kings, and monsters. Most of the edifice is dark and noisy, for the passages are vaulted with marble and arranged so that "when the doors open there is a terrifying rumble of thunder within."

As if the maze were not already hard enough to visualize, Pliny reminds his contemporaries that this labyrinth bears no resemblance to the mazes they know: "It is not just a narrow strip of ground comprising many miles of 'walks' or 'rides,' such as we see exemplified in our tessellated floors or in the ceremonial game played by our boys in the Campus Martius, but doors are let into the walls at frequent intervals to suggest deceptively the way ahead and to force the visitor to go back upon the very same tracks that he has already followed in his wanderings [*sed crebris foribus inditis ad fallendos occursus redeundumque in errores eosdem*]." According to Pliny, then, the Egyptian labyrinth is quite unlike the unicursal, two-dimensional mosaic labyrinths surviving in some abundance

6. The Egyptian labyrinth was probably the mortuary temple of Amenemhet III at Hawara: see note *d* on pp. 68–69 of the Pliny text; Matthews, pp. 12–16; and Kern, chap. 3, who suggests that, to the ancients, "labyrinth" signifies chiefly "admirable stone building."
"Apollodorus" (date uncertain), whose concerns are chiefly literary, and Pausanias (fl. 150 A.D.), describing Greece, are the only historical-geographical writers to pay much heed to the vanished Cretan monument that modern readers think of as *the* maze. Naming Daedalus as the architect, "Apollodorus" describes the Cretan labyrinth, with what may be a tag from a lost play of Sophocles, as a chamber "that with its tangled windings perplexed the outward way"—*The Library* 3.4, trans. Sir James George Frazer, LCL, 2 vols. (London: William Heinemann, 1921). For Pausanias, who apparently assumes that no description of the labyrinth is needed, see *Description of Greece*, trans. W. H. S. Jones, LCL, 4 vols. (Cambridge: Harvard University Press, 1959), Attica, 27.10. Strabo (63 B.C.–19 A.D.) mentions the Cretan labyrinth in connection with Minos (10.4.8) but does not describe it; he also notes "the caverns, and the labyrinths built in them, which are called Cyclopeian" near Nauplia (8.6.1). The association of mazes with caves occurs periodically in classical and medieval literature.
7. Other authors mention twelve courts and three thousand rooms (Herodotus) or one thousand houses and twelve palaces (Pomponius Mela, first century A.D.), further testimony to the vastness of the Egyptian labyrinth, and all descriptions agree on the innumerable enclosed curving passages, colonnades, and subterranean tunnels that make the labyrinth so dazzlingly complex in layout.

from the classical period: these have no false turnings and offer no real possibility of getting lost but instead involve repeated turns and twists that infallibly guide the eye, finger, or footstep to the center (see plate 3).[8] Nor is it like the *lusus Troiae*, that horse-ballet/tournament ritual with interlocking paths so popular in imperial Rome, of which more later. Instead, the Egyptian building is a multicursal architectural construction, multistoreyed, full of twisting corridors and doors and halls, whose darkness and myriad passages would make a stranger become irretrievably lost.

As there is unanimity on the magnificence of the ancient labyrinths as works of art, so too there is agreement on the complexity of their floorplans. But some dissension exists concerning the exact nature of that complexity. Pliny explicitly contrasts the more complicated multicursal form of the Egyptian (and, by extension, the Cretan) labyrinth with the unicursal design of mosaic floors, and early authorities agree that one could easily get lost in three-dimensional labyrinths. But an intriguing hint of confusion between unicursal and multicursal designs may be found in Pomponius Mela's account of the Egyptian building, which has "one descent down to it, but inside has almost countless routes which are doubtful [*ancipites*] because of the many deviations, which turn this way and that with a continuous curvature, and entrances that are often dead ends [*revocatis*]. The labyrinth is entangled by these routes, which impose one circle on another; by their bending, which constantly returns as far as it had progressed; and by a wandering which is extensive but which can nevertheless be unraveled." Mela seems to want it both ways: the building's many paths, multiple internal entrances, and dead ends are sure signs of an inextricable, multicursal maze, yet at the same time he apparently envisages a single entry to the whole maze and a continuously curving path, winding back and forth, that eventually leads to extrication—a design that would resemble the unicursal pattern. Perhaps Mela simply blurred Pliny's careful formal distinction in trying to describe the maze's groundplan in words; but this uncertainty—or is it a tendency to see the maze as both unicursal and multicursal?—is characteristic of much classical and medieval thought and may reflect a reconciliation of the unicursal model familiar in art with the multicursal model of literature. We return to this subject in the next chapter.

If the great labyrinths are structurally so complex that they confuse wanderers and writers alike, why so? What is the reason for such elaborate structure? The historian-geographers do not tell us directly, but they permit informed guesses. One reason may be purely aesthetic. Labyrinths are insurpassable paragons of architectural skill, and many writ-

8. For these pavements, see Matthews, chap. 8; Santarcangeli, chap. 9; Kern, chap. 6; and chap. 2 below.

ers make a point of preserving the names of the architects: the maze-maker Daedalus's fame is widespread, and Pliny mentions the restorer of the Egyptian maze and the Lemnian architects while noting with chagrin that the forgotten designer (*artifex*) of the Etruscan maze deserved greater praise than its vainglorious sponsor, Lars Porsenna. As the pinnacles of human art, labyrinths might well be intensely complicated and artificial: the more elaborate, the more beautiful. As highly important buildings, too, labyrinths might fitly be intricate. True, the precise functions of ancient mazes were open to debate. According to some sources, the Egyptian and Etruscan labyrinths were monuments to their commissioners, who were either entombed within or simply memorialized. Others suggest that the Egyptian labyrinth was, or included, a great palace.[9] As witness to the preeminence of patrons and architects alike, an ornate and intricate structure, "greater than all human works" according to Herodotus, is justifiable on purely artistic grounds. So too if, as Pliny reports, the labyrinth was a temple to the Sun-god and contained precincts for all the Egyptian gods.[10] The religious and commemorative functions of ancient labyrinths suggest another reason for complex structure: as protection, to impede access to sacred places or to deny a quick escape to thieves or the sacrilegious. We will see variations on many of these putative functions of the Egyptian labyrinth later: the complex architectural splendor of a labyrinth makes both a compelling propagandistic statement honoring architect or commissioner and an effective defense against intrusion. Form follows function.

Although there may be ample aesthetic and pragmatic justification for the intricacies of the Egyptian, Lemnian, and Etruscan mazes (the Cretan labyrinth presents a different problem, as we shall see), the *effect* of such buildings is curiously double, enforcing dismay as well as delight. Pliny notes that visitors to the Egyptian labyrinth are "exhausted with walking" even before reaching "the bewildering maze of passages," and he cites Varro's description of the pyramid-bedecked "tangled labyrinth [*labyrinthum inextricabile*]" in Etruria, "which no one must enter without a ball of thread if he is to find his way out." Even with a guide, Herodotus experienced "countless marvelings" at the Egyptian maze's "extreme

9. For the labyrinth as tomb see Pliny, who suggests numerous reasons for the Egyptian maze's construction; Diodorus (1.66); Herodotus (who claims that twelve cooperative Egyptian kings created a common monument to their glory); and Strabo. For the labyrinth as palace see Demoteles (cited by Pliny); Herodotus; and Strabo. We know nothing about the function of the labyrinth on Lemnos.

10. Strabo cites another use for the Egyptian labyrinth: citizens administered justice there in important cases and sacrificed to the gods. Why these functions require so complex a building is not immediately obvious unless ancient law was as labyrinthine as Victorian law seemed to the Dickens of *Bleak House*. In any case, the connection between judgment and labyrinth, reflected in the association of the Cretan labyrinth with Minos the Law-giver, recurs in Dante's *Divine Comedy*, Chaucer's *House of Fame*, and the anonymous *Assembly of Ladies*, to be discussed later.

complication," and he never penetrated the dangerous lower chambers inhabited by dead kings and sacred crocodiles. Strabo comments that "no stranger can find his way either into any court or out of it without a guide." In short, the complexity of these mazes renders them baffling to strangers within, however admirable the buildings may be from a purely artistic point of view. For historical-geographical writers, the labyrinth is thus simultaneously a stupendous work of art and an image of confusion: objectively, as artifact, it is a magnificent design; subjectively, as experience, a potential chamber of horrors. Because of its structural complexities, its vast array of halls, crypts, corridors, and winding paths, its "ambages," "anfractus," and "errores," the labyrinth is difficult to enter and to leave ("inexplicabilis," "inextricabilis"). And the legacy of this legendary complexity? As later metaphorical uses of "labyrinth" suggest, any complicated building with many chambers and corridors is potentially labyrinthine; any building or mental process difficult to penetrate or escape without a guide is a kind of maze; and the most authentic mazes, at least in literature, are multicursal, allowing wrong choice and, consequently, perpetual entrapment.

Some solutions to the maze's entanglements are implied or stated by ancient writers. Visitors may have a guide or a ball of thread; habitués may learn the labyrinth's intricacies in time. Strabo recommends changing one's point of view: from the top of the building, one can see its design more clearly. This is the earliest reference I know to the important idea that the maze's ability to bewilder depends on one's perspective, in that a privileged view from above may (like the diagrammatic mosaics) reveal a clearly articulated groundplan, whereas anyone inside the structure will be reduced to confusion. Once you learn the maze or see the labyrinth whole, then, elaborate chaos is transformed into pattern. This potential conversion of the labyrinth from confusion to order, from involved process to brilliant product, is a common theme in later writings, particularly those dealing with metaphorical mazes of epistemology or of literary texts.

What are the main features of the historical-geographical labyrinth that inform later literal and metaphorical treatments of the image? First, the labyrinth is a miraculous work of art, a masterpiece of master-architects, a fitting monument to the fame of designer and commissioner, a worthy temple or palace for gods or men. Second, the very intricacy that makes the maze an architectural wonder as an artifact renders it almost incomprehensible as a process experienced by the disoriented wanderer. There is thus a pronounced tension between the maze as complex order and the maze as chaos. This characteristic ambiguity and convertibility of the maze, perceived as an inextricable prison one moment and as great art the next, is often encountered in later labyrinthine art and metaphor. In short, the maze is an embodiment of

contraries—art and chaos, comprehensible artifact and inexplicable experience, pleasure and terror. Other attributes of the maze important to later writers appear in these early descriptions. Darkness and noise, concomitants of chaos, recur in later labyrinths. So too with some of the maze's functions: as a tomb (later associations will be with death or with hell); as an elaborate memorial to sponsor or builder; as a place of worship or judgment; as a place requiring a guide; as a fitting habitat for monsters, whether painted (as in Pliny) or real (as in Herodotus); as an image of deceptiveness; and as a building intricately designed to protect from intruders what lies within. All these connotations of the labyrinth's structure, effect, attributes, and functions reappear in later works, perhaps most systematically in Chaucer's *House of Fame*.

Because the Egyptian maze was the most fully described of the four ancient labyrinths, later physical descriptions of labyrinths as buildings, as real places, are frequently based on the Egyptian monument, the Cretan maze having been dismissed by Pliny as analogous, inferior, and derivative.[11] In the twentieth century, labyrinthine speculations can be based on Sir Arthur Evans's archaeological research, which uncovered an elaborate palace at Knossos built between 1800 and 1400 B.C. and profusely decorated with meander patterns and double axes (the labrys) related to the Minoan bull cult.[12] But this Cretan palace, destroyed in 1400 B.C., was unknown to classical and medieval writers and had no direct impact on literature or the visual arts, unless perhaps its very disappearance permitted imaginative legends about the Cretan maze to thrive unchecked by constricting reality.

These legends, the stuff of fiction rather than the "facts" we have just examined, were most authoritatively transmitted to later periods by Virgil's *Aeneid* and Ovid's *Metamorphoses* and *Heroides* 10, which became standard school texts in later classical and medieval times. The poems as-

11. Some authors, Cedrenus and Claudian among them, thought the real Cretan labyrinth was a system of caves at Gortyna instead of a building at Knossos: see Matthews, p. 23; Charles Daremberg, *Dictionnaire des antiquités* (Graz: Akademische Drück-u. Verlagsanstalt, 1969), *s.v. labyrinthus*. Kern (chap. 2) discusses the tradition of the labyrinth as a cave but assumes that no Cretan labyrinth structure ever existed; instead, the Cretan labyrinth design, so common on Hellenistic coins, describes the choreographic pattern of a labyrinth dance signifying the end of Athenian tribute to Crete, an initiation rite, or the role of Theseus as true founder of the city of Athens. Perhaps; but I am concerned neither with speculation on the unknowable ultimate origins of pattern and legend nor with the maze's prehistoric religious or other functions but rather with documentable classical and medieval interpretations of the labyrinth.

12. See Arthur John Evans, *The Palace of Minos at Knossos*, 4 vols. (London: Macmillan, 1921); for a brief summary, see Matthews, chap. 6. One fresco of meander patterns constitutes the only early example of a multicursal maze, although there is no clear entry and no center: see Evans, fig. 256. For further anthropological-archaeological twentieth-century comments on Egyptian and Cretan labyrinths, see Knight, *Cumaean Gates*; Borgeaud, "The Open Entry"; Clark, *Catabasis*; Deedes, "The Labyrinth"; Santarcangeli, chaps. 4 and 5; and Kern, chaps. 2 and 3.

sume prior knowledge of the Cretan myth, though it is not clear whence that knowledge would normally have come; for some readers, it might have been supplied by commentators such as Servius (b. ca. 350 A.D.).[13] Most of the explicit references to the Cretan legend in Virgil and Ovid (Virgil's description of the *lusus Troiae* is an exception) stress the story of the maze, not its structure; their interest lies more in the characters whose destinies are touched by the labyrinth than in the grand artifact itself. Hence while the labyrinth continues to connote artistry, if only because it was built by the great architect Daedalus, negative connotations of confusion and imprisonment come increasingly to the fore, and the complex *process* of the labyrinth overshadows the idea of the labyrinth as complex *product*. If historical-geographical writers, delighted by labyrinthine artistry, provide ancient roots for metaphorical interpretations of the labyrinth *in bono*, classical poets tend rather to anticipate the labyrinth *in malo*.

Virgil uses the image of the labyrinth far more richly than either Pliny or Ovid. In Chapter 8, I show how the labyrinth functions as a central image in the *Aeneid* as a whole; here, however, I discuss only the two passages that refer explicitly to the labyrinth and thus help establish its potential metaphorical significance in later ages.

The first passage (*Aeneid* 5.545–603) is an exception to the general rule that classical poetry stresses the plot and characters of the Cretan myth rather than the labyrinth as artifact, and as an exception it provides a useful transition between the historian-geographers and the poets. Here Virgil describes the culmination of Anchises' funeral games in Sicily, where the more timorous Trojans will remain to build a new Troy. Aeneas summons his young son Ascanius, who has devised an elaborate course for his fellows on horseback ("cursus . . . instruxit equorum," 5.549) to honor Anchises. Three mounted troops of a dozen boys each are led forth by little Priam, Atys, and Ascanius, galloping in intricate patterns, charging and withdrawing, "interweaving circle into circle in alternation" (5.584/768), now feigning battle, now peace.[14] To suggest the entwined complexity of this ritual, Virgil uses two similes:

> ut quondam Creta fertur Labyrinthus in alta
> parietibus textum caecis iter ancipitemque
> mille viis habuisse dolum, qua signa sequendi

13. Readers may wish to refer to my summary of the story at the end of the Introduction.

14. Although hereafter I quote Fairclough's archaic but literal prose LCL translation of the *Aeneid*, giving parenthetical references to Latin line numbers, here I quote Allen Mandelbaum, *The Aeneid of Virgil* (Berkeley: University of California Press, 1982), l. 768. Alternative interpretations in square brackets are my own, and, along with comments on various shades of meaning, are based on Lewis and Short, checked against the *Oxford Latin Dictionary*.

falleret indeprensus et inremeabilis error:
haud alio Teucrum nati vestigia cursu
impediunt texuntque fugas et proelia ludo,
delphinum similes, qui per maria umida nando
Carpathium Libycumque secant luduntque per undas. (5.588–595)

As of old in high Crete 'tis said the Labyrinth held a path woven with blind walls, and a bewildering [double] work of craft with a thousand ways, where the tokens of the course were confused by the indiscoverable and irretraceable maze: even in such a course do the Trojan children entangle their steps, weaving in sport their flight and conflict, like dolphins that, swimming through the wet main, cleave the Carpathian or Libyan seas and play amid the waves.

Virgil goes on to say that Ascanius revived the game when he encircled Alba Longa with walls and that it has come down to Virgil's day "as an ancestral observance" (5.601); in Augustan times, he says, "the boys are called Troy and the troop Trojan" (5.602).

The *lusus Troiae* or Trojan Ride was well known in Rome. Noble youths staged these complex equestrian ballet-tournaments at least as early as Sulla's time (ca. 80 B.C.); the rides contributed to the festivities at Julius Caesar's triumph in 46 B.C., Augustus favored them, and Nero performed in them.[15] Of course Virgil is complimenting Augustus by tracing the origin of the *lusus Troiae* to Aeneas and Ascanius, but it is nevertheless possible that the game is indeed ancient and that tradition informed Virgil's linking of the game with the labyrinth: an Etruscan wine-pitcher dating from the seventh or sixth century B.C. shows two horsemen riding out of a diagrammatic unicursal labyrinth with "truia" inscribed in one of its coils (see plate 2). The meaning of *truia* is much debated: possibly an Etruscan word for "Troy," it is also, more hypothetically, an obscure Latin word meaning "dancing-floor" or "arena."[16] The design clearly establishes a connection between rituals on horseback

15. See Suetonius, *The Lives of the Caesars* 1.43 and 6.7; Matthews, chap. 18; and John L. Heller, "Labyrinth or Troy Town?" *CJ*, 42 (1946), 123–139, which discusses attempts to reconstruct the game. For an extensive bibliography of Troy-game literature, see August Friedrich von Pauly, *Realencyclopädie der classischen Altertumswissenschaft*, ed. Georg Wissowa (Stuttgart: Alfred Drückenmuller Verlag, 1956), Suppl. 8, cols. 904–905. Kern (chap. 5) cites the games at the founding of Alba Longa to support his hypothesis that labyrinth dances, on or off horseback, were practiced at the founding of Roman cities as a magically protective act delimiting a privileged space; he also sees the game as a male initiation rite. I see no clear evidence for either conjecture, although the youth of the riders offers some, if not sufficient, support for the initiation theory.

16. For the Tragliatella pitcher, see G. Q. Giglioli, "L'oinochoe de Tragliatella," *Studi Etruschi*, 3 (1929), 111–159; Kern, pp. 87–91; and Heller, "Labyrinth or Troy Town." For the etymology, see Heller's article and his "A Labyrinth from Pylos?" *American Journal of Archaeology*, ser. 2, 65 (1961), 57–62. The significance of the couples copulating rather ingeniously behind the labyrinth is puzzling: are mazes linked with lust this early?

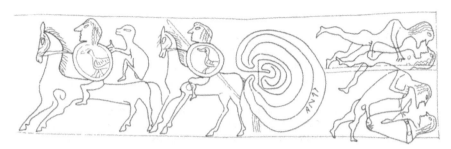

2. Horsemen, Cretan-style maze, and copulating couples from the Tragliatella wine-pitcher (Etruscan, seventh century B.C.). The inscription in the maze design reads "Truia." Drawing by Robert Ouellette after G. Mariani.

and labyrinths, so Virgil was presumably not creating his simile from thin air. Whether or not the Etruscans also anticipated his linking of such games with Troy, and I tend to agree with John L. Heller that they did, there may be a connection between the *lusus Troiae* of Iulus Ascanius and the abundant turf-mazes and stone circles of northern Europe often known as "Troy-town" or "Julian's Bower," discussed in Chapter 5. For the moment, I limit my observations to other qualities of the labyrinth that later readers might have extrapolated from Virgil's account. (This extrapolation might work two ways: from the brief description of the maze itself, or by analogy from the description of the labyrinthine Trojan ride.)

Several aspects of the maze in Book 5 can be mentioned very briefly. Virgil, like the historian-geographers, connects the maze with fame and memory, at least by analogy, in associating labyrinthine games with the honoring of Anchises and the implied honoring, in later Roman rides, of Rome's Trojan ancestors. And Virgil here associates the labyrinth with (fairly serious) play and game, although few later writers develop the idea. Three aspects of Virgil's *lusus Troiae*/labyrinth simile require fuller discussion.

The comparison of the *lusus Troiae* to the labyrinth is based on the fact that both are complex in pattern, difficult to follow, and interwoven ("alternosque orbibus orbis / impediunt," "textum"). This complexity is partly the result of a multicursal design: if the Cretan labyrinth has its thousand ways, the *lusus Troiae* has at least three interlocking paths corresponding to the three troops of riders with their entangled steps. In maze and game alike, complexity derives from studied artistry: the Trojan ride, a performance of considerable intricacy, presumably required a Daedalian choreographer (Epytides? Ascanius himself?) who taught ("instruxit") the figures to performers who had to be "paratum," ready,

probably in the sense of "rehearsed." This impression of artistry is heightened by the description of the maze itself as "ancipitem . . . dolum," a double (multicursal?) work of craft. The comparison of game to labyrinth is apt, then, because of the artistic complexity they share.[17] The effect of this complexity, however, differs. In the maze, described as if experienced from within, the emphasis is on confusion and entrapment ("indeprensus et inremeabilis error"—indiscoverable and inescapable wandering). The Trojan Ride, admired from without, elicits only joy, and its participants, having committed the pattern to memory, appear to feel no confusion. Here again is the perspective-dependent paradox of the artistic labyrinth: within, at least to the untutored, all is tricky chaos; without, or to the enlightened maze-treader, all is careful pattern. This passage, like Strabo's offhand remark, might suggest to a thoughtful interpreter that labyrinths and labyrinthine art, properly absorbed and understood, viewed from the right mental or physical angle, are quite literally art of the highest order; but it might also anticipate the common late medieval reluctance to call pleasurably labyrinthine art a labyrinth in fact (see Chapter 7). The Trojan Ride is very like a labyrinth, but Virgil gives us a simile, not metaphorical equation; readers are free to limit or expand the resemblances between game and building.

A related extrapolation is that Virgil suggests the coexistence of process and product in the *lusus Troiae*/maze comparison. The labyrinth itself is characteristically dual, both an artifact—a work of objective craft—and a sequence of bewildering disorientations; the Trojan Ride includes not only the dynamic movements of the mounted troops but also, implicitly, the static patterns left on the sand by the horses' hooves, patterns that presumably help suggest the comparison to a labyrinth. In other words, Virgil evokes a *diagrammatic* pattern of the maze, which is more usually described as a *building*. Maze diagrams have been common since prehistoric times, and fourth-century Hellenistic coins spread the common unicursal circular design across the civilized Mediterranean; but Virgil's text is the earliest I know to envisage the two-dimensional design of a maze and link it with the three-dimensional Cretan building. His simile helps explain a problem that has bothered virtually every modern writer on the subject: how did the word *labyrinthus*, in classical literature almost always used for a building in which one could get lost, come to refer to the unicursal two-dimensional maze, in which one cannot get lost, found in Roman mosaics as in medieval churches and fields? Pliny shows that by his time the same word referred to both phenomena;

17. Indeed, the *lusus Troiae* is compared both to artificial complexity (the labyrinth) and to natural intricacy (the playfully interwoven paths of the dolphins); analogous comparison of Daedalus's work to nature's occurs in other classical and early Christian writings. See below, on the adjective *daedalus*, and chap. 3.

and Virgil's description of the *lusus Troiae*, which Pliny probably had in mind, may have helped the association to develop.[18]

Finally, we should note the presence and implications of some terms commonly used of labyrinths, terms that isolate special qualities of the maze: the blind walls, the double woven path, the thousand ways, the *inremeabilis error*. Virgil uses *texere* twice, and later analogies between discourse and labyrinths presumably reflect their similar status as texts, things woven.[19] What we do *not* find in this passage (or, for that matter, in the historian-geographers) is any overt reference to the Cretan labyrinth's salacious history or its chief mythological function: to conceal Pasiphae's shameful progeny and to imprison anyone who ventures within. Perhaps such references would be out of place in the description of an ancient, noble, ongoing Roman ritual. Nevertheless, there are— especially for postclassical readers—oblique glances at the negative face of the Cretan maze in such words as *anceps* ("double," but also "dangerous, hazardous, perilous"), *dolus* ("artifice; deception"), *inremeabilis* (from which, like hell or death, one cannot return), and *error* ("wandering, going astray"—physically, morally, or intellectually). But despite the latent seaminess of lexis and labyrinth alike, in Book 5 Virgil presents a labyrinth quite literally reformed: a complex artistic process and product, a conversion of the ancient Cretan prison to a playful, solemn, and forward-looking Roman ritual, very much a labyrinth *in bono*.

The history of the labyrinth *in malo*—or at least partly *in malo*—is outlined in Book 6.1-105, when Aeneas lands in Italy at Cumae. After passing through the groves of Trivia (Diana of the Crossroads), he comes to the temple of Apollo built by Daedalus, who there dedicated his wings to the god after his ill-fated flight from Crete. There too Daedalus sculpted door panels illustrating the Cretan legend: the death of Androgeos, the Athenian tribute to Crete, and Crete itself.

> hic crudelis amor tauri suppostaque furto
> Pasiphae mixtumque genus prolesque biformis
> Minotaurus inest, Veneris monumenta nefandae;
> hic labor ille domus et inextricabilis error;

18. Pliny's comment, quoted earlier, can be read several ways. He differentiates the Egyptian labyrinth from familiar Roman ones in that the Egyptian maze is multicursal and deceptive, on the one hand, and three-dimensional, on the other. He does not clearly identify the Trojan Ride—presented by Virgil as multicursal—as either multi- or unicursal: the main point of the passage is to contrast mosaic mazes with the Egyptian building, and the Ride seems to be brought in as a complex ceremony that uses mosaic-like two-dimensional floor-markings as a guide to the horsemen, an ancient analogy to the modern taping of stage floors to orient dancers.

19. The usage of *textus* to refer to a literary text, common in medieval Latin, occurs as early as Quintillian: see Lewis and Short and the *Oxford Latin Dictionary, s.v. textum/textus*, and Brian Stock, "Medieval Literacy, Linguistic Theory, and Social Organization," *NLH*, 16 (1984–85), 13–29, here 21.

magnum reginae sed enim miseratus amorem
Daedalus ipse dolos tecti ambagesque resolvit,
caeca regens filo vestigia. (6.24-30)

> Here is the cruel love of the bull, Pasiphae craftily mated, and the mongrel breed of the twiformed offspring, record [memorial, tomb] of monstrous [impious] love; there that house of toil [or: the workmanship of the house], a maze [a wandering, a going astray] inextricable; but lo! Daedalus, pitying the princess' great love, himself unwound the deceptive tangle of the palace, guiding blind feet with the thread.

Aeneas wants to study (*perlegere*) the relief, but the Sibyl hurries him on to her oracular and rather labyrinthine cavern with "its hundred entrances, hundred doors, whence rush as many voices" (6.43-44). Later Aeneas proceeds through labyrinthine quests for the golden bough and for his father Anchises in Hades: the maze at the temple doors is a significant clue to the book's action.

In Chapter 8, I treat the labyrinths of the *Aeneid* more fully, but several points claim attention now. If the labyrinth manifested complex artistry in Book 5, so too in Book 6, but the emphasis shifts from the labyrinth itself to its human context, its story. Virgil hints, albeit elliptically, why the labyrinth was built: to conceal the doubly named, double-natured Minotaur, and to bewilder the Athenians sent as its fodder. Inextricable error, deceptive windings, and dead ends are no longer mere aspects of artistic design but rather necessary impediments in a building whose multicursal form follows a sinister function; the Egyptian palace has become a prison, and the celebratory *lusus*, public ritual enactment of adult life, is replaced by a grim private ritual of death. The association of the labyrinth with fame, familiar from the historian-geographers and *Aeneid* 5, remains, but it shades into infamy: the labyrinth, like the Minotaur, is a monument to impious lust—indeed, to insane bestiality—and is implicated in Theseus's later betrayal of the loving Ariadne. The death implicit in the memorial functions of the Egyptian and Etruscan mazes and in Anchises' funeral ballet here becomes violent, unnatural. The literary ground is fully prepared for later metaphorical identification of the labyrinth *in malo* with destructive love, seductive treachery, sin, death.

So unspeakable are the labyrinth's causes and contents that its very name remains unspoken; we read simply "hic labor ille domus et inextricabilis error," yet the context and the presence of several key words—*labor, inextricabilis error, dolus, ambages*—make it clear that this is indeed the labyrinth. Few later descriptions of the maze, including Ovid's and Pliny's, do *not* include these words, which describe some of the most definitive characteristics of the labyrinth and shape its metaphorical potential. As many writers follow Virgil in punning on *labor* and *labyrinthus*,

so too many, Ovid and Prudentius among them, apparently assume their readers will understand "maze" when enough qualities and key words of the maze have been mentioned, even if the word "labyrinth" occurs nowhere in the text.

Yet *labor* is itself ambiguous: as a noun, it can refer to arduous *process*—toil, hardship, suffering—but it can also refer, far more optimistically, to a *product*, the accomplished work of an artist.[20] And despite the full weight that Virgil gives here to the horrors of the maze, it is Daedalus, among the maze's cast of characters, who dominates the passage as artist and father, escaping from the labyrinth he himself created to found a temple to Apollo, god of poets and artists, and ornamenting that vast new building with an image of the old labyrinth and a scene in which he offers a solution to its entanglements—a ball of thread—that he himself could not use once the maze had become his own prison. The art of the old labyrinth may have been in the service of evil, and the art of the new labyrinth and temple may carry seeds of failure and frustration (the artist cannot depict the death of his son Icarus, and he seems almost entrapped in the self-reflexive creation of new artistic mazes). Yet through his craftiness he has twice solved the inextricable labyrinth—by the *aide-mémoire* of a thread and by flight—and that flight in itself suggests the double perspective on mazes (the experience within, the view from without) we have met before. He has created the original labyrinth by art, and he has, in a sense, reduced its very real dangers to art in the service of Apollo. That reduction admittedly poses a different sort of danger to pius Aeneas, erstwhile wanderer in mazes of impious love; he must be chastened when he wishes to study the doors at length, to remain, after so many books of *errores*, in one labyrinth when he ought to be proceeding through others that lie ahead. Art, even difficult labyrinthine art, is no substitute for life and duty. Nevertheless, Virgil's emphasis on the role of Daedalus as artist necessarily presents the labyrinth as an artistic triumph as well as a house of suffering. The labyrinth's duality as art and as (moral as well as physical) confusion is restated.

The Daedalus-artist-labyrinth-Apollo conjunction here may authorize later associations of Daedalian art and labyrinths with poetry or rhetoric. The link between Daedalus and craftsmanship in general was commonplace, as use of the adjective *daedalus* ("artificial, skillful"; "intricately worked") makes clear. Thus Virgil praises "daedala Circe" (*Aeneid* 7.282), whose perverse brilliance in animal husbandry rivaled that of Daedalus (helping Pasiphae) when she mated immortal stallions with mortal mares, and in *Georgics* 4.179 the bees craftily construct "daedala tecta," labyrinthine hives. Often it is Nature who is Daedalian (Lucretius, *De natura rerum* 1.7 and 5.234). However, the connections between

20. Thus Lewis and Short interpret *labor* in this passage.

Daedalus and poetry are suggested by more writers than Virgil. Lu-
cretius speaks of "verborum daedala lingua" (4.549), "the tongue, cun-
ning crafter of words." Sextus Pompeius Festus, epitomizing the Au-
gustan Vérrius Flaccus, derives the adjective from the Greek *daidallein*,
"to vary"; a skillful varying of words is, after all, the essence of poetry,
and surely that is what the verbal pyrotechnician Ausonius (fourth cen-
tury A.D.) has in mind in coining "logodaedalia," a term he uses pe-
joratively despite his own exceedingly ornate practice.[21] Himself a cun-
ning crafter of words, Virgil is also skilled at variations on the Daedalian
art of the labyrinth, an image he transforms creatively even as he tames
it, Romanizes it. Seeing its dangers as well as its grand potential, he
shows Ascanius turning its complexity to a noble game of the warrior's
life and Aeneas extricating himself from its moral temptations and de-
laying byways to achieve his goal. For Virgil, passage through the laby-
rinth can be a (reversible) voyage from confusion to clarity, and so the
positive and negative connotations of the maze, its objective artistry and
its subjective disorder, are held in a delicate balance.

What Virgil handled allusively and suggestively, his younger contem-
porary Ovid treats in the *Metamorphoses* and the *Heroides* at greater
length and more literally; after all, Virgil subordinates the Cretan myth
to a greater purpose, the epic journey of Aeneas, whereas Ovid's subject
is myth itself, recounted with considerable detail, fanciful ingenuity, and
charming dramatic invention. The Ovidian focus on the characters asso-
ciated with the labyrinth rather than on the labyrinth itself domesticates
the maze, which becomes more important simply as a setting and less
resonant as an image than in Virgil. The dual status of the maze as
artistic marvel and moral emblem remains prominent, however, at least
in the *Metamorphoses*, to which we turn first.

Set in that large section of the *Metamorphoses* exemplifying what
Brooks Otis calls "the pathos of love,"[22] the Cretan interlude offers a
comprehensive version of the myth, including Minos's encounter with
Scylla, Pasiphae's conception of the Minotaur, its imprisonment in the
labyrinth built by Daedalus to hide Minos's shame, its death at the hands
of Theseus, his abandonment of Ariadne, the flight of Daedalus and
Icarus from Crete, Icarus's death, and—to point the poetic justice of
Daedalus's loss—the story of the master architect's murder of his clever

21. See Festus, *De verborum significatione . . . cum Pauli Epitome*, ed. Carl O. Mueller
(Leipzig: Libraria Weidmann, 1839), *s.v. daedalam*; and Ausonius, *Technopaegnion* 14.1.
 The location of Virgil's sculpted maze may also help establish an association between
labyrinth and poetry in later years: the temple lies near the groves of Trivia, the word itself
suggesting the crossroads inevitable in multicursal mazes and, for medieval commentators,
the academic *trivium*, which comes to have its own mazy associations. See Pseudo-Bernard
Silvester, J&J, pp. 30–31.
22. Otis, *Ovid as an Epic Poet* (Cambridge: Cambridge University Press, 1966), chaps. 6
and 7.

nephew, whose metamorphosis into a partridge provides humorously far-fetched justification for the inclusion of the whole history in Ovid's poem. That Ovid's audience, like Virgil's, knew this history intimately is clear from what Ovid omits even in his expansive retelling of the myth: we are not told, for instance, that Athens sent its young men to Crete as tribute for the death of Minos' son Androgeos, or that Daedalus helped Pasiphae consummate her lust for the bull, nor is the famous labyrinth ever called by its proper name, all points explained in great detail by medieval Ovidian commentators.

What Ovid *does* tell us about the labyrinth, that circumambulation named only by circumlocutions, is worth quoting in full for its tremendous importance in later literature.[23] Worried that his wife's foul lust was visible to all in the form of the "monstrum biforme," the Minotaur,

> destinat hunc Minos thalamo removere pudorem
> multiplicique domo caecisque includere tectis.
> Daedalus ingenio fabrae celeberrimus artis
> ponit opus turbatque notas et lumina flexu
> ducit in errorem variarum ambage viarum.
> non secus ac liquidus Phrygius Maeandrus in arvis
> ludit et ambiguo lapsu refluitque fluitque
> occurrensque sibi venturas aspicit undas
> et nunc ad fontes, nunc ad mare versus apertum
> incertas exercet aquas, ita Daedalus implet
> innumeras errore vias vixque ipse reverti
> ad limen potuit: tanta est fallacia tecti.
> Quo postquam geminam tauri iuvenisque figuram
> clausit, et Actaeo bis pastum sanguine monstrum
> tertia sors annis domuit repetita novenis,
> utque ope virginea nullis iterata priorum
> ianua difficilis filo est inventa relecto,
> protinus Aegides rapta Minoide Diam
> vela dedit. . . . (8.157-175)

Minos planned to remove this shame from his house and hide it away in a labyrinthine enclosure [lit.: many-folded house] with blind passages. Daedalus, a man famed for his skill in the builder's art, planned and performed the work. He confused the usual passages [or: confused the signs that might provide orientation] and deceived the eye by a conflicting maze of divers winding paths [or: led one's eyes into error by the winding twists of the various paths]. Just as the watery Maeander plays in the Phrygian fields, flows back and forth in doubtful course and, turning back on itself, beholds its own waves coming on their way, and sends its uncertain waters now towards their source and now towards the open sea: so Daedalus made those

23. As Otis notes, the "*Metamorphoses* was, more than any other work, the medium by which classical myth was known and understood"—*Ovid as an Epic Poet*, p. 343.

innumerable winding passages, and was himself scarce able to find his way back to the place of entry, so deceptive was the enclosure he had built.

In this labyrinth [lit.: in which] Minos shut up the monster of the bull-man form and twice he fed him on Athenian blood; but the third tribute, demanded after each nine years, brought the creature's overthrow. And when, by the virgin Ariadne's help, the difficult entrance, which no former adventurer had ever reached again, was found by winding up the thread, straightway the son of Aegeus, taking Minos's daughter, spread his sails for Dia.

Many points here were noted, adapted, embroidered, and sometimes rationalized by later writers. First, Ovid's account, perhaps even more than Virgil's, provides the raw material for a reading of the labyrinth *in malo*. As in the Cumaean sculpture, so here the labyrinth is functionally a prison; to that end were its inextricable complexities designed. Both the quoted lines and their larger Ovidian context, involving Scylla's passion for Minos and Ariadne's ill-fated elopement, emphasize the shamefulness of lust, for whose most outrageous product the maze was crafted. The fact that Minos the law-giver ordered the imprisonment of the Minotaur supports later associations of the maze with just imprisonment.[24] These points may well have influenced later redactors of a narrowly moral bent to consider the labyrinth a prison for monstrous cupidity, an image of sin, or hell itself, even though such interpretations belie Ovid's typically deft presentation (and diminution) of the labyrinth as a private lunatic asylum commissioned by a cuckolded king to prevent personal embarrassment.

If Ovid fuels the interpretation of the labyrinth *in malo*, however, he also accentuates the artistry of the maze, not so much in describing it as in remarks about Daedalus the master builder and inventor who, despite his dubious morals, comes fairly to fame as the greatest of artists, his many-folded house the supreme achievement of human architecture, however greatly Pliny might have preferred the anonymous Egyptian architects.[25] But Ovid also presents Daedalus almost as a trickster who

24. Minos was proverbially a law-giver in the ancient world: see Plato, *Laws* 1.630D; *Apology* 41A; *Gorgias* 524A. For Strabo, the Egyptian labyrinth was also a place of judgment. Presumably the (Pythagorean) choice between paths, one's final location in Hades, and the act of judgment after death were often interconnected, as in the *Gorgias*.

25. Daedalus's reputation is incorporated into the Latin language itself: as we have seen, "daedalus" comes to mean "skillful, artificial," and the man himself is glossed repeatedly as the greatest *artifex*, even a *figura* for God: see Fausto Ghisalberti, "L'Ovidius Moralizatus di Pierre Bersuire," *Studj Romanzi*, 23 (1933), 129–130, and *Ovide moralisé en prose*, ed. C. de Boer, *Verhandelingen der Koninklijke Akademie*, 61 (1954), p. 229. In the classical period Daedalus was famed for having created moving statues (see Plato, *Meno* 97D) as well as labyrinth and wings, and in the *Euthyphro* (11B–D) Socrates himself jokingly claims descent from Daedalus. Diodorus Siculus reports that Daedalus was so great an artist that the Egyptians worshiped him as a god (1.97). Yet his work was not always honored in classical times: as his masterpiece, the maze, has a dual potential, so too does its architect. Plato

outwits himself: the remarkable ability to alter nature through art (8.188-189) leads to the death of his son, and as for his mazy masterpiece, we learn that even Daedalus could scarcely retread the ambiguous corridors of his own construction. While in a sense this comment undercuts Daedalus's stature—he becomes an absent-minded professor of architecture rather than the tragic figure of the *Aeneid*—it also suggests the provocative possibilities of the complex maze as a symbol of the deceptive trickiness of difficult art. The ingenious planner comprehended his creation as artifact, but he was almost thwarted by the maze as process. Later uses of the maze to signify difficult art—art that loses its viewers or readers because of its devastating complexity—may well be indebted to Ovid, whose story of the baffling labyrinth that bewilders its own creator was so well known. Here, as in later variations on this theme, the maze's convertibility works both ways: from disorder to order and sometimes, treacherously, back again.

The *Metamorphoses* highlights many qualities of the labyrinth found in Pliny and Virgil: the complex artistry of the building, its ability to entrap, its multicursal winding ways, its deceptive nature, its darkness ("caeca tecta"), and the need for a guide, a perfect architectural memory, or wings to get out. The maze's duality as artistic order and physical confusion survives in Ovid, and yet the weight of context and lexis (*ambages, ambiguus, error, variae viae*) tips the balance toward confusion both physical and moral, especially given Daedalus's own difficulties with his re-

mentions that "according to the sculptors Daedalus would look a fool if he were to be born now and produce the kind of works that gave him his reputation" (*Hippias Major* 282A). For other writers, too, he is (merely?) an astrologer: see Palaephaetus, *De non credendis historiis libellus* (Antwerp: Gregorius Bontius, 1528), A6r.

Martianus Capella sees Daedalus as an ancestor of Geometry, who can represent the heavens on her abacus board (*De nuptiis philologiae et mercurii*, ed. Adolph Dick [Stuttgart: B. G. Teubner, 1969], VI.579). Commenting on this passage in the ninth century, Remigius of Auxerre takes the typical medieval view: "Daedalus, that is, every ingenious man"—*Commentum in martianum capellam*, ed. Cora E. Lutz (Leiden: E. J. Brill, 1965), 289.1; and for Alan of Lille (ca. 1116–ca. 1202) he is the master builder (*Anticlaudianus* 2.352). Benvenuto da Imola (fourteenth century) took a rather more jaundiced view of the matter, doubting that Daedalus or any other one person could have built the labyrinth, a subterranean work of great complexity: *Comentum super Dantis Aldigherij Comoediam*, ed. J. P. Lacaita, 5 vols. (Florence, 1887), 1, 387. Nevertheless, Daedalus's medieval reputation was glorious and widespread: a ninth-century architect named Winihard at St. Gall was praised for being like Daedalus in ingenuity (Hans Reinhardt, *La Cathédrale de Reims* [Paris: Presses Universitaires de France, 1963], p. 76); a fourteenth-century formulary from Orléans mentions a request to "the most learned of architects, worthy of being compared to Daedalus," to repair a mill, arguably a rather paltry task (*Le Formulaire de Tréguier*, ed. Léopold Delisle [Orléans: H. Herluison, 1890], pp. 7–8); and Daedalus seems to merge with that equally legendary and ingenious fellow Wayland, whose "house" is a labyrinth in two fourteenth- and fifteenth-century Icelandic manuscripts preserved in Copenhagen (Kern, figs. 468–469). Daedalus's less savory reputation in the English Renaissance is delineated by F. T. Flahiff, "Labyrinth: Some Notes on the Crafty Art of Daedalus," *White Pelican*, 3 (1973), 3–23.

calcitrant creation. This shifting of the balance is a natural consequence of Ovid's emphasis on plot and character rather than on the labyrinth as a structure: the labyrinth is, in Book 8, to be *used*, built for dubious purposes, something to be experienced and escaped as quickly as possible, not something to study and admire. Thus it is hardly surprising that the labyrinth degenerates still further in *Heroides* 10, a letter from Ariadne to Theseus consisting entirely of the hysterical reproaches and fantasies of a wronged, self-righteous girl.[26] As in the *Metamorphoses* and *Aeneid* 6, the labyrinth is not named: it is simply a "curving house" (10.71) full of "doubtful passages" (10.128), identified by its confusing attributes alone. But here its famous creator also goes unnamed, for this is no palace of artistry but a place of death (we hear exactly how Theseus kills the Minotaur, 10.101-102) and, symbolically, an emblem of lust, treachery, and deceit. Significantly, the lovelorn Ariadne, imprisoned in her voluminous passions, leads Theseus from the maze's "dubias vias" (10.128) only to find herself trapped on an island with no passage over the sea's "ambiguas vias" (10.62). The more we are invited to empathize with maze-walkers, to share a subjective perspective, the more labyrinthine confusion dominates and art recedes.

Before we turn from the story of the Cretan labyrinth, it is worth remembering that classical tellers of the myth, unlike publicists of the Egyptian maze, never thought for a moment they were writing a true history. It would hardly have been news to them that Augustine should deride "that beast the Minotaur, which was shut up in the labyrinth, from which men who entered its inextricable mazes could find no exit" and "the artificer Daedalus" as lying fables pure and simple.[27] After all, Virgil himself speaks only "as rumor has it" (*Aeneid* 6.14). Part of the received tradition in the Middle Ages was the nonsupernatural interpretation held by Servius and others that Daedalus really arranged for the scribe Taurus to sleep with Pasiphae in his house, that Pasiphae's twins (one by Minos, one by Taurus) were the reality behind the Minotaur of mixed breeding, and that the wings Daedalus flew with were really sails, the first to be seen in the Mediterranean.[28] None of this affects Daedalus's reputation for ingenuity—most redactions still credit him with building a real Cretan labyrinth—but Servius's explanation may have helped later writers decide to allegorize the *domus daedali* itself as a symbol of lust.

26. I follow the Latin text in *Heroides and Amores*, trans. Grant Showerman, LCL (London: William Heinemann, 1914).

27. *De civitate Dei* 18.13, trans. G. Wilson, in Whitney J. Oates, *Basic Writings of Saint Augustine*, 2 vols. (New York: Random House, 1948).

28. Servius Grammaticus, *In Aeneidos*, ed. Georg Thilo and Hermann Hagen, 2 vols. (Hildesheim: Georg Olms Verlagsbuchhandlung, 1961), 6.14. For a different but equally debunking interpretation, see William of Conches (twelfth century), *Glosae in Iuvenalem*, ed. Bradford Wilson (Paris: Librairie Philosophique J. Vrin, 1980), pp. 110–111.

Such, then, are the definitive classical descriptions of the labyrinth and the associated Cretan myth, the literary witnesses known to generations of later writers both in themselves and as overlaid by numerous commentaries. This chapter has highlighted suggestive details that will later be glossed and embroidered, the many seeds of the profuse metaphorical flowerings of the image of the maze. We have considered the inherent paradox of the labyrinth: its ability to signify both complex artistic order and chaotic confusion, depending on whether it is viewed from without as a static artifact, a magnificent product of human ingenuity, or experienced from within as a bewildering process, a dynamic prison. We have seen the tricky convertibility of the maze, which can become clear to those it has confused or baffle those who, like Ovid's Daedalus, think they understand its symmetries. We have seen that an emphasis on the maze as an historically real structure is often associated with admiration, whereas an emphasis on the myth, with concurrent attention to the labyrinthine experiences of entangled human beings, frequently involves implicit or explicit moral judgments that anticipate later uses of the labyrinth as a symbol of something evil. There have also been hints of an intriguing problem: the difference between the literary tradition, which generally envisages a multicursal labyrinth, and the tradition of the visual arts, which establishes a unicursal pattern. The importance of this apparently awkward discrepancy is explored in the next chapter.

· C H A P T E R T W O ·

The Labyrinth as Significant
Form: Two Paradigms

Sed uisne rationes ipsas inuicem collidamus? Forsitan ex huius modi
conflictatione pulchra quaedam ueritatis scintilla dissiliat.

Let us set our arguments against each other and perhaps from their
opposition some special truth will emerge.

<div align="right">Boethius, Consolation of Philosophy 3pr12.25</div>

C HAPTER 1 examined the major classical texts that defined
and transmitted the physical facts and narrative implications
of the labyrinth to later ages. A recurrent theme in that
discussion was the maze's inherent duality as the embodiment of simulta-
neous artistry and confusion, order and chaos, product and process,
depending on the observer's (or the writer's) point of view. So far, we
have looked at the principle of labyrinthine duality chiefly as it manifests
itself within the written tradition, although allusions have been made to
the contrasting witness of the visual arts. Now it is time to expand our
understanding of the labyrinth's insistent duality and convertibility by
confronting directly the dramatic formal conflict between the multicur-
sal model generally assumed by literature and the unicursal model af-
firmed by the visual arts. Boethius (ca. 480–524 A.D.), great reconciler of
apparent contradictions, presents Lady Philosophy's remedy for this
kind of conflict: "Let us set our arguments against each other and per-
haps from their opposition some special truth will emerge."[1] So too
here: the baffling discrepancy between visual and literary paradigms of
the labyrinth, surprisingly enough, offers the key to a fuller appreciation
of the idea of the labyrinth in classical and medieval times.

1. Boethius, *The Consolation of Philosophy*, trans. Richard Green (Indianapolis: Bobbs-
Merrill, 1962), 3pr12 (p. 72).

· A Clash of Paradigms ·

As I have suggested, numerous visual depictions of labyrinths survive from antiquity: on prehistoric rock carvings (plate 1), on a Linear B tablet from Pylos, on sixth-century Egyptian seals, on the Tragliatella pitcher (plate 2), on Hellenistic coins, on gems, in a graffito on a house in Pompeii, and on Roman floor mosaics all over Europe and North Africa (plate 3). Often these representations stand free of any mythological context, but sometimes they are explicitly or implicitly linked with the Cretan legend: the graffito, perhaps a flamboyant variation on "Beware of Dog!" is labeled "Labyrinth: the Minotaur lives here"; coins may combine maze and bull's head; pavement labyrinths, of which more than fifty survive, are sometimes framed by scenes from the legend or enclose the fight between Theseus and the Minotaur. Most ancient labyrinths are unambiguously two-dimensional, diagrammatic, showing the maze's pattern as viewed from above. Some mazes, often categorized as the "Cretan type," are circular, others rectangular; most have clearly defined centers, but a few contain just a corner or loop where the wanderer would reverse direction. Some are simple in structure, having only one axis around which the path curves continually, where others are more complicated, being divided by axes into four or more segments through which a maze-walker would pass sequentially. Naturally these variants, in appropriate permutations and combinations, have elicited formal taxonomies that need not concern us here.[2] What is most significant for present purposes is that, except for one fresco at Knossos, unknown from 1400 B.C. until Sir Arthur Evans's excavations, and a wall labyrinth (only vaguely multicursal) at Poitiers dating from the twelfth century, all classical and medieval mazes share a remarkable characteristic: *they are unicursal, with no forked paths or internal choices to be seen.*[3]

2. Several significant formal characteristics, such as the generally circular shape of the medieval labyrinth and the number of its circuits, are discussed in chap. 5 in relation to the visual witness in the Middle Ages.

3. For illustrations of and commentary on ancient labyrinths, see Matthews, chap. 8, Santarcangeli, chap. 9, and Kern, chaps. 2–6. For a classification of labyrinths by type, see Wilhelm Meyer, "Ein Labyrinth mit Versen," *Sitzungsberichte der Königliche Bayerischen Akademie der Wissenschaften*, 2 (1882), 267–300; Batschelet-Massini; and Kern, chap. 7. The Cretan fresco from the palace of Minos (Evans, fig. 256) offers a choice of paths but no truly false ones, for there is no clear center in this elaborate version of the key-pattern. The Poitiers maze (Kern, figs. 242–243; Matthews, fig. 55) has an entry but no center; if one takes a wrong turn at the sole opportunity for choice, one may be caught in an endless loop so long as one makes the same choice every time one passes that point; otherwise, one emerges from the maze by the path of entry. Neither the fresco nor the church labyrinth, then, is really what we now think of as a multicursal labyrinth, nor are they the sort of thing envisaged by classical literature. Indeed, Kern argues (p. 211) that the Poitiers graffito represents not the pattern of a pavement labyrinth formerly found in the cathedral but a carelessly drawn tracing of the path *through* a labyrinth of the common Chartres type (see plate 17).

This strange situation has puzzled virtually every modern writer on labyrinths, for to post-Renaissance minds a maze is either multicursal or not really a maze at all. And as we have seen, written witnesses pretty generally endorse—and the poetic tradition insists on—the multicursality of the maze at Crete. For centuries, however, not one visual artist seems to have drawn a labyrinth with false turnings or multiple paths even though some classical and medieval writers, and presumably some artists, knew perfectly well that there were two radically different models of the labyrinth: the multicursal labyrinth-as-building described in literature, that complex construction with many chambers and winding paths in which one can easily get lost, and the unicursal labyrinth-as-diagram in which a single twisting path laboriously meanders its way to the center and then back out.

The inconsistency evokes singularly little explicit classical or medieval commentary, and one could easily conclude that it went unnoticed. But the problem was apparent to at least two writers, whose words are correspondingly precious. Pliny (p. 21 above) in the first century A.D. and Boccaccio in the fourteenth make a point of the contrast between the labyrinths of art and history: Pliny emphatically states that the deceptive, confusing three-dimensional Egyptian labyrinth is strikingly different from familiar two-dimensional unicursal pavement mosaics, and Boccaccio, glossing Dante's *Commedia*, writes, "This [Cretan] labyrinth was not made as we design ours, that is, with circles and windings of the walls, through which anyone who goes without turning round infallibly arrives at the middle and then, following the windings without turning, comes outside; but there was, and still is, a mountain all excavated within, made with square chambers so that each chamber has four doors, one in each side, each door leading to a similar room, so that a man who enters grows bewildered and does not know how to get out."[4]

If these distinctions were known to Pliny and Boccaccio, they must have been known to others as well, artists among them, unless we assume that every artist who placed a minotaur in the coils of a unicursal diagrammatic labyrinth was ignorant of the very story he was illustrating—and that assumption is hard to accept, particularly because on occasion artists created labyrinths of some complexity and sophistication. Some

Many pavements and manuscripts include the key-pattern or meander (plate 6), usually not considered a labyrinth because of its simple design. Yet for Nonius Marcellus (fourth century A.D., compiler of the first surviving Latin dictionary), this meander is "a kind of design similar to the labyrinth"—*De conpendiosa doctrina*, ed. Wallace M. Lindsay (Leipzig: B. G. Teubner, 1903), *s.v. meander*.

4. Boccaccio, *Il comento alla Divina Commedia*, ed. Domenico Guerri, 3 vols. (Bari: Laterza, 1918), 2, 108. It is not at all clear what Boccaccio means by "our" walled fourteenth-century labyrinths; but for a later rendition of what such a maze would look like, see plate 10.

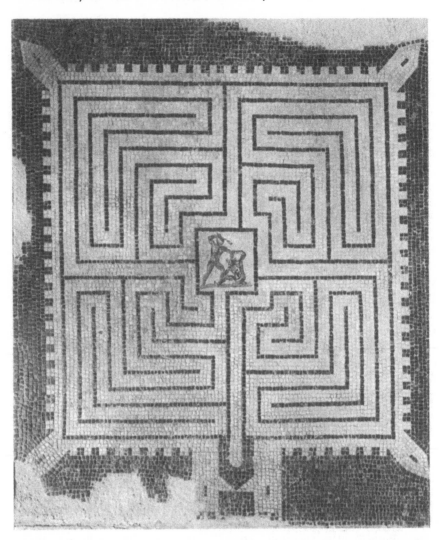

3. Roman mosaic labyrinth found in the Via Cadolini, Cremona. The crenella-
tions and towers hint at the three-dimensional reality of the labyrinth here
diagrammed. Photograph courtesy of the Soprintendenza Archeologica, Milan.

Roman pavements border their elaborate unicursal diagrams with tur-
rets and battlements, thereby suggesting both the exterior view of a
three-dimensional building and its disorienting, circuitous interior
groundplan, presented as if viewed from above (see plate 3 and Kern,
plates 100-103, 106-107, 109, etc.). Such artists apparently combine two
points of view within one work of art, offering a visible representation of
labyrinthine duality and the importance of perspective in mazy matters.

Much later, two related medieval manuscripts offer an exterior view of the Cretan maze as a sphere crammed with crenellations, doors, and windows whose proliferation hints at the confusion that lurks within (see plate 18).[5] Yet even these illustrations, reflecting in their fashion the artistry/confusion duality of the maze, do not show a multicursal diagrammatic maze pattern. Surely it would have been easy to modify a unicursal diagram, putting a false turning here or a dead end there, to create a visible illustration of the incontrovertibly multicursal Cretan maze. But no multicursal diagrams are to be found, even in explicit association with the Cretan legend, and there are no satisfactory explanations for the discrepancy between literary description and artistic realization.

True, sheer force of habit, the conservative tendency that dominates western art, may have perpetuated the traditional unicursal pattern familiar from time immemorial: if labyrinths on rocks, coins, floors, and walls, in ancient buildings and medieval cathedrals, manuscripts and fields, had always been unicursal, it would have taken a brave artist to initiate a change, no matter how well he knew Pliny, Virgil, or Boccaccio. And as John Murdoch notes, diagrams in manuscripts were often stock illustrations supplied by workshops, illuminators, or doodling casual readers who might, like paperback cover artists today, have no concern with accurately reflecting the literary content, preferring to copy stereotypes from one text and manuscript to another.[6] Such considerations might explain why *most* pre-Renaissance mazes in the visual arts are unicursal, but why *all* are unicursal despite literary witnesses to the contrary remains a mystery.

Should we then conclude that the form of a maze was a matter of complete indifference to classical and medieval people and should be so to us? Pliny and Boccaccio didn't think so, nor should we. In fact, the major premise of this chapter is that we can learn a great deal about mazes from a close study of form, both the visible form of the typical unicursal design in art and the easily imagined form of the multicursal labyrinth of literature. As E. H. Gombrich has noted, form defines much of an image's symbolic potential, and that generalization is particularly true of the Middle Ages, when writers and authors were acutely alert to the significance of even such simple geometric forms as the circle, the triangle, and the pentangle.[7]

Therefore, this chapter explores the formal implications of the com-

5. See also Kern, chap. 6, and Hugo Buchthal, *Miniature Painting in the Latin Kingdom of Jerusalem* (Oxford: Clarendon Press, 1957), plates 113b and 151c and pp. 75–76. Kern argues simply that the ancient battlemented pavement labyrinths represent cities.

6. John E. Murdoch, *Album of Science: Antiquity and the Middle Ages* (New York: Charles Scribner's Sons, 1984), p. xi.

7. Gombrich, *The Sense of Order: A Study in the Psychology of Decorative Art* (Ithaca: Cornell University Press, 1979), p. 244.

peting models of the maze and the logical consequences of the discrepancy between them. The incompatibility between the two paradigms, so obvious to modern eyes, might seem to create an insoluble problem or interpretive dead end. But instead, the apparent contradiction affords valuable insight into the classical and medieval concept of the labyrinth, and it does so in several ways. First, it forces us to look far more carefully at the precise implications of each model than we might have done had there been no formal conflict. Thus our understanding of metaphors involving mazes, whether unicursal, multicursal, or a blend of both, will be sharper. Second, the dearth of classical and medieval commentary on the clash of paradigms suggests that modern definitions of mazes as essentially and primarily multicursal may be far too narrow for classical and medieval ideas of the labyrinth—we may be bypassing a general category that includes both variants to focus on the mutually exclusive subcategories familiar to us. It bothers us that the same word, *labyrinthus* or *laborintus*, was unhesitatingly used to denote both unicursal diagrams in art and the multicursal Cretan maze in literature, but most medieval writers were not disturbed at all. These two pieces of evidence—the negative finding that only Pliny and Boccaccio felt a need to mention the difference in models, and the positive finding that a single signifier comfortably described two very different signifieds—force us to transcend meaningful differences and search out characteristics common to both visual design and verbal description, for these shared characteristics are precisely what define the general category "labyrinth" *as it was understood in classical and medieval times*, and they also constitute the physical basis for most classical and medieval metaphorical transformations of the maze image. Thus a structural comparison of the models defines the maze, highlights its symbolic potential, and provides the basis for an historically plausible taxonomy of metaphorical mazes.

If this chapter is theoretical and speculative, it is because theoretical speculation is warranted and methodologically necessary. Pliny's and Boccaccio's remarks confirm that my perception and analysis of the contrast between the models, though more detailed than theirs, is not alien to classical and medieval modes of thought. Expatiating on the implications of geometrical forms was a common medieval diversion, and solving apparent contradictions by transcending them to find a more inclusive model is also characteristically medieval.[8] Although medieval people do not seem to have preserved detailed abstract reasonings about the implications of unicursal and multicursal form, they might well have had thoughts similar to those that follow. In fact, I suspect that similar analy-

8. For medieval meditations on geometrical forms, see Arthur, *Medieval Sign Theory*, chap. 1; see Peter Elbow, *Oppositions in Chaucer* (Middletown: Wesleyan University Press, 1975), for a short but useful exploration of reconciliation through transcendence in Boethius and Chaucer.

ses formed the tacit theoretical underpinning for many uses of the labyrinth image, and that I am therefore reconstructing ideas taken so much for granted that they went unspoken. As we will see in later chapters, classical and medieval evidence—the explanations, glosses, etymologies, and metaphorical uses of the labyrinth-as-concept and the labyrinth-as-visual-symbol—confirm the conclusions reached here through formal analysis.

Yet it also remains true that most classical and medieval writers blurred or ignored the distinctions between models; their concept of "labyrinth" subsumed both models, even when the differences were clearly recognized. Assuming that mazes are by definition multicursal, we find these writers' easy acceptance of unicursal diagrams jarring in the extreme. We become fixated on the contradictions between literature and art and ignore implications of labyrinthine form that must have struck medieval people as equally important, indeed even more important. When we do so, we may be concentrating on *accidentia*, in the Scholastic sense: on attributes that are not absolutely necessary for a thing to *be* a thing. For instance, most pigs are beigy-pink, but beigy-pinkness is not a necessary condition for being a pig, only for being a Yorkshire pig; similarly, containing many paths is not a necessary condition for being a maze, only for being a multicursal maze. Since medieval people called both uni- and multicursal mazes *laborinti*, they must have seen multi- and unicursality as accidental qualities (however useful and suggestive for metaphor). What makes a maze a maze for a medieval writer, however, is something else; there must be *essential* qualities shared by both kinds of maze, attributes a maze must possess to be a maze at all. These essential similarities, these general characteristics found in both models, influenced creators of maze-metaphors at least as much as the differences that distinguish one subcategory from the other. Having chosen the labyrinth as a vehicle for metaphor, metaphor-makers were free to draw upon any accidental characteristic of either model appropriate to their metaphors.

Our search, then, is initially for the implications—chiefly structural, but also metaphorical—of each model, next for the essential qualities they have in common that define the classical and medieval idea of the labyrinth, and finally for reasons why the peaceful coexistence of the two models was positively advantageous to writers and artists alike. Accordingly, I begin with a brief examination of each model, considered abstractly as if it were a three-dimensional structure (references to specific instances and texts will come in later chapters; here I want to keep the theoretical argument as uncluttered as possible). As the labyrinth is both artistic product and confusing process, we must employ a kind of double vision here. Some comments will assume a privileged and objective overview—the clear understanding of the maze's complex pattern that is

available only to the enlightened. Other comments will reflect the bewildered subjective perspective of someone enmeshed in disorienting paths and unable to determine at the point of entry whether the maze is unicursal, multicursal, or even a maze at all.

· The Multicursal Model ·

The multicursal maze, as we have seen, apparently derives from literary tradition; its mythological trappings and form would have been familiar chiefly to the literate.[9] Its structural basis, in contrast, is familiar to everyone: as the term "multicursal" suggests, this kind of maze is a series of choices between paths. Classical writers knew a great deal about the *bivium*, the Herculean or Pythagorean choice represented by the letter *Y*, with one road leading gently to pleasure and the other austerely to virtue; Christian writers would lend the image biblical authority by referring to Matthew 7:13-14, the choice between the broad path to destruction and the narrow way to life (to name only one of many biblical examples of the metaphor).[10] The multicursal labyrinth is even more rigorous, however, for it does not consist of a single crucial choice; rather, it incorporates an extended series of *bivia*, an array of choices. It embodies frequent testing and repeated confrontations, with no apparent end to the struggle until the goal or the entry is achieved. Hence this type of maze is a perfect symbol of intellectual and moral difficulty as well as aesthetic complexity. The characteristic quality of movement through such a maze is halting, episodic, with each fork or alternative requiring a pause for thought and decision. The direction of movement is constantly shifting, now here, now there, as the wanderer's choices and the maze's paths lead him (or her, although most maze-walkers in classical and medieval literature are male). In addition, a maze-walker may lose confidence, retrace his (or her) steps, take another path, right or wrong. The essence of the maze experience is confusion, doubt, and frustration as one ambiguity succeeds another. Uncertainty may be heightened in that the maze-walker without a guide cannot know until reaching the end that the chosen path is correct; indeed, he or she cannot even be sure there *is* an end or center. The multicursal maze is dangerous even if no minotaur is lurking, for one risks getting lost and

9. In the following discussion, readers may want to imagine being inside a labyrinth of the sort they must have solved in puzzle books as children, or they may wish to refer to plate 4, which shows an extremely simple multicursal maze in which success depends partly on choosing the right point of entry and partly on making correct choices within.

10. For other discussions of the Pythagorean letter, see Cipolla, *Labyrinth*, pp. 42–47, and Erwin Panofsky, *Hercules am Scheidewege*, Studien der Bibliothek Warburg, 18 (Leipzig and Berlin, 1930).

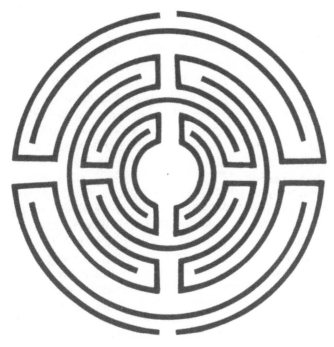

4. Example of an early multicursal labyrinth, adapted from Claude Paradin's *Dévises héroïques* (1551). The original includes a Virgilian text, "Fata viam invenient" (the fates will find a way—*Aeneid* 3.395). Drawing by Robert Ouellette.

remaining perpetually imprisoned; in such a maze one may find no solution, no center, no exit. The maze, then, is potentially inextricable, as so many classical and medieval texts insist; survival and escape may well depend not only on the maze-walker's intelligence, memory, and experience but also on guidance—Ariadne's thread, instructive principles, signposts, or advice along the way.[11]

But who is responsible for the wanderer's success or failure? In some contexts, blame might attach to the maze-maker who created a sadistically impossible design, to the maze itself as an intrinsically deceitful ("anceps") structure, or to guides who fail to materialize, give bad advice, or lure the wanderer into the maze in the first place. Normally, however, the multicursal maze highlights the role of the individual: he controls his

11. See Borgeaud for the intriguing idea—albeit one I have found explicitly in no classical or medieval texts—that the route *into* a maze is inevitable, but the route *out*, thanks to "forgetfulness," is "suddenly complex" and demands memory or other assistance: "The Open Entrance," pp. 22–23. The sudden shift Borgeaud intuits is, perhaps, yet another instance of the unpredictable convertibility of the maze as an image.

passage through the maze by his ability to choose and perhaps by memory, and however puzzled and despairing he may be, his fate is as much the result of his (ab)use of free will as it is a consequence of the architect's devious design. Both models of the maze entail structural *error* or wandering: but in a multicursal maze more obviously than in a unicursal one, these *errores* are not merely circuitous paths but also errors of judgment (when the wrong path is chosen) or of memory and concentration. The multicursal maze leaves most choices to the wanderer, and consequently it emphasizes an individual's responsibility for his own fate.

This labyrinthine paradigm is clearly analogous to other images associated with the maze in literature: the crossroads, the forest, the desert, the ocean, an interlace pattern, a series of caves, any confusing or trackless waste with superabundant choices and no unambiguous path, places from which safe exit is difficult or impossible without a guide or Daedalian wings. Analogous processes include such things as a chivalric quest with optional adventures, the composition or exegesis of a text or argument, and the attempt to make sense of too many pieces of data at once. Morally, the experience of multicursal mazes can be positive (the wanderer learns or accomplishes something important and transcends the confusion of the maze); negative (the wanderer chooses badly, fails miserably, and remains imprisoned); or neutral (the path through the labyrinth is the only way to get from A to B, but the process and goal carry no moral connotations).

· The Unicursal Model ·

The unicursal model, familiar in most periods and cultures from prehistoric times, comes from the visual arts and is part of popular culture rather than an exclusively learned model. Its structural basis is a single path, twisting and turning to the point of desperation but entailing no dead ends or choices between paths. The maze-walker simply goes where the road leads, for the maze itself is an infallible guide to its own secrets, defining precisely the only course that can be taken. The pattern is not difficult to follow, then, although its complexity means that the wanderer may not know where he is going and how he is getting there. The characteristic quality of movement through this model is steady and continuous; any flagging is caused by the wanderer's exhaustion rather than by the need for choice. The direction of movement varies as the path reverses its orientation; but where a multicursal maze contains routes to the center that are more and less direct, depending on whether the right choices are made along the way, a unicursal maze by its very nature defines the most circuitous route conceivable within any given space, the longest possible way to get to the center. In most surviving

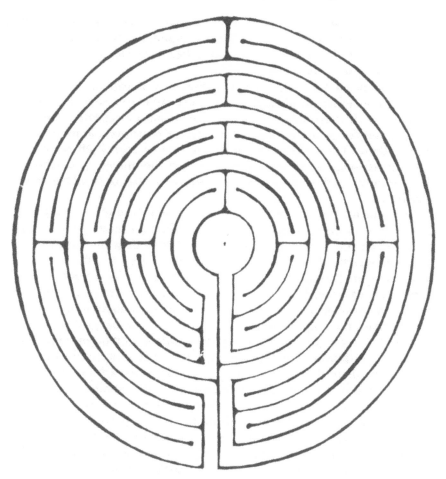

5. Typical circular unicursal diagrammatic labyrinth of the so-called Chartres type; illustrates that many mazes were designed with compasses and also shows clearly how the pattern is derived from symmetrical interruptions of concentric circles. Note that upon entering the maze, one almost immediately would near the center, only to recede farther and farther until the final successful approach. From a manuscript (ninth and eleventh centuries) from Auxerre containing numerous texts on heresy. Paris, Bibliothèque Nationale MS. lat. 1745, fol. 30v. By permission.

unicursal designs, the path leads in and out repeatedly so that, ironically, one may unknowingly be closer to the goal as the crow flies early in the journey than when one is almost through the course. Full of unavoidable delays, a unicursal maze is a perfect symbol of the need for the patient endurance of unpredictable twists of fate. Only persistence can achieve the desired end (assuming that the end of a particular maze *is* desirable;

that is not always the case). The maze itself is the truest guide, but encouragement may be needed lest the wanderer retreat in despair; alternatively, if the goal poses a threat rather than release, incitement to retrace one's steps may be appropriate.

The essence of the unicursal maze experience, as with the multicursal, is confusion and frustration. But in a unicursal maze, confusion results from inherent disorientation rather than from the repeated need for choice, and frustration is directed toward the structure and its architect rather than toward one's own incapacities. The road itself seems too long, increasingly so as one inevitably nears the unseen goal—though the wanderer might well not be certain there *is* a goal, or that he wants to reach it.

In a unicursal maze, obviously, there is by definition no danger of getting lost. It takes no special skill, other than constitutional perseverance, to emerge at the goal or exit; the labyrinth is not inextricable, however inescapable its turnings may seem subjectively. But there are other dangers. Perhaps there is a minotaur threatening its own kind of inextricability; indeed, we shall see that many unicursal mazes contain death, the devil, or hell. Such mazes also hold the danger of immobility and despair, the temptation to stop short of a desirable goal.

A multicursal maze usually makes the wanderer and his own errors of judgment responsible for his fate; in a unicursal maze, individual responsibility diminishes. One's wanderings (*errores*) in such a maze may be merely physical, prescribed by the circuitous path, although sometimes wandering in itself suggests moral culpability: errors, strayings from the straight and narrow. If the multicursal wanderer actively determines his course (although his choices are usually limited by fixed alternatives), unicursal labyrinths enforce passive dependence on the whim of the maze-maker who has already plotted the path; thus the unicursal wanderer must submit completely to the structure. The multicursal maze exemplifies the constant choice demanded of an individual, but the unicursal pattern describes the inevitability to which everyone in that particular maze must be subject. In effect, a unicursal maze-walker is Everyman, not an individual.

But if the unicursal labyrinth in itself involves no choice except whether to continue, it nevertheless implies at least *one* choice: whether to enter in the first place. (Initial choice also exists with a multicursal maze, but its impact is lessened by the continuing sequence of equally important choices.) A number of critical choices are located within a multicursal maze, but a single crucial choice may be located before the entrance to a unicursal maze. If the multicursal maze is an emblem of continual choice, the unicursal maze may represent a single decision as momentous as the Herculean or Pythagorean dilemma. Choosing to enter a unicursal labyrinth abrogates all future decisions except the decision to

6. The Greek key pattern or meander. Drawing by Robert Ouellette.

retrace one's steps, if there is time to do so before the maze-walker reaches the center or confronts the Minotaur; it commits one to a terrifyingly unforeseeable course of events during which one is subject to the power of the maze and the will of its builder. The unicursal path is technically simple but potentially even more horrifying than the multicursal path, in which one retains some power to choose. Thus the unicursal maze, like the multicursal, can easily become a prison where a wanderer requires guidance, even though that guidance is most aptly given *before* entry or as counsel to turn back.

Structures analogous to the unicursal maze are comparatively few: the winding road, the meander, and the key-pattern (see plate 6) come to mind. If the choice to enter is an aspect of structure, then the unicursal maze resembles a single *bivium*, not a series. Analogous experiences and processes range from life itself, fatalistically conceived, to the temporally linear reception of a literary text or philosophical argument (if choices of interpretation are ignored and the literal level is emphasized). In the moral realm, the unicursal labyrinth can be positive, with connotations of patience in adversity (the saintly wanderer is committed to "the way, the truth, and the light" and performs a convincing imitation of Christ; Christian precepts for the virtuous life may define a single if complicated path analogous to a unicursal labyrinth, as we will see in Prudentius); it can be negative, involving persistence in folly (an ignorant, careless, or evil maze-walker embarks on the deceptively simple primrose path to hell); or it can be neutral (one follows a consistent if involuted mental process or argument doggedly to its logical conclusion).

· The Essence of the Maze ·

At first glance, the unicursal and multicursal paradigms involve so many differences that it is hard to imagine how the same word could apply to both. One contains a single path, the other many; one proves patience, the other tests intelligence or intuition; one is virtually inextricable, the other easy to escape, at least in theory. Looking deeper, however, we find more than sufficient similarities to explain why classical and medieval people included both models in the category "labyrinth."

In what follows, as in my discussion of each model individually, I focus on abstract implications of the labyrinth as a structure in order to clarify the issues; in later chapters we will examine illustrative texts. I apologize in advance for an inevitably labyrinthine characteristic of the following remarks: as in a multicursal maze, we have to go over some of the same ground more than once to explicate the complicated subject.

Classical labyrinth texts reveal the labyrinth's duality: embodying both superb design and unfathomable chaos, its elaborate complexity causes admiration or alarm, depending on the observer's point of view and sophistication. This dual potentiality is inherent in unicursal and multicursal mazes alike. Anyone immersed in either mazy process and unable to see the pattern whole will become disoriented and confused, either by endless choices or by the dizzying turns of the single path that distort all sense of direction. Yet viewed from above, considered as product rather than process, either design seems admirably intricate and, most likely, highly symmetrical: an image of order containing and controlling magnificent complexity.[12] Both designs are thus *planned chaos*, examples of artistic elaboration that baffles or dazzles according to the beholder's perspective (and the architect's skill).

Metaphor can exploit either or both of these elements. Sometimes, especially in classical and early Christian literature, the labyrinth represents only the artistry of well-structured complexity and consequently is completely praiseworthy. Conversely, when the labyrinth is an emblem of chaos alone or of artistry gone wrong, as in many medieval writings, its connotations are entirely negative. Most interesting, however, are labyrinth metaphors that involve both elements of the paradox, artistry *and* chaos. Sometimes the opposing qualities are simply balanced: what to the naive seems confusing is to cognoscenti incomparable design. More often, a process of moving from one point of view to another—a kind of convertibility—is implied. The normal maze experience, and certainly most process- and progress-oriented maze metaphors, envisage a perspective-mediated conversion from disorder to order: as Strabo found order in the Egyptian maze by looking down upon it, so anyone viewing the diagram of a labyrinth or experiencing and then comprehending it can understand its principles and structure and appreciate its artistry. But sometimes order disintegrates into chaos: as Daedalus was puzzled by his own construction, so too those who have studied the diagram of a multicursal or even a unicursal maze would grow confused upon experiencing its three-dimensional realization. Many maze metaphors focus on this process of conversion from confusion to admiration,

12. I am assuming that a multicursal maze, had any been drawn in classical and medieval times, would have been an adaptation of the unicursal pattern, preserving its near-symmetry: see plate 5. Certainly the manuscripts showing an exterior view of a spherical maze (plate 18) and the descriptions by Pliny and Boccaccio suggest symmetry in the multicursal design.

or vice versa. A few makers of moral or intellectual labyrinths (Pruden-
tius, perhaps Boethius and Dante, the author or authors of *La Queste del
Saint Graal,* possibly some builders of cathedral mazes) take the process
even further, implicitly imagining the conversion of a multicursal to a
unicursal path: if one passes successfully through a multicursal labyrinth
without retracing one's steps, a mapping of one's travels would describe a
unicursal pattern: multiplicity still exists in the maze itself, but the cor-
rect choices of the maze-walker define a single path that others can
follow.[13] I stress, however, that with very few exceptions, classical and
medieval literature give no sense that one model is in moral or aesthetic
terms intrinsically superior to the other.

If unicursal and multicursal mazes alike are dual, containing
perspective-dependent artistry and chaos, each quality being convertible
to its apparent opposite, they also share a structural feature that helps
create that dual potentiality: a complicated series of winding passages.
Both models are based on the concept of the path, the journey from
beginning to end; both imply a sequence of movements or perceptions,
usually designed intentionally as a sequence; and both may involve
choice, although the nature, implications, and prominence of that choice
vary greatly. But whether the labyrinth consists of a single path or many,
whether choice is paramount or ignored, the course from entry to center
is profoundly circuitous, turning to and fro and covering much more
ground than is necessary to get from one point to another. The word
most often used to describe this circuitous labyrinthine process is *am-
bages.* Related to *ambo* ("two," "both") and *ambiguitas* ("equivocation,"
something with a double sense) through the root *ambi-* ("around,"
"roundabout"), the word itself suggests the dual potentiality that charac-
terizes so many aspects of the labyrinth. The *Oxford Latin Dictionary* lists
the meanings of *ambages*:

1 (a) A roundabout or circuitous path, course, etc., meanderings, twists
 and turns [the labyrinth of *Aeneid* 6.29 is the first example given]
 (b) a roundabout or circuitous movement, wandering to and fro;
 (c) (applied to various long, involved, or fluctuating processes; to an
 intricate system of beliefs; to a tortuous scheme).
2 Long-winded, obscure or evasive speech, a circumlocution, digres-
 sion, evasion. . . .[14]
3 Mental confusion or uncertainty.

13. This curious conversion of the multiple to the single may help explain why church
labyrinths, often carrying significance *in bono,* are unicursal: Christ remedied the false
turnings of sinners by taking the right path through a maze of worldly choices and tempta-
tions, thus defining an effective route to salvation and transcending earthly and infernal
labyrinths. The unicursal maze preserves that single path.
 One person's definitive reading of a complicated polysemous text might also involve an
analogous conversion from multiplicity to specificity.
 14. Lewis and Short add "ambiguity" as an alternative meaning here.

Ambages is therefore a singularly appropriate key word in many descriptions of labyrinths and labyrinthine processes, with *ambiguus* a popular choice as well. Both models of the maze fully exemplify this crucial feature: their passages are invariably roundabout, although the multicursal labyrinth may be doubly ambiguous in offering alternative paths. The labyrinth's incorporation of *ambages* is, then, a more inclusive and, I would argue, a more categorically important characteristic than whether the maze offers one or a number of paths. If "labyrinth" applies equally to unicursal and multicursal mazes, then one essential labyrinthine characteristic for classical and medieval writers is the path's circuitousness, its digressiveness, its detours, delays, and diversions. A labyrinth must be circuitous in process, it must have *ambages*; those *ambages* may be simply roundabout, as in a unicursal design, or they may involve doubleness, choice, uncertainty. Anything circuitous—a multiepisodic quest, an ornate and highly amplified text, a complex piece of logic—is labyrinthine in this sense, and since neither model permits straightforward access to the center, both partake of labyrinthine *ambages*. How a maze-walker copes with *ambages*, and whether there are directions, will determine what he learns, whether he emerges successfully, and what his final perception of the labyrinth will be—order or chaos.

It is, of course, impossible in this discussion completely to separate labyrinthine form from function and objective apprehension of the whole from subjective experience of a sequence of the parts. But in order to isolate other important qualities shared by unicursal and multicursal models, I turn from an emphasis on what the labyrinth objectively *is*—a complexly structured convertible artifact with a circuitous pattern—to a closer look at what the labyrinth subjectively *does* to those inside. This topic involves a feature of the labyrinth we have so far slighted: its center. Most labyrinths—in literature and in art, unicursal and multicursal—have a center, whether or not the maze-walker is aware of it.[15] In a real sense, a labyrinth asserts the presence of order in apparent chaos, if one can only see it. There is a grand maze-maker, a Daedalus, be he divine, diabolical, or human, and that maze-maker has so structured the work of art that its circuitous toils lead to a goal, good or ill, enlightening or destructive. Most mazes are designed on behalf of, and in subordination to, their centers. Labyrinths are teleological, obviously and explicitly so when they are unicursal: persistence necessarily attains the goal. But multicursal mazes also contain a route to the center, although a guide may have to supplement sheer perseverance if the traveler is to find it. Even multicursal mazes designed to be so long and

15. As Jesse M. Gellrich suggests, "The insistence on fixed and centered structure . . . is obvious in many medieval notions, such as the *axis mundi*, the navel at the center of the world, the geocentric cosmos, and the New Law of Charity (maintained as the organizing principle of every chapter and book of the Bible)"—*The Idea of the Book in the Middle Ages: Language Theory, Mythology, and Fiction* (Ithaca: Cornell University Press, 1985), p. 48.

confusing that only the elect can solve them—mazes intended to be more or less impenetrable—have a center containing something so valuable or so shameful as to warrant protection.[16]

The fact that mazes have centers does not imply that every maze-walker *knows* there is a center: maze-walkers may not even know they are in a maze, especially when it is a metaphorical one. Nor does the existence of a center imply that everyone will reach it, even if the maze is unicursal; and reaching the center does not guarantee that one can get out again. The possible relationships between the maze-walker and the center or exit help us identify several common functions of the labyrinth and, consequently, some shared characteristics of both paradigms that define the full idea of the labyrinth and its metaphorical potential.

First, the maze may be intended to imprison those who enter, either before they reach the center (the maze is impenetrable) or afterward (the maze is inextricable), by entrapping them in its coils, perhaps as prey for the Minotaur. Such a maze is almost by definition *in malo*, at least from the point of view of the victim. It is easy to see how a three-dimensional multicursal maze could be impenetrable and inextricable in practice, however possible it may be in theory to escape. Indeed, "inextricabilis" and "inexplicabilis" are as commonly descriptive of mazes as "ambages." At first glance, however, it is hard to see how a unicursal labyrinth could be either impenetrable or inextricable, even though diagrammatic illustrations of the Cretan myth invariably show single-pathed mazes. A hungry minotaur can make any maze inextricable, of course, but there is another solution, one that involves changing one's point of view. Subjectively, anyone in either type of three-dimensional labyrinth and ignorant of its pattern may perceive it as impenetrable and/or inextricable, whether it is so in fact or not. Even in a unicursal maze, by definition penetrable and extricable, one feels imprisoned by the curving walls, by one's narrowly limited view ahead and behind. One's movement, like one's vision, is severely constricted, for whether there is one road or many, one

16. One cannot take centers for granted in the labyrinths of our own century: perhaps the fear that there is no center after all is part of the terror of the maze. Indeed, the absence of a center may be even more threatening than the presence of a minotaur, for reasons that Jacques Derrida explores: "The function of [a] center was not only to orient, balance, and organize the structure—one cannot in fact conceive of an unorganized structure—but above all to make sure that the organizing principle of the structure would limit what we might call the *play* of the structure. By orienting and organizing the coherence of the system, the center of a structure permits the play of its elements inside the total form. And even today the notion of a structure lacking any center represents the unthinkable itself": "Structure, Sign, and Play in the Discourse of the Human Sciences," in *Writing and Difference*, trans. Alan Bass (Chicago: University of Chicago Press, 1978), pp. 278–293, here pp. 278–279. Derrida goes on to note that "the center . . . can be either inside or outside, [and] can also indifferently be called the origin or end" (p. 279). Philippe Borgeaud makes the suggestive if limited point that "the labyrinth always has two centers: where one is and where one desires to be"—"The Open Entrance," p. 23. This statement is really true only if "center" is used metaphorically as "goal," and only from the subjective point of view of a wanderer in an unpleasant maze.

cannot strike out in any direction one pleases or leap out of the maze entirely. Thus both models are subjectively impenetrable and inextricable prisons, at least while one is in them, and most labyrinth metaphors stressing inextricability involve a subjective or psychological component; some labyrinths—those of sin, for example—are woven by the maze-walker himself, either directly or because he has rendered himself prey to Satan of his own free will. (Both paradigms are appropriate here, though their nuances differ: one can choose to enter a unicursal path of sin that leads inevitably to the prison of hell at the center; or one can repeatedly choose the wrong path of a multicursal maze and end disastrously. Here as elsewhere, the imagined form of a metaphorical maze normally has no intrinsic correlation *in bono* or *in malo*.)

If mazes can be prisons, they can also be useful, difficult, carefully structured paths leading somewhere important, even if that place is finally outside or beyond the labyrinth (labyrinths are almost always places one wants to escape, either to avoid danger and confusion or to attain a more comprehensive perspective). The labyrinth-as-prison is a process of *ambages* from which one cannot, or thinks one cannot, escape; but there is also a labyrinth with a happy ending, a metaphorical labyrinth-as-progress, carefully shaped by a master architect to direct the worthy wanderer to a profitable end: the path, the choices between paths, the prescribed *errores*, all are designed to carry the wanderer over just the right territory to achieve something that could not have been reached by a direct route. The architect knows that a certain process is necessary if the wanderer is to get where the architect wants him to go and learn what should be learned. If the maze is unicursal, the architect has calculated the precise sequence of turns and disorientations needed for the wanderer to appreciate the center when he gets there. If the maze is multicursal, the architect has foreseen alternative routes, some of which may lead to failure for people who cannot learn, concentrate, remember, and choose properly; but other paths may prove and perfect the wanderer before providing enlightenment, which may well be presented as mental or physical extrication from the labyrinth, a rising above it to see its pattern, and a transformation of confusion into understanding.

Focusing on the subjective experience of the maze-walker, however, shows a more frightening picture. The maze-walker may be involved in a process of confusion for his own good, but he is nevertheless confused, perhaps the more so in proportion to the good he may achieve. Even if the labyrinth was designed to be extricable, it will not seem so—in fact, it will be a labyrinth precisely because it feels inextricable, aimless, confusing. Its very point is to impose a confusing and difficult process on someone because that extraordinarily baffling process is just what it takes to prepare the maze-walker for moral, aesthetic, or intellectual transcendence. As T. S. Eliot said in a context not wholly dissimilar,

In order to arrive at what you do not know
You must go by a way which is the way of ignorance.[17]

Both models delineate the way of ignorance—ignorance of the path, the pattern, the goal, the maze-maker's intentions. Whether there are choices and guides or not, one cannot know what lies around the next curve until one gets there; means dominate ends, process obscures product, and the wanderer must continue, choose, or retreat with no sure knowledge of the consequences. Yet if the maze-maker is being fair, then the maze-walker, by his very perseverance, withdrawal, or choices, will find the goal he deserves: success or failure, imprisonment or escape, confusion or understanding. This subjective if temporary ignorance of path and goal, this intense immersion in process, is yet another important labyrinthine characteristic shared by both models and generating numerous metaphors, many of them involving epistemology. Few if any images of a planned path through ignorance to understanding are better than the labyrinth, and both models describe the path equally well, if with the subtle difference that a unicursal maze-walker follows a universal and authoritative curriculum whereas a multicursal wanderer participates more actively and selectively in his own education. In a unicursal maze one learns by precept; in a multicursal maze, by dialectic.

This chapter began with the assumption that the formal aspects of labyrinths and the apparent contradictions between models were important; we followed, as it were, each of two opposing paths in a multicursal maze. Tracing the complexities of a maze's paths may lead to an appreciation of its magnificent design, to new knowledge facilitated by experiencing and then transcending confusion; so too here, where the ambiguities of the two paradigms have begun to resolve themselves into a clearer, more privileged vision of their commonality. If the apparently happy and usually tacit coexistence of both types of labyrinth under one name can be taken as evidence that shared features are more important in defining the idea of the labyrinth than features peculiar to one model—if we move beyond subcategorical distinctions to categorical imperatives—we may reconcile the conflicting paradigms by identifying those shared characteristics. The most important characteristics common to both models seem to be these:

I. Pertaining to the labyrinth as artifact, as objective pattern:
 a. The labyrinth's dual and convertible potentiality as a sign of confusion (within) and of complex artistic order (without or above); the

17. T. S. Eliot, *The Four Quartets*, "East Coker," ll. 140–141, quoted from *The Complete Poems and Plays* (New York: Harcourt, Brace, 1952). There are clearly potential similarities between the labyrinthine path to knowledge and the mystical *via negativa*, but I will not explore them here.

labyrinth as magnificent handiwork of a superlative architect, once
it is properly and comprehensively perceived;

b. The labyrinth's structural principle: confusing *ambages*, circuitous-
ness, ambiguity; the presence of physical, intellectual, or moral
errores;

II. Pertaining to the labyrinth as subjective process, as path(s) surround-
ing an unseen goal or center:

a. Real or apparent impenetrability and inextricability; the labyrinth as
prison, at least for some maze-walkers;

b. The path of ignorance; difficult but necessary process and progress
that may lead to knowledge, transcendence, extrication.

Such are the primary and defining qualities of a labyrinth of either mod-
el in the classical and medieval periods: each has an architect, benevolent
or malevolent, whose artistry is manifested in a construction with a cir-
cuitous and therefore confusing pattern that bewilders the ignorant as it
delights the knowledgeable. Each model seems inextricable and impene-
trable, depending on what lies within and whether the wanderer persists
or retreats, choosing right or wrong once (in deciding to enter a unicur-
sal maze) or repeatedly (in a multicursal maze). Each may lead the wor-
thy wanderer toward a conversion from confusion to perception. These
are the essential qualities of a maze; any labyrinth, real or metaphorical,
must have all or most of them to be considered a labyrinth at all.

Both models, then, share enough common qualities to justify inclusion
in a common category. In fact, the preceding discussion has almost de-
fined the differences between models out of significant existence: al-
though a characteristic may be highlighted in one model, it is always at
least latent in the other. Apparent distinctions turn out to be matters of
degree rather than of kind, accidental, in the Scholastic sense, rather
than essential. A multicursal maze stresses repeated choice, but a unicur-
sal model implies a choice—possibly a critical choice—to enter. Unicur-
sal mazes emphasize the rewards of persistence, but that virtue may be
equally necessary in a multicursal labyrinth. Multicursal mazes are more
obviously inextricable, but an intelligent wanderer can theoretically solve
them and escape, and even unicursal mazes can be efficient prisons.
Guidance is often crucial in multicursal mazes, but it may be helpful in
unicursal ones as well.[18]

We return, then, to the question with which we began this chapter.
Why do the visual arts show unicursal labyrinths rather than multicursal

18. Some readers may wonder why I have not therefore included choice, the need for
persistence, and the usefulness of external guidance as essential qualities of the maze. I
have not done so because although these qualities are theoretically and potentially present
in both models, they are normally developed only in one or the other. Few literary treat-
ments of a traditionally multicursal maze such as the Cretan one, for instance, play with the
idea of perseverance, and many uses of the unicursal maze ignore initial choice completely.

ones? If the question still has no definitive answer, it can be addressed more confidently now we have explored and transcended the contradictions between paradigms. I suggest the main reason for the absence of multicursal diagrammatic labyrinths in art is that there was no real need for them: the unicursal design found in mosaics, fields, churches, and manuscripts conveyed the labyrinth's essential qualities so effectively that there was no real pressure to modify the time-honored design.[19] Unicursal patterns may be as symmetrical and ornate as multicursal ones, and they connote artistry just as well. They are just as circuitous, as full of *ambages*. They may also be just as confusing and inextricable to the eye: a maze of either type is, in Gombrich's term, a "restless figure,"[20] a pattern that pulls about our vision incessantly. Whether or not a diagrammatic maze possesses false turns, the complexity of the design may be vaster than the eye can comprehend in a glance, for the eye can focus on only part of a complicated field at one time: "A highly redundant design of identical elements offers no easy anchorage for our apparatus on which to 'lock in.' It drifts and loses its place."[21] True, a unicursal diagrammatic pattern is not, to onlookers, a path of ignorance. But it *does* give an enlightened overview of difficult process, facilitating both our imagined immersion in twisting paths and the eventual transcendent perception of the whole that brings comprehension and appreciation.

The unicursal diagram does well enough to convey the idea of the maze, and it has powerful historical precedent in art. The best solution that can be found to the mystery is that classical and medieval eyes saw insufficient difference in the implications of the two models to warrant a new design. Why, then, did maze-makers in the sixteenth and seventeenth centuries suddenly start to draw multicursal mazes? In their quest for historical authenticity, the humanists may have wanted to make their illustrations a more accurate reflection of classical texts, so they replaced the old-fashioned medieval representation—generally unicursal and diagrammatic—with multicursal or architectural (three-dimensional) models. In addition, the popularity of Hercules at the Crossroads as a Renaissance motif may have superceded the unicursal design, which carries much the same message of single exemplary choice. The multicursal maze, stressing repeated individual choice, may have developed as a useful complementary image. Whatever the reason, Renaissance and Baroque maze-makers did their revisionist work so well that their more restricted version of the maze became definitive.[22] Since their time, to

19. As we will see in chap. 5, there may have been multicursal three-dimensional *buildings*.

20. Gombrich, *Sense of Order*, chap. 4.

21. *Sense of Order*, p. 131.

22. For Hercules, see Panofsky, *Hercules am Scheidewege*; Kern also suggests that the appearance of multicursal mazes in mid-sixteenth-century art may derive from a wish to make art correspond to literary texts (p. 99).

our loss, western culture has focused narrowly on repeated choice as the single essential characteristic of a maze.

The richest, most potent, most adaptable signs are those that offer the widest and most subtly nuanced array of characteristics to be drawn upon and modified by those who use and interpret them. The more options, the better, so long as the general import of the sign's potential is clear—and we have seen that in the case of the labyrinth, it is clear. What Augustine said of the joys of multiple verbal meanings in scriptural interpretation applies equally to a visual or conceptual sign like the labyrinth:

> [Sometimes] things signify not one thing but more, and not only two diverse things, but sometimes many different things in accordance with the mean- ing of passages in which they are found. . . . When . . . not one but two or more meanings are elicited, even if what he who wrote the passage intended remains hidden, there is no danger if any of the meanings may be seen to be congruous with the truth taught in other passages of Holy Scriptures. . . . For what could God have more generously and abundantly provided in the divine writings than that the same words might be understood in various ways which other no less divine witnesses approve?[23]

The existence of many signifying possibilities in the labyrinth gave au- thors and interpreters a great deal of flexibility, and they took full ad- vantage of it. Two models are richer than one.

Classical and medieval people thus did well to accept both models as equally labyrinthine. Writers, if not purveyors of diagrams, had as an easily available option the use of a clearly unicursal or clearly multicursal maze, and the choice of one or the other might efficiently accentuate certain features—the importance of guidance or intelligence as opposed to patience in adversity, a single or repeated choice, determinism or free will. But even for the majority who did not concern themselves with the differences between models, the historical presence of alternatives was no less beneficial. The impressively diverse metaphorical potential of the classical and medieval labyrinth may well have been a consequence of the existence of two identically named paradigms whose superficial incom-

Huston Diehl ("Into the Maze of Self: The Protestant Transformation of the Image of the Labyrinth," *JMRS*, 16 [1986], 281–301) discusses Renaissance labyrinth imagery in literature and art and argues that the maze's significance changed with the Protestant emphasis on man's dependence on God's grace to escape damnation. Diehl's argument is based on a narrow view of the medieval maze (solely as represented in cathedral labyrinths) as "a spiritual experience" of "meaningful action" whose "destination is known, desired, and spiritually rewarding" (p. 284). This oversimplification of the medieval idea of the maze vitiates Diehl's analysis of "Protestant" mazes. Moreover, he does not directly address the issue of uni- and multicursality, nor does he relate these models to his conjecture that Protestant mazes reveal man's inability to help himself find salvation.

23. Augustine, *On Christian Doctrine* 3.25–27 (pp. 101–102).

patibilities created an irresistible pressure to fuse the two by transcending their differences. This conflation and reconciliation of models, each with powerful traditional authority from literature or from art, was what made the idea of the labyrinth so rich, flexible, and useful.

Form does matter, then, even if it is often ignored, even if usually there is no question of hierarchy or of development from one model to another. Thus our initial examination of the two models as if they were diametrically opposed was not the setting up of a straw man. But form has turned out to matter in a different way from what we may have expected: it probably forced the development of a more inclusive concept of the labyrinth, and it has provided us with a method for discovering what that concept is, expanding our horizon of expectations.

Perhaps it is appropriate to comment here on another aspect of the labyrinth in the visual arts: the implications of most artists' decision to depict the labyrinth diagrammatically rather than as a three-dimensional structure.[24] The diagram of a maze simultaneously shows magnificent pattern and convoluted process, effectively imaging the artistry/confusion paradox; as with optical illusions, we may find ourselves flashing back and forth between perceptions of the whole and its parts, thereby experiencing labyrinthine convertibility. Because we can see the artistic whole, intermittently at least, the labyrinth's confusing process is counterbalanced by an assurance that a great maze-maker, a controlling artist, planned the maze so that it has order, a path to a stable center, a promise of rest within. A diagrammatic labyrinth paradoxically clarifies its own confusion; it holds structural design and the psychological tensions created by that design in perfect equilibrium, suggesting order in chaos, the purposefulness of apparent aimlessness, unity controlling multiplicity. A diagrammatic representation does a better job of illustrating several of the labyrinth's essential qualities than do three-dimensional illustrations, and that may help explain why diagrams are much more numerous.

In this chapter, then, a Boethian "special truth" has emerged from the apparent conflict of paradigms, reconciling unicursal and multicursal designs, artistic and literary tradition. Primary characteristics and secondary implications of the models have provided us with an inclusive mapping of the idea of the labyrinth as well as a sensitivity to possible nuances and minor distinctions that may assume major importance in individual cases. We have begun to explore the abstract basis for the rich symbolic potential of classical and medieval labyrinths. As constructs well and elaborately designed, mazes are emblems of great artistry; by the same token, they may exemplify the appalling confusion that results when a creator's talents or a perceiver's analytical skills are insufficient to

24. The implications of most medieval labyrinths' circularity will be discussed in chap. 5.

meet the challenge. As processes involving a constant interplay between authority (the pattern channeling the maze-walker along previously determined courses) and the individual (who, even in a unicursal maze, may play the game or not), they are superb models for the consequences of single or multiple moral, intellectual, and hermeneutic choices exercised within some constraints and leading finally to freedom or to imprisonment. As structures that often intend and describe changes in perspective, they are models for enlightenment or for the process of learning the order (moral, intellectual, or aesthetic) that gives meaning and form to apparent chaos. Unified entities composed of discrete but linked parts (the length of path that lies between turnings), they image multiplicity and unity, parts and the whole, means and ends, always depending on one's point of view and sophistication. The inclusive classical and medieval idea of the labyrinth allows an author to combine aesthetic and moral process, object and subject, authority and experience. It even integrates within one coherent and comprehensive image divine and authorial intention (the architect's plan), the resulting construct (the world-maze, the text-labyrinth), and the human being's, or reader's, or hearer's response (the experience, choices, and conclusions of the maze-walker). If there is nevertheless a Derridan *aporia* present in the simultaneous affirmation of a unicursal and a multicursal model—and I think there very well may be—this is not the place to deconstruct the maze.[25]

25. If I were to indulge in deconstructive fancy, I would argue that the implicit simultaneous affirmation of both models in the Middle Ages received so little contemporary attention because it constitutes an important *aporia*: a self-contradiction that, if recognized, could turn the edifice of orthodox theology into a flimsy house of cards. As we will see, the labyrinth often represents the course of life from birth to death and the fixed order of God's created universe. In this context, the multicursal model makes an orthodox statement about man's relationship to God and to his own fate: God designs the master plan, the paths and laws within which individuals, aided perhaps by grace, ecclesiastical instruction, or the sacraments, choose their own course and thus their own ends: entrapment and damnation or extrication and salvation. This model illustrates the interactions of divine ordinance and human free will. The unicursal labyrinth, on the other hand, is potentially heterodox, more appropriate in a classical, fatalistic context: God establishes an inevitable pattern that all who enter must follow, so that individual free will is irrelevant. This model, then, is deterministic; yet it is the model appearing even in cathedrals and sacred manuscripts.

Certainly one can devise arguments that get around the free will-determinism impasse: perhaps the goal in the multicursal model is eschatological, heaven or hell, whereas the goal to which all must come in the unicursal model is death. Perhaps the choice to enter and persist in a unicursal labyrinth constitutes a free choice to move toward heaven or hell, depending on whether this particular labyrinth is *in bono* or *in malo*. Nevertheless, I suspect that the general medieval refusal to confront the different implications of each model may owe something to fear of what a closer inquiry might discover. Far easier to accept both models and blur the distinctions, especially when, by so doing, one satisfies another important medieval impulse by "valuing the universal over the particular and the typical over the individual"—A. J. Minnis, *Medieval Theory of Authorship*, p. 2.

My goal has been more modest: to extrapolate the classical and medieval definition of the maze from the examination and juxtaposition of its two models. The following chapters consider the metaphorical fruits of these labors, the transformations and varied meanings of particular mazes and metaphors.

A Taxonomy of
Metaphorical Labyrinths

Ab obscuris ad obscuriora transimus, et cum Moyse ingredimur in
nubem et caliginem. Abyssus abyssum invocat, in voce cataractarum
Dei, et gyrans gyrando vadit spiritus, et in circulos suos revertitur. Laby-
rinthios patimur errores, et Christi caeca regimus filo vestigia.

We pass from obscurity to greater obscurity, and enter with Moses into
cloud and darkness; deep calls to deep at the sound of the cataracts of
God, and, circling in circles, the spirit goes forth and returns to its own
circuits. We endure labyrinthine errors and guide our blind footsteps by
the thread of Christ.

> Jerome, Preface to Book 2, *Commentary on Zacharias*

I N CHAPTER 1, the literary tradition of the labyrinth defined by
Virgil, Ovid, and Pliny suggested the inherent and convertible
duality of the maze as monument of admirable artistic com-
plexity and cause of subjective confusion. Chapter 2 approached laby-
rinthine duality from a complementary perspective, using the conflict
between two persistent paradigms, the multicursal maze of literature
and the unicursal maze of art, as a means to identify the essential charac-
teristics and formal implications of classical and medieval mazes. These
essential characteristics define the maze as a complicated artistic struc-
ture with a circuitous and ambiguous design whose confusing toils are
intended by their clever architect to entrap or enlighten errant maze-
walkers, denying or controlling access to a center that may contain good
or evil, and leaving the maze-walker with higher knowledge or in chaotic
limbo. Now we move from theory to practice and see how these struc-
tural features inform a wide variety of classical and early Christian texts
that use the labyrinth metaphorically. As in several later chapters, I
present here a fairly comprehensive survey of mazes, partly because
literary labyrinths have so seldom been studied in themselves or in rela-

tion to mazes in the visual arts. My aim is dual: to show how the idea of the labyrinth and its structural features generate metaphor, and to indicate what metaphorical meanings mazes typically attract.

Metaphors rely on analogies between the qualities of a sign and the comparable attributes of what is signified. Metaphorical associations of the labyrinth thus develop naturally from the essential characteristics identified in Chapter 2; indeed, I began to suggest there, in purely abstract terms, how specific formal qualities of the classical-medieval maze imply metaphorical potential, how structure generates possible meaning. Chapter 3 fleshes out that discussion with reference to classical and early Christian texts and derives its taxonomy of metaphorical labyrinths from the form and functions of the labyrinth itself rather than from such extraneous categories as the world as labyrinth or the text as labyrinth. It is true that this taxonomy, like most others, is somewhat arbitrary: if all labyrinths manifest certain essential characteristics simply by virtue of being labyrinths, it may seem artificial to divide maze metaphors according to the prominence of one labyrinthine feature or another, as I do here. In most cases, however, maze metaphors *do* highlight one characteristic, subordinating the others. When the maze signifies a prison, for example, the metaphor accentuates inextricability even though the cause of that inextricability involves another labyrinthine characteristic, a complexity of structure that may well be artistically admirable in itself. It may help to remember that our perception of labyrinths is tied to point of view, and one property or another predominates according to the beholder's perspective. So too with metaphorical mazes, which often presume a particular point of view. Do we see the maze in its entirety—from outside and above, with its structure neatly mapped as in a diagrammatic drawing? Then we see the maze as artifact, and we may be struck most by its admirable albeit complex order. Do we watch as a wanderer becomes increasingly entangled without any guidance? If so, we may be aware chiefly of the maze's inextricability or impenetrability. Do we experience a labyrinth's immediate psychological effect by joining a wanderer within the maze and then emerging into clarity as and when he does? Then the text emphasizes the maze as complex process leading from ignorance to enlightenment.

This chapter is therefore divided into three sections, each roughly corresponding to the essential labyrinthine quality highlighted in metaphor: (a) the labyrinth as a sign of complex artistry; (b) the labyrinth as a sign of inextricability or impenetrability; and (c) the labyrinth as a sign of difficult process. These categories correspond to three of the four primary qualities of the classical-medieval labyrinth as defined in Chapter 2. Examples in each group may allude to the labyrinth's convertibility—to sudden changes in the beholder's perception whereby confusion becomes clarity or vice versa. Each text may draw on other major or minor

characteristics of the maze, although those other qualities are subordinated to the chief defining feature emphasized by the metaphorist. And each includes, implicitly or explicitly, reference to the maze's fourth essential quality: the structural presence of *ambages* and circuitousness. I have not used this labyrinthine necessity as the governing principle of a fourth category because it is so much a given in all cases that one cannot base on it meaningful distinctions between metaphors. *Ambages* are the basic units of which labyrinthine artistic complexity is composed; they render the maze inextricable or impenetrable; they define the difficult process a wanderer undergoes. It is possible to isolate artistry, inextricability and impenetrability, and difficult process as dominant features on which metaphors are based; it is impossible to do so with *ambages*, the indispensable labyrinthine quality.

· The Labyrinth as a Sign of Complex Artistry ·

Many metaphorical uses of the labyrinth have a major aesthetic component based on the fact that, fully perceived and appreciated, the maze transcends apparent disorder to reveal a grand design. The analogy between the maze and what it signifies rests on the intricate complexity of the signified's structure once it is, perhaps with some difficulty, seen whole as a work of art. Often, as in the texts of Chapter 1, the architect is celebrated as well as his artifact—the creator is praised through the creation that testifies to his skill and fame, for a maze's very complications assert the ordering intelligence of the maze-maker. Thus the labyrinth generally functions *in bono* as a sign of complex visual or verbal artistry in the classical and early Christian periods (this is not always true in medieval literature); but there may also be degrees of excellent complexity, and human architects and labyrinths are not necessarily the best.

Sometimes the ancient labyrinths, works of men, are compared with the works of animals. Thus Aelian (170–233 A.D.) comments on the protective architecture of the ant: "Historians celebrate the underground passages of the Egyptians; they also with the company of poets celebrate certain labyrinths in Crete. They have yet to learn of the elaborate tracks with their mazy windings dug by ants in the earth. Now in their wisdom these make their underground dwelling so very tortuous as to render access difficult or totally impossible for such creatures as have designs upon them."[1] The greatest architects, then, are no cleverer than unthinking creatures. Gregory of Nazianzus (330–390) goes farther,

1. Aelian, *On the Characteristics of Animals*, trans. A. F. Scholfield, LCL, 3 vols. (Cambridge: Harvard University Press, 1959), 6.43.

finding the human artistry of labyrinth dances and structures (not to mention labyrinthine reasonings and rhetoric) inferior to the instinctive, God-given architectonic ability of animals. Stressing the vastness of God and his utter incomprehensibility to human reason, Gregory suggests that we can learn to know at least something of an intrinsically labyrinthine and mysterious God through his magnificent handiwork, both in itself and as manifested through God's creatures, whose architectural skill surpasses ours. Who, Gregory asks, gave the bees their ability to construct their miraculously regular and complex hives? Who taught the spider to make its web, that perfect trap full of intricate windings? What Euclid could imitate this fine geometry, what Phidias could fashion such beauty? "What harmonious dance of Knossos, Daedalian work, performed by a young girl and reaching the height of beauty? Or what Cretan labyrinth, with the difficult exit and inextricable turnings—to use the poets' word—returning so many times on itself through the artist's craft?"[2] And, he continues, he has said nothing of the treasury of the ants; but if you understand all this, then consider the diversity of plants, of the earth itself!

For the stoic Aelian and the saint as well, the implications are clear: who is man to pride himself on his labyrinthine artistry—who even is the legendary Daedalus—in comparison to the thoughtless animals, whose craft is still greater? And if animal artistry surpasses ours, what of the divine artistry that empowered the animals? For Gregory, God himself is the only true Daedalus, father of architects, and his labyrinthine handiwork is the cosmos. That is what needs, and defies, explication; "search, man, and see if you can follow even one of these paths!" (28.27). God's obscurity, which we can try to penetrate as if it were a labyrinth, is the true and humbling goal of intelligent endeavor, but we are unlikely to succeed. There is perfect order in the divine labyrinth of creation, but the feeble tool of human reason, limited in perspective and nature by its imprisonment within the mundane maze, ill equips us to discover it. To

2. Gregory of Nazianzus, *Second Theological Oration* 28.25, in *Discours* 27–31, ed. Paul Gallay and Maurice Jourjon (Paris: Editions du Cerf, 1978). The sequential mention of Ariadne's dance, ultimately derived from the *Iliad*, and the Cretan labyrinth is suggestive but inconclusive: Are dance and structure linked because of their common creator Daedalus? because one takes place in, or is shaped by, the other? because both derive from the matter of Crete? Neither Gregory nor common sense provides a definitive answer. The whole oration is characterized by labyrinthine language—language referring to the following of difficult and obscure paths to reach some goal—which is appropriate, given the subject of the discourse. Whether this Greek text was known in the Latin Middle Ages I do not know; certainly Guibert of Nogent, Thomas Aquinas, and even Ralph Higden cite other works by Gregory. In any case, I am not arguing the direct transmission of this and other Greek texts but wish to suggest instead that one person's way of interpreting the labyrinth might have been duplicated by others independently; the metaphorical potential of the image itself is most important.

For a full discussion of this passage and of the Oration itself, which ends with a quasi-Dantean ascent above the mundane labyrinth, see Miller, *Measures of Wisdom*, pp. 345–361.

us, much is and must remain confusion, enigma, and darkness. We cannot work our way through the labyrinth to see God, or at least not by the exercise of reason.

The work of man earns somewhat greater esteem with Marius Victorinus (fourth century), who explains the origin of the classical ode's strophe, antistrophe, and epode by referring to Theseus's dance at Delos after he conquered the labyrinth. In this ritual—presumably related to Ariadne's Daedalian dancing floor in the *Iliad* and to the dance mentioned by Gregory—Theseus "imitated the confused and twisting journey of the labyrinth with the boys and girls who had escaped with him, singing as they danced first in one circuit, then winding back."[3] Victorinus notes that this dance also mimics celestial harmony, so that the first pattern of the dance, moving to the right, imitates the turning of the heavens from east to west; the second, to the left, enacts the orbits of the planets (*erratic* stars, to use labyrinthine language) from west to east; and in the third movement all stand still like the earth, around which everything else circles. Victorinus thus suggests that labyrinth, cosmos, dance, and (to return to Victorinus's nominal subject) the structure of poetry are all related instances of magnificent but complex design composed of turns and counterturns. Human labyrinths imitate divine cosmic art. We will see in Chapter 5 how Victorinus's comments on the labyrinth dance may inform the fourteenth-century dance at Auxerre Cathedral.

A more difficult and problematic linking of poetry, fame, the labyrinth, and nature comes from Ennodius (fl. 513), bishop of Pavia, wordsmith of "sonorous humanism and unprofitable virtuosity."[4] Following a tortuous path through the Alps, he reflects, "Why, fame of the ancient poets, do you entwine labyrinthine recesses with your tongues, which anyone re-reading would fear [or: so as to frighten a reader]? There [as described in poetry] was a laudable wandering made by a craftsman, when Daedalus twisted the straight way with his ingenuity. Here [in the Alps] nature carries man through the clear air."[5] One expects stylistic labyrinths from Ennodius; this textual one seems to associate pagan poetry with mazes, partly in that classical poets wrote *about* the terrors of the labyrinth. *Ars poetriae* may thus be *ars daedala*, a position consistent with Ennodius's own ornate practice. He also seems, like Aelian and Gregory, to be making a point about art vs. nature: labyrinthine poets

3. Marius Victorinus, *Ars grammatica*, in *Grammatici latini*, ed. Heinrich Keil, vol. 6 (Hildesheim: Georg Olms Verlagsbuchhandlung, 1961), p. 60. For Victorinus, a rhetorician and Christian convert mentioned in Augustine's *Confessions* (8.3,4) and well-known to the Chartrian philosophers, see Pierre Hadot, *Marius Victorinus: Recherches sur sa vie et ses oeuvres* (Paris: Études Augustiniennes, 1971).

4. Pierre de Labriolle, *History and Literature of Christianity from Tertullian to Boethius*, trans. Herbert Wilson (London, 1924; repr. New York: Barnes & Noble, 1968), p. 489.

5. Ennodius, *Carmina* 1.1, *PL*, 63, 310.

are artificers, like Daedalus, however praiseworthy the *errores* they craft; and their art is inferior to Nature's, whose tortuous path is truly the way to Olympus. God's labyrinth exceeds man's, and the fame of God the creator surpasses that of mere poets, whose paltry pride in their complex workmanship pales in comparison. Probably there are also hints here of a common metaphorical association of the maze we shall examine shortly: pagan learning is a dizzying labyrinth of deception, Christian learning is true order. Daedalus's work, a real building, presumably falls somewhere in between.

As God's labyrinthine structures, whether built by him or his nonhuman creatures, eclipse those of human architects and dancemakers, so too, as Ennodius suggests, with labyrinths of words—poetic or prophetic texts. Human poetry and rhetoric—complex arts moving circuitously from beginning to end—are potentially labyrinthine. Thus Sidonius Apollinaris (431–487) praises one Peter's poetry: "We have the completed work; weaving [*texens*] it with art in the dimeter, he has run a hard journey and labyrinthine ways."[6] The difficulties of composition (and perhaps of comprehension) are arduous, but the labyrinthine product is admirable. Prophetic texts inspired by God constitute still more magnificent mazes, as Jerome (345–ca. 420) knew from his own exegetical experience with baffling (and highly poetic) books of the Bible. Jerome uses and develops the idea of the labyrinth so elegantly in his commentary on *Ezekiel* that it merits special attention.

The passage in question begins the last book of the commentary, after Jerome has discussed Ezekiel's vision of the reconstruction of the Temple in Jerusalem, a highly complicated building with so many chambers, galleries, winding stairs, and passages that it is a labyrinth in its own right:[7]

What I should have said at the beginning of the Temple of Ezekiel I am now going to say at the end, reversing the order, mindful of the verse, "Here is the toil of the house and the inextricable wandering" [*Aeneid* 6.27], concerning which the same poet writes elsewhere, "As once in lofty Crete the labyrinth is said to have had a route woven [*textum*] of blind walls, a deception which was difficult in a thousand ways, where undetectable and irretraceable wandering while following the signs would trick one" [*Aeneid* 5.588–591]. So also I, entering the ocean of those scriptures and, so to speak, the labyrinth of the mysteries of God, of whom it is said "He made darkness his covert" [Psalm 17:12] and "there are clouds in his circuit"; I do not claim perfect knowledge of truth, but dare offer some indications of

6. Sidonius Apollinaris, *Epistulae et carmina*, ed. Christian Luetjohann, *MGH Auct. antiq.*, 8, p. 165, ll. 88–91.

7. One cannot help wondering whether the eastern tradition that Solomon built a labyrinthine palace or prison (see Batschelet-Massini, pp. 36–39, and Kern, pp. 163–165, plates 197–199) is based on the great temple in Jerusalem.

doctrine to those who wish to know, not by my own powers, but through the mercy of Christ, who himself resolves the tricks and doubtful turns [ambages] for us in our wanderings, guiding our blind footsteps by the Holy Spirit. Following him, we will be able to reach the haven, an explanation of the prophet Ezekiel.[8]

Presumably the labyrinth occurred to Jerome as an introductory topos for several reasons. He may have seen an analogy between ancient labyrinths and the Egyptian complexity of the temple he has just elucidated: the greatest Judaeo-Christian building reminds him of the summit of pagan architecture, and perhaps, as happens later in connection with some cathedral labyrinths, he wishes to suggest that holy biblical architecture rivals and even excels the pagan, a point like Gregory's and Ennodius's but replacing the superiority of God's own handiwork with the superiority of divinely inspired craft. There is also an analogy between the unraveling or explication of the complex ancient labyrinths and the exegesis of the Temple, which is full of symbolic details that create a kind of multicursal labyrinth for the interpreter, who may choose among countless potential meanings for each concrete feature.[9] For an exegete, the Temple is not merely a house of holy art but also a house of much holier toil than the Cretan labyrinth in the first Virgilian passage Jerome quotes. Perhaps, too, Jerome hopes his elaborate exegesis will decorate Ezekiel's description of the Temple as fittingly as Daedalus's sculpted labyrinth arrayed the temple at Cumae in Virgil.

I have already hinted that Jerome's sophisticated discussion employs the labyrinth not only as an exemplary artifact but also as fruitful if difficult process; like Virgil, both of whose explicit references to the labyrinth he quotes, Jerome deals with both structure and story. The Temple is implicitly a bewildering labyrinth to be solved and finally appreciated, and so too is the text describing it. This text, an "ocean" of possibilities with no clear signposts, is also "a labyrinth of the mysteries of God," an enigmatic prophecy in which a God of darkness, clouds, and circuits has chosen to present himself to humanity. *Why* God has done this remains unclear—perhaps so that what is wrenched from the text with difficulty will be more appreciated, as theoretical defenses of allegory often hold, or perhaps to anticipate the enlightening educational role of Christ-Theseus. In any case, truth is veiled in the labyrinth of mystery,

8. Jerome, *Commentariorum in Ezechielem prophetam, PL*, 25, 447–449. I cannot identify the source of Jerome's second biblical quotation.

9. Rather ironically, the Temple, seen by Jerome as the subject of a labyrinthine text to be carefully retraced and explained in his exegesis, becomes a popular source of thematic texts to organize the introduction (*accessus*) to medieval books: see A. J. Minnis, *Medieval Theory of Authorship*, pp. 64–66. What was a source of confusion for Jerome becomes a means for later writers to impose order; in short, the same labyrinth betokens both clarity and chaos.

which Jerome enters like any wanderer in a maze, well aware of possible *errores*, of the misjudgments and deceptions that may develop from textual *ambages*. Perhaps the unraveling of *Ezekiel* is as complex as the Trojan Ride and as fraught with peril as Theseus's entry into the maze. Fortunately, Jerome has a guide: Christ-Theseus, who has trodden the labyrinth and understood it, resolving its *ambages* for Jerome, who need only follow in his footsteps through Ezekiel's intellectual subtleties to arrive at the transcendence of a valid interpretation. Jerome's exegesis, apparently adopting the fallacy of imitative form, itself becomes a labyrinth: appropriately and gracefully, he reverses the natural order of explication and chooses an artificial order, juxtaposing beginning and end as the twisting path of a labyrinth might do and as Geoffrey of Vinsauf and others later recommend for artistic texts.

Thus, as for Gregory of Nazianzus, God is as mysterious as the labyrinth, and he reveals himself through labyrinthine art—here, a complex temple and a difficult text. If there are tricks and *ambages* in Ezekiel's labyrinth, however, they are there not to deceive but to enrich and to serve as an occasion for the grace of inspiration. God the labyrinth gave Ezekiel a vision of a temple-labyrinth which Jerome perceives as such; and as Christ unravels the labyrinth of the text for Jerome, so Jerome's interpretation will do for us.[10] Complex creative artistry begets complex hermeneutic artistry, and both Jerome and his readers require divine assistance lest they err in tracing their respective texts, in making determinate what is cloudy. In describing this metaphorical labyrinth whose dangers are intellectual and whose elaborate circuits may lead to enlightenment, Jerome has followed the advice of his contemporary, Augustine, turning Egyptian gold to better use and Christianizing classical ideas of the structure and myth of the labyrinth.[11] Complex and artistic texts also are seen as labyrinths, sometimes overly obscure ones with unavailing guidance, in medieval literature.

In these examples, the labyrinth is a sign of magnificent and complex artistry in a structure or text whose apparent confusions may, with the right perspective (or intelligence, or supernatural aid), be revealed as admirable order—the order of an intricate building, of words, of the

10. In medieval manuscripts, commentary is often written in the margins, surrounding the commented text on the page. In one sense, commentary is an external tribute to, or decoration of, the enclosed text; in another, it is a textual clue that, followed carefully, explicates what lies within, carrying the reader to the center of the labyrinth.

11. For Augustine, see *On Christian Doctrine* 2.40 (para. 60), p. 75.

Similar associations of the maze with a difficult prophetic text and with God as author of that text inform Jerome's *Commentary on Zacharias*—*PL*, 25, 1453; see epigraph to chap. 3. The association of the labyrinthine circles with the spirit and the contexts of Jerome's biblical allusions suggest that again God and his words are the obscure, mysterious labyrinth, which we may interpret only by grace, or perhaps by the contextualizing "thread" of the New Testament.

cosmos, of God himself. This order is difficult for the artist to achieve and the observer to perceive, but effort or grace may lead to appreciation and understanding of the grand design; these mazes are convertible from chaos to clarity. Labyrinths of artistry imply and celebrate the presence of an architect who may be merely human, as in the classical texts of Chapter 1 or Sidonius's description of the poet's work, but more often in Christian texts the greatest praise is reserved for God as ultimate or immediate *artifex*; his mazes are *in summo bono*, man's only comparatively excellent. All these labyrinths of art are penetrable and extricable, if only for the elect; but because the process of penetration is so difficult, these mazes have an affinity with the labyrinths of difficult process to be considered later. We will eventually see the medieval progeny of mazes of artistic complexity in cathedrals, in manuscripts, in the *maisons de dédale* built by aristocrats, and, more or less covertly, in some great medieval poems. The idea of labyrinthine complexity, but generally not the name of labyrinth, will also be manifest in medieval poetic and rhetoric: as we shall see, the labyrinth's connotations *in malo* grew so dominant that in the Middle Ages the word was seldom used in praise of art even though the thing itself and the name of its architect survive *in bono*.

· The Labyrinth as a Sign of Inextricability or Impenetrability ·

Many metaphors are based on the impossibility of escaping from the maze (if seen as hazardous) or finding the center (if good lies inside) without special aid, metaphors that see the labyrinth as a dangerous prison or an unfathomable protection for something precious. Unlike artistic mazes, inextricable ones are usually *in malo*—one would hardly want to escape from something beneficial. Impenetrable labyrinths, on the other hand, may contain unattainable good. Both types are included here because they involve the idea of the maze as perpetual process. Many authors describing inextricable labyrinths write as if from a privileged perspective: they see where the ambiguous circlings lead, and they warn against labyrinthine perils. The very act of writing, then, extends Ariadne's thread to unwary maze-walkers, although these texts may suggest other kinds of guidance through mental or moral *errores*. If metaphorists see the dangers of these *errores* and fear their inextricability, they do not invariably conceive of labyrinths as multicursal. Sometimes continuous choice is envisaged, and if so, the very existence of alternatives may be perilous: choice, for many early Christian writers, implies the possibility of straying from the true path, and multiplicity of any sort may have seemed exceptionally dangerous to believers in one God surrounded by pagan pantheons. Sometimes the imposition of a

clear road to salvation on a dangerous multicursal network is implied, as with Gregory of Nyssa (335–395) invoking Christ-Theseus, Ambrose, and Prudentius. Yet with Gregory Thaumaturgus (213–270) a single path is perilous and the existence of many options advantageous, and some authors seem to have in mind no particular form at all for their mazes. What matters is not so much form as the fact that these mazes, however constructed, are prisons unless guidance is offered. Most inextricability metaphors naturally involve a kind of narrative, describing the confusing and frustrating (or, alternatively, speciously appealing) process of treading a labyrinth whose design and goal are unknown. Plot—the temporal sequence of maze-exploration—is more important than structure or the perception of artifact as artifact, yet this plot is seldom related explicitly to the Cretan myth. Predictably, the shaping role of the architect, stressed in metaphors of artistic complexity, recedes in many examples of the inextricability topos, whereas in others the labyrinth seems to be constructed by the wanderer's own moral and mental failings, which weave an unnecessary maze and complicate what ought to be straightforward: far from being useful processes, these labyrinthine *errores* are veerings off from the right way. In any case, inextricable mazes are to be escaped if at all possible, and although a rescued maze-walker's perceptions may shift so that the maze seen whole looks different from the maze as experienced from within, one generally does not come to see it as good. If anything, these deceptive mazes of harmful digression look better from the inside; an overview reveals horrors that may be hidden from someone just embarking on the twisting path to ruin. These metaphors, then, lead to the realm of morality, and labyrinthine aesthetics are left behind.

Sometimes the minotaur within these mazes is death. A large Roman mosaic on a tomb in Susa, Tunis, reads, "Here enclosed, he loses his life."[12] Christian writers are more optimistic; their labyrinthine prisons of death may be escaped, with the right guidance. For Gregory of Nyssa, the labyrinth is primarily that everlasting death from which only Christ-Theseus extricates us:

> It is impossible to reach the same goal without following the same path. Those who wander, constrained in a labyrinth, know not the way out; but if they find someone who knows the maze well, they follow him through the complicated and deceptive turns of the building to its end. They would never have escaped had they not followed their guide step by step. Reflect: so is the labyrinth of life inextricable for man if he does not follow the path

12. See Matthews, pp. 48–50, and Kern, pl. 145. The presence of a minotaur in the maze's center clarifies why the image is appropriate and through whose agency the unicursal design is inextricable.

that led Him who once entered outside. This labyrinth symbolizes the inextricable prison of death, where unhappy mankind was once imprisoned.[13]

Only by choosing the single path that Christ defined within an implicitly multicursal maze—in this case, Gregory goes on to say, the path of baptism—can one escape the maze of death, erring life, and human ignorance. Some such tradition presumably informed medieval carvers who placed mazes on baptismal fonts and, more broadly, the many medieval writers and cathedral-designers who saw Christ-Theseus as harrower of hell and charter of a safe path to salvation.[14]

But one need not be Christian to see life as a maze, disentanglable unless special aid avails, however popular this metaphor was to become in the Middle Ages. Seneca (4 B.C.–65 A.D.) deals with the subject in his forty-fourth moral epistle, evoking a situation and image that may have influenced Boethius in the *Consolation of Philosophy*. Seneca's addressee, Lucilius, has complained of mistreatment by nature and fortune, but Seneca blames Lucilius's lack of philosophical perspective for his troubles. Lucilius is too entangled in the world; like most men, he has mistaken the means for the end:

> While seeking happiness, they are really fleeing from it. For although the sum and substance of the happy life is unalloyed freedom from care . ∴. yet men gather together that which causes worry, and, while travelling life's treacherous road, not only have burdens to bear, but even draw burdens to themselves; hence they recede farther and farther from the achievement of that which they seek, and the more effort they expend, the more they hinder themselves and are set back. This is what happens when you hurry through a maze; the faster you go, the worse you are entangled.[15]

The essence of the maze of life is frustration; urgent struggles toward the unseen goal may well lead one away from it, as the winding course of a maze may veer from center to periphery. Vision within the maze is restricted and false goals seem true, with bitter unhappiness and Lucilius's kind of fuzzy thinking the inevitable consequences. Seneca advocates a transcendent alternative: one frees oneself from this labyrinth of futility "simply by distinguishing between good and bad things," by looking "not to the source from which these things come, but to the goal

13. Gregory of Nyssa, *La catéchèse de la foi*, trans. Annette Maignan (Paris: Desclée de Brouwer, 1978), chap. 35, pp. 90–91.

14. See Francis Bond, *Fonts and Font Covers* (London: Oxford University Press, 1908), and plate 15, the Norman font at Saint Martin's, Lewannick, Cornwall. For Gregory, Christ's three days in the labyrinth of hell correspond to triple immersion in baptism.

15. *Seneca ad Lucilium epistulae morales*, trans. Richard M. Gummere, LCL, 3 vols. (London: William Heinemann, 1925), 1, 286–291.

towards which they tend." A rational overview, a choice not to follow the traces blindly, frees one from the tyranny of popular opinion and the labyrinth of heedless, hasty life. Fortune may have helped create this maze, but she cannot contain the free philosophical mind, which, like Daedalus, flies above the apparently inextricable mental prison-labyrinth of life and sees true goals.

For Christian writers, the trammels of mundane mazes are more likely to be woven by sin than by insufficient philosophical detachment. Sometimes original sin is responsible, as with Prosper of Aquitaine (390–463), whose *Carmen de ingratis* abounds in labyrinthine language. He describes the moral blindness and mental corruption caused by original sin in a passage whose imagery anticipates the beginning of the *Divine Comedy*: "The vigor of the mind is blunted and clothed in darkness, and its dull eye cannot bear the lightning of divine light. Thus judgment limps, having fallen into by-ways; in its blind, bandaged efforts there is motion, but there is also wandering [*error*]. So the will continues, always wanting something to rush towards; and having thus entered into the ambiguities [*ambages*] of doubtful paths, the will is deceived by the labyrinth."[16] The fallen mind is its own maze.

More often, actual sin is the labyrinth, as in Ambrose's exposition of Psalm 118:59, "I have thought on my ways and turned my feet unto thy testimonies." Ambrose interprets these lines as an intention "to walk in the paths of your commandments, which will not let me wander [*errare*], nor my footstep turn aside in devious, twisting ways." He continues by describing those who, ignorant of the way, follow paved routes and thereby avoid "the swervings of error." Others presumptuously "follow some shortcut. Leaving the public road, they often run into labyrinths of error and are punished for having left the road, until after much labor they try to find the path they had left."[17] Here, rather atypically, the "path"—presumably the way, the truth, and the light—runs through the labyrinth of trackless countryside but is not part of it. Apparently anything with no clear, direct way out is a sort of maze. Ambrose's almost infinitely multicursal labyrinth is an image of willful sin, which creates its own prison; the contrasting path—perhaps a correct unicursal track laid down in a multicursal wilderness by Christ, scripture, and saints—is right conduct in accordance with received principle. Though not necessarily inextricable, Ambrose's sin-built labyrinth could well become so if

16. *PL*, 51, 126.
17. In Ambrose, *Expositio psalmi CXVIII* 8.31, *CSEL*, 62 (Leipzig: G. Freytag, 1913), 168. Ambrose's dates are ca. 340–397. Augustine uses a similar image without, however, mentioning the labyrinth explicitly: in matters of interpretation, "it is more useful not to leave the road, lest the habit of deviating force him to take a crossroad or a perverse way": *On Christian Doctrine* 1.36 (para. 41), p. 31.

no authoritative guide appears to remedy inexperience, for the great labor its victims expend merely makes them wish for a path; it does not take them any closer to it.

Since labyrinths are woven of *error*, the maze is often used in early Christian and medieval times alike to illustrate the fatal attractions and confusions of heresy and paganism. Thus Hippolytus of Rome (d. 235) claims to have "broken through the labyrinth of the heresies" with the clarity of truth, and Caelius Sedulius (fifth century) chastises pagans, "Daughters of Theseus, why do you wander in labyrinthine caves and frequent the blind thresholds of Daedalus' house?"[18] Here the maze's traditional darkness contributes to its inextricability, echoing the blindness of false believers. Prudentius (348–after 405) draws on the doubleness of the multicursal maze in attacking the folly of those who remain heretics in his own enlightened day, when even pagans like Plato and Aristotle, who "wove [*texit*] twisted ravings" and were driven by "the double labyrinth and circular error," knew there was only one God.[19]

Although this is the only time Prudentius mentions the maze explicitly, he habitually associates heresy, sin, and spiritual death with the labyrinthine process of moral choice in life; like Ovid and the Virgil of *Aeneid* 6, he may have felt that sufficient density of labyrinthine language establishes the reference adequately.[20] In the *Apotheosis* and elsewhere, Prudentius is obsessed with the conflict between unicursal and multicursal options, which mirror the choice between one God and many. Everyone faces a choice between a single path of virtue and infinite paths of vice: "Hard is it to discern the narrow way of salvation amid twisting paths. So many cross-roads meet us, which have been trodden smooth by the misguided straying of the faithless; so many side-roads join together, where tracks intertwine on this hand and that; and if, wandering [*errans*] at random, a man follows them, leaving the straight path, he will plunge into the snare of a hidden pitfall [of dark reasoning (*ambagibus*) and intricate arguments]" (*Apotheosis* praef. 5-24). In this dark wandering, stones are set up to trip us or to guide us on the true path, depending on

18. Hippolytus of Rome, *Philosophumena* 10.5, trans. F. Legge, 2 vols. (London: SPCK, 1921), 2, 149, and Caelius Sedulius, *Carmen paschale* I.43–44, ed. Nicolaas Scheps (Delft: W. D. Meinema, 1938). Batschelet-Massini (pp. 40–42, 57) also discusses the labyrinth-heresy association commonly found in Christian apologetics.

19. Prudentius, *Apotheosis* praef. ll. 200–204, in *Works*, trans. H. J. Thomson, LCL, 2 vols. (Cambridge: Harvard University Press, 1962). Parenthetical references to Prudentius are to this edition.

Prudentius may be the first to associate Aristotle with labyrinths, a topos considered in chap. 7.

20. Batschelet-Massini also notes Prudentius's habitual use of labyrinthine language and believes that a passage from the *Contra Symmachum* concerning the road to death was used as an inscription on a labyrinth in the early basilica in Tigzirt, Algeria (pp. 40–41). On the latter point, I remain unconvinced: see *Dictionnaire d'archéologie chrétienne et de liturgie*, ed. F. Cabrol and H. Leclerq (Paris: Librairie LeTouzey et Ané, 1924–), *s.v.* Tigzirt.

whether we are blind or guided by the torch of faith so that "our steps may be straight" instead of "erring in the darkness" (praef. 40-41). The crossroads are those of heresy; the single path—a true unicursal path through a multicursal maze of error, in essence—is Christ's.

Sometimes the crucial choice of the right path appears simply. In the *Hamartigenia* (2.789-803) two brothers face a *bivium*, one road fair and shady, the other narrow and arduous in its ascent, and in such a passage it is hard to see anything truly labyrinthine. But, well aware of life's complexity, Prudentius usually complicates the choice until the image of a labyrinth is inescapably evoked, as in *Contra Symmachum* (2.843-857), where he argues against allowing the worship of pagan gods. Sym-machus had endorsed a multicursal approach to knowledge: "The grand secret of mysterious truth can only be sought out by a multiplicity of ways and widespread tracks; the course which is to search out the hidden God must trace him by diverse ways and tread a hundred paths." Prudentius characteristically believes in a single God and path:

> Much going about of ways involves windings and uncertainties and more confused wandering [*multa ambago viarum / anfractus dubios habet et perplexius errat*]; none but the single way is free from straying [*errore*], the way where there is no turning aside into a by-road nor hesitation at a number of forks [*biviis*]. Yet I do not deny that a double path always confronts us and that mortality goes two ways, in uncertainty as to where its ignorance is carrying its steps. The one splits into many branches, but the other is one and single. One follows after God, the other worships a number of deities and has as many offshoots as there are statues in the temples or phantoms flitting about in unsubstantial monstrous shapes.

There are ultimately only two paths, depending on whether one chooses God or gods, and the "simplex via" of God, however much it may twist, is single—a unicursal authorized version superimposed on a deceptive multicursal maze whose paths degenerate into futile branchings and dead ends. In recommending the Ariadne's thread of Christian dogma, Prudentius defines the double maze of belief according to its goal and its guide:

> It is a single path, then, on which God is our guide. . . . On the manifold way the guide is the devil, who on the left hand splits it into the confusion of a hundred paths. One way he drags bearded philosophers, another way men who are mighty in riches and honor. He tempts them on with the voices of birds, too, and cheats them with soothsaying, incites them with the obscurities [*ambage*] of a raving old Sibyl, entangles them in astrology. . . . Do you not see how it is but one way, that wanders in many windings under a guide who will not let you go to the Lord of salvation, but shows you the road to death along by-ways. . . . Depart ye afar, and enter into your own

darkness, whither that guide calls you, who goes before you over tangled ways far from the road, in the night of hell! (*Contra Sym.* 2.882-904)

Divine authority defines a single path to the goal of salvation, safe extrication from the mundane maze; even the devil's multicursal paths are finally single in that they all lead to inextricable hell. For Prudentius, life is a maze or, rather, a pair of mazes: in one, God is guide and reward; in the other, confusion and death abound. Pagans like Plato and Aristotle had no choice but to whirl along the downward windings of the demonic labyrinth, but Christians have supernatural assistance to find the single path to heaven.

Lest we think all multicursal mazes are evil in early Christian writings, Gregory Thaumaturgus views the inextricable labyrinths of pagan thought quite differently. Prudentius accused Symmachus of leading people into multiple mazes on the pretext that only thus would the truth be found. Gregory agrees with Symmachus's method, if not with his polytheism. He praises Origen for making his disciples study many philosophies lest they become imprisoned in one school of thought. For Prudentius, the single path leads to truth; for Origen and Gregory, adhering to a single philosophy creates a tyrannical maze of error holding its victims captive like a swamp that "allows them neither to retrace their steps nor to cross it and effect their safety" or like a dense forest from which a wanderer seeks escape but, "turning in a variety of directions and lighting on various continuous paths within it, he pursues many a course, thinking that by some of them he will surely find his way out: but they only lead him further in, and in no way open up an exit for him inasmuch as they are all only paths within the forest itself."[21]

Or again, we might take the similitude of a labyrinth, which has but one apparent entrance, so that one suspects nothing artful from the outside, and goes within by the single door that shows itself; and then, after advancing to the farthest interior, and viewing the cunning spectacle, and examining the construction so skillfully contrived, and full of passages, and laid out with unending paths leading inwards and outwards, he decides to go out again, but finds himself unable, and sees his exit completely intercepted by that inner construction which appeared such a triumph of cleverness. But, after all, there is neither any labyrinth so inextricable and intricate, nor any forest so dense and devious, nor any plain or swamp so difficult for those to get out of who have once got within it, as is discussion [*lógos*], at least, as one may meet with it in the case of certain of these philosophers.

21. All quotations are from chaps. 13–15 of Gregory Thaumaturgus, *Panegyric on Origen*, trans. Alexander Roberts and James Donaldson, in *Ante-Nicene Christian Library*, vol. 20 (Edinburgh: T. & T. Clark, 1871), pp. 68–75.

Gregory's three images are alike in their inextricability, which relates them to fruitless philosophical discussion, and in their lack of any valid goal; Gregory does not necessarily suggest that truth lies *within* these philosophical mazes but that it may be found *through* them if one can escape their toils and find a way out. The first two similes remind us of Ambrose's maze, the pathless and therefore infinitely multicursal countryside.[22] Gregory's true labyrinth, equally though more systematically multicursal, is distinguished from swamp and forest by its artificiality, artistry, and deceptive convertibility whereby aesthetic pleasure turns to confusion with that duality so typical of the maze. Yet although Gregory is well aware of the inextricable dangers that individual multicursal mazes create for the ignorant and single-minded, he, like Origen, sees their value to the enlightened: one learns much from a maze so long as one has a guide like Origen, who led his followers through perilous places "whenever anything tortuous and unsound and delusive came in our way." This Origen accomplished through familiarity with the ground (mazes can be memorized, after all) and because he was "safe in his own altitude," possessor of the privileged perspective that grants a comprehensive vision of both the forest and the trees, the labyrinth as a whole and as a pattern of paths. For Gregory, errands into multicursal mazes are dangerous but necessary; one must experience confusion, trusting one's guide to see one safely out and elucidate the necessary lessons. Labyrinths of words are valuable so long as one has "all freedom to go round the whole circle of knowledge," ultimately assessing the labyrinths of knowledge accurately thanks to an exalted Christian perspective. Multicursal mazes of philosophy, deficient in themselves, are valuable so long as they are not finally inextricable, for Gregory shares Milton's distrust of "fugitive and cloistered virtue." Gregory's sophisticated vision of the maze as essential trial by error has much in common with romances such as the *Queste del Saint Graal* and with the beneficial mazes of difficult process we will encounter in the next section.

So far inextricable labyrinths have generally represented serious moral or intellectual error. But the image can be a light-hearted cliché as well. Thus Jerome mentions that "a decision which is not doubtful, but clear" can emerge from "labyrinths of entangled dispute," and Sidonius describes a friend's "inextricable labyrinth of complicated business" in which "he does not know what to reject or choose."[23] The ease and grace

22. In Arabic, a similar logic seems to prevail: the words *tih*, *taiha*, and *mataha* (all related to *taha i*, to get lost, to perish, to confuse) all mean both labyrinth and desert: see Hans Wehr, *A Dictionary of Modern Written Arabic*, ed. J. Milton Cowan (Wiesbaden: Otto Harrassowitz, 1961). I am grateful to Jane Dammen McAuliffe for this reference.

23. Jerome, *Contra Iohannem* 14, *PL*, 23, 382; Sidonius, *Epistolae et carmina*, *MGH Auct. antiq.* 8, p. 28.

of such allusions indicate how familiar the labyrinth and its attributes were in the early Christian period, and although in these examples labyrinths are bothersome, they are neither very bad nor particularly immoral.

Labyrinths of impenetrability are also founded on the idea of the maze as a place in which one cannot get where one wants to go or understand what must be understood; this labyrinthine nuance is reflected in one possible meaning of the common medieval etymology "labor intus," "difficulty going in." Since one cannot get in, presumably to reach a desired goal, the impenetrable maze carries fewer negative connotations than does the inextricable labyrinth. The function of this impenetrability, as in the Cretan myth, is usually to protect something inside: in the passage from Aelian, the ants are protected; for Gregory of Nazianzus and Jerome, God's mystery is veiled by the cosmic or textual maze. According to Vegetius, the Roman legions had labyrinthine impenetrability in mind when they took the Minotaur as a heraldic sign: "Just as the Minotaur was described as hidden in the deepest, most secret labyrinth, so too the counsel of the leader ought always to be hidden."[24] The labyrinth that may have figured on the robes of Roman emperors carries a similar message: a medieval manuscript claims that imperial robes were decorated with "a labyrinth made of gold and pearls, in which is found a minotaur made of emerald holding its finger to its mouth, for just as no one might examine the labyrinth, so no one ought to betray the secrets of the monarch."[25]

Perhaps it is also in this context that one should take Prudentius's description of the Tiburtine catacombs in his praise of Hippolytus of Rome. Although Prudentius does not use the word *labyrinthus*, it seems to have been in his mind, suggested perhaps by the name and fate of this saintly namesake of Theseus's ill-fated son (Saint Hippolytus too was martyred by wild horses) and also by the physical nature of the catacombs, those caves into whose "hidden depths a downward path shows the way by turning, winding steps," the whole a "fabric of narrow halls running back [*texant*] on either hand in darksome galleries," a fit "place of concealment" for the body of a man who lapsed into heresy

24. Vegetius, *Epitoma rei militaris* 3.6, ed. Carl Lang (Leipzig: B. G. Teubner, 1885). See also Festus, *De verborum significatione, s.v. minotauri*. This tradition has intriguing implications for Chaucer's *Knight's Tale*, where Theseus's emblem is the Minotaur.

25. See A. F. Ozanam, *Documents inédits pour servir à l'histoire littéraire de l'Italie* (Paris: Jacques Le Coffre, 1850), which transcribes the *Graphia aureae urbis romanae* found in Bibl. Laur. Pluteus 89, infer., cod. 41, a manuscript (also containing a Vegetius text) dated by A. M. Bandini (*Catalogus codicum latinorum bibliotecae mediceae laurentianae*, [Florence: Petrus Leopoldi, 1774–77], III.408) as from the thirteenth–fourteenth centuries. Ozanam suggests the *Graphia* must originally have been written between the sixth and eighth centuries (p. 91). Kern dates the manuscript ca. 1030 and asserts that it enjoyed great influence during the Italian Middle Ages (p. 291).

only to reform and call "people away from the path on the left and [bid] them follow where the way on the right calls, presenting himself as their guide on the straight road and rejecting all windings, the very man who was formerly the cause of their going astray."[26] Thus the deceptive labyrinth of heresy is appropriately converted to the protective labyrinth of a sacred tomb.[27]

A fusion of labyrinthine inextricability and impenetrability also occurs in the *De civitate Dei* of Prudentius's contemporary, Augustine (354–430).[28] Like Prudentius, Augustine associated pagan philosophy with labyrinthine thought; and like Prudentius, he often used language that creates the mental image of a maze without explicitly mentioning the word. Refuting the neo-Platonic concept of recurring cycles, within which there can be no "new thing," and arguing that the creation of man and the sacrifice of Christ are just such "new things" that "shatter these revolving circles" (12.17/18), he contrasts "the straight path of sound doctrine" with the "circuitous paths discovered by deceiving and deceived sages" (12.13/14). Platonists and their ilk are "entangled in these circles," and "they find neither entrance nor egress . . . since they cannot penetrate the inscrutable wisdom of God" (12.14/15). Hence, "the wicked walk in a circle: not because their life is to recur by means of these circles, which these philosophers imagine, but because the path in which their false doctrine now runs is circuitous" (12.13/14). The image inescapably conjured up by this language is a circular labyrinth at whose center sits a God unsearchable in his totality by the human mind, least of all the pagan mind. The wicked see themselves as trapped in infinite circles, a temporal labyrinth with no goal, no ending that does not immediately transform itself into another beginning of the same ineluctable process. For Augustine, this pagan labyrinth of time is a fiction: Christ is the "straight path" (12.20/21) who leads believers to truth and to the God so inaccessible to pagans and who frees his followers from the illusion of endless recurrence. The *real* labyrinth in which pagan philosophers find themselves, for Augustine, is their way of mental error, as inescapable as the endless temporal circles they imagine. The wicked thus condemn

26. Prudentius, *Peristephanon* 11, in *Works*, 2, pp. 307, 315, 317 (ll. 35–38, 154–156, 163–164).

27. The labyrinth in San Reparatus, Orléansville, Algeria, could also be a protective device. The fourth-century pavement, near the north entry to the church, shows a square unicursal labyrinth whose center is another labyrinth of sorts, made of a grid of letters: traced from the center in any direction, the letters read "sancta ecclesia." Perhaps the center represents the mysteries of the church, protected from the dangers of the world by a labyrinth of secrecy. See Matthews, p. 54 and fig. 42; Santarcangeli, pp. 285–288; Kern, figs. 98–99. The labyrinth could also signify the world, to which the Church forms a stable center or guiding clue.

28. Augustine, *De civitate Dei* 12.13/14–20/21; I follow Oates's translation in *Basic Writings of Saint Augustine* and, for the Latin, Bernard Dombart and Alphonsus Kalb, eds., *CCSL*, 48 (Turnholt: Brepols, 1955); English and Latin chapter numbers differ by one.

themselves to futile circles that are inextricable (short of conversion) and that render God a totally impenetrable mystery. Dante's *Inferno* provides a not dissimilar vision of the fate of the damned.

For Augustine, the labyrinth of pagan thought thus spawns a vision of a labyrinth that is (patterned) infinity, rather like Gregory Thaumaturgus's potentially endless philosophical labyrinth. In Simplicius's important commentary on Aristotle's *Physics*, the labyrinth explicitly becomes an endless figure signifying infinity. Normally labyrinths have ends (a goal, a center, or an exit), but these features are irrelevant for Simplicius. Although a labyrinth is spatial and "theoretically able to be traversed," its peculiar construction makes it "practically impossible to traverse" and therefore infinite.[29] So neutral and logical a discussion of the labyrinth's inextricability is extremely rare; although the idea of the labyrinth's infinity is seldom developed, it may be inherent in identifications of the labyrinth with the infinite and impenetrable mystery of God.

Most inextricable labyrinths carry heavy moral freight. Their structural *errores*, whether traps laid by devils and heretics or confusions created by maze-walkers themselves, are inescapable unless special aid is granted. Prisons whose darkness and obscurity correspond to the moral or intellectual blindness of their inhabitants, they afford no sight of a goal, no sense of pattern, and they lead almost inevitably to chaos, death, and damnation. Thus they become useful signs for everything constricting and imprisoning (death, life, sin, heresy, pagan philosophy). Whenever the labyrinth is used *in malo*, its primary characteristic is likely to be its inextricability. Yet, in still another assertion of labyrinthine duality, the very *ambages* that make a labyrinth so inextricable may also render it impenetrable, a useful sign for everything protecting and enfolding a precious mystery. The labyrinth's negative connotations predominate, however, and the vast majority of medieval labyrinth metaphors link inextricability and evil. Representing death, sin, heresy, and hell so commonly and effectively in classical and early Christian times, the maze remains a favored symbol *in malo*.

· The Labyrinth as a Sign of Difficult Process ·

If the *ambages* of inextricable mazes entrap the wanderer and the windings of impenetrable labyrinths deny access to a wished-for goal, the difficult processes of this final category are, at least in theory, benevolently teleological: these *ambages* are educational, leading the maze-walker to a conclusion—even a transcendence—greatly to be desired. A

29. See Aristotle, *Physics* 3.4, trans. Philip H. Wicksteed and Francis M. Cornford, 2 vols. (Cambridge: Harvard University Press, 1970), and Simplicius, *In Aristotelis physicorum commentaria*, ed. Hermann Diels (Berlin: G. Reimer, 1882), p. 470.

circuitous route may be the only effective way to reach a goal. Ignorant almost by definition, the wanderer will be baffled and confused while immersed in the processes of intellectual mazes, but the labyrinth is designed to lead to enlightenment; it is a mental exercise, a challenge to be met if there is to be any progress. Because these labyrinths are intended to teach, the writer-architect may even conduct a guided tour of his artistic product by participating in the action, which is frequently a dialogue, dialectic, or debate. His certainty of the pattern contrasts with the wanderer's ignorance and bewilderment, and the confusion/artistry duality of the maze may be prominent thanks to the coexistence of two perspectives within the text. Usually these mazes are labyrinths of words and concepts carefully strung together, not the physical structures of complex artistry or the moral quandaries of inextricable labyrinths, although mazes of difficult process have much in common with textual mazes. There is, however, a slight difference in emphasis: in many mazes of difficult process we experience what it is like to be *inside* an artistically wrought verbal labyrinth *before* the moment of enlightenment that permits appreciation of the whole structure. These mazes may be unicursal, multicursal, or perhaps both at once: they may include abundant alternatives—sometimes too many—and there may be dead ends or circular reasoning that gets nowhere; but when a knowledgeable guide is present, there will also be a sense of relentless if circuitous progress. These mazes, then, are intended to function *in bono*, although they may fail to achieve their ends if the architect has overcomplicated his creation or if the neophyte wanderer is not up to the challenge.

The labyrinth as a metaphor for learning seems to be related to concepts of perception and thought as intrinsically labyrinthine processes—involuted, circuitous, doubling back at blind alleys or enforced turns, working by trial and error or by successive approximation. The roots of the metaphorical uses of the labyrinth in this context may lie in the complex linear functioning of perception and the brain, as outlined by the faculty psychology that dominated classical and medieval epistemology.[30] The explicit description of perception as a labyrinth is rare, though it does occur. Both Galen and the Naassene heretics thought that hearing was a labyrinth.[31] And Prosper of Aquitaine's description of the mental incapacities produced by original sin, quoted earlier, suggests

30. For a brief discussion of faculty psychology, some fascinating illustrations indicating the linearity of perception, and a bibliography, see Edwin Clarke and Kenneth Dewhurst, *An Illustrated History of Brain Function* (Oxford: Sandford Publications, 1972), chaps. 2–5. See also Edwin Clarke and C. D. O'Malley, *The Human Brain and Spinal Cord: A Historical Study Illustrated by Writings from Antiquity to the Twentieth Century* (Berkeley: University of California Press, 1968).

31. Galen, *De usu partium* 8.6, ed. Georg Helmreich, vol. 1 (Leipzig: B. G. Teubner, 1907), 468, and Hippolytus of Rome, *Philosophumena* 5.11 (1, 143). The inner ear itself is not generally described as a labyrinth until the Renaissance.

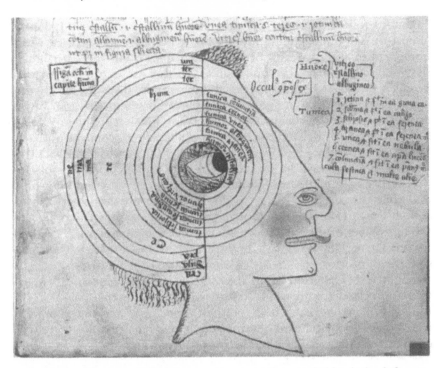

7. Eye-brain diagram dating from 1350–1400 but probably derived from a treatise by Magister Zacharias of Salerno and Constantinople (twelfth century). London, British Library MS. Sloane 981, fol. 68r. By permission of the British Library.

that fallen man exists in a perceptual maze. The brain itself has a laby-rinthine structure of convolutions or *gyri*, their very complications re-flecting the high level of human intelligence according to Erasistratus (third century B.C.). There are also the brain's "chambers" of imagina-tion, reason, and memory, crammed with images and surrounded by passages like the courts of the Egyptian maze; the finely branching net-work of veins in the *pia mater*, described in 1615 as "a mazey laberynth"; and the *rete mirabile*, the wondrous net described by Galen, Rufus of Ephesus, and others as a complex interlace in which the animal spirits essential to accurate perception are manufactured.[32] Diagrams of eye and brain are more vaguely labyrinthine, featuring concentric circles with divisions and links between them (see plates 7, 8). I have found no incontrovertible early European evidence that the brain was viewed ex-

32. See Clarke and Dewhurst, chaps. 2, 3, 5; Helkiah Crooke, *Microcosmographie* (London: W. Jaggard, 1615), p. 465; Galen, *De usu partium* 9.4. Throughout the Middle Ages, the *rete mirabile*, a feature of pig and ox brains, was erroneously assumed to exist in the human brain.

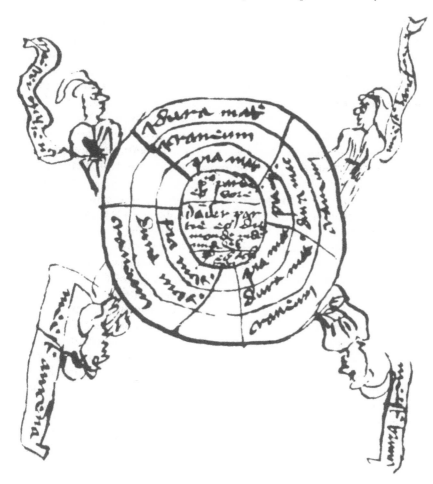

8. Vaguely labyrinthine diagram of the brain, from Jehan Yperman's *Cyrurgie* (1328). Ghent, University Library MS. 1273, fol. 3v. By permission.

plicitly as a maze, but there may have been such a tradition in India, and certainly the similarity might have been apparent to anyone who had ever seen a brain.[33]

In any case, metaphorical labyrinths involving the idea of difficult process appear frequently and explicitly in the context of mental activities, particularly the processes of teaching, learning, and understanding. Sometimes a labyrinth of difficult process defeats its own instructional aim, either through the artist's failure to shape it well enough or through the maze-walker's inability to perceive its order because he can-

33. For India, see Jill Purce, *The Mystic Spiral*, p. 98.

not choose among too many alternatives and is disoriented by too many data. Thus a character in Macrobius's *Saturnalia* (ca. 400 A.D.) reports that the "rounded phrases" and "volubility" of "a glib Greek" have rendered him "unable to cope with this labyrinth of words." And Cassiodorus (sixth century) is swamped by a "labyrinth of explanations." Hence the labyrinth becomes an appropriate sign of general mental perplexity: Lucian (second century) refers to "inextricable and labyrinthine questions," and Ennodius, embroiled in a knotty procedural issue, asks for help to "overcome the sinuous twist of this labyrinth." Such usages may well have contributed to the common medieval notion that any text explicitly called a labyrinth is bad, or at least ineffective, art. But the labyrinth also promises the joys of mastering almost insoluble difficulty: Sidonius eulogizes a philosopher who "thought it the height of pleasure if by chance the treasures of his knowledge were aired when some labyrinthine puzzle arose," and Marius Mercator (fourth century) advocates marking manuscript margins with a labyrinth to indicate a textual passage repaying careful study, a practice C. Du Cange attributes to Isidore of Seville (560–636).[34] It is in this sense that labyrinthine art, even if it is not called by that name, is so often judged excellent in later periods.

In teaching and learning, the subjective problems created by a labyrinthine experience are particularly important. If a learned doctor of the church like Jerome can penetrate Ezekiel's labyrinth of prophecy only with divine aid, how much more sensitive are the problems of leading the ignorant through material that will seem intolerably labyrinthine until they have achieved some wisdom! We have seen Gregory Thaumaturgus's praise of Origen for doing just that, as well as Gregory of Nazianzus's ironic invitation to try to comprehend the grand obscurity of the cosmic maze by carefully following one track or another. Without using the word "labyrinth," but with some density of language usually associated with mazes, he worries elsewhere in the *Second Theological Oration* that his exceptionally ornate discussion is "too subtle" for the common ear, that his argument has been too "tortuous and enigmatic." He knows that difficulty is not bad in itself: "What is acquired with difficulty is usually preserved the better," a common topos. Gregory

34. Macrobius, *Saturnalia* 7.5.1, trans. Percival Vaughan Davies (New York: Columbia University Press, 1969); Cassiodorus, *Historia Tripartita* 5.37, in *PL*, 69, 1017; Lucian, cited in Meursius, *Crete*, p. 69; Ennodius, *Libellus pro Synodo*, ed. F. Vogel, *MGH Auct. antiq.*, 7, 56; Sidonius, *Epistolae et carmina*, *MGH Auct. antiq.*, 8, p. 62; Marius Mercator, *Concilium universale ephesenum*, in *Acta conciliorum oecumenicorum*, ed. E. Schwartz, tom. 1, vol. 1, pt. 1 (Berlin and Leipzig: Walter de Gruyter, 1924–26), p. 81; C. Du Cange, *Glossarium mediae et infimae latinitatis* (Paris: Librairie des Sciences et des Arts, 1938), *s.v. labyrinthus*. Although Isidore describes the classical labyrinths (15.2.36), the edited text does not recommend the maze as a marker of difficulty: see *Etymologiae* 1.21.10, where the cryphia (⊙) is suggested for difficulty or insolubility. Perhaps in some manuscripts the mark was elaborated into a labyrinth.

finds our nature so imperfect that the divine is necessarily obscure to us, for God "makes the darkness his covert" (Psalm 17:12, a passage quoted also by Jerome). In fact, "the more perfect our discussion of God, the more difficult it is of access. . . . Every obstacle, no matter how small, halts discussion in its course . . . as when one pulls the reins of a horse and makes it turn with the unexpected shock."[35] One cannot prove that Gregory had the maze metaphor in mind, but his epistemology sees the attempt to acquire knowledge of God as a necessarily labyrinthine process: confusing, difficult of access, full of hidden twists and turns. The safest and surest course is to rise above the labyrinths of earthly creation and human reasonings to glimpse God the architect at the center of all things.[36]

The labyrinthine process of learning is particularly marked in the dialectical method, so common in classical and medieval education. One may be led down exceedingly circuitous and often branching paths, quite at the mercy of the word-architect who limits the options. Predictably, Plato (428–348 B.C.) was well aware of the pitfalls of his chosen method, especially when used badly. The *Euthydemus* is a lighthearted discourse involving Socrates and two verbal tricksters who abuse word-play to turn every question inside out many times over. The results are predictable: their grotesque argument "seemed like falling into a labyrinth; we thought we were at the finish, but our way bent round and we found ourselves as it were back at the beginning, and just as far from that which we were seeking at first" (*Euthydemus* 291B). The persistent and senseless ambiguity of the questions and answers make the investigation fail, bending back and forth interminably as in a maze without a center. The dialectical method permits such fruitless circuitousness, though it does not, from Plato's point of view, necessitate it. Socrates, Daedalian offspring that he is, clearly relishes the absurdities of the peculiar procedures of this dialogue, which may anticipate what medieval writers have in mind when they decry the inextricability of "Aristotle's labyrinth." Badly used, dialectic is a labyrinth of difficult process going nowhere.

But for all his ironic humility, Socrates is sophisticated in the art of argument; he is wise enough to see the pattern of the labyrinth created by buffoons pretending to instruct him. The situation is quite different when a wise man seeks to instruct buffoons. Thus, in a passage we will return to in Chapter 9, Philosophy almost loses her obtuse pupil Boethius when she creates a kind of logical labyrinth with her difficult circular argument proving that evil does not exist. Boethius, eager to learn but querulous in temper, objects: "'You are playing with me,' I said,

35. Gregory of Nazianzus, *Oration* 28.11, 12, 21.
36. See Miller, *Measures of Wisdom*, pp. 352–361.

'by weaving a labyrinthine argument from which I cannot escape [*inextricabilem labyrinthum texens*]. You seem to begin where you ended and to end where you began. Are you perhaps making a marvelous circle of the divine simplicity?'"[37] Such indeed is Philosophy's tactic, and after retracing the path of the argument and hearing Philosophy's explanation of her method, Boethius is finally able to fly with philosophical wings from confusion to clarity, from immersion in this particular labyrinth to the elevated perspective that bestows comprehension. In so doing, he carries his still less sophisticated audience (most of his readers) along with him. Labyrinths, especially when recognized as such, have pedagogical uses: they institutionalize repetition and explication.

Augustine too was keenly aware of the labyrinthine nature of learning. He openly discusses the dangers of mental labyrinths in the early work *Contra academicos* (386–87). He and his friend Alypius are debating in the presence of the youths Licentius and Trygetius, and Augustine worries lest the dialogue be too intricate for boys "unable to discriminate acute and subtle arguments"; the youngsters may not realize that Alypius is "not extricating [him]self by complicating matters"—that difficult argument is not necessarily correct reasoning. After a break, Augustine is not surprised to find Licentius scribbling poetry as respite from the rigors of argument; one cannot remain in labyrinths indefinitely. Afraid that the debate has overtaxed the boy, Augustine says, "While I wish to invite both of you back to the arena of those intellectual exercises that impart refinement to the mind, I fear lest it become a labyrinth for both of you."[38] A good teacher must always beware of creating exhausting labyrinths for the unsophisticated, even though identical arguments may seem labyrinths of artistry to the learned from their wiser perspective; labyrinthine arguments are relative in impact like the maze itself, and the skilled teacher considers this relativity in gauging the receptive capacities of his students. We will see later how concerned medieval rhetoricians and preachers were with this problem.

In a dialogue on the role of the teacher (*De magistro*, ca. 389), Augustine delineates a labyrinthine theory of education, and although he (unlike his translators) never mentions the labyrinth explicitly, the process he describes explains so neatly the usefulness of a circuitous, confusing, labyrinthine dialectical method that it is worth summarizing briefly. After some potentially confusing discussion of sign theory, Augustine's

37. Boethius, *The Consolation of Philosophy* (523–524), 3 pr. 12, p. 72. For the Latin, see *Boethii Philosophiae consolatio*, ed. Ludwig Bieler, *CCSL*, 94 (Turnholt: Brepols, 1957). Additional examples of Boethius's concept of labyrinthine argument are noted in chap. 9.

38. *Contra acad.* 3.6, 7, trans. Denis J. Kavanagh in *The Writings of St. Augustine* (New York: Cima Publishing, 1948). For the Latin text, I use *Oeuvres de St. Augustin*, 1st ser., vol. 4, ed. R. Jolivet (Paris: Desclée de Brouwer, 1939). Earlier in the dialogue, Augustine has referred to Daedalus (3.3).

son Adeodatus has lost track of the argument. This does not surprise his father, who knows the discussion is "entangled [*implicatum*]," so he begins again.[39] When Adeodatus is again confused, Augustine admits there have been "so many circumlocutions [*ambagibus*]" (p. 378/180) that it is hard for Adeodatus to know where he is, let alone where the discussion is going. Later still, Augustine reviews the "great circling [*circuitus*]" they have undergone, summarizing the points they have determined so far and raising another question: Is Adeodatus sure of all these concepts now? The boy answers, "I wish indeed to have arrived at certainty after such great debate and complications [*ambagibus*], but your question disturbs me. . . . The problem is such a labyrinth [*implicatio*] that I am not able to explore it thoroughly or to answer with assurance" (p. 386/190). And so Augustine retraces the chain of reasoning to ensure that Adeodatus will understand.

What Augustine is teaching Adeodatus is that the teacher does not instruct his student, but rather, by repeated questioning, he reminds the pupil of what the pupil already knows. Often in this process the pupil does not know an answer because he cannot see the issues whole; thus "he is advised to do it part by part when he is questioned by one step after another about those very parts of which the whole consists, which he is unable to grasp in its entirety." The pupil is led circuitously and repeatedly over the same ground, just as in a labyrinth, so that he learns it well and comes to see the whole pattern, not just its fragments, and "by means of questions put in such a way [he] is able to teach himself" (p. 391/198). This kind of inward self-instruction, guided by a wise and sensitive teacher, may well be tortuous and time-consuming, but it is the only effective way to teach—or rather, for Augustine, to remind the pupil of what he already knows. Of course, the process of learning is labyrinthine whether or not prior knowledge is involved: one moves in circles, forward and back, seeming to recede but in fact ever approaching by successive approximation the knowledge that is the goal. And this knowledge could not be reached so effectively by a direct route, a shortcut, for the process itself determines whether the product will be understood. The psychology of learning and the labyrinthine dialectical method are, for Augustine, perfectly matched: in the hands of a wise teacher, dialectic is the guiding clue that carries the mind through all the slow, essential, indirect paths to knowledge.[40] The duality of the maze again is

39. For the English, I follow *Concerning the Teacher*, trans. G. C. Leckie, in Oates, *Basic Writings* (here, chap. 5, p. 372); for the Latin, *CCSL*, 29 (Turnholt: Brepols, 1970), pp. 156–203; here, p. 171. Further references will be given parenthetically.

40. For an interesting parallel discussion of the text, see Seth Lerer, *Boethius and Dialogue: Literary Method in "The Consolation of Philosophy"* (Princeton: Princeton University Press, 1985), pp. 51–56. Although Lerer does not overtly see the dialogue as embodying labyrinthine principles, he notes not only the importance of *ambages* and circuitous argu-

relative: for the ignorant it is simply confusion, but for those able to learn it is confusion leading to a perception of order and meaning. What was a labyrinth to Licentius is elegant reasoning to Augustine. This theory of learning will be very important when we come to discuss the labyrinthine aesthetic of later medieval literature and the reception of complicated texts.

As to whether these instructional labyrinths are unicursal or multicursal, the answer is that they are really both at once, rather like the moral mazes of Prudentius. Intrinsically, there are countless paths— innumerable ways to approach the goal of specific knowledge. At the same time, the path selected by the teacher from so many possibilities may seem unicursal: he knows where he is going and how to get there. But to the pupil, the same mental journey may appear multicursal, with one series of questions and choices superceded by another series, leading to an as yet unimaginable goal. Perhaps the convertibility of the maze manifests itself most obviously in intellectual labyrinths.

In this chapter we have seen how the labyrinth's essential features suggest its metaphorical significance from the time of Plato through the sixth century A.D. The labyrinth as a sign of complex artistry most commonly refers to admirable artifacts, whether the work of God, man, or animal; these are incontrovertibly labyrinths *in bono*, and although their magnificence depends on initially baffling complexity, we are most aware of the inherent order controlling multiplicity. Inextricable mazes, on the other hand, emphasize the perpetual imprisonment that multiplicity and complication can enforce, and these labyrinths tend to operate *in malo*. Impenetrable labyrinths frustrate maze-walkers because the

ment but also the dialogue's "two contradictory movements," "one which sees dialogue as a linear progress towards truth; the other which sees it as a circuitous set of restatements whose goal is unclear" (p. 52). These two movements—which I would see as circling about a goal unknown *to the student* or reader, which is at the same time linear progress toward that same goal *as perceived by the teacher*—precisely define the quality of motion experienced in a circular maze and suggest the effect of divergent points of view.

See also Lerer's discussion of Augustine's *Soliloquia* (pp. 46–51), in which Augustine casts himself as student and progresses from craving a shortcut to contentedly following the winding course of argument.

The labyrinth of learning implicit in Augustine's discussion resembles the "affective process" hinted at by Aegidius Romanus and developed by Judson Boyce Allen in respect to certain medieval texts: when "the literal ordering of a text's material corresponds exactly to the order of that mental process whereby that material was invented [or discovered, or structured] and made significant," then "its meaning must arise out of the dialectic motion through its parts that is the experience of its characters" (*The Ethical Poetic of the Later Middle Ages: A Decorum of Convenient Distinction* [Toronto: University of Toronto Press, 1982], pp. 92–93). In other words, it is only by experiencing the process of a text as it is written, with all its involutions and false turnings, that its meaning can be grasped; form and meaning are inseparable, and the *modus agendi* (mode of literary treatment) is precisely the necessary *modus docendi* (method of instruction).

desirable goal cannot be attained; these mazes have something in common with failed labyrinths of difficult process, where knowledge that ought to be achieved remains distant. Ideally, if artist and maze-walker have done their respective work properly, mazes of difficult process lead to valuable goals: the transcendence of labyrinthine confusion, highlighted here as in the mazes of inextricability, and the appreciation of labyrinthine artistry. With these backgrounds in mind, we are ready to pursue the further metamorphoses of the labyrinth in the Middle Ages.

The Labyrinth in
the Middle Ages

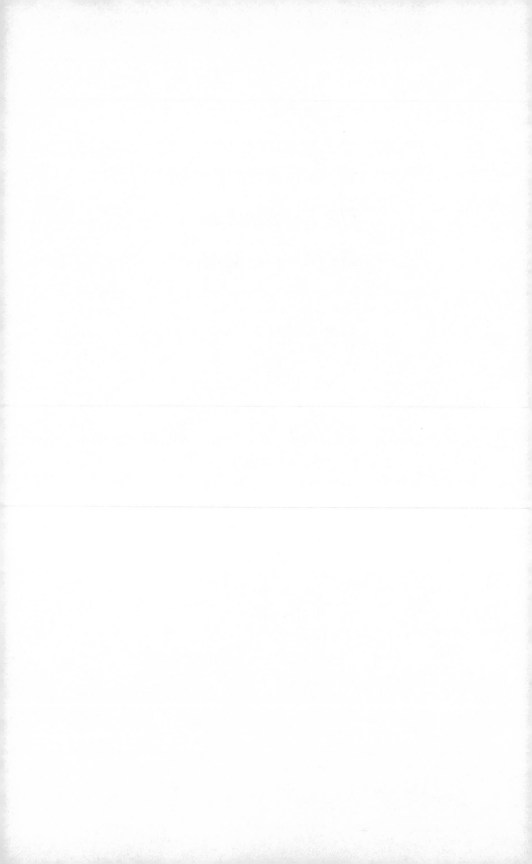

Etymologies and
Verbal Implications

Laberinthus dicitur de labor et intus.

The word "labyrinth" comes from "labor" and "intus."
 Nicholas Trevet, *Commentary on Boethius's "Consolation of Philosophy"*

A S PART One examined the idea of the labyrinth in classical and early Christian times, exploring typically labyrinthine dualities, establishing the maze's essential characteristics, and surveying the range of metaphors generated by those characteristics, so Part Two traces the labyrinth's medieval metamorphoses from Isidore of Seville (560–636) to the late fifteenth century. As in Part One, the discussion here is thematic and selective rather than chronological or all-inclusive: there is no significant, temporally linked development of the labyrinth within the period, and listing every labyrinth reference would be tedious even if it were possible. However, I cast my nets reasonably wide for three reasons: to describe the medieval idea of the labyrinth—real, mythical, metaphorical—with adequate breadth; to cast glimmerings of new light on particularly interesting texts; and to assemble representative or important materials as an aid to interpreting literal and figurative uses of the labyrinth elsewhere. In so doing, I will not track the transmission of labyrinth lore from one author to another; that would be virtually impossible, so well and widely known were the many faces of the labyrinth. Instead, I want to show how the labyrinth's range of significance increases even as its older meanings are preserved and how the formal qualities and metaphorical and mythical associations of the labyrinth are related to a labyrinthine aesthetic that pays careful heed to the dangers and delights of artistic complexity and difficulty. I will not argue that this aesthetic, so characteristic of some great works of the late Middle Ages, could never have arisen without the labyrinth, but

rather that, just as the models of the cathedral, the pilgrimage, the interlace, and the wheel of fortune have proved fruitful in illuminating the structure and aesthetic of medieval narrative,[1] so too the labyrinth is a useful analogy for literary structures and strategies and for the complex processes of creating and interpreting texts.

Throughout, I build on distinctions and conclusions drawn in Part One: distinctions between the maze as admirable real building and as shady setting for mythical narrative, for instance, or ideas of the maze's convertibility, or the kinds of meanings that attach themselves to labyrinths one or another of whose essential features is stressed. As in earlier times, so in the Middle Ages artists and writers usually ignored, if they recognized at all, the distinction between unicursal and multicursal design—a distinction generally implying no particular hierarchy. The medieval definition of the labyrinth remains inclusive, and its essential characteristics remain more important than whether it contains one or more paths. By way of introduction to Part Two, I show how yet another kind of evidence—the witness of philology—recapitulates distinctions and conclusions already noted and supports the divisions of the subject represented by subsequent chapters.

Because many medieval writers believed that etymology determines much of a word's meaning, medieval derivations of *labyrinthus* and the implications of its vernacular synonyms are important. As that influential practitioner Isidore of Seville noted, "if you know the origin of a word, you understand its force the faster," advice that stimulated countless commentators and preachers throughout the Middle Ages.[2] Since Isidore himself apparently did not discuss the roots of *labyrinthus*, for an early etymology we turn to the seventh-century Virgil scholia, recalling that it was during grammatical analysis of classical texts that medieval students first encountered etymology as an interpretive technique. Here we find that "the labyrinth is so called because no one can *elabi inde*, that is, escape from thence." Quite classically, the emphasis in this derivation is on the inextricability of the maze, as with the fifteenth-century humanist Ascensius's *laboriosus exitus domus*, "the house difficult of exit."

1. See, e.g., Erwin Panofsky, *Gothic Architecture and Scholasticism* (Cleveland: Meridian Books, 1957); Robert M. Jordan, *Chaucer and the Shape of Creation: The Aesthetic Possibilities of Inorganic Structure* (Cambridge: Harvard University Press, 1967); R. F. Baldwin, *The Unity of the Canterbury Tales*, Anglistica, 5 (Copenhagen, 1955); Christian K. Zacher, *Curiosity and Pilgrimage: The Literature of Discovery in Fourteenth-Century England* (Baltimore: Johns Hopkins University Press, 1976); Eugène Vinaver, *The Rise of Romance* (Oxford: Clarendon Press, 1971), chap. 5 and passim; John Leyerle, "The Interlace Structure of *Beowulf*," UTQ, 37 (1967), 1–17; and Colbert I. Nepaulsingh, *Towards a History of Literary Composition in Medieval Spain* (Toronto: University of Toronto Press, 1986).

2. Isidore of Seville, *Etymologiae* 1.29.2; on etymology in preaching, see Thomas Waleys, *De modo componendi sermones* cap. 7, Charland, p. 378. The medieval fascination with etymology has a modern parallel in post-structuralist playfulness.

One of Nicholas Trevet's etymologies opts instead for impenetrability: *laboriosa ad entrandum,* difficult to enter.[3]

But what lies inside, rather than whether one can get in or out, is what matters in the most popular etymology, deriving *laborintus* (the common medieval spelling) from "labor" and "intus."[4] This etymology is far more ambiguous, suggestive, and indeterminate than *elabi inde,* confirming a modern view that "the effect of etymological retracing is not to ground the word solidly but to render it unstable, equivocal, wavering."[5] In fact, *labor intus* can be interpreted to highlight various essential qualities of the maze. Read as "an artistic *opus* lies within," the phrase connotes labyrinthine artistry. If we take *labor* as a verb, "I fall, or perish, or err, or go wrong within (or while going in)" justifies a range of moral interpretations *in malo.* Returning to *labor* as a noun, "hardship, or fatigue, or exertion, or application to work lies inside" emphasizes the idea of difficult process, whether the anticipated outcome is success or failure. The key word in almost all medieval etymologies is *labor,* with all its connotations of difficulty. Both Huguccio of Pisa and the author of a 1349 *accessus* or introduction to Eberhard of Germany's grammatical treatise *Laborintus* gloss the word "having labor within," and Hugh of Saint Victor contrasts the labyrinth (containing labor) with Noah's ark (containing rest).[6] Etymologically speaking, then, the labyrinth is a process involving internal difficulty (or error, or artistry, or fatiguing effort); and what happens inside is more important than whether it is hard to get in or out.

No medieval synonym for *labyrinthus* comes in for etymological scrutiny, so far as I know, but some speculation is revealing. The most common synonym is *domus daedali* (*dédale, maison de dedalus*), stressing the nature of the labyrinth as a *construction,* a three-dimensional house; and the naming of Daedalus suggests the superb craftsmanship and architectonic skills involved. As we will see, "Daedalus's house" is often the term

3. Virgil Scholia in Abstrusa on *Aeneid* 5.588, quoted by H. J. Thomson, "Fragments of Ancient Scholia on Virgil Preserved in Latin Glossaries," in W. M. Lindsay and H. J. Thomson, *Ancient Lore in Medieval Latin Glossaries,* St. Andrews University Publications, 13 (London, 1921), p. 131; Ascensius, *Aeneis Vergiliana . . . cumque Iodici Badii Ascensii elucidatione* (Paris, 1501), 172r; Trevet, *Augustinus De civitate Dei cum commento* (Basel, 1490), E4r.

4. See, inter alia, the commentary on the *Aeneid* attributed to Bernard Silvester, *Commentum super sex libros Eneidos,* p. 37, and Nicholas Trevet's *Expositio super libris quinque Boethii De consolatione philosophiae,* London BL MS. Burney 131, fol. 48r (in Edmund T. Silk's unpublished ed. of Trevet, *Exposicio . . . super Boecio De consolacione,* p. 496). I am very grateful to Mrs. Eleanor Silk for generously providing me with a copy of her late husband's valuable, if unfinished, edition.

5. J. Hillis Miller, "Ariadne's Thread: Repetition and the Narrative Line," pp. 148–66 in Valdés and Miller, *Interpretation of Narrative,* p. 159.

6. Huguccio, *Derivationes,* Oxford MS. Bodley 376, fol. 100v; Faral, p. 38; Hugh, *De arca Noe morale, PL,* 176, 679–680. A twelfth-century MS. (Zwettl Cod. 255, 12v) suggests a related etymology: inscribed in the center of a maze are the words "Nomina eorum sunt in labore" (see Kern, plate 156).

chosen to describe a labyrinth conceived as an elaborate and dazzlingly articulated work of art. The German *Irrweg*, "wandering path," "path of error," on the other hand, reflects the maze's circuitousness, its ability to induce confusion, its nature as process rather than artifact; the word implicitly accentuates moral danger. The English *mase*, of uncertain origin, also stresses difficult process, annoyance, confusion. The Norwegian cognate *mas* refers to exhausting labor, annoying pertinacity, whim, fancy, or idle chatter, according to the *Oxford English Dictionary*; the verb *masa* means to toil, to be busy, to pester, to worry, to chatter.[7] Whatever its roots, the word enters Middle English with Old English *amasod*, "astonished, bewildered."[8] The progress of the word *mase* suggests how English medieval people must have thought of labyrinths, so I will devote a little space to tracing that development.[9]

Amased and *masedli* appear only three times in the thirteenth century, and only in the *Ancrene Riwle* (ca. 1200–1225); the *MED* offers the definition "out of one's mind, irrational, foolish," corresponding to the Latin "infatuatus"; there are as yet no particularly labyrinthine connotations to the word. When the noun *mase* appears (1300), it means "a source of confusion or deception; vision, fantasy, delusion; deceit," but only in a very general sense. In about 1325, however, a Legend of Saint Brendan uses *masen* as a verb: "Hy wende alond as mased men; hy nuste ware hy were [they went ashore as mazed men; they didn't know where they were]." The disorientation reflected here links the English word to the labyrinthine experience for the first time, although there is no explicit connection with the labyrinth itself. From the time of Chaucer and Gower in the last two decades of the century, however, the *MED* testifies to a great proliferation of uses of the word in labyrinthine, or potentially labyrinthine, connections. In the *Legend of Good Women* l.2014 (ca. 1386) Daedalus's creation is a "hous . . . shapen as the mase is wrought," and Gower (*Confessio Amantis* 5.5295-5296) describes the Cretan labyrinth's effect with a pun: a maze-walker "ne scholde noght come oute / Bot gon amased al aboute." Both examples clearly assume an audience familiar with "mazes"; indeed, Chaucer apparently believes that the Cretan labyrinth is less well-known than an English "mase" and needs a little explanation. By the end of the fourteenth century *mase* as a noun must have been a fairly common term for a familiar design.

How did it happen that an Old English word describing a state of mind came to signify a labyrinth? The answer must lie in the confusion and bewilderment common to both: if a mazed man is confused or

7. See Matthews, chap. 20.
8. See *Judgment Day II*, l. 126, in Elliott Van Kirk Dobbie, *Anglo-Saxon Minor Poems, Anglo-Saxon Poetic Records*, 6 (New York: Columbia University Press, 1942).
9. See *MED, s.v.* amased, amasing, mase, masedliche, masedness, masen.

deluded and a labyrinth confuses and deceives, then a labyrinth is a maze. *Maze* comes to signify *labyrinth* by a kind of metonymy, the effect giving its name to the cause. Confusion is one of the labyrinth's typical consequences, and this short history of the English word *mase* demonstrates that fact yet again. Unfortunately an author's choice of one or another synonym for *laborintus* is not an infallible guide to the correct interpretation of the labyrinth image: *dédale*, connoting the craft of a master builder, need not necessarily indicate that artistry is the principal feature of a given use of the image, nor need *Irrweg* in a text necessarily preempt an awareness of artistry by its allusion to winding path and wanderer. Nevertheless, word choice, whether by an author or by his vernacular, may alert us to the existence of a slightly privileged meaning. It is, in any case, significant that both the maze's duality as art/confusion and the importance of the viewer's perspective (baffled within, clear-sighted without) are embedded and encoded in linguistic options (*mase* vs. *Irrweg* vs. *dédale*; the various possibilities for *labor intus*).

These philological musings are an appropriate introduction to Part Two, each of whose chapters corresponds roughly, and not exclusively, to what kind of *labor* is *intus*. Chapter 5 considers real labyrinths: visible representations of the maze, whether in aristocratic estates, churches, fields, or manuscripts. Many of these embody the idea of *labor* as a noun describing an artifact of complex artistry, just as in the historical-geographical tradition and in the first section of Chapter 3; and many are also called *domus daedali*, with connotations of architectural skill (thereby avoiding the increasingly pejorative connotations attached to the word *labyrinth* in the Middle Ages). There are, of course, exceptions: for consistency, I have grouped together all visual, or once visible, materials, and naturally some mazes in art carry significance *in malo*. But the fact that almost all the surviving mazes discussed in Chapter 5 (actual buildings and gardens are no longer extant) show the labyrinth as a diagram, two- or minimally three-dimensional, means that the whole pattern is visible, that the maze's order and artistic design are fully apparent. Artistry may serve a bad master, but it is art nevertheless, and so I think it would have struck medieval observers.

Many of the literary examples in Chapter 6 take *labor* in a more negative sense: "I fall, perish, err, suffer, go wrong"; *labor* is a verb, a process to be undergone by a wanderer, and the labyrinth tends to be an *Irrweg*, a place of perilous *error*, a path to disaster unless sound guidance intervenes. Here are grouped three sorts of texts: mythographical texts that gloss the Cretan legend, nonmythographical texts that use the labyrinth as a kind of moral shorthand, and selected texts that exploit the moral implications of the labyrinth extensively and creatively. Here, too, there are exceptions: as in the poetic classical texts of Chapter 1, emphasizing the story's morality does not necessarily entail that the structure's artistry

should go unnoticed, and so occasionally God appears as the super-Daedalian architect of a morally ordered universe or Christ-Theseus sorts out labyrinthine traces for us, as in the maze-as-inextricable texts of Chapter 3. These, then, are moral labyrinths, and they usually, though not invariably, lead *in malo*. Mazes of this sort predominate in medieval literature, contributing to the bad odor generally attached to the word *labyrinth* if not necessarily to the thing itself.

The idea of *labor* as "work, effort, fatigue, application to a task" or, as a verb, "to be mistaken, to err intellectually," informs many texts considered in Chapter 7, texts that also reflect the confusion and bewilderment associated with *masen*. Like the metaphors of difficult process discussed in Chapter 3, the textual labyrinths of Chapter 7 are complicated and circuitous, but usually the intellectual difficulties they pose are penetrable, intelligible, leading someplace worth going to. They are both artifacts and processes, works of art and the activity of creating or interpreting them. Verbal mazes may be good or bad, effective or ineffective instruments of instruction. But however labyrinthine they may be, they are seldom called labyrinths unless they fail in their goal of enlightenment through difficulty. Although the word *labyrinthus* could and did describe great artistry in classical and early Christian writings, and although the clear visual diagram of a labyrinth, perhaps labeled "domus daedali," may have admirable connotations in the Middle Ages, *laborintus* so commonly refers to something dangerous and inextricable (or impenetrable, in a negative sense) that its explicit medieval occurrences *in bono* are few and far between. In many texts noted in Chapter 7, the idea of the labyrinth is laudable, but the name is not. When a work is actually called a labyrinth, it is often being damned as bad, overly complicated art. It is as if a labyrinth viewed from a privileged perspective, appreciated and understood, converted from confusion to clarity, thereby ceases to be a labyrinth and becomes something else or at least requires a euphemism. Textual labyrinths and the labyrinthine aesthetic that seems to inform them, then, are the subject of Chapter 7.

This ordering of general medieval materials into three categories and chapters follows the logic latent in etymology; it also catches up various threads of Part One—"real" vs. fictional and metaphorical mazes; the witnesses of art and literature; and the characteristics of artistry, (moral) inextricability, and beneficial if arduous process. If the divisions of Part Two do not exactly parallel those of Part One, it is because precise duplication would be inappropriate even if it were possible; even mazes are only *almost* symmetrical.

Mazes in Medieval Art
and Architecture

Ther was a Clerk, on Dedalus,
.
And he made of his oghne wit,
Wherof the remembrance is yit,
For Minotaure such an hous,
Which was so strange and merveilous,
That what man that withinne wente,
Ther was so many a sondri wente [turning],
That he ne scholde noght come oute,
But gon amased al aboute.
 Gower, *Confessio Amantis* 5.5286, 5289–5296

I N THE medieval period even more than in classical and early
 Christian times, the idea of the labyrinth depends on visual as
 well as verbal witnesses. Interrelationships between art and the
written word can vary greatly. The two witnesses may be virtually inde-
pendent in status if not in inspiration: an unnamed turf-maze adorns an
English field, for instance, or an account of the Cretan myth exists in
manuscript with no illuminations and no clear indebtedness to any visual
model. Frequently, however, the visual and the verbal interact: the con-
text of a visible labyrinth (on a baptismal font, at the beginning or end-
ing of a manuscript text) suggests an interpretation; an accompanying
legend or related records suggest the meaning of a church- or turf-
maze; visual mazes illustrate texts by representing the physical object
mentioned or by denoting the complexity of a concept; written records
describe lost real labyrinths; a literary idea such as Christ-Theseus's har-
rowing of hell stimulates, or perhaps is later attached to, labyrinths in
cathedral naves. This chapter deals with visible, or once visible, mazes as
they shape, enlarge, and clarify the broader medieval idea of the laby-
rinth in both art and literature. It examines how medieval people might

have known, thought about, and attributed significance to labyrinths as real places they might enter or as artistic designs they might see. This discussion necessarily skims over ground charted in greater detail by Kern, Santarcangeli, and Matthews, to whom I refer the reader for background, additional documentation, and plates. But despite their explorations, there is more to be said, so I consider some important implications of these visible mazes in themselves and in their interactions with literature, focusing always on the meanings of the maze, where determinable, and their confirmation and expansion of the idea of the labyrinth.

Visual materials and related texts are particularly important because they provide the strongest medieval testimony to the classical view of the labyrinth as an artistic work of magnificent complexity, proof of its architect's skill and its commissioner's exalted status just like ancient labyrinths in historical-geographical accounts. True, bewilderment and even terror may lurk within some visual mazes: labyrinths are inherently dual, potentially good or evil, highlighting product or process, order or chaos. But visual mazes, so far as we can reconstruct their meaning, seem most commonly to emphasize the brilliant conception and execution of the *domus daedali*, which create first confusion and then admiration.

The ability of the visual labyrinth to signify elaborate artistry certainly owes something to its typical design and presentation. Most mazes in medieval art are diagrammatic and unicursal, as in classical times. If the observer's eye becomes too involved in the pattern's circuits, the temporary confusion common to any "restless figure" results. But because the path is unicursal, one's eye eventually finds rest and stability at the center: confusion leads to certainty, for a unicursal labyrinth's structure and process are fixed. And because the maze is diagrammatic, it offers us a privileged God's- or artist's-eye view of the whole. Eventually our eye can take it all in, seeing where, how, and why confusion is converted to order. The diagrammatic labyrinth is thus a superbly effective image of simultaneous and perspective-dependent order/chaos, of an organizing totality controlling complexly organized parts. Like a Gothic cathedral or scholastic *summa*, it is, in Jesse M. Gellrich's words, one of "many medieval forms that are so determined to clarify their own method of construction that they reveal every joint and seam."[1] Because the diagrammatic unicursal labyrinth exposes its structure and solves itself, it betokens controlled artistry; but because it achieves its end through disorientation and confusion, it differs from cathedral and *summa*: it represents also the difficulty of attaining clarity for artist and observer alike, whose eventual success is thereby rendered more impressive.

1. Gellrich, *The Idea of the Book in the Middle Ages*, p. 74, discussing Panofsky, *Gothic Architecture and Scholasticism*.

A second feature of the labyrinth in the visual arts is at least as important in defining some of its metaphorical potential *in bono*. Most medieval (and many ancient) labyrinths are not merely diagrammatic and unicursal; they are also round, constructed—usually by compass—on the basis of a series of concentric circles (cf. plate 5). These circles are generally bisected twice, by radii in the sign of a cross; thus it is the cross's axes that break the circles, turning them into labyrinthine patterns. Typical medieval mazes thus consist of a perfect form, the circle—the shape of the world, the universe, eternity.[2] They are stamped with the cross, perhaps suggesting the impact of Christ on the world (see the discussion of Augustine's *De civitate Dei* in Chapter 3) or, less favorably, indicating a disruption of perfect order.[3] They combine two important principles: the path defines linear progress (the march of time, of Christian history, of human life); the whole pattern illustrates circular perfection (the cosmos, eternity, liturgical and seasonal repetition and renewal). In this context, as we shall see, labyrinths in churches or other sacred contexts may fitly represent not only human but divine artistry or even the intersection of human and divine perspectives and actions.

These introductory comments are intended merely to suggest that the typical medieval labyrinth has certain features that make it a particularly apt sign of complex artistry; we will return to other formal aspects of the medieval labyrinth as they arise. First, however, we turn from the typical to the atypical: the three-dimensional labyrinth, distant descendent of the historian-geographers' aristocratic triumphs of architecture.

· The Three-Dimensional Labyrinth (Buildings and Gardens) ·

What did medieval people think about the labyrinth as a three-dimensional structure? One major source of information, Pliny the Elder's praise of the four ancient labyrinths, was known to the Middle Ages both directly and through paraphrases. Pliny himself provides ample incentive for later writers to associate mazes with sublime art; but Isidore of Seville and his followers replace Pliny's description of the Egyptian labyrinth as an incomparably splendid building with selective and evocative descriptions more fruitful for moralists than for architects. Isidore treats labyrinths under the rubric "public buildings," along with gymnasia, circuses, amphitheaters, and towers. He begins not with Egypt but with the Cretan maze and myth, and he defines a labyrinth as a building

2. On the popularity of *rotae* or circular diagrams in the Middle Ages, see Murdoch, *Album of Science*, pp. 52–61, and plates 46–58. I would suggest that the labyrinth is a variation on the theme of the *rota*, often used in similar contexts.

3. The importance and possible significance of these *broken* circles is discussed in chap. 10.

with intricate walls whose exit one cannot discover without a ball of string. The building is so constructed that when the doors are opened terrible thunderings rumble within, and, after descending more than a hundred steps to enter, one finds many strange statues and dark, misleading passages that make a return to the light seem impossible. The three other ancient labyrinths are mentioned almost as an afterthought, though their most terrifying classical attributes have been ransacked for the Cretan description.[4] Egyptian artistry—indeed, any artistry—almost vanishes; presumably medieval imitators of Daedalus took their cues directly from Pliny, not from Isidore, whose emphasis on the myth transforms Pliny's objectivity into sensationalism. Visualizing the structure from Isidore's lurid facts is problematic: might the Isidorean maze look something like a cathedral crypt? Illuminators may have been baffled: no manuscripts of the *Etymologiae* illustrate the labyrinth in its proper place in the text, and three illuminated manuscripts of Isidore's imitator Raban Maur offer a diagrammatic unicursal maze. One decks the diagram with a more or less three-dimensional gateway, thereby acknowledging the text's reference to a building, and two manuscripts show a rather sketchy three-dimensional amphitheater above that might conceivably be interpreted as an exterior view of a maze (see plate 9).[5] Only a few illuminators show any kind of three-dimensional labyrinth until the fifteenth century, so readers of Isidore and indeed of most other manuscripts were left to use their imagination in mentally reconstructing the buildings so suggestively described in the texts but visually represented, as in classical mosaics, by a unicursal floorplan if by anything at all. I have found no illustrations of the Cretan labyrinth as a tower (as Laurent de Premierfait envisages his "maison Dedalus") or as a cave, whether manmade (Lydgate, Boccaccio) or natural (the Venetian traveler Giovanni Barzizza).[6] The three-dimensional challenge of the classi-

4. Isidore, *Etymologiae* 15.2.36; cf. Raban Maur's virtually identical account in *De universo* 14.12 (*PL*, 111, 387–388), and Ralph Higden, *Polychronicon*, ed. Churchill Babington, Rolls Series, 41 (London, 1865–82), 1.311 and 2.385, describing mazes as inextricable "turnenges" full of thundering noises.

5. See also Kern, plates 155 and 158–160. The association of maze with amphitheater exists in a Carolingian eulogy of Verona, describing its Roman amphitheater as "a vast labyrinth, great in circumference, from which an ignorant intruder can find no way out, unless with the aid of a lamp or a ball of thread"—"Versus de Verona," in *MGH Poetae lat. aevi carol.*, 1, ed. Ernest Duemmler (Berlin, 1881), 119. The similarity between amphitheaters and medieval labyrinths—both designed in concentric circles broken by radial axes, both without easily recognizable internal reference points—is obvious. Order and chaos are inherently conjoined in both images.

6. See Laurent, *Des cas des nobles hommes et femmes* 1.7.14, ed. Patricia May Gathercole (Chapel Hill: University of North Carolina Press, 1968), p. 129; John Lydgate, *The Fall of Princes*, l. 873 and l. 4338, ed. H. Bergen, EETS, e.s. 121 (1918), pp. 24 and 118; Boccaccio, *Comento alla Divina Commedia*, 2, 108; Santarcangeli, p. 115; and Kern, pp. 41–42. Oddly enough, Lydgate is translating Laurent, who is translating Boccaccio, and Lydgate elsewhere (l. 2681 ff.) describes the labyrinth much more conventionally as "an hous . . .

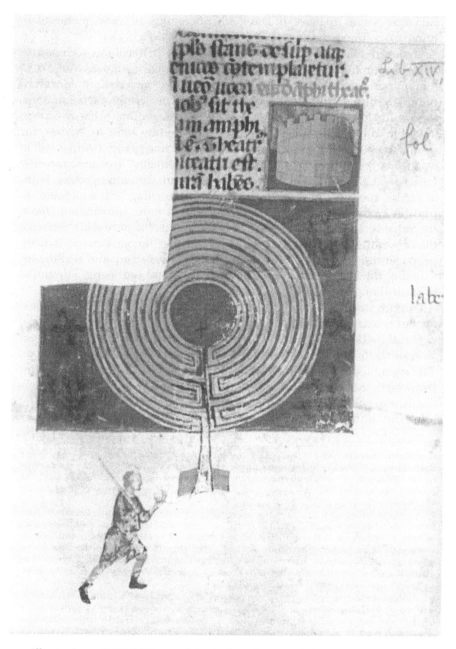

9. Illustration of "Otfrid"-type labyrinth with gate (below) and amphitheater (above) from Raban Maur's *De rerum naturis*. Berlin (West), Staatsbibliothek Preussicher Kulturbesitz MS. lat. fol. 930 (late fourteenth century), fol. 64r. By permission.

cal maze seems to have defeated the ingenuity of most medieval il-
luminators (for exceptions, see plates 10, 18, 19).[7]

Medieval architectural claimants to the style of Daedalus were not so
easily demoralized. Despite the paucity of visual evidence, some real
buildings and gardens in the Middle Ages were conceived, or conceived
of, as labyrinths; unfortunately, we must rely on skimpy verbal descrip-
tions to try to reconstruct them. In the twelfth century a self-conscious
imitation of antique architecture was apparently built at Ardres for
Count Arnold of Guines by one Louis of Bourbourg, who, "with a skill in
woodwork very little different from that of Daedalus," executed not only
a palace but also "a nearly inextricable labyrinth, containing recess with-
in recess, room within room, turning within turning."[8] It is pleasing to
find the architect's name preserved, although more information about
the purpose and nature of his work would have been useful; perhaps
this labyrinth was a spectacular gazebo gracing the gardens at Ardres,
propagandistic testimony to the count's taste, classicism, and wealth, an-
ticipating the Renaissance programmatic gardens and living labyrinths
of Carlo Emanuele near Turin or Ippolito d'Este at Tivoli.[9]

Roughly contemporary with Arnold's labyrinth is the most famous
medieval maze of all, Rosamund Clifford's *camera*, that curving and im-
penetrable Daedalian creation allegedly constructed by Henry II at
Woodstock to shield his mistress from his wife, Eleanor of Aquitaine.
The legend is first mentioned by the thirteenth-century chronicler John
Bromyard, and later historians repeat and embellish both the bower's
description and the narrative of Eleanor's vengeance. Unfortunately, the
historicity of this labyrinthine building is dubious: medieval chroniclers

dyvers and vnkouth, / Full off wrynkles and off straungenesse, / Ougli to know which is
north or south." Possibly the inconsistencies reflect not textual variants in the manuscripts
but the difficulty of visualizing the Cretan maze. William of Conches's commentary on
Boethius also reports that the labyrinth is a kind of cave (*domus subterranea*): London BL
MS. Royal 15 B 3, fol. 86v.

7. For reproductions, see Kern, plates 155 and 158–160. For other illuminations hint-
ing at a third dimension, see Kern, plates 184, 203, 205, and 207, the last three illustrating
the city of Jericho as a labyrinth. Plates 174–175 and my plate 10 show mid-fifteenth-
century three-dimensional labyrinths. Earlier, only three illuminators of the *Histoire an-
cienne jusqu'à César* attempt exterior views of a three-dimensional spherical labyrinth (see
plates 18 and 19 and Buchthal, *Miniature Painting in the Latin Kingdom of Jerusalem*, plates
113b and 151c; and Appendix, MSS. 4–6).

8. Reported by the chronicler Lambert of Ardres, *Historia comitum Ardensium et Guisnen-
sium, A.D. 800–1200*, in Petrus de Ludewig, *Reliquiae manuscriptorum* (1727), p. 549 (as noted
by Matthews, pp. 111 and 233). Kern (p. 248) thinks Lambert's reference to the building as
a labyrinth is purely metaphorical, but the description accords rather well with Boccaccio's
comments on the original Cretan maze, cited above in chap. 2.

9. See Elisabeth Blair MacDougall, "Imitation and Invention: Language and Decora-
tion in Roman Renaissance Gardens," *Journal of Garden History*, 5 (1985), 119–134, here
120–121, and Kern, plate 443 and chap. 15. On the popularity of *gloriettes* and other
elaborate garden buildings, see John Harvey, *Medieval Gardens* (London: B. T. Batsford,
1981), pp. 106–107 and plates 56–59 and 62.

so exultantly invented bloodcurdling accusations against Eleanor that the labyrinth story may be yet another piece of character assassination. In any case, John Harvey concludes from Woodstock records that the bower was simply an orchard. Nevertheless, it is significant that such medieval chroniclers as Ralph Higden accepted unquestioningly the idea that a royal labyrinth, a summerhouse of sin designed for lust and ending in murder, had once existed; perhaps more authentic examples lent credibility to the legend.[10]

In the later Middle Ages, aristocratic French gardens contained other *dédales*, and here the distinction between labyrinthine garden buildings and true horticultural labyrinths made of hedges blurs. In 1338 workers were paid to maintain pergolas, rose gardens, and a *maison dédalus* at the castle of Hesdin; Charles V of France (1364–1380) had a *maison de dédale*, along with pavilions, orchards, and tunnel arbors, in his gardens at the Hôtel Saint Pol in Paris; accounts of the dukes of Burgundy mention a *maison dédalus* at Rouvres in 1372; in 1431 John, duke of Bedford, tore up the hedges of a *dédale* at the Hôtel des Tournelles in Paris to make room for a stand of elms; and in 1477 King René of Anjou's *dedalus* in the gardens of Baugé was rebuilt. The duke of Bedford's unwanted *dédale* was presumably a true hedge-maze, but the nature of the others is unclear: hedge-mazes, mosaics, turf-mazes, and labyrinths covered by pergolas have all been proposed.[11] Given the precedent of Louis de Bourbourg, the medieval assumption that the Woodstock maze was a building, and the general popularity of summerhouses and other buildings in medieval gardens, however, I think we cannot discard the possibility that some of these later mazes were ornate buildings, labyrinthine in artistry if not in groundplan. Boccaccio's description of the mazes familiar in mid-fourteenth-century Italy, quoted in Chapter 2, clearly suggests that his contemporaries built three-dimensional mazes, but whether of stone or plants he does not say. Some illustrations of the Cretan maze from the mid-fifteenth century show a roofless stone building that fits Boccaccio's description and that might possibly represent some actual Italian construction (see plate 10).[12]

Thus it is impossible to tell when hedge-mazes of the Hampton Court (1690) variety first appeared in medieval Europe and whether the *dédale*

10. See Matthews, p. 165; Higden, *Polychronicon* 7.22; Virgil B. Heltzel, *Fair Rosamund: A Study of the Development of a Literary Theme* (Evanston: Northwestern University Press, 1947); and Harvey, *Medieval Gardens*, p. 11.

11. See Matthews, p. 112; Frank Crisp, *Medieval Gardens*, 2 vols. (London: Bodley Head, 1924), 1, 70; Marie Luise Gothein, *A History of Garden Art*, 2 vols. (London, 1928; repr. New York: Hacker Art Books, 1979), 1, 188; Harvey, *Medieval Gardens*, p. 92; Santarcangeli, pp. 325–326; Kern, pp. 329–330; and Marguerite Charageat, "De la maison Dédalus aux labyrinthes, dans l'art des jardins, du Moyen-Age à la Renaissance," *Actes du XVII^{ième} Congrès International d'Histoire de l'Art, Amsterdam 1952* (The Hague, 1955), pp. 345–350.

12. See Kern, plates 174–175, and Bord, *Mazes and Labyrinths*, plate 56.

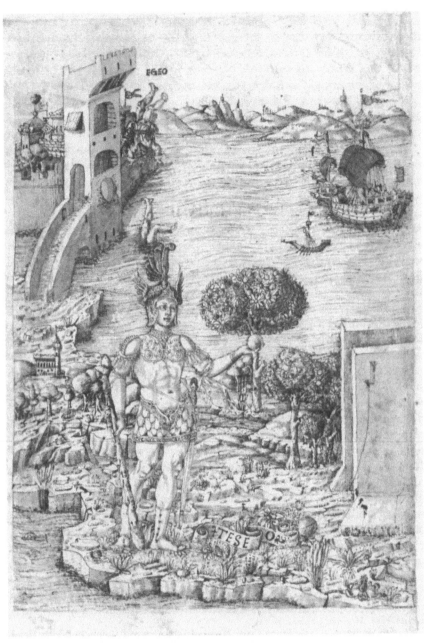

10. Illustration of the Cretan legend with three-dimensional labyrinth. Italian copperplate, ca. 1460, attributed to Maso Finiguerra. London, British Library

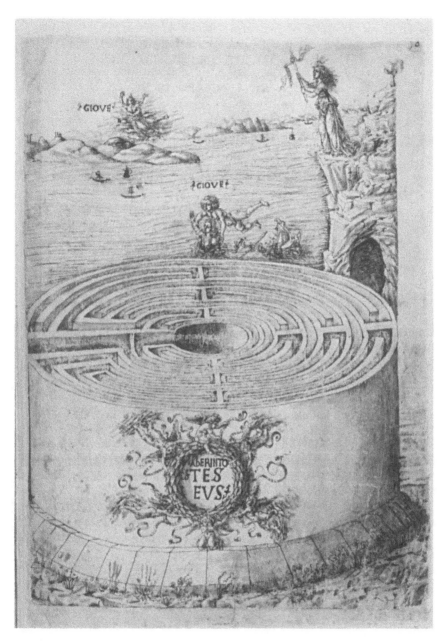

Department of Prints and Drawings 197.d.3, fols. 29v and 30r. By permission of
the British Library.

uprooted by the duke of Bedford was one of the earliest examples.[13] Certainly by the time an anonymous English author wrote *The Assembly of Ladies* (ca. 1450), these elegant, baffling playgrounds were well-known, and treading the maze was an attractive if frustrating recreational activity. Chapter 6 considers the significance of this labyrinth at some length; here, we simply look at what it tells us about the nature and uses of medieval hedge-mazes. Having nothing better to do one afternoon, a group of ladies enters the labyrinth:

> Som went inward and went [thought] they had gon oute,
> Som stode amyddis and loked al aboute;
>
> And soth to sey som were ful fer behynde
> And right anon as ferforth [well advanced] as the best;
> Other there were, so mased [bewildered] in theyr minde,
> Al weys were goode for hem, both est and west.
> Thus went they furth and had but litel rest,
> And som theyr corage [spirits] dide theym so assaile
> For verray wrath they stept over the rayle.[14]

Maze-walking seems to be a normal aristocratic diversion, but responses to the experience are highly individual: one group is completely disoriented; the second, poised in mid-maze, is either enjoying a pleasant view or hesitating between one path and another; the third group, seemingly far behind the rest, has in fact proceeded just as near the goal, presumably by a different path. The fourth group is thoroughly confused, and the last group of angry spoilsports climbs the rails to get out. The narrator, in contrast, is so exhausted that she seeks a "streyte [narrow; direct] passage" (l. 47) leading to an arbor, where she falls asleep. Presumably all the ladies enjoy treading the maze, but just as clearly the physical and emotional endurance required may be rather taxing.

If this poem gives a comprehensive early account of the three-dimensional maze experience, it also suggests some features of the garden maze's construction. It must be large, or the narrator would not be so tired; and if a lady can step over the rails in medieval costume, the walls or hedges cannot be very high. Neither can they be so low that one can easily see the design from within, or the frustration experienced by

13. In chap. 6 we will consider two texts—the *Gesta romanorum* (ca. 1300) and *Les Echecs amoureux* (ca. 1370–1380)—that contain gardens seen as moral labyrinths; conceivably these texts reflect the actual existence of hedge-mazes in the fourteenth century, much earlier than most garden historians would allow.

14. Lines 34–42, *The Floure and the Leafe and The Assembly of Ladies*, ed. D. A. Pearsall (London: Thomas Nelson, 1962). While finding the language consistent with a mid-century dating, Pearsall assumes the presence of the maze would place the poem later, perhaps in the 1470s; but given the dating of the duke of Bedford's maze, 1450 seems plausible as a date for the poem.

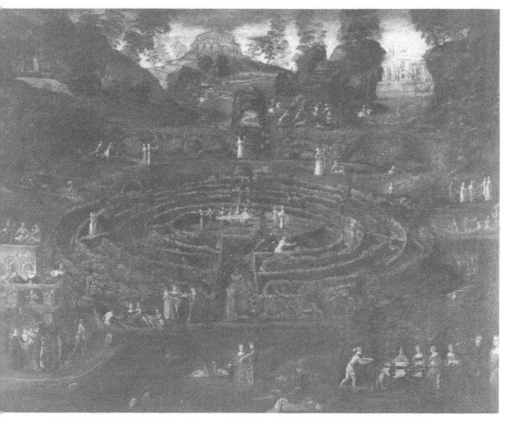

11. Painting of a garden maze, ca. 1550, once attributed to Tintoretto and now to Pozzoserrato. London, Hampton Court. Copyright reserved to Her Majesty Queen Elizabeth II.

several strollers would be unlikely. Finally, it seems probable that the maze is multicursal, involving choices among paths, and, if so, this is a very early example of that design. In many respects, then, and except for its probable multicursal design, the maze of the poem resembles waist-high hedge-mazes depicted in numerous works of art from roughly 1550 to 1650 (see plate 11, a painting at Hampton Court once attributed to Tintoretto).[15] Entertaining places of dalliance, conversation, and exercise, hedge-mazes presumably served many of the same functions as any other garden while intensifying the normal garden's formal artistry and adding an element of challenge.

15. The painting is now attributed to Pozzoserrato: see Rodolfo Palluchini and Paola Rossi, *Tintoretto: Le opere sacre e profane*, 2 vols. (Milan: Alfieri, 1982), plate 669.

Despite the pejorative moral connotations of many literary labyrinths and despite the grim descriptions of real mazes in Isidore and others, then, there was a different, secular aristocratic tradition in the Middle Ages. We cannot begin to determine whether such architectural wonders as Louis of Bourbourg's confection at Ardres were inspired by Pliny's descriptions of the creations of ancient kings, by Ovidian playfulness, or by something else entirely. Nor can we tell whether horticultural mazes might be a refinement of the more democratic English turf-maze, to be discussed shortly. But clearly these three-dimensional *maisons de dédale*, whether as buildings or as horticultural extravagances, were flamboyant works of art fit for a king's garden, intended to confuse and dazzle, creations of complex artistry and baffling intricacy, medieval status symbols harmonizing order and chaos. That most of these mazes are named for Daedalus suggests that architectural intricacy and ingenuity were salient features, and, like some cathedral labyrinths, noble *dédales* may well have served as sublime artificial symbols of the designer's Daedalian craft, as excellent a quality in a gardener or secular architect as in the founder of a cathedral. Since, as we shall see, most medieval literary references to labyrinths link them with sin, error, confusion, and damnation, it is all the more important to remember what the aristocratic three-dimensional labyrinth teaches: that in a parallel courtly tradition, a maze, like a garden, might be a palace of pleasure, beguiling nothing but the time. These mazes may be as close as the Middle Ages come to art for art's sake; if literature can be justified as recreation, so can labyrinths.[16]

· Diagrammatic Labyrinths ·

If three-dimensional mazes represent an attractive if atypical variation on the theme of the labyrinth, diagrammatic mazes are the medieval norm. Here I include medieval mazes that are either quite flat (the great cathedrals' pavement labyrinths, for example) or, while minimally three-dimensional, so low that their design can be seen clearly by anyone standing inside them (the turf- or stone-mazes). I separate them from three-dimensional mazes because these two-dimensional labyrinths intrinsically highlight the orderly albeit circuitous design of the labyrinth by affording a comprehensive overview. All save one (the graffito in Poitiers—see Chapter 2, n. 3) are indisputably unicursal, so that it would be impossible for anyone to get lost even were the design extended into three dimensions. If the three-dimensional mazes owe a good deal to the classical literary tradition, diagrammatic mazes are akin to the floor

16. See Glending Olson, *Literature as Recreation in the Later Middle Ages* (Ithaca: Cornell University Press, 1982).

mosaics of classical art. If architectural and horticultural mazes were rare and associated with the aristocracy, many diagrammatic labyrinths were visible to thousands in churches or fields. Although not every viewer would have understood their potential metaphorical significance, knowledge of their existence and form at least would have been common in much of western Europe. Whoever designed them, and for whatever reason, they became part of medieval popular culture and thus represent our only chance to see what illiterate people might have known about the idea of the labyrinth. Since a great deal has been written about them, I limit my comments to necessary background and new interpretations or speculations.

Turf-Mazes and Stone-Mazes

What architectural and horticultural labyrinths were to the aristocracy, turf-mazes may have been to English medieval peasants: places of aesthetic delight and slightly arduous recreation.[17] Or such, at least, is one of their generally mysterious functions. The English countryside is dotted with earthwork labyrinths or turf-mazes (see plates 12 and 13): unicursal mazes, often circular and about forty feet in diameter, cut in the ground to a depth of six to twelve inches. These mazes have fascinated antiquarians since the seventeenth century. Several, particularly those with elaborate designs unparalleled in demonstrably medieval mazes, date from the Renaissance or later, but a goodly number are generally assumed to be very old. As so often happens with manifestations of early popular culture, facts about these mazes are hard to come by: local oral history and late records are usually the only source for their antiquity, names, and uses. Speculations abound, of course. For example, Edward Trollope noted that turf-mazes usually are found near churches and concludes they may have had ecclesiastical functions;[18] but no place in England is ever very far from a church, and no medieval accounts survive of religious uses of the turf-maze. The earliest record of a turf-maze and its use apparently dates from 1353: Matthews describes the treading of a "Shepherd Ring" near Boughton Green, Northamptonshire, during the annual June Fair chartered by Edward III in that year.[19] But does the treading of the maze date from official recognition of the fair, or might it have been an earlier or a later practice? Other problems raised by turf-mazes are equally insoluble. Nevertheless, I join Matthews, Kern,

17. See Matthews, chaps. 10–12; Santarcangeli, pp. 340–353; Edward Trollope, "Notices of Ancient and Medieval Labyrinths," *ArchJ*, 15 (1858), 216–235; and Kern, chap. 9, which includes a map showing the distribution of turf-mazes and a full catalogue with illustrations.

18. Trollope, *ArchJ*, 15, 227–228.

19. Matthews, p. 75.

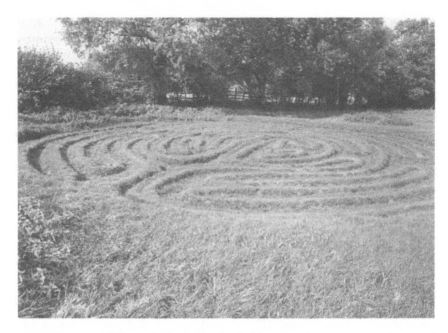

12. Turf-maze at Wing, Rutland, England. Photograph courtesy of the Royal Commission on the Historical Monuments of England.

and others in assuming that turf-mazes and the treading of them were known in England in the Middle Ages. First, the patterns of many turf-mazes are very old, resembling those of French cathedral labyrinths or prehistoric mazes carved on rocks, as at Rocky Valley in Cornwall (see plate 1).[20] Second, Shakespeare mentions treading the maze as an established folk custom, and folk memory often goes back a long way.[21] As we have seen, Chaucer and Gower may have assumed that their listeners knew the word *mase* and its confusing design because of a widespread familiarity with turf-mazes, whatever their function. On balance, then, we may tentatively include turf-mazes and assorted playful if obscure festivities involving them as part of the labyrinth lore available to English medieval writers and readers. The idea of the labyrinth as a challenging game, so familiar today, presumably played its part in the Middle Ages in *dédales* and turf-mazes alike.

One of the most intriguing features of turf-mazes is their names. Here

20. Kern (pp. 221–222) discusses the theory that early turf-mazes in England were Christianized by the imposition of cruciform axes and designs borrowed from French cathedrals. I do not think the evidence permits a tracing of influence from France to England or vice versa.

21. See *Midsummer Night's Dream*, 2.1.99–100, and *Tempest*, 3.3.2 and 5.1.242.

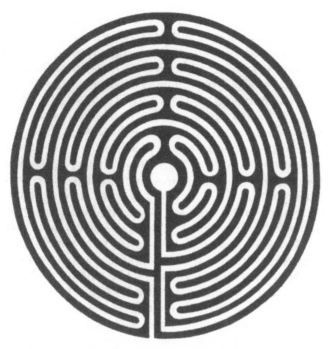

13. Diagram of Julian's Bower, turf labyrinth at Alkbor-
ough, Lincolnshire, England. Drawing by Robert Ouellette
after W. Matthews and G. Yorke.

again, we are on somewhat uncertain ground: none of the names is
firmly documented before the Renaissance. But if the names are indeed
older, as they may well be, they can tell us something about popular
medieval interpretations of mazes. At least three Lincolnshire turf-
mazes were called Julian's Bower, and although the name is clearly at-
tached to the maze only in 1544, local tradition dates an Alkborough
example to 1200. Conceivably, as several writers have suggested, the
name refers to Julius Ascanius's Trojan Ride; however, it is likely that in
the Middle Ages the name would suggest Saint Julian, patron saint of
hospitality. If so, the name is either an ironic allusion to the troublesome
journey any maze involves or a more straightforward reference to wel-
come rest at the maze's center.[22] But the Trojan connection is unam-
biguous elsewhere: eight turf-mazes are called "Troy," "Walls of Troy,"
or, in Wales, "Caerdroia" ("walls of Troy" or, perhaps, "city of turnings").
Since the labyrinth on the Tragliatella wine-pitcher is also "truia," and
since the seigneur de Caumont in 1418 described the Cretan labyrinth as

22. For the Alkborough dating, see Kern, p. 224.

"called by the vulgar the City of Troy,"[23] a continuous tradition seems to link the maze design with Troy and perhaps with the Trojan Ride of the *Aeneid* and Roman custom. This ancient tradition, along with the Trojan names for some turf-mazes, offers tentative evidence that turf-mazes nominally associated with Troy did indeed exist in medieval England. If so, given the tremendous interest in Troy in a country allegedly founded by descendents of Trojan Aeneas, the labyrinth and related rituals might have had special importance for English writers.[24]

Turf-mazes were common only in Britain, though a few existed in Scandinavia and Germany. Norway, Sweden, Finland, Iceland, and Russia, however, contain more than five hundred labyrinths of the prehistoric Cretan pattern (see plate 1) whose paths are outlined by stones. Many of these apparently date back to the Middle Ages, and many are called "Troy-town" ("Trojaburg"); others are named "Jerusalem," "Babylon," "Nineveh," "Jericho," or "Wayland's House."[25] These place names (except Nineveh) also occur in connection with mazes in medieval manuscript illuminations or literature.[26] The striking overlap between learned and popular labyrinth names lends credence to claims that the names of turf- and stone-mazes are medieval in origin.

It is obvious why mazes might be associated with the legendary Wayland, the Daedalus of the north; but why are they linked with cities? Santarcangeli speculates that since Troy was the archetypal city for many medieval people, the labyrinth associated with Troy (via the *lusus Troiae*) might come to denote other cities as well. Kern believes that the Trojan Ride was performed at the foundation of Roman cities, and that the maze-city association is based on that ritual.[27] There are still closer parallels between labyrinths and Jericho: the Hebrews circled that city for seven days, the number of circuits in many mazes, and Rahab, like Ariadne, helped the Hebrew spies escape from the city with the aid of a scarlet thread.[28] Babylon, linked by Petrarch with the labyrinth that is

23. Matthews, p. 156.

24. Later we shall see how the *Assembly of Ladies* and *House of Fame* link Saint Julian and the maze, and Chaucer's poem brings Aeneas into the equation as well.

25. See Matthews, chap. 17; Santarcangeli, chap. 6; Kern, chap. 16. These authors also report connections between Trojaburgs and dancing, although the function of the stone-mazes is as mysterious as that of turf-mazes. John Kraft's definitive study of Trojaburgs may be enlightening in this regard.

26. Constantinople is linked with the maze in medieval art, though not in folk tradition. See Batschelet-Massini, MSS. A9b, A14, A15; Santarcangeli, p. 251; Kern, plates 200–207; Petrarch, *Liber sine nomine (Book without a Name)*, trans. Norman P. Zacour (Toronto: Pontifical Institute of Medieval Studies, 1973), letters 8 and 10.

27. Santarcangeli, pp. 69–73, and Kern, pp. 26–27 and 93–101. W. L. Hildburgh argues that turf, stone, and probably church mazes had an apotropaic function, in themselves and for anyone who ran their course: see "The Place of Confusion and Indeterminability in Mazes and Maze-Dances," *Folklore*, 56 (1945), 187–192.

28. Santarcangeli, pp. 68 and 275. See Kern, pp. 171–182, for a full if occasionally problematic discussion of the Jericho-labyrinth tradition and its possible relationship to the Trojan Ride.

Avignon, is continually associated with confusion in the Middle Ages, so that city and the maze are appropriately likened to each other.[29]

I suggest, however, that the origins of the link between maze and city return us to the idea of the labyrinth as a complex artistic whole composed of confusing parts. Isidore of Seville tells us that "urbs" is derived from "orbis," since ancient cities were always circular in form.[30] So too are all mazes named after cities. What could be more complicated and simultaneously more artistically put together than a great ancient city? One round, complex, artistic entity is fitly designated by another. The metaphoric equivalence stresses yet again the maze's characteristic tensions between order and chaos and defines another significance of the image in medieval literature, a significance fusing objective admiration for elaborate design with recognition of subjective, process-induced confusion. Popular as well as aristocratic culture may have been fully conscious of the artistic magnificence of the maze as artifact and the bewildering consequences of the maze as process.

Labyrinths in Churches

If secular labyrinths in aristocratic and popular culture alike tend to glorify the artistry of man, ecclesiastical labyrinths generally celebrate the triumphs of divine artistry and of human ingenuity in the service of God. Here too the labyrinth usually operates *in bono* and offers an occasion for joy, either in itself or as the locus of festive ritual; labyrinthine complexities in this context represent an aesthetic hallmark of artistry or an intellectual and moral challenge to be overcome with divine aid.

England had turf-mazes and other northern countries had stone labyrinths to familiarize their inhabitants with the characteristic form of the unicursal maze (and perhaps with some aspects of the labyrinth as metaphor), but northern France and northern Italy located their diagrammatic mazes in churches and cathedrals. Before we consider the significance of these labyrinths, a little background information is useful.[31] Except for some early Christian labyrinth mosaics in Africa, the earliest church mazes existed in Italy (Pavia, Piacenza, Ravenna—all dated vari-

29. Petrarch, *Liber sine nomine*, letters 8 and 10. According to one possibly relevant tradition, Nimrod, builder of the Tower of Babel, had a son named Icarus who later went to Italy: Brunetto Latini, *Li Livres dou tresor* 61.134 ff., ed. Francis J. Carmody, University of California Publications in Modern Philology, 22, (Berkeley, Calif., 1948).

30. Isidore, *Etymologiae* 15.2.3.

31. For lists, drawings, and descriptions of church mazes, see Matthews, chap. 9; Santarcangeli, pp. 282–301; Kern, chap. 8; L. Deschamps des Pas, "Le Pavage des églises," *Annales Archéologiques*, 12 (1852), 137–153; Julien Durand, "Les Pavés-Mosaiques en Italie et en France," *Annales Archéologiques*, 15 (1855), 223–231, and 17 (1857), 119–127; Jules Gailhabaud, *L'Architecture du V^me au XVI^ème siècle*, vol. 2 (Paris, 1858); Emile Amé, *Les Carrelages emaillés du Moyen-Age et de la Renaissance* (Paris, 1859), pp. 31–53; Hans Reinhardt, *La Cathédrale de Reims*, pp. 75–82; and Batschelet-Massini, pp. 59–61. Many French church labyrinths were destroyed around the time of the Revolution.

ously from the tenth to twelfth centuries). By the twelfth and thirteenth centuries they had spread widely, particularly in major cathedrals of northern France (e.g., Auxerre, Sens, Chartres, Reims, Amiens). Except for the Poitiers graffito, which might be minimally multicursal (see Chapter 2, n. 3), these labyrinths are all unicursal; most are circular (one is square and four are octagonal) and have the cruciform axes appropriate to a church. Those in France tend to be large (thirty or forty feet in diameter), those in Italy smaller (ten or so feet in diameter); a few small mazes are found on walls, but most are set in the nave pavement. It is often impossible to determine their exact dates or which came first, but their tendency to cluster in certain areas (within a hundred miles of Paris, for instance, or in the related cathedrals of Sens, Chartres, and Auxerre) indicates that architects or their clerical commissioners readily adopted an attractive feature of a neighboring church for their own use. Nor is it clear why England should have had no pavement labyrinths, or whether the existence of turf-mazes has anything to do with this lack.[32] There are, however, fourteenth-century roof bosses (at South Tawton, Devon, and Saint Mary Redcliffe, Bristol—plate 14) and a Norman baptismal font (Saint Martin's, Lewannick, Cornwall—plate 15) with labyrinth designs.

The purposes and symbolism of church labyrinths concern us here, for thus do these mazes exemplify and extend the idea of the medieval labyrinth. Although little conclusive information is available, a good deal of contextual evidence survives on which to base informed speculation. Medieval art historians have long known that virtually every detail of a church might have a symbolic purpose, or at least an appropriate symbolic interpretation, as William Durand (1230–1296) shows so ingeniously in the *Rationale divinorum officiorum*.[33] Unfortunately, Durand offers no commentary on the great pavement labyrinths that existed in

32. Matthews (pp. 69–70) cites *The Dictionary of Architecture* (London: Thomas Richards, 1867), *s.v. maze*, as evidence for a pavement labyrinth at Canterbury Cathedral, but Francis Woodman, author of *The Architectural History of Canterbury Cathedral* (London: Routledge & Kegan Paul, 1981), kindly confirmed in personal communication that there is no basis in fact for such a claim.

If turf-mazes were habitually used for secular diversions, one can see why the labyrinth design might be left off cathedral floors lest they be abused, especially during services. No such practical objections could be raised to nontreadable mazes.

33. Book 1 is translated as *The Symbolism of Churches and Church Ornaments*, trans. John Mason Neale and Benjamin Webb (Leeds: n.p., 1843). For a judicious assessment of the caution necessary in finding symbolic meaning in medieval architectural structure, see John Leyerle, "The Rose-Wheel Design and Dante's Paradiso," *UTQ*, 46 (1977), 280–308, here 290–291. Since labyrinths are decorative rather than structural features, we may safely assume they were intended to have symbolic import. For studies of church symbolism, see, inter alia, Adolf Katzenellenbogen, *The Sculptural Programs of Chartres Cathedral* (Baltimore: Johns Hopkins University Press, 1959); Emile Mâle, *The Gothic Image: Religious Art of France of the Thirteenth Century*, trans. Dora Nussey (New York: Harper & Row, 1958); and Panofsky, *Gothic Architecture and Scholasticism*.

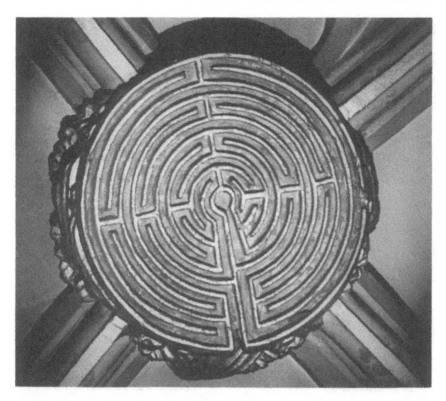

14. Roof boss, north aisle, Saint Mary Redcliffe, Bristol (fourteenth–fifteenth century). Photograph courtesy of the Royal Commission on the Historical Monuments of England.

his day: all we learn is that the pavement per se is either humility (1.16) or the foundations of the faith (1.28). What, then, were the pavement labyrinths intended to represent? Not, surely, what countless authors since 1817 have assumed despite the utter lack of supporting medieval evidence: that the feeble, the sick, and stay-at-homes during the crusades performed token pilgrimages on their feet or knees in these church labyrinths in lieu of undertaking a real voyage to Jerusalem.[34] This

34. The original perpetrator of the theory seems to have been J. B. F. Gérusez, *Description historique et statistique de la ville de Reims*, vol. 1 (Reims, 1817), pp. 315–316. Among modern literary critics reluctant to discard the hypothesis are D. W. Robertson, *A Preface to Chaucer* (Princeton: Princeton University Press, 1962), p. 373; B. G. Koonce, *Chaucer and the Tradition of Fame* (Princeton: Princeton University Press, 1966), p. 251; Donald R. Howard, *The Idea of the Canterbury Tales* (Berkeley: University of California Press, 1976), pp. 325–330; Diehl, "Into the Maze of Self," pp. 283–284; and John G. Demaray, *Dante and the Book of the Cosmos*, Transactions of the American Philosophical Society, 77, pt. 5 (1987), pp. 21–23, 99. Even Kern seems to endorse the penitential use of church labyrinths, as though something that *may* be traversed on foot was necessarily *intended* to be traced in a reverent

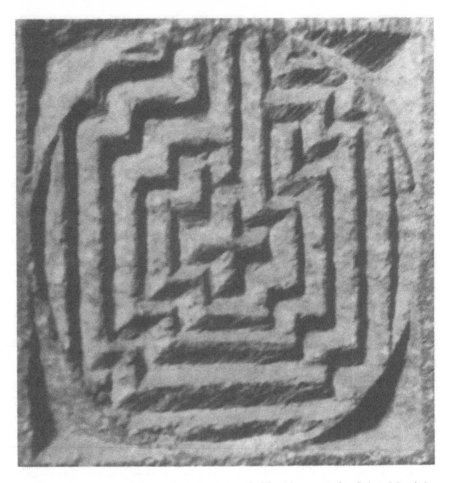

15. Face of octagonal baptismal font (probably Norman) in Saint Martin's, Lewannick, Cornwall. Photograph courtesy of the Royal Commission on the Historical Monuments of England.

tenacious fantasy has meager roots in reality. A few church labyrinths were known as "chemins de Jérusalem," but documentation of the name is post-Renaissance.[35] As classical and early Christian writings show, life can be compared to a labyrinthine journey; since life may also be com-

spirit. He suggests that the placement of most church mazes at the western part of the nave indicates their function as "a buffer zone. The faithful had first to interiorize the idea of the labyrinth—with all its implications—by physically tracing its windings; only then were they permitted to proceed further, to advance towards the Holy Sacrament" (p. 128). The hypothesis is attractive if rather difficult to put into practice, and it rests on conjecture alone.

35. See Matthews, p. 60, and Kern, pp. 194–195.

pared to a pilgrimage, the argument would go, a pilgrimage must be a labyrinth, and vice versa: an elementary if faulty syllogism, plausible enough in the abstract. But although a labyrinth might sometimes have represented a pilgrimage, I have found no indisputable medieval examples of the metaphor, and in the absence of the tiniest shred of evidence that pavement labyrinths were used for real or substitute pilgrimages, the hydra-like hypothesis should be dismembered for good. Fortunately, we can reconstruct the symbolism and function of several church labyrinths, even though that reconstruction necessarily involves a certain amount of speculative interpretation of the existing medieval evidence.[36]

First, the labyrinth may be a sign of the aesthetic magnificence of Christian architecture. Labyrinths at Reims (1240; plate 16), Amiens (1288), and possibly Chartres (ca. 1194–1220; plate 17) contained effigies of the chief architects and founding bishops, as Jules Gailhabaud showed in 1858; the labyrinth is thus "synonymous with all great enterprises, that is to say, a kind of seal placed by the architect to consecrate his work."[37] Accomplished medieval sculptors sometimes signed their works rather boastfully: in the Last Judgment tympanum at Autun, Gislebertus (fl. 1125) places his "hoc fecit" directly below the feet of Christ; at Saint Etienne, Toulouse, the sculptor Gilabertus (fl. 1125) signs his name with the addendum "vir non incertus [not an unsteady man; or, a man of respected lineage]"; the Italian Niccolò claimed credit for four cathedrals; and Wiligelmo, working at Modena, ensured his reputation with an inscription reading, "Among sculptors, your work shines forth, Wiligelmo. How greatly you are worthy of honors." A gifted Spanish illuminator, Florentius (fl. 945), signed an exceptionally rich manuscript even more extravagantly, if with verbal modesty: the text "Florentius indignum memore [Florentius, remember you are unworthy; or, perhaps, Remember the unworthy Florentius]" constitutes an elaborate letter-labyrinth like that at San Reparatus: begin at the top center of the page, read the letters either horizontally or vertically, and the scribe's prayer takes shape. This labyrinth is set in a maze-like interlaced frame and faces the monogram of Christ on the opposite page.[38] If

36. For a range of other speculations, as well as an argument that church labyrinths betray Norman influence, see Kern, chap. 8.

37. Gailhabaud, L'Architecture, n.p. For Reims, Amiens, and Chartres, see also Matthews, figures 50, 48, and 47, and Kern, plates 247–248, 218–219, and 224–226. Reinhardt, Reims, gives a good account of scholarship on these architects' labyrinths. One other maze perpetuates fame: in Saint Etienne, Caen, the abbey guard chamber contains a labyrinth including coats of arms of illustrious Norman families (Matthews, p. 65).

38. George Zarnecki, Art of the Medieval World (Englewood Cliffs, N.J.: Prentice-Hall, and New York: Harry N. Abrams, 1975), pp. 285, 271, and 270; and John Williams, Early Spanish Manuscript Illumination (New York: George Braziller, 1977), pl. 6. Williams notes that such "commemorative labyrinths" were common in Spain but generally were plays on the name of the commissioner.

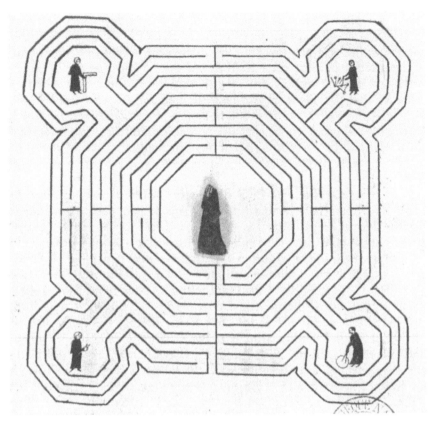

16. Drawing of labyrinth with figures of architects in the nave of Reims Cathedral, by Jacques Cellier. The labyrinth dates from 1240. Paris, Bibliothèque Nationale MS. fr. 9152, fol. 77r. By permission.

sculptors and illuminators wanted due fame, it is hardly surprising that the builders of Amiens and Reims should claim credit for their work, or that, like Florentius, they should do so in a way that blends theoretical humility with justifiable pride. The church labyrinths are, after all, set in the lowly pavement, and they do not include signatures; but they implicitly equate the medieval architect with that master builder, Daedalus. The pavement *dédale*, then, suggests that a great Christian structure, the complex High Gothic cathedral, is fully as magnificent in design and execution as any Cretan monument: indeed, the Christian work quite literally stands far above the Cretan. Like the great ancient labyrinths described by Pliny, these architects' labyrinths bear grandiose witness to

the genius of the builder and serve as emblems of magnificent design.[39] Even when a church labyrinth did not include specific reference to the architects, the aesthetic message might persist: Christian art surpasses, or at least rivals, the ancient labyrinths; the temple of Christ triumphs over the labyrinth-decked temple of Apollo at Cumae and offers a safer passage to the afterlife. The inherent ambiguity of the maze as complex artistry and confusing chaos would thus resolve itself in the direction of artistry, perhaps with a glance at the *labor* involved in the creation of so richly articulated a building as the Gothic cathedral.

Almost any church labyrinth, then, might be interpreted as signifying the marvelously articulated complexity of the building that contains it, but other legitimate interpretations based on medieval evidence exist as well. If the architects' labyrinths, or indeed any church labyrinth as a visible ornament, make an aesthetic statement, the liturgical uses of pavement labyrinths sometimes assert moral-doctrinal truths, as the labyrinth ritual of the Cathedral of Saint Stephen at Auxerre demonstrates. During the Middle Ages, a number of dioceses practiced Easter rituals involving dances, ball-throwing, or both together. John Beleth (fl. 1182) reports (and discourages) such rites at Reims and elsewhere, and there may also have been Easter labyrinth dances during the later Middle Ages at Sens, Chartres, and Amiens.[40] The most complete records are from Auxerre, whose pavement labyrinth was the site of a fascinating Easter ceremony.[41] From at least as early as the fourteenth century until 1538,

39. So I would also interpret the roof boss labyrinths at South Tawton, Devon, and Saint Mary Redcliffe, Bristol (plate 14). An interesting variation on this theme occurs at Saint Mary Redcliffe: a roof boss in the north transept illustrates the vaulting design for the nave. Demaray (*Dante and the Book of the Cosmos*, p. 22) interprets these mazes differently.

40. Beleth, *Rationale divinorum officiorum* cap. 120, *PL*, 202, 123; Batschelet-Massini, p. 61; Kern, pp. 190–192; Yvonne Rokseth, "Danses cléricales du XIIIe siècle," *Mélanges 1945, III: Études Historiques* (Paris, 1947), pp. 93–126. Trollope reports post-medieval Easter festivities at the Comberton, Cambridgeshire, turf-maze: *ArchJ*, 15, 232. The existence of a dance at Chartres is questioned by Yves Delaporte in his edition of *L'Ordinaire chartrain du XIIIe siècle* (Chartres: Société Archéologique d'Eure-et-Loir, 1953). Delaporte suggests that the "chorea" occurring at vespers for several days after Easter was not a dance but a second (and therefore differently named) chorus singing in organum (pp. 256–257). Usually, however, *chorea* means "carol"—a danced song—and so I believe it should be interpreted in the Chartres ordinary. I have not been able to obtain Wolfgang Krönig's study of an Easter dance at Sens Cathedral (Kern, p. 131, n. 33).

41. The texts are published by Du Cange, *Glossarium, s.v. pelota*. The Auxerre dance has been widely discussed: see E. K. Chambers, *The Medieval Stage*, 2 vols. (Oxford: Oxford University Press, 1903), 1, 128–129 and n. 4; Louis Gougaud, "La danse dans les églises," *Revue d'Histoire Ecclésiastique*, 15 (1914), 229–245 (for Auxerre, 235–236); Edith B. Schnapper, "Labyrinths and Labyrinth Dances in Christian Churches," in *Festschrift Otto Erich Deutsch*, ed. Walter Gerstenberg, Jan LaRue, and Wolfgang Rehm (Kassel: Bärenreiter, 1963), pp. 352–360; Erwin Mehl, "Der Ausweg aus dem Labyrinth," in *Volkskunde: Fakten und Analysen*, ed. Klaus Beitl (Vienna: Selbstverlag des Vereines für Volkskunde), pp. 402–428 (410–418); E. L. Backman, *Religious Dances in the Christian Church and in Popular Medicine* (London: Allen & Unwin, 1952), pp. 66–73; Santarcangeli, pp. 296–298; and

the Auxerre canons assembled in the nave at vespers for Easter Monday, when the dean would take in his left hand a large ball (*pilota*) presented by one of the new canons. He then danced a *tripudium* in the center of the circular pavement labyrinth while the others joined hands and danced "circa daedalum": whether they followed the course of the labyrinth or simply danced around the outside is unclear, but the description of the dance as "garland-like" suggests that either the dean or the canons may have traced the labyrinthine path, its turnings resembling the interlacings of a garland. This dance was accompanied by Wipo's famous Easter sequence *Victimae Paschali laudes*, sung by the dean and presumably by the dancers in antiphon. All the while, the *pilota* was thrown back and forth between the dean and the canons. The sequence and its accompanying dance completed, all repaired to a communal meal.

Describing the *ludus* is one thing, but interpreting it is quite another; since this is our fullest account of the actual use of a church labyrinth, however, the attempt must be made. Noting the general medieval disapproval of paschal dances, Erwin Mehl thinks the ritual must be pre-Christian in overtone; Werner Batschelet-Massini traces Easter dances to Victorinus's account of the ancient labyrinth dance, discussed in Chapter 3, that betokened the harmony of the spheres. There is also a resemblance between the Auxerre ritual and the carol, a circle-dance performed hand in hand with a leader who sings the verses as the others sing the chorus.[42] Attempts to determine the origins of the Auxerre *ludus* would be not only fruitless but ultimately irrelevant: what we need to discover is the significance of the markedly Christian performance.

Perhaps the best starting point is the Easter sequence itself, one of most popular sequences in the Middle Ages and a standard feature of the Easter liturgy.[43] The first three stanzas praise Christ, the paschal lamb who redeemed his sheep, reconciled sinners to God the Father, and now, having defeated death, reigns as Lord of Life. The next two stanzas are a rudimentary dialogue: the disciples ask Mary Magdalene, "What did you see on the way?" to which she responds that she has seen the tomb of the living Christ and his resurgent glory; Christ has risen and goes before his followers into Galilee. The final stanzas profess faith in the resurrection. The dialogue provides dramatic opportunities that

references in the previous note. None of these discussions has provided a fully satisfactory explanation of the ritual. My article "The Auxerre Labyrinth Dance," *Proceedings of the Society of Dance History Scholars*, 1985, pp. 132–141, examines the ritual in greater detail and from a different point of view.

For a labyrinth design from Auxerre, see pl. 5; the cathedral labyrinth may well have had an identical pattern.

42. On the carol, see Richard Leighton Greene, *A Selection of English Carols* (Oxford: Clarendon Press, 1962), pp. 2–9.

43. *The Oxford Book of Medieval Latin Verse*, ed. F. J. E. Raby (Oxford: Clarendon Press, 1959), pp. 184–185.

were soon exploited: the whole sequence was pressed into service in Easter plays, and even in other contexts a dramatic disposition of roles and corresponding gestures was employed.[44] It is thoroughly appropriate, then, for the sequence to be performed as a kind of dramatic action at Auxerre, perhaps as a dialogue between dean and canons.

The general significance of the Auxerre *ludus* is clear from its date of performance and sung text. The dance must be a celebration of the harrowing of hell and the resurrection: although the harrowing is not specifically mentioned, the conflict between life and death referred to in the third stanza traditionally takes place in hell, where Christ is "dux vitae mortuus," the dead Lord of Life. Why, then, the labyrinth, the dance, and the ball? The first two elements are easy enough to account for. As we have seen and will see again, the labyrinth sometimes signifies inextricable hell, solved by Christ-Theseus whose footsteps define the unicursal course to salvation through theoretically multicursal paths to torment.[45] As for the dance, as Batschelet-Massini claims, the Auxerre play may draw on Victorinus's linking of circle dances with Theseus's triumphant labyrinth dance on Delos and the music of the spheres, an image of restored cosmic harmony; twelfth-century commentaries on *tripudia* interpret round dances to sung accompaniment as cosmic order or the dance of the blessed in heaven, with the leader of the carol often Christ himself.[46] Labyrinth and dance together, then, constitute a celebratory dance performed by religious saved by Christ-Theseus from the labyrinth of hell through the mysteries of Easter, a dance that incidentally imitates and invokes cosmic order and eternal bliss.

But what about the ball? Most writers fall back on Chambers's folklore-inspired assumption that the ball represents the sun, which in turn represents Christ, but this interpretation is dubious, not least because however vaguely appropriate it may be in connection with Easter, it has nothing to do with the labyrinth myth.[47] For a more plausible interpretation, we must turn to medieval literature. According to the *Ovide moral-*

44. Karl Young, *The Drama of the Medieval Church*, 2 vols. (Oxford: Clarendon Press, 1933), 1, 273–296.

45. The fact that Christ has unraveled the labyrinth of hell once and for all and established the proper path may provide partial justification for the unicursal design of church labyrinths; the greater visual stability of the unicursal design, already discussed, may also be involved.

The Christ-Theseus tradition, encountered in Gregory of Nyssa, receives further attention in chap. 6.

46. See James Lester Miller, "Choreia: Visions of the Cosmic Dance in Western Literature from Plato to Jean de Meun" (diss., University of Toronto, 1979), pp. 477–511.

47. See Chambers, *The Medieval Stage*, I, 128–129 and n. 4. Chambers's speculation is followed by Backman, Schnapper, Mehl, and Kern: Backman, for example, claims that the ball represents "Christ as the Sun of Righteousness or the Sun of Resurrection," and the dance "the exit from the kingdom of the dead" (p. 73); Kern sees the ritual as a Christianized version of a pagan dance: the ball is a "victorious paschal sun" and the dance neutralized the evil power of the labyrinth (pp. 191–192).

isé, when Christ-Theseus entered the labyrinth of hell to save his people from eternal death, he destroyed the deadly Minotaur with the aid of two significant props: two *pelotons* or balls. One was a ball of pitch, to be rammed into the Minotaur's gullet so he could not bite, and the other was a ball of thread to guide Theseus back through the maze's deceptive windings. Thus the two great dangers of the labyrinth—the monster within and the maze's entangling inextricability—could be overcome. In Christ's entry into the maze of hell, the ball of pitch was Christ's humanity, which deceived the devil into thinking Christ was guilty of original sin and hence subject to death and hell; by allowing the sinless Christ into hell, Satan violated the conditions of his infernal realm and lost his power over the just, and thus Christ's *peloton* of humanity disarmed Satan.[48] The ball of thread was Christ's divinity, which permitted a safe retracing of the labyrinth and the rescue of just souls within—the harrowing of hell and the resurrection.[49]

This information makes the possible meanings of the Auxerre ball-tossings clearer and more firmly grounded in medieval tradition: through their actions, each canon assists in the slaughter of the devil-minotaur and the triumph over hell by throwing the dean the helpful *pilota.* Further speculation is possible but depends on the actual pattern of the dance. If the dean dances in the center and the others wind in and out of the maze, the dean might symbolize the devil-minotaur (perhaps a rather appealing and festive role-reversal!). The canons would then simultaneously imitate the heroic deeds of Christ-Theseus and anticipate symbolically their own release from hell through the mysteries of Easter. If, on the other hand, the dean traces the labyrinthine path while the others dance around the outside, it is he who imitates Christ-Theseus while the canons mimic the revolving spheres of cosmic order and the circle dance of the blessed in heaven, thus embodying the context and consequences of Christ's penetration of the labyrinth. The hymn they sing provides a vocal imitation of the music of the spheres to complement the danced visual imitation of planetary and spiritual harmony.

Whatever the actual choreography of the dance as it was performed in the Middle Ages—and that we shall never know—the symbolic depth afforded the Auxerre labyrinth rite by medieval connotations of the maze, the dance, and the *pilota* is impressive. Through the dance and ball-throwing, the canons celebrate the harrowing of hell and the resurrection by a joyful song and dance that mimics not only the central truths

48. For an overview of medieval theories of the atonement, see Hastings Rashdall, *The Idea of Atonement in Christian Theology* (London: Macmillan, 1920).

49. See Pierre Bersuire, *Ovidius moralizatus (Reductorium morale XV),* ed. J. Engels, Werkmateriaal 2 (Utrecht: Instituut voor Laat Latijn der Rijks-universiteit, 1962), pp. 125–126; the poetic *Ovide moralisé,* ed. C. de Boer, *Verhandelingen der Koninklijke Akademie,* no. 30 (Amsterdam, 1931), 144–145; and *Ovide moralisé en prose,* pp. 226–227.

of the Redemption but also Theseus's memorial dance of deliverance on Delos, the dance of the blessed spirits in Christian tradition, and the harmony of the universe. We do not know who invented this ritual, of course; but whoever did must have interpreted the myth of the labyrinth in much the same fashion as Victorinus, Gregory of Nyssa, and the mythographers. Only thus could the elements of the labyrinth dance and the ball develop strikingly appropriate Easter associations.

If Easter dances and ball games were indeed fairly common, many of them probably carried the same meaning as the Auxerre rite, and other church labyrinths may have been used in similar celebrations of the *labor intus* of Christ-Theseus and, implicitly, the perfect order of the theological cosmos, a theme we return to shortly. Whether some mazes were created for this purpose or were simply adopted as the appropriate ecclesiastical site remains in doubt. In any case, the Auxerre labyrinth ritual was a triumphant reenactment of a central portion of the creed. For anyone who understood this symbolism of the church labyrinth, then, the pavement maze could indeed represent Durand's foundation of faith and serve as a reminder of the chief reason for being a Christian: the promise that the labyrinth of hell might not be inextricable after all.

Other church mazes corroborate the interpretation of the labyrinth as a symbol of the harrowing of hell, redemption, and resurrection. First, although most church mazes are circular, four thirteenth-century examples (St. Quentin, Arras, Reims, Amiens) are octagonal. The number eight traditionally signifies rebirth and resurrection in Christian symbolism (many baptismal fonts are octagonal as a result), and so it seems fairly likely that the alteration of design in some church labyrinths after about 1200 may reflect a desire on the part of the builders to bring the symbolism of resurrection into greater prominence.[50] Second, several early church labyrinths had inscriptions or etchings alluding to the harrowing of hell. San Michele, Pavia, contains a labyrinth with eight circles, the number of resurrection; in the center Theseus slays the Minotaur, and an encircling inscription reads "Theseus intravit monstrumque biforme necavit [Theseus entered and killed the Minotaur]." The redemptive symbolism is heightened by adjacent depictions of David slaying Goliath and a man killing a dragon, both incidents typologically linked with the harrowing of hell. A labyrinth at Lucca Cathedral showed Theseus and the Minotaur at the center; the inscription stated that no one could leave the labyrinth except Theseus, with Ariadne's aid. Though not explicitly Christian, in an ecclesiastical context this inscrip-

50. For the significance of the number eight, see Vincent Foster Hopper, *Medieval Number Symbolism* (New York: Columbia University Press, 1938); Mâle, *The Gothic Image*, p. 14; and *Glossa ordinaria* on 1 Kings 17:14, *PL*, 113, 556. The labyrinth at Lewannick, Cornwall (plate 15), is on an octagonal baptismal font.

tion could well suggest Christian truth foreshadowed by pagan myth. Finally, the maze at San Vitale, Ravenna, has a pathway decorated with triangles pointing from the center to the outside; the movement implied is from confinement to freedom, and anyone seeing this maze may well have supplied the appropriate Christian interpretation.[51]

So far, then, we have established two medieval reasons for placing labyrinths in churches: as a sign of the enclosing cathedral's magnificence and the architects' genius, and as a sign of hell made extricable through the labors and unicursal footsteps of Christ-Theseus—a sign of redemption as well as a warning to those who will not follow Christian doctrine. The first meaning reflects the labyrinth's artistry, the second its nearly inextricable nature; the first makes an aesthetic statement, based on the coherence of the labyrinth as a grand whole composed of elaborate parts, the second asserts moral-doctrinal truths (with aesthetic overtones of cosmic order) and demonstrates how Christ-Theseus's complex linear, unicursal path gives artistic and moral fixity and a sure goal to a potentially confusing and unstable process. Neither meaning, of course, need be exclusive, any more than the pavement must, for Durand, mean only humility or only faith.

The third and potentially most important meaning of the church labyrinth fuses aesthetics with theology and involves the artistry of God, the cosmic labyrinth. Literature provides ample evidence for seeing God as a kind of Daedalus and the universe as his labyrinthine masterpiece—we have seen examples in Chapter 3 and will see more in Chapter 6—but attributing such meanings to cathedral mazes involves speculation, for no convenient labels or records attest to this interpretation. Instead, we work from the formal implications of the labyrinth and its placement in certain cathedrals. I have already noted that most church mazes were circular and that they were placed in the nave of Gothic cathedrals. In context, this circularity is surprising: as Erwin Panofsky notes, "the very concept of an isolated circular unit conflicted with the ideals of Gothic taste." Hence the presence of a circular maze in a Gothic cathedral may be an example of the Gothic and scholastic interest in reconciling opposites: in *concordia discors*, in *sic et non*.[52] This possibility is oddly appropriate because the labyrinth itself embodies *concordia discors*, reconciling subjective confusion with magnificent design, constructing circular design from linear progress, showing how apparently endless circuitous-

51. For a diagram of the San Michele maze, see Matthews, fig. 144, and Kern, plates 239–241. Durand reports that Saint Gereon, Cologne, also combined the labyrinth and the David and Goliath motif: *Annales Archéologiques*, 17, p. 121. For the typology of David and Goliath, see *Glossa ordinaria* on 1 Kings 17:21, *PL*, 113, 556–557; and *Biblia pauperum* 28, ed. J. Ph. Berjeau (London: John Russell Smith, 1959). For Lucca and Ravenna, see Matthews, p. 56 and fig. 46, and Kern, plates 233–234 and 245–246. Kern argues for a very late dating of the Ravenna mosaic.

52. Panofsky, *Gothic Architecture*, pp. 64–71.

ness inevitably leads to the center if the labyrinth, like those in cathedrals, is unicursal. When Panofsky writes about the circle, however, he is concerned not with labyrinths but with that far more obvious violation of the Gothic arch, the rose window, which was so important that Gothic builders adjusted their principles, and sometimes their architecture, to include it. In labyrinth and rose window, then, we have two manifestations of inappropriate forms incorporated into the grand design. Given the equally Gothic love of symmetry of parts, perhaps we can trace some enlightening symmetries between rose window and labyrinth, forms that coexist in several cathedrals (Sens, Auxerre, and Chartres, to name three with round labyrinths; four octagonal mazes also were placed in churches with rose windows).

John Leyerle's ingenious study of the rose window at San Zeno, Verona, provides the key: that rose window, like some others, is characterized by doubleness and hence is in itself a kind of *concordia discors.* Viewed from the outside, the window outlines a *rota fortunae,* the familiar wheel of fortune; viewed from within, it is a rose of light: "the design of these windows produces two patterns, coincident and inseparable, but not the same: the stone tracery forms the wheel, the *rota,* and the pierced openings form the rose."[53] Leyerle's interpretation of this already double image is dual: initially the wheel of fortune seems to contain the rose of earthly love; but, from a different mental perspective, the wheel of fortune is an emblem of the round world, thoroughly subject to God's providence and part of the cosmic scheme of concentric circles reaching from earth to the Empyrean, and the rose is Mary, symbol of divine love. Thus, "the two-sided, coincident design showed the world and heaven in their differences and, more important, in their connections. The *rota-rosa* window . . . was simple in its physical pattern, but extremely complex in its significance; it was based on the circle, the most perfect of all shapes, and yet presented a multiple visual statement about the coherence, harmony, and mystery of the medieval Christian world picture."[54]

As with the *rota-rosa,* I would argue, so with the labyrinth, most intrinsically dual of images, another circular design fusing complexity and simplicity, another example of *coincidentia oppositorum.* From one perspective, the labyrinth may represent the treacherous course of human life on its way to an uncertain goal. A legend on the maze at San Savino, Piacenza, for example, equated the labyrinth with the world, large of entry but narrow of exit; trapped by the world, weighed down with sins, humankind can return to the doctrine of life only with difficulty.[55]

53. Leyerle, *UTQ,* 46 (1977), 287; see also Bruce Knapp, "A Note on Roses and Wheels," *Comitatus,* 1 (1970), 43–45.
54. Leyerle, *UTQ,* 46 (1977), 303.
55. The Latin text is given by Matthews, p. 57, and Kern, p. 211.

Taken *in malo*, then, the labyrinth may represent the entanglements of this deceitful world, fatal unless God is one's guide. The moral of this reading of the maze is very like the moral conveyed by the wheel of fortune: commit yourself to earthly things and they will enchain you. But just as fortune turns out to be an aspect of providence as viewed from a limited terrestrial perspective, so the seemingly inextricable labyrinth is not necessarily a chaotic prison: it is simply what divine order looks like when viewed from within time, where a linear and sequential perspective is natural. What seems like a maze to us as we move through it darkly is in fact a vision of order to God in eternity, just as fortune is what providence looks like to people bound on earth and in time. From a more enlightened point of view, one that considers the underlying principle of structure, the confusing maze is really the perfect order of creation, as fortune is really an aspect of the perfect justice of eternity.[56] The maze-world that entraps us is simultaneously the ordered cosmos; as always with mazes, interpretation depends on point of view, and the true view of the cosmic labyrinth reveals aesthetic order and magnificent design—divine artistry, in short, superior in kind and degree to the human artistry paid tribute in the architects' labyrinth. In most cathedrals, the labyrinth imitates the concentric circles of the cosmos and is stamped with the sign of the cross; the unicursal path may, as at Auxerre, represent the path to freedom traced by Christ-Theseus, or it may suggest a tour through cosmic circles, charting the course that a celestial voyager like Dante would follow. As God creates the circular cosmos with his compasses in so many illuminations, so too is the labyrinth constructed.[57] Moreover, it is presumably not by chance that virtually all French labyrinths have twelve concentric circles, possibly alluding to the zodiac that occasionally accompanies the design and measures human time, within whose constraints the world only seems to be confusedly labyrinthine.[58] The labyrinth in the Gothic cathedral, then, may well

56. These concepts will be illustrated at greater length in Part Three, in connection with various literary texts.

57. For the motif of God with compasses, see John Block Friedman, "The Architect's Compass in Creation Miniatures of the Later Middle Ages," *Traditio*, 30 (1974), 419–429. Most medieval circular mazes seem to have been drawn with compasses, a fact with interesting connections to the Ovidian myth in which Daedalus's nephew invented the compasses and thereby provoked his uncle to kill him. If God used compasses (metaphorically at least) to create the cosmos and man uses them to create the labyrinth, the cosmos-labyrinth analogy might have struck many who saw or constructed a maze.

58. Zodiacs and labyrinths coincide at Pavia, Cologne, and Saint Bertin, Saint Omer. I arrive at the figure twelve by counting the central circle as well as the eleven circles through which a wanderer would pass before reaching the central goal. Others (see Kern, p. 186) count only the eleven external circles, a number often associated with transgression and sin, suggesting that the labyrinth represents hell or the fallen world. Probably medieval observers would have counted eleven or twelve as their interpretative predilection moved them, but in strictly formal terms it seems more appropriate to view these mazes as having twelve circles.

serve a symbolic function analogous to that of the *rota-rosa*. First, both circular forms must be harmonized with the aesthetic of the pointed arch, and in the process the *concordia discors* intrinsic to labyrinth and *rota-rosa* alike is reduplicated in the *concordia discors* of the cathedral itself. Second, both architectural features make a statement about the perfection of God's design in relation to the mundane and moral limitations imposed on human perception of that design, limitations that lead us to see providence as fate or fortune and the universe as a bewildering labyrinth, misperceptions we can transcend through the teachings of the church, the imitation of Christ, and the right perspective. Only by following the right process, footsteps, or guiding thread can we see divine creation and justice truly; morality, epistemology, and aesthetics coincide.

The symmetries are manifested most clearly at Chartres (see plate 17), where the pavement labyrinth is set in the nave so that the great west rose Judgment window would, if folded down, almost overlap it.[59] The outside of the maze, completely enclosed in a lead circle, has little projections so that the maze resembles a Catherine wheel; the axes of the labyrinth suggest the wheel's spokes (as well as the Cross). Perhaps the wheel of fortune is an instrument of Christian testing and shows itself in the labyrinth as well as in the window. At the maze's center is the outline of a six-petaled flower, echoing the facing window: wheel, rose, and maze all coincide in one form. Entering the cathedral from the west and moving along the nave, in imagination or in reality one might encounter labyrinthine error, labyrinthine life, to be rescued and guided by Christ's footsteps. Standing between the altar and the maze and looking westward, one could, like Boethius in the *Consolation of Philosophy*, raise one's eyes from the confusion and limited perceptions of earth to the uncompromised concentric circles of divine order and justice in the rose, which

Neoplatonic cosmology, known to the Middle Ages through Macrobius's *Commentary on the Dream of Scipio*, would also have twelve divisions: earth, the seven planets, the fixed stars, the World-soul, Mind (mens, noûs), and god; this fact, along with the correspondence at Chartres to the twelvefold West Rose, is noted by Keith Critchlow, Jane Carroll, and Llewylyn Vaughn Lee, "Chartres Maze: A Model of the Universe?" *Architectural Association Quarterly*, 5, 2 (1973), 11–20. Critchlow et al. argue that the Chartres maze is a diagram of "not only the structure of the universe but also in Neoplatonic terms . . . the 'shells of reality' through which the wanderer would imitate the soul-journey" (p. 18). Given Chartrian philosophers' interest in Neoplatonism, the suggestion is plausible, although other speculations in the article—the division of the maze into sections reflecting lunar months, for instance—seem less so. Many manuscript mazes and classical mazes, though few church mazes, have seven circuits plus a center, the eighth circle: see Batschelet-Massini's and Kern's catalogues. This design would correspond more closely to the common medieval design of the cosmos, with the eighth circle representing the fixed stars. Batschelet-Massini, who relates many manuscript labyrinths to the idea of cosmic harmony, surprisingly does not find the number of circuits significant (56–57).

59. Critchlow et al., p. 16.

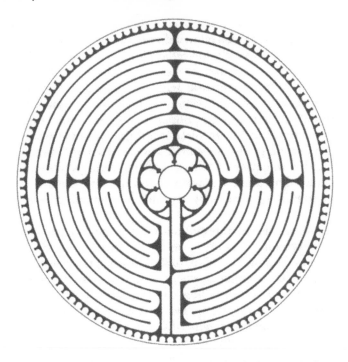

17. Diagram of the labyrinth in the nave of Chartres Cathedral (ca. 1194–1220). Drawing by Robert Ouellette after Gailhabaud.

portrays the wounded Christ at the Last Judgment. At the right time of the day and year—perhaps at Easter?—the light from the window might illuminate the maze, just as, at the harrowing, Christ as Light entered the gates of hell. Such might be some of the meanings of the pavement labyrinth at Chartres and elsewhere, and the rich significance of the *rota-rosa*-labyrinth as complicated interrelated emblems of perspective-dependent divine order would more than justify the violation of typical Gothic form.[60] In itself and in juxtaposition with the *rota-rosa*, then, the

60. Batschelet-Massini offers a somewhat different reading of the Chartres labyrinth (59–61). Having discovered that a number of manuscript mazes appear in connection with Easter or the Easter computus (an aid to finding the date of Easter in any year), noting that Easter is often seen as the first Sunday of creation, and citing the use of the maze in paschal dances, he concludes that the maze was most frequently a symbol of cosmic harmony and that this meaning would be especially marked at Chartres, given the iconography of the *porta regia*. His conclusions are complementary to mine, although I allow for a moral level of interpretation which he, working chiefly from manuscript illuminations, finds improbable. Medieval literary sources, combined with a slightly different analysis of the manuscript material, have persuaded me that the moral interpretation of mazes is always a

labyrinth is the incarnation of duality. A symbol of worldly error, it defines a sure path through error and suffering. A magnificent artistic whole, it describes and transcends the fragmentary complications, the partial views and subjective confusions, that are intrinsic to any sublimely comprehensive work of difficult human or divine art. Divinely teleological, it represents the moral and perceptual confusions to which humanity is born and points the way to fullest comprehension.[61]

In summary, then, the church labyrinths, which made the circular unicursal design familiar to many thousands of medieval people, had several complementary functions and meanings, any or all of which might be understood in any single example. They bestowed honor and fame on human architects of genius and founding bishops of vision by implicitly comparing them to Daedalus. They affirmed the superiority of Christian art to pagan craft. As a setting for paschal dances, they encouraged the reenactment of the central events in Christian time: Christ's harrowing of hell and resurrection. They taught the similarities and differences between God's cosmos and man's world, between God's vision and man's, and asserted forcefully if ambiguously that what may seem chaotic to man's limited perspective is really perfect though complex order, part of the divine plan of salvation. With Christ, the true Theseus, as guide, humankind can trace confusing *ambages* to discover that the mythically multicursal and unstable labyrinth—of life, of the world, of hell—is in fact unicursal, stable, and extricable, and that its baffling complexity is a necessary and beautiful part of the intelligible concentric-circular design superbly articulated by God, the perfect artifex, whose creative ingenuity is only faintly imitated by Daedalus and his descendents. As Gregory of Nazianzus asked, what is Daedalus's work compared with God's?

Labyrinths in Manuscripts

If thousands gained some familiarity with the form and meaning of the labyrinth through church and turf-mazes, comparatively few saw illuminations in manuscripts. Yet these manuscript mazes constitute an

possibility. For additional readings of the Chartres labyrinth, see Painton Cowen, *Rose Windows* (San Francisco: Chronicle Books, 1979), pp. 98–99, and Demaray, *Dante and the Book of the Cosmos*, pp. 22–24.

61. Leyerle notes that rose windows were sometimes called *oculi*, eyes (pp. 292–295). As the eye itself was seen as a series of concentric circles (see chap. 3 above and pl. 7), we may draw further analogies between rose window, eye, and labyrinth, which share a concentric circular design with the cosmos: in the traditionally dark labyrinth, the eye at first is almost blind, seeing a complex path rather than a divine pattern; but through Christ, the sacraments, and learning, one comes to see that pattern as what it is: a chart of human passage through the perfect creation of God, manifest in the rose *oculus*.

important visual witness to the medieval idea of the labyrinth: sometimes texts and labyrinths gloss each other, and it is fascinating to see just where medieval scribes thought the labyrinth an appropriate illumination. Since Batschelet-Massini and Kern have extensively catalogued and interpreted manuscript labyrinths, I treat the subject very selectively, focusing on how the manuscript tradition confirms and anticipates ideas encountered elsewhere in this book.[62]

First, some background. There are some seventy-four known illustrations of the labyrinth in about sixty medieval manuscripts. Even when the text clearly alludes to a multicursal maze, such as that at Crete by describing the building or the combat between Theseus and the Minotaur or Ariadne's thread, diagrammatic illuminations, which are in the vast majority, are unicursal. Obviously this time-honored version of the visual labyrinth satisfied medieval expectations so thoroughly that no modifications in the direction of multicursality were deemed necessary. This is not to say there were no changes at all in the pattern inherited from ancient times, however. Diagrammatic mazes took several forms, as we have seen in this chapter, varying in the number of circuits surrounding the center (occasionally six or seven but usually eleven, creating a pattern with seven, eight, or twelve circuits if the center is counted as one); the external shape of the maze (circular, octagonal—in cathedral mazes only—or square); and the number of axes dividing the maze into more or less separate sectors. Most manuscript and cathedral mazes conform to what Kern calls the Chartres type (e.g., plates 5, 17): they are circular with eleven corridors plus a central medallion and have four internal sectors created by the superimposition of a cross on the concentric circles.[63] This predominant circularity, in conjunction with the labyrinth's diagrammatic presentation, strengthens the association between the labyrinth and divine order noted in the church maze; that most manuscript mazes have either eight or twelve circles, including the

<hr/>

62. Kern's chap. 7 catalogues over sixty illustrations and summarizes a good deal of current scholarship, including two works I have been unable to obtain: Helmut Birkhan, "Laborintus—labor intus: Zum Symbolwert des Labyrinths im Mittelalter," in *Festschrift für Richard Pittioni zum 70. Geburtstag* (Vienna, 1976), pp. 423–454, and Wolfgang Haubrichs, "Error Inextricabilis: Form und Funktion der Labyrinthabbildung in mittelalterlichen Handschriften," in *Test und Bild: Aspekte des Zusammenwirkens zweier Kunste in Mittelalter un früher Neuzeit*, ed. C. Meier and U. Ruberg (Wiesbaden, 1980), pp. 63–174.

Several illuminations cited by neither Kern nor Batschelet-Massini are listed in the Appendix.

63. Kern's typology (see pp. 125–127), based on the number of circuits and axes, also includes the Cretan (circular, seven corridors plus a central medallion, one radial axis: see plates 1, 2) and the Otfrid (circular, eleven corridors and a central medallion, one radial axis: see plates 9, 20, 21). Batschelet-Massini, discounting the significance of the number of corridors, also describes three categories: A (circular, one radial axis); B (the square Roman maze with four quadrants, each joined to the next by a single passage); and C (circular, four quadrants, each penetrated by paths from other quadrants at more than one place).

central medallion, further supports a labyrinth-cosmos identification. And, as Kern suggests, the superimposed cross may lend an overtly Christian form to the Chartres type, though Christian meaning need not necessarily follow in any given example. If there are, then, some formal changes in the diagrammatic maze over the years (the Cretan and Otfrid types tend to be earlier than the Chartres type, which predominates in the Middle Ages), those changes loosely support the idea of the labyrinth as a work of Christian art and a potential model of the cosmos of a Daedalian God or the path of a Christ-Theseus.

Such other pressure as there may have been to alter the representation of the maze worked in the direction of a three-dimensional model as illustration of the Cretan legend. Two French manuscripts of the late fourteenth century emphasize the idea of the labyrinth as a prison for the Minotaur by depicting the maze as a barred cage. Two thirteenth-century manuscripts of the *Histoire ancienne* show a minotaur standing in front of a spherical building covered with windows and doors (plate 18 and Appendix, manuscripts 4 and 5), and two Florentine prints from the fifteenth century, perhaps better considered as Renaissance documents, illustrate Theseus's entry into a roofless chest-high stone building similar to the contemporary mazes Boccaccio described (plate 10). Most extraordinary of all is an illumination in another manuscript of the *Histoire ancienne*, BN fr. 20125 (plate 19), which represents an attempt, however clumsy in execution, to project the traditional circular unicursal diagram onto a three-dimensional sphere whose whole surface is apparently covered by a winding path that circles out of our line of vision. Though divided into four quadrants like most medieval mazes, this maze lacks a clear center at the midpoint of the design: instead, the innermost part of the path extends upward and simply stops. Some classical and medieval illustrations—see plates 3 and 9—add towers or gates or crenellations as if to hint at the labyrinth's three-dimensionality, but BN fr. 20125 is the only pre-fifteenth-century medieval manuscript to present a diagrammatic maze as if it were completely three-dimensional. The independence and creativity of these late medieval illustrations reflect a wish to link illumination and text more closely, although it would be some time before that wish would generate true multicursal designs.[64]

What most concerns us now is the context of labyrinth illuminations: where did medieval artists think the embellishment appropriate? What kinds of texts made them think about labyrinths? Naturally, many labyrinths are literal illustrations of the historical Cretan maze in texts concerning Aeneas, Theseus, or Troy, even though the illustration may not

64. See, respectively, Kern, plates 171–172; Appendix, MSS. 4 and 5, and my plate 18; Kern, plates 174–175, and my plate 10; Appendix, MS. 6, and plate 19. For mazes with towers, etc., see also the classical examples listed in chap. 2, p. 42, and the Jerichos mentioned in chap. 5, n. 7.

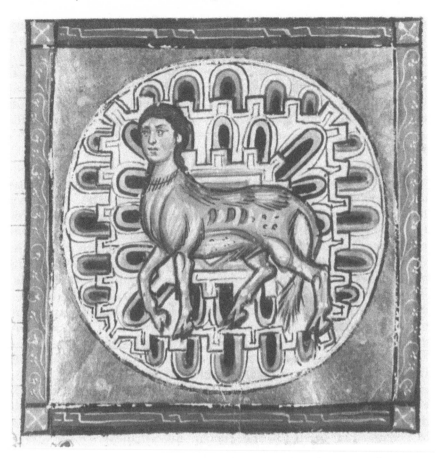

18. Architectural depiction of the Cretan labyrinth, the Minotaur at the center. From a manuscript of the *Histoire ancienne jusqu'à César*, from Acre, 1250–1275. Dijon, Bibliothèque municipale MS. 562 (323), fol. 115r. By permission.

appear at the most appropriate place in the text.[65] Several manuscripts of Raban Maur's *De universo* use a diagrammatic maze to clarify the discussion of the ancient labyrinths (plate 9).[66] In the Hereford Mappa Mundi (late thirteenth century) the labyrinth marks Crete, and in such

65. See Kern, plate 186 (Servius's commentary on the *Aeneid*); plate 165, from a collection of Trojan histories; plates 169–173 and my plates 18 and 19 (Appendix, MSS. 4–6), from the *Histoire ancienne*; and my plate 25, Dante's *Divine Comedy*. See also Jacques Monfrin, "Les *translations* vernaculaires de Virgile au Moyen Age," in *Lectures Médiévales de Virgile*, Collection de l'École française de Rome, 80 (Rome, 1985), pp. 189–249, and chap. 8, n. 4, below.

66. See also Kern, plates 158–160. Raban Maur's source, Isidore's *Etymologiae*, is also associated with labyrinth illuminations, though they do not occur where the text describes mazes: a tenth-century manuscript (Paris BN lat. 13013, fol. 1r) from the monastery of

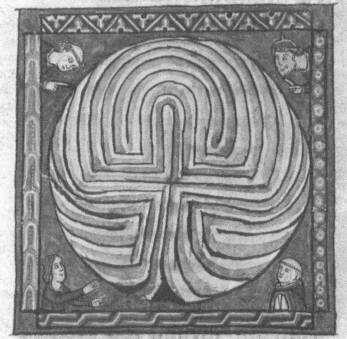

merum qui to; defuooient ceaus
qui la dedens eftoient.

en cele maifon fu al monftres
enclos. en celui oans eftoient al
oarthenes fougir au roi minos de
crete quil li deuoient chafcun an
enuoier. Soij. uailles. z Soij. mefchi
nes de treuage. z tels com li uns

19. Labyrinth from a manuscript of the *Histoire ancienne jusqu'à César*, French, thirteenth century, in which a diagrammatic design seems to be projected onto a sphere. Paris, Bibliothèque Nationale MS. fr. 20125, fol. 158r. By permission.

works as the *Liber floridus* it illuminates the mythical history of Minos and Pasiphae.[67]

Often manuscript mazes have more figurative connotations, either in themselves or in context. Sometimes the labyrinth implicitly connotes complex artistry. That artistry may be spatial, architectural: a twelfth-century manuscript (Munich Clm 14731) containing various historical and theological texts juxtaposes a map of the world, a ten-circuited maze containing the combat between Theseus and the Minotaur, and a seven-circuited labyrinth representing Jericho, explicitly likened to the moon (plates 20, 21).[68] The juxtaposition might suggest to the sophisticated reader analogies between labyrinth and world, great city, and cosmos, all of them elaborate creations consisting of disparate but ordered parts, even though the Thesean maze, taken on its own, represents chiefly itself. The maze-city equation, familiar in turf and stone labyrinths, often occurs in other manuscripts as well. Usually the city involved is Jericho, whose special relationship to the labyrinth we have already discussed, but Constantinople is also depicted as a maze.[69]

The complex artistry to which a visual maze alludes may also be verbal and intellectual, following the same logic that led Eberhard of Germany to name his rhetorical treatise *Laborintus*. Of the sixty manuscripts with mazes, sixteen include labyrinth drawings at critical junctures: the beginning or ending of a work.[70] Noting only the presence of *initial* labyrinths, Kern (p. 128) suggests they may reflect some "subliminal intuition of the labyrinth's initiatory function in classical antiquity." Instead, I propose two other possible meanings: first, the labyrinth might hint at the complexities of the preceding or following text in the spirit of Marius Mercator's recommendation of marginal mazes as a sign of difficulty; and, second, the labyrinth might function as it does in the cathedrals of Reims and Amiens, as a seal of approval for work craftily constructed.

Saint-Germain-des-Près opens with such a drawing, accompanied by the relevant text from Isidore (see Kern, plate 153), and an eleventh-century manuscript (Paris BN MS. nouv. acq. lat. 2169, fol. 17r—Kern, plate 155) includes a maze near a passage on the computation of the date of Easter; above it is a cross overlying concentric circles with a text arguing contempt of the world, of oneself, etc. This second example obviously has moral-theological connotations rather than literal historical or geographical ones.

67. See Kern, plates 179 and 161–163.

68. See also Batschelet-Massini, A9, and Kern, plates 178 and 202. Other manuscripts (e.g., Rome Vat. lat. 1960, fol. 264v—Kern, plate 170) also juxtapose maps of the world and labyrinths.

69. See Kern, plates 180 and 200–214, and pp. 166–171.

70. See Kern, plates 150, 152, 153, 157, 164–167, 177, 182, 184, 188, and 203, as well as MSS. 1, 2, and 3 in my Appendix (and plates 22, 23, and 25). I include in this category mazes at the beginning or ending of complete texts within manuscripts or of manuscripts themselves. Obviously some of these illuminations may be later additions, but they are all apparently medieval, and even—especially?—a late addition may serve as critical commentary.

Thus it is not surprising to find that labyrinths appear in five manuscripts of Boethius' *Consolation of Philosophy*. In one manuscript (St. Gall 825), a maze appears in Book 3, prose 12, where Boethius accuses Philosophy of weaving inextricable dialectical labyrinths. This maze may be simply the visual gloss of a verbal reference. But in four other manuscripts the labyrinth appears at the work's end, as if it were a fitting emblem of the labyrinthine artistry and intellectual complexity of the composition, woven as it is of intricate meters and interlocking, rigorously argued prose sections.[71] We return to the more thematic aspects of the *Consolation* illuminations shortly.

Other figurative manuscript labyrinths have moral or religious significance. Sometimes the maze appears *in malo*: given the frequency with which heresy and the labyrinth are linked, it is not surprising that a maze should decorate Paris BN MS. lat. 1745, a manuscript from Auxerre whose focal interest is heresy (plate 5). Similarly, the image occurs in a tenth- or eleventh-century miscellany, possibly from Auxerre, illustrating the Cretan myth with a labyrinth drawing and adding Caelius Sedulius's lines comparing pagan philosophy to a maze.[72] Other pejorative connotations of the maze occur as well. In a copy of Servius's commentary on the *Aeneid* there is, appropriately enough, a labyrinth, although it appears in Book 10 rather than Book 5 or 6; written along the windings of the path in a later medieval hand is a Latin distich likening the maze to hell and the Minotaur to the devil, a most un-Servian equation. The added text may be a product of the medieval literary tendency to denigrate the labyrinth per se. An alchemical treatise is only slightly less negative: it contains a labyrinth accompanied by a Greek poem naming Solomon as builder and suggesting an analogy between the complexities of life and the convolutions of the maze, in which Death is the Minotaur.[73] All these examples play on the maze's dangerous inextricability, although the illustrations feature the usual unicursal design.

Sometimes Christ seems to figure as guide to the maze, even if its exact significance is not easy to determine. For instance, a thirteenth- or fourteenth-century Icelandic manuscript shows one of the Magi kneeling at the entrance to a labyrinth; is this perhaps a reference to Christ-Theseus, or an acknowledgment that Christ has descended to the labyrinth of this world?[74] Similarly, Oxford Bodley Auct. F. 6.4 (Appendix,

71. For the Boethius manuscripts, see Kern, plates 183 (St. Gall 825, p. 176), 184 (Munich Clm 800, fol. 55v), and 185 (Cambridge Trinity Hall 12, fol. 50r); and my plates 22 (Oxford Bodley Auct. F. 6. 4, fols. 61av and 61bv) and 23 (Florence Bibl. Laur. Plut. 78.16, fol. 58r).

72. See Kern, plate 166, and, for Sedulius, chap. 3 above.

73. See Batschelet-Massini, A6, and Kern, plate 186; and Batschelet-Massini, pp. 34–40 and C10, and Kern, plate 197. Cf. also Jerome's implicit association of Solomon with labyrinths in chap. 3 above.

74. See Kern, plate 151.

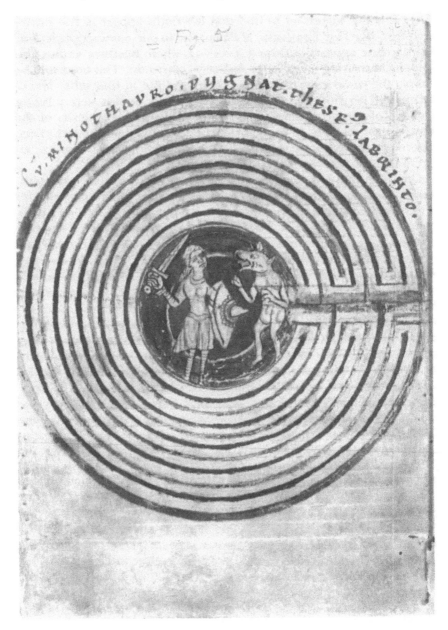

20. Illustration of the Cretan labyrinth. The inscription reads, "Cum Mino-thauro pugnat Theseus laborinto." *Libellum de septem miraculis mundi*, Saint Em-meram, Regensburg, Germany, late twelfth century. Munich, Bayerische Staatsbibliothek MS. Clm. 14731, fol. 82v. By permission.

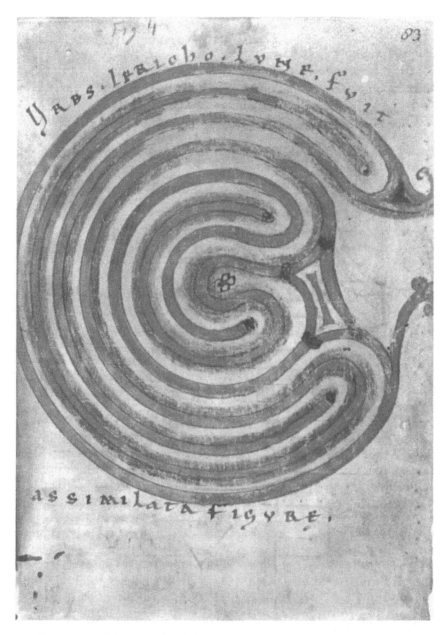

21. Illustration of the city of Jericho as a labyrinth, facing the illumination here reproduced as plate 20. The text reads, "Urbs Iericho lune fuit assimilata figure." Munich, Bayerische Staatsbibliothek MS. Clm. 14731, fol. 83r. By permission.

1b), containing the *Consolation of Philosophy* with Trevet's commentary, places a labyrinth next to a hymn to Christ, describing the miraculous cure of a blind man (cf. Mark 8:22-25). The juxtaposition may be coincidental, but those who added the maze and text may have wished that Christ might serve as guide to the dark maze of Boethian complexity rather like Theseus or Philosophy.[75]

The most fascinating labyrinth illuminations *in bono*, as Batschelet-Massini has pointed out, occur in manuscripts linking the labyrinth with Easter or with the cosmos. Drawings of the labyrinth may accompany the computus, a formula for determining the date of Easter according to the phases of the moon. A maze in a copy of Isidore's *Etymologiae* occurs in the context of Easter, and an autograph manuscript of Otfrid of Weissenburg's Gospel Harmony apparently links the labyrinth at the manuscript's beginning with an illustration of the Crucifixion.[76] These examples may assume an equivalence between Theseus, solver of the labyrinth, and Christ, harrower of hell. Cosmic rather than strictly theological labyrinths are found in several manuscripts: a ninth-century St. Gall codex containing a poem about the planets, stars, and seasons juxtaposes a diagram of the planets in their concentric circles with a seven-circuited maze; Bodley Auct. F. 6. 4 (plate 22) combines a maze (albeit one of thirteen circuits plus a medallion) with verses on the zodiac; and an eleventh-century manuscript containing Martianus Capella's *Marriage of Mercury and Philology* and Remigius of Auxerre's commentary divides books 1 and 2 of the *Marriage*, just before a discussion of the music of the spheres, with the image of a maze.[77] These three manuscripts may well assume a connection between God's architecture and that of Daedalus.

This Easter-cosmology group suggests two possible interpretations of the labyrinth, both of which we encountered in the discussion of church mazes: first, that the labyrinth is a sign for God's art, the magnificent if complex order of the cosmos (the planets are, after all, *errantes*—wandering as opposed to fixed stars—and their apparent retrograde movements complicate the tidy pattern of concentric circles); second, that Christ's actions at Eastertide—the descent into hell, the harrowing, the resurrection—are analogous to, and signified by, the deeds of Theseus in the maze. The illuminations in the *Consolation of Philosophy* may well support the idea that God's handiwork is a labyrinth of apparent confusion but actual clarity: Philosophy's labyrinthine circular argument on the nature of God turns out to lead to circles of divine simplicity, and Boethius moves from the prison-labyrinth of the world to the com-

75. See Appendix, 1b, for the text.
76. See Batschelet-Massini A7, C1, and C5, corresponding to Kern, plates 154, 153, 156; and see Kern, plates 153 (Isidore) and 150 (Otfrid).
77. See Batschelet-Massini A4 and Kern, plate 152; Appendix; and Kern, plate 157, and Batschelet-Massini, p. 60.

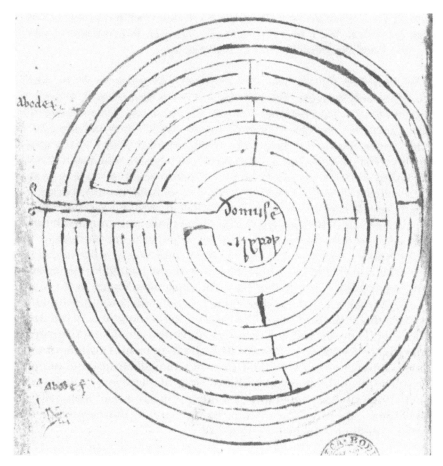

22. Labyrinth from a fourteenth-century manuscript of Boethius's *Consolation of Philosophy*. Oxford, Bodley Auct. F. 6. 4, fol. 61av. By permission.

prehensive perspective from eternity. For him, the confusion of the maze transforms itself into the order of God's perfectly constructed concentric universe once he has risen above the purely mundane perspective, as I discuss at length in Chapter 9. So too representations of cities as labyrinths strengthen our sense of the maze's dual nature as a sign of complex artistic order and of the bewilderment experienced by someone so immersed in that order he cannot see its abstract pattern.

Thus illuminations in medieval manuscripts confirm some familiar ideas; interesting in itself as a place of historical and mythical importance, as fact and as story, the labyrinth easily extends itself into metaphorical dimensions. As an artifact, it indicates human craftsmanship

and divine cosmic artistry; as a process, it describes moral and intellectual confusion, but it also occasions the Thesean intervention of Christ (or the Boethian ministrations of Philosophy).

We have seen that the *labor* in a labyrinth may represent error, confusion, sin, and struggle. But that same *labor* is also artistry, a meaning highlighted by that common synonym for the maze, *domus daedali*. The visual witnesses we have examined in this chapter may include *labor* in both senses, yet by and large they resolve the labyrinth's characteristic duality affirmatively. The architectural models with which this chapter began stress the pleasures of complex structure and hence are appropriately called *dédales*; the two-dimensional models intrinsically place great weight on the design that underlies confusion. Testimony to the fame of the architect and the surpassing skill of the guide, the church labyrinths apparently signify the triumph of order, whether in the aesthetic or the moral sphere, at the same time as they suggest the relativity of the perception of that order, which depends on the beholder's perspective. The manuscript mazes often have the same significance *in bono*, and hence they too are orderly, describing a fixed path, concentrically circular and unicursal in design. That artistic representations of the maze often signify the marvels of sophisticated pattern should not surprise us: after all, art makes order out of chaos all the time, and anyone who has drawn a maze knows the rich pleasure of taming difficulty and defining structure through complexity. In art, then, the labyrinth, whatever its moral implications, is intrinsically a thing of pleasure, an image of perfect human and divine creation; its dangers are far more evident in the literary tradition, to which we now turn.

Moral Labyrinths in
Medieval Literature

Quod evenit in labyrintho properantibus; ipsa illos velocitas inplicat.

This is what happens when you hurry through a maze: the faster you
go, the worse you are entangled.

Seneca, *Epistulae morales* 44

I F THE medieval visual arts typically stress the artistic *labor* in-
volved in the *domus daedali* as an artifact *in bono*, many literary
texts, influenced by the context of the Cretan myth, take the
labor intus completely or partially *in malo*. The labyrinth becomes preemi-
nently a temptation to moral *error*, an emblem of the world as an almost
inextricable occasion of sin. Medieval meanings of *error*, reflected in
vernacular cognates, suggest many pejorative possibilities, all of which
we will encounter: instability and incertitude; sin; madness; false opin-
ion or culpable ignorance; heresy; a straying from the right path.[1]
Whether its architect is God or sinful man, whether it is really or only
superficially attractive, whether its metaphorical transformations are
based on the essential qualities of the labyrinth itself or on the mythical
plot that surrounds it, the moral maze is intensely perilous, to be trod-
den carefully, avoided entirely, or escaped as quickly as possible. As with
the visual mazes of Chapter 5, we are dealing here with rather a mixed
bag of examples: not all moral mazes are completely evil any more than
all visual mazes embody only admirable labyrinthine artistry. When the
labyrinths that are moral arenas are created by God, they may be para-
gons of art like so many mazes discussed in Chapter 5, but when they are

1. See *Thesaurus linguae latinae* (Leipzig: Teubner, 1900–); R. E. Latham, *Revised
Medieval Latin Word List from British and Irish Sources* (London: Oxford University Press for
the British Academy, 1965); *MED*; Frédéric Godefroy, *Lexique de l'ancien français*, ed. J.
Bonnard and A. Salmon (Paris: Librairie Honoré Champion, 1976).

built by men or women, their artistry is more deceptive. In either case, danger is more prominent than artistry, even when that danger is disguised by beauty (and therefore the more treacherous). Like the intellectual labyrinths of Chapter 7, moral mazes may teach valuable lessons, but their chief purpose is not instruction. The labyrinthine quality most emphasized here, as in early Christian mazes *in malo*, is inextricability: moral mazes are fatal prisons unless special guidance or exceptional virtue circumvent their entanglements, and if learning is involved, it is moral rather than intellectual. These labyrinths accent moral choice, either at the point of entry or within. Although medieval writers seldom envisage moral mazes as specifically multicursal or unicursal, some completely bad mazes (mazes of heresy, for instance) are inherently unicursal, entailing only the choices to enter and then to persist or retreat, whereas more polyvalent mazes (e.g., mazes representing the world created by God) involve repeated internal choice.[2] The duality characteristic of all mazes is present here as well. The most perilous prisons may seem most enchanting. If moral confusions lead to desperate ends, divine order is thereby asserted. If God builds a complex and multicursal world, men define their own course through it. If sinners become embroiled in means, paths, and processes, authors and readers have a privileged vision of ends, of the whole maze as complex pattern and product. These dualities, dependent on point of view, will become especially marked in some of the texts examined in the last part of this chapter.

I have divided this chapter into three sections. The first describes some particularly interesting mythographic texts—moralistic interpretations of the story of the Cretan labyrinth read in the context of other classical myths. Accounts like these would have been familiar to most medieval writers, and it is against this quasi-commentarial background that some of the more creative developments of the idea of the labyrinth can best be read. The second section offers a representative survey of nonmythographic texts that illustrate, with greater or lesser degrees of skill, common literary associations and uses of the maze. At worst, these examples illustrate labyrinthine clichés and give us a sense of what middle-brow audiences might have understood in the way of labyrinth references; at best, they show major writers treating the idea of the labyrinth with considerable originality, but usually fairly briefly or intermittently. The final and longest section offers readings of four texts that develop the idea of the labyrinth creatively and in a sustained fashion. Here the idea of the labyrinth begins to serve as a guide to our understanding of a work of art as a whole.

The mazes encountered in these three sections are metaphorical.

2. In *La Queste del Saint Graal*, we shall see a rare occurrence of a hierarchy of mazes: pathless, multicursal, and unicursal.

Therefore it is important to recall that some medieval literary references to the labyrinth do not involve metaphor; especially in the later Middle Ages, there was a healthy concern with the literal status and interpretation of texts.[3] Especially in commentaries on and retellings of the Cretan myth, the labyrinth is often simply itself, an historical building. Thus medieval commentators frequently gloss "labyrinthus" in *Aeneid* 5.588 in Servius's terse words: "Labyrinth: a place in Crete with intricately entangled walls built by Daedalus, in which the Minotaur was enclosed." If some literally minded commentators such as Anselm of Laon fleetingly raise the possibility of metaphor by adding that *laborintus* is derived from the ambiguous *labor intus*, they spell out no metaphorical elaborations.[4] A similarly literal reduction of the labyrinth to a mere physical prop occurs in Chaucer's *Legend of Ariadne*, which shares Ovid's emphasis on the heroine's misery after her abandonment.[5] Chaucer gives a full description of the "hous . . . krynkeled to and fro" (l. 2012) but only to show how important Ariadne's help was to the ungrateful Theseus: the maze is mere scenery, even though it might easily have symbolized the intricacies and dangers of passionate love, and even though Chaucer elsewhere uses the metaphorical potential of the maze with inventiveness and subtlety. Some commentaries derived from Servius, who believed that the Minotaur was really a pair of twins fathered by Minos and his scribe Taurus, demythologize the story, getting rid of the mysterious labyrinth altogether: glossing Juvenal's first satire, William of Conches (ca. 1080–ca. 1154) tells of Pasiphae's love for the bull, Daedalus's assistance, and the building of the labyrinth; but "this is the truth of it": all Daedalus really built was a *thalamus* (bedroom or marriage-bed) for the queen and her paramour Taurus, by whom she had a child reputed to be Minos's and hence called Minotaurus. When Minos found out, Daedalus was simply thrown in prison.[6] So much for art! The debunking Servian tradition might have reduced the labyrinth to insignificance, but fortunately such was not the case, and many commentators who report Servius's interpretation, if not William's still more rationalistic reading, go on to find moral import in the myth: the story isn't true, but we can still learn from it.

After all, many medieval writers shared a passion for exegesis, trying

3. See A. J. Minnis, *Medieval Theory of Authorship*, esp. chaps. 3 and 4.

4. Servius Grammaticus, *In Aeneidos*, I, 635; Anselm of Laon's gloss reads, "*laborintus*: the house of Daedalus where the Minotaur was imprisoned, called *laborintus* from *labor intus*" (BL MS. Add. 33220, fol. 48r). Christopher C. Baswell's dissertation, "'Figures of Olde Werk': Visions of Virgil in Later Medieval England" (Yale University, 1983), is an invaluable study of explicit and implicit Virgil commentaries.

5. Chaucer, *The Legend of Good Women*, 1886–2227. Gower's version of the story (*Confessio Amantis* 5.5231–5495) is similar in emphasis and treatment. Both works follow Ovid's *Heroides* 10 closely.

6. William of Conches, *Glosae in Iuvenalem*, pp. 110–111.

to find some scientific, philosophical, theological, or exemplary truth hidden beneath every item in the lexicon of the books of nature and authority, although exegetical attitudes and practices varied widely from century to century and even from author to author. In general, as Judson Boyce Allen notes, "medieval people . . . tended to be more interested in the mythologization than in the fact, more interested in the meaning of an event than in its bare material existence."[7] More interested in mythical than in historical labyrinths, in fact. Thus most medieval mazes, visual or literary, carry heavy symbolic potential, functioning as a clue to a splendid array of meanings.[8] Fascinating to medieval artists and writers as an historical object, the maze is still more captivating as a sign—in texts discussed in this chapter, a sign of the dangers of earthly life. In these examples, the maze functions metaphorically both as product and as process. Sometimes the labyrinth is a sign in itself, a metaphorically potent object, as we saw so often in Chapter 5; more often, it is the myth of the labyrinth, the story, that elicits the continuous metaphorical transformation of allegory.

· The Mythographers ·

By far the richest store of explicit interpretations of the maze lies in the vast body of mythographic writing, including the many commentaries on classical and certain medieval texts (Dante's *Divine Comedy*, for one) that mention the labyrinth. These commentaries tend to fall into the two categories described by Brian Stock in discussing approaches to myth in the twelfth century: literal commentaries cover such matters as grammatical sense, etymology, historical background, and rhetorical devices; allegorical interpretations emphasize moral and philosophical significance, demythologize the text (as in euhemeristic readings), and unwrap cosmological or natural truths from their mythical *integumentum* by

7. Judson Boyce Allen, *The Ethical Poetic*, p. 253. Allen's and Minnis's complementary treatments of medieval literary critical practice are invaluable to an understanding of how medieval people read literary or biblical texts.

8. For an example of the medieval symbolic mentality, see Alan of Lille, *Liber in distinctionibus*, PL, 120, 687–1012. Although any physical object *might* be interpreted allegorically in an astonishing number of ways, however, it need not be so interpreted. Just as the *distinctiones* show there were no set meanings for any item, so too no set formula, mechanically applied, would decode texts correctly: see Brian Stock, *Myth and Science in the Twelfth Century: A Study of Bernard Silvester* (Princeton: Princeton University Press, 1972), chap. 1; Edouard Jeauneau, "L'Usage de la notion d'*Integumentum* à travers les gloses de Guillaume de Conches," *Archives d'Histoire Doctrinale et Littéraire du Moyen Age*, 24 (1957), 35–100; and V. A. Kolve, *Chaucer and the Imagery of Narrative* (Stanford: Stanford University Press, 1984), for a brilliant demonstration of how medieval people may have read visual images.

means of "scientific" interpretation.[9] Later we will consider how allegory itself constitutes a kind of labyrinth and embodies a labyrinthine aesthetic, but here I show briefly how a few fourteenth-century mythographers deal with the Cretan story as moral allegory. I do not pretend to offer a comprehensive survey of interpretations. Nor will I discuss the development of the mythographic tradition, its preoccupations, techniques, and practitioners.[10] Instead, I have chosen a few influential texts to illustrate what kinds of significance the labyrinth might have within the larger context of the myth that engendered it—in other words, how the plot within which the labyrinth figures suggests and defines its metaphorical meaning. It is worth remembering that many medieval writers using the labyrinth metaphorically in their own works would have first come upon its story in a classical or mythological text (the *Aeneid*, the *Metamorphoses*, the *Eclogue of Theodulus*) with an accompanying commentary either in the manuscript itself or in the person of a teacher. As the visual form of the labyrinth helps shape its transferred meanings, so does mythological commentary.

Boccaccio (1313–1375) was an exceptionally learned secular mythographer whose monumental *Genealogy of the Gentile Gods*, Book 14, mounts an impressive defense of poetry and the allegorical approach he

9. See Stock, *Myth and Science*, pp. 32–33. Baswell ("'Figures of Olde Werk'") divides medieval Virgil commentaries into three groups, subdividing Stock's second category: "humanizing" commentaries, the most numerous group, provide background information that helps a reader perceive Virgil in his own historical setting; allegorical commentaries see the *Aeneid* as an exposition of the ages of man or the stages of virtue; and moral commentaries see Aeneas as an exemplary model for human life and the classics as, among other things, a source of exempla for preaching; one thinks of the classicizing friars so sensitively analyzed by Beryl Smalley (*English Friars and Antiquity in the Early Fourteenth Century* [Oxford: Basil Blackwell, 1960]) and Judson Boyce Allen (*The Friar as Critic* [Nashville: Vanderbilt University Press, 1971]). Especially in the later Middle Ages, all three approaches may coincide, as in the third commentary in London BL MS. Add. 27304 (Baswell, chap. 3).

10. Among the more interesting mythographers whose work I will *not* discuss here are the following: Hyginus (second century), *Myths*, ed. Mary Grant (Lawrence: University of Kansas Press, 1960); Fulgentius (fifth century), *Opera*, ed. R. Helms (Leipzig: Teubner, 1898); the Vatican Mythographers, *Scriptores rerum mythicarum latini tres*, ed. Georg Henry Bode (Celle, Belgium, 1834); the ninth-century *Ecloga Theoduli* (see Bernard of Utrecht, *Commentum in Theodolum* [1076–1099]), ed. R. B. C. Huygens [Spoleto: Centro Italiano di Studi sull'Alto Medioevo, 1977]); Odo Picardus's commentary, *Liber Theoduli cum commento* (London: Richard Pynson, 1505); Arnulf of Orléans (twelfth century), in Fausto Ghisalberti, "Arnolfo d'Orléans: un cultore di Ovidio nel secolo XII," *Memorie del Reale Istituto Lombardo di Scienze e Lettere*, 24 (1932), 157–234; John of Garland (thirteenth century), *Integumenta Ovidii: poemetto inedito del secolo XIII*, ed. Fausto Ghisalberti (Messina and Milan: Giuseppe Principato, 1933); John Ridewall (fourteenth century), *Fulgentius metaforalis*, ed. Hans Liebeschütz, Studien der Bibliothek Warburg, 4 (1926); Giovanni del Virgilio (fourteenth century), in Fausto Ghisalberti, "Giovanni del Virgilio: espositore della 'Metamorfosi,'" *Giornale Dantesco*, 34 (1933), 1–110; Thomas Walsingham, *De arcana deorum*, ed. Robert A. van Kluyve (Durham: Duke University Press, 1968); and Palaephaetus, *De non credendis historiis*.

deemed necessary to penetrate its praiseworthy obscurities.[11] Drawing on some hundred and seventy-five sources, Boccaccio varies his approach to each myth as he sees fit; usually he provides humanistic historical and literary background, and his interpretations may be euhemeristic, moral, theological, and even naturalistic/scientific. The large exegetical repertoire at his disposal makes it significant that Boccaccio chooses to emphasize the Cretan legend's moral and psychological import. Having pondered the story and its interpretations for some time, Boccaccio tells us, he finally realized its true purpose: to teach us how bestial vice is begotten in the soul, signified by Pasiphae. Minos the lawgiver is reason, who sets the soul on the right path, but Venus, or concupiscence, causes their separation: no soul can be a friend both to reason and to carnal desire. Pasiphae's passion for the bull shows how the soul wrongly loves mundane pleasures, which God meant us to use properly. Guided by Venus-sensuality, however, we abuse these gifts, fall prey to bestial lust, and couple with the bull, trusting more in ingenious craft (Daedalus) than in nature. Thus minotaurs are begotten as tokens of vice; the monster's dual form signifies that while sinners seem human, their acts reveal their true animal nature. Like the Minotaur imprisoned in a winding labyrinth, the wicked human heart is entangled in unspeakable desires. Only Theseus can kill this monster of depravity: he is the prudent man whose virility (Ariadne, on etymological grounds) teaches him to root out diabolical vice.[12]

Clearly Boccaccio was sensitive to Virgil's and Ovid's hints that the labyrinth was built to cover the shame of lust and to the early Christian notion that the true path contrasts with the labyrinth's winding ways (cf. Ambrose and Prudentius); these ideas underlie his own reading of the myth. But Boccaccio's rather humanistic interpretation makes the labyrinth an emblem of the circuitous ways of sin in opposition to the "rectum iter" dictated not by God but by Reason (Minos). Implicitly a work of corrupt art as opposed to healthy nature, the heart's maze is inextricable for sinners but penetrable to the prudent, manly man. Later we shall see how Boccaccio develops this moral-psychological interpretation of the myth, blaming sinners for entrapping themselves in mazes of their own creation, as the thematic and narrative basis for the *Corbaccio*.

Writing at roughly the same time, Pierre Bersuire (ca. 1290–1362) was

11. For the complete text, see *De genealogia deorum gentilium*, ed. Vincenzo Romano (Bari: Laterza, 1951); for a translation of the preface and books 14 and 15, see Charles G. Osgood, *Boccaccio on Poetry* (Indianapolis: Bobbs-Merrill, 1956). The work was begun before 1350, and revisions continued throughout Boccaccio's life: see Vittore Branca, *Boccaccio: The Man and His Works*, trans. Richard Monges and Dennis J. McAuliffe (New York: New York University Press, 1976), p. 109. We return to Boccaccio's defense of poetry in chap. 7.

12. Boccaccio, *De genealogia* 4.10.

a somewhat controversial Benedictine prior and friend of Petrarch, with whom he discussed matters mythological. Bersuire's immensely popular *Ovidius moralizatus*, which went through several recensions, views classical mythology as a compendium of useful exemplary and allegorical knowledge, a guide to daily conduct in the courts of kings or popes and in moral and spiritual realms as well.[13] His comprehensive explication of the Cretan myth is at once more practically and more theologically oriented than Boccaccio's; almost a *summa* of allegorical commentary, Bersuire's exegesis deserves extensive paraphrase. First he recounts the tale of Pasiphae and the bull, the Minotaur, and the labyrinth, twisted with *ambages*, created to entrap all comers as fodder for the rapacious beast within. In typically clerical fashion, Bersuire uses Pasiphae as an excuse to rail against female lasciviousness; he then proceeds from sociological editorial to moral reading. Pasiphae is the human soul married to Christ, who is estranged by her sinfulness; she couples with the devil and conceives monstrous affections. Alternatively, in the sphere of ecclesiastical government, Pasiphae is the Church, Minos an absent prelate, and the bull the devil, who leads the Church into sin and error; the Minotaur represents evil, which devours human flesh.

Next, Bersuire describes Theseus's arrival, Ariadne's love, and Daedalus's advice to take balls of pitch and of string into the maze to prevent the monster from biting when attacked and to help Theseus unwind (*explicare*) the labyrinthine *ambages*. The Minotaur signifies the devil, hell, and death, which have devoured human souls and bodies since time began: thanks to Adam, we are all Athenians subject to Minos-Lucifer. The maze of *ambages* is the abyss of hardships (*difficultatum*) so constructed that no one can return to its gates. But Theseus, a king's son, is Christ, who also accepted the lot of common humanity and therefore descended to the Minotaur; with the thread of divinity and the pitch of humanity, he overcame death, hell, and the devil, freeing himself from the maze of hell in the resurrection and taking with him Ariadne, or human nature. More practically, Theseus is any ungrateful person who casts off his benefactor (or abandons Ariadne); but she, deified by Bacchus (God), earns a heavenly reward.

After suggesting various interpretations of Theseus's return to Athens and his father's misguided suicide, Bersuire returns to Crete and the

13. On the complicated textual tradition, see Pierre Bersuire, *De formis figurisque deorum*, ed. J. Engels, Werkmateriaal 3 (Utrecht: Instituut voor Laat Latijn der Rijksuniversiteit, 1966), pp. iii–xx, which suggests that Bersuire was an incessant reviser and that the text went through at least four fairly comprehensive recensions. In his edition of chaps. 2–15 of the *Reductorium morale*, the *Ovidius moralizatus* (Werkmateriaal 2, 1962), Engels prints the latest (post-1350) recension, which includes materials from the poetic *Ovide moralisé* and from John Ridewall's *Fulgentius metaforalis*. I follow this version here (pp. 123–130). Another recension is printed by Fausto Ghisalberti, *Studj Romanzi*, 23, 5–136. See also Smalley, *English Friars and Antiquity*, pp. 261–264.

industrious Daedalus, whose construction of the labyrinth is described in some detail. Ironically, Daedalus himself is imprisoned in his own work of art for having helped Pasiphae and Ariadne. With characteristic ingenuity, he concocts wings to flee the labyrinth and Minos's tyranny. Here Daedalus is the sinner whom the devil-Minos imprisons in the labyrinth of vice and worldly goods, encircled by so many crimes that he cannot find the way out. There is only one way to escape the labyrinth of world and sin: don wings of contemplation and head for celestial realms, scorning the sea of worldliness and the labyrinth of time (*saeculi*). Moreover, Bersuire notes, Daedalus's imprisonment shows that people who build labyrinths and *involutiones* for others will fall into them themselves.

Bersuire then discusses the fall of Icarus and the poetic justice of that fall (Daedalus had murdered his nephew Perdix by pushing him off a cliff). The story of Icarus teaches us to pursue the *via media*, depicts the disobedience of rebellious youth, and warns against earthly delights (the sea) and pride (the sun), which ruin spiritual wings (virtues) as well as mundane ones (earthly power and nobility). Perdix, clever inventor of the saw and compass, was saved by Athena, who honors intelligence; he now flies close to earth as a partridge (*perdix*), fearing another fall. Thus he rightly mocked Daedalus after Icarus's death, when Daedalus dedicated his wings at the temple of Apollo at Cumae. This part of the story teaches that those who climb high through ingenuity will fall through envy; the wise man seeks humble station and welcomes the security of poverty.

Like all his other mythological interpretations, Bersuire's readings of the various segments of the Cretan myth thus include practical, if cynical, advice for daily life as well as theological commentary; he treats mores, morals, and allegory in the strict sense. Compared to Boccaccio's less ambitious and more coherent interpretation, however, Bersuire's is full of inconsistency: Minos can be Christ or the devil, Theseus an ungrateful wretch or Christ, and Daedalus an envious craftsman or a true contemplative. It is as if the *ambages* of the labyrinth had become ambiguities in the text, or as if Bersuire had taken every interpretive path presented in Ovid's multicursal textual maze. To use modern terminology, the myth of the labyrinth affords a network of gaps or indeterminacies to be filled in by preacher or reader at will in an attempt to generate a morally useful interpretation. Boccaccio interprets the myth as a whole (to be fair, he tackles less of the myth than Bersuire); Bersuire focuses on a series of quasi-independent episodes, each interpreted according to its immediate narrative context. But if Boccaccio's single reading is selective and consistent, Bersuire charts a richer, more evocative course, suggesting how, in its Ovidian context, the labyrinth as a sign can appropriately convey multiple meanings *in malo*: shameful love, sin and vice, hell, death, the world and worldliness, time, and—to be utterly

pedestrian—any elaborate plot. These meanings take shape partly from Bersuire's ingenuity, partly from the mythical context, and partly from essential labyrinthine qualities: *ambages* and involutions; the psychological and moral confusion they engender; and, most clearly, inextricability, although Bersuire makes much of the possible ways out—the help of a guide (Christ), careful instruction (by Daedalus, who helps both Theseus and Icarus), the wings of contemplation. Bersuire even hints at the connection between labyrinths and learning we saw in early Christian writings when he describes the labyrinth as difficulty requiring explication. Few single texts show the scope of the moral labyrinth's metaphorical potential *in malo* so well as Bersuire's, although none of his interpretations is unique.

Perhaps because Bersuire took the labyrinth so thoroughly *in malo* in his last recension of the *Ovidius moralizatus*, he hints only obliquely at the maze's admirable artistry, a concept that was present, if downplayed, in the *Metamorphoses*. That artistry is highlighted in one of Bersuire's sources, the anonymous French *Ovide moralisé*, which suggests other facets of the labyrinth's metaphorical potential (8.1-1928). This early fourteenth-century poetic version of the *Metamorphoses*, presumably intended for aristocratic lay audiences, spends much more time recounting and embellishing the Ovidian stories than did Bersuire or Boccaccio, who wrote in Latin for the learned. Thus the *Ovide moralisé* offers a long description of Pasiphae, extended laments for Ariadne, and so on, more for dramatic impact than for moral instruction. But there are also didactic summaries of the lessons to be learned from antiquity, which, if they are less colorful than the poet's brilliant evocation of Pasiphae's deranged love for the bull, nevertheless concern us more. According to the moralization, God was so distressed at the presumption of the rebel angels that he created for them

> l'infernal cage
> Qui tant et horrible et obscure
> Et pleine de male aventure. (8.1418-1420)

This cage is the labyrinth of hell from which none can depart, and so Daedalus is a figure for God, "li bons charpentiers / Qui est maistres de touz mestiers" (8.1431-1432). After the fall, man too was dispatched there as tribute to another horned beast, the devil. To ransom mankind, God fought fire with fire: against the double devil-minotaur he sent Christ-Theseus of "double-nature" (8.1476). The divinity and humanity that Bersuire represents by the two *pelotons* here reside in Christ-Theseus himself, whose divinity is "couverte / Souz l'ombre de l'umanité" (8.1480-1481). Thus Christ-Theseus is able to destroy the monster and lead his people to safety. This Theseus, however, is no ingrate: he

abandons Ariadne because she signifies the Jews whom God loved until they betrayed him, and Phaedra represents the faithful Gentiles.

This author's consistency in interpretation, contrasting with Bersuire's eclectic approach, leads us to expect a novel handling of the flight of Daedalus, and here too we are not disappointed. We are reminded that Daedalus signifies the Creator of heaven and hell, of sky, earth, air, and sea; Daedalus's imprisonment in Crete signifies Christ's stay in hell, after which he longed to see his homeland. God-Christ-Daedalus chose to return in such a way that mankind could follow, escaping the trammels of the labyrinth-world-hell. Thus God-Christ-Daedalus made wings, the right one indicating the love of God and the left, love of one's neighbors; thus we too can fly to heaven.

The poet's interpretation of the myth is consistent chiefly because he interprets the story in the light of the ransom theory of the atonement, whereby the fall of man gave the devil just title to human souls until such time as the devil should overstep his bounds by letting the sinless Christ die and enter hell under the cover of his human flesh (hence the significance of Bersuire's pelotons and our poet's "double nature"). But consistency has its downside: there are fewer interpretations than in Bersuire, who probably expected the preachers for whom he was writing to create their own coherence by using only part of the story at a time; and the poet gets into minor difficulties by equating both God the Father and Christ with Daedalus and having both Theseus and Daedalus signify Christ. He does, however, provide a marvelous vision of God the Good Carpenter, whose cosmos is implicitly a labyrinth containing the smaller prison-labyrinth of hell—a remarkable instance of the inherent dualism *in bono* and *in malo* of the maze. That a Daedalian God created a cosmic labyrinth, an idea we have already met in Gregory of Nazianzus and in the discussion of the Chartres maze, is highlighted in the fifteenth-century *Ovide moralisé en prose* (pp. 226-229). Or, as Bersuire put it in an early recension, "Daedalus the architect is God, who built the *mundi machinam*."[14] As these examples show, even in the generally pejorative Ovidian context the maze may figure as product of divine artistry, but it is a dangerous piece of art all the same, a place where *error* is possible, indeed virtually inevitable.

In this brief account of several fourteenth-century mythographic moralizations of the Cretan story, then, we have seen how the legendary context and the author's purpose combine to shape the labyrinth's metaphorical meanings. Writers interested in the plot as a coherent and morally significant entity, like Boccaccio and the author of the poetic *Ovide moralisé*, create consistent interpretations by limiting the labyrinth's connotations to one or two major meanings—the toils of sin and lust in Boccaccio's comparatively humanistic interpretation or, for the more

14. In Ghisalberti, "L'Ovidius Moralizatus," pp. 129–130.

theologically minded poet, the divinely ordered but dangerous cosmos containing an inextricable prison for those who fall prey to sin. On the other hand, Bersuire, providing a full array of the legend's moral uses, sacrifices allegorical consistency in order to expand the symbolic potential of each important element in the story. Interest in the maze as story, as process, as syntax, generates one kind of retelling, and interest in the maze as object, as an item in a metaphorical lexicon, generates quite another. Both approaches contribute to the labyrinth's metaphorical potential, which includes meanings based on mazy inextricability (lust, sin, hell, death, crime, vice, worldliness, the world, life, time), on complex artistry (the world, the cosmos), and on the moral and psychological confusion created by the maze's *ambages* and *errores*. In most cases, the maze functions as a place where moral error is almost inevitable, an inextricable prison unless special aid intervenes. As in Virgil (*Aeneid* 6) and Ovid, the mythical context—the focus on story—virtually demands an interpretation *in malo*. Even if the labyrinth-world is God's creation, full of the highest artistry, noble and attractive in its own right, it poses infinite dangers for the unwary, who may easily make the wrong choice and fall into that inner labyrinth of hell without the guidance of Christ-Theseus, the reason of Minos, or Daedalian wings of contemplation.

· Moral Labyrinths in Other Literature ·

If the Cretan labyrinth's explicit mythological context elicits a good deal of mythographic interpretation *in malo* by highlighting the maze's seamy moral history and its dangerous inextricability, that same emphasis predominates in nonmythographic medieval works, whether they allude to the myth or simply to the maze as an image. This section briefly surveys representative passages where the labyrinth appears more or less casually as an image of potentially inextricable mundane *errores*; later we will examine several texts that make more extended, and often more innovative and allusive, use of the labyrinth and the Cretan myth as process and plot.

We have seen how often the maze signifies the vagaries of earthly life for medieval mythographers as well as classical and early Christian writers. This meaning of the maze is popular in other medieval literature as well. For example, Lydgate's "Calendar" includes a prayer for aid in labyrinthine confusion: "Teche us to lyue wel, o bysshop Seynt Blase, / For þis wrecchid lyfe is but as a mase." An inscription, probably from a tombstone, sees the world as a maze from which death offers rescue: "The beginning of April seized me from this labyrinth."[15] Both exam-

15. See *The Minor Poems of John Lydgate, Part I*, ed. Henry MacCracken, EETS, e.s. 107 (1911), p. 364, ll. 34–35, and Durand, *Annales Archéologiques*, 17, 126–127.

ples envisage escape from the world-labyrinth, Lydgate's by intercession and right conduct, the tombstone by death and, perhaps, the salvation of Christ-Theseus. In a lighter vein, the rhetorician Eberhard of Germany sees the teacher's life as an inextricable maze: "He sits in the snare of the labyrinth, the clamorous prison and mournful house," plagued by recalcitrant students who, perhaps, see their *magister* as a minotaur.[16]

The view of the world as an attractive but dangerous moral labyrinth is handled far more subtly and pervasively in Langland's *Piers Plowman*.[17] Because I intend to discuss the poem's labyrinthine nature more extensively elsewhere, here I merely skim the surface. An allegorical lady, Holy Church, advises Will, the dreamer, how to proceed safely through the mundane labyrinth. Baffled by his dream of the fair field of folk who are "wandrynge as þe world askeþ" (B. Prol. 19), most of them up to no good in their pursuit of wealth, Will is in sore need of the exegesis that Holy Church can provide. She begins by asking, "sestow þis peple, / How bisie þei ben aboute þe maȝe? (B. I.5-6). The maze is worldly life, dedicated to the pursuit of Lady Meed, and the labyrinth image is appropriate: the people on the field, immersed in the complexities of life, cannot see where they are really going, as one cannot see the end of a maze from within. It is only Will, looking down on the scene from the Malvern Hills, who notices on one hand the Tower of Truth and on the other the Dungeon of the Devil, and who sees that most people are moving toward hell. From this elevated perspective, Holy Church offers a clue to the labyrinth, but Will all too quickly forgets what he has learned once he is embroiled in the maze on the plain, subject to its bewildering profusion of temptations.

In a sense, the whole poem deals with the problems of a mazed character so confused by the moral *ambages* and apparently contradictory guides repeatedly confronting him that he cannot sustain the privileged vision from above the labyrinth that would allow him to orient himself: such are the intense difficulties of living in the world, difficulties Langland refuses to dismiss lightly. The quest in Passus 8 through 12 for Dowel, Dobet, and Dobest (the triad itself representing a maze-like trifurcation of a concept initially presented simply as Do Well) is particularly maze-like and bewildering, as Will journeys through the labyrinth of the mind to be directed by an overabundance of seemingly authoritative characters, each speaking according to his or her own perspective and

16. Eberhard of Germany, *Laborintus* 835–836, in Faral, p. 366. The idea of schoolteacher as minotaur corresponds to the possible dean-minotaur comparison in the Auxerre ritual, discussed in chap. 5.

17. Citations are to *Piers Plowman: The B Version*, ed. George Kane and E. Talbot Donaldson (London: Athlone Press, 1975). The maze appears in all three texts, which date from ca. 1367–1386: see the parallel text edition by Walter W. Skeat (London: Oxford University Press, 1886). For the idea of the labyrinth of the world in medieval Persian poetry, see Henry Corbin, *En islam iranien*, vol. 2 (Paris: Gallimard, 1971), pp. 326–331.

most offering too many (and too inconsistent) definitions of the exemplars Will seeks; as we shall see, excessive data that cannot easily be aligned create a mental maze of the worst sort. In many respects, it is this mental maze of the fallen mind that generates the perceptual handicaps and limited, fragmentary vision that make the world itself seem labyrinthine and so forcefully create the need for a reliable guide to help Will see where his true journey lies. It is only when Will runs a breathless race to find Jesus in Jerusalem (passus 15-18) that the myriad paths of the mundane and epistemological mazes become a straight path to Truth. But in the movement from clarity to confusion so obsessively repeated in the poem, the clear vision of Jesus—the way, the truth, the light, significantly shown freeing the just souls from hell—disintegrates all too quickly in the real world to which Will returns, and Will's (and the reader's) senses of direction, and of the order of the actual and moral universe, cannot endure. The poem ends where it began, in the maze of the world. Langland may have been a visionary who saw the cosmic labyrinth whole, but he was also a realist well aware that living creatures can never escape mortal mazes for long, whatever moral fables and classical myths claim.[18]

Sometimes, as in the *rota-rosa* cathedral labyrinths, the world-labyrinth is closely connected to Fortune, a harsh and irrational mistress with inexplicable ways. Thus, for De Guilleville and his translator Lydgate, Fortune has a great tree (the world) on which influential people nest while those below "Loke vp-ward, and al day gaze, / As yt wer vp-on A maze." Juan de Mena's *Laberinto de Fortuna* tells of the narrator's voyage through Fortune's great palace, where, without order but with apparently absolute power, she rules the "orbe universo / con toda la otra mundana machina," the five zones of the earth and the seven circles of the planets, in which the narrator, safely guided by Providence, sees a number of the Cretan characters as well as a Dantean galaxy of others.[19] In both instances, the unpredictability of Fortune, the complexity of her

18. It would be impossible for Langland *not* to have known this, entangled as he was throughout much of his life in systematic revisions and retracings of the labyrinth of his own text.

19. See De Guilleville, *The Pilgrimage of the Life of Man*, ed. F. J. Furnivall (London: Roxburghe Club, 1905), ll. 19571–19572, and Juan de Mena, *Laberinto de Fortuna*, ed. Louise Vasvari Fainberg (Madrid: Alhambra, 1976); the quotation is from stanza 32. The connection between fortune and labyrinth may also be expressed by a pun in stanza 63, which refers to "los muchos reveses del grand Laberinto," where "reveses" can mean turnings or temporal reverses. The twelve areas of the cosmos correspond to the most common number of circuits in a medieval labyrinth. Juan de Mena lived from 1411 to 1456.

See Nepaulsingh, *Literary Composition in Medieval Spain*, pp. 109–124, for more extensive discussion and bibliography on the *Laberinto de Fortuna*, a work whose structural complexity in some ways exemplifies labyrinthine literary structure, and whose borrowings from Dante and Virgil indicate that its author was consciously working in the labyrinthine tradition to be examined in Part Three.

realm, and the inextricability of her prison for anyone without divine assistance and perspective are the qualities linking her with the labyrinth. Particularly in the *Laberinto de Fortuna*, where Fortune's complex realm is simply one misleadingly confused face of the perfectly ordered kingdom of Providence, there may be an assumption that what mundane folk, with their imperfect vision, see as a labyrinth is in reality the splendid artistry of the cosmos. The contrast between providential and time-bound views of the world, implicit in cathedral mazes, as we have seen, will receive further attention later.

One of the most elegant and creative moral applications of the labyrinth myth, here referring not to the whole world but to the disreputable papal world of Avignon, comes in Petrarch's *Liber sine nomine*, a collection of satirical letters, written between about 1342 and 1359, that condemn Avignon as the third Babylon and fifth labyrinth.[20] Thematically unified by a continuing contrast between Avignon and Rome as cities of chaos and order, the collection repeatedly returns to the labyrinth as a perfect sign for the corruption and confusion that characterize the papal city of Avignon, where the Church lay in Babylonian captivity from 1305 until 1378 and where Petrarch felt himself imprisoned for scattered years throughout his life. Appropriately, the labyrinth myth threads its way through the letters, with constant indebtedness to Virgil, Ovid, and Pliny: "Whatever you may have read of the Babylons of Assyria or Egypt, of the four labyrinths, of the portals of Avernus and the forests and sulphurous marshes of the lower world, is all child's play compared with this hell. . . . 'here is Pasiphae coupled with the bull,' to quote Virgil, 'and the mongrel offspring and two-formed progeny, the Minotaur, memorial of her foul love.' Finally, you may see here every disorder, gloom, or horror to be found or imagined anywhere" (Z67-68/D94-96). The image is most thoroughly developed in the tenth letter, where Petrarch offers an extended justification of his chosen metaphor:

> You can indeed be surprised by five labyrinths when other authors, I believe, mention only four. They know of those in Egypt, Lemnos, Crete and Clusium in Italy, but they say nothing of the labyrinth of the Rhone, the most confusing and by far the worst of all, either because it did not yet exist,

20. Parenthetical page numbers marked Z refer to Zacour's translation, cited in chap. 5, n. 26; numbers marked D refer to the Latin text edited by Ugo Dotti (Rome: Laterza, 1974). The *Liber sine nomine* includes many more labyrinth references not noted here. For an argument that "the labyrinth and its variations [e.g., images of the "difficult journey," the Pythagorean Y, wandering, captivity, hell] constitute an important nucleus of Petrarchan imagery" throughout Petrarch's work, see Cipolla, *Labyrinth: Studies on an Archetype*, chap. 2 (previously published as "Labyrinthine Imagery in Petrarch," *Italica*, 54 [1977], 263–289). Cipolla's discussion, which amply demonstrates Petrarch's literary obsession with the labyrinth, could have profited from a wider knowledge of the literary tradition; his Jungian bias prevents as careful an analysis of the texts as one might wish.

or because it was not yet known. I constantly refer to it—how justly, anyone who wishes to know may learn by coming here. Here is the dreadful prison, the aimless wandering in the dwelling place of shadows, tyrannical Minos, and the voracious Minotaur, memorial of forbidden love—but no healing medicine, no love, no charity, no promises worthy of trust, no friendly counsel, no thread as a silent guide to mark the twisted path, no Ariadne, no Daedalus. There is only one hope of salvation here, gold. Gold placates the savage king and overcomes the frightful monster; the guiding cord is woven of gold; gold reveals the forbidding doorway, shatters the bars and stones, bribes the stern doorkeeper, and opens the gates of heaven. What else? Christ is sold for gold. (Z72–73/ D110–112)

The image of Avignon as a labyrinth from which only Christ can guide one (letter 8) is too obsessive and too richly evocative for all its elements to remain stable in Petrarch's interpretation any more than they did in his friend Bersuire's comparably rich if slightly less classical reading. Letter 11, for instance, transforms the evil guiding thread of bribery into the more admirable "thread of a noble contempt" (Z76/D122). Avignon's sexual perversions are fitly imaged by the Minotaur's maze, but the idea to which Petrarch constantly returns is the futile inextricability of the place, an idea often enriched by other images of entrapment:

That's the one place on earth where there is no room for thoughtful coun-sel, where everything goes round aimlessly and without purpose. And among all the miseries of that place, there is this final trick: that everything is smeared with birdlime, and is covered with hooks and nets, so that just when you think you have escaped you find yourself more tightly held and bound. There is no light anywhere, no one to lead you, no sign to guide you along the twisted paths, but only gloom on all sides and confusion every-where. (Z91/D156–158)

Yet finally, as the stories of Theseus and Daedalus show, escape from this classically dark prison, which Petrarch likens to the underworld in the *Aeneid*, is possible: in 1357, Petrarch writes to his friend Francesco Nelli,

You have escaped; you have broken out; you have swum to safety; you have flown free. Well done! . . . I knew that the "descent to Avernus was easy," the gate of the labyrinth was wide, and that the way out was hard and difficult to find. . . . As soon, therefore, as you return to this soil [Milan] which had lent you to the lower world, you will consecrate your propellant wings to Christ—not Phoebus, as Daedalus did—and take heed never to look again upon Knossos. (Z118/D218)

For Petrarch, then, the labyrinth of Avignon is a blind cesspool of sin, home of two-formed lust (lechery and avarice), especially confusing to the innocent, a place of error and danger, an earthly hell from which

escape is impossible without countless attempts and divinely inspired contempt for the world—or at least, for *that* world. Despite Petrarch's reliance on Pliny, there is no artistry in this maze: Daedalus appears only as a potential guide who flew above the maze on wings of contemplation and celebrated his escape by dedicating his wings to a god. The labyrinth as sign for the endless corruption of earthly courts overcomes its potential significance as artistic order, as in Bersuire's last recension, which also blends morality with political cynicism. True order, for Petrarch, is the antithesis of the labyrinth. In this he is typical of many medieval writers, for whom the labyrinth had developed so many connotations *in malo*, thanks to its mythical context, that it was hard to accept the more positive idea of the labyrinth as splendidly ordered complexity that confuses us only when we cannot comprehend its underlying system.

Worldly labyrinths are often labyrinths of sin, as many of the texts here and in Chapter 3 suggest. Two kinds of moral *error* are most commonly seen as labyrinthine: lust, which engenders minotaurs and mazes, and heresy, which entraps the ignorant first in *errores* and finally in damnation. Both kinds of sin involve serious mental confusion and impairment: earthly love is often a kind of madness, medieval writers tell us time and again,[21] and heresy implies a more intellectual and systematic confusion. We turn now to several representative texts describing these mazes of sin. Later we will study the most extensive and vitriolic medieval development of the labyrinth of love, Boccaccio's *Corbaccio*; for the moment, less extreme and far more graceful examples must suffice.

We have seen how Petrarch associates the maze with sexual and moral corruption in the *Liber sine nomine*; he uses the image much more delicately in the *Canzoniere*, as is appropriate to his ambivalence toward love there. The *Canzoniere* describe Petrarch's progress through the labyrinth of earthly love from his "first youthful error"[22] through the succeeding prisons, nets, knots, and entanglements of love, to the liberating knowledge, fostered by his spirit-guide, the dead Laura, that he must "reprimand my soul / For that error of mine that nearly slew / The seed of virtue" (364) and turn from his beloved to the Virgin (366). Although the idea of entrapment in error is recurrent in these sonnets, the labyrinth appears explicitly only toward the end of the sonnets *in vita*. In sonnet 211, Petrarch describes his dependence on Love, who is "treach-

21. See John Livingston Lowes, "The Loveres Maladye of Hereos," *MP*, 11 (1914), 491–546, and Penelope B. R. Doob, *Nebuchadnezzar's Children: Conventions of Madness in Middle English Literature* (New Haven: Yale University Press, 1974). *Error* sometimes means madness in medieval Latin and French.

22. *Canzoniere* 1; except for sonnet 224, I quote Anna Maria Armi's translation in the dual-language Petrarch: *Sonnets and Songs* (New York: Grosset & Dunlap, 1968). For the Italian, I follow *Le rime*, ed. G. Carducci and S. Ferrari, introd. G. Contini (Florence: Sansoni, 1899). For a psychoanalytic reading of the labyrinths of the *Canzoniere*, see also Cipolla, *Labyrinth*, chaps. 2 and 3; the latter chapter equates Laura with the Great Mother archetype, seeing both as mistresses of the labyrinth.

erous and blind," who makes the senses rule reason, who fastens the lover to limed boughs. The cause of all this?

> In thirteen hundred twenty-seven, I
> At the first hour, in April's sixth day,
> Entered the labyrinth and lost my way
> [Nel laberinto intrai: né veggio ond'esca].[23]

After some twenty years (see *Canzoniere* 212), the poet finally recognizes the true nature of his prison: his life has been "a long wandering through the blind labyrinth" (224; my translation). Why love should be a labyrinth is clear, especially in the context of these poems with their endless images of entrapment: love is blind, futile, filled with error, seemingly inextricable; that is the moral equation. Yet Petrarch, humanist that he is, seems also to draw on Pliny's description of the labyrinth as admirable art and witness to fame, connotations avoided in the darker world of the *Liber sine nomine*. Read as a moral and psychological narrative process, the *Canzoniere* constitute a guiding thread through the dangerous labyrinth of love, from obsession with an earthly woman to devotion to a heavenly Ariadne, the Virgin. Seen entire as a work of art, however, they resemble the labyrinth as magnificent artifact, for they constitute a complex, well-structured monument: to the fame of the lady so ornately described and metaphorically entombed within, and to the glory of the Daedalian poet seeking laurels. Filled with complex poetic structures and characterized by oxymorons and antitheses that mimic stylistically the ambiguous choices within the maze, Petrarch's magnificent, ordered artistry accomplishes what Pliny's ancient labyrinths and architectural cathedral mazes do: perpetuates the fame of the inspirer and builder.[24]

23. It may be significant that Sonnet 211, composed earlier in Petrarch's life, was given final placement in the *Canzoniere* only in 1369. F. J. Jones suggests further that the calendrical date of this sonnet within the sequence corresponds to November 2, All Souls' Day; perhaps it is fitting that Petrarch speaks explicitly of his own entry into the labyrinth on the day of the commemoration of the dead, when he might well be thinking of Laura's exit from the labyrinth of life. See Jones, "Arguments in Favor of a Calendrical Structure for Petrarch's 'Canzoniere,'" *MLR*, 79 (1984), 579–588, esp. 581–582.

24. On the *Canzoniere* and the theme of fame, see Mariann S. Regan, "The Evolution of the Poet in Petrarch's *Canzoniere*," *PQ*, 57 (1978), 23–45; on the elaborate order of the work, see Thomas P. Roche, Jr., "The Calendrical Structure of Petrarch's *Canzoniere*," *SP*, 71 (1974), 152–172, and Jones, "Arguments in Favor of a Calendrical Structure for Petrarch's 'Canzoniere.'" Giuseppe Mazzotta also sees the labyrinth as structurally important: "The *Canzoniere* and the Language of the Self," *SP*, 75 (1978), 271–296: Mazzotta writes, "It is the metaphor of the labyrinth . . . that best describes the *Canzoniere*: it designates a monadic structure in which the parts are a series of communicating vessels simultaneously proximate and disjointed and in which each partition leads to and separates from another. The metaphor is particularly apt because it also suggests the poet's experience of being locked in a cosmos of his own creation from which there are no exits (as sonnet 89 dramatizes) and where the only thing left for the poet is to call and make his voice resonate" (p. 295).

Thus Petrarch's labyrinthine works, probably quite unintentionally, reflect the characteristic duality of the maze. The inextricable and wholly immoral labyrinth of Avignon in the *Liber sine nomine* finds a sweeter, more poignant counterpart in the *Canzoniere*'s labyrinth of earthly love, through which the narrator finds the transcendent love of God. And within the *Canzoniere*, there is a contrast between the maze as process, a sequence of partial, limited views amid the *errores*, and the maze as artifact, the whole sequence as a work of labyrinthine art and grandeur. If Petrarch escaped the mazes of ecclesiastical corruption and sensual passion, the man who sought laurels as ardently as he did Laura may never have escaped the labyrinthine implications of the lust for fame. Be that as it may, if most medieval moral labyrinths ignore the maze's artistry or replace it with specious artifice, the *Canzoniere*, far less obtrusively moral, incorporates labyrinthine magnificence of form and complexity of language.

Another use of the psychological labyrinth of love within a collection of poems labyrinthine in their metrical complexity and linguistic obscurity occurs in the fifteenth *chanson* of Richard of Fournival (1201–1259), poet, surgeon, and chancelor of the cathedral of Amiens.[25] The *chanson*'s narrator avoids love because he knows full well that it is a trap in which those who want to escape only entangle themselves the more (stanzas 1 and 2). In stanzas 4 and 5, this trap is identified as the inextricable "maison Dedalu." Theseus had a thread to guide him out, the poem says, but the narrator has none; far be it from him to be more daring than Theseus! This graceful, lighthearted little lyric shows that the labyrinth need not be sinful whenever it signifies the psychology of love.

An equally graceful but more serious treatment of the labyrinth of earthly love appears in the allegorical poem *Les Echecs amoureux*, written by an anonymous early French humanist in 1370–1380.[26] In this attractive work, the first French poem to receive a near-contemporary prose

25. See introduction and text in *L'oeuvre lyrique de Richard de Fournival*, ed. Yvan G. Lepage (Ottawa: Editions de l'Université d'Ottawa, 1981); Lepage fully describes the poem's metrical sophistication and provides alternative readings of Richard's rather cryptic language.

26. The fullest discussion of *Les Echecs amoureux*, which survives in two manuscripts, is by Pierre-Yves Badel, *Le Roman de la Rose au XIV* siècle: Étude de la reception de l'oeuvre* (Geneva: Librairie Droz, 1980), pp. 263–315; see also Ernst Sieper, *Les Echecs Amoureux: Eine altfranzösische Nachamung des Rosenromans und ihre englische Ubertragang* (Weimar: Emil Felber, 1898), which summarizes the first section of the poem; S. L. Galpin, "Les Echez Amoureux: A Complete Synopsis with Unpublished Extracts," *Romanic Review*, 11 (1920), 283–307; Christine Kraft, *Die Liebesgarten-Allegorie der "Echecs Amoureux": Kritische Ausgabe und Kommentar* (Frankfurt: Peter Lang, 1977); and, for Lydgate's somewhat amplified translation, ca. 1410, *Reason and Sensuality*, ed. Ernst Sieper, EETS, e.s. 84, 89 (1901, 1903), which I quote. The substantial prose commentary on the poem, extant in five manuscripts, was translated by Joan Morton Jones: "The Chess of Love" (diss., University of Nebraska, 1968).

commentary in French, Nature advises the narrator to avoid the path of sensuality, winding from west to east to west, and to choose instead the path of reason, which twists in the opposite direction toward God. The motif of choice continues when the poet meets Venus, Juno, and Pallas and reconfirms the Judgment of Paris. Venus directs the narrator to the Garden of Deduit, identified by the fifteenth-century commentator as the garden of this world. On the way, Diana warns him against this garden from which no man returns (I quote from John Lydgate's translation):

> For thys the house of Dedalus
> With the clowthy [clue?] and the threde,
> Dedly perilouse, who taketh hede.
> It is so wrynkeled to and froo
> That man not how he shal goo,
> For who hath onys ther entre,
> To com ageyn yt wyl nat be. (3604–3610)

What the lover eventually finds in this garden, a direct descendant of the gardens of the thirteenth-century *Romance of the Rose*, is labyrinthine in a moral-psychological rather than a physical sense, although the images of choice associated with multicursal literary labyrinths persist: for instance, after being checkmated in the garden, the poet is urged to reject sensuality and choose the path of Reason, itself double in that it leads to the Contemplative Life of Pallas and the Active Life of Juno (marriage, child-rearing, and so on). The poem is finally incomplete, and in a sense it disproves the warning of Diana: with appropriate instruction, with a guide to the larger labyrinth of life, one *may* return to the path of Reason from the maze-like garden of which the commentator says, "as one did not know how to get out of this house of Daedalus when one got too far into it, so mad lovers cannot withdraw from the garden of Mirth when they are too far involved" (p. 629). *Les Echecs amoureux*, like the *Ovide moralisé*, seems to imagine a double labyrinth: worldly life is implicitly a maze of choices for good or evil, and it contains the still more perilous explicit labyrinth of love, from whose error and madness Reason offers rescue—and more choice. The inherent duality of the maze reasserts itself. One might also detect here the typical medieval reluctance to call a good labyrinth by its proper name: although the world of the poem is just as labyrinthine—as full of doubtful choices and winding paths—as the dangerous garden, only the garden is explicitly called a labyrinth.

If sensual love is one avoidable maze of moral error, heresy is another, as we saw in Chapter 3. Since *error*—wandering, deviating from the true path—is the word most usually applied to heresy, what better image is there than the labyrinth, whose very structural principle is continuous

error? The labyrinth of love receives delicate treatment in many texts, and that is appropriate: sensual love is most dangerous when most attractive. Labyrinths of heresy, however, are presented more savagely. Thus Abbo of Fleury (ca. 950–1004), schoolmaster turned abbot, complains bitterly: "Under sheep's skins wolves take refuge in the monastery, hide themselves on the lower branches, and, whenever they find time, do evil, agitating the more simple brethren with false circumventions, deceiving the unwary with alluring smooth-tongued ruin, and casting those corrupted by the poison of their iniquity into the labyrinth of their error."[27] Such men are hard to root out, as Henry, abbot of Clairvaux (late twelfth century), complains: heretics "have no certain paths and walk in circular ways, and most savage monsters are hidden in the labyrinth of fraud."[28] Both the heretics and the damnation they teach seem to be represented by the Minotaur here, and the "circular ways" are heretical modes of argument which baffle unsophisticated listeners. The most serious dangers lurk when these Daedalian heretics are themselves great doctors, such as Berengar of Tours, whose "subtle speeches" drew many other "perversi" into the "labyrinth of error," as Durand of Troarn (d. 1088) complained, or those whom Walter of Saint Victor (d. ca. 1190), in a futile protest against Aristotelianism, labels the "four labyrinths of France" (Peter Abelard, Peter Lombard, Peter Pictaviensis, and Gilbert of Poitiers).[29] In references like these (and there are many), the *process* of the labyrinth—its complexities and ambiguities—is stressed; its victims are confused by subtle arguments they cannot follow or refute, and their chosen guides are deceptive. These mazes, in short, involve psychological or intellectual error, like the philosophical mazes Augustine feared he was creating for Licentius in the *Contra academicos*. Labyrinths of heresy are dangerous for two reasons: they are practically inextricable even though they are often conceived as unicursal in themselves, leading inevitably to theological error; and their goal is damnation. I might have discussed these labyrinths, involving the abuse of intellect, in the next chapter, which focuses on verbal and intellectual mazes of difficult process, but I include them here because labyrinths of heresy conceal no profit in their difficulty; their confusing passages are designed to bewilder rather than enlighten, and the harm they cause is moral and spiritual. Metaphors comparing heresy to labyrinths are probably the least innovative and the most mechanically applied of all medieval maze metaphors; hence, no more need be said of them.

27. Abbo of Fleury, *Epistolae*, PL, 139, 429; cf. a mention of the labyrinth of error as a way around perjury, col. 433.

28. Henry of Clairvaux, letter cited in the *Chronicle of Roger Hoveden*, ed. William Stubbs, Rolls Series, 51 (1869), 2, 160.

29. For Durand, see *Liber de corpore et sanguine Christi: Contra Berengarium et eius sectatores*, PL, 149, 1417; for Walter, *Excerpta ex libris Gualtieri de S. Victore contra Quatuor Labyrinthos Franciae, PL*, 199, 1127.

· Readings of Selected Texts ·

Since this book is meant to cast light on literature involving the idea of the labyrinth as well as to extrapolate the medieval idea of the labyrinth from literature, art, and formal principles, I turn now to several texts that make creative and extended use of the idea that this world is a treacherous labyrinth, inextricable without careful guidance. In all these works, the setting is, explicitly or implicitly, a labyrinth in which one may learn how to lead a moral life, and thus the idea of the labyrinth may serve as a useful interpretive tool. In two texts, the *Queste del Saint Graal* and the tale of Gardinus from the *Gesta Romanorum*, the idea of the labyrinth is used so freely that the maze is not mentioned explicitly at all. Yet I will argue that the *Queste*'s setting (an often trackless forest full of unknown and ambiguous paths) and its action (repeated moral choice in ignorance of where that choice will lead) conjure up the idea of the labyrinth very effectively; intentionally or not, the *Queste* describes the moral labyrinth that is this world. It does this so impressively, and demands such extensive analysis, that I use it as this section's capstone even though it is chronologically the earliest work. Moreover, it serves as an ideal transition to Chapter 7, which deals with texts *as* labyrinths, not merely as containing labyrinths. I realize that this violation of chronology may distress some readers, but the logic of books about labyrinths, like the logic of labyrinths themselves, sometimes demands that the first shall be· last. In the *Gesta* tale, the Cretan myth and the idea of a mundane labyrinth inspire a Christian homily in the spirit of the *Ovidius moralizatus*. Two other works—Boccaccio's *Corbaccio* and the anonymous *Assembly of Ladies*—name the labyrinth explicitly and ring their own elaborate changes on its theme. The *Corbaccio* directs the labyrinth's myth and image toward a savage condemnation of women, whereas the *Assembly of Ladies* develops the idea rather than the story of the maze.

The *Gesta Romanorum*

The story of Gardinus the Emperor comes from the *Gesta Romanorum*, a popular and influential collection of moralized exemplary tales that was probably compiled in Latin by an Englishman around 1300 and then translated into many other languages.[30] This tale is based on the Ovidian legend of Theseus, Ariadne, and the Cretan labyrinth, but neither the

30. *The Early English Versions of the Gesta Romanorum*, ed. Sidney J. H. Herrtage, EETS, e.s. 33 (London: Oxford University Press, 1879), no. 31, pp. 111–121. I quote the Harley 7333 translation, made ca. 1440. This work, which exists in over 165 manuscripts, was once attributed to Pierre Bersuire (pp. x–xi); Boccaccio, Gower, Chaucer, and Hoccleve were among the authors influenced by it (p. xviii). The *Gesta* tales were probably intended for preaching purposes, like Bersuire's *Ovidius moralizatus*.

characters nor the labyrinth, here transmuted into an inextricable garden full of labyrinthine perils, figures by name. If traditional moralizations of Ovid derive morality from the classical legend, this romantic tale of Tirius and the princess goes a step further, reshaping the myth to justify the elaborate moral deduced from it. Although it is not technically mythography, the *Gesta* tale embodies the mythographers' didactic spirit and method of recounting a narrative in order to extract its moral significance.

To win Gardinus's beautiful daughter, young Tirius must face the dangers of Gardinus's fair but inextricable garden and its harmful denizens: a ferocious lion, three men who lead him from the right path, seven fruit trees, and so on. He is aided by the princess and by a mysterious Lady of Solace, who gives him two presents: a magic ointment that, smeared on his armor, will make the lion's teeth fall out, and a ball of thread to help him find his way out. Tirius dispatches the lion but succumbs to other dangers and loses the precious ball of thread. The Lady of Solace helps him retrieve it, and he emerges from the garden unscathed to marry the princess. The resemblance of this romantic exemplum to the classical myth is sporadic but marked: the emperor is a kind of Minos, Tirius is Theseus, the princess is Ariadne, the Lady of Solace plays a Daedalian role in teaching Tirius to solve the labyrinth-garden's dangers by the ointment (cf. the ball of pitch) and the clue of thread, and the lion is the first incarnation of the Minotaur in this story, which elaborates on the classical version by adding other dangers—three ruffians, fruit trees.

The reasons for the author's expansion of the classical myth emerge in the moralization. The emperor is Christ and his garden is the world, in which everyone has been slain by sin. The Lady of Solace is Mary, who lives in the forest of Holy Church; the clue of thread is the law of God, and the thread itself represents the sacraments: one ties the thread to the garden gate by baptism and then navigates the world with sacramental aid. The lion is the devil, defeated by the armor of the works of mercy and the ointment of alms-deeds. The trees, predictably, are the seven deadly sins, and the three men are the world, the flesh, and (again) the devil, who lead men astray. With Mary's help, even a sinner can retrieve the thread of virtue and "fynde passages" to escape and win the princess (eternal life). Thus the dangers of the traditional labyrinth—the Minotaur and the inextricable *errores*—proliferate, generating additional symbols of serious threats to Christian life, and the events of the classical myth multiply, offering an ampler outline of Christian Everyman's passage through the labyrinth of life.

Just as the story owes a great deal to the classical myth, so too the interpretation is indebted to traditional moralizations of that legend: if the labyrinth often represents world, flesh, and devil, here those enemies of mankind inhabit the garden; if the labyrinth symbolizes sin and

worldly pleasure, the garden maze is festooned with fruit trees; if the labyrinth is inextricable without a guide, so the garden entraps anyone unaided by the Lady of Solace. Classical plot, medieval exegeses of the legend, and popular Christian images whose symbolic meanings coincide with those of the Cretan props are blended into an attractive new whole. By taking salient features of the myth and its traditional moralization and using them as the basis for a new story, the unknown author is able to avoid the inconsistencies that characterize commentaries like Bersuire's and create a moral exemplum that to an unlearned audience might well have been more appealing than the Ovidian legend. And by transforming the labyrinth into a deceptive garden, an occasion for sin and virtue, the author effectively suggests the perilous beauty of the world, divinely created as an excellent place, harmful not in itself, like the Ovidian labyrinth, but because of evil inhabitants who use the seductive garden to befuddle and disorient the wanderer. Thus the author of the *Gesta* fuses the labyrinth's pleasing artistry with its horrible inextricability far more effectively than most mythographers. If the *Gesta* did not tell popular audiences anything specifically about labyrinths, it tells us a good deal about how creatively the idea of the labyrinth could be developed. In a sense, the anonymous author has created a new story not from the traditional myth but rather from a moral commentary on that myth: myth, new text, and commentary interpenetrate in the most intimate, and most typically medieval, fashion.

Il Corbaccio

If the *Gesta* author wove a charming moral tale in the mythographic tradition, Boccaccio, mythographer extraordinary, tapped his learning to create something altogether nastier. His exegesis of the labyrinth of lust in the *Genealogy of the Gentile Gods* equates the Minotaur with the human heart deformed by depravity and entangled by worldly delights. This interpretation is fleshed out in *Il Corbaccio*, the "atrabilious cautionary tale" also known as *Il laberinto d'amore*.[31] A typically ill-tempered *remedia amoris* and Boccaccio's last fictional narrative, the *Corbaccio* is in Anthony Cassell's words "thematically and structurally . . . a puzzling and intriguing book."[32] But the Cretan myth provides important clues:

31. The succinct description of the work is Thomas G. Bergin's in *Boccaccio* (New York: Viking Press, 1981), p. 199. Parenthetical citations in my text are to Anthony K. Cassell, *The Corbaccio* (Urbana: University of Illinois Press, 1975); I have also consulted Tauno Nurmela's edition (Suomalaisen Tiedakatemian Toimituksia: Annales Academiae Scientiarum Fennicae, ser. B, 146 [Helsinki, 1968]), on which Cassell's translation is based. The *Corbaccio* is dated variously from 1355 to 1365 and is thus contemporaneous with the *De genealogia*, on which Boccaccio worked from ca. 1350 on.

32. Cassell, p. xi. Cassell goes on to describe the book's structure as defined by the conventions of the dream vision genre.

as the *Gesta* author used the myth as a basis for his own elaborations, so Boccaccio does here.

The title may or may not be part of the clue: we do not know whether "Il laberinto d'amore," appearing in several manuscripts, was Boccaccio's own title, but even if it was not, it reflects medieval scribes' perception that the work is labyrinthine and thus conveys important information about the reception of the text. V. M. Jeffery's conjectures on the etymology of *corbaccio* also hint at labyrinthicity. Normally the word means "ugly, ill-omened crow," but it may play on two Greek words meaning "region" and "frenzied," so that *corbaccio* ("mad, disordered place") and *laberinto d'amore* are ingenious synonyms.[33] If the title also alludes to the fable of the crow decked out in peacock's feathers, a figure of the absurd feminine vanity characteristic of the widow in Boccaccio's work,[34] Boccaccio's single-minded treatise has an aptly polysemous title; we shall see later how labyrinth and widow are integrated in the text. However one reads the title, the labyrinth suggests setting, plot, and much of the work's imagery. The best way to show this is to summarize the story, accenting its labyrinthine process and qualities but remembering that other influences, including the opening of Dante's *Divine Comedy* and the conventions of dream vision, are also important and that they coincide in many ways with the typical labyrinth experience.[35] As Boccaccio's title suggests many meanings in one word, so the work fuses several traditions into one narrative.

Rejected by the widow he loves, the narrator-dreamer tempers despair by recalling that worldly fortune is unstable in comparison to divine realms. Like Boethius, whose *Consolation* is echoed here, he thinks he has moved from blind self-pity to clear-sightedness. His imagined moral progress foreshadows his dream, in which he actually succeeds in moving from the confusion of the labyrinth to the mountain top with its enlightened perspective on the maze below. As the dream begins, he follows a "delightful and beautiful path" that suddenly is choked with brambles and fog so he cannot retrace his steps. In utter darkness, he senses a "desolate wilderness . . . without any track or path, and surrounded by rugged mountains" (p. 6). Unable to escape and terrified by howling beasts, he repents "having entered there without foreseeing

33. See V. M. Jeffery, "Boccaccio's Titles and the Meaning of *Corbaccio*," *MLR*, 28 (1933), 194–204. Jeffery notes that Boccaccio often used titles or names based on Greek and that the present title, following her etymology, describes the setting for what she considers an autobiographical rejection of love.

34. Anthony K. Cassell, "The Crow of the Fable and the *Corbaccio*: A Suggestion for the Title," *MLN*, 85 (1970), 83–91.

35. Cassell elucidates many debts to Dante, which include the savage wood, the beasts, and the aged guide; these features are common to many dream vision poems, as Cassell notes. I argue in chap. 10 that Dante's *Divine Comedy* is a labyrinthine poem; I think Boccaccio's recognition of that fact is reflected in his own development of the labyrinth theme.

where I was to end up" (p. 7) and calls on God. So far, then, we have simultaneously a variation on conventions of dream vision, extensive allusions to Dante in the dark wood, and entry into a labyrinth full of potential minotaurs, as dark, dangerous, inextricable, and disorienting as any ancient maze but still more terrifying in that it is not merely confusing but completely trackless.

As usually happens in dream visions and moral mazes, the narrator's prayer is answered by the appearance of a guide, the old man whose widow is the dreamer's beloved. She it was who led the dreamer to the treacherous path that only seems beautiful; "although the entrance to this place is very wide for anyone who wants to enter it through madness and lust, it is not easy to leave again" (p. 10).[36] The dreamer's education begins when he asks where he is and whether "anyone who enters . . . can ever leave by himself" (p. 10). The guide answers that the valley has many names: the Labyrinth of Love, the Pigsty of Venus, the Enchanted Valley, the Valley of Sighs and Woe, the Court of Love. The howling beasts are "wretches—of whom you are one—who have been caught in the net of false love," and the place is a labyrinth "because men become as trapped in it as they did in that of old, without ever knowing the way out" (pp. 10–14). Escape is impossible without divine aid and personal wisdom and fortitude.

To nurture this wisdom, the guide elicits an account of the dreamer's entry into the labyrinth of love. The imagery of entrapment expands as the dreamer admits that he has "entangled myself in the snares of love" and "shackled and given my liberty and subjected my reason to the hands of a woman" (p. 20). Finally he accepts his guide's diagnosis: "you yourself were the origin of your own error" (p. 21). In other words, the maze is man-made, woven by sins; as in the *Genealogy*, the lustful man entangles himself in the windings of his own desires, becoming a beast-man and turning his heart into a labyrinth. Love, that maze-like "thing without reason or order" (p. 23), hardly befits a middle-aged scholar like the dreamer.

Having retraced his steps in memory, knowing how he got in if not how to get out, the dreamer ponders the nature of the labyrinth in which he finds himself. Here the work becomes so venomous a catalogue of antifeminist clichés that at least one critic sees the *Corbaccio* as a satire on misogyny rather than an example of it.[37] But since Boccaccio's writings

36. Cassell lists related passages in the *Divine Comedy* and Boccaccio's own commentary (*Esposizione sopra la Comedia*) but ignores the echo of *Aeneid* 6.126–129 and Dante's biblical source, Matthew 7:13–14, a passage with which Prudentius does much. Cf. the association of Aeneas's descent into hell with entry into the labyrinth in Petrarch's *Liber sine nomine*, epistle 19.

37. See Jean-Pierre Barricelli, "Satire of Satires: Boccaccio's *Corbaccio*," *Italian Quarterly*, 18, no. 72 (1975), 95–111. Bergin (pp. 196–203) and Cassell (pp. xviii–xxvi) also discuss the problem of tone, Boccaccio's place in antifeminist tradition, and the incongruity of certain features in the work.

are crammed with antifeminist sentiments, most likely his virulence here is intended as the wisdom that leads one out of the maze. This supposition is justified by further developments of the labyrinth image, which show how the *corbaccio* of the title is also the labyrinth itself in more ways than the etymological.

As the entry to the labyrinth seems pleasant but then reveals its true ugliness, so too with women, who seem fair because cosmetics and clothing mask their true deformity. These superficial adornments correspond to the Daedalian artifices that bestial minds prefer to nature in the *Genealogy*.[38] The labyrinth of lust found in sinful hearts shifts its anatomical location: we hear of the "blind and dismal prison he falls into who stumbles beneath their [women's] sway" (p. 34), and in the *ad feminam* satire that follows, the guide reveals his wife's inmost secrets, stripping away artifice to reveal nature and shedding pitiless light on the labyrinth's classical darkness. He describes his wife's vagina as an "obscure valley" (p. 42), and what follows is a grotesque *effictio* of female genitals, described as great gulfs, enormous ports accommodating many ships at once, gaping mouths, and so on (pp. 55–56). These are among the metaphors recommended by the Bolognese rhetorician Boncompagno da Signa in his extravagant list of apt metaphors for the genitals—a list that also suggests "a putrid lake, a press for feces, a labyrinth of shame."[39] Boccaccio does not make this last comparison explicit, but it may have been in his mind: if the "obscure valley" of the genitalia is also the gulf and the terrible river, surely they are also to be equated with the dark valley in which the dream itself takes place—the enchanted valley, the pigsty of Venus, the labyrinth of love. The fourteenth-century physician Bernard of Gordon recommended curing foolish love by forcing besotted lovers to anatomize an old whore and look at rags covered with menstrual blood, a *remedium* more or less pursued by the guide here, and consequently the *Corbaccio*'s message differs only in verbosity and tone from that of the Old French *Lay of the Lecher*, in which the court of love is built on one foundation: *con*.[40] After his tawdry recital, the guide tells

38. In this context, one is struck by the guide's comment that the Virgin, one of only eleven wise women in the history of the world, was remarkable for her *natural* beauty, which, unlike the artificial beauty of fourteenth-century women, was not carefully calculated to arouse lust (p. 33).

39. Boncompagno, *Rhetorica novissima* (1235), ed. Augusto Gaudenzi, *Biblioteca iuridica medii aevi*, vol. 2 (Bologna, 1892). If the female genitals are often linked with the labyrinth, as Santarcangeli suggests (pp. 209–213), so too are the intestines: see Vindicianus (late fourth century) in Theodorus Priscianus, *Euporiston*, ed. Valentine Rose (Leipzig: B. G. Teubner, 1894), p. 477. For the association of the female genitals with the labyrinth in India, see Kern, pp. 384–385. Others may have suspected the connection between genitalia and labyrinth in the *Corbaccio*: Jeffery notes that some critics find "a second obscene meaning" in the title and suggests that "manly delicacy" has prevented its publication: *MLR*, 28, 195.

40. For Bernard of Gordon, see Lowes, *MP*, 11, 501; *The Lay of the Lecher* is printed in *Bawdy Tales from the Courts of France*, trans. Paul Brians (New York: Harper & Row, 1972).

the dreamer, "if you did not abandon your error, you should be considered more bestial than any other foolish beast" (p. 57). Thus the dream's pleasant path becomes the mental valley-labyrinth of love, which in turn is revealed as the obscure valley and shameful labyrinth of the female genitals once disguising artifice is cast aside. Such is your beloved, Bernard would say to the lover; such is the end of lust, and such the beast found in the foul labyrinth of love. Beneath the lady is the *corbaccio*, the old crow, the labyrinth of chaos; the work's title rings its changes.

Like Swift in Celia's closet, the dreamer is cured: "These things . . . have so completely reversed my opinion and changed my mind, that without any doubt at all, I now think the opposite of what I thought before" (p. 71). He is ready for the grace that will lead him "outside of this labyrinth" (p. 73). He promises to reverse his course (as one naturally does at the center of a labyrinth) and help the widow achieve salvation the best way a poet can: by exposing her in his book. By enumerating the labyrinths of love, the poet extricates himself, his book becoming the thread to free his readers from similar mazes. Finally he can "see the way clear" and will "never stray from the path of light" (p. 75). He leaves "not a valley but a thing deep as Hell, gloomy, and filled with darkness" (p. 76) to warn those "who, with eyes closed, set out without a guide through unsafe places, trusting too much in themselves" (p. 77).

Distasteful as the *Corbaccio* may be, it offers an extravagant portrait of the labyrinths of love, a portrait heavily dependent on medieval ideas about mazes, sin, and women and, at the same time, a coherent arrangement and expansion of those traditions. The labyrinth, I would argue, is the work's unifying theme. As an image of inextricability, it represents the world of the lover: his heart imprisoned by sin, his confused mind and darkened vision, and the real cause of his entrapment—the treacherous labyrinth of his beloved's genitals. As a story, the *Corbaccio* suggests the myth's *dramatis personae*: the widow, mistress of Daedalian artifice, corresponds to the labyrinth's first mover, Pasiphae, bereft of her reasonable husband just like Boccaccio's widow; the bestial denizens of the maze are minotaurs, mongrels who only seem human; the guide is part Minos the law-giver and part Daedalus, the man who knows the labyrinth and the way out; the dreamer, of course, is Theseus, the prudent man who learns to see the foul truth beneath fair appearances. He gains insight in the darkness of the maze and learns to reverse not merely his steps but also his conduct to free himself from the errors of a labyrinth completely *in malo*. The only duality in this labyrinth is the contrast between feminine artfulness and blunt reality.

The Assembly of Ladies

In remarkable contrast to the *Corbaccio*, *The Assembly of Ladies*, a charming if somewhat uneven Middle English poem of the mid-fifteenth cen-

tury, uses the idea of the labyrinth of life with unobtrusive delicacy and tact, and its secular focus is unusual among medieval works about moral labyrinths. In Chapter 5, I used this delightful and often realistic allegory to illustrate the experience of being in a real garden labyrinth. Here we see how the poem uses the literal setting and mental experience of a maze to describe the moral labyrinth of this world.

Like *Il Corbaccio, The Assembly of Ladies* is a dream vision, but unlike that work it belongs to the courtly tradition of love poetry. Familiarity with similar works by Chaucer and other late Middle English writers creates a readerly expectation that waking and dreaming activities and settings will be closely related and that there will be a blending of allegorical content with realistic and even comic detail, and such indeed is the case: the maze the dreamer treads before she falls asleep has symbolic and realistic aspects, and the framing maze journey is reiterated by the dream-quest. Throughout, the social function, physical description, psychological effects, and symbolic potential of the maze are handled with the easy grace that led C. S. Lewis to describe this poet as "the lost Jane Austen of the fifteenth century."[41]

One September afternoon, as the narrator and other gentlefolk stroll in a garden, a young man asks the narrator what she is doing. She replies that she wants "To walke aboute the mase, in certeynte, / As a woman that nothyng rought [had no cares]" (17-18)—a paradoxical response, for certainty is the last quality normally associated with mazes.[42] Pressed by his questions and urged not to defer an answer, she responds, "Abide" (24), she will speak in due course: as the maze is a delaying process that (if unicursal) inevitably leads to a conclusion, so the story of her maze-adventure will be long and circuitous. Although the narrator describes herself as "the symplest of alle" (7), her experiences are, then, a puzzle, a maze to be explored at leisure. She then tells her adventure. One afternoon, having nothing better to do, she and her lady friends walked the maze, following whatever paths they liked and reacting to the experience as their temperaments inclined them (see p. 110 above). What her account subtly reveals is an array of attitudes toward and

41. C. S. Lewis, *The Allegory of Love: A Study in Medieval Tradition* (1936; New York: Oxford University Press, 1958), p. 250. I follow common practice in referring to the author as "she" because the narrator is female—and because there are so few recorded women authors in the Middle Ages that I seize any plausible opportunity to turn "anon." into a woman. I like to think that this one was named Ariadne.

Parenthetical line references cite D. A. Pearsall's edition of *The Floure and the Leafe and The Assembly of Ladies*.

Comparatively little has been written about the poem. The fullest discussion is by John Stephens, "The Questioning of Love in the Assembly of Ladies," *RES*, n.s. 24 (1973), 129–140. I have not seen Judith Davidoff's article, forthcoming in *M&H*.

42. "In certeynte" might be a line-filler, but I agree with Stephens that the phrase is significant, not least because it is so astonishing in context.

courses through the maze of life, not merely a vividly imagined report of wandering in a garden labyrinth. Some people, like the folk on Langland's fair field, have no sense of direction at all, being sure they are walking one way when in fact they are moving in the opposite direction; others are hesitant observers, looking on rather than choosing a path; still others—the last shall be first?—seem to lag behind but suddenly find themselves near their goal. One group of optimists is "so mased in theyr minde" (38) that any path is fine with them, and others are so frustrated that they climb over the rails, refusing to endure the maze at all. The narrator, in contrast, tires and finds her way to a pleasant arbor for a nap. No lessons are drawn from these various ways of coping with a maze; like so much else in this gentle, understated poem, moralization is left to the reader.

After the realism of the maze, the poem moves, as John Stephens has noted, to the more overtly symbolic realm of the enclosed arbor with its turf-benches and turning wheel: all its flowers—pansies, forget-me-nots, and so on—are traditionally associated with love, but they would not all be in bloom in September. We are in a *locus amoenus*, an idealized landscape that may lie at the geographical center of the maze or that is at least an appropriate reward for the narrator's persistence and cleverness in finding her way: after *labor intus*, rest. Here she dreams of a journey to the court of Lady Loyalty, who will hear, but not resolve, bills of complaint presented by the dreamer, her friends in the maze, and other wronged ladies.

The dream journey recapitulates the frame journey through the maze. Here too the dreamer travels in solitude, although her friends eventually join her (they are a little behind her in the dream just as they seem to be in the frame maze). Both journeys are long and tiring, requiring the labor and involving the confusion that give labyrinth and maze their respective names. Both demand persistence: the maze does so by its very nature, and in the dream Lady Perseverance summons the dreamer to Loyalty's assembly while Lady Diligence guides the anxious heroine, who is reluctant to set forth because "ther is none of us that knoweth the way" (128), as in an unfamiliar maze. Diligence and the dreamer set off at dawn, worried that they may be late, and they pray to Saint Julian, not merely the patron saint of hospitality but also, particularly in England, the patron of maze-walkers, or so I conjecture.[43] Both journeys involve delays, the maze structurally, the way to the Assembly because of numerous comically realistic pauses as the dreamer changes her clothes and frets about her appearance (253-256), waits for her tardy friends (285-371) and for further instructions from Perseverance (372-406), explains why she alone has not come with an identifying motto (309-315 and 411-

43. See the discussion of Julian and turf-mazes above, chap. 5.

413), and endures the ministrations of seemingly infinite allegorical functionaries at Loyalty's castle, euphemistically named Plesaunt Regard but in fact a Bleak House of bureaucratic delays. If some of the dreamer's companions jumped over the rails of the frame maze "for verray wrath," she herself becomes remarkably testy now and then, as when she urges Perseverance to make haste: "Grete cost alwey there is in taryeng, / And long to sue it is a wery thyng" (419-420).

After further delays, Lady Loyalty hears her supplicants' complaints; her own motto, appropriately enough, is *A endurer* (489). In fact, one begins to suspect the poet of falling into the fallacy of imitative form, so long is the reader's struggle through the delays of this maze-like dream. Finally the dreamer herself speaks of her extreme melancholy and of lacking reward commensurate with her deserts, but, although Lady Loyalty promises a remedy, justice will not be served quite yet: all the cases are bound over until some later date, when another journey must be made to another assembly. If the reader does not yet suspect that the journey is a dream-transformation, and perhaps the underlying meaning, of the treading of the frame maze, the analogy between waking and dreaming actions is confirmed when the narrator awakens "al amased" (739), as bewildered by her long and inconclusive dream as by the garden maze, but apparently reassured by the promise of an eventual solution and justice.

Just as finding a path through a multicursal maze is a maze-walker's responsibility, so interpreting the poem's garden maze and labyrinthine dream journey is left to the reader. Stephens suggests that the frame maze and the endless seeking it involves are "a metaphor for a state of mind" (p. 132) and, less cogently, may be related to the traditional labyrinth of lust; he further argues that the poem's subject is the instability of earthly love, a problem insoluble in this life. I suggest instead that the maze experience portrayed in the frame and metaphorically traced in the dream demands another, broader medieval interpretation: the maze is the labyrinth of earthly life, full of delays and uncertainties, where the only sure counsel for maze-walkers is the motto of Loyalty, the implicit message of the labyrinth: *A endurer*. With guidance from Perseverance and Diligence, wandering and questioning may cease and justice may prevail, though perhaps not in this life (even Minos, judge of the underworld and founder of labyrinths, rules in an afterlife). As the narrator's patient treading of the garden maze leads to a pleasant arbor and sleep, if not necessarily to extrication from the maze, and as the tedious journey to Loyalty earns the promise of reward, so too the careful walking of the world-labyrinth leads to peace after labor, order after chaos; and perhaps the knowledge that there is an end toward which all paths converge is what produces the dreamer's paradoxical "certeynte."

In a sense, then, the allegorical lesson discreetly embodied in the

Assembly of Ladies is a secular version of the moral of the *Gesta* story: happiness, or at least relief, awaits maze-walkers who follow the advice of a lady of solace. If the *Assembly* appeals more to modern taste, perhaps that is because of its experiential emphasis, its lack of explicit moralizing, and its refusal to resolve issues that poets often find less pat than preachers do. Although both poet and preacher are working with the tradition of the world as a moral labyrinth, the preacher sees the maze and its symbolic content as artifact, God's complexly crafted design, where the poet is concerned with process, with the limited vision possible inside a maze. Although the frame maze seems to be multicursal, the poet does not emphasize the need to choose one path or another within the dream; persistence, not intelligence, is the issue. Good guides, and stoical endurance of the maze of this world, will somehow lead to a peaceful arbor; perfect understanding is beyond human powers. All we can finally choose is our attitude in treading the maze, wherever it leads; all we can learn with certainty is patient perseverance.

La Queste del Saint Graal

One of the finest and most elaborate treatments of the idea of the labyrinth is found in *La Queste del Saint Graal*, written anonymously in about 1225.[44] This is a work of labyrinthine artistry and complexity, a circuitous, ambiguous literary process carefully designed to afford transcendent enlightenment to readers who stay its course, participating in its characters' confusions and learning as they learn. For the moment, however, I focus on the moral labyrinths within the work rather than on the work itself as an intellectual labyrinth. I cannot prove that the author had the labyrinth in mind in constructing the *Queste*, for he never mentions the word; but the work draws upon so many labyrinthine qualities and connotations that the *idea* of the labyrinth, as understood in the Middle Ages and inherent in the unicursal and multicursal forms of the maze, informs and is fully embodied in the work. If there is a shaping image in the *Queste*, I believe it is the labyrinth, a visual analogy that

44. In parenthetical refs., M refers to Pauline N. Matarasso's translation, *The Quest of the Holy Grail* (Harmondsworth: Penguin, 1969); P refers to Albert Pauphilet's edition, *La Queste del Saint Graal* (Paris: Librairie Honoré Champion, 1949).
So much has been written on the *Queste* that I have not tried to survey the secondary literature. Works I have found helpful on the ideas of paths and patterns include Susanna Greer Fein, "Thomas Malory and the Pictorial Interlace of *La Queste del Saint Graal*," *UTQ*, 46 (1977), 215–240; Sandra Ness Ihle, *Malory's Grail Quest: Invention and Adaptation in Medieval Prose Romance* (Madison: University of Wisconsin Press, 1983); Charlotte C. Morse, *The Pattern of Judgment in the* Queste *and* Cleanness (Columbia: University of Missouri Press, 1978); Tzvetan Todorov, "The Quest of Narrative," in *The Poetics of Prose*, trans. Richard Howard (Ithaca: Cornell University Press, 1977), pp. 120–142; and, more generally, Vinaver's *The Rise of Romance*.

includes path and interlace but goes far beyond them to unify important themes, images, and patterns.

The *Queste* tells a well-known story: the search for the Holy Grail, a spiritual adventure bringing success to a few and failure to most, a harbinger of and moral justification for the imminent fall of Camelot. Chapter 2 showed that quests and labyrinths have much in common: they are journeys pursued individually, if sometimes undertaken jointly, in search of a prized goal; they involve conscious choice to engage in a difficult process, full of obstacles, delays, and setbacks—there is *labor* of all sorts *intus*. Success depends on internal virtues such as persistence in adversity as well as on external guidance.

But quests that are particularly rather than incidentally labyrinthine have important features not necessarily common to every journey. Unusual circuitousness will be an essential part of the design. Both moral and physical *error* will probably be involved. The darkness of the classical maze and blindness or the partial vision induced by the path's recurrent twisting may figure thematically. The labyrinth's characteristic duality will appear somehow: the difference between unicursal and multicursal modes of movement may be highlighted, for example, or contrasting points of view—process-induced ignorance versus transcendent understanding of a grand design. References or parallels to the Cretan myth may be detected, and the *sens* of the work will overlap substantially with metaphorical meanings normally associated with the maze. Explication— the physical unwinding of a path and the intellectual unraveling of problematic meaning—will be demanded, for the maze's impenetrability and inextricability will play a role in the action and its significance. The quality of the journey will be specifically labyrinthine: practical and moral choices among paths may be involved, and so will a kind of passivity: maze-walkers operate within constraints established by the architect's design and are not free to go exactly where they choose. Finally, quests that are truly labyrinthine will have an architect who frames the grand design within which the questers move to enact or subvert the overarching pattern by their choices and persistence. What seems to be chance or *aventure* in a labyrinth is really providence, human or divine, when viewed from the right perspective. With these things in mind, let us see how the *Queste* is specifically as well as generally labyrinthine.[45]

45. Many works, including numerous epics and romances, are labyrinthine in general and specific senses; four are considered in detail in Part Three. The generally labyrinthine nature of the *Queste* has been recognized by scholars including Matarasso, Vinaver, Ihle, Todorov, and Fein. But to my knowledge no one has systematically explored the theme; even Fein, who repeatedly speaks of the maziness of the *Queste* (pp. 217, 218, 219, 221, 233), is concerned to show that the *Queste* is a "pictorial interlace"—as I argue in chap. 7, a less useful and inclusive analogy—rather than a labyrinth, although we draw on much of the same textual evidence. What Fein sees as interlace, I see as the idea of the labyrinth in the *Queste*.

The goal of the grail quest is "to learn the truth of the Holy Grail" (P61, my translation): it is paradoxically an intellectual and spiritual journey pursued by physical wanderings, a search for what is both known (the veiled grail appears to Camelot at Pentecost) and unknown: "This is no search for earthly things but a seeking out of the mysteries and hidden sweets of Our Lord, and the divine secrets which the most high Master will disclose" (M47/P19). Like the impenetrable labyrinths of Gregory of Nazianzus, Vegetius, and imperial robes, the physical and spiritual complications of the grail quest protect what is valuable from the unworthy, whose physical *errores* represent and occasion inextricable moral error. For the chosen and well-choosing few, the labyrinth is penetrable, bestowing enlightenment and transcendence of mundane things; for the ill-choosing many, it is endless error and spiritual blindness. But for everyone it is an unknown path of ignorance in which means and end—the patterned roads and the knowledge of the Grail—are laboriously unfolded, even though we know from the start who will succeed and who will fail: one of the author's strategies is to provide characters and readers alike with moments of privileged vision that usually prove unsustainable in the real world, at least for the characters.

The knights' choice to pursue a common goal—to enter the maze, as it were—is difficult, but once the choice is made, each knight goes his own way, "striking out into the forest one here, one there, wherever they saw it thickest and wherever path or track was absent" (M52–53/P17). The place of testing and significant choice, then, is the trackless forest wasteland, in itself not unlike other landscapes described as labyrinths: Boccaccio's valley, Ambrose's wilderness, Jerome's ocean, Gregory Thaumaturgus's forest and swamp—all impenetrable, inextricable, and unpatterned. The forest of the *Queste* is repeatedly described as having "ne voie ne sentier," as in this significant first description, and errant knights—whether wandering physically or erring morally—constantly plunge into the opaque unknown in their quest for the still more unknowable grail. Yet despite recurrent references to its pathlessness, its "desvoiable" nature, the forest paradoxically contains many paths, forks, and crossroads: for some seekers, infinite ambiguity is narrowed to crucial choices between morally significant alternatives, so that if the forest is a wilderness-labyrinth, it is also a multicursal maze with well-defined channels. The apparently careless inconsistency between pathlessness and too many paths is reconciled by the labyrinth tradition, which categorically includes both alternatives. Both pathless wastes and complex patterns of interconnecting roads confuse wanderers because they contain no direct, unambiguous track to the desired destination. They differ in that wastelands manifest no inherent pattern; they have potential but no form, no guidance. Or, to look at it another way, the labyrinthine forest, like the world it signifies, offers an infinity of courses to be de-

fined by errant knights whose passing establishes a path, but within that infinity better and worse ways have already been conceived, and possibly, as we shall see, there is a single correct road, a unicursal path superimposed on deceptive multiplicity, as in the writings of Prudentius.

How, then, do the knights of the Round Table define their interwoven paths through the maze and consequently determine their own success or failure? Arthur, who tries to dissuade his men from the enterprise, refuses to enter the labyrinth at all; for the tragic monarch of the material world, the forest is impenetrable. He defines no path for himself or for others.[46] By analogy, in the spiritual context of this romance he is timorous Aegeus who will not join his people in the maze; the end of his reign is inevitable, and his authority will pass, albeit briefly and in another kingdom, to the Thesean Galahad, himself limited to defining a path only a few can follow. Arthur deserves what he most fears—that none of his knights will return, that the quest will prove endless. Those who do enter have different opportunities for choice. Many confront *bivia*, the forked roads that, in sequence, delineate a multicursal labyrinth. The squire Melias fails at the first and most clearly marked *bivium* in the tale: despite a warning that the left-hand road is only for the best knight in the world, he chooses the sinister path of pride and is dreadfully wounded. As he learns later, when the *bivium* is explained in one of the internal glosses that constitute *ex post facto* guidance and permit one to learn from one's mistakes, so it is with those who are blind to "la chevalerie celestiel" and choose "la seculer" (P45): they proceed willfully, discounting unambiguous guidance and the obvious symbolism of left and right. But labyrinths are by definition unpredictable to those within: thus Gawain, well-meaning but lacking in persistence and impervious to advice, twice chooses the right-hand path and yet goes awry.[47] Gawain's boon companion Hector reaches Corbenic and the grail, but, having followed the right path in the wrong spirit,[48] he is turned away, and he plunges "into the forest there where he saw it thickest" (M267/P261). For him, the mystery remains impenetrable. In the labyrinth of this world,

46. It is a convention of Arthurian romance (as well as practical politics) for the king to stay home while his knights seek adventure. Nevertheless, Arthur's reluctance to participate in the Grail quest seems to go beyond convention.

47. Having chosen to follow the path of Galahad, Gawain takes the right-hand path after wrongly killing seven knights at the Castle of Maidens (M78/P53); he misses Galahad but learns of his own sinfulness, although he disregards advice to do penance and embark on a more fruitful path. Later, he and Hector are directed along a steep, narrow path to their right (M166/P151), but on the way Gawain kills Owein. When they finally take the right path to Nascien the hermit, seeking "to be enlightened where we were in darkness and to receive assurance where we are in error" (M169/P155), they are told how and why they have failed, but they do not profit from Nascien's guidance. Gawain, indeed, sets off intending to return when he has more leisure, but he never retraces his steps, and the earthly labyrinth is inextricable for him.

48. Cf. Ihle, *Malory's Grail Quest*, p. 89.

those without grace cannot achieve holiness even if they follow what are in a literal sense the right roads; unless they do so spiritually, the long-sought transcendent goal turns to wilderness and chaos. The maze is inextricable to anyone whose blind conduct and perverse self-will deny the existence of roads and architect.

The good knights choose better. Bors, for instance, finds moral and literal choice coinciding when he comes to a crossroads where he must decide whether to save his brother Lionel or rescue an abducted virgin (M187/P175). Having taken the only door among many that leads to Christ by a full confession (M176–177/P162–163), having unconsciously absorbed the moral of a puzzling dream, he chooses correctly. If Bors can find his way through a multicursal maze of choices, Lancelot faces an even more complex process, and since he travels the most complicated and comprehensive maze of all, it is worth looking at his experiences in detail, for some aspect of them is shared by every other quester.

After Galahad has defeated his father Lancelot and Perceval in battle, signifying that they are still imperfect, Perceval suggests, "We would do better to retrace our steps, for if we go astray [desvoier] at this point I fear it will be long before we find our road [droit chemin] again." Instead, Lancelot pursues Galahad. In itself this is an admirable ambition, but Lancelot's manner of proceeding is ominous: "keeping to neither track nor path, but following where fortune [aventure] led" (M81/P57). For a sinner like Lancelot, this is rash action indeed, like that of the fools who leave the right path to find a shortcut through Ambrose's moral wilderness. In the darkness, Lancelot sees nothing "by which to steer his course," and when he comes to a bivium the inscription is illegible. In the shadowy forest maze that mirrors his spiritual blindness, he can neither guide himself nor decipher the means of guidance. Ironically, thanks to the workings of aventure, he arrives precipitously at his goal, a chapel where the grail heals a sick knight. But the doors are barred, and when the grail appears Lancelot is paralyzed: he has not come in the right spirit, with the right preparation. It is as if he had followed the first stretch of a labyrinth that leads almost directly to the innermost circle, from which he is granted a vision of the goal he cannot reach until he has traced the twisting paths out to the very edge again and earned access to the center. Acknowledging his moral blindness, Lancelot seeks guidance from a hermit and confesses his faults, couched in terms of the bivium: "I have gone to my death down that wide road which . . . is the portal and the path of sin. The devil . . . hid from my eyes the everlasting woe that lies in store for him who treads that road to its end." The hermit holds out hope: "Just as you may see a man wander at times from his path when he falls asleep and retrace his steps at once on waking, so also it is with the sinner who falls asleep in mortal sin and veers from the right way; he too returns to his path, which is his Maker, and directs his steps

towards the Most High Lord who ever cries: 'I am the way, and the truth, and the life'" (M88/P65). Here Lancelot begins his penitential tracing of a better track through the multicursal maze; the hermit's guidance, his own virtuous impulses, and the aid of the Holy Ghost who will "make you a path" (P116) help him choose as he could not at the dark *bivium*, and he asks God "to lead him back into a path which would profit his soul" (M136/P118). At least one moment of hesitation between alternatives has been overcome.

Unlike Gawain, Lancelot knows he must seek moral (and directional) guidance from others. His next hermit-guide also uses the imagery of paths and choices. Once Lancelot had the rectitude (*droiture*) that "holds to its unwavering course so steadfastly that no eventuality can shift it from that path." Yet Guinevere led him from "the path of righteousness [*droite voie*]" into a blind "path of lust," which left him "unable to hold to track or trail." Donning a hair shirt, Lancelot sets off in a submissive spirit "where fortune takes me. For I have no notion of the whereabouts of what I seek" (M142–146/P124–129). Fortune or "aventure" is what providence sometimes looks like in the mundane maze; it last led Lancelot to the frustrating encounter with the grail that was for him a moral turning point. Now, humbled, he willingly submits to *aventure* and good advice, knowing he cannot find his way through the labyrinth by prowess and intelligence.

Lancelot's progress is next assessed by an enigmatic maiden who knows what he seeks and who tells him, "You were once closer to it than you are today, and yet are closer now than ever you were before, if you hold fast to what you have embarked on" (M146–147/P130). She means, of course, that he was physically closer to the grail at the chapel of the sick knight, but that he is spiritually and temporally closer now. As it describes Lancelot's wanderings, however, the paradox evokes the visual image of a labyrinth. At first its course may lead straight to the center, but then it twists away to the periphery before eventually turning back to the goal. At the periphery, then, one may be closer to the goal in time— that is, nearer to the end of the path—than when one is geographically close at the start (cf. plate 5). Lancelot fails to understand because he is in the maze, ignorant of its pattern; but if he perseveres on the right path, he will achieve transcendent understanding, if not of the grail itself then of the grand design that leads to it. The maiden's cryptic words succinctly describe the labyrinth experience and reflect the dual perspective inherent in the idea of the maze.

Encouraged, Lancelot follows the same path until it forks. This time the cross at the *bivium* has no inscription: perhaps, in a state of comparative grace, Lancelot needs none, being able to choose correctly on his own. He sleeps and dreams of Christ, who reveals the spiritual significance of the motif of choice: "It is for thee to choose whether I love or

hate thee" (M148/P131). When Lancelot awakes, he prays he should not stray from the "droite voie" (P132) and proceeds on the path he had followed the day before. We are not told whether this is the right or the left fork, perhaps because his state of mind almost guarantees that whichever path he takes will be morally right. As if in confirmation of grace, he defeats a knight who had earlier robbed him, yet he charitably ties up the knight's horse for him to find when he revives.

Still another hermit interprets Lancelot's dream and urges him to continue as he has begun. Lancelot rides off, "following neither track nor path, for his thoughts were wholly on his life and his soul's weal" (M155/P139). However laudable his meditation, however, he has left the path and gets into trouble: happening upon a tournament between black and white knights, he supports the black underdogs and is taken prisoner by the white forces, who free him when he promises to do their will. Wisely, he leaves by a different path. These events, and indeed Lancelot's progress throughout the quest, are explicated by the anchoress whose dwelling he finds to his right. Her words, like those of all holy interpreters in the work, reassert the contrast between the limited perceptions of one caught in a maze and the transcendent vision available to those who know its true nature: the white and black knights were real knights engaged in earthly jousting, but they are also heavenly and sinful forces, respectively, and Lancelot chose wrong because his perspective was terrestrial. She continues in familiar imagery: "the hermits and religious . . . set your feet upon the path of Jesus Christ, which quickens with life and greenness like the forest. . . . And when you had left them, you shunned the path you had followed earlier, the mortal sins which were your former habit" (M159/P144).[49] She urges him to stay on the path of truth in the forest, so "vast and labyrinthine [*desvoiable*] in its depths" (M160/P145).

But Lancelot reaches an impasse where he is left passive, dependent on grace. A black knight slays Lancelot's horse, leaving him "hemmed in at all sides: in front flowed the [Median] river, to either side rose the cliffs, and at his back lay the forest. With whatever attention he considered these obstacles, he could see no salvation here below" (M161/P146). The labyrinth is inextricable without external aid, and here the *Queste* abandons Lancelot to narrate other knights' adventures. Much later we return to Lancelot, still "hemmed in [*enclos*]" by river, cliffs, and the forest so "vast and tortuous and mazy [*desvoiable*]" (M254/P246), waiting for the grace that arrives in the form of the ship

49. This interpretation of the forest as life-giving and self-renewing suggests that seeing only a "forest of error" (Fein, p. 225) is too limited. If the forest seduces and deceives, it also tests and makes worthy, like an instructive maze penetrable to the elect. As we shall see, the forest contains three different kinds of labyrinth, each with different moral implications.

carrying Perceval's dead sister. So long as he is on this ship, Lancelot moves as God wishes; as in so many medieval works, the boat without sail or oar has Grace as its invisible helmsman, and those guided by grace are on a unicursal path of truth.[50] In token of Lancelot's renewed virtue, and perhaps of his proper choice not to choose at all in the terrible valley, Galahad joins him on the ship for half a year. Eventually Lancelot is carried to Corbenic and a vision of the grail that leaves him paralyzed but in spiritual bliss for twenty-four days. That Lancelot explicates these events himself confirms that he has achieved transcendent vision, however partial and ephemeral it may be. Unworthy of sustained company with the grail, Lancelot returns to Camelot, one of only four to have reached the goal.

Thus Lancelot undergoes the most complex labyrinthine experience of any knight. At the start, and later in a significant relapse, he charges through the sinful labyrinth of trackless waste decried by Ambrose; but both times his offense is mitigated by his good intent—finding Galahad and then saving his own soul—so that, after major and minor humiliations, he receives guidance and mends his ways. He also passes with many hesitations (and for him, hesitation is an improvement) through the more formally multicursal moral labyrinth of the world; confronting repeated *bivia*, he gradually learns how to make the moral choices those physical bifurcations signify in the many-leveled landscape of the *Queste*. Aware of his own inadequacies, he welcomes guidance from hermits and maidens who see the labyrinth whole. He makes mistakes, leaves the right path, chooses new roads, and for a time finds the labyrinth inextricable. In this romance, so insistent on the necessity of grace, moral choice can take you only so far, leaving you in a dark, impassable valley. But Lancelot negotiates the intricacies of the world-labyrinth well enough to merit the best guidance of all: on the ship of Perceval's sister, he abandons conscious choice of direction and goes as God wills. Essentially, he enters a unicursal maze, or at least the true path defined by God

50. None of the ships in the *Queste* is under human guidance, though only this ship, built to carry Perceval's sister, is specifically described as being without sail or *aviron*, usually "oar" (M254/P246–247); the white ship that carries Bors, Perceval, and Galahad to the Ship of Solomon and that ship itself have sails, but God and *aventure* as steersmen (cf. M133/P119). That all these ships correspond to the rudderless boats common in medieval literature is made clear by a conversation between Bors and a priest: when Bors says, "A man's heart is the helm [*aviron*] of his ship and steers it where he lists, to harbor or to hazard," the priest responds, "At the helm [*aviron*] there stands a master who holds and governs it and turns it where he would; so it is too with the human heart. For a man's good works proceed from the grace and guidance of the Holy Ghost, the evil from the enemy's seduction" (M178/P165). Thus God and grace provide both impetus and direction to those in the holy ships of the *Queste*. It is also worth remembering that for Jerome the ocean is a labyrinth to be navigated only with God's help.

For other steerless boats in medieval literature, see Kolve, *Chaucer and the Imagery of Narrative*, pp. 325–340.

in a multicursal terrain. Lancelot fleetingly attains his goal, and he has wisdom and grace enough to wend his way back through the forest to Camelot, bearing news of his vision. If he does not completely transcend the worldly labyrinth, he charts it thoroughly, becoming an exemplary Everyman, as Charlotte Morse has argued.[51] What and how he learns explains why a circuitous path may be necessary to achieve instruction: steps must be retraced, literally or intellectually (as when his experiences and visions are explicated); and the long way round may be the only way to become worthy of the goal. Thus Lancelot teaches us by taking no path, the wrong path, and the only path—the three structural options of the medieval idea of the labyrinth. He chooses his way with the devil's guidance, his own misinformed free will, and divinely inspired aid, finally learning patience and his own limitations and submitting to the sure, silent control of *aventure* and a providential ship.

Less experienced than Lancelot, Perceval is wiser, always acknowledging his need for guidance: while Lancelot plunges into the forest after Galahad, Perceval knows they cannot find the Good Knight, so he decides to retrace his steps to a good anchoress. Significantly, he can find "no path to take him there direct. However, he steered the best course he could" (M94/P72). Aiming lower, accepting his limitations, Perceval traverses the wilderness with care; good sense, good intent, and, presumably, grace guide him to his anchoress aunt, who proves his patience by making him wait for an interview and then for his departure. He is rewarded with the information that the Round Table images "the roundness of the earth, the concentric spheres of the planets and of the elements in the firmament," and that Galahad is a figure for Christ (M99–100/P76–78): he learns, implicitly, that he is moving through the well-planned labyrinth of the cosmos and that Galahad may function as Christ-Theseus—indeed, that he will do so for Perceval, if Perceval remains chaste. With directions to find Galahad, Perceval sets off, turning always to the right to find an abbey and then, in a chapel without an entrance, to find Mordrain, sick, blind, and ancient, who had approached too near the grail (M103/P81). Perceval's course recapitulates and corrects Lancelot's path to the adventure of the sick knight, as is proper: the knight entrapped by the labyrinth of lust cannot accomplish what the chaste knight can. If Perceval's right turns do not bring him directly to the grail, neither does he experience Lancelot's failure in finding the grail when unprepared. A slower, steadier, more circuitous approach fares better.

Later, a demonic horse carries Perceval to an island where he barely resists sexual temptation, instinctively chooses right, receives further guidance, and boards a providential white ship. He is instructed to "go

51. Morse, *Pattern of Judgment*, pp. 56, 59, 82–90.

wheresoever adventure leads thee," in assurance that God will guide him (M133/P115). Having patiently proven his spiritual worth, he submits to God's will and is led thenceforth, however circuitously, to the grail. Perceval's time in the wilderness and the multicursal maze is limited; in fact, he confronts no obvious *bivia*, though he must repeatedly choose between good and evil on the island, and his virtue and submission earn him unicursal passage to what he seeks.

If Perceval's course shows what Lancelot's might have been, Galahad, who needs no perfecting, defines the ideal unicursal path by recapitulating Christ's. He is the Theseus of this world-labyrinth, repeatedly rescuing his fellows and showing the right path even though no one can keep up with him until they have been purified by confession and trial. When Galahad can be found at all in the earlier parts of the *Queste*, he is often on a distinct path, moving as *aventure* and his path lead him.[52] He arrives where and when he is needed, without making any conscious choices to find his way.[53] Thus, told to find the Castle of Maidens, he thanks God for guidance (clearly moral rather than physical) and arrives almost immediately (M72/P46). We are not surprised that he of all knights goes right: he is perfect, "li Bons Chevaliers," and he has been sent in token of Christ to banish folly and error (M64/P38). Like Christ, he walks the true path, defining a unicursal course through the multicursal maze of this world, almost without active volition: thus he, even more than Bors and Perceval, spends much of his time in ships, passively accepting God's will and going where God sends him.[54] This passivity, echoing Christ's preeminent virtue of patience, extends to Galahad's whole career: we are constantly reminded that he is foreordained to achieve the grail and to perform certain miracles on the way; his course is charted from the start, and he fulfills almost as many prophecies as Christ himself. Significantly, one of his first adventures, purging the Castle of Maidens, signifies the harrowing of hell, the event in Christ's life foreshadowed by Theseus's penetration of the labyrinth. No wonder, then, that Galahad so easily

52. Thus, while his companions head into the wilderness upon leaving Camelot, Galahad's path leads him directly ("droit") to the abbey of the Shield (M53/P26); we are not told that he takes either path at Melias's *bivium*, but later he arrives to save Melias "com ses chemins l'i amena" (M68/P42). And after rescuing Perceval, he takes the "wide road" through the forest "come aventure le menoit" (M207/P195). After wounding Gawain in a tournament, he leaves "as fortune shaped his course" (M209/P197), and when he leaves Lancelot on the ship, again he follows "where chance shall take you" (M259/P252). For Galahad, the right path and *aventure* are synonymous: Providence lays down his path.

53. As Todorov puts it, "With Galahad, hesitation and choice no longer have any meaning; the path he takes may divide, but Galahad will always take the 'good' fork"—"The Quest of Narrative," p. 140. Actually, Galahad never is shown taking one or the other fork, even at Melias's *bivium*.

54. Ihle also comments on Galahad's passivity: *Malory's Grail Quest*, p. 76. More generally, she notes, "In order to have adventures in the *Queste*, a knight must submit himself entirely to God's will and live in a state of preparedness and penance. Passive acceptance of God's will, rather than reliance on one's own prowess, determines success" (p. 71).

finds his way; he is already marked as a figure of Christ, and here some medieval readers might see him as a new Theseus destined to unwind the worldly labyrinth. Galahad never experiences the inextricability that plagues his fellows and forerunners: Lancelot in the valley, Perceval on the island, or the Maimed King who "had pushed too deep into the forest to find his own way out, being unfamiliar with its paths" (M220/P209), and who can be cured only by Galahad, master of all paths.

The imagery of path and choice in the *Queste* is shaped into a highly sophisticated development of the idea of the labyrinth. Normally, as we have seen, there is no hierarchy among the various forms of the maze, which, indeed, most writers do not even distinguish one from another. Yet Prudentius and Ambrose imply that a single path, whether through a wilderness or a multiplicity of choices, is best, and unicursal cathedral labyrinths that define the path of Christ-Theseus, like those at Auxerre and possibly at Chartres, may make a similar point. The author of the *Queste* goes still further: he makes systematic distinctions between three forms of maze and links each with a moral state. First, there is the thick, trackless waste without guides (though *aventure* may operate behind the scenes); those who rush into it are in a morally perilous condition, unable to see the paths that may actually be offered. In avoiding paths, or in failing to see them for what they are, such people deny the existence of a grand pattern and the architect into whose plan they fit. In a very real sense, they take themselves out of the running. The multicursal path, full of *bivia*, dead ends, and backtracking, contains abundant if sometimes misleading guidance: ambiguous signposts, inscriptions, dreams, visions, explications, and exhortations of holy advisers, which the wanderers are free to accept or reject. This is the probative world of moral choice where providence looks like fortune, the one where most other romances take place. Neither good nor bad in itself, this multicursal maze is precisely what one makes of it. Yet because the multicursal maze intrinsically emphasizes individual choice, activity, and self-reliance, it is dangerous: success may foster independence and pride. The multicursal maze is implicitly Pelagian: by choosing right, one can apparently merit salvation even without grace. The fates of Hector and Gawain show what the author thinks of that proposition. In the *Queste*, as in so many works of Christian heroism, the elect—those who are chosen rather than those who choose—move beyond multicursal choices and individual volition to a wise passivity: submission to God's will as expressed by *aventure*, rudderless boats, and the single path of Christ or Galahad laid out in prophecy. This is "the path of Jesus Christ, which quickens with life and greenness like the forest," for it is found within the forest and leads to regeneration, transcendence, penetration of and extrication from the maze. Galahad is on that path from the beginning,

and he need not even choose whether to continue; the only guide he needs is *aventure*, the shaping hand of the architect. Of those tested by the difficult process of multicursal options and found worthy, Perceval attains the security of a unicursal path rapidly, Bors more slowly, and Lancelot with the utmost difficulty; others find it not at all as they wander aimlessly, without grace, *aventure*, or willing participation in a cosmic pattern.[55] Thus in the *Queste* an individual's moral worth determines not merely his passage through the labyrinth but also what kind of labyrinth he must tread. And possibly, just possibly, the interwoven subplots of the work are developed from these three forms of the labyrinth.

All paths in a maze are circuitous, digressive; that is one thing that differentiates them from ordinary paths and helps us distinguish true mazes from interconnected roads. In the *Queste*, paths are remarkably roundabout. When Perceval wants to retrace his steps to the anchoress, there is no direct route; you can get here from there, but not vice versa. Early in the romance, we suspect that digression may be the right path when we learn that Christ set Joseph of Arimathaea on the road of wandering (M58/P32). Galahad frequently wanders almost randomly, now here, now there, now ahead, now behind (M207, 269/P195, 262), always arriving where and when he must. In one of the work's most astonishing passages, "a passage which audaciously boasts its narrative non-sense" according to Tzvetan Todorov, Galahad, Bors, and Percival journey to the sea in obedience to Christ's instructions to conduct the grail to Sarras. "The three of them covered so much ground that they came to the sea in less than four days' riding. They would have got there sooner still save that, being strangers to those parts, they did not take by any means the shortest route."[56] For Todorov, "the 'unnecessary detail' is perhaps, of all details, the one most necessary to narrative." Perhaps; yet I suggest that in this extraordinary circuitousness we are dealing with a meaningful signal: the most direct route is not necessarily the correct route in moral and spiritual matters—or, for that matter, in labyrinths. The forms must be obeyed, and certain kinds of disorientation may be the prerequisite for the truest orientation.[57]

Circuitous routes and complex processes may be best for several reasons. Lancelot's direct approach to the grail fails, and only his stumbling,

55. Todorov makes a simpler but somewhat analogous distinction in contrasting Galahad's "ritual ordeals," demonstrating his worthiness, with Bors's and Perceval's "narrative ordeals," through which they become worthy: "The Quest of Narrative," p. 131. One might also detect an independent trace of the same idea—that right motion through a multicursal maze brings the peace of unicursal guidance—in *The Assembly of Ladies*.

56. Todorov, "The Quest of Narrative," p. 137; and M278/P273.

57. One is struck, also, by the fact that the three days it takes Galahad and his companions to extricate themselves from the labyrinth of Logres correspond to the three days Christ-Theseus spent in hell before liberating the just. Judicious patience and passivity characterize both Christ and his true knight.

hesitant passage teaches him what he desperately needs to know, whereas Perceval's delays instruct him in patience. Galahad's roundabout rovings conform to God's time and direction, not ours, reminding us that there is a difference; in the cosmic labyrinth as in non-Euclidean geometry, the proper, even the shortest, distance between two points may very well not be a straight line. As in the forest, so in the tale as an artistic construct, as has often been noted, the narrative digresses from one knight to another, backward and forward in time, always accentuating the sudden change in direction with a reference to "li contes" and its vagaries: "the tale now turns aside a while from the mainstream of its subject [de sa droite voie et de sa matiere]" (M221/P210). Internal digressions abound, as visions, events, prophecies, and the history of the grail are explicated. Some things, it seems, cannot be learned without preparatory delays, digressions, and interpretations that enforce a second or third covering of the same ground, as in labyrinthine theory of learning outlined in Augustine's De magistro. In labyrinths and learning alike—in the world-labyrinth as in the text-labyrinth—the longest way round may be best. Complexity—moral, spiritual, physical, intellectual—requires subtle, careful tracing rather than direct statement; people see, hear, and understand only what they have been prepared for. As Todorov has said of the systematic reduplication of the errant knights' and our own experience in the Queste, whereby so often dream or prophecy heralds an event that much later acquires explanatory commentary, "we arrive slowly at comprehension of what was given from the beginning";[58] delayed comprehension, understanding gained only through confusion, is what a labyrinth is all about. Morally, too, the delays imposed by circuitous processes are important: if choice proves you, patience makes you almost perfect, as actor and as reader.

Circuitousness and repeated explication, then, help make one morally worthy to find a way—or, rather, to be conducted by grace in its various forms—out of the inextricable/inexplicable labyrinth of this world. They also help one penetrate the mysterious labyrinth of the grail, to move from the darkness of forests and mazes into the light of truth. As we have seen, being inside a labyrinth entails partial vision, from here to the next turning. This partial vision afflicts many of the characters in the Queste, and references to blindness are common.[59] As Morton Bloomfield said of romance in general, "Something is happening about which we cannot be clear. In the eyes of God, in another dimension, all these episodes are no doubt explicable, but to human eyes, in the human dimension, something puzzling is going on. The center of the story is not

58. Todorov, "The Quest of Narrative," p. 135.
59. See, e.g., Ihle, Malory's Grail Quest, pp. 84–88. One of Ihle's themes is partial vision, although she associates this characteristic with Gothic architecture in general rather than with mazes.

within the tale but beyond it. . . . One is driven to assume that if he were to see the events from above or from another center the inexplicable would be explicable."[60] That is why we need guides, prophecies, and explications. The very presence of interpreters who clarify the inner meaning of dreams and visions illustrates the dual or multiple perspectives implied by mazes, which can be seen in part (from within) or whole (from above, or through memory and insight). That the questing knights need their services reminds us of the limited vision inherent in the mazy forest, and the interpretations—privileged word from above, as it were—help us locate events within the overall pattern that we and the wanderers sense but do not see. They remind us of the goal and the process necessary to reach it; they also reassure us that the twisting roads have meaning, that there is a great architect who planned the labyrinth in which readers and knights find themselves. Nowhere is this clearer, of course, than in the prophecies concerning Galahad and the digressions on the history of the grail, which forcefully assert that there is order in chaos, that providence guides the wheel of fortune-*aventure*, if we can only see it. As Morse has emphasized in her felicitously entitled *Pattern of Judgment*, "the *Queste* recounts the beginning of history in Paradise and, in the advent of Galahad and the judgments on Carcelois and the leprous lady, foreshadows its ending," thereby "placing the Round Table fellowship in the pattern of sacred history" (p. 68). The pattern of adventures justifies the pattern of judgment, reflecting the circular labyrinthine patterns of providence echoed in the circular Round Table and the cosmos it figures (M99/P76). The work as a whole, then, remedies partial vision and allows a transcendent view of the whole design of human history as patterned by God the great architect, even though some mysteries remain ineffable; if the labyrinth of the world becomes transparent, the labyrinth of God, the full meaning of the grail, does not.[61]

I have argued that the *Queste del Saint Graal* is a labyrinthine work of art showing the world as a moral labyrinth in which humans work out their destinies by making moral choices with the aid of privileged explication (and *inexplicabilis* is an adjective almost as commonly descriptive of mazes as *inextricabilis*). This world-maze is an admirably complex work of divine art, wrought by a Daedalian God, patterned by moral laws of cause and effect, and bound together temporally by prophecy and fulfillment. Those within the labyrinth must navigate confusing and circuitous *ambages* and *errores* to attain their goal of salvation, or else be doomed to imprisonment in *error*. But the labyrinth leads those who

60. Morton W. Bloomfield, *Essays and Explorations: Studies in Ideas, Language, and Literature* (Cambridge: Harvard University Press, 1970), pp. 106–107. Also discussed by Ihle, *Malory's Grail Quest*, p. 60.

61. See Ihle, *Malory's Grail Quest*, pp. 40–53, on the ineffability of the grail.

solve its windings to a transcendent understanding of the patterns of individual and human history even as those entrapped within are subject to continuing blindness and partial vision. In depicting the world as a labyrinth, the *Queste* draws on the vast medieval store of labyrinthine qualities and connotations. It combines the ideas of inextricability and impenetrability with subtle ingenuity; it alludes to the ancient idea of the labyrinth as a pathless waste for those whose lives deny the existence of a moral order, and it shows how the repeated choice and special guidance demanded in the multicursal maze develop and illustrate moral rectitude. It also draws upon the peculiar characteristics of the unicursal maze to illustrate that those who persist in the path of righteousness may move beyond choice to enjoy the careful and circuitous direction of grace. Thus, perhaps, the *Queste* not only suggests an unusual hierarchy of labyrinths but also transcends the *aporia* that may be inherent in the two visual models of the maze to demonstrate how individual effort and divine grace, free will and predestination, are compatible aspects of divine order. Overlaying action with commentary, providing what Todorov calls a "double narrative," the work repeatedly exemplifies the dual perspective implied by the labyrinth's simultaneous embodiment of process and product.[62] Indeed, the maze's characteristic dualities pervade the *Queste*: blindness and insight, chaos and order, confusion and clarity, path and plan, unicursality and multicursality, vision from within time and from eternity. The work draws on conventional meanings of the labyrinth: as lust (for Lancelot and perhaps, indeed, for all, given that chastity is an absolute prerequisite for success); as fortune/providence; as sin; as a place of violent death; as a learning process.[63] Even the narrative line is labyrinthine, turning now here, now there, in the story of the quest.

Texts may be superlatively labyrinthine in effect whether or not authorial intention is brought into consideration. Speculation on intent is always tricky, and particularly so in the case of anonymous authors, but a few words on the subject may nevertheless be profitable. If the author consciously used the idea of the labyrinth in shaping the *Queste*'s form and content, as I am almost convinced he did, it is easy to see why: the

62. Todorov, "The Quest of Narrative," p. 123. See also E. Jane Burns's discussion of the multiple perspectives within the narrative voice of the *Estoire del Saint Graal*, whereby "the unitary voice of God is subtly displaced by the plural and all-powerful voice of *li contes*," producing "a text which weaves in and out of time," "insisting on a plurality of temporal modes"—"The Teller in the Tale: The Anonymous *Estoire del Saint Graal*," *Assays*, 3 (1985), 73–84. Though Burns's analysis refers primarily to the *Estoire*, it suggests yet another way the text of the *Queste* is as labyrinthine as its imagery.

63. At times, the work seems almost to allude to the Cretan myth; at least, those with obsessively labyrinthine mentalities may detect parallels between Arthur and Aegeus or between Galahad and Theseus, for instance, or one may find the hair sacrificed by Perceval's sister, one of the most important explicators of all, oddly reminiscent of Ariadne's thread.

tradition of the labyrinth provided an amazingly rich and varied image that might lend coherence to many concepts important in the work, not least the reconciliation, or at least the containment, of crucial dualities: grace and merit, fortune and providence, limited vision and transcendent understanding, and the relationship of all these ideas to a search for the best path through a complicated world. The labyrinth is, after all, the place that best incorporates *error*, and the Latin word's Old French derivatives suggest how much that is pertinent to the *Queste*'s themes can grows from a single linguistic root. *Errer* describes both physical and moral or behavioral voyaging and conduct—literal journeys through the forest and spiritual ways of life. *Erroier* means "to go astray, to err." *Erre* means "way, path," *errement* may signify "adventure; order, disposition; legal process," and *error* refers to ardent desire, confusion, difficulty, suffering.[64] A definitive labyrinthine attribute, *error*, thus implies real and moral journeys, a true path and a way of error, desire to attain a goal and the confusion and difficulty of getting there, individual volition and customary procedure, chaos and order. In these derivatives of *error*, in labyrinths, and in the *Queste*, human wanderings and confusion may, from another point of view, manifest divine order, and the choice of path and mode of proceeding may constitute a process of justice. No wonder an author might choose the image of the labyrinth to show patterns of judgment for *chevaliers errants*.

What is not so easy to explain is why the author would then have left the image inexplicit. I can offer two suggestions, neither completely convincing. The *Queste* was written in the vernacular, presumably for the laity; since the classicizing friars had not yet done their work, an early thirteenth-century author might have felt that the labyrinth was too exotic an image, let alone too unfamiliar a word in French,[65] for a comparatively unlearned audience to comprehend easily, and perhaps inappropriate as an explicit concept in a deeply Christian work about Arthurian knights. Alternatively, the word *labyrinth*, at least in Latin, may have carried so many purely pejorative connotations that the monastic, if not Cistercian, author may have thought its significance *in malo* would overshadow the meanings *in bono* employed in the *Queste*. Labyrinths were often associated with heresy in this period, as we have seen; indeed, two of the four so-called labyrinths of France, Peter Abelard and Gilbert

64. See *Dictionnaire de l'ancien français jusqu'au milieu du XIVᵉ siècle*, ed. A. J. Greimas, 2d ed. (Paris: Larousse, 1968), and Godefroy, *Lexique de l'ancien français*.

65. I have not been able to identify the earliest use of *labyrinthe* in French. Much later than the *Queste*, the term *maison Dedalus* was used to translate *labyrinthus* in 3p12 of Boethius's *Consolation of Philosophy*: cf. Jean de Meun (ca. 1300; Dedeck-Héry ed., p. 231); the mid-fourteenth-century translation in Bodley MS Douce 352, f.46r; and the anonymous Benedictine translation (ca. 1380), Bodley MS Douce 298, f. 51v. This term, highlighting the human artificer, might have struck the *Queste* author as inappropriate for so spiritual and Christian a vision of the maze.

of Poitiers, had been violently opposed by that great Cistercian Bernard. The word may thus have been too loaded, its meaning too narrow in popular usage, to allow the considerable freedom the *Queste* author took with the idea behind it. I would have liked to prove that the labyrinth was consciously chosen as the central image in the *Queste*, but I will be content if I have shown that the idea of the labyrinth organizes and unifies the text—a good deal of the imagery, concepts, and structure—and that it does so better than the image of the forest or the concept of interlace, which receive further discussion in the next chapter.

Textual Labyrinths: Toward
a Labyrinthine Aesthetic

Nemo ambigit ... cum aliqua difficultate quaesita multo gratius inveniri.

What is sought with difficulty is discovered with more pleasure.
<div align="right">Augustine, On Christian Doctrine 2.8 (13)</div>

T HE PREVIOUS chapter looked at labyrinths *in* medieval texts; now we turn to a broader subject: the text, and the complex intellectual processes related to its creation and reception, *as* labyrinth. The essential qualities of the labyrinth, defined in Chapter 2, remain the basis of these speculations on the inherent labyrinthicity of much medieval literature and literary theory. A text that is well-constructed according to medieval theories of rhetoric is, as we will see, often very like a maze: it is an ornate, highly complicated work of art, elegantly ordered by interwoven parts comprising an admirable whole.[1] As the text itself is a labyrinthine artifact, so its creation and reception are labyrinthine processes. Its *labor intus* implies both the author's meticulous workmanship and the reader's painstaking interpretation. And because labyrinthine texts are so complex, apprehension of the whole may be thwarted by inextricable immersion in its parts: writers and readers may not achieve the privileged understanding that patterns and makes sense of internal *errores* and *ambages*. Would-be Daedalian writers may grow bewildered by the sheer proliferation of their sources or their own verbiage; readers or listeners may be so disoriented by elaborate amplification, circuitous expression, and a multiplicity of interpretive

1. Medieval rhetorical writings included treatises on poetry, letter-writing, and preaching.

options that they lose all sense of the whole or even abandon the pursuit of a center entirely, closing the manuscript or sleeping through the sermon. Intellectual and literary labyrinths can be as inextricable and inexplicable as architectural ones, an idea we have already encountered in Chapter 3.

Verbal mazes are also convertible and perspective-dependent: the very *ambages* that confuse one reader or listener may delight another and lead him or her to a transcendent vision of the whole, and a work that is enigmatic on one reading may yield precious knowledge when its windings are probed a second or third time. Persistence pays off with difficult texts as it does with mazes, and appropriate guidance, like the interpretive statements embedded in the *Queste del Saint Graal* or the leading questions of the old man in the *Corbaccio* or the moral appended to the *Gesta* tale or Jerome's commentary on Ezekiel, can often help.

The labyrinthine characteristic most prominent in intellectual and textual mazes is difficult, circuitous process: per ardua ad astra. Often this elaborate process is prescribed by what I will call the labyrinthine aesthetic of much medieval literature, an aesthetic outlined in rhetorical handbooks and defenses of poetry. Difficulty is privileged partly as a method of attaining elegance and well-wrought artistry; partly as a way of keeping the unworthy from profaning the finer achievements of civilization; and partly as a pedagogical technique to ensure that knowledge, once gained, is appreciated.

The labyrinthicity of intellectual and textual processes may be seen as good or bad. If the artistic design of the whole work succeeds, the labyrinthine process functions *in bono*, and the artistry is penetrable and perceptible to those meant to penetrate and perceive. But when artistic complexity goes awry, serving an unworthy end or leaving its intended audience imprisoned in complexity—when the textual labyrinth is inextricable, in short—it is to be condemned. Thus the labyrinths of scripture, esteemed by Rudolf of Saint Trond as by Jerome, are admirable, whereas the heretical labyrinths woven by Peter Abelard, according to Walter of Saint Victor, are not—at least to their critics. Similarly, the difficulties of complex literature, praised by lovers of rhetoric like Geoffrey of Vinsauf and Boccaccio, are problematic for pastors like Hugh of Saint Victor and Robert of Basevorn, who privilege the spiritual needs of unsophisticated audiences easily confused by rhetorical devices that enchant the learned; the crucial issue is whether the complex work is penetrable and extricable or not, and for whom. Good textual labyrinths exercise the mind of the creator and interpreter, leading to a goal of enlightenment for the intended reader; bad labyrinths involve art in the service of a bad master or, alternatively, language so complex that the intellectual wayfarer is sidetracked when a more direct path or a plainer

style might have taught him something. Labyrinthine complexity and convertibility, then, may be assets or liabilities.

Parts of this chapter involve a fair degree of speculative interpretation of medieval evidence. I am going to argue that the idea of the labyrinth informs a good deal of medieval literary theory (the writings of Geoffrey of Vinsauf and the poetics of Boccaccio, for instance). Yet neither Geoffrey nor Boccaccio mentions the labyrinth explicitly in the discussions in question. How, then, can they be describing a labyrinthine aesthetic? As we saw clearly in Ovid and Virgil, and with strong probability in Prudentius, the *Gesta Romanorum*, and the *Queste del Saint Graal*, people writing about labyrinths don't always name them. The refusal to use the word may be witty, as in Ovid: name a circuitous thing circuitously. It may come from the desire not to confuse an audience by unfamiliar references, as with the *Gesta*. It may be a matter of keeping the classics and Christianity separate, as perhaps with Prudentius and the *Queste*. Presumably none of these reasons applies to Geoffrey or Boccaccio. However, it is possible that writers, particularly writers defending ornate secular literature, might avoid the *word* "laborintus" because of its generally pejorative connotations in the moral contexts reviewed in Chapter 6, even though the *idea* of the labyrinth in its full complexity is perfectly acceptable. Geoffrey advocates an exceedingly elaborate "high" style: as Jane Burns has noted, among rhetoricians "the guiding principle for both reading and writing is not Truth but artifice."[2] And Boccaccio justifies rhetorical obscurity as good in itself. Now, it is very likely that it was not really as dangerous to defend rhetoric, the high style, and poetic difficulty as medieval theoreticians sometimes pretended; but even so, recriminatory vituperations from antiliterary rednecks might legitimately be expected. Why, Geoffrey and Boccaccio might have asked, provide extra ammunition by pointing out that one was actually recommending the creation of labyrinths of words—perilous, inextricable, error-filled imitations of pagan rather than Christian art? For so those moralists who inveighed against secular fiction might well have interpreted the labyrinth. Moreover, few writers would like to imply that they were intentionally instilling the confusion so often associated with labyrinths; perhaps difficult process is one thing, labyrinthine involution quite another (even Geoffrey, master of circumlocution, speaks repeatedly of the need to be *clear*—to sophisticated readers, of course). Not many people went as far as Eberhard of Germany, whose rhetorical treatise is called *Laborintus*, a title that provides a fair measure of justification for assuming that an inherently labyrinthine aesthetic might be consciously perceived as such. If the word *labyrinth* was not often used to

describe praiseworthy literature and literary theory in the Middle Ages, in contrast to the honoring of labyrinthine art in classical and early Christian times, then, the common pejorative associations of the word may have played some role in that curious omission.[3]

But my argument does not rely on the conscious use of the labyrinth by authors like Geoffrey and Boccaccio. I propose merely that the *idea* of the labyrinth is a useful model or analogue for, and codification of, the way much literature was thought to be designed, written, and understood. Consciously or not, many medieval theoreticians saw complex literature as labyrinth*ine*: as highly patterned art, circuitous and ambiguous in design, expression, and experience; relative and convertible; inextricable or impenetrable if badly wrought or if intended for a select few; and teleological in one sense or another: either some new knowledge is to be achieved at the center of the textual maze or the circuitous process itself is beneficial, exercising or relaxing the faculties. In the labyrinthine spirit of duality, difficult literature can be a labyrinth *in bono* or *in malo*, depending on what one thinks of labyrinths and literature in general and in particular. Complex literature is none the less labyrinthine even if its writers thought of labyrinths not at all.[4] If at times in this chapter, in Hans-Georg Gadamer's words, I "understand what the text did not at all intend to say, but [that] which we find expressed in it," I am also treating the labyrinth as an implicit "parallel system" or covert image that may reasonably be extrapolated from a text and used to shed light upon it.[5]

To begin this discussion of verbal labyrinths, consider the description of a labyrinthine literary text in Hugh of Saint Victor's *De arca Noe morali* (ca. 1125–1130), in a passage that suggests how he thinks writing is, and is not, a labyrinth. Hugh spends four long books explaining the manifold symbolism of the ark, the need for each man to build his own spiritual house of God, the reason why so much labor is involved in the process, and the final symbolism of the ark as container of all human history, all mystery, all faith, existing beyond time in an eternal present. At last, he asks, "What then is this ark, about which we have said so many

3. Although the word *labyrinth* was often avoided where it might have been expected in texts with a high density of labyrinth lexis, the visual image, and thus the principles implied in that design, continued to denote great artistry during the Middle Ages, as we saw in chap. 5.

4. Cf. Martin Esslin: "A descriptive term applied post factum may be useful even if the people to whom it is applied are unaware of its existence and meaning, provided that such a term is not taken as totally defining the works to which it is applied, but merely as descriptive of certain features which they have in common and which are basic to them": *An Anatomy of Drama* (New York: Hill & Wang, 1976), p. 59.

5. See Hans-Georg Gadamer, *Truth and Method*, trans. Garrett Barden and John Cumming (New York: Seabury Press, 1975), p. 304, and Judson Boyce Allen, *The Ethical Poetic*, pp. 146–149.

things, and in which so many different paths of knowledge are contained? You do not think it is a maze, I hope? For it is not a maze, nor is there toil therein, but rest [*Non labyrinthus, nec labor intus, sed requies intus*]."[6] Hugh's witty etymological disclaimer suggests that he knows very well that his work consists of and enjoins labyrinthine processes. Both the text and the processes of understanding and reform it advocates are long, circuitous, and arduous, potentially as exhausting and bewildering as any inextricable maze. Hugh's extended exegesis is itself loosely labyrinthine in structure: he offers so many perspectives on a biblical text, so many alternative interpretations of each detail, that the "many different paths" create a multicursal hermeneutic maze of staggering complexity and artistry crammed with choices and clues each of which leads to an important center of new knowledge.[7] But Hugh insists that neither his text nor the work it entails is ultimately *labor* or a labyrinth, and the implied reasons are revealing: through toil comes eventual rest, and there are no frustrating blind alleys, for each path is fruitful. For Hugh, apparently, true verbal labyrinths—and he takes the word in a strictly pejorative sense—take you nowhere, but his own labyrinthine work brings transcendence of mundane mazes through the perception of stable order from the privileged perspective of eternity. Textual complexity and interpretive multiplicity suggest labyrinths to Hugh, else why would it occur to him that people might think his treatise a labyrinth? His defense is that because his work is not inextricable and profitless like mazes *in malo*, it is not really a maze. Perhaps, too, he sees the ark as a better image of cosmic complexity than the pagan labyrinth: *domus Dei* is not *domus daedali*.[8] Hugh's comments, then, reflect the inherent labyrinthicity of difficult texts—their complex artistry, their circuitousness, their reliance on the polysemousness that turns one path into many, their convertibility from confusion to order. At the same

6. I use Sr. Penelope's translation, *Selected Spiritual Writings* (London: Faber, 1962), p. 151; see also *PL*, 176, 679–680.

7. The structural analogy between multicursal maze, allegory, and medieval *distinctio* (a medieval technique for ordering various interpretations of a key word or concept by listing, and often diagramming, the options as branches of a single topic) is implicit elsewhere: Hugh comments, "We set out to talk about one ark, and one thing has so led to another that it seems now we have to speak not of one only, but of four. . . . Let us call the first Noah's ark, the second the ark of the Church, the third the ark of wisdom, and the fourth the ark of mother grace. Nevertheless, there is in a certain sense only one ark everywhere. . . . The form is one, though the matter is different" (*Selected Spiritual Writings*, pp. 59–60).

8. See *Didascalicon* 6.2 and 6.4 on scripture as *domus*. In later quotations from the *Didascalicon*, I follow Jerome Taylor's translation, *The Didascalicon of Hugh of Saint Victor: A Medieval Guide to the Arts* (New York: Columbia University Press, 1961), here pp. 140–141. I have checked the translation against C. H. Buttimer's Latin edition (Washington, D.C.: Catholic University Press, 1939).

time, he bows to the common view that good texts should not be called labyrinths because they are not inextricable or impenetrable. So generally were mazes and inextricability linked in the popular imagination that the *idea* of the labyrinth may inform a good text, but the *name* should be omitted.

Hugh's comments suggest the relativity or convertibility of the labyrinth: what seems labyrinthine while in process becomes order once labor brings understanding. This is one reason why the labyrinth is a useful model for difficult texts or arguments presenting complex ideas in a circuitous or elaborately articulated order to enhance effective teaching. To the learner or decoder, such a text may seem a labyrinth; to the teacher or encoder, it is well-ordered to convert ignorance to mastery. Knowledge, then, has two faces: the confused, pejoratively labyrinthine face turned to the student as yet ignorant of what may be discovered, and the ordered face delineated by the experience of the labyrinth. As the *rota-rosa* contains two designs in one figure, so the labyrinth is a dual image of circuitous confusion and concentric circles of order.[9]

In a similar spirit of duality, the labyrinth may be a model both for the literary work as textual product and for the intellectual processes a text implies, from its conception as a text to the choices and difficulties involved in its writing and reception. We are now ready to pursue the analogy more systematically. At the start of his well-known treatise *On Christian Doctrine*, Augustine notes that the study of scripture demands "a way of discovering those things which are to be understood, and a way of teaching what we have learned."[10] Regardless of whether literature is didactic or recreational, certain requirements pertain to any considered act of communication: the author/speaker must have discovered something to say (in medieval rhetorical terms, there must be *inventio*); the chosen material must be appropriately ordered (*dispositio* or arrangement); and the content must be expressed clearly and, if possible, ele-

9. Concentric circles, the underlying structural basis of most medieval mazes, were often used as a visual teaching device: see John of Garland's stylistic *rota Vergilii*, "Poetria magistri Johannis anglici de arte prosayca metrica et rithmica," ed. Giovanni Mari, *Romanische Forschungen*, 13 (1902), 883–965, here 900; Ramon Lull's diagrams, several of them printed in Frances A. Yates, "The Art of Ramon Lull," *Journal of the Warburg and Cortauld Institutes*, 17 (1964), 115–173, and *The Art of Memory* (London: Routledge & Kegan Paul, 1966); Harry Bober, "An Illustrated Medieval Schoolbook of Bede's *De Natura Rerum*," *Journal of the Walters Art Gallery*, 19–20 (1956–57), 64–97; and Murdoch, *Album of Science*, pp. 52–61. Hugh uses the image to suggest divine order in his second treatise on the ark, *De arca Noe mystica*: God appears within the ark holding a sphere, whose outermost circle shows the heavens and the zodiac; inside is a circle of air, seasons, and the winds; inside that, a map of the world: see *Selected Spiritual Writings*, pp. 31–32. *Rotae* of winds, elements, humors, and qualities were common mnemonic devices.

10. Augustine, *On Christian Doctrine* 1.1 (p. 7).

gantly (*elocutio*).[11] These steps, enumerated in countless classical and medieval rhetorical treatises, are at least potentially labyrinthine; they provide a useful framework for discussing the intellectual activities that go into the creation of texts (and figure in many other contexts as well). We begin with invention, which I interpret fairly loosely to include all the mental processes involved in finding material to write about.

· Labyrinthine *Inventio* ·

Most often, as medieval theory and practice tell us, authors cull their material from preexisting works—from literary authority (for the poet) or biblical/theological writings (for the religious writer)—rather than from experience: writing about new material was considered too easy to merit serious discussion in an art of poetry.[12] The best composition, then, involves "invention" in a peculiarly medieval sense; far from being novel, a good subject entails reshaping other people's works or an arduous retracing of steps such as one might experience in a labyrinth. To find and develop this material, to "invent" it, writers normally applied certain procedures: for students of John of Garland (ca. 1195–ca. 1272), questions like "where? what? what kind? how? for what purpose?" would be guides to invention; others might search the Aristotelian categories and topics for methods of invention.[13] Whether authors rely on John, Aristotle, or other guides, they find a bewildering assortment of choices,

11. I use standard medieval rhetorical terms, but one might as easily use the vocabulary of the medieval *accessus* and speak of labyrinths appropriate to the *forma tractandi* (manner and style of treating a subject) and the *forma tractatus* (order and arrangement of parts in a work). The *forma tractandi* becomes labyrinthine when it involves ambiguity, puns, circumlocutions, etc.; the *forma tractatus* is labyrinthine when it involves interlaced narrative structures (discussed below), debate structures, theme-and-variations structure offering choices of points of view on a subject (as in the "Marriage Group" of Chaucer's *Canterbury Tales*), and so on. Similarly, the *forma tractatus* is particularly labyrinthine when, in Judson Boyce Allen's words, "the literal ordering of a text's material corresponds exactly to the order of that mental process whereby that material was invented and made significant." In such works as *Piers Plowman*, Boethius's *Consolation of Philosophy*, and *Sir Gawain and the Green Knight*, "meaning must arise out of the dialectic motion through its parts that is the experience of its characters," and "the experience of it is its meaning" (*The Ethical Poetic*, pp. 92–93). Allen and Minnis (*The Medieval Theory of Authorship*) devote considerable attention to the *forma tractandi* or *modus agendi* and the *forma tractatus*.

12. See Douglas Kelly, "The Scope of the Treatment of Composition in the Twelfth-and Thirteenth-Century Arts of Poetry," *Speculum*, 41 (1966), 273, and Geoffrey of Vinsauf's *Documentum de modo et arte dictandi et versificandi*, sec. 132, in Faral, p. 309. Faral prints the shorter form of the *Documentum*; the longer version, which discusses how to treat original material, is being edited by Sr. Margaret F. Nims of the Pontifical Institute of Medieval Studies, Toronto.

13. See *The Parisiana Poetria of John of Garland*, ed. Traugott Lawler (New Haven: Yale University Press, 1974), pp. 8–51; for a general view of methods of invention, see James J. Murphy, *Rhetoric in the Middle Ages: A History of Rhetorical Theory from St. Augustine to the Renaissance* (Berkeley: University of California Press, 1974).

a multicursal labyrinth of material and questions to ask about that material. But the mention of Aristotle is particularly significant because "Aristotle's labyrinth" seems to have been a medieval catchphrase in intellectual matters. What exactly did people mean by it?

Aristotelian concordances do not help: the only explicit labyrinth mentioned is "the sculptor's labyrinth," a spiral model used in ornamenting capitals. A peripheral source for the idea might be Simplicius's use of the labyrinth to illustrate Aristotle's concept of infinity as something difficult or impossible to traverse, a meaning consonant with medieval usage of the formula, as we shall see.[14] But we can do better than that: I would locate Aristotle's labyrinth—or, better yet, labyrinth*s*—not in an Aristotelian passage but in the whole Aristotelian corpus and methodology. For Prudentius, pagan philosophy, and in particular the philosophy of Plato and Aristotle, was a labyrinth; consequently, Aristotle's labyrinth can be simply the study of Aristotelian thought, which is pagan and therefore misleading. But Theodore Prodromos, a Greek writer of the twelfth century, more suggestively fears wandering "in the labyrinth of syllogisms," including the works of Aristotle and Plato: for Theodore it is presumably not pagan philosophy in general but rather logic and dialectic, taught in the west from the twelfth century on largely through the works of Aristotle, that constitute Aristotle's labyrinth.[15] In the visual arts, diagrams of Aristotelian categories, fallacies, rules for constructing syllogisms, and so on, are complicated and ornate, offering baffling arrays of choice which, if they do not exactly constitute multicursal labyrinths, bear some resemblance to them.[16] In literature, John of Salisbury was one of many whose praise of the *Topica* and *De sophisticis elenchis* is tempered by awareness of their bewildering difficulties. Thus he condemns "those who follow Aristotle . . . in a confusing babel of names and verbs and subtle intricacies [and thereby] blunt the mental faculties of others in their effort to show off their own intellectual capacity," using too much "obscurity" and "involved language."[17] The *Posterior Analytics*,

14. For Aristotle see *Historia animalium* 2.1, in Aristotle, *Works*, ed. J. A. Smith and W. D. Ross (Oxford: Clarendon Press, 1910), vol. 4; for Simplicius, see chap. 3, n. 29 above. The enthymeme, that rhetorical syllogism that rests on probability and hence may easily be false, might also have seemed deceptively labyrinthine.

15. For Prudentius, see chap. 3; for Theodore, *In Bareum, PG*, 133, 1412. On the two *Analytics*, the *Topica*, and the *De sophisticis elenchis*, see Murphy, *Rhetoric in the Middle Ages*, p. 106 and passim. In treating Aristotle's labyrinth of dialectic under "invention," I am thinking more of how one uses dialectic to discover what one wants to write about than of a dialectical method of presenting the material. Obviously, an author can enter Aristotle's labyrinth as inventor and as disposer.

16. See Murdoch, *Album of Science*, passim. The multicursal maze resembles a tree diagram in offering an extended series of choices, but where the choices in a tree branch *out*, the choices of a multicursal labyrinth eventually circle inward toward a single goal.

17. John of Salisbury, *The Metalogicon* 4.3, trans. Daniel D. McGarry (Gloucester, Mass.: Peter Smith, 1971), p. 207. For the Latin text, see *Opera omnia*, ed. J. A. Giles, 5 vols. (Oxford: J. H. Parker, 1948), 5, 159.

a standard school-text, is "extremely subtle" and "even more perplexing than the rest," and the *Perihermeneias* is essential despite, and indeed because of, its difficulty: Aristotle's "thoughts are very subtle," and his "wording is very difficult to understand. However, we should be thankful for both these features, for while the thoughts instruct, the words exercise our minds."[18] Although John does not mention a labyrinth per se, his language reflects the labyrinthine qualities he found in Aristotle's thought and words, and his appreciation of the *uses* of that difficulty takes us close to a labyrinthine theory of instruction if not to a labyrinthine aesthetic, both of which privilege circuitous process. Medieval consciousness of the difficulties and occasional inextricability of dialectic was keen, as commentaries on the labyrinth in Boethius's *Consolation* reflect: thus Denis the Carthusian (1402–1471) defines labyrinthine arguments as so complex that entangled readers can neither solve nor abandon them, always returning to the point whence they began: this sort of thing creates yet another conceptual labyrinth, that of oblivion, as Boncompagno da Signa notes.[19]

Humanists such as Erasmus, Milton, and Locke found the scholastic method, with its heavy dependence on Aristotle, labyrinthine in a pejorative sense. Walter of Saint Victor anticipated them, labeling Abelard, Lombard, and the others "the four labyrinths of France," all of them "puffed up by the same Aristotelian spirit."[20] More often, however, Aristotle's labyrinth connotes laudable complexity accessible only to the elite. Thus Arnulf of Milan (d. 1077), in a charmingly modest prologue to his history of the Milanese archbishops, demurs that he can provide only a simple chronological narrative account: he has never mastered the Quadrivium, and as for the Trivium, "meager wit has narrowed me so that I see only with difficulty the entrance to Aristotle's labyrinth [dialectic?] and the intensely difficult access to the palace of Tully [rhetoric]."[21] Much later (ca. 1300), a formulary from Orléans, a university noted for its classicism and later for its legal studies, indicates what a commonplace Aristotle's labyrinth had become: three form letters wish the student "health and easy entry into Aristotle's labyrinth," and if the formula itself does not suggest the value a knowledge of that particular labyrinth was thought to have, the linking of the maze with "the pearl of knowl-

18. *Metalogicon* 4.6 and 3.4 (pp. 212 and 166); for the Latin, 5, 162 and 130.

19. For Denis, see *Enarrationes seu commentaria in V libros . . . de consolatione philosophiae, Opera omnia*, vol. 26 (Cologne: Typis Cartusiae S. M. de Pratis, 1906), p. 424; for Boncompagno, *Rhetorica novissima*, p. 276.

20. Erasmus, Letter to Dorp (No. 337), in *The Correspondence of Erasmus, Collected Works*, vol. 3, trans. R. A. B. Mynors and D. F. S. Thomson, annotated by James K. McConica (Toronto: University of Toronto Press, 1976), p. 125; Milton, *Paradise Lost* 2.561; Locke, *Essay Concerning Human Understanding* 3.10.9; Walter, *PL*, 199, 1127. For labyrinths in *Paradise Lost*, see Diehl, "Into the Maze of Self," 293–296; I would interpret the evidence somewhat differently.

21. Arnulf, *PL*, 147, 289.

edge" in one letter makes it clear that this labyrinth is excellent to master, while sending the letter "in Thesean faith" suggests that mastery is eminently possible.[22] Aristotle's labyrinth, then, might be dialectic or even the Seven Liberal Arts, given the general intrusion of Aristotelian method into all branches of university curricula. Despite Arnulf's distinction, then, rhetorical invention could well take would-be writers into one or another part of the vast labyrinth of Aristotle's methods and writings, especially once the *Rhetoric* was translated into Latin by William of Moerbeke in about 1270.

Even people who know their way around Aristotle's labyrinths of topics, categories, and dialectic might find that thinking and writing about difficult intellectual concepts constitute an epistemological labyrinth. Thus Hugh of Saint Victor apologizes that his discussion of human intellectual powers has necessarily created "an inextricable labyrinth" not by "involved words" (rhetorical language), which presumably could have been avoided, but by "obscure matter."[23] And even material not intrinsically labyrinthine may become so when the sheer profusion of views and alternatives defies order and analysis. Ralph Higden, asked to write a history of the world, faces just this problem of mastering and arranging infinite data and understandably hesitates: "þoo toke I hede þat þis matir, as laborintus, Dedalus hous, haþ many halkes [recesses] and hurnes [corners], wonderful weies, wyndynges and wrynkelynges, þat wil nouȝt be vnwarled [unraveled]. . . . My witt is ful luyte to unwralle þe wrappyinges of so wonder werkes: þe matire is large, writers þerynne beþ many."[24] Invention, comprehension, and disposition fail when sources are inextricable; a good writer must be a Daedalian master of complexity. Thus invention can involve Thesean adventures through the verbal and conceptual mazes that provide subject matter to write about.[25] Understanding what is going on in labyrinthine sources is difficult, not least because of the profusion of choices and the circuitous logical processes required.

· Labyrinthine *Dispositio* ·

Disposition, the ordering of material that constitutes the writer's second task, is at least as labyrinthine as invention: its aim is a brilliantly and effectively structured work of linguistic art; it, too, involves constant

22. *Le Formulaire de Tréguier*, pp. 16, 20, 25.

23. Hugh, *Didascalicon* 1.4 (my trans. from Buttimer, p. 10).

24. Ralph Higden, *Polychronicon* 1.7; I cite Trevisa's expanded translation; Higden glosses the labyrinth "inextricabilem . . . intricationem"—1, 8–9.

25. Authority constitutes a multicursal labyrinth through which a medieval writer traces his own characteristic path, following now this source, now that, and periodically branching out on his own—a posture that Chaucer typically adopts, most clearly in *Troilus and Criseyde*.

202 · The Labyrinth in the Middle Ages

choice; and, according to rhetorical handbooks, it often deploys a circuitously "artificial" order that circles back and forth in time, as in the *Queste del Saint Graal*. Ironically, although the labyrinth is, as I will argue, the most appropriate analogy to poetic ordering, there is little explicit mention of mazes in this context, perhaps because few medieval authors want to recommend weaving confusion by imitating a labyrinth, even with contrary precedent in Jerome, Ennodius, and Sidonius. After all, as Thomas Aquinas notes, "Sapientis est ordinare [it is the function of the wise man to order]," and although the idea of the labyrinth includes order, popular medieval connotations of the word do not. Nor do labyrinths necessarily offer the "better and more certain path" detected by an early commentator in Geoffrey of Vinsauf's *Poetria nova*.[26] But if models for the poetic process provide few explicit labyrinths, many highlight one or another characteristic *in bono* of the labyrinth, and if we put the models together, the resulting composite image points to an implicitly labyrinthine aesthetic. It is worth noting that disposition was an extremely important aspect of medieval poetry, even though the subject is not extensively discussed in many rhetorical treatises, which focus more heavily on *elocutio* or expression. Douglas Kelly, Jane Baltzell, and others have emphasized that medieval theorists repeatedly advocated having a clear idea of what the poem was to accomplish, how it could best be structured to that end, and how the general plan should determine subsequent choices of style, ornament, and so on; and Edgar de Bruyne comments that preaching manuals in particular recommend "composition of incredible complexity, the theoretical simplicity and verbal virtuosity of which astonish us"—an opinion with which any student of medieval literature must concur.[27] If God ordered all things by number, measure, and weight, so should the human *artifex*, and ordering a text is no exception.

Medieval authors discussed *dispositio* in interesting and suggestive ways. In many *accessus* or academic prologues, the concept of *ordinatio* is addressed under the headings "formal cause" (the dual formal causes are the *forma tractandi* or method of treatment and the *forma tractatus* or arrangement of sections) and "final cause" (the end toward which the

26. I quote Thomas from A. J. Minnis, *Medieval Theory of Authorship*, p. 146. For Geoffrey's commentator, see Marjorie Curry Woods, *An Early Commentary on the Poetria Nova of Geoffrey of Vinsauf* (New York: Garland, 1985), pp. 18–19. Both Minnis and Allen (*The Ethical Poetic*) devote much attention to medieval discussions of disposition and the importance of the reader's understanding of the author's ordering principles.

27. Kelly, *Speculum*, 41, 261–278; Jane Baltzell, "Rhetorical 'Amplification' and 'Abbreviation' and the Structure of Medieval Narrative," *Pacific Coast Philology*, 2 (1967), 32–39; Edgar de Bruyne, *The Esthetics of the Middle Ages*, trans. Eileen B. Hennessy (New York: Frederick Ungar, 1969), p. 203. Many scholars in the earlier part of this century believed that because *dispositio* did not receive lengthy explicit treatment in rhetorical handbooks, it was not important to poets; this view is now largely discarded.

writing is directed—its perceived utility for its readers). Thus, commenting on Aristotle's *Ethics*, Aquinas distinguishes between two kinds of order. As A. J. Minnis summarizes, "One kind of order is that which the parts of a whole have among themselves. For example, the parts of a house are mutually ordered to each other. Another kind of order is that of things to an end."[28] Order is dual: there is an intrinsic and internal order of the thing itself as an artifact, and there is the order whereby the artifact is constructed for a purpose, thereby embodying a teleological process. Perhaps the best image of this dual order is the labyrinth, simultaneously depicting artifact and process.

Thus it is not surprising that rhetorical treatises illustrate disposition with metaphors that reflect one or more aspects of the text/labyrinth-as-artifact or the text/labyrinth-as-process. One such metaphor is building a house, which alludes simultaneously to process and to the resulting artifact. Other common metaphors describe process only: the following of a path, or circling around a certain point. Yet another metaphor, more common in twentieth-century analyses of medieval writing than in medieval works themselves, is the interlace, based in part on the idea of the text as a weaving together of words. All these metaphors merit further discussion in the quest for an implicit labyrinthine aesthetic.

Comparisons of house to literary work are based on the fact that both artifacts demand disposition, actual construction, and elegant decoration. The best-known example is from Geoffrey of Vinsauf's *Poetria nova*:

> If a man has a house [*domum*] to build, his impetuous hand does not rush into action. The measuring line of his mind first lays out the work, and he mentally outlines the successive steps in definite order. The mind's hand shapes the entire house before the body's hand builds it. Its mode of being is archetypal before it is actual. . . . [Thus, in writing poetry] let the mind's interior compass first circle [*circinus . . . praecircinet*] the whole extent of the material. (N16–17/F198–199)[29]

28. Minnis, *Medieval Theory of Authorship*, p. 147.
29. On the house-poem analogy, see Charland, p. 194, and Ernest Gallo, *The Poetria Nova and Its Sources in Early Rhetorical Doctrine* (The Hague: Mouton, 1971), p. 137; for the three parts of building, see Isidore, *Etymologiae* 19.9, following a passage in praise of Daedalus. The *Poetria nova* (ca. 1210) is by far the most popular rhetorical handbook; surviving in more than two hundred manuscripts, it enjoyed considerable commentarial attention into the sixteenth and seventeenth centuries: see Gallo, "The *Poetria Nova* of Geoffrey of Vinsauf," in James J. Murphy, *Medieval Eloquence: Studies in the Theory and Practice of Medieval Rhetoric* (Berkeley: University of California Press, 1978), p. 52, and Woods, *Early Commentary on the Poetria Nova*, pp. xvii-xxii.
 I generally quote from *Poetria nova*, trans. Margaret F. Nims (Toronto: Pontifical Institute of Medieval Studies, 1967), with bracketed Latin from Faral's edition (pp. 194–262); parenthetical references are to those editions.

The passage suggests an analogy that some of Geoffrey's readers may well have noticed: if architect is to house as poet is to poem, if the greatest architect is Daedalus and his greatest work the labyrinth, then great literature too may appropriately be labyrinthine in artistry, as Ezekiel's prophecy was to Jerome or as the scriptures in general were to Rudolf of Saint Trond (1070–1138).[30] The presence of aristocratic labyrinth-buildings in the Middle Ages might have facilitated the analogy. That Geoffrey's text-house is designed with compasses goes still further to evoke the image of the labyrinth, that circular *domus* traced with compasses, emblem of human and divine art in cathedrals.[31] Implicitly, then, a great poem is as complex and brilliantly structured as a labyrinth.

Geoffrey's poem-*domus* involves a circling process. We shall see more about the circling/circuitousness essential to maze and fine poem under *elocutio*, but for the moment consider two accounts of the didactic and aesthetic importance of a winding or circling movement in texts seen whole, as artifact. First, Peter of Cornwall praises a sermon by Gilbert Foliot for its circuitous design: "It ran backwards and forwards on its path from its starting-point back to the same starting-point."[32] The pattern described here is not merely a path: it is best imagined as the circuitous path of a maze. For Robert of Basevorn, "The more the end [of a good sermon] is like the beginning, so much the more subtly and elegantly does it end."[33] Again, the labyrinth allows for just such a conjunction of beginning and ending: "You seem to begin where you ended and to end where you began," Boethius says while accusing Philosophy of weaving labyrinths;[34] and this circular construction is a familiar feature in *Pearl, Sir Gawain and the Green Knight*, and *Piers Plowman*. This sort of circular structure—*labyrinthine* structure—is both beautiful and didactically effective, as Augustine argues in the *De magistro*.

If the image of a house plotted by compasses suggests a labyrinth-as-artifact containing a labyrinth-as-process in the form of a path circling back and forth, the idea of following a path constitutes another common

30. See chap. 3 for Jerome; Rudolf, *Vita sancti Lietberti, PL*, 146, 1451. Hugh of Saint Victor makes much of the analogy between sacred scripture and a well-wrought *domus*, but given his predilection for direct, uncomplicated, noncircuitous statement, his scriptural *domus* is presumably no more a labyrinth than his ark is: see *Didascalicon* 6.4 (Taylor, pp. 140–141).

31. I do not mean to imply that all circular structures *are* labyrinths, but rather that circular structures are potentially labyrinth*ine*, especially if they involve changes of direction, backward and forward movement, and so on, as poetic order does for Geoffrey.

Geoffrey's metaphor may also suggest a comparison of the poet-architect to God, who circumscribed the cosmos with compasses and *logos*.

32. Quoted by A. C. Spearing, *Criticism and Medieval Poetry* (London: Edward Arnold, 1964), p. 75.

33. Robert of Basevorn, *The Form of Preaching* (1322), trans. James J. Murphy in *Three Medieval Rhetorical Arts*, ed. Murphy (Berkeley: University of California Press, 1971), p. 200; for the Latin text, see Charland, p. 310.

34. Boethius, *Consolation of Philosophy* 3p12 (Green, p. 72).

metaphor for poetic composition. This metaphor, stressing teleology rather than the shaping of an artifact, reflects the linearity, be it unicursal or multicursal, of composition, writing, and even reading. The image is related to the use of "ploughing" for writing and "furrow" for a line of verse,[35] but let us turn again to Geoffrey for a full exposition in the context of natural and artificial order in poetry:

> The material's order may follow two possible courses: at one time it advances along the pathway [*limite nititur*: "labors on the narrow path"] of art, at another it travels the smooth road [*sequitur stratam*: "follows the open road"] of nature. Nature's smooth [*linea*: "straight"] road points the way when "things" and "words" follow the same sequence, and the order of discourse does not depart from the order of occurrence. The poem follows the pathway of art if a more effective order presents first what was later in time, and defers the appearance of what was actually earlier. Now, when the natural order is thus transposed, later events incur no censure by their early appearance, nor do early events by their late introduction. . . . Deft artistry inverts [*vertit*: "turns"] things in such a way that it does not pervert them [*non pervertat*]. . . . The order of art is more elegant than natural [*recto*: "direct"] order, and in excellence far ahead, even though it puts the last things first. (N18–19/F200)[36]

In ordering a poem, authors face a *bivium* or, if they decide to follow both natural and artificial order at various points, a series of *bivia*, whose goal is excellent structure. The moral *bivia* with which we are familiar, choices between good and bad paths, take on aesthetic trappings: the easy wide road is clear ("manifesta" for the commentator), direct, and generally accessible to writer and reader alike. In contrast, the narrow artistic path that is "subtle and known to few" (the commentator's words) entails an arduous artistic struggle. When Arnulf of Milan decided to follow natural chronological order because he found the entry to Aristotle's labyrinth too narrow, he may have had in mind something like this; Geoffrey's path of art, rhetorically effective and elegant, is also more labyrinthine, in that it does not move directly from point A to point B in a straight line like natural order but rather winds circuitously back and forth in time like the narrative line of the *Queste del Saint Graal* or the path of a maze, whether unicursal or multicursal. Artificial order, in short, creates a digressive and meandering labyrinth for writers as they write and readers as they read. The mazy nature of this order is en-

35. Ernst Robert Curtius, *European Literature and the Latin Middle Ages*, trans. Willard R. Trask (New York: Harper & Row, 1953), pp. 313–314.

36. Cf. Jerome's assumption that putting first things last is a labyrinthine order of proceeding and Ennodius's linking of labyrinth, poem, and path.

Bracketed translations in the quotation reflect shades of meaning detected by Geoffrey's early commentator: Woods, *Early Commentary on the Poetria Nova*, pp. 22–25.

hanced by Geoffrey's next comments, which suggest a multicursal pattern: "The first branch of order has no offshoots; the second is prolific: from its marvelous stock, bough branches out into boughs, the single shoot into many, the one into eight. The air in this region of art may seem murky and the pathway rugged, the doors locked and the theory itself entangled with knots" (N19/F200). There are several things to be noted here. First, this cluster of images (paths, branchings, darkness, knots, keys) frequently attends the labyrinth as emblem of difficulty. Since Geoffrey proceeds to give examples of artificial order from the story of Minos, Scylla, and Androgeos, the prelude to Ovid's labyrinth story but a far simpler episode to use as an illustration, it is conceivable that the labyrinth was consciously or subconsciously in Geoffrey's mind as he wrote on artificial order.[37] More important, however, is the suggestion, picked up by Geoffrey's early commentator, that artificial order is not merely circuitous but also "multiplex" in comparison to the "simplex" natural order.[38] The commentator stresses the obscurity and complexity of the subject, and perhaps for him "simplex" and "multiplex" refer only to whether an author chooses natural or artificial order, Geoffrey's nominal, and probably real, topic. But, as Kelly has shown, these terms have a long rhetorical history and suggest something far more complicated: an author's decision to follow the comparatively simple course of telling one story, however artificially it may be ordered, or many.[39] Artificial order is itself a kind of circuitous labyrinth; when artificial order is applied to "multiplex" narrative, something even more labyrinthine results.

Kelly distinguishes two major kinds of multiple narrative: (1) a complex story linking many disparate elements and episodes that are united by some feature like a common protagonist (*Yvain*, the *Divine Comedy*, *Sir Gawain and the Green Knight*); (2) interlaced stories like the French cyclic romances, their complexity augmented by the sheer number of linked but divergent episodes that may have little in common. The first kind of narrative line is, I would argue, analogous to a unicursal labyrinth—complicated, circuitous, full of turnings (probably carefully highlighted) from one episode to another; the second is like a multicursal maze, for the narrative line not only twists and turns but also chooses completely different (and carefully highlighted) paths from time to time. The *Queste del Saint Graal* is *structurally* a multicursal labyrinth in this narrative sense,

37. Geoffrey may also have chosen the story because the Cretan myth as a whole was sometimes seen as representative of all poetic fictions and hence might appropriately figure in a general introduction to the writing of poetry: see Pseudo-Bernard Silvester, J&J, p. 37.

38. Woods, *Early Commentary on the Poetria Nova*, pp. 24–27.

39. See Douglas Kelly, "The Source and Meaning of *Conjointure* in Chrétien's *Erec* 14," *Viator*, 1 (1970), 179–200.

for we turn from Galahad to Gawain to Lancelot to Perceval as *"li contes"* prescribes, even though, as interlaced narrative goes, the *Queste* is not particularly ornate, and even though the characters' progress may, as we have seen, be a course through every kind of maze; the labyrinths *in* the text complement the labyrinth *of* the text. What Kelly describes as "gliding junctures," subtle transitions from one episode to another, characterize multiple narrative of the first sort—in labyrinthine terms, there are turns and redirections rather than new paths. But multiple narrative of the second sort contains "open junctures," carefully marked choices to pursue a completely different course among the *ambages* that present themselves.[40] One major reason for these marked junctures, of course, is to weave disparate material together into an artistic whole, as the turnings of either form of narrative-maze noticeably define its complex pattern.

To summarize the discussion of disposition so far, then, artistic ordering inherently, if not explicitly, resembles the labyrinth, paramount emblem of artificial order. Geoffrey's direct road of natural order, going straight to the point in a manner that can be followed by anyone, is not labyrinthine at all; it is simply a path, in structure if not in expression the shortest distance between two points. But artificial order is truly labyrinthine. For its creator, it involves multicursal choices of methods and narrative sequence; for its reader, it is circuitous and convoluted. These winding complex narratives resemble unicursal or multicursal mazes in design depending on whether the discourse offers a single guiding thread ("simplex" narrative) or a choice of many ("multiplex"). Whether or not medieval disposers thought of labyrinths as they constructed or theorized about their Daedalian artifacts, the ordering process and consequent pattern of an aesthetically satisfying poem are remarkably like the construction and design of a labyrinth, which is, after all, a well-built circular house full of circuitous and sometimes competing paths. Whether Geoffrey had the labyrinth in mind or not, his images for the construction of poetry define the medieval labyrinth.

One more metaphor for disposition must be considered here, although it does not appear in rhetorical handbooks: the interlace, often used by modern scholars as a model for medieval narrative structure.[41] *Interlace* is a modern term for that complex, interwoven pattern of fo-

40. Kelly also discusses the common use of *ambages* to describe the circuitous process of medieval multiple narrative.

41. E.g., Rosemund Tuve, *Allegorical Imagery: Some Medieval Books and Their Posterity* (Princeton: Princeton University Press, 1966), pp. 359–370; John Leyerle, "The Interlace Structure of Beowulf," *UTQ*, 37 (1967), 1–17; Eugène Vinaver, *The Rise of Romance*; Susanna Greer Fein, "Thomas Malory and *La Queste del Saint Graal*," *UTQ*, 46 (1977), 215–240. Fernand Lot first applied "interlace" to romance in 1918; on French interlace studies, see Fein, 216–217.

liage, zoomorphs, and paths that ornaments medieval art from Anglo-Saxon times through the thirteenth and fourteenth centuries. There are numerous literary analogues to the interlace structure seen in the visual arts. Interlace may be verbal, as in macaronic texts, the writings of Alcuin and Aldhelm, and the "finely locked words laced together" of the troubadours; it may be narrative and structural, as in medieval romance and Spenser, where one strand of the narrative is followed until another is picked up and then another, with the story often returning to the first strand not where it was abandoned but at some further point that can be better understood thanks to the intervening segments of narrative.[42] Sometimes literary interlace is thematic and sometimes pictorial, as in *La Queste del Saint Graal*, where, as Susanna Fein argues, "through a narrative interweaving of different knights' movements and through much descriptive detail [the author] gradually builds a distinct maze-like image of paths within a forest . . . [a] pictorial interlace."[43] Often varieties of interlace combine: thus, as Fein shows, the pictorial interlace of the *Queste* becomes thematic by reflecting the meaning of visual interlace for the Cistercians, for whom "inhabited scrolls frequently symbolized the struggles of man against the vices and complexities of this world."[44]

Writings on the aesthetic of the interlace have taught us a good deal about how many medieval artists and writers saw their work as ordered complexity, multiplicity in unity, an array of seemingly disparate but ultimately interconnected elements; and interlace studies confirm the importance and immense variety of artificial orders in literature—orders where the effective presentation of material demands something other than chronological narrative because the patterning of events is far more important than temporal sequence. Based on "an understanding of the great aesthetic possibilities of digression and recurrence," interlace emphasizes overall design rather than individual linear history, with the result that, in Eugène Vinaver's words, "everything that happens remains present, firmly fixed in the mind, as if the mind's eye could absorb simultaneously all the scattered fragments of the theme, in the same way as our vision can absorb the development of a motif along the entire length of an interlaced ornament."[45] Or, one might add, as someone above the labyrinth sees the integrity and symmetry of its exquisite design in one glance.

42. For stylistic interlace, see Leyerle, *UTQ*, 37 (1967), 4–5, and Linda M. Paterson, *The Troubadours and Eloquence* (Oxford: Clarendon Press, 1975), 91–98 and passim; for narrative and structural interlace, see Vinaver, Tuve, Fein, and Kelly (*Viator*, 1).

43. Fein, 217; Leyerle also discusses thematic interlace.

44. Fein, 221.

45. Vinaver, pp. 92 and 83. For an argument that the premise of many interlace studies—the existence of a master designer who plots the whole complex scheme—is untenable, at least in the French cyclic romances, see Burns, *Arthurian Fictions*, pp. 12 and 82–84.

But if the interlace is a useful model for the disposition of medieval poetry, one justified by a mass of evidence in the visual arts, I would argue that the labyrinth is an even more useful and inclusive model. In fact, as I will suggest, the interlace is best considered as a partial labyrinth. True, the two models are similar in many respects: both are interwoven, *textus*, like poetry itself.[46] Both incorporate digressions and *errores*—wanderings, delays, moral failings, all essential qualities in romance, as Patricia Parker has shown—and exhibit what Vinaver calls an "excess of constructive subtlety" so that they serve as excellent mirrors of universal complexity.[47] If interlace in the visual arts is sometimes geometrical and sometimes composed of plants and animals, the labyrinth, most often geometrical, can also be perceived as involving foliate forms: Nonius Marcellus glosses *maeander* as "a kind of picture similar to the designs of labyrinths, hindered by tendrils [*claviculis*]."[48] The two terms are associated in literature in at least one important context: Jean de Meun's and Chaucer's translations of Boethius' "Ludisne... me inextricabilem labyrinthum rationibus texens":

Jean de Meun: "You mock me," I said, "or you play or you deceive me by weaving me with your reasonings the house of Daedalus so interlaced [*entrelacié*] that one knows not how to undo it . . . [and you have used] proofs and interlaced arguments."

Chaucer: "Scornestow me," quod I, "or elles, pleyestow or disseyvistow me, that hast so woven me with thi resouns the hous of Didalus, so entrelaced that it is unable to ben unlaced . . . [by using] proeves in cercles."[49]

46. On *textus*, see Leyerle, *UTQ*, 37 (1967), 4, and Brian Stock, "Medieval Literacy, Linguistic Theory, and Social Organization," *NLH*, 16 (1984–85), 21. Poetry is often seen as woven: cf. Boccaccio, *De genealogia* 14.7. So too is the labyrinth: see Boethius, *De consolatione* 3p12; *Aeneid* 5.589; Sidonius, *Epistolae* 9.13.

Donald R. Howard (*The Idea of the Canterbury Tales*, pp. 327–329) briefly compares maze and interlace: both involve turnings and both "express confusion and puzzlement; they symbolize the world"—a valid but, in my view, overly limited conclusion in that both maze and interlace suggest order as well as chaos. Howard also notes that mazes, unlike interlaces, have a beginning and an end; but I would not agree that "the interlace was visual, the labyrinth tactile."

47. Parker, *Inescapable Romance: Studies in the Poetics of a Mode* (Princeton: Princeton University Press, 1979), pp. 4–25 and passim; Vinaver, p. 77. Parker's discussion of Ariosto is particularly interesting in this context.

48. On the two types of interlace, see Vinaver, p. 78; for Nonius, *De conpendiosa doctrina*, p. 203. Geometrical interlace in art could be considered a multicursal version of the diagrammatic maze (perhaps the first medieval attempt to design such a thing?), with natural interlace a version of the garden maze or the labyrinthine forest.

49. Jean's translation is edited by V. L. Dedeck-Héry, *MS*, 14 (1952), 165–275; the quotation is from p. 230. For Chaucer's translation, see *Riverside Chaucer*, pp. 438–439 (ll. 154–157, 182). Minnis established Chaucer's indebtedness to Jean and to Nicholas Trevet's commentary: see "Aspects of the Medieval French and English Traditions of the *De Consolatione Philosophiae*," in *Boethius: His Life, Thought, and Influence*, ed. Margaret Gibson (Oxford: Basil Blackwell, 1981), pp. 312–361. The picture is fleshed out by Mark J.

For Jean as for Chaucer, who follows his translation, labyrinths include interlacings. For us and for medieval people, then, interlace and labyrinth are related designs, and modern interlace studies often use the image of the maze to explain what they mean by interlace, as Fein does in the passage quoted above.[50]

With all these common features, why is the labyrinth a better, fuller paradigm for medieval literary structure? First, the labyrinth is richer and more comprehensive in formal implication than interlace, and it corresponds more closely to the workings of an actual text. Vinaver and others use interlace to describe the complex narrative pattern of romance, where stories are inseparably entangled, and note that both romance and interlace have in some respects "no beginning, no end, and above all no center—no 'means of guidance.'"[51] Now, this is all very suggestive, but it is not strictly true. Like labyrinths, and unlike interlace, romances and other writings *do* have beginnings and ends, often very neatly linked (even "unfinished" poems have an end to the text). Narrative literature, like labyrinths and unlike interlace, usually has a center— a dominant hero, a central place, thematic centers that may take the form of images. And narrative always has guidance, if not in explicit authorial commentary and thematic statement, then in the thread of the text itself: by disposition, amplification and abbreviation, and narrative line, the author defines a start, a path, and a finish, which, as Vinaver rightly notes, interlace does not. Since labyrinths by definition provide these things, they are a closer analogue to poetic texts: both mazes and texts have beginnings and endings, centers and guiding paths. Interlace does very well as a model for the inner workings of a complex poem, in which characters, themes, and audience are entangled and confused until a pattern emerges, or at least the end is reached, but the labyrinth accounts for both the inner workings and the shape of the whole. The interlace is a brilliant model for "multiplex" romances that interweave the stories of many knights—indeed, this is really the model's most appropriate use—but a diagram of paths through a multicursal labyrinth does just as well, and the unicursal labyrinth is a better model for the majority of medieval narratives, which deal with *one* major char-

Gleason: "Nicholas Trevet, Boethius, Boccaccio: Contexts of Cosmic Love in *Troilus*, Book III," *M&H*, 15 (1987), 161–188, and by Gleason and Minnis in *The Medieval Boethius: Studies in the Vernacular Translations of De Consolatione Philosophiae*, ed. A. J. Minnis (Cambridge: D. S. Brewer, 1987).

50. See also Vinaver, pp. 69 and 77n., and C. S. Lewis, *The Discarded Image: An Introduction to Medieval and Renaissance Literature* (Cambridge: Cambridge University Press, 1964), p. 194, treating interlaced narrative as an example of the medieval "love of the labyrinthine."

51. Vinaver, p. 69.

acter's wanderings. If interlace is a fruitful model, a useful embodiment of the medieval aesthetic of complexity, that is because interlace describes the middle sections of a multicursal labyrinth; the full medieval idea of the labyrinth provides a still more accurate model, a better guide, and a richer concept. Moreover, the labyrinth is the best model for one intriguing aspect of much medieval poetry: it incorporates both linearity (movement from A to B, from beginning to end, from birth to death) and circularity (repetition, possibly with variation; the representation of cycles, narrative, structural, and thematic—seasonal, liturgical, historical). This perfect synthesis of linearity and circularity constitutes one of the most significant features of much labyrinthine poetry and poetic theory.

In addition to being a better model for medieval narrative on purely structural grounds, the labyrinth is also more likely to have been a *conscious* model, for, as we have seen, it has a rich literary tradition in itself and in connection with poetic process and achievement. In almost every description of the labyrinth from classical antiquity onward, *error* is an explicit characteristic of the maze but not necessarily of interlace, which has far less extensive a literary history. Moreover, the labyrinth is repeatedly seen as the most illustrious example of sublimely complicated artistry and hence an apt metaphor for magnificent poetry. Symbolism we must read into the interlace pattern is thus demonstrably present in the history of the maze, so that while Vinaver, Leyerle, and others make a good case for the medieval perception of an analogy between interlace and poetry, the case is even stronger for the labyrinth as a conscious medieval model for literature.

· Labyrinthine *Elocutio* ·

We have now seen how the idea of the labyrinth serves as a model for invention and disposition—how it is explicitly used as a metaphor for various inventive processes and how it covertly underlies and unifies common metaphors for disposition, which merge into the image of a circling if sometimes bifurcated path through a well-crafted *domus*. So too with the third part of writing, *elocutio* or expression, through which literary design is implemented and ornamented with words. In disposition, the writer's path requires a choice between artificial and natural order; in elocution, as in a multicursal maze, authors confront another crucial *bivium*, the choice between amplification or abbreviation of their material, both courses full of labor for the poet-traveler. Given the medieval predilection for poetry that reshapes old stories by altering narrative order and infusing new significance, both roads must be followed from time to time: as Geoffrey's *Documentum* states, one way to cast a

story freshly is "not to delay where others delay, but where they delay, let us go quickly, and where they go quickly, let us make delays."[52] However, rhetorical handbooks emphasize the delaying tactics of amplification as the best means to give received material a novel slant. This emphasis on amplification suggests another way medieval rhetoric is labyrinthine: both mazes and amplification expand a given idea or pattern, and both involve circuitous delays that cover far more territory than strictly necessary to get from A to B. Both, too, add complexity to a path that might otherwise be artlessly direct, like natural order. Artificial order and amplification go hand in hand as artistic and enlightening complications that make us shift directions and see things in unusual perspectives and revealing close-up.

Analogies between amplificatory techniques and labyrinths emerge in the names and descriptions of the tropes (significantly, "turns"), the figures of speech and thought used in amplification.[53] Repetition (*interpretatio, expolitio*) "take[s] up again in other words what has already been said" (N24/F204), thus circling back over the same ground as one may do in a maze. Circumlocution (*periphrasis, circuitio, circuitus eloquendi*) is essentially labyrinthine, and Geoffrey's comments point the resemblance: "Do not unveil the thing fully but suggest it by hints. Do not let your words move straight onward through the subject, but, circling it, take a long and winding path [*ambagibus*] around what you were going to say briefly" (N24/F204). Apostrophe is labyrinthine in effect as a "mode of delay. By it you may cause the subject to linger on its way, and in it you may stroll an hour" (N25/F205). Personification too "lengthen[s] our route" (N32/F211), but digression—a structural characteristic of the maze—is far more interesting. "If it is desirable to amplify the treatise yet more fully, go outside the bounds of the subject and withdraw from it a little. . . . A kind of digression is made when I turn aside from the material at hand, bringing in first what is actually remote and altering the natural order. For sometimes, as I advance along the way, I leave the middle of the road, and with a kind of leap I fly off to the side, as it were; then I return to the point whence I had digressed" (N35/F213). Geoffrey's prose *Documentum* clarifies that he is talking about two different kinds of digression: (1) moving from one part of the primary matter to another, and (2) jumping from the story to quite different material. Commentaries divide the second category into the more common poetic

52. Section 133 (Faral, p. 309).
53. Although Geoffrey, like many rhetoricians, generally discusses the tropes as they would be used within sentences, there is little doubt that these ornaments were adapted to much larger narrative structures: see Kelly, "The Source and Meaning of *Conjointure*"; Burns, *Arthurian Fictions*, p. 77; and, for an extended discussion, Ihle, *Malory's Grail Quest*, which argues that the *Queste* amplifies, using *interpretatio, circumlocutio*, and *digressio* extensively, whereas Malory abbreviates.

variety—passing to a related subject, dropping it, and returning to the main path—and the less common sort, in which a radical change in subject is gradually related to the main narrative.[54] Such digressions are labyrinthine not only in their circuitousness but also in moving into apparent irrelevancies that prove instructive, just as a maze seems to move away from the goal only to approach it more nearly. Augustine treats the pedagogical uses of apparent digression (see Chapter 3 above), and medieval digression, properly controlled, has exactly the same labyrinthine utility, especially in sermons, as Robert of Basevorn notes, adding that when one wishes to teach, the "curiosior" kind of digression—the more artistic sort—is less useful than the "manifestior" or clearer sort.[55] The more didactic one's intent, the less digressions should rely on the hearer's ingenuity to supply relevance, and vice versa. A preacher must be a clear guide to labyrinths, but a poet may create labyrinths for readers to delight in.

Other rhetorical ornaments have labyrinthine implications: *dubitatio*, in which one hesitates between this alternative and that, mimicking hesitation at the *bivia* of multicursal mazes; *occupatio*, in which an author sketches the path not taken as if filling in untrodden parts of a multicursal maze; and *complexio*, when a series of phrases or sentences (or, perhaps, an episode or a whole work) begin and end in the same manner. Even polishing one's style—revising, retreading the same path—involves a kind of labyrinthine development, as Geoffrey describes it: "With unflagging energy I turn now in one direction, now in another, and I adorn the subject now with one figure, now with another. I do not turn it over in my mind once only; rather I reconsider it many times. At last the active mind, when it has completed its circuit, chooses one form out of many. . . . As I revolve the subject, I evolve it more" (N86–87/F257). Such are the difficulties of the rhetorician's work and of his finished creation, to which Eberhard and his commentator may well have been alluding by entitling his treatise *Laborintus* and glossing that title "laborem habens intus."

· Difficult Process ·

By now it should be clear that the medieval aesthetic features a predilection for difficulty, complexity, ornateness, circuitousness, artificiality—all qualities associated with the labyrinth. This love of difficulty is

54. See Faral, p. 274, and Marjorie Curry Woods, "Poetic Digression and the Interpretation of Medieval Literary Texts," *Acta Conventus Neo-Latini Sanctiandreani*, ed. I. D. McFarlane, Medieval and Renaissance Texts and Studies, 37 (Binghamton, N.Y.: MRTS, 1986), 617–626.
55. Charland, pp. 297–298.

manifested in many ways, not simply by a fondness for artificial order or elegant digression or elaborate amplification. In art, the interlace pattern is popular; in architecture, complicated sculptural programs; in music, increasingly complex polyphonic and rhythmic intricacies.[56] Poetry and romance employ complex or multiplex narrative, the verbal obscurity and stanzaic elaboration of the troubadours, amazing feats of versification as in the songs of Machaut's *Remède de Fortune* or the anonymous English *Pearl*.[57] Difficulty is artistically valuable in itself, as Geoffrey suggests when he praises the reworking of existing stories by noting, "the more difficult, the more praiseworthy."[58]

But difficulty offers more than aesthetic pleasure for the cognoscenti: it also has practical educational benefits, or so many writers claimed. The uses of difficulty were appreciated as early as Aristotle's *Rhetoric*, which argues that metaphors, puns, and riddles give pleasure because one learns something new and surprising from them, and Augustine notes succinctly that "what is sought with difficulty is discovered with more pleasure."[59] Sacred texts are often fraught with difficulties whose penetration brings profit as well as pleasure: "The obscurity itself of the divine and wholesome writings was a part of a kind of eloquence through which our understandings should be benefited not only by the discovery of what lies hidden but also by exercise."[60] Difficulty even stimulates the memory: as Boccaccio notes, "Whatever is got at the cost of a little labor is both more pleasing and more carefully observed than that which gets to the reader's mind of itself."[61] The love of difficulty, probably common to intelligent people in every culture, did not go unchallenged, of course, and it is worthwhile to look selectively at a literary debate that raged through much of the Middle Ages. Boccaccio may

56. On music, see Albert Seay, *Music in the Medieval World*, 2d ed. (Englewood Cliffs, N.J.: Prentice-Hall, 1975).

57. See Paterson, *The Troubadours and Eloquence*; Guillaume de Machaut, *Oeuvres*, ed. Ernest Hoepffner, vol. 2 (Paris: SATF, 1911), and commentary by William Calin, *A Poet at the Fountain: Essays on the Narrative Verse of Guillaume de Machaut* (Lexington: University Press of Kentucky, 1974), pp. 70–72; and *Pearl*, ed. E. V. Gordon (Oxford: Clarendon Press, 1953), Appendix 1.

58. Geoffrey, *Documentum*, Faral, p. 309.

59. Aristotle, *Rhetoric* 3.11, trans. W. Rhys Roberts (New York: Modern Library, 1954; originally published in the Oxford Aristotle), pp. 190–193; Augustine, *On Christian Doctrine* 2.8 (13), p. 38.

60. Augustine, *On Christian Doctrine* 4.9, p. 123. In like spirit, Alexander of Hales and Saint Bonaventure mention the benefits to be derived from the fact that scripture's mode of proceeding is "multiplex" even though a simpler "uniform mode" might be thought better at conveying information—see Minnis, *Medieval Theory of Authorship*, pp. 126–127.

61. *De genealogia* 15.12, in *Boccaccio on Poetry*, p. 136. Following parenthetical references are to *De genealogia* 14.12 in Osgood's translation (O) and Jeremiah Reedy's edition (R), *Boccaccio in Defence of Poetry: Genealogiae Deorum Gentilium Liber XIV*, Toronto Medieval Latin Texts (Toronto: Pontifical Institute of Medieval Studies, 1978).

serve as spokesman for defenders of difficulty, and Hugh of Saint Victor as a wise and sympathetic representative of a different view. Both repeatedly use labyrinthine language to discuss verbal complexity.

Arguing that poetic obscurity should not be condemned, Boccaccio responds to the charge that poets wish "to make an incomprehensible [*inextricabile*] statement appear to be wrought with exquisite artistry" (O58/R50)—all flash, no substance, as it were. If poets and rhetoricians are obscure, he asks, what of philosophers, whose entangled words admit no consistent interpretation? what of Holy Writ itself, crammed with obscurity and ambiguity, as befits the word of the "sublime Artificer of the Universe" (O59/R51)? Boccaccio categorizes textual difficulties: some problems lie in the eye of the dull beholder, others in a subject's inherent complexity, and still others in the practice of veiling truth with art to protect deep meaning from unworthy eyes (as a maze sometimes protects hidden knowledge). The artist's aim in this last case is not "to deprive the reader of the hidden sense, or to appear the more clever; but rather to make truths which would otherwise cheapen by exposure the object of strong intellectual effort and various interpretations, that in the ultimate discovery they shall be more precious" (O60/R52). Poetic obscurity, then, is always "extricabilis" to the seeker: "I repeat my advice to those who would appreciate poetry and unwind its difficult involutions. You must read, you must persevere, you must sit up nights, you must inquire, and exert the utmost power of your mind. If one way does not lead to the desired meaning, take another; if obstacles arise, then still another; until, if your strength holds out, you will find that clear which at first looked dark" (O62/R54). This reads very like counsel to someone in a multicursal maze, and indeed Boccaccio is showing how labyrinthine art begets a hermeneutic labyrinth. Whether the art in question is poetry, sacred scripture, or philosophy, the advantages of difficulty are the same, and Boccaccio quotes Augustine to express them: "Perhaps the words are rather obscurely expressed for this reason, that they may call forth many understandings, and that men may go away the richer, because they have found that closed which might be opened in many ways, than if they could open and discover it by one interpretation. . . . [There is obscurity] not in order that it may be denied thee, but that it may exercise him that shall afterward receive it" (O60–61/R52). Petrarch supplies further justification for difficulty, which pleases and profits: "What we acquire with difficulty and keep with care is always the dearer to us" (O62/R53). Such reasoning is often used to justify the writing of allegory, which is partly what Boccaccio is doing here; but it also applies to secular, purely recreative poetry, and indeed the troubadours' discussions of their complex art bear witness to the fact that many medieval people "delight in knowing and also in the effort of acquiring knowl-

edge."[62] "The fascination of what's difficult," to quote Yeats, is a constant pressure in medieval aesthetics; the lure of the labyrinth is endlessly attractive, and perhaps Aristotle had the explanation when he observed that "it is . . . pleasant to complete what is defective, for the whole thing thereupon becomes our own work"[63]—not that difficult poetry is defective in the sense of being flawed, but rather that, as reader response theories of literature recognize, it demands the active engagement of readers who help create the meaning of a text by filling in what Wolfgang Iser would call its gaps and indeterminacies and who thus value what they themselves have done. When we complete the course of the labyrinth, we value the center all the more.[64]

Yet complexity is dangerous, and not just for writers who become as entangled in their own creations as Daedalus was. Hugh of Saint Victor, concerned lest his own work be considered a fruitless labyrinth, was sensitive to the tension between necessary or productive difficulty and frustrating perplexity, and he offers a balanced response to apologiae like Boccaccio's. He acknowledges the difficulties of scripture, which not only follows artificial order frequently but also is itself both a well-built *domus* and a bewildering, trackless forest. Such complexity causes students of equal abilities but different mental habits to have different experiences in reading:

> The one penetrates it [the text] quickly. . . . The other labors long and makes little progress. . . . Consider two men both travelling through a wood, one of them struggling around in bypaths but the other picking the short cuts of a direct route: they move along their ways with the same amount of motion, but they do not reach the goal at the same time. . . . Therefore, whoever does not keep to an order and a method in the reading of so great a collection of books wanders as it were into the very thick of the forest and loses the path of the direct route.[65]

There is a guide through the divine complexity that so resembles the labyrinths of the *Queste* or Jerome: the Seven Liberal Arts, the Trivium

62. For the troubadours, see Paterson, *The Troubadours and Eloquence*, passim; the quotation is from Geoffrey of Vinsauf (N89, F259).

63. Aristotle, *Rhetoric* 1.11, p. 72.

64. I cannot resist mentioning the work of Dennis Oppenheim, who constructed a vastly enlarged replica of a simple laboratory maze by deploying bales of hay on a field. He ran cattle through the maze, which they devoured as they progressed. Oppenheim notes, "In solving the maze they learned it. They digested the information that they were housed in" ("Janet Kardon Interviews Some Modern Maze Makers," *Art International*, 20 [April–May 1976], p. 67). Oppenheim has thus created a fascinating objective correlative for the process of learning by wandering through a maze as well as for the delicious satisfaction of solving labyrinthine difficulties.

65. I quote Taylor's translation, *Didascalicon* 5.5 (pp. 126–127). For scripture as *domus*, see *Didascalicon* 6.4; for artificial order, see 6.7.

and Quadrivium, so named "because by them, as by certain *ways* [*viae*], a quick mind enters into the secret places of wisdom."[66] If scripture's artificial order and semantic complexity frustrate untrained minds, secular poetry and philosophy are still worse, for they "are always taking some small matter and dragging it out through long verbal detours [*ambagibus*], obscuring a simple meaning in confused discourses." Anyone who "willingly deserts truth in order to entangle himself in these mere by-products of the [true] arts, will find, I shall not say infinite, but exceedingly great pains and meager fruit."[67] The involutions of the *sacra pagina* are worth the trouble of penetrating, but rhetorical and dialectical flourishes and circumlocutions in a lesser cause are problematic. Yet for Hugh even this circuitous and ambiguous literature *may* be profitable, for we learn better when entertaining literature occasionally offers light relief from serious study, and "we sometimes more eagerly take up a thought we come upon in the midst of a story."[68] By implication, secular labyrinthine literature can be relaxing, preparing readers for something better and sometimes even instructing them, but one wouldn't want to make a steady diet of it.

Other medieval writers, interested in the potential utility of their work, knew that excessive difficulty could imprison readers or listeners in a labyrinth of words like the one Macrobius bemoaned. Not everyone would approve of Boccaccio's lack of concern for those who cannot penetrate obscurities. Thus Boncompagno da Signa, lawyer-rhetorician, warns of leading people into epistemological labyrinths of definitions or mazes of prolixity, and Agobard of Lyons, as early as the ninth century, urged the meticulous correction of texts so that careless errors might not create "such confusion that nothing at all can be understood" or make "the order of divine words to be changed and the text of truth to be woven into a labyrinth of error."[69] Quite apart from the dangers of leading people into heresy, medieval authors, even secular ones, were intensely aware of the need to communicate effectively with mixed audiences: the troubadour Giraut de Bornelh thus rejects the obscure *trobar clus* for a style "that all people may understand," noting that "I could certainly make the song more veiled [*cobert*], but a song does not have a perfect reputation when not everyone can share in it"; yet at the same time he admits that he cannot realistically expect "to sing to every-

66. Hugh, *Didascalicon* 3.3 (p. 87).
67. Hugh, *Didascalicon* 3.4 (p. 88).
68. Hugh, *Didascalicon* 3.4 (p. 89).
69. See Boncompagno, *Rhetorica novissima*, pp. 257 and 280; for Agobard, *Epistola* 18, MGH Karol. aev. epist. 5, ed. E. Dümmler (Berlin, 1899), p. 233. Boncompagno's penchant for belaboring linguistic labyrinths is presumably related to his general interest in an intelligible rhetorical style: see Ronald G. Witt, "Boncompagno and the Defense of Rhetoric," *JMRS*, 16 (1986), 1–31.

one communally."[70] Preachers were exceptionally alert to the challenge of speaking artistically for the learned and clearly for the ignorant, as Guibert de Nogent (twelfth century) witnesses: "Though he [the preacher] preaches simple and uncomplicated matter to the unlettered, at the same time he should try to reach a higher plane with the educated; let him offer to them what they are capable of understanding."[71] Usually authors or preachers try to satisfy both audiences by blending clear doctrine, amusing examples, and subtle allegories. But as preaching techniques, given elaborate exposition in *artes praedicandi* that flourished in the later Middle Ages, became ever more sophisticated, exaggerated complexity and difficulty grew common. If the poetry of the troubadours, the *dolce stil nuovo*, and the *Gawain*-poet was brilliantly complicated, so too were Oxford and Paris university sermons whose labyrinthine aesthetic is reflected in Th.-M. Charland's comment that "the English preacher loves complication for the sheer pleasure of emerging from it skillfully."[72] Thus the Dominican Thomas Waleys (d. ca. 1349) cautions preachers against paying more heed to elegant words than to clarity of thought lest the congregation grow confused and forgetful, and although he appreciates the exquisite dilation of a theme which provides many paths to meaning, he chastises sermonizers so fond of curiosity and eloquence that they create too many divisions of the theme and collect too many authorities in support of their points.[73] In other words, he is distressed by overcomplication, by formal and stylistic labyrinths that bewilder the less sophisticated. Robert of Basevorn, writing in 1322, highlights the perilous intricacies of sermon structure in his comments on Circuitous Development (*circulatio*), which presupposes a division of the sermon's theme into three parts, which are again divided into three, thus:

70. Paterson's translation, *The Troubadours and Eloquence*, pp. 91–92, 94.

71. From Guibert, *A Book about the Way a Sermon Ought To Be Given*, trans. Joseph M. Miller, in *Readings in Medieval Rhetoric*, ed. Joseph M. Miller, Michael H. Prosser, and Thomas Benson (Bloomington: Indiana University Press, 1973), p. 170.

72. Charland, p. 133. Charland has a useful introduction to medieval preaching and prints the text of Thomas Waleys's *De modo componendi sermones* and Basevorn's *Forma praedicandi*. See also Murphy, *Rhetoric in the Middle Ages*, chap. 6.

73. Charland, pp. 335 and 391. Will might have progressed more quickly through the labyrinths of *Piers Plowman* had his mentors heeded Waleys's advice.

Circuitous Development . . . is . . . an artificial linking of the first part of the last principal statement to the second part of the first principal statement, namely, *g* to *b*, and again the linking of the second part of the last principal statement, namely *h*, to the third part of the first principal statement, namely *c*. This double connection of the last to the first is called Circuitous Development, so that if either connection is lacking there is no encirclement [*circulatio*]. It is called Circuitous Development in the image of extending a circle where the end and the beginning are the same.[74]

If this formula sounds labyrinthine, it is, and Robert knows it: "Some doubt the usefulness of this ornament. I know that it is more decorative than useful [*magis curiosum quam utile*]. I generally do not use it even if it presents itself, because it dulls the mind of the listener by making an unsolvable labyrinth [*inexplicabile labyrinthum*], unless the listener is very subtle." What is intelligible interlaced ornament to the learned leaves others in confusion, with typical labyrinthine relativity.

Labyrinthine writing was not universally privileged in the Middle Ages, nor did all literature conform to the labyrinthine aesthetic promulgated by many rhetorical handbooks. Some writing and preaching aim chiefly at being comprehensible; naturally, such works often use the plain or humble style to instruct directly, straightforwardly, offering an unimpeded path to an important goal no one can afford to miss. Some literature is more elaborately constructed but not particularly confusing: the tale of Gardinus from the *Gesta Romanorum*, for instance, carefully glosses and retraces its circuitous and figurative steps to ensure understanding, taking readers by the hand after giving them a chance to make discoveries on their own. Such works are partially labyrinthine in their tactics. Other writings, like the *Queste del Saint Graal* or *Piers Plowman* or *Pearl*, are consistently labyrinthine: ornate and circuitous in form and expression, they necessitate frequent interpretive choice, and although their circlings and digressions may confuse us, that confusion is part of our education and enjoyment. And some works—*Sir Gawain and the Green Knight*, Chaucer's *Canterbury Tales*—are labyrinthine in the extreme, privileging ambiguity from start to finish even as they are laid out in superbly articulated and cross-related patterns; these works are paragons of labyrinthicity as artifacts and processes alike.

For many medieval writers, then, an artistically wrought text is very like a labyrinth: difficult, complex, circuitous, digressive, full of profitable and pleasurable *ambages*, having circumlocutions and ambiguities of the sort one finds routinely in allegory. Formally, such texts have the elaborate and appropriate structure so often linked with Daedalian artifacts. However, the meaning is explicable only with beneficial effort,

74. Robert of Basevorn, in *Three Medieval Rhetorical Arts*, pp. 190–191, and Charland, pp. 301–302.

and the *process* of the text—how it says what it says—may rival the content in importance, just as, in a labyrinth, the process of getting to the center is (at least in theory) more than half the fun and most of the learning experience. The process and meaning of the text may even be the same: readers can learn what the text has to teach them only by laboriously tracing all the implications of the narrative's ambiguous and confusing path. Much labyrinthine narrative constitutes a *Bildungsroman* for protagonist and reader alike.[75] Both text and labyrinth are obscure in all the right ways, thereby providing effective learning, the joy of discovery, and active participation in creating textual meaning. As allegory veils truth from casual and scornful observers, so the poetry of the labyrinth protects its full meaning as carefully as the imperial maze emblem protected the mysteries of the ruler. If labyrinths need explication, so do labyrinthine texts, whether the explication comes through the guidance of a commentary or preacher or through readers' flight on their own wings of contemplation. Naturally, the complex text contains labyrinthine dangers: careless readers or listeners may be lost, lazy, or seduced into interminable error; the goal may seem trivial in comparison to the labors involved in reaching it. But the ideal labyrinthine text is finally penetrable and extricable, albeit with difficulty, for its intended audience; it is as useful and magnificent a work of art as the ancient buildings, proving that persistent artistry and equally persistent interpretive labors triumphantly convert confusion and chaos into order and meaning. Such is the labyrinthine aesthetic that characterizes much great medieval poetry as well as great works of other ages—a Shakespearean play, a Bach fugue, a ballet by Sir Frederick Ashton, novels by Proust or Calvino, works in which both process and content are important, in which inextricable difficulty gives way to an epiphany of order created jointly by the structures of the work and the interpretive activity of audience or reader.

Such, then, is my hypothetical reconstruction of the links between the parallel systems of labyrinth and poetry considered as process and product. Because the labyrinth often had pejorative associations in medieval moral writings, the analogies between maze and poetry are usually inexplicit, and it may well be that few writers consciously saw the labyrinth as model for the creation and reception of literary texts. Nevertheless, I contend that the medieval idea of the labyrinth does in fact constitute such a model, illuminating and underlying a good deal of poetic theory and practice. Seen as a magnificent artifact, the *domus daedali* is a model for the carefully crafted literary *domus*. As a laborious process of artistic making, of the careful intertwining and ordering of circuitous paths, it is a model for poetic and rhetorical composition. As an initially confusing

75. See Allen, *The Ethical Poetic*, pp. 92–93, and my n. 11 above.

process to be experienced, understood, and transcended, it is a model for the hermeneutic process. After all, a good labyrinth of words is designed to be comprehended: it leads to valuable goals (new knowledge, relaxation, improvement of skills), and its ambiguous, difficult method of reaching those goals is both pleasurable and instructive. A bad verbal labyrinth, on the other hand, privileges empty or overly ornate artistry at the expense of eventual comprehension: the medium is the only message. Such texts are pejoratively called labyrinths.

My chief concern here has been literary theory, and I have necessarily indulged in a great deal of speculation. Demonstration of the actual practice of writing consciously—one might even say self-consciously—labyrinthine texts must await substantial exposition in Part Three, which describes an extraordinary sequence of richly crafted labyrinths of words: Virgil's *Aeneid*, Boethius's *Consolation of Philosophy*, Dante's *Divine Comedy*, and Chaucer's *House of Fame*.

Labyrinths of Words: Central Texts and Intertextualities

In Part Three, we rise above the labor of reconstructing the idea of the labyrinth to more expansive regions and trace the grand tradition of labyrinthine texts from Virgil's *Aeneid* through Boethius's *Consolation of Philosophy* and Dante's *Divine Comedy* to Chaucer's *House of Fame*. Each of these texts reflects and redefines the received idea of the labyrinth, transmitting it, enriched, to later ages and particularly to later authors in the continuous tradition here represented: Boethius knew Virgil, Dante followed boldly in the footsteps of both Virgil and Boethius, and Chaucer apologetically rewrote Virgil, Boethius, and Dante in the *House of Fame*. Here we witness what Hans Robert Jauss called the "dialogue of great authors": examples of the high-level reception and imitation/translation/interpretation of the labyrinthine textual heritage. Naturally, imitation does not mean slavish repetition: despite the reverence each author had for his predecessors, each text is not merely a fresh rewriting of borrowed themes from a novel perspective but also, implicitly or explicitly, a correction of honored antecedents.

I do not mean to imply that each text is *primarily* a commentary on or adaptation of its predecessors, or that the idea of the labyrinth is equally prominent in all of them, though my discussion focuses on these matters. However, each text includes overt or covert commentary on and adaptation of earlier texts, and each develops, inter alia, the idea of the labyrinth found therein. Nor is this a comprehensive study of literary indebtedness; rather, it is a highly selective examination of the treatment of labyrinthine themes and structures in a chain of texts related in many other ways as well. I do not assume that everything labyrinthine in these texts was placed there consciously: although I have no doubt that authorial intention is sometimes involved, I am content to suggest intertextualities while looking at each text *as* text and showing how each in its

own way draws on a wide range of labyrinth lore and uses the image, characters, structures, and metaphorical significances of the maze to shape and give meaning to a new work of complex artistry. In short, I am taking the labyrinth as an important "narrative image," to use V. A. Kolve's term, in these texts: a central visual image, its potential meaning stemming from both visual and literary tradition, that enriches the text it informs—a "memorial center of meaning and meditative suggestion for the entire poem." My goal in these readings, like Kolve's, "is not to shrink the narrative to an icon, but rather to explore the icon as the vital center of a work vivid and valuable as a whole."[1]

We will cover a good deal of familiar territory in these chapters, encountering specifically or implicitly labyrinthine places, people, and characteristics. *Labores*, *errores*, and *ambages* abound thematically, with all their attendant ambiguities. Various kinds of inextricability, inexplicability, and impenetrability recur in recognizable guise and context: epistemological, philosophical, theological, spiritual, physical, moral, linguistic, artistic. Each text raises the possibility of transcending earthly labyrinths, of converting confusion into order. But each work also reflects the extraordinary difficulties inherent in that process: life is too complicated to permit easy clarity, and human vision—real and metaphorical—too limited. Moreover, some mysteries cannot be penetrated by human beings: one cannot always see the labyrinths of the gods whole. What understanding can be achieved depends partly on the protagonist's patience and partly on his choices, informed by guides with a (comparatively) privileged perspective. But guides may be fallible even when offering Ariadne's thread or Daedalian wings to help the protagonist cope with the circuitous passages and ambiguities that are the only path to knowledge in the various labyrinths that constrain human life and thought. Several of these works even question the skill and benevolence of the cosmic architect.

Labyrinthine convertibility is a central issue in these texts. Conversion from confusion to comprehension, however fleeting and imperfect, is the goal of all the systematic disorientations inflicted on the protagonist. As for Augustine in the *De magistro*, so for these later authors labyrinthine circuitousness is the only possible means to the end, knowledge; moreover, one becomes morally worthy of reaching that goal only by enduring enforced twists and turns with good grace. There is no direct path, or none that could avail, as the pilgrim Dante discovers when he attempts to climb the mountain in *Inferno* 1.

If the world is a labyrinth in these works, what of choice, what of human responsibility? As in many medieval texts, both unicursal and multicursal models of the maze are implied as appropriate. Sometimes

1. Kolve, *Chaucer and the Imagery of Narrative*, pp. 72, 69, and 83.

there is no apparent choice other than to continue in ignorance on a given course; sometimes hard decisions must be made, or blind alleys confronted and steps retraced. Labyrinthine questions of the intricate interrelationships of fortune and providence, free will and determinism, merit and reward, appear again and again. And whatever the form of the world-maze, these texts play with the tensions between linearity—the path actually trodden, from beginning to end, or the line of a chronological narrative, or the diachronic progression of Christian time and history—and circularity, which echoes variously the circular perfection of God's cosmos, synchronic eternity, the entangling cycles of repetition without resolution, the circularity of reasoning, and the recurrent seasons of the natural or liturgical year. This merging of the linear and the circular (or at least the circuitous) within one image is peculiarly labyrinthine.

Although these texts deal with labyrinths and include labyrinthine images, Cretan characters (or people who enact their roles), and labyrinthine language, metaphors, and themes, they are also in themselves labyrinths of words: complexly structured and elaborately patterned verbal creations. They are all difficult, ambiguous works that force us to share the protagonist's limited point of view, seeing only what he sees or is shown, learning as he learns—slowly, laboriously, with false starts and confusions and misunderstandings. We must trace his progress with him if we are to learn what he learns, for the text itself is a kind of Ariadne's thread extricating us from the maze we all inhabit for the work's duration. Only thus can we achieve any sort of privileged vision at all. It is for this reason that subsequent chapters follow the works' narrative order: by treading the textual path very carefully we come to perceive its pattern.

These texts are labyrinthine in another sense as well: they have acquired so much commentary over the centuries that they resemble multicursal mazes: each line branches out into seemingly infinite interpretations. It is probably impossible for anyone to track every hermeneutic path for each work. In any case, it has been impossible for me, although I have consulted a goodly number of medieval commentaries on and translations of Virgil, Boethius, and Dante, as well as modern readings of all four texts. In general, when medieval commentaries deal explicitly with labyrinths in these works, they gloss direct mentions of maze or myth by relating the Cretan story and citing the odd detail from Servius or Pliny or earlier medieval commentaries. And that is just what one would expect from middle-level commentaries documenting institutionalized readings of revered texts. Hence I rarely allude to the medieval commentarial tradition, because it is not particularly pertinent to the readings I offer: each text in the series discussed in Part Three is perhaps the best high-level commentary on the labyrinths of its pre-

decessors.[2] Modern scholarship and criticism are sometimes more to the point than middle-level medieval commentaries, and I indicate parallel analyses and acknowledge actual indebtedness as appropriate. But I cannot pretend to have read all the secondary commentary; had I done so, this book would have taken another decade or two to complete. If here and there I retread unaware a path already trodden by someone else, my apologies; in general, I assume that since I approach the texts from the new perspective opened by material presented in Parts One and Two, my analyses too will break some new ground.

2. The labyrinthicity of the first three texts was, however, recognized outside the chain of texts discussed here: thus the labyrinth is sometimes chosen to illustrate manuscripts of Virgil, Boethius, and Dante (see chap. 5), and several writers—notably Boccaccio and Juan de Mena, as well as Chaucer—imitated the *Aeneid*, the *Consolation*, and the *Comedy* in new works in which labyrinths are important (see chaps. 6, 10, and 11).

Virgil's *Aeneid*

Hic labor ille domus et inextricabilis error.

Here is the toil of that house, and the inextricable wandering.

Virgil, *Aeneid* 6.27

THE *Aeneid*, one of the most influential works of western literature, is the earliest major example of truly labyrinthine literature: it includes explicit images of the maze and references to its myth, employs a labyrinthine narrative structure, and embodies themes associated with the idea of the labyrinth (as defined in previous chapters).[1] Although the importance of the labyrinth in Books 5 and 6 has not gone unnoticed,[2] the full extent and significance of

1. In this chapter I continue to follow the LCL Latin text of the *Aeneid*, trans. Fairclough, but translations are my own unless otherwise noted.

2. See Robert W. Cruttwell, *Virgil's Mind at Work: An Analysis of the Symbolism of the Aeneid* (1947; rpt. New York: Cooper Square Publishers, 1969), chap. 7, for a fairly comprehensive but bizarre examination of labyrinths in the poem; Mario di Cesare, *The Altar and the City: A Reading of Virgil's Aeneid* (New York: Columbia University Press, 1974), pp. 83–84 and chap. 4; William Fitzgerald, "Aeneas, Daedalus, and the Labyrinth," *Arethusa*, 17 (1984), 51–65 (the best study to appear to date); W. F. Jackson Knight, "Vergil and the Maze," *CR*, 43 (1929), 212–213, and, following Cruttwell's work, *Roman Vergil* (London: Faber & Faber, 1944), pp. 167–169, and *Vergil: Epic and Anthropology* (London: Allen & Unwin, 1967), chaps. 8–9; Michael C. Putnam, *The Poetry of the Aeneid* (1965; rpt. Ithaca: Cornell University Press, 1989), pp. 85–88; and Clark, *Catabasis*, chap. 6.

Focusing more narrowly on Daedalus and the Cumaean gates in Book 6: William S. Anderson, *The Art of the Aeneid* (Englewood Cliffs, N.J.: Prentice-Hall, 1969), pp. 55–62; A. J. Boyle, "The Meaning of the *Aeneid*: A Critical Inquiry, Part II: Homo Immemor: Book VI and Its Thematic Ramifications," *Ramus*, 1 (1972), 113–151, esp. 113–119; Page duBois, *History, Rhetorical Description, and the Epic* (Cambridge: D. S. Brewer-Biblo, 1982), pp. 35–41; D. E. Eichholz, "Symbol and Contrast in the *Aeneid*," *Greece and Rome*, ser. 2, 15 (1968), 105–112; P. J. Enk, "De labyrinthii imagine in foribus templi cumani insculpta," *Mnemosyne*, ser. 4, 2 (1958), 322–330; Cynthia King, "*Dolor* in the *Aeneid*: Unspeakable and Unshowable," *Classical Outlook*, 56 (1979), 106; Margaret de G. Verrall, "Two Instances of Symbolism in the Sixth *Aeneid*," *CR*, 24 (1910), 43–46; Brooks Otis, *Virgil: A Study in Civilized Poetry* (Oxford: Clarendon Press, 1964), pp. 284–285; Viktor Pöschl, *The Art of Vergil*, trans. Gerda Seligson (Ann Arbor: University of Michigan Press, 1962), pp. 149–

labyrinthine imagery and ideas in the *Aeneid* have not yet been explored. I hope to show that the idea of the labyrinth constitutes a major if sometimes covert thread in the elaborate *textus* of the *Aeneid*, providing structural pattern and thematic leitmotif. Three works of complex visual art are described in minute detail in the poem: the doors of the Temple of Juno in Carthage depicting the Trojans' *labores* (1.460), the Cumaean gates with their Daedalian memorial of the Cretan myth, and the shield of Aeneas, proclaiming the future of Rome. The centerpiece of this triptych, the first thing Aeneas sees when he lands in his country of destiny, depicts the history of the labyrinth; this fact surely hints at broad potential significance for the image and its myth within the poem.[3] As we shall see, the labyrinths of Books 5 and 6, discussed in Chapter 1, are only part of a network of allusions that gradually shape a vision of Aeneas's life as a laborious errand through a series of mazes.[4] First I trace the idea of the labyrinth in the poem; then I explore its significance for the work as a whole.

150; Eduard Norden, *P. Vergilius Maro Aeneis Buch VI* (Stuttgart: B. G. Teubner, 1957), pp. 121–130; Harry C. Rutledge, "Vergil's Daedalus," *CJ*, 62 (1967), 309–311, and "The Opening of *Aeneid* 6," *CJ*, 67 (1972), 110–115; John W. Zarker, "Aeneas and Theseus in *Aeneid* 6," *CJ*, 62 (1966), 220–226.

And, discounting the importance of the labyrinth even in Book 6: Robert A. Brooks, "*Discolor Aura*: Reflections on the Golden Bough," *AJP*, 74 (1953), 260–280, repr. in Steele Commager, *Virgil: A Collection of Critical Essays* (Englewood Cliffs, N.J.: Prentice-Hall, 1966), pp. 143–163.

3. See duBois, who argues that the *ekphraseis* in the *Aeneid* "define massive, significant thresholds that instruct those who pass through them" (p. 29) and represent Aeneas's past, present, and future, which Aeneas understands less and less fully.

4. In what follows, I generally ignore Homeric parallels, cross-relations with other classical literature (including Catullus 64), and the Augustan context. I assume that Virgil knew the traditions preserved for us by Pliny, Plutarch, and others, even though that assumption cannot be verified (but see Enk on Varro and Pliny). I read from a medievalist's perspective, at my disposal the lexicon of labyrinth lore established in preceding chapters. Yet I do not read as a medieval commentator would have done: I have looked at a broad range of published and manuscript commentaries and marginalia, from Servius through the fifteenth century, and have found little to support my interpretation. However, the vastly popular *Histoire ancienne jusqu'à César* (early thirteenth century) makes the Daedalian sculptures the focus of its précis of Book 6, and at least three manuscripts of this work select the labyrinth (twice accompanied by the Minotaur) as one of only two or three illustrations of the whole history of Aeneas: for Paris BN fr. 20125, see plate 19, Appendix, MS. 6, and Monfrin, "Les *translations* vernaculaires de Virgile au Moyen Age," pp. 189–249; for Paris BN fr. 9682 and Dijon Bibl. Municipale 562, see Buchthal, *Miniature Painting in the Latin Kingdom of Jerusalem*, pp. 68–87 and Catalogue (also my plate 18). Surprisingly, Jeanne Courcelle omits these illuminations in her discussion of *Histoire ancienne* manuscripts: Pierre Courcelle, *Lecteurs païens et lecteurs chrétiens de l'Énéide*, vol. 1: *Les Témoignages littéraires*, and vol. 2, by P. Courcelle and Jeanne Courcelle: *Les Manuscrits illustrés de l'Énéide du X^e au XV^e siècle* (Paris: Institut de France, 1984). For readers of the *Histoire ancienne*, then, text and sometimes illuminations would point to the importance of the labyrinth in the *Aeneid*. As the following chapters show, other medieval readers also noticed and creatively imitated the centrality of the labyrinth.

For a far-ranging discussion of medieval Virgil commentaries, see Christopher Baswell, "'Figures of Olde Werk.'"

The *labor* and *error* associated with mazes are repeatedly emphasized in the *Aeneid*. The poem dwells on *labores* of various sorts: works of suffering, achievement, and art. The psychological and physical *labores* of Aeneas, his companions, and his descendents are necessary to build Rome, whose characteristic art will be government (6.851-854), bringing order to chaos. Through his labors, Aeneas becomes a second, more complex, version of Theseus, the maze-tamer king who knows how to handle *errores*, and of Daedalus, inventor, artist, exile, and shaper of chaos. Aeneas's labors also render him kin to Hercules, whose labors are celebrated in Arcadia, whose slaying of the giant Cacus foreshadows Aeneas's destruction of Turnus, and whose successful descent into Hades preceded that of Aeneas (6.392).[5]

If labyrinthine *labor* ("hic labor ille domus"—6.27) pervades the *Aeneid* thematically and verbally, so does its labyrinthine twin, *error*, whether as circuitous wandering or as mental misjudgment. For example, Book 3 is a narrative labyrinth describing Aeneas's *errores* (1.755) throughout the Mediterranean, wanderings whose goal is a stable *domus* and whose geographical pattern imitates the meanderings of the maze. After much tracing and retracing of steps in Troy, Aeneas sails first to Aeneadae and then to Delos, originally an *errans* isle that was eventually fixed in place only to instigate other errors by its ambiguous oracles to wanderers (3.76, 96-101); the labyrinth's characteristic shapeshifting from chaos to order and from stability to instability, a recurrent motif in the poem, is thus reflected in the portrayal of Apollo's birthplace just as the labyrinth itself will figure on his temple at Cumae. At Crete, ancient home of mazes and Trojans alike, the voyagers vainly wish to retrace their steps to Delos (3.143) and find the end of their labors (3.145). Despite divine and human guidance, they wander through blind waves (3.200, 204) to the Strophades, where the Harpies give directions but predict obstacles. At Buthrotum, Helenus prophesies a circuitous course (3.376) on pathless tracks (3.383) before Aeneas may find rest after labor (3.393) in Italy, so near in space yet so distant in time. Instead of taking the nearest path, Helenus advises, Aeneas must go the longest way round (3.412-413, 430), until finally the Sibyl shows the path and tells what *labor* to flee and what to follow (3.459-460).[6] Although the proper route is clearly defined, the Trojans take the shortest path despite Helenus's warning (3.507); soon they are lost, *ignari viae* (3.569)—the human condition in

5. On Hercules, see Anderson, pp. 70–72; Camps, chap. 8; Otis, pp. 334–336; Putnam, p. 134; Kenneth Quinn, *Virgil's Aeneid: A Critical Description* (Ann Arbor: University of Michigan Press, 1968), p. 123; and Di Cesare, p. 146. Pseudo-Bernard Silvester cites Hercules as an exemplar of the virtuous descent to Hades: J&J, p. 32, and S&M, p. 32.

6. The idea of fleeing vs. following, related to the continuous to-ing and fro-ing within a maze as well as to the idea of choosing the right path, is picked up at the end of Anchises' commission to Aeneas in 6.892.

this poem's universe—and must retrace their steps (3.686-691), arriving at an illusory end of wandering labors in Drepanum (3.714). After further *errores* (1.32), they wander off course, driven to Carthage by Juno's storm. Throughout their erratic voyage the Trojans confront typically labyrinthine dangers: circuitous paths that near a goal only to turn away or reveal the goal as false; enforced delay and hesitation among uncertain choices; unreliable guides in the form of ambiguous visions and prophecies, or uncertain helmsmen plagued by darkness; perils represented or announced by monsters as double in form as the Minotaur—the Trojan Horse, wooden animal concealing men; Polydorus, whose vegetable form has human blood; the bird-maiden Harpies; the dog-maiden Scylla. By such methods the text covertly establishes the image of the labyrinth: *labor* through blind *error*,[7] a seemingly endless search for a clear path to the perpetually deferred goal of *requies* after *labor*, a preordained *domus*. If *labor* is the content of Aeneas's mission, *errores* define its form: the two concepts are as intimately connected in the poem as in a maze. Success, therefore, demands both the persistent patience of the passive unicursal maze-walker and the active intelligence that can choose the right path in a multicursal maze.[8]

While the *errores* of Book 3 suggest the subjective experience of tracing a labyrinthine path, analogues to the labyrinth as an object and to the *monstrum biformis* within figure at the start of Book 2. In the proximate causes of Troy's downfall, the Trojan Horse and the serpents that kill Laocoon and his sons,[9] we may detect a constellation of words and ideas traditionally linked with the labyrinth. Like the Cretan labyrinth defined by Virgil himself in Books 5 and 6 (see Chapter 1), the horse is a monu-

7. The *errores* are both mental and physical: neither Aeneas's nor Anchises' judgment is always sound, as Anchises himself acknowledges (3.181). Indeed, Aeneas's *labores* and *errores* generally involve at least a temptation to mental error.

8. The theme of labyrinthine wanderings is subtly heralded upon Aeneas's arrival in Libya, when he speaks in the words of a maze-walker: he asks that Venus lighten his labor and tell him where he is, for he has wandered in ignorance (1.330–333). She responds by leading him into a metaphorical labyrinth of love by describing the *ambages* (1.342) of Dido's life; the *ambages* of the Dido episode will delay Aeneas's own progress. Dido's history also suggests the labyrinth: it involves complexity (*ambages*), blind impiety, the concealing and then unweaving (*retexit*) of the blind crime of her house (*caecum domus scelus*). The collocation of blindness, crime, a house, and weaving connotes a labyrinth. Dido goes on to found her city through deception involving a bull; this *magna regina* has something in common with the abandoned Pasiphae and Ariadne abandoned.

9. On the imagery and significance of horse and serpents, see Bernard M. W. Knox, "The Serpent and the Flame: The Imagery of the Second Book of the *Aeneid*," *AJP*, 71 (1950), 379–400, repr. in Commager, *Virgil*, pp. 124–142; Boyle, "The Meaning of the *Aeneid*: A Critical Inquiry. Part I: Empire and the Individual: An Examination of the *Aeneid*'s Major Theme," *Ramus*, 1 (1972), 63–90, here, 81–85, and part II, 136ff. (on serpents and the golden bough); Otis, *Virgil*, pp. 242–250; and Putnam, *Poetry of the Aeneid*, chap. 1, which also compares Aeneas's wanderings in Troy with his journey through the underworld and Nisus's and Euryalus's quest through the "malignant maze of the obscure wood" (p. 57)—a comparison he does not explore further.

mental work of art linked with trickery (*dolus*: 2.15, 44—cf. 5.590, 6.29) and built by guileful Greeks (Calchas and Epeos vs. Daedalus). Both creations are intricately woven (*textum*: 2.16, 185—cf. 5.589, 593) and contain *error* (2.48, 6.27). Like the Cretan maze, the horse is dark and cavernous (*caecus*: 2:19, 5.89, 6.30; *caverna*, 2.19, 53—implicit in Books 5 and 6). Labyrinth and horse alike contain both danger and crafty Greeks: the Minotaur and the Athenians Daedalus and Theseus in the labyrinth, Ulysses and his companions in the horse. Each involves a hybrid *monstrum biformis*: the Minotaur is a fierce bull-man, the horse a wooden animal containing armed men. Both are prisons, the labyrinth intentionally and the horse temporarily (2.257-259), but both become extricable through treachery: Ariadne's and Sinon's (he too is a Greek master of artful deceit—2.195). Each structure was built to deceive and then to kill, and each bewilders its beholders (2.39, 5.589) before destroying them.[10] Confusion before a labyrinthine dilemma, and the question of how best to tackle that situation, will be a recurrent motif in the *Aeneid*, and its history starts here, as Aeneas begins his narration.

Confronted by the baffling and deceptive work of labyrinthine art, the Trojans hesitate, filled with doubt (2.39). In contrast, the hasty Laocoon charges forward, denounces the horse as a weapon, a hiding place for Greeks, or some other trick (*error*), and hurls his spear at its curved side. He sees the significance of the dangerous horse almost as clearly as Daedalus understood the maze, and his intended solution to the mystery is nothing if not direct. But while Laocoon's mind penetrates the horse, his spear does not: straightforward approaches and brute force may kill minotaurs, but they don't work with mazes. Had Theseus plunged into the labyrinth unprepared, death would have been certain, and almost throughout the poem, whenever Aeneas tries a direct route, he is forced into circuity. Laocoon's instincts are right: if Troy is to survive, the horse must be destroyed. But just as the Greeks have deceptively constructed their labyrinthine horse, so fate and the gods have shaped a labyrinthine trap for the Trojans; in the cosmic scheme of things, Troy must fall or Rome cannot be founded. Caught in the larger labyrinth crafted by the gods (a subject to which we will return), Laocoon cannot succeed.

The immediate instrument of Laocoon's downfall, and indirectly of Troy's—the twin serpents—also has something in common with mazes.

10. Like the labyrinth (cf. 6.29), the horse is ambiguous, eliciting competing interpretations among the Trojans. Moreover, the description of the wooden horse may hold an aural echo of labyrinthine *ambages*. Frederick Ahl argues that to read classical writers as they read each other, we must be alert to puns and "included" words—collocations of letters in one or more adjacent words that spell out, or sound very much like, other words—see *Metaformations: Soundplay and Wordplay in Ovid and Other Classical Poets* (Ithaca: Cornell University Press, 1985). If Ahl is right, one might hear hints of "ambagibus" in *compagibus* (2.51).

With their vast coils (2.204), their sinuosity (2.208), their entanglements (2.215), their reduplicated windings (2.218), their knots (2.220), the snakes are as circuitous as the maze and, while not individually *biformis*, taken together they are as double as the Minotaur itself. When these monstrous beasts glide in from Tenedos, Laocoon is in the midst of sacrificing a bull, and the imperfect tense of the verb *mactabat* (2.202) is significant: while Laocoon has an accurate interpretation of the horse, his attempt to destroy it is futile, imperfect, incomplete, and similarly he can slay neither the bull nor the quasi-minotaurs within the horse. Instead, he himself is like a wounded bull half-sacrificed (2.223-224) as he falls victim to the mazy snakes.[11] Oddly enough, it is fitting that in his death throes Laocoon resembles the Minotaur as well as the bull he was trying to sacrifice: Laocoon must die if Troy is to be penetrated by the clever Greeks and Rome established. In this poem, Laocoon is unintentionally on the wrong side; trying to play Theseus's role and save his people, from the only perspective that finally counts he is the bull-man who must die.

Thus the narrative of Aeneas's *errores* requested by Dido (1.755-756) begins with two disguised manifestations of the labyrinth, though we may well see them as such only in retrospect: the deadly horse as a static parallel to the deceitful house of Daedalus and the serpents as a kinetic mirror of its fatal, convoluted duality, with Laocoon the tragic bridge between them. The crafty product and circling process normally united in the maze are initially broken into constituent parts,[12] but they come together when the terrible windings of the serpents open the horse's path to Troy.

Troy itself traditionally has labyrinthine associations: it gave its name to medieval and perhaps to ancient mazes and was, like some mazes, virtually impenetrable.[13] Ironically, the labyrinthine city is penetrated by labyrinthine trickery, and Aeneas, habitual treader of mazes, is driven from the labyrinth of Troy into labyrinthine *errores* thanks to the sinister manifestations of the maze in horse and serpents. Here we see that it is

11. My association of the Trojan Horse and the serpents with the labyrinth myth is obliquely supported in Dante's *Inferno* 12, where the Minotaur, conceived in a "false cow" (12.13), plunges back and forth in a simile generally assumed to be derived from *Aeneid* 2.223-224 (*Inf* 12.22-24). Apparently, the combined ideas of the wooden cow and the Minotaur brought Laocoon's death to Dante's (subconscious?) mind.

For the Sophoclean tradition that Laocoon deserved to die for impiety, see Joseph Gibaldi and Richard A. LaFleur, "Vanni Fucci and Laocoon: Servius as Possible Intermediary between Vergil and Dante," *Traditio*, 32 (1976), 386-397.

12. The structure of the first episode in Book 2—Trojan Horse, Laocoon, the treacherous Sinon, Laocoon's death, the Trojan Horse—constitutes a concentric panel, one common method of achieving what I would call a labyrinthine poetic structure. See Di Cesare, *Altar and City*, p. 40.

13. Cf. the Tragliatella wine-pitcher, chap. 1 above and plate 2, and the names for turf-mazes in chap. 5.

not only men who create labyrinths, but also nature and the gods: the human craft of the horse is supplemented by the terrible, divinely ordained serpents. The association of labyrinths with warfare, to be developed in the Trojan Ride and the battles in Italy, begins here, and perhaps too the idea that passion creates mazes, if there is a veiled parallel between the artfully built wooden cow (in which Pasiphae satisfied her lust and begot the monster that occasioned the maze) and the maze-like, minotaurish Trojan Horse, terrible consequence of the forbidden love of another *magna regina*, Helen, and Paris.

After Troy's walls are breached, Aeneas undergoes *labor, error,* and other labyrinthine experiences in the mazy city. He ignores Hector's injunction to wander over the seas—to seek foreign *errores,* as it were—and instead rushes about the city in blind fury, searching a path to the center (2.359-360) and undertaking untold *labores* (2.362). There is a covert allusion to the Cretan myth, and perhaps an implication that the tragic cycle of the labyrinth myth is destined for repetition, when Aeneas kills the Greek Androgeos, namesake of Minos's son whose death caused the Athenian tribute to the Minotaur.[14] As Aeneas follows the path of Fortune rather than common sense (2.387-388), his *error* (2.412) in donning Greek arms leads to the death of many Trojans. He penetrates the labyrinthine house of Priam with its secret doors and fifty chambers, and his mother Venus promises an end to his *labores,* granting him a momentary privileged view above the labyrinth of Troy by revealing the gods themselves in combat. Leading his family to safety, he and his comrades seek one goal by many paths (2.716) as in a multicursal labyrinth; they almost achieve it (2.730-731), but Anchises alarms Aeneas, who runs confusedly through unknown byways (2.736), losing Creusa but reaching safety—escaping the maze of Troy, as it were. Immediately he retraces his steps into chaos (2.750-754) until Creusa's ghost sends him forth to Hesperia and a royal wife. Thus Aeneas's path within Troy recapitulates the labyrinth and sets up the expectation that he may continue to run through one maze after another, just as he has done here, throughout the poem. Significantly, he wanders *despite* supernatural guidance from Hector and Venus and, once, *because* of Anchises' words, which precipitate dangerous but ultimately profitable deviation as they will do in Books 3 (the journey to Crete), 5 (the founding of Acesta), and 6 (the journey through Hades).

Book 2, then, contains repeated manifestations of the labyrinth and links them with blindness, *furor,* deceit, violence, and inextricability: escape one maze and you find yourself in another. Moreover, one tragic theme common to the myth and the *Aeneid* is established: mazes and minotaurs batten on innocent victims. As Athens lost her youths to the

14. Also noted by Boyle, "The Meaning of the *Aeneid*: II," 116.

Cretan terrors, so Troy is lost to the labyrinthine horse, so Laocoon and his sons succumb to the sinuous embrace of the serpents, so Creusa is lost in the frantic byways of the city. Even those who triumph over the maze—Daedalus, Theseus, Aeneas in Book 6—suffer losses: Daedalus loses his son, Theseus his father (Aegeus) and son (Hippolytus; cf. 7.1000), and Aeneas a father exhausted by *errores* and the son-like Pallas, if not Ascanius.

In contrast to Troy, Carthage initially seems to be a counterimage to the maze: a place of rest from *errores*, a haven of stability, order, and constructive *labores*. It is a new city nearly completed, with a well-ornamented temple and a kindly people at fruitful work. Yet elaborate artful cities are intrinsically, if neutrally, labyrinthine, and thanks to divine trickery, Carthage functions like a maze *in malo* by imposing delay on Aeneas's fated *labor*, even if the diversion seems attractive.[15] Carthage shares some of the dangerous doubleness of mazes: as Venus fears, it is for Aeneas a doubtful house (*domus ambigua*) with inhabitants who, if not *biformes*, are at least *bilingues*, double-tongued (1.661). There divine craft and Aeneas's graces transform the noble Dido into a type of Pasiphae, blindly craving an impossible love as she wanders furiously through a newly disordered city. There too Aeneas, glorious as Apollo (or Theseus?) at the labyrinth-dance on Delos (4.143–146), wanders pathless wilds (*invia lustra,*: 4.151) before consummating the affair with Dido in a convenient cave. Dido's love turns the orderly splendor of Carthage to chaos with the perverse convertibility of mazes; wherever Aeneas does not find ready-made labyrinths, confusing and apparently inextricable situations are created for him, and at Carthage it takes forceful guidance from Mercury to pry him loose. Dido is abandoned like Ariadne, a casualty of what, to medieval eyes at least, would look like a labyrinth of love.

Thus Books 1–4 subtly, indeed almost imperceptibly, lay the groundwork for the explicit labyrinths of Books 5 and 6. Aeneas escapes to Italy, like Daedalus, and like him Aeneas unerringly holds the middle course (5.1–2), only to be plunged into a storm as dark, disorienting, and deviation-provoking as a labyrinth. Palinurus retraces the path to Sicily; detour to and delay in Carthage give way to detour to and delay in Sicily. But this is repetition with a difference: the unwitting bringer of disorder in Carthage, Aeneas now imposes order on grief and offers rest after labor when he institutes Anchises' funeral games. Sanctioned by an auspicious seven-coiled serpent (5.85), these games begin and end with implicitly and explicitly labyrinthine rituals: the ship race and the Trojan Ride.[16]

15. Correspondingly, Aeneas's presence delays the completion of the city: all work ceases with Dido's mad love (4.86–89).

16. Images and events from Book 2 recur in varied form: the labyrinthine Trojan Horse is transformed into a labyrinthine Trojan horse-ballet; the malignant serpents bringing

Like a benevolent maze-maker who will not overtax the players of his game, Aeneas lays out the long course and sets up a visible goal, a *signum sequendi* to show where the ships must retrace their paths; would that Fate's labyrinths for Aeneas were so clearly demarcated. As in the Cretan myth, lots are drawn, but this sea-voyage is far less risky than the Athenian victims' journey to Crete. Named for monsters, three of them hybrids like the Minotaur (Chimaera, Centaur, Scylla), the ships set forth in noisy confusion.[17] The twists and turns of the race, the diverse choices of course, the obstacles and collisions, the forced delays, Gyas's casting overboard of his guiding helmsman—all these suggest not merely a safer version of the Trojans' sea-*errores* but also movement within a multicursal maze. Cloanthus, steering with care the closest course, wins and is fitly rewarded with a cloak bordered by a double meander, a kind of maze,[18] whose center alludes to Daedalus's flight from the labyrinth by depicting Ganymede's eagle-flight to the heavens (5.250–257). This first contest, then, is a well- and fairly structured labyrinth-game, with Aeneas its careful architect.

The funeral celebrations end with another labyrinth game, the *lusus Troiae*, discussed in Chapter 1.[19] Here too the dangers of the maze are tamed, and indeed Romanized, as *errores* define the artistic pattern within which *labores* joyously imitate the works of war and peace-making which constitute Rome's art. In context, the ritual serves many thematic functions. A counterimage to the Trojan Horse, that violent quasi-maze of war where beast conceals man, the Trojan Ride in equally tricky art shows noble boys in mimic war controlling both beasts and deceptive pattern. Optimistically, it shows Ascanius's symbolic mastery both of the passionate *furor* that undid Dido, whose horse he rides, and of the labyrinth, thereby pointing to a glorious future for Ascanius himself and for Rome.[20] As Pseudo-Bernard Silvester aptly notes, the horse ballet betokens prudence, which "discerns what should be followed and what

death become the benevolent serpent at the funeral games; if Troy was a city destroyed by fire, in Sicily the burning of the ships leads to the building of a new city, but both burnings cause Aeneas great confusion and doubt. These intricate symmetries reflect a labyrinthine aesthetic.

17. Again following Ahl's methodology, I note the (fairly common) collocation "elabitur undis" (5.151)—a hidden mention of "labyrinthus"? Cf. Knox (in Commager, *Virgil*), pp. 123–130, for similar sound patterns and their connection with serpents.

18. See chap. 2, n. 3 above.

19. Useful discussions of Book 5 include Di Cesare, *Altar and City*, pp. 83–85; Fitzgerald, "Aeneas, Daedalus, and the Labyrinth," 59–61; J. William Hunt, *Forms of Glory: Structure and Sense in Virgil's Aeneid* (Carbondale: Southern Illinois University Press, 1973), p. 25; Otis, *Virgil*, pp. 272–276; and, above all, Putnam, *Poetry of the Aeneid*, chap. 2.

20. Ascanius's discipline here contrasts with Icarus's tragic indiscipline and heralds Ascanius's self-control in withdrawing from combat in Book 9 after slaying only one rather despicable character.

should be fled" and ably reads the inherently baffling *signa sequendi*.[21]
The happy mood of the well-choreographed ritual recalls the thankful
labyrinth dance on Delos celebrating escape from the Cretan maze—a
dance that is mentioned fleetingly in Carthage. More pessimistically,
however, one might suspect that although triumphs over the maze are
possible in controlled conditions, in daily life the guiding *signa* are not so
legible; Ascanius, like Aeneas, may find that the patterns of real war
cannot be discerned, let alone diagrammed or committed to memory.
Similarly, Aeneas contrives orderly war-games framed by harmless laby-
rinths in Sicily, but the wars in Italy will be framed by far more fatal and
chaotic mazes.[22] One might remember, too, that just such boys as these
Trojan riders fell victim to the Cretan maze, as Polites fell in the sack of
Troy, as Lausus and Pallas will fall in Italy. Youth does not always tri-
umph. With characteristic labyrinthine duality, then, the *lusus Troiae*
looks both ways. The delicately traced thousand paths of this play-
labyrinth will be retraced triumphantly when the grown Ascanius founds
Alba Longa, but in Sicily they coincide temporally and imagistically with
Iris's path through the thousand-colored rainbow to incite the burning
of the ships (5.590, 609), a serious impediment to the Trojans' attaining
their true goal and eternal city. If Ascanius masters the labyrinth and its
checks, the wavering (*ambiguae*, 5.655) Trojan women shun further *la-
bores* (5.617) and refuse to complete their passage. Even Aeneas is caught
in a *bivium*, unable to choose whether to proceed or linger, his indecision
in marked contrast to the youths' sure paces. Nautes, master of art and
signa sequendi (cf. 5.705), and the ghost of Anchises become double
guides to this new maze of uncertainty and counsel a double course: let
the weary stay, and let the others proceed to Italy. The solution is in the
spirit of the Trojan Ride: incorporate all valid paths into one grand
pattern. Yet Aeneas's marking of the boundaries of the new Sicilian city
stands in laborious contrast to the gaiety of the boys' ride and the future
lusus Troiae at Alba Longa. More sophisticated in his creative response to
mazy doubleness, Aeneas advances: after losing Palinurus to that bough
of Lethe, an ironic anticipation of the golden bough that leads Aeneas to
his helmsman's shade, Aeneas steers his own course past the Sirens to
Italy.

The importance of explicit and implicit mazes in Book 6, the "Janus-
book," has long been recognized; as the poem's major turning point, this

21. S&M, p. 28; J&J, p. 26.
22. As the double meander frames the elevation of Ganymede on Cloanthus's cloak in
the ship-race, so the two labyrinth-games frame a kind of elevation of Ascanius in the
funeral games section, another instance of labyrinthine structure at work. Later Ascanius is
as it were lifted out of the earthly fray by a god when Apollo orders him to stay away from
battle (9.638–656).

book is fitly introduced by Daedalus's maze, whose very presence at this juncture supports a labyrinthine reading of the work.[23] Mazes hold myriad turning points, however, and the labyrinths of Cumae do not signify that Aeneas, like Ganymede on the cloak and Daedalus in Crete, is about to fly free from *errores*. On the contrary, Aeneas's first steps in Italy, like his wanderings in Book 3, lead him through a series of mazes, confirming that arrival in the promised land does not mean an end to labors, errors, or labyrinths. I have discussed the temple sculptures in Chapter 1, showing that the bright face of the labyrinth displayed in the Trojan Ride here turns dark, exposing violent death, monstrosity, insane lust, and inextricable imprisonment; the ephemeral mastery of Book 5 becomes the partially failed artistry of Book 6.[24] As the Trojan Ride looks forward to Rome and back to Troy, so too the mazes of Book 6 recapitulate Aeneas's Trojan and Carthaginian past and anticipate the labyrinths of Latium.

Seeking his future path as bidden by Helenus and Anchises, Aeneas comes to the Temple of Apollo at Cumae and confronts the first maze of Book 6, Daedalus's sculpted doors with their legend of the Cretan labyrinth. A would-be Theseus striving to guide his people through seemingly inextricable *errores* and to found a true home with his labors, Aeneas sees a dubious and ironic image of his struggle: *hic labor ille domus et inextricabilis error* (6.27), a phrase that effectively paraphrases the whole poem. There, too, are the causes of the inescapable man-made maze: the god-induced passion of a love-mad queen for a bull and their monstrous hybrid progeny. There he sees the sacrifice of innocents and its cause: Minos's vengeance for the death of a beloved son, bringing other youths to unspeakable destruction. And there, perhaps, lies hope: Daedalus, cunning crafter of *ambages*, unwinding his construction with a thread for

23. Wendell Clausen, "An Interpretation of the Aeneid," *Harvard Studies in Classical Philology*, 58 (1964), 139–147, repr. in Commager, *Virgil*, pp. 75–88, here, p. 85. Others noting the pivotal nature of this book include Otis, p. 218; Boyle, "The Meaning of the *Aeneid*: II," 113; duBois, *History*, p. 40.

24. On failed artistry, see Boyle, "The Meaning of the *Aeneid*, II."

In interpreting the labyrinth in Book 6, many critics compare Aeneas to Daedalus or Theseus and Dido to Ariadne, seeing the doors as cautionary or exemplary art in which Aeneas might read his past to leave it behind (e.g., Zarker) or learn from it (e.g., Fitzgerald). Others view the Cumaean doors as an emblem of secrecy (Knight), protection (Cruttwell), or the kingdom of death in which Aeneas undergoes initiation-rebirth (Knight, Otis, Enk, Di Cesare, Clark). Approaching Book 6 by a different path, I retread some of the same ground as these critics, but with a different perspective.

The most thoughtful treatments of labyrinths in Book 6 are by duBois and Fitzgerald, whose readings and emphases differ from yet are complementary to my own. Enk's short article gives a good overview of previous scholarship. A perceptive reading of Book 6 that omits any explicit discussion of labyrinths but has a good deal to say about Daedalus and failure is Charles Paul Segal's "*Aeternum per saecula nomen*, the Golden Bough and the Tragedy of History: Part I," *Arion*, 4 (1965), 617–657, and "Part II," *Arion*, 5 (1966), 34–72.

a great queen—but is she Pasiphae or Ariadne?[25] —and, implicitly, freed by flight.

What Aeneas finds, though we cannot tell whether he understands it, is indeed his past, present, and future.[26] He has passed through many labyrinths, but many lie ahead: the price of his Italian *domus* will be continuing, which is to say inextricable, labor and error. Dido's fatal god-induced passion lies behind him; like Theseus, he has cruelly abandoned a generous hostess. Behind him, too, is the wrongful love of Paris and Helen, partial cause of the Trojan War and hence of the humanly crafted and divinely ordained labyrinths of Book 3; but the mad passions of Queen Amata and Turnus await to weave other mazes. Hybrid or double monsters lie behind—in Troy, in the book of *errores*—and ahead: the snake-haired Allecto, the Dira, and, as we shall see, Turnus and Aeneas himself. So too with the death of (comparative) innocents calling for revenge: Laocoon and his sons, Priam's son Polites, Creusa, Dido, Palinurus, all lie behind, and, ahead, Pallas, Lausus, Camilla. Aeneas's guiding hope is the thread of ambiguous prophecies of Roman destiny, promising that he will transcend the labyrinth and found a new Troy just as Daedalus reduplicated his Cretan *domus* by artistry in a foreign land. As this reading of past and future history latent in the doors indicates, however, the labyrinthine prognosis is not optimistic. Theseus's escape from the labyrinth was followed by an ill-fated descent to Hades, from which he had to be rescued by Hercules, and Daedalus himself flew from the labyrinth because he could not escape its toils any other way. The cost of escape—the loss of Icarus—was so great that it made him leave his sculpture unfinished, endless as labyrinths and *errores* seem to be while one is in them. Similarly, Aeneas's escapes from his mazes may not be permanent, and if he is to be architect of his new *domus* after so many failed attempts, he too, or so the doors suggest, will pay a heavy price. Aeneas is trapped in labyrinthine delays as he peruses the sculpture until the guiding Sibyl rudely extricates him: he is not to muse on mazes but to tread them.[27]

The second labyrinthine structure in Book 6 is the Sibyl's noisy cave with its hundred doors—or so anyone familiar with descriptions of the Egyptian labyrinth might think. Modern archaeology has confirmed what Virgil, who wrote the *Aeneid* nearby, presumably knew well: the

25. On the ambiguity of "magnum reginae . . . amorem," see Fitzgerald, "Aeneas, Daedalus, and the Labyrinth," 63n14.

26. On Aeneas's silence and incomprehension, see Fitzgerald, duBois, and Segal. DuBois takes the Cumaean relief as a kind of psycho-history, representing Aeneas's present.

27. Aeneas's first task is to sacrifice seven bullocks and ewes whose number recalls the youthful Athenians in the relief: *Iuvencus* (6.38), significantly, can mean either bullock or young man. Fitzgerald notes the connection between Aeneas's sacrifice and the tribute to the Minotaur (p. 58) but interprets Aeneas's act as payment for the Sibyl's prophecies. I would see the allusion as a suggestion that the mythic pattern is beginning yet again.

Sibyl's cave lies at the end of a long man-made tunnel with lateral galleries and rooms branching off, and finally three rooms of which the last is further subdivided in three. The place itself, like Virgil's description, is thus quite labyrinthine.[28] Here Aeneas invokes Apollo, patron of errant islands, ambiguous oracles, and labyrinthine gates, as former guide through the seas of Book 3 and reminds him of the Trojans' *labores* and wandering gods (*errantes*, 6.68); here the Sibyl, in *ambages* common to maze (6.29) and oracle (6.99) alike, foretells future trials recapitulating the wars of Troy but promises a safe path (6.96). Like the temple doors, these prophecies entangle truth with uncertainty (*obscuris vera involvens*, 6.100), and the Sibyl's proffered guidance is hardly as palpable as Ariadne's thread. Nor is this the help Aeneas wants: instead, he craves to follow Theseus and Hercules to Hades (6.122–123), a passage the Sibyl describes as intensely arduous: "easy is the descent to Avernus: night and day the door of gloomy Dis stands open; but to recall thy steps and pass out to the upper air, this is the task, this is the toil! [*hoc opus, hic labor est*]."[29] In this second labyrinth of Book 6, then, Aeneas finds ambiguous guidance, wishes to emulate the maze-solver Theseus, and hears the annunciation of yet another maze—or, rather, two, for the quest for the golden bough itself involves Aeneas in something very like a maze, at least by the standards of early Christian writers.[30]

If Virgil's Hades is most labyrinthine in its fabled inextricability, it

28. See Raymond V. Schoder, "Vergil's Poetic Use of the Cumae Area," *CJ*, 67 (1971–72), 97–105, and extensive notes and diagrams in R. G. Austin's edition of and commentary on Book 6 (Oxford: Clarendon Press, 1977). Borgeaud reports that excavations at Ephyre, where Theseus descended into the Underworld, reveal a temple of Hades designed as a labyrinth: see "The Open Entrance," p. 19.

29. Fairclough's trans. The resemblance to the earlier description of the labyrinth is noted by Verrall, Enk, and Fitzgerald, among others. Petrarch apparently assumed that Virgil's Hades was a labyrinth: "I knew that the 'descent to Avernus was easy,' the gate of the labyrinth was wide, and that the way out was hard and difficult to find" (*Liber sine nomine*: Z118/D218). In the *Corbaccio* (p. 10), Boccaccio also alludes to Virgil as he descends into the labyrinth of love.

30. Cf. Ambrose and Gregory Thaumaturgus, chap. 3. The goal—the bough—is hidden in a vast, thick wood and imprisoned by shadows; to find it, Aeneas must rely on two doves sent by Venus, who point the way (6.194) and offer signs (6.198) to follow. (Pseudo-Bernard Silvester also emphasizes the wood's impenetrability and tracklessness—S&M, p. 60; J&J, p. 62). These elements loosely evoke a labyrinth, especially if one harks back to Aeneas's path to the Cumaean temple, which juxtaposes Trivia's grove with the golden temple of Apollo (*Triviae lucos atque aurea tecta*, 6.13). As the path to Daedalus' sculptures involves trees and gold, so too does the path to the labyrinth of Hades. Lines 9–263 involve concentric panel—or labyrinthine—structure: see Quinn, *Virgil's Aeneid*, pp. 160–161.

The golden bough itself was associated with a *bivium*, if not with a full-fledged labyrinth, by commentators: see Servius, *ad* 6.136, on the Pythagorean Y, followed by Pseudo-Bernard Silvester (S&M, p. 63; J&J, p. 64) and Landino (see Jane Chance, "The Medieval Sources of Cristoforo Landino's Allegorization of the Judgment of Paris," *SP*, 81 [1984], 145–160). After a précis of Pseudo-Bernard's reading of the *Aeneid*, John of Salisbury compares correct moral judgment to the discovery of a straight path in the midst of tangled error, for which one needs the bough of virtue as guide: *Policraticus* 8:24–25.

See also Segal, "*Aeternum per saecula nomen*: Part I" on the bough's ambiguities.

nevertheless shares other characteristics with the maze. To the living it is normally impenetrable: only with talisman and guide can Aeneas fathom its secrets and acquire the knowledge he seeks. Entered through a cave, the vast *domus Ditis* (6.269) is dark and cavernous, filled with hybrid monsters: centaurs, *scyllae biformes* (2.286), gorgons, harpies, the hundred-headed Briareus, the Hydra, Geryon, Cerberus (6.285–289, 417–421). Peopled by errant shades (6.329), Hades has serpentine rivers, the nine-fold inextricable *inremeabilis* Styx (6.425, 439), and various paths, including a *bivium* (6.540) whose right-hand path leads to Elysium, its left-hand path to Tartarus and the castle of Cretan Rhadamanthus, where Theseus is perpetually imprisoned. Among its denizens Hades numbers other Cretans: Minos as a judge, with his urn (and the proximity of infants and the falsely executed) recalling the drawing of lots for his slaughter of innocent Athenians in Crete; Phaedra; Pasiphae (6.426–436; 445; 447).

On the paradoxically easy path (6.776) of the Elysian Fields, Aeneas finds Anchises, who praises his son's mastery of the hard journey, the *iter durum*, through piety (6.698). There Aeneas sees, without full understanding, his own posterity, the city-builders and law-givers, bringers of stability. Yet stability is finally impermanent: even in Elysium one has no certain home (6.672), and while the cycles of metempsychosis render Hades extricable to some, they also prescribe a potentially endless sequence of earthly labors, a concept that naturally horrifies Aeneas (6.719–721).[31] One is freed from the Underworld only to face the *labores* and *errores* of life again, imprisoned in yet another blind prison, the body (6.734). Error and labor are endless, and the vision of Roman glory is barely adequate compensation. No wonder Aeneas, arriving in the new world, seeks a *straight* path (6.900) to Caieta.

Aeneas may have escaped Hades, and he may have bade farewell to his Trojan and Carthaginian past, as many critics believe,[32] but he has hardly escaped from labyrinths, for Books 7–12 continue to lead him in winding paths.[33] He first passes *daedala* Circe's isle; like Pasiphae a daughter of the sun, Circe too creates hybrid monsters, men in bestial shapes and perverse Daedalian breedings (7.282); she weaves fine webs in her impenetrable grove, and her very name conjures up the circles of the maze.[34] Yet her dangers are only metaphorically meant for Aeneas;

31. Cf. Augustine's horror of the cycles of pagan time, discussed in chap. 3.

32. E.g., Boyle, "The Meaning of the *Aeneid*: I"; L. A. MacKay, "Three Levels of Meaning in *Aeneid* 6," *Transactions and Proceedings of the American Philological Association*, 86 (1955), 180–189; Otis, *Virgil*, p. 303; Rutledge, "The Opening of *Aeneid* 6," 112.

33. This would not have surprised Fulgentius, who etymologized Lavinia's name as "laborum via": *Fulgentius the Mythographer*, trans. Leslie George Whitbread (Columbus: Ohio State University Press, 1971), p. 108.

34. Most Roman pavement labyrinths were square, but the Cretan form of the maze (see plates 1, 2), well-known across the Mediterranean, was circular.

his labors and labyrinths now will have to do with war—war created simply as one further delay by Juno, angry that the Trojans have found a path through all obstacles (7.296–315). Her agents, predictably, are another hybrid (Allecto with her serpent hair and vicious wandering [7.557]) and another distraught queen, Amata, herself invaded by, indeed fused with, a serpent of wrath recalling those of Book 2 (7.346–353).[35]

In this chaos of war, Aeneas finds allies and divine weapons, which in turn evoke the idea of the labyrinth. Aeneas arrives at Pallantium during the festival of Hercules, that man of labors who also escaped twin serpents and returned from hell. His local adventure with Cacus, described at length (8.185–270), reveals parallels to Theseus's triumph in Crete and anticipates Aeneas's combat with Turnus.[36] Vile inhabitant of an impenetrable cave whose doors were decked with the heads of his murdered human fodder,[37] Cacus stole Geryon's bulls from Hercules, dragging them backward into his cave: "and, with the signs of their course thus turned backwards, he hid them in the rocky darkness; whoso sought them could find no marks leading to the cave" (8.209–212; trans. Fairclough). The lines connote a labyrinth, a dark and inaccessible house, grave of innocent victims, with the deceptive *signa sequendi* found in mazes. Here this monster—*semihomo, semifera* (8.194, 267), like the Minotaur—was finally destroyed by Hercules, liberator of cattle and of the tribes from whom Cacus had exacted such fearful tribute. Hercules is a model for Aeneas: savior of peoples, master of *labores* imposed by Juno's wrath, flouter of inextricability, destroyer of blind evil.[38] Yet Hercules, dressed in a lion's skin and given to fury, liberator of beasts as well as men, is also a warning: do not become the monster you destroy, do not let Theseus merge with the Minotaur.

Another optimistic image similarly undercut is Aeneas's shield, product of the Daedalian art and labor of Vulcan—Cacus's father as well as Venus's husband. Woven in sevenfold circles (8.448), miraculously *textum* (8.625), its pageants of Roman history intertwined with dolphins leaping through the sea (cf. the Trojan Ride, 5.594–595), the shield is at once a work of complex art heralding the end of Aeneas's labors and a harbinger of war and violence. Its first vignette, the roots of Rome, depicts

35. Note that *errare* is used to describe the serpent's movements. Extending the labyrinthine parallels, Amata spins in circles (7.379) and leads her matrons in pathless woods (7.580).

36. Anderson, *Art of the Aeneid*, pp. 71–72, also discusses parallels between the Hercules-Cacus and Turnus-Aeneas battles.

37. Cf. the victims depicted on the doors at Cumae, Turnus's displaying the heads of Nisus and Euryalus outside the Trojan fort in Book 9, and his decorating his chariot with the heads of Trojan brothers (12.511–512), incidents that link Turnus with Cacus.

38. Putnam, *Poetry of the Aeneid*, p. 134, notes puns on *kakós* (Greek: evil) and *caecus* (blind) in Cacus's name.

the twins Romulus and Remus suckled by the wolf—another unnatural conjunction of beast and man, and an instance of doubleness that, with Romulus's murder of Remus, will become duplicity. Cities are founded on death. This is part of the burden of fame that Aeneas, *rerum ignarus*, lifts on his shoulders.

In Books 9–12 the labyrinths of war, faintly adumbrated by the Trojan Horse and Ride and the shield, ambiguously enunciated in the labyrinths of Cumae and Hades, become manifest. Book 9 recapitulates Book 5: the bewildered Turnus and his horsemen besiege the Trojan camp, wildly circling its impenetrable walls and finding no entrance (9.57–58); their movements recall the labyrinthine mock-battle of the Trojan Ride, but while the Trojan boys imposed order on chaos, now, with labyrinthine convertibility, chaos reigns alone. As in Book 5, incendiary Iris urges the destruction of the Trojan fleet, but again there is repetition with a difference: Virgil develops the second mazy simile from the Trojan Ride as the ships are miraculously changed into seanymphs who frolic like dolphins (9.119–120), eventually warning Aeneas of his people's peril.[39]

Imprisoned in their virtually impenetrable and inextricable camp and greedy for fame, Nisus and Euryalus decide to find a dangerous path through the encircling foe to summon Aeneas to the rescue. Sure of the *bivium* they seek and of their path through the dark valleys (9.238, 243–245), believing, as it were, that they know the labyrinthine ground through which they must pass, they possess the confidence of the youths in the Trojan Ride and the blessing of Ascanius.[40] Yet the riders' mastery of the maze in Sicily, their ability to turn war to peace, finds no match in the youthful pair's Italian exploits. The path they seek becomes a broad road of mayhem (9.323) as Nisus slaughters sleeping Rutulians like a lion in a sheepfold (9.339), cutting a path instead of following one (9.356). Instead of delivering their message, they become minotaurs, beast-men, and thus it is fitting that they never escape the maze alive. As they follow the left bend of the road (9.372), a glint of moonlight on Euryalus's plundered helmet betrays them to approaching reinforcements, who

39. The dolphin motif is also noted by Cruttwell, *Virgil's Mind*, pp. 93–96; Di Cesare, *Altar and City*, p. 84; and Putnam, *Poetry of the Aeneid*, p. 87.

40. Are the seven gifts Ascanius offers them (9.263–266) a talisman related to the traditional seven circles of the Cretan maze in its ancient representations? Does Mnestheus's gift to Nisus of a lion's skin (9.306–307) simultaneously recall Hercules' rages and foreshadow the leonine rampage on which the Trojans embark? The contrasts between this expedition and the games on Sicily may be pointed by the reference to the game one of the Trojans' victims had recently finished playing and would no doubt have liked to prolong (9.337–338). So too Nisus and Euryalus, runners in that deceptive footrace on Sicily, might have wished their graver exploits in Italy had a happier outcome, as they might have done had the pair kept their original noble goal in view.

block off all escape: "On this side and that the horsemen bar the well-known crossways, and with sentinels girdle every outlet. The forest spread wide with shaggy thickets and dark ilex; dense briars filled it on every side; here and there glimmered the path through the hidden glades" (9.379–383; trans. Fairclough). Euryalus's ill-gotten booty hinders him (*impediunt*: 9.385; cf. 5.585, 593) and he mistakes his path, only to be taken; it is as if his furor and greed have transformed a theoretically penetrable forest into an inextricable labyrinth. Nisus gets free but turns back to find his friend: "Where shall I follow, again unthreading all the tangled path of the treacherous wood [*rursus perplexum iter omne revolvens fallacis silvae*]? Therewith he scans and retraces his footsteps and wanders [*errat*] in the silent thickets" (9.390–393; trans. Fairclough). The lexis of labyrinths is as dense as the forest itself, and one is reminded of Aeneas's fruitless quest for Creusa in the maze of fallen Troy. Finally both youths die in redeeming nobility, but their errand into the treacherous maze has brought failure and death. The Trojan Ride has small counterpart in real war, and the Trojan pair's overconfidence and failure find a parallel later in Book 9 in Turnus's failure to end the war when, having penetrated the Trojan camp, his blood-lust leads him to insane slaughter like a tiger among the herds when the simple expedient of opening the gates to his army (9.730, 756–761) would have ruined the Trojans. He manages to escape, doubtfully retracing his steps (9.797) to withdraw from this particular prison as Nisus and Aeneas earlier retraced their steps *into* war-mazes, but Turnus too will shortly find himself in another labyrinth.

Book 10 offers no significant labyrinths, though it reminds us of the high price demanded by mazes and war alike: the wasteful deaths of noble youths like Pallas and Lausus. In Book 11, however, Turnus once again seeks out a labyrinthine setting for the slaughter of Trojans and once again fails, in this case by retracing his steps too soon. Hearing that Aeneas is approaching through the mountains while his cavalry attacks in the plains, Turnus leaves the main battle to Camilla and sets an ambush in a winding valley suitable for tricks (*doli*) of war. There is a dark, narrow, vaulted path through impenetrable woods; the entrance is narrow, and the path can be blocked by Rutulian troops in a double pass (*biviae fauces*, suggesting perhaps the fatal throat of the double Minotaur). Above is a secret plain from which reinforcements can charge downward to the right or left or hurl stones at the foe (11.515–516, 522–529). This description of the constrained, covered path through the impassable forest and the double jaws of the gorge evokes the Cretan labyrinth, whereas the mountain hiding-place and the possibility of hurtling stones at victims echo the description of Cacus's cave. Turnus, like the Minotaur and Cacus, has the advantage of knowing the territory

(*regione viarum*, 11.530), and here surely he would have prevailed had he not left prematurely after hearing of Camilla's death in another labyrinthine combat.[41]

But the labyrinth of war cannot be evaded for long. In the midst of general battle, Turnus and Aeneas begin a final if intermittent engagement whose pattern is strikingly labyrinthine. Frantic to save her brother Turnus, the goddess Juturna assumes the form of his charioteer and steers Turnus erratically across the battlefield, this way and that, as Aeneas tracks him in winding circles (12.481–482). Frustrated by their failure to meet face to face, Aeneas and Turnus rage and slaughter indiscriminately until Aeneas attacks the Latin city, Amata kills herself, and Turnus finally seeks single combat. Aeneas and Turnus battle like bulls (12.716): both, maddened in warfare, have become like minotaurs. Turnus races insanely along labyrinthine paths, now here, now there, entangling doubtful circles (*incertos implicat orbis*, 12.743) and finding himself in an inextricable situation, surrounded by Trojans, a vast marsh, and high walls (12.744–745). His steps impeded (*impediunt*, 12.747), Aeneas pursues like a hound after a stag who, terrified of high banks and traps, flees and turns again on a thousand paths (*mille fugit refugitque vias*, 12.753; cf. 5.590, the labyrinth's paths also being banked by walls). This is the true labyrinth of war, earnest of the Trojan Ride's game, as "five circles they weave at a run and retrace [*retexunt*] as many again, this way and that; they seek no light nor playful [*ludicra*] prize, but strive for Turnus' blood and life [12.763–764]." Jupiter sends down a fierce hybrid, a Dira—perhaps Allecto, who first caused the wars in Book 7—and Virgil stresses her double nature by describing her as one of a pair of serpent-haired winged twins (12.845; there are traditionally *three* Dirae). As if to signal that the mad race through the maze is over and it is now time to face the Minotaur, Aeneas decries delay and flight; using the language of the labyrinth myth, he challenges Turnus to use art, to fly to the stars, or to hide in a cave (12.892–893) if he must escape. Trapped like Cacus, ambushed as he had hoped to ambush Aeneas, Turnus responds like Cacus or as he himself had planned in the mountain pass: he hurls a stone, but one that fails of its mark. In an action echoing Laocoon's attack on the Trojan Horse, Aeneas casts his spear through the outermost circle of Turnus' seven-circled shield (12.925):

41. If Turnus plots an ambush reminiscent of mazes and of Cacus's fight with Hercules, Camilla's exploits suggest the labyrinth and Euryalus's fatal flaw in his labyrinthine journey. Camilla kills Orsilochus by a circular flight in which she doubles back in a narrower circle to cut him off (11.694–695), and she dies by the spear of the crafty Arruns, who repeatedly circles and tracks her, trying now this approach, now that, until her true goal displaced by the desire for booty, she opens herself to his attack (11.759–817). Her death is described in words exactly echoed—or retraced?—in Turnus's death (11.831, 12.952). Ironically, Turnus's labyrinthine ambush is cut short just moments before success (11.903–905) thanks to the labyrinthine strategies of Aeneas' most unattractive ally, Arruns.

this time the protective labyrinth is breached, and Turnus wounded. Though Turnus begs for mercy, Aeneas sees the *(in)signum* (12.944) that must be followed to escape this labyrinth of war: the baldric plundered from Pallas, which enrages Aeneas enough to kill Turnus. At the chronological beginning of Aeneas's history within the *Aeneid*, Laocoon died like a bull after trying to penetrate the labyrinthine Trojan Horse with brute force; at the end, raging like a bull, Aeneas succeeds because he has already carefully trodden all the mazes laid down by the gods, and in the heart of the labyrinth, action that seems shockingly direct after so much circuitousness is the only appropriate response. Yet the *Aeneid* closes not with Aeneas, but with Turnus' descent to the shadows of another labyrinth, Hades. A minotaur has been killed, but the labyrinth, and perhaps a hero who partakes of minotaurish rage, survives.[42]

Framed chronologically by labyrinths of war (the horse, the single combat of Turnus and Aeneas) and enclosing labyrinths of art (the Trojan Ride, the Daedalian panels) at its center, the *Aeneid* and its *iter durum* unfold as a sequence of labyrinths: explicit and implicit, architectural and narrative, *labor* as art, *labor* as toil, *error* as wandering, *error* as misjudgment. The mythical labyrinth characters are all there: Minos, lawgiver and vengeful destroyer of innocents; Pasiphae and Phaedra, afflicted by the gods with insane passion; Androgeos, beloved son whose death begets further tragedy; the Minotaur, terrifying beast-man of cruel appetite; Daedalus, cunning architect both master of and mastered by his complex art; Icarus and Hippolytus, youths cut down in their first flowering; Ariadne, the gracious guide abandoned; Theseus, ambiguous savior and seducer, treader of labyrinths in Crete, Delos, and Hades. All of them appear not merely as themselves but in others—Dido, Turnus, Cacus, Pallas, Ascanius, Lausus, and most particularly Aeneas himself. The myth provides an implicit commentary on the poem, hinting at a dark continuity of human motive and pattern. Qualities associated with the labyrinth appear and reappear, often in conjunction: darkness; inextricability; interwoven circular *errores*, circuitous processes, unforeseen delays, sudden checks, forced or voluntary retracings of steps; paths of ignorance, physical *ambages*, and verbal ambiguities; crucial choices guided by equivocal *signa sequendi* (omens, dreams, prophecies); passive endurance of a path imposed by unseen forces. The concept of the city as labyrinth appears in Books 2 and 4 and figures in the allusion to the Trojan Ride at Ascanius's foundation of Alba Longa, lending irony to

42. Even critics whose readings of the poem do not seriously involve the idea of the labyrinth recognize at some level that the poem ends in a maze: cf. Hunt, who describes "a labyrinthine maze of dream and reality interfused and of success and failure inextricably mingled" (p. 86), and Adam Parry, "The Two Voices of Virgil's *Aeneid*," *Arion*, 2, 4 (1963), 66–80, repr. in Commager, *Virgil*, pp. 107–123: "Aeneas' end . . . will see him as far from his fulfillment as his beginning" (p. 118).

Aeneas's quest for a stable city, a fixed *domus Aeneae*: will Rome too exhibit not merely the artistic order but also the chaos of the double labyrinth? Is the poem a series of labyrinthine journeys in search of new labyrinths? The ancient linkage of fame and labyrinths figures in the *Aeneid* as well: the Trojan Ride commemorates Anchises and, for the reader, anticipates the future fame of Rome, elsewhere depicted in the labyrinths of Hades and Aeneas's shield. Since ancient mazes in Egypt and Etruria were monuments to the dead, does the covert association of fame with labyrinths here celebrate chiefly the dead—including the victims of the road to Rome? As Pliny challenged the vast (and largely wasted) expense of the ancient monuments, does Virgil hint that the costs of building Rome may also be disproportionately great?[43] The labyrinth's endlessness appears in a particularly frustrating form: solving one maze brings brief triumph, but another maze always lurks.

In style and structure, the *Aeneid* employs a labyrinthine aesthetic (see Chapter 7). Lexically and syntactically, its style often relies on ambiguity.[44] The poem mimics the infinitely intricate and highly patterned design of the maze in many ways. Aeneas's geographical wanderings trace a pictorial labyrinth of error; moreover, the *Aeneid* is the *locus classicus* of what medieval rhetoricians called artificial order—an order associated with the maze in Chapter 7.[45] Beginning *in media res*, the poem constantly winds backward and forward in time, not only in narrative chronology but also in the patterns of retold histories, prophecies, and fulfillments. As in a maze, the same ground is retraced time and again, literally and metaphorically, and while there is undoubtedly linear progress, cyclical patterns also emerge. As we have seen, the blending of linear and cyclical movement finds a visual analogue in the circular labyrinth.[46] Moreover, the poem is highly artificial and labyrinthine in its symmetries, particularly in its use of ring structure, concentric panels (in which the narrative leads to a central point and then retraces its steps outward), and interlace.[47] Diagrams of the poem—and admittedly there

43. On Virgil's doubts about the adequacy of fame as compensation, see Hunt, *Forms of Glory*, esp. pp. 35–36; Boyle, "The Meaning of the *Aeneid*: II," 133–135; and Segal, "*Aeternum per saecula nomen*," parts 1 and 2.

44. See Camps, *Introduction*, p. 64, and Quinn, *Virgil's Aeneid*, pp. 127 and 394–414.

45. The best-known medieval discussion of the *Aeneid* in this context is Pseudo-Bernard Silvester's, which comments on the poem's double point of view and double narrative order, noting that frequent ambiguities demand multiple interpretation: S&M, pp. 3–5 and 11; J&J, pp. 1–3 and 9.

46. Thus I disagree with duBois's statement that Virgil "cannot trust absolutely any meta-historical patterning of history, either cyclical or linear" (*History*, pp. 49–50); I believe Virgil conflates and affirms both traditional views of history by adopting the model of the maze.

47. For descriptions of the poem's elaborate symmetrical structure, see Otis, *Virgil*, chaps. 6 and 7 and p. 392; Quinn, *Virgil's Aeneid*, chap. 3; Camps, *Introduction*, chap. 6 and passim; George E. Duckworth, *Structural Patterns and Proportions in Vergil's Aeneid: A Study of*

could be almost as many as there are analysts—thus suggest the concentric symmetry of the maze. Structure repeatedly calls attention to itself, and Virgil's art imposes an intensely complex artistic order on the often chaotic events related, so that the reader is far more closely attuned to parallels and symmetries than the characters trapped within the history being related.

There may be many reasons for Virgil's preoccupation with structure. Complicated narrative patterns were fashionable, as Catullus's Carmen 64 (significantly, also concerned with the labyrinth myth) demonstrates; obviously Hellenistic and Augustan poets prided themselves on Daedalian linguistic architecture. W. A. Camps rightly suggests that Virgil imposes architectural unity where Aristotelian unity is lacking—and I would add that the particular architectural model evoked is the labyrinth.[48] Perhaps, like some Ricardian poets, Virgil favored ornately patterned structure as a metaphorical defense against and response to the confusions and uncertainties of his world.[49] But whatever its causes, the *Aeneid*'s labyrinthine structure has important and somewhat paradoxical effects: on one hand, it supports the assumption that just as the poem is more tightly and carefully structured than the world it describes seems to be, so too there is a complex, elegant, symmetrical (and therefore rational) cosmic order wrought by a divine craftsman that we can only take on faith. On the other hand, the *Aeneid* shows the failure of Daedalus and the irrationality and limited control of the gods; in that context, perhaps the only truly rational order is that imposed by an artist or poet who creates labyrinths of symmetry where reality offers only labyrinths of chaos.

I am arguing, then, that Virgil made such extensive use of the idea of the labyrinth in the *Aeneid* that it becomes one of what Michael Putnam calls the "unifying imaginative patterns discernible in any masterpiece."[50] The labyrinth might have seemed appropriate for many reasons. Its myth provided an archetypal narrative for the story to be told—

Mathematical Composition (Ann Arbor: University of Michigan Press, 1962), chaps. 1 and 2; Philip Holt, "*Aeneid* V: Past and Future," *CJ*, 75 (1979), 110–121; Hunt, *Forms of Glory*; and Gordon Williams, *Technique and Ideas in the Aeneid* (New Haven: Yale University Press, 1983), pp. 75–81.

48. Cf. Camps, *Introduction*, pp. 58–59. Virgil generally liked concentric panel construction (see Otis, *Virgil*, passim) and reduplicated narrative patterns within a work (see A. M. Crabbe, "*Georgic* 4 and the *Aeneid*," *Proceedings of the Virgil Society*, 17 [1978–80], 10–31).

49. Cf. Charles Muscatine, *Poetry and Crisis in the Age of Chaucer* (Notre Dame: University of Notre Dame Press, 1972), chap. 2, "The *Pearl* Poet: Style as Defense."

50. Putnam, *Poetry of the Aeneid*, p. x. I hesitate to claim the maze as *the* central image because the labyrinth myth does not obviously account for recurrent images of fire and the hunt. On these images, see Boyle, "The Meaning of the *Aeneid*: I," 81–85; Knox, "The Serpent and the Flame"; Hunt, *Forms of Glory*, chap. 6; Otis, *Virgil*, pp. 70–79, 240–250; and Putnam, *Poetry of the Aeneid*, chap. 4, esp. pp. 171–172 on "tracking" and p. 187 on impious fury.

a dangerous, self-sacrificial, circuitous quest through uncertainty and confusion to destroy evil and establish a new and stable order, but an order whose stability can never be taken for granted, as the histories of Theseus, Aeneas, and Rome suggest. Its architectural significance as order containing chaos provided a model for poetry and the Roman art of government alike, and also a warning that the costs of order may be high and order itself unstable and dependent upon one's perspective. It was also an appropriate vehicle for examining and tying together a number of major philosophical concerns. Let us close by looking at how the labyrinth works in this regard.

What is the nature and order of the world in which Aeneas struggled? It is, of course, a labyrinth. To wanderers within its darkness, especially those without supernatural guidance, it consists of delay, detours, confusion, apparent futility. As Gordon Williams writes, "Only the backward view inspires confidence; there is no view forward."[51] Without the overview that external guidance or historical hindsight can provide, there is only chaos. Even with guidance, even for Aeneas, who is occasionally granted privileged vision—the vision that can found an empire—the possibilities of reliable knowledge remain scant. Supernatural guidance often takes the form of dim and ambiguous prophecies, like Apollo's oracle in Book 3. Omens must be interpreted: the Trojans misread the twin serpents from Tenedos, and only Anchises understands what the flame on Ascanius's head signifies (2.680-704). Dreams and visions may offer clear advice, as when Hector's ghost urges Aeneas to flee Troy (2.289-295), but advice may not be followed. Without supernatural intervention, Aeneas could never accomplish his labors; with it, his path is far from clear or easy. If the hero, with privileged vision, finds the labyrinth hard to fathom, how much harder is it for those who can't see far enough, or from a high enough vantage point? Even when Aeneas views the future in Hades or on his shield, he cannot fully grasp what he sees and remains profoundly *rerum ignarus*. Although there are multiple internal perspectives on the action of the *Aeneid*, no perspective—not even Jupiter's—seems fully reliable.[52] Thus the labyrinth, with its emphasis

51. Williams, *Technique and Ideas*, p. 39.

52. On the function of visions and supernatural intervention, see N. C. Webb, "Direct Contact between the Hero and the Supernatural in the *Aeneid*," *Proceedings of the Virgil Society*, 17 (1978–80), 39–49.

On Virgil's use of multiple perspective, see Gian Biagio Conte, *The Rhetoric of Imitation: Genre and Poetic Memory in Virgil and Other Latin Poets*, trans. Charles Segal (Ithaca: Cornell University Press, 1986), pp. 157–179, and Philip Holt, "*Aeneid* V," and "Who Understands Vergil's Prophecies?" *CJ*, 77 (1982), 303–314. Otis, *Virgil*, chap. 3, considers the tensions between Virgil's "subjective style" and his alleged desire to "expound a single moral and point of view which will dominate the reader."

On problems with Jupiter's knowledge, see Quinn, "Did Virgil Fail?" in *Cicero and Virgil: Studies in Honor of Harold Hunt*, ed. John R. C. Montago (Amsterdam: A. M. Hakkert, 1972), repr. in Harold Bloom, *Modern Critical Views: Virgil* (New York: Chelsea House,

on the importance of perspective, is an appropriate model for the kind of world in which perfect knowledge (and therefore perfect action) is impossible, even to gods.

Labyrinths have architects, at least in theory. Who is the architect of Virgil's labyrinth-world? The gods modify the mazes Aeneas must tread: Juno designs delays and diversions, and Jupiter intercedes, through Mercury, to get Aeneas back on track. Jupiter, who views the world from above as if it were a map (1.223-226), can unroll the scroll of fate (1.262); but who wrote it? Since disorder is as prevalent among gods as among men and even Jupiter's efficacy is not unquestionable, we can conclude only that there is no absolute and omnipotent architect, or at least none whom Virgil lets us see.[53] Virgil himself is inside a labyrinth, seeing clearly only in retrospect.

Labyrinths simultaneously address and evade the question of free will vs. determinism in that all mazes limit the range of possible choices, and unicursal labyrinths preclude all choice (other than whether or not to continue) after entry.[54] Free will is therefore operative but restricted, very much as in the *Aeneid*. Clearly Aeneas and his descendents will found and rule Rome: the goal of the labyrinth is prescribed by fate and confirmed by history. Yet that goal can be reached in a number of ways, some defined by the gods (e.g., the diversion to Carthage), some by human choice (e.g., whether to kill Turnus). There are, it seems, at least three levels of path-mapping and maze-defining: Fate's, the gods', and humanity's. Fate disposes broadly, the gods alter details, and men choose among fixed options. Although Aeneas protests "I do not pursue Italy of my own free will" (4.361), often he *does* move voluntarily. Thus a complex labyrinth, unicursal in some places and multicursal in others, with adjustable walls that can be moved arbitrarily to create and remove dead ends, constitutes an excellent model for how fate and free will operate in the *Aeneid*. Once one enters, the ultimate goal is established, but unicursal stretches between moments of significant choice (e.g., the storms in which Aeneas and his people have no control of direction) require persistence, and multicursal junctures demand choice. Internal flexibility may reduce or increase the time required to complete the course, and

1986), pp. 73–83, which suggests that some discrepancies result from Virgil's incomplete revision of the poem.

53. Cf. Gordon Williams, *Technique and Ideas*, p. 38, for whom the gods are "a synecdoche for the chaos and lack of pattern that characterize events viewed in the immediate context of their occurrence."

54. See chap. 2. For conflicting discussions of free will and determinism in the *Aeneid*, see, e.g., Conte, *Rhetoric of Imitation*, pp. 175–179; Otis, *Virgil*, pp. 353–354, 377, and passim; Camps, *Introduction*, chaps. 4–5; Williams, *Technique and Ideas*, chaps. 1–2; Quinn, *Virgil's Aeneid*, p. 123; Parry, "Two Voices," 118 and 123; and W. R. Johnson, *Darkness Visible: A Study of Vergil's Aeneid* (Berkeley: University of California Press, 1976), pp. 114–134.

may lead down this path or another. Because the master-maze thus contains a series of successive labyrinths, the question of what to follow, what to flee, is crucial (3.459-460, 6.892). Yet the *signa sequendi* are confused, deceptive, conducive to *error* (5.590-591). The *Aeneid* argues that, however independent and wise one may be, the cards are stacked. For most of us, the labyrinth wins in the end, especially when architects and gods unfairly change the course and the rules in mid-journey, as they often do (see particularly the divine interventions in Book 12).

Because the maze offers some choice, there are better and worse ways to tread it. *Pietas*, the paramount virtue in the *Aeneid*, is a quality most necessary in mazes, where success involves persistence in and respect for the paths and goals that are laid out, patient endurance of the unavoidable twistings and confusions that lie between *bivia*, and the exercise of moral intelligence at points of choice. If Aeneas is not perfect in this respect, he does a better job of maze-walking than anyone else (with the possible exception of the comparatively untried Ascanius who, having mastered the labyrinth in play, opts out of the labyrinth of war at Apollo's injunction). Turnus fails in the labyrinth because he, like his divine allies, cannot accept its existence and constraints; a brave and often sympathetic antagonist, he denies the order imposed by prophecy and human agreement and tries to step out of established paths altogether until finally he is trapped in a maze of death.

Yet Aeneas too fails to achieve perfect virtue, and taking the labyrinth as a model for the world of the *Aeneid* explains his failure. First, no one can see well enough to tread the labyrinth perfectly: as error is inherent in the maze's structure, so it is in the choices made within, especially when guidance is ambiguous. Yet even if perfect vision were possible, it might not be enough. As labyrinths are characteristically dual and convertible, so are those trapped within, at least in Virgil's view. What Theseus battles in the maze is the Minotaur, the man-beast, and in the successive labyrinths of the *Aeneid* the monster within can never be slain once and for all. All humanity is double, hybrid; all are potentially minotaurs.[55] This theme of doubleness, of hybridization, echoes throughout the poem. There are hybrid creatures: the harpies, the beasts on Circe's island, the terrors at the elm of false dreams in Hades, Allecto, the beasts conquered by Hercules (including Cacus, half-man, half-beast), the Dira who brings Turnus to despair. There are men conjoined with animals: the Trojan Horse, the Trojan sailors in their ships named for hybrids, Daedalus and Icarus as bird-men, Pasiphae in her wooden cow, Amata invaded by the serpent, Hercules and Nisus with their lions' skins, Turnus with the chimera on his helmet and the cow-woman Io on

55. Pseudo-Bernard Silvester predictably associates the hybrids in Hades with vice: S&M, pp. 68–72; J&J, pp. 70–75.

his shield,[56] Romulus and Remus at the wolf's teats. Men fight like beasts in the labyrinth of war: Nisus, Euryalus, Turnus, even Aeneas. Things often come in twos, for no particular narrative reason: two serpents in Troy (and twin snakes in Allecto's maddening of Turnus, in Hercules' infant labor, in the depiction of Cleopatra); two doves leading to the (hybrid) golden bough; the double plumes of Romulus seen at Lethe; two gates at the exit to Hades (where one might have expected Aeneas merely to retrace his steps); double gates of war in Latium and in Olympus; the centaur-like twins Catillus and Coras, the pairs of twins or brothers slain in Troy and Italy, the double flame on Augustus's head on Aeneas's shield, the two robes woven by Dido that Aeneas brings forth to place on Pallas's bier (only one of which is actually used). Latinus swears vainly by Latona's twins (Apollo and Diana, patrons of the Cumaean labyrinths) and double Janus that the treaty in Book 12 will not be broken.

This insistent iteration of doubleness and hybridization points to a deeper dualism in the universe and in mankind,[57] a dualism enhanced by Aeneas' own double ancestry: human and divine, Cretan and Italian (cf. 3.180, where Anchises reveals his "ambiguous race and double ancestry"). Yet this dualism also figures in an optimistic pattern: as Aeneas's double ancestry resolves itself in a single Aeneas, as the two lines of Aeneas and Evander are traced back to a single root (8.142), so the double heritage, Italian and Trojan, will generate one nation (12.190–191, 820–828). All men are double, minotaurs, in some proportion or other, and therefore human failure is inevitable because of what men are as well as because they tread continual labyrinths. Yet unity, or at least a fusion of duality, is fleetingly possible, as we see in one of the noblest images in the poem: the Trojan youths mastering their horses in the labyrinthine complexities of the Trojan Ride. The fragility of unity and order renders them the more admirable and also the more tragic: men tame labyrinths only in ephemeral games.

Virgil's vision is bleak: human history is an unending series of labyrinths inhabited at best by would-be incarnations of Theseus who discover that they themselves may act like minotaurs. Virtuous action is possible, but not continuously. Escape is possible, but it is temporary: one recurrent pattern in the poem is escape, celebration, and entry into another labyrinth. Thus Daedalus escapes from Crete, dedicates his wings to Apollo, and sculpts a maze; Theseus solves the labyrinth, celebrates at Delos with a labyrinth dance, and enters the labyrinth of Hades; Aeneas flees the labyrinths of Troy and the waves, appears in

56. DuBois also notes this point (*History*, pp. 39–40).
57. Cf. Brooks, "Discolor Aura," 146, who notes "that particular dualism which is the essence of the *Aeneid*."

Carthage like Apollo at the Delian dances, and falls into labyrinths of love; he escapes through labyrinthine storms to Sicily and celebrates with the Trojan Ride only to seek out Cumae and the terrible labyrinths of war. We and he see visions of his descendants, of the glory his labors and errors make possible, but he himself is left in the maze, having slain a minotaur but having done so in a fury that leaves him suspect. His reward is deferred, present within the poem only in prophecy. If chaos and order alternate in the *Aeneid* as in perceptions of the labyrinth, the poem ends with chaos. If one labyrinth is extricable, the succession of labyrinths is endless. The achievement of even temporary order may well be worth while—the labyrinth, after all, is far worse—yet the costs of that inevitably impermanent order are high.

Many readers, particularly those adopting a perspective from within the labyrinth, find in the poem a profound sense of human waste and failure; others, espousing a more detached overview, see the triumph of order and *pietas*. In the *Aeneid* as in a labyrinth, both responses are simultaneously and equally valid, and one might argue that *because* failure is inevitable, because the odds are so long, fleeting success and virtue (which need not coincide) are all the more laudable.[58] Labyrinths, like life, involve chaos and order, destiny and free choice, terror and triumph—all held in balance, all perspective-dependent. In the *Aeneid*, that is simply how the universe is built.

Book 1 begins with Virgil's singing of Aeneas's quests for a stable city and ends with another song by the Carthaginian Iopas: "hic canit errantem lunam solisque labores" (1.742). "He tells of the wandering moon and the sun's labors": the creation of man and beast, rain and fire, the guiding *Triones*, haste and delay. Iopas's song, carefully balancing one item against another, is a tightly structured *labor*, a work of art like Virgil's, though in miniature. Iopas condenses and crystallizes the labyrinthine meanings and cycles of the *Aeneid*: in the beginning were *error* and *labor*, the moon and the sun, the twins Diana and Apollo who guard the double Cumaean doors. In the beginning was the cosmic labyrinth. And the results? Man and beast, the elements of the Minotaur. Rain and

58. Thus I would finally disagree with Boyle, who values Turnus more highly than Aeneas simply because Aeneas aims higher and fails to reach that goal; even at his worst, I would argue, Aeneas is more admirable even though imperfect. Putnam too is disappointed in Aeneas: *Poetry of the Aeneid*, chap. 4, esp. pp. 192–193. See also Douglas J. Stewart, "Aeneas the Politician," *Antioch Review*, 32, 4 (1973), repr. in Bloom, *Modern Critical Views: Virgil*, pp. 103–118.

Taking more moderate positions on Aeneas's failure are Brooks, Clausen, Johnson (who gives perhaps the most sensitive refutation of Boyle's and Putnam's positions, pp. 114–134), Parry, Hunt, Quinn (esp. chap. 1), and George E. Dimock, Jr., "The Mistake of Aeneas," *Yale Review*, 64 (1975), 334–356. For generally positive views of Aeneas's achievement, see Otis, esp. pp. 313–382; Rutledge, "Opening of *Aeneid* 6" and "Vergil's Daedalus"; and Anderson, *Art of the Aeneid*. For an overview of the debate, as well as a discussion of inconsistencies in the poem, see Quinn, "Did Virgil Fail?" pp. 73–83.

fire, life-giving and life-destroying, elements of Aeneas's sea-journeys and Dido's passion and the Italian wars, elements coming together in the repeated image of the storm. The "gemini Triones," the constellation of the plough-oxen or the greater and lesser bears:[59] these celestial guides are also beasts, one destructive, the other plodding but productive, the pairing suggesting the minotaur that is man with his double nature. Speed and delay, straightforward passage vs. the circuitousness of the labyrinth. In the world of the poem as in Iopas's song, all these dualities are necessary and inescapable; together they define the cosmic labyrinth within which human history, before and after death, must also be a story of journeys through the maze. As for the art that gives us a privileged view of the labyrinth, we are left with an analogous vision: Daedalus crafting a well-structured but unfinished sculpture that is only partially studied by Aeneas in an elaborately constructed but unfinished, or at least unpolished, poem.[60]

59. Often called the Septemtriones rather than the two triones. Presumably the use of one form would evoke the other, and although Virgil stresses duality in Iopas's song, seven is an important number for the labyrinth, as the common Cretan design had seven circuits. In this context, the seven circles of Aeneas's and Turnus's shields, already noted, connote the labyrinth. Similarly, that Aeneas is inconsistently described as having wandered for seven years both on his arrival in Carthage (1.755) and almost a year later in Sicily (5.626) suggests an intentional association of Aeneas's wanderings with the labyrinth. The seven-fold serpent winding around the altar in Sicily might anticipate the labyrinthine Trojan Ride. One might also see a succession of seven cities leading from Troy to Rome: Aeneadae, Pergamum in Crete, Buthrotum, Carthage, Acesta, Alba Longa, and finally Rome.

60. See Quinn, "Did Virgil Fail?"; that the *Aeneid* remained unfinished at Virgil's death was well known to later ages thanks to Donatus's *Life*.

Boethius's *Consolation of Philosophy*

Ludisne, inquam, me inextricabilem labyrinthum rationibus texens, quae nunc quidem qua egrediaris introeas, nunc uero quo introieris egrediare, an mirabilem quendam diuinae simplicitatis orbem complicas?

"You are playing with me," I said, "by weaving a labyrinthine argument from which I cannot escape. You seem to begin where you ended and to end where you began. Are you perhaps making a marvelous circle of the divine simplicity?"

<div align="right">Boethius, Consolation of Philosophy, 3p12</div>

I F VIRGIL bequeathed to the Middle Ages a pessimistic pagan example of the highest labyrinthine artistry, the Christian Boethius, working in the labyrinthine tradition of the classical and early Christian authors considered in Chapter 3, used the received idea of the labyrinth in an optimistic theodicy demonstrating that what appears to be a labyrinthine world of random confusion and injustice is in fact, with the proper perspective, a manifestation of the cosmic order created by divine providence.[1] True, the labyrinthicity of the *Consolation*

1. In this chapter I quote (and sometimes modify) Green's translation and Ludwig Bieler's Latin edition; sentence numbers refer to Bieler.

My appreciation of Boethius has been deepened by the following discussions: Henry Chadwick, *Boethius: The Consolations of Music, Logic, Theology, and Philosophy* (Oxford: Clarendon Press, 1981); Pierre Courcelle, *La Consolation de Philosophie dans la tradition littéraire: Antécédents et posterité de Boèce* (Paris: Études Augustiniennes, 1967); Richard A. Dwyer, *Boethian Fictions: Narratives in the Middle French Versions of the Consolatio Philosophiae* (Cambridge: Medieval Academy of America, 1976); Caroline Eckhardt, "The Medieval *Prosimetrum* Genre (from Boethius to *Boece*)," *Genre*, 16 (1983), 21-38; Peter Elbow, *Oppositions in Chaucer*, chap. 1; *Boethius: His Life, Thought, and Influence*, ed. Margaret Gibson (Oxford: Basil Blackwell, 1981); Seth Lerer, *Boethius and Dialogue*; F. Anne Payne, *Chaucer and Menippean Satire* (Madison: University of Wisconsin Press, 1981), chaps. 1 and 3; and Winthrop Wetherbee, *Platonism and Poetry in the Twelfth Century: The Literary Influence of the School of Chartres* (Princeton: Princeton University Press, 1972).

One of the most provocative discussions of the *Consolation* is Elaine Scarry's "The Well-Rounded Sphere: The Metaphysical Structure of the *Consolation of Philosophy*," in *Essays in*

is not as marked as that of the *Aeneid*;[2] yet the idea of the labyrinth seems to underlie and support much of the *Consolation*'s content and imagery, and the very structure of the argument is inherently labyrinthine: themes and images are retraced from book to book, Philosophy's discourse winds away from its goals only to approach them the more closely, and the dialogic structure of the work involves repeated shifts in perspective of the sort typically associated with labyrinths and labyrinthine convertibility. In short, the *Consolation* not only involves labyrinths and labyrinthine matters but also reflects labyrinthine epistemology and aesthetics, discussed in Chapters 3 and 7. If this hypothesis seems improbable at first glance, the fact that illuminations of mazes accompanied five medieval manuscripts of the *Consolation* sanctions a closer look at labyrinths in the work.[3] After considering how earlier labyrinth traditions may have informed the *Consolation*, we will examine the work as a central text in labyrinthine literature.

The *Aeneid* may have suggested the sustained metaphorical equation of an exemplary human journey through life with a labyrinth-voyage in search of a stable homeland, yet Boethius's journey differs from that of Aeneas. Both heroes are first seen at their nadir, imprisoned in despair and longing for death, but Boethius's narrator progresses rapidly thanks to reliable guidance from Philosophy, who leads him to a lofty perspective and privileged vision that, at least within the time-span of the work, can be maintained. For a Christian, even one following Philosophy rather than purely Christian doctrine, the *iter durum* through the labyrinth of life in this world may be inevitable, but it is not inextricable. From Virgil, too, may come Philosophy's sibylline ability to grow to greater than mortal stature (1m1); yet Boethius's guide, unlike the Sibyl, accompanies him every step of his way and leads him to a vision of the

the *Numerical Criticism of Medieval Literature*, ed. Caroline D. Eckhardt (Lewisburg: Bucknell University Press, 1980), pp. 91-140. Approaching the work from very different points of view, she and I agree on the importance of careful aesthetic design and of circles and spheres in the structure of the imagery; the meaningful repetitiousness of subject matter; and the thematic importance of changes in perspective (cf. also Elbow). In seeing the labyrinth as an important image in the work, however, I remain alone.

An excellent bibliography of studies on Boethius is included in Russell A. Peck, *Chaucer's Romaunt of the Rose and Boece, Treatise of the Astrolabe, Equatorie of the Planetis, Lost Works, and Chaucerian Apocrypha: An Annotated Bibliography, 1900 to 1985*, The Chaucer Bibliographies (Toronto: University of Toronto Press, 1988).

2. For example, some important recurrent images in the *Consolation*—music, speech and silence, healing and sickness—have no obvious connection with the labyrinth. Nor do characters from the Cretan myth figure explicitly in the *Consolation*, though there are analogies between Philosophy and Ariadne and Daedalus, and the idea of the Minotaur, half-man, half-beast, may be reflected in Boethius's emphasis on bestial men, a common theme in Book 4 and elsewhere.

3. See "Labyrinths in Manuscripts" in chap. 5 above, and plates 22 and 23. Neither Courcelle nor Diane Bolton ("Illustrations in Manuscripts of Boethius' Works," in Gibson, *Boethius*, pp. 428-437) mentions these illuminations.

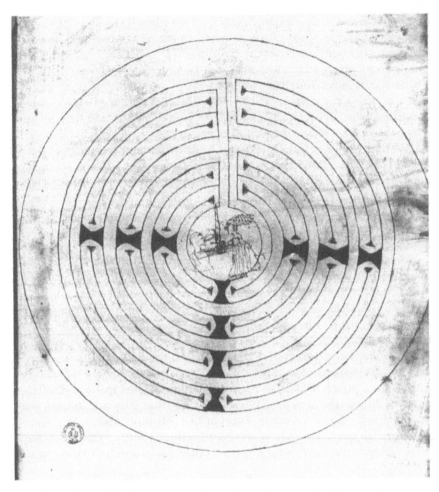

23. Illustration of the Cretan maze, from the endpaper of a fourteenth-century manuscript of Boethius's *Consolation of Philosophy*. Florence, Laurentian Library, MS. Plut. 78.16, fol. 58r. By permission.

heavens, not of Hades. The necessity of following a circuitous and laborious path to the goal is manifest in *Aeneid* and *Consolation* alike, but the epistemological importance of retracing one's steps is paramount in the *Consolation*, where circuitousness is far more than mere delay. *Error* is inevitable in both works, and hybrid monstrosity lies latent in human nature, yet the *Consolation* suggests that these obstacles can be overcome. Perhaps the greatest differences in the relative uses of the labyrinth reflect the pagan vs. Christian viewpoints of the authors: if a cyclical worldview prescribes an interminable series of intermittently extricable labyrinths for Virgil, for Boethius the labyrinth is extricable when a

sufficiently enlightened perspective—a perspective unavailable even to the gods in the *Aeneid*—is achieved. For Virgil, the cosmos is a labyrinth with traces of order; in the *Consolation*, the world looks like a labyrinth of confusion only because distorted human perception cannot fully grasp the principles and reality of divine order, symmetry, and simplicity. In many respects, then, the *Consolation* can be seen as a Christian Roman's revision and correction of the labyrinthine world view inherent in the *Aeneid*, a revision that also resolves the *Aeneid*'s ambiguities about the relationships between fate, free will, and divine justice; in Boethius's cosmology the suffering of the innocent, so tragic a part of Virgil's labyrinthine world, is merely an illusion.[4]

The *Consolation* is closer in philosophy to Seneca's brief but suggestive description of life as a labyrinth (see Chapter 3). Lucilius, like the Boethius-persona, blames fortune for his adversities, and Seneca, like Philosophy, has little patience with blind self-pity. True happiness resides in freedom from the pursuit of false felicity, and the cure is transcendent vision: seeing false goods for what they are and pursuing the one true goal. Although Boethius and Seneca might well disagree in defining that goal, the close parallels between the subject and imagery of Books 1-3 of the *Consolation* and Seneca's letter suggest that Seneca's labyrinth may have provided Boethius with the germ of his *prosimetrum*, while Virgil showed how a core labyrinth image might be varied and expanded in the course of a long, ambitious work.

Coincidentally, subconsciously, or intentionally, Boethius borrows a good deal else from received labyrinth tradition. In seeing the world as an apparently impenetrable labyrinth that is really divinely ordered artistry, he echoes Gregory of Nazianzus and Jerome; in comparing the quest for false felicity to a multicursal journey into dead ends, he reflects Gregory of Nyssa, Ambrose, and Prudentius; in emphasizing an elevated, comprehensive point of view as a remedy for labyrinthine blindness, he reiterates Gregory Thaumaturgus; in seeing fallen man's labyrinthine mind and passions as a cause of blindness, he concurs with Prosper of Aquitaine. Surer labyrinthine debts, perhaps, accrue to Macrobius, Plato, and Sidonius, for whom labyrinths of words can be supremely deceptive; the tradition that language and dialectic may be treacherous mazes initially informs Boethius's protest that Philosophy is toying with him by weaving labyrinthine arguments. Yet finally Boethius's view of labyrinthine logic resembles Augustine's in the *De mag-*

4. In "Figures of Olde Werk" (pp. 267-283), Christopher Baswell suggests that "the very echoes of the *Aeneid* [in Boethius] carry an implied critique of their source" (p. 270). He also describes the constant linking of *Aeneid* and *Consolation* in medieval commentaries on either work, which frequently invoke one text to explain the other; indeed, sections of commentary on the *Aeneid* are sometimes plagiarized *in toto* for application to the *Consolation*; see pp. 277-283.

istro:[5] learning is necessarily circuitous, a protracted and repetitive retracing of *ambages* to arrive by memory at what one already knows. We have seen that pagan thought itself was sometimes considered a dangerous labyrinth (cf. Prudentius, Caelius Sedulius). Appropriately enough, as a devotee of classical philosophy and a would-be reconciler of Plato and Aristotle, Boethius redeems pagan philosophy and labyrinth alike: while both pagans and Christians are hampered mentally by living in a labyrinthine world, the *Consolation*'s central conversion of the bewildering labyrinth into an image of the justly ordered cosmos is mediated not by Christ-Theseus but by the Aristotelian and Platonic methodology and assumptions of Philosophy, who becomes as reliable a guide through labyrinthine thought as Origen was for Gregory Thaumaturgus.

My hypothesis, then, is that the *Consolation* relies on a labyrinthine aesthetic, labyrinthine structures, and patterns of imagery that consistently depict the world in which we live as a labyrinth—an apparently inextricable prison, full of misleading paths and dead ends, in which our natural vision is dim and fragmented and our nature made bestial by vices more potent than Circe's cup. Yet the recovery of proper perspective reveals seeming chaos to be supreme art, created and patterned by God. The labyrinth's convertibility thus dominates Boethius's use of the metaphor, and the conversion from confusion to clarity is achieved by means of the two mythologically ordained ways to escape the maze: the retracing of one's steps with a guiding thread, and flight to an elevated perspective. Let us see how this hypothesis works itself out in the *Consolation*, always remembering that the image of the labyrinth does not become explicit until the middle of the work, just as in the *Aeneid*,[6] and hence that a reader's perception of labyrinthicity throughout the work may well be evident only in privileged retrospect.

The work begins with the narrator in prison, exile, and despair; surrounded by muses, he is disoriented, blinded by tears, unable to lift his eyes above the earth or even remember what he is (1m1–1p3).[7] From

5. And, of course, the Platonic view as well.

Edmund T. Silk suggests parallels between Augustine's dialogues and the *Consolation*: "Boethius's *Consolatio philosophiae* as a Sequel to Augustine's Dialogues and Soliloquia," *Harvard Theological Review*, 32 (1939), 19-39. However, he does not notice that Augustine's view of dialectic as a labyrinth for the unsophisticated (see chap. 3 above on the *Contra academicos*) might have influenced the *Consolation*.

6. Perhaps Virgil's joyous Trojan Ride and the bleaker vision of the Cumaean Gates are conflated in the *Consolation*: Boethius ironically describes labyrinthine argument as play ("Ludisne me," he asks), yet it is actually serious (and ultimately joyful) revelation. As the Cumaean labyrinth refers to Daedalus's flight and is followed by journeys to Hades and past Circe's isle, so in Boethius the labyrinth passage in 3pr12 is followed by Orpheus's descent to Hades, a flight by mental wings, and a description of Circe's witchcraft. Both protagonists reach their *patria*, but triumph is deferred: Aeneas receives no reward within the poem, and Boethius's narrator remains physically in prison and dishonor.

7. Like Aeneas, he is nearly drowned; like Icarus (or Daedalus at Cumae), he has fallen into grief. Dante will find himself, literally and metaphorically, in like position at the start of the *Comedy*.

this concatenation of subjectively inextricable prisons, Philosophy comes to free him. She is a compassionate if acerbic Ariadne, and, having been abandoned once (1p2), she will never let her scholar desert her again once she has restored his vision (e.g., 1p2, 1p3, 1p6–1m7) and helped him retrace his steps to knowledge (e.g., 1p5–1m7).

But Philosophy is not merely an Ariadne: she is simultaneously an image of both the labyrinth and its transcendence, as the narrator's initial description of her reveals (1p1). What she wears is *textus*, like the labyrinth: with subtle artifice she has woven the delicate threads of her robe—the texts, the labyrinths of words and arguments, by which she is expressed among men, and by which she will lead Boethius from his many prisons. *Intextum* in her robe is a symbol of the change in perspective maze-walkers need and find in her: the ladder from practical to theoretical knowledge. Her stature too suggests transcendence: her height is now mortal, now touching heaven—she can see from both human and god-like points of view. Yet in this double stature and double vision she is *ambigua*, partaking of maze-like ambiguity. Thus she embodies visually both the exquisite artistry of woven word-mazes and the means of rising above and so transforming labyrinths that seem confusing to those who cannot comprehend them as art. She wears the guiding threads of Ariadne, and her ladder and changing height suggest the flight-enhanced perspective of Daedalus. These two modes of escaping the labyrinth, seen here at one glance, are employed throughout the *Consolation*.

The theme of retracing associated with Ariadne begins almost immediately, along with the theme of apparent worldly and moral (dis)order. In his bitter complaint against Fortune and cosmic injustice, the narrator retraces the events of his fall from honor (1p4), but Philosophy counters with a reminder of first principles (1p3, 1p5–1m7)—a more productive retracing of his intellectual past—and with images of cosmic order and justice (1m2, 1m4, 1m6, 1m7). The narrator himself can recall the well-ordered orbits and paths of celestial bodies (1m5), but he foolishly believes that these concentric circles of divine law are superseded by unjust Fortune in human life. He sees mundane chaos and divine clarity but assumes complete disjunction between the two. That is why Philosophy must restore his vision and define the right path (1m7), which will prove to be a circuitous retracing of steps leading him to recall what he has forgotten: the way out of the labyrinth of his own fallen mind.

Book 1 opposes recurrent images of chaotic blindness, darkness, and imprisonment with images of light, stellar orbits, and order—two extremes on the ladder of possible perspectives on the world. But Book 2 fuses the image of celestial circles with that of the inextricable prison into the dominant image of Fortune's wheel (2p1, 2m1, 2p2), whose operations constitute the subject of this book. This fusion of extremes mirrors the narrator's faulty belief that the only order governing this prison-

world is imposed by the mechanical turnings of Fortune's wheel, not the perfect circles of cosmic architecture. A blind goddess of ambiguous visage (2p1.11) with multiform deceits (2p1.3), Fortune fitly rules what the narrator sees as a random, chaotic world, though Philosophy points out errors in his perspective (2p4.22, 2p5) and recommends a loftier overview in which "the whole circumference of the earth is no more than a pinpoint" (2p7.3). The narrator's vision of the world as subject to the irrational wheel of ambiguous Fortune, then, is refuted by Philosophy's logical demonstration that the gifts of Fortune are imperfect in themselves and by her closing poetic evocation of true order, in which all things are bound by love (2m8).

Book 2 defines the itinerary for the recurrent retracings of ground already covered that characterize Book 3 and establish its labyrinthine methodology. Ready for more difficult arguments, the narrator learns they will guide him "to the goal your mind has dreamed of. But your vision has been so clouded by false images you have not been able to reach it" (3p1.5). First, however, there will be a digression, as in other productive epistemological mazes: an examination of false felicity that revisits subjects discussed in Book 2 from a different perspective. This circuitous retracing is a necessary preparation for the narrator's eventual escape from intellectual dead ends by a "turn . . . in the opposite direction" (3p1.7). "In spite of its hazy memory, the human soul seeks to return to its true good; but, like the drunken man who cannot find his way home, the soul no longer knows what its good is," Philosophy says (3p2.13), establishing the dominant metaphor of Book 3: the attempt to find the single path among many by which man, blinded by errors induced by body, imperfect perspective, oblivion, and passion, may retrace the path to his true country. As the gifts of Fortune (riches, honors, power, fame) were examined and found wanting in Book 2, so here they are reexamined as paths that lead only to dead ends, not to the goal of true happiness (3p3–3p9). In Book 3, however, we view these illusory goods as it were from above, able to see each path and its actual goal, and implicitly the varied false paths form a multicursal maze going nowhere.[8] The substance of Book 2 has been retraced and augmented, and the metaphor adopted in this discussion is that of multiple deviations from the true single path upward.[9] The summation of the argument is

8. Cf. the labyrinthine imagery of the following passages: "Mortal men laboriously pursue many different interests along many different paths, but all strive to reach the same goal of happiness"; "all men try by different means [tramite–path] to attain this state . . . even though foolish error draws them toward false goods" (3p2.2, 4); "However weak the vision of your dream may be, you have some vague idea of that goal of true happiness toward which you gaze. Nature leads you toward true good, but manifold [multiplex] error turns you away from it" (3p3.1); "these are the wrong roads [deuia] to happiness; they cannot take anyone to the destination which they promise" (3p8.1).

9. The emphasis on return and retracing is pointed in 3m2 by the repetition in lines 34-38 of re-, and the alliteration of or- links order, beginning, and circle, reinforcing the

again a retracing of all the specific paths found wanting (3p8.3-6), and the following *metrum* emphasizes both their deviousness and the need to change one's perspective to find the true path—to look to the starry heavens rather than to earth (3m8). To confirm his understanding, the narrator retraces the argument yet again (3p9.2) before Philosophy declares that the origin of this particular multicursal labyrinth, the hopeless pursuit of false paths, comes from human *error*, which has divided what is *simplex* and indivisible. In so doing, she too retraces the argument yet again (3p9.17-21). The pedagogical use of such constant repetition is evident: no reader of the *Consolation* is likely to forget what paths lead to false felicity. In a movement that will be echoed and explicitly linked with the labyrinth in 3p12, the *Consolation* then turns away from multiplicity and the fragmented paths of the mundane maze to the unity and simplicity of divine order: "Now turn your mind's eye in the opposite direction," Philosophy urges (3p9.24), and indeed the major turning point of the work has been reached: Boethius can look upward and invoke divine aid for this new beginning.

The following poem, the much-admired and discussed "O qui perpetua," offers a powerful counterimage to the labyrinth of earthly life so far evoked, hinting that what has seemed to be a confusing labyrinth is simply divine order misperceived and misunderstood. Echoing and crystallizing Plato's *Timaeus* 28-37, Philosophy hails God as architect of a universe whose parts reflect a perfect pattern and comprise a perfect spherical whole. In lines that gave medieval commentators some concern, God transforms chaotic matter into order and sets the cosmos in motion, radiating goodness that circles back in an eternal returning.[10] The universe is thus circular and ordered, not fluid and chaotic; God has converted what was confused and implicitly labyrinthine into supreme art. His artistry is Daedalian, but his circular handiwork should dazzle us with its symmetry, not bewilder us; if we *are* bewildered, that is because of our limited perception. God offers a perfect perspective and like Theseus can lead us from the labyrinth: "The sight of thee is beginning and end; one guide, leader, path, and goal" (3m9.28). These potentially labyrinthine metaphors, implying a guided tour through confusion to understanding and vision, will be elaborated in the rest of the *Consolation*.[11]

idea of return as cosmic order: "*Repetunt proprios quaeque recursus / rediituque suo singula gaudent / nec manet ulli traditus ordo / nisi quod fini iunxerit ortum / stabilemque sui fecerit orbem.*" Lerer also notes the recurrence of the syllable *or-* (p. 142) and the importance of "returning, reviewing, and recapitulating" (p. 164) in Book 3, though he does not relate this theme to the idea of escape from the labyrinth.

10. See Wetherbee, *Platonism and Poetry*, p. 32, and Trevet, *Exposicio*, ed. Silk, pp. 395-397.

11. Vision may never be perfect, however: Trevet interprets Boethius's reference to the "mens profunda" (3m9.16) as God's *incomprehensibility* (p. 419), an idea Boethius develops

The wrong roads, goals, and points of view having been rejected, the narrator and Philosophy are now on the right track. The narrator finds certain what before was doubtful (3p11.35) and sees clearly what he failed to remember before: that all things naturally seek the good. Metrum 11 identifies progress with Platonic reminiscence, which enables one to avoid the *deviae* of earth and reveals what dark error concealed (*texit*). The clue to the labyrinth of this world is within, and, as with Augustinian epistemological mazes, memory is the key. Yet the narrator still has far to go before he realizes fully that the world he thought of as random, confused, and unjust—a labyrinth of sorts—is really, could he but see it from the right perspective, as orderly as the cosmos.

The following prose makes explicit the image of the maze (3p12.30— see epigraph), which has underlain so much of the work's imagery so far. In reminding the narrator that God truly governs the world, Philosophy argues that evil is nothing. These words provoke the narrator's complaint that she is toying with him, weaving inextricable labyrinths, entering where she went out and leaving where she entered. He recapitulates her argument in yet another retracing of old ground and concludes by noting that "you proved [*explicabas*] all this without outside assumptions and used only internal proofs which draw their force from one another" (3p12.35). What does the labyrinth image here mean, and how is it transformed in the course of the discussion?

Let us examine the text more closely. Initially the narrator accuses Philosophy of weaving an Aristotelian labyrinth of words and arguments to mock and bewilder him, an implication picked up by both Jean de Meun and Chaucer: "Me moques tu . . . tu me deçois," Jean glosses, and Chaucer echoes, "Scornestow me . . . disseyvistow me."[12] Deceitfulness is a recurrent attribute of labyrinths of pagan or heretical thought; the narrator's assumption that Philosophy is playing with him, on the other hand, suggests the playfulness of overly sophisticated yet empty rhetoric. But Philosophy's labyrinth is far different in kind and intent, as the narrator comes to realize. His succeeding discourse reveals his gradual internal illumination. At first, Philosophy's interwoven reasonings strike him as an inextricable labyrinth: perhaps because he cannot escape the force of their logic, or he is confused, or he finds the argument pejoratively circular, or he has great difficulty comprehending it.[13] In any

in Books 4 and 5 in contrasting God's ways of seeing with man's. If God has, and affords us, a view from above the apparent labyrinth, in some respects he remains himself a labyrinth, as in Virgil, Dante, and Chaucer.

12. Jean, ed. Dedeck-Héry, p. 230; Chaucer, ed. Robinson, p. 357. That "ludisne me" is doubly glossed suggests that both Jean and Chaucer were in some doubt as to how to interpret the phrase.

13. Medieval commentators offer a variety of interpretations: Bovo of Corvey glosses *inextricabilem* "inrecuperabilem; indissolubilem" (BL Harley 3095, 71v); the anonymous

case, presumably he thinks he needs further explication if he is ever to be extricated from her prison of words. Yet while seeming to develop his metaphor of labyrinthine inextricability, in fact he contradicts it: if Philosophy enters (*introeas*) where she comes out (*egrediaris*) and vice versa, then she, at least, retraces her steps perfectly, wandering freely in and out, and her argument is not at all inextricable to *her*. What is really going on is that Philosophy is weaving (*texens*) and folding (*complicas*)— designing, tracing, completing—a circle, joining the end and the beginning perfectly as God himself does in the visions of cosmic order described in 3m2 and 3m9. If God created spherical order from (comparative) chaos, so from complex multiple arguments, from various lines of thought, Philosophy evolves the perfect circle of divine simplicity. By complicating, she explicates; her weaving of labyrinths is directly analogous to God's principles in creating and ordering the cosmos. The narrator's apparent irritation turns to admiration:[14] he retraces the argument, thereby demonstrating that he comprehends its design, and he concludes that "you proved all this without outside assumptions and used only internal proofs which draw their force from one another." As in 3m9, what is intrinsic is better than what is extraneous, and this realization comes, as 3m11 foreshadowed, from within the narrator himself: "The man who searches deeply for the truth, and wishes to avoid being deceived by false leads [*deuiis*], must turn the light of his inner vision upon himself."[15] The narrator experiences an epiphany, an electric apprehension of the truths expressed in those earlier metra, that is all the more convincing because it is delayed, like the attainment of any goal in

twelfth-century commentator of Erfurtensis Q. 5 sees labyrinthine reasoning as difficult to get out of and shows where and how Philosophy emerges from the argument only to enter again (ed. Edmund Taite Silk, *Saeculi noni auctoris in Boetii consolationem philosophiae*, Papers and Monographs, 9 [Rome: American Academy, 1935], 214-215). For Pseudo-Thomas Aquinas, Philosophy's labyrinths create labors of (presumably inescapable) intellectual difficulty with circular reasons (*Boetius cum triplici commento*, British Library incunabulum C.48.g.13, L2r; Courcelle identifies Pseudo-Thomas as William Whetley, Thomas Waleys, or Marquard: *Consolation*, pp. 322-323). The anonymous French Benedictine versifier (ca. 1380) of Bodley Douce 298 finds "raisons sophistiques" intended to "enuoluper" Boethius (51v). According to Nicholas Trevet (d. 1328), the narrator at first thinks Philosophy's reasons are circular and hence prove nothing, and the labyrinth connotes difficulty in penetration of the argument. Later Trevet notes that labyrinths metaphorically represent circumlocutions, and he points out that Philosophy's reasoning is not really circular but rather internally derived: *Exposicio*, ed. Silk, pp. 496-497. Denis the Carthusian thinks a labyrinthine argument is so complex and all-consuming that the listener cannot escape, always returning where he started: *Opera omnia*, 26, p. 425.

14. Medieval commentators recognize this admiration: cf. Trevet, ed. Silk, p. 495, glossing *ludisne*: "admiratur Boecius connexiones et reuoluciones istas racionum quibus ipse contradicere non potest," a sentiment repeated by Pseudo-Thomas, L2r. Cf. also Denis the Carthusian, p. 424.

15. See Lerer, *Boethius and Dialogue*, pp. 132-134, on the superiority of intrinsic arguments in Boethius.

a maze. Suddenly the narrator really *knows* (because he has followed the traces himself, without Philosophy's prompting) that what seems labyrinthine is really our imperfect perception of the perfect circles of divine simplicity; and Philosophy's labyrinthine argument has served as the guiding thread to that privileged vision.[16] Philosophy acknowledges that they have come to "the most important point of all" and continues in the language of divine and cosmic order: "As Parmenides puts it, the divine essence is 'in body like a sphere, perfectly rounded on all sides'"—a perfectly symmetrical transformation and simplification of the round labyrinth, a vastly superior embodiment of the principles of Fortune's wheel. Moreover, she continues, "you have learned, on Plato's authority, that the language we use ought to be related to the subject of our discourse." The language of the labyrinth and the language of divine simplicity, of perfect cosmic circularity, are more closely related than they might appear.[17] Labyrinths and labyrinthine arguments are another side of order, a way of perceiving order; from the proper point of view, they *are* order as exposed by the conversion of apparent disorder.[18] After a warning that the narrator must not follow Orpheus in turning his eyes from true light, losing the new perspective he has gained, the rest of the *Consolation* expounds the lesson of the convertibility of the labyrinth.[19] Fitly, Book 3 itself has a kind of circular structure: it opens with a promise that Boethius will turn the direction of his glance and ends with a warning not to look back.[20]

The repetitive retracings of the argument in Book 3 and the recurrent

16. Boethius takes a positive view of labyrinthine arguments elsewhere, suggesting that material must be ordered and arguments constructed to serve as a guiding path (*via*) and thread (*filum*): see *In topica Ciceronis*, *PL*, 64, 1043, and *In Isagogen Porphyrii commenta*, ed. Samuel Brandt, *CSEL*, 48 (Leipzig: G. Freytag, 1906), 136.

17. Trevet was well aware of this: he links Philosophy's labyrinthine mode of argument with Plato's advice that words must conform to their subject: "[Philosophia] affirmat . . . quos ista inuolucio et connexio racionum prouenit ex conformitate ad rem de qua locutus est" (ed. Silk, pp. 498-499).

18. William of Conches comments on the convertibility of Philosophy's labyrinthine propositions (BL MS. Royal 15 B 3, 86v), and although he is considering the passage in purely logical terms, it is interesting that labyrinths evoke for him the attribute of convertibility.

19. A Picard commentator on the *Consolation* (ca. 1315) clarifies the teleological and epistemological function of the labyrinth. The "maison Dedalus" of 3pr12 is simply an "espesse," or outward manifestation, of the fact that Philosophy must "emplique" (perplex, confuse, entrap) and "encerne" (encircle) Boethius in order to make him understand the "merveilleus cerne" (wonderful circle) of divine perfection. Through complication comes enlightenment, and integument and hidden meaning correspond exactly because of their shared circularity. The circles of the maze and the circlings of intrinsic argument, once clarified and simplified and converted, express the circularity of God. For the text, and for comments on the particular importance of explication in this commentary, see J. Keith Atkinson, "A Fourteenth-Century Picard Translation-Commentary of the 'Consolatio Philosophiae,'" in Minnis, *The Medieval Boethius*, pp. 32-62.

20. Scarry finds other kinds of circularity in Book 3: see "The Well-Rounded Sphere," p. 112.

images of the circles of divine order since Book 1 have the desired effect—
an escape from the labyrinth-as-mental-prison, a successful journey
through the epistemological labyrinth, moments of privileged vision in
poetry (3m9) and prose (3pr12). But this does not mean that all retrac-
ings are at an end or that the narrator's vision is perfect. Indeed, as Book
4 begins, the narrator does look back, though not like Orpheus: wishing
to understand rather than repeat past mistakes, he voices an earlier
preoccupation: "Since there is a good governor of all things, how can
there be evil, and how can it go unpunished?" (4p1.3). In essence, he is
asking whether the world rewards minotaurs, and Philosophy responds
that it would indeed be monstrous if there were not perfect justice in
God's supremely ordered house (*dispositissima domus*). The second tradi-
tional means of escape from the labyrinth is invoked as she echoes the
last line of 3m9: "I shall . . . show you the path which will take you home.
And I shall give wings to your mind which can carry you aloft, so that,
without further anxiety, you may return safely to your own country
under my direction, along my path, and by my means [*vehiculis*]" (4p1.9).
The language of flight and returning, of bright heavenly circles and
dark earthly exile, combine in 4m1, and indeed throughout Book 4,
confirming the narrator's sustained change in perspective and its effect
on his ability to see the true path home. Henceforth, he resolves the
labyrinth both by retracing his steps and by rising above it to see it as it
really is. Philosophy is both Ariadne and Daedalus.[21]

Book 4 hammers home the difference between privileged and imper-
fect perspective: true sight reveals that earthly kings wear chains of
passion, whereas mundane vision sees only honor and power (4m2); true
vision sees wicked men as beasts, but earthly sight sees human bodies
(4p3), a reversal of Circe's magic (4m3). The narrator, learning that evil
men are inevitably punished on earth, thinks ordinary men would have
trouble seeing that fact (4p4), and Philosophy agrees that most men are
blind (4m5). Despite his privileged perspective, however, the narrator
still thinks that God permits injustice on earth, and Philosophy concedes
that worldly affairs often seem "random and confused" (4p5), a paradox
she will explicate and evolve (*explicare, euoluere*, 4p6.1) by a new begin-
ning and by weaving new arguments (*ordine contexo rationes*, 4p6.6). The
narrator has revealed that he remains in an intellectual labyrinth, and
labyrinthine methods are required to help lead him out, just as in 3pr12.

Thus Philosophy begins to explain the relationship between fate and
providence, once again drawing on labyrinthine language and imagery

21. Appropriately, as Ariadne and Daedalus are fused in Philosophy, their methods of
escaping the maze—retracing and ascending—are aspects of the same process in the
Consolation, for man's true home is above: in 4m1 the mind *recurrat*, recourses, the circle of
stars (l. 14); it *reseeks* (*requiris*) a forgotten road skyward which will carry him back (*referat*)
if Philosophy *releads* him (*reducem*).

(4p6.7-13). Providence is the will of God, the perfect *artifex* who disposes all things *simpliciter* from a perspective of eternity, whereas fate is the unfolding (*explicatio*) of that will in time and operates *multipliciter*. Providence determines and perceives the whole pattern in the simultaneity of eternity, like Daedalus the *artifex* who views the maze as artifact; fate implements the twists and turns prescribed by the divine architect, revealing only parts of the pattern at any one time. Implicitly, providence operates in the realm of circular simplicity expressed in 3pr12; fate, which is woven (*texitur*) like the labyrinth and which acts through multiplicity, is intrinsically a creature of the mundane labyrinth. In an image anticipating the sudden inversion of the universe in Dante's *Paradiso* and also reflecting the conversion of complex maze to circular simplicity in 3pr12, Philosophy compares God to the center of a series of concentric spheres: the unmoved center is perfect simplicity, but what is farthest from the center "is most entangled in the nets of fate" (4p6.15): the world, at the rim of this inverted cosmos, seemingly trapped by the dictates of fate, resembles an imprisoning, entangling maze. The fact that humans have difficulty seeing that the apparently irrational labyrinth of fate is really the perfect order of providence is the consequence of limited, earth-bound human perception: divine "order . . . controls mutable things which otherwise would be disordered and confused. Therefore, even though things may seem confused and discordant to you, because you cannot see the order that governs them, nevertheless everything is governed by its own proper order directing all things to the good" (4p6.20-21). Apparent confusion—the seeming injustice and randomness of the mundane labyrinth—is really perfect order. As Philosophy adds, "when you see something happen here contrary to your idea of what is right, it is your opinion and expectation which is confused, while the order in things themselves is right" (4p6.34). Labyrinths are in the eye of the beholder, and proper understanding reveals them to be concentric circles of divine artistry. Things as they truly are form the subject of 4m6: God's laws of love are best discerned by an unclouded vision of the circling stars, showing how God recalls all things to their proper paths and orbits.[22] The book ends with a justification of adversity, of *labor*, as the surest path to heaven (4p7, 4m7), and with praise of Hercules who conquered foul beasts, showing the path to all.[23] What seems confusion, then, is the well-ordered *domus Dei*, visible to all who look upward with clear sight after defeating their own bestial impulses.

22. 4m6 appropriately recapitulates the vision of order in 2m8: the narrator, having retraced and reviewed the apparent injustice of Fortune's world as sketched in Book 2, now appreciates the clarity of the cosmos.

23. A labyrinthine subtheme in Book 4 is the danger of becoming, rather than overcoming, hybrid monsters: men become bestial through vice and conquer beasts through virtue, as the exempla of Circe and Hercules show.

In most respects the journey is complete by the end of Book 4, but, as usual in profitable labyrinthine processes, there is always room for another digression, occasioned by the narrator's curiosity about chance. Philosophy acknowledges that she had intended to return the narrator to his own country as quickly as possible—or at least by a route as direct as one ever finds in mazes—and that she was worried lest the narrator be exhausted by *deviis* (5p1.5). But the narrator needs to search out this particular *devia*, however, which addresses two issues intrinsically associated with the labyrinth metaphor: how can there be freedom of choice within a well-ordered cosmos ruled by law, where the paths to be followed are already prescribed, as in a maze? and what kinds and degrees of perspective on the universe are possible—how much of the pattern can we see while tracing a single path? The answers are interconnected: once the varieties of vision and modes of knowing are analyzed, the problem of free will is solved, for everything depends on point of view— and indeed images of darkness and blindness, contrasting with images of clear vision and lofty perspective, dominate this book as they did the first. God's perspective is so comprehensive and so simple that he sees everything in an eternal present, looking down from above (5m2, 5p6). Man's vision is more complex, necessarily fragmented (as in a labyrinth) because it exists in time and hence sees linearly, not comprehensively. Vice, ignorance, and passion are utterly blinding and constraining (5p2). Sheer physicality limits perception: "the human mind, overcome by the body's blindness, cannot discern by its dim light the delicate connections between things" (5m3.8-10). Yet by reminiscence—the retracing of steps in memory—the philosopher attains a comparatively privileged vision: "He works with what he remembers of the highest truth, using what he saw on high in order to fill in the forgotten parts" (5m3.28-31). Philosophy, that is, can sketch in at least part of the labyrinth, for "intelligence, as though looking down from on high, conceives the underlying forms and distinguishes among them all" (5p4.32). God's vision, then, permits him to see what men in their limited wisdom choose to do. The multicursal labyrinth of life is constraining, and human vision within the maze is woefully imperfect, but nevertheless men bear responsibility for their own actions: although there may be only one path returning to God, there are many false paths, and every path is freely chosen. If the *Aeneid* ends with Turnus's descent *sub umbras*, the *Consolation* ends with a radically different, if no less frightening, vision of the supreme architect seeing and judging all things: we see God, "praescius Deus," looking down on the labyrinth *sub specie aeternitatis* and finding it to reveal perfect order.

For Boethius, then, the labyrinth is the perfect circular creation of God as overlaid and apparently complicated by a multiplicity of paths defined by blind or wicked men who cannot see what they are doing; yet

all paths lead to the ends their followers deserve, and there is a true path outward and upward for those who achieve the perspective to find it—a perspective gained with the help of explicatory and educational labyrinthine arguments. Confusion and chaos are moral, perceptual, epistemological illusions: they are simply what multicursal order looks like from our limited and fragmented point of view, and the true philosopher converts them mentally to clarity, symmetry, and perfect circularity, well-disposed by a master architect. This may be cold comfort for the narrator, as F. Anne Payne asserts, but it is rather more encouraging than the endless labyrinths encountered by Aeneas.[24] In any case, Boethius's demonstration of how the mundane labyrinth, or rather our perceptions of the temporal world, may be converted into the perfectly ordered artistry of God is one of the most potent statements of the relativity of the labyrinth, and one that may well have influenced the maze-makers of the Gothic cathedrals, Dante, and a rather more skeptical Chaucer.

Is the *Consolation*, like the *Aeneid*, structured like a labyrinth? I think the answer is a qualified yes. True, the *Consolation* seems to lack the careful and systematic concentric panels that characterize the *Aeneid* and make it structurally labyrinthine when seen as a whole. But there are *generally* concentric structures in the *Consolation*: Books 1 and 5 emphasize kinds of vision and the effects of perspective on the perception of order; 2 and 4 feature dangerous ladies, Fortune and Circe, who lead their admirers to dead ends; and 3 marks the change in Boethius's orientation and direction, during and after which he reconsiders and reevaluates topics discussed earlier. But I would not make too much of this: concentric patterns in the *Consolation* function much more heavily in imagery than in formal structure.[25]

It is in its intellectual modes of proceeding that the work is structurally most labyrinthine. Dialectic by its very nature is somewhat labyrinthine, as we have seen, and here those mazy qualities are reinforced by the

24. Working from the generic perspective of Menippean satire, Payne argues that the narrator is silenced but not satisfied at the end of the *Consolation*: Philosophy has outtalked him, but she has not given any truly convincing answers. Wetherbee too sees this silence as ominous (*Platonism and Poetry*, pp. 21-22); Lerer (*Boethius and Dialogue*, pp. 231-236) and Scarry ("The Well-Rounded Sphere," pp. 115-116) take far more optimistic views.

25. If there are few *formal* concentric patterns in the *Consolation*, the work is nonetheless complexly structured and in that sense labyrinthine. For the fullest discussion of structure, see Scarry, "The Well-Rounded Sphere," which identifies numerous overlapping and hierarchical conceptual and imagistic patterns, and which also demonstrates striking numerological interrelationships between books, arguing that these patterns—most of them involving threes, nines, and twenty-sevens—structure the *Consolation* aesthetically by number just as the Demiurge structures the cosmos proportionately in the *Timaeus*. Although I would not take the analogies and cross-relations as far as Scarry takes them, and would interpret some of them differently, her exposition convincingly demonstrates the fact of highly elaborate structure.

constantly repeated retracings of previous arguments.[26] The work's dialogue-debate structure constantly offers alternatives, and indeed many alternatives are dropped in one place only to be taken up later, as if the author were determined to follow all multicursal leads to reconstruct the most complete groundplan possible. The pedagogical advantages of circuitous process are amply displayed. The final digression, Book 5, is clearly marked as a deviation, albeit a profitable and necessary one—just the sort one would expect in a beneficial epistemological labyrinth. The *Consolation*'s alternation of prosae and metra, too, has labyrinthine aspects: as Seth Lerer notes, the poetry shows while the prose argues.[27] I would put it a little differently: the poetry gives an overview, almost a gestalt, of major issues, while the prose sequentially traces the options within the labyrinth of discourse. The poetry, so often the vehicle for transcendent visions of cosmic order, suggests pattern, and the prose labors along a twisting path with a more constrained field of vision. To relate the work's prosimetrical form even more closely to the labyrinth, the poetry suggests Daedalian flight from and perspective on the maze—a simultaneous view from above; the prose defines the linear temporal process of retracing one's steps with Ariadne's thread, the texts and logic of Philosophy.

If I read the *Consolation* rightly as labyrinthine poetry, Boethius's adaptation of the labyrinth tradition is extraordinarily rich and creative. Shunning the easy sensationalism of the Cretan legend, he abstracts the cool philosophical essence of the labyrinth, an aspect merely touched upon by most of his predecessors (with the obvious exception of Virgil). He focuses on one of the labyrinth's most provocative and challenging characteristics, its ability to signify both confusion and artistic order depending on whether the perceiver struggles within or looks on from above, and he fully exploits the potential of this convertible image as a metaphor for the bewilderment experienced by those embroiled in the world and the admirable clarity of the cosmos properly understood, seen as it were with the temporally simultaneous overview of the divine architect. He mediates conversion from one view to another, the exemplary "plot" of the *Consolation*, by means of both traditional escapes from the labyrinth—retracing one's steps with a guiding thread and flight to a loftier perspective—and indeed he fuses these mythologically discrete solutions to labyrinthine inextricability by showing that the way back to

26. Cf. also Lerer, who discusses repeated patterns of imagery (*Boethius and Dialogue*, p. 7, chap. 4, and passim) and notes "a continual sense of repetition as the governing principle of the *Consolation*'s composition"; see also Scarry, "The Well-Rounded Sphere."

27. Lerer, *Boethius and Dialogue*, p. 144. On the functions of, and tensions between, prose and poetry, see also Anna Crabbe, "Literary Design in the *De Consolatione Philosophiae*," in Gibson, *Boethius*, pp. 237-274; Scarry, "The Well-Rounded Sphere," pp. 99-105; and Wetherbee, *Platonism and Poetry*, pp. 77-82.

the point of entry is also the way upward to God. He similarly conjoins the ideas of impenetrability and inextricability: extrication from the labyrinth of faulty earthly perception is simultaneously a penetration of divine mysteries accessible to the elect philosopher. Moving outward from a constricting earthly center is also moving inward toward God, the center of the inverted—and rightly perceived—universe. The spiritual maze is simultaneously the epistemological maze: one returns to God by way of a circuitous and arduous passage through the well-woven verbal labyrinths of dialectic, whose textual architecture constitutes Ariadne's thread. If, as Lerer has convincingly argued, Boethius "makes method his theme,"[28] that theme is the constructive method of the intellectual labyrinth *in bono*. It is no wonder that Boethius's philosophical and epistemological adaptations of the labyrinth should have had considerable influence on Dante and Chaucer, as we shall discover. And it is also singularly fitting that five medieval manuscripts of the *Consolation* should illustrate the work with an illumination of the diagrammatic labyrinth, its complexity of pattern mirroring the difficulty and beauty of the work's argument and poetry, its concentric circles echoing the circles of divine simplicity, its simultaneous representation of a full overview and a prescribed path reflecting the double perspectives—eternal and temporal, celestial and mundane, objective and subjective—so perfectly blended in Boethius's work.[29]

28. Lerer, *Boethius and Dialogue*, p. 11.
29. See chap. 5, n. 71, above, and plates 22 and 23. Four of the five manuscripts place the labyrinth at the end of the *Consolation*, where its significance might be the more fully comprehended and where, perhaps, it might represent just what God views from eternity. In any case, the maze is perhaps the most appropriate, revealing, and enigmatic last word for the work, and incidentally a mark of praise for a well-crafted labyrinth of words.

Dante's *Divine Comedy*

Indi m'han tratto sù li suoi conforti,
 salendo e rigirando la montagna
 che drizza voi che 'l mondo fece torti.

From there his counsels have drawn me up, ascending and circling this
mountain, which makes you straight whom the world made crooked.

<div align="right">Dante, Purgatorio 23.124–126</div>

THE LITERATURE of Christian conversion is labyrinthine by nature: converts, whose very name implies a purposeful change in direction, turn from false ways to true ones and from a disoriented, blind pursuit of false goods to an often circuitous quest for the right goal, in light of which previous paths seem chaotic and futile. Conversion and persistence in the new path come by grace, not solely by will or intellect, so converts must have supernatural aid. Their way may be twisted by error and complicated by impediments, delays, and backslidings; converts must retrace their steps to avoid danger, correct past mistakes, or learn what is truly essential. Eventually, they achieves their goal: transcendence of mundane confusion and participation in divine order. It is therefore hardly surprising that Dante's *Divine Comedy*,[1] that great chronicle of conversion, should be a labyrinthine poem.[2] Since the significance of the idea and myth of the laby-

1. I follow Giorgio Petrocchi's text, with Charles S. Singleton's translation and commentary, in *The Divine Comedy*, Bollingen Series 80, 3 vols. in 6, corrected ed. (Princeton: Princeton University Press, 1977).

2. On the *Comedy* as conversion literature, see Charles S. Singleton, *Dante Studies 2: Journey to Beatrice* (Cambridge: Harvard University Press, 1958), pp. 39–56, and "In Exitu Israel de Aegypto," *78th Annual Report of the Dante Society of America* (1960), reprinted in *Dante: A Collection of Critical Essays*, ed. John Freccero (Englewood Cliffs, N.J.: Prentice-Hall, 1965), pp. 102–121; and Freccero, *Dante: The Poetics of Conversion*, ed. Rachel Jacoff (Cambridge: Harvard University Press, 1986), esp. "The Prologue Scene" (reprinted from *Dante Studies*, 84 [1966], 1–25), "The Firm Foot on a Journey without a Guide" (reprinted from *Harvard Theological Review*, 52 [1959], 245–281), and "Pilgrim in a Gyre" (reprinted from *PMLA*, 76 [1961], 168–181).

rinth in the *Comedy* has gone by and large unnoticed in the vast body of medieval and modern commentary on the poem, however, I begin with additional reasons why we might expect the labyrinth to be a recurrent theme in the *Comedy* and how the labyrinth motif fits in with some other generally recognized patterns.[3]

We have just seen that the idea of the labyrinth plays a major role in the *Aeneid* and the *Consolation of Philosophy*. Virgil and Boethius were profoundly important to Dante—the former a beloved guide and master in the *Comedy*, the latter a consolation after Beatrice's death and a "sainted soul . . . who makes the fallacious world manifest" (*Para.* 10.125–126).[4] As a perceptive reader of both texts, Dante might well have noticed—and intentionally imitated and modified—their subtle, inventive variations on the theme of the labyrinth.[5] In *Convivio* 4.12 he praises and quotes both the *Consolation* and another classical labyrinth

Not all conversion literature is equally labyrinthine. Augustine's *Confessions*, for instance, frequently uses imagery associated with the labyrinth (see citations from Augustine in Freccero's "Prologue Scene") but does not draw explicitly on the labyrinth's myth, structure, and traditional interpretations. As the presence of Virgil shows, Dante, writing in a fully Christian era, can afford greater deference to his pagan classical heritage, including the labyrinth myth, than Augustine could.

3. John G. Demaray dedicates several pages to summarizing existing research on medieval church labyrinths, associating them (and other circular ecclesiastical architectural features) with Exodus pilgrimage and hence with the *Comedy*; but this association depends on his acceptance of the very shaky substitute pilgrimage theory of church labyrinths: see *Dante and the Book of the Cosmos*, pp. 21–23. Demaray notes a general structural analogy between circular church mazes and Dante's circular hell and purgatory (p. 23, n. 24) but does not take any further the idea of the labyrinth in Dante.

4. Virtually every commentary notes Dante's indebtedness to Virgil, although recent criticism emphasizes Virgil's insufficiency as guide and Dante's correction of Virgil and the *Aeneid*: see, e.g., Teodolinda Barolini, *Dante's Poets: Textuality and Truth in the Comedy* (Princeton: Princeton University Press, 1984), esp. pp. 201–256; Robert Ball, "Theological Semantics: Virgil's *Pietas* and Dante's *Pieta*," *StIR*, 2 (1981), 59–79; Marguerite Chiarenza, "Boethian Themes in Dante's Reading of Virgil," *StIR*, 3 (1983), 25–35; Robert Hollander, "Dante's Use of *Aeneid* I in *Inferno* I and II," *Comparative Literature*, 20 (1968), 142–156, his *Studies in Dante* (Ravenna: Longo, 1980), pp. 131–218, and his *Il Virgilio Dantesco: Tragedia nella "Commedia"* (Florence: Leo S. Olschki, 1983); Mark Musa, *Advent at the Gates: Dante's Comedy* (Bloomington: Indiana University Press, 1974); Christopher J. Ryan, "Virgil's Wisdom in the *Divine Comedy*," *M&H*, 11 (1982), 1–38; Albert L. Rossi, "A l'ultimo suo: *Paradiso* XXX and Its Virgilian Context," *Studies in Medieval and Renaissance History*, n.s. 4 (1981), 39–88; Jeffrey T. Schnapp, *The Transfiguration of History at the Center of Dante's Paradise* (Princeton: Princeton University Press, 1986); and Paul W. Spillenger, "An Aspect of Vergil's Role in the *Commedia*," *Romance Notes*, 24 (1983), 55–58.

For Dante and Boethius, see, inter alia, Marguerite Chiarenza, "Boethian Themes in Dante's Reading of Virgil," *StIR*, 3 (1983), 25–35; J. Freccero, "Casella's Song: *Purgatorio* II, 112," in *Dante: Poetics of Conversion*, pp. 186–194 (reprinted from *Dante Studies*, 91 [1973], 73–80); Edward Moore, *Studies in Dante, First Series: Scripture and Classical Authors in Dante*, intro. Colin Hardie (1896; Oxford: Clarendon Press, 1969), pp. 282–288 (and, on Virgil, pp. 166–197).

5. The impact of the *Aeneid*'s labyrinths would have been the more striking if, as Ulrich Leo argues, Dante reread the epic just before writing *Convivio* 4; *a fortiori* if Dante then

text, Seneca's *Moral Letters to Lucilius* (see Chapter 3 above), just before developing his own rather labyrinthine metaphor for human life:

> The right [moral] path is lost through missing the way, as are the roads of the earth; for as from one city to another there is of necessity some one road which is the best and most direct, and some one other which is ever receding from the goal, namely, that which goes in the opposite direction; and many others, some approaching nearer to the goal, others diverging farther from it; so in human life there are divers paths, one of which above all is the right road, and another the wrong, and certain other paths which are more or less wrong or right. And as we see that the path which goes straightest to the city fulfills the desire and brings repose after toil, while that which goes in the opposite direction never fulfills the desire or brings repose, so it is with our life: a wise traveller arrives at the goal and rests; the man who misses the way never arrives at the goal, but in much weariness of mind ever with greedy eyes keeps gazing before him.[6]

Obviously we cannot tell whether Dante recognized and consciously re-traced the specifically labyrinthine tracks laid down by Virgil and Boethius; I would like to think he did, just as he consciously borrowed so much else from them. But the only "proof" we are likely to discover lies in the evidence to be presented in this chapter, which can finally establish only intriguing intertextualities and what I trust is a convincing argument that the idea and myth of the labyrinth participate in the shaping of the text and illuminate our reading of it, regardless of Dante's conscious intentions or subconscious memories.

Whatever Dante may have meant us to see in the *Comedy*, some medieval readers found labyrinths there—and I do not mean the lengthy, pedantic glosses on the maze's myth and structure found in trecento commentaries on *Inferno* 5 and 12. Three medieval writers of some genius explicitly and creatively adapted the idea of the labyrinth in works that self-consciously imitate the *Comedy* (and the *Aeneid* and the *Consolation* as well). Boccaccio's *Corbaccio*, examined in Chapter 6, conflates *Inferno* 1 with the myth of the labyrinth; Juan de Mena's *Laberinto de Fortuna* (also Chapter 6) finds its narrative structure in the *Comedy*, superimposes the idea of the wheel of fortune from Boethius, and gives the whole the name of the maze. And, as we shall see, in *The House of Fame* Chaucer draws consistently and insistently on Virgil, Boethius, and

read *Aeneid* 5 and 6 for the very first time. See Leo, "The Unfinished *Convivio* and Dante's Rereading of the *Aeneid*," *MS*, 13 (1951), 41–64 (here, pp. 55–61).

6. Trans. William Walrond Jackson (Oxford: Clarendon Press, 1909), pp. 236–237. For the Italian, see *Il Convivio*, ed. Maria Simonelli (Bologna: Riccardo Pàtron, 1966), pp. 164–166.

For references to Seneca in Dante, see Moore, *Studies in Dante*, pp. 288–290.

Dante to create an unrivaled labyrinthine extravaganza. In that imitations and rewritings of texts are also commentaries upon them, these progeny of the *Comedy* testify to their authors' appreciation of its labyrinthicity. The visual arts offer a number of more or less labyrinthine illuminations of the *Comedy*, to be noted in due course. One manuscript, however, is worth mentioning here: Vatican Biblioteca Apostolica MS. Barb. lat. 4112, made in Florence in 1419.[7] Each canticle begins with a framed miniature, and two of these have labyrinthine implications. The *Inferno* miniature (see plate 24) shows Dante and Virgil pursued by the three beasts, with the *selva oscura*, tipped with gold, behind: is the illuminator alluding to the golden bough, found in a forest as labyrinthine as Dante's? Above is a mountain, its side gouged open in a pattern that suggests, first, several impossibly steep but direct paths to the top and, second, the carved circular channels of which hell and purgatory are built; thus the mountain's form suggests both path and pattern, and the circular structures of both Inferno and Purgatorio. To the right is the gate to hell, before which stands Minos as a winged demon, his tail wound about him seven times; thus he directs his visitors to the seventh circle and the Minotaur. The first miniature, then, includes multiple allusions to the Cretan legend and to labyrinthine physical structures in the *Comedy*. The purgatory miniature shows Dante, Virgil, and Cato to the left; to the right sits the angel who guards the gate of purgatory—who strictly controls entry to the seven labeled terraces and the eighth level of the Earthly Paradise, which are channeled out of the mountain behind with their concentric circular structure very marked. This miniature, too, highlights the difficult entry to what I will later argue is a kind of maze. The paradise miniature is not relevant to present purposes, but the manuscript's final illumination, at the very end of the text, is (see plate 25): it shows a centaur, arms outstretched and palms turned up in a welcoming gesture, in the center of a Chartres-type twelve-circuited maze; in the bottom right-hand corner is a Cretan-style seven-circuited maze. These drawings may have been added later, but they convey a familiar message: this complex, difficult work of art is completed, and its proper sign is the labyrinth.[8] These textual and visual examples argue that high-level medieval reception of the *Comedy* involved an appreciation of Dante's labyrinths, even though his followers

7. See Peter Brieger, Millard Meiss, and Charles S. Singleton, *Illuminated Manuscripts of the Divine Comedy*, Bollingen Series 81, 2 vols. (Princeton: Princeton University Press, 1969), 1, 327 and 2, pls. 12b (and XIVa), 24a, and 29a.

8. A legend—which may have been added by a still later hand—reads, "This is the labyrinth of the Minotaur"; but the Minotaur is so singularly gentle, even kindly, that one is far likelier to interpret the illustration as a sign of the privileged secrecy of divinity, as with the labyrinth and Minotaur allegedly pictured on Imperial robes (see chap. 3), or perhaps as a token of the dual nature of Christ, than as anything remotely threatening. See chap. 5 on labyrinth illuminations at the beginning or end of texts.

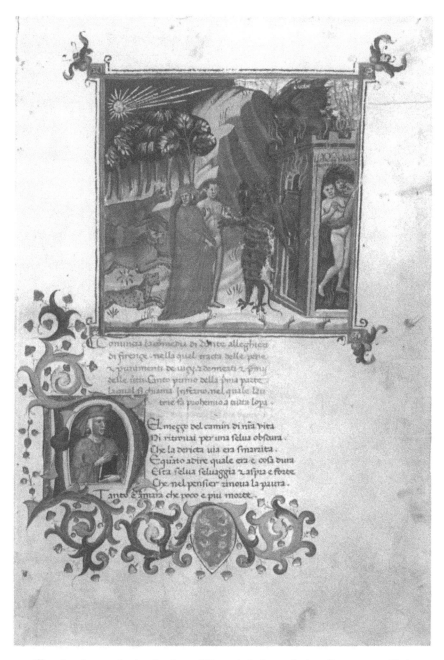

24. Illumination at the beginning of Dante's *Inferno*, dating from 1419. Vatican, MS. Barb. lat. 4112, fol. 8r. By permission.

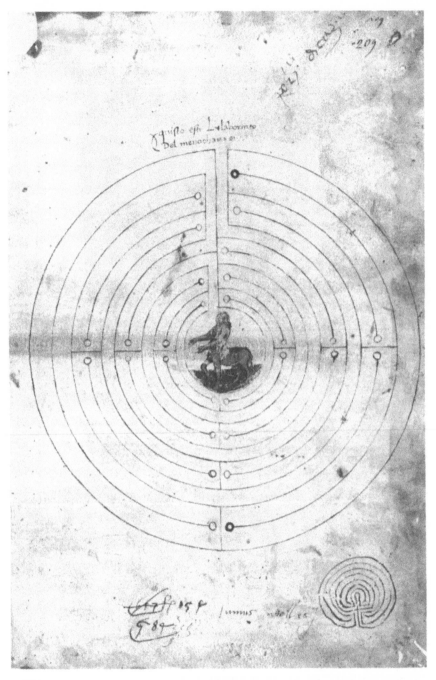

25. Illumination at the end of Dante's *Divine Comedy*, dating from 1419. Vatican, MS. Barb. lat. 4112, fol. 209r. By permission.

may not have seen them exactly as I do.[9] For these authors, as for Dante, life is metaphorically a quest for liberty from labyrinths.

If Dante, or at least his text, builds on the idea of the labyrinth found in the *Aeneid* and the *Consolation*, however, that idea is carefully modified and shaped. A few significant differences in approach are worth noting. The pagan Virgil used the labyrinth as an image of the cosmos and human life alike; neither he nor his hero could escape the mundane labyrinth to achieve a perspective in which chaos becomes enduring order, and Virgil doomed Aeneas, and implicitly all mankind, to the perpetual retreading of one maze after another. In the *Comedy*, Dante, a new Aeneas, both follows and corrects this Virgilian vision of an inextricable round of labyrinths, showing which labyrinths can be transcended, how, and why. Like Aeneas, he is an exile committed to the founding of a new empire in Italy; but, unlike Aeneas, he seeks to become "a citizen of that Rome whereof Christ is Roman" (*Purg.* 32.102). Indeed, Virgil can serve as Dante's guide only for part of his pilgrimage because Virgil himself, like other just pagans, was not granted the thread of grace which leads safely through worldly labyrinths to the city of God: hence he resides eternally in the noble castle that houses Plato and Aristotle, weavers of the labyrinth of pagan thought (see Chapters 3 and 7).

As a Christian, Dante is closer to Boethius, who described the conversion of apparent earthly chaos to cosmic order; who, like Augustine, appreciated the intellectual (and spiritual) benefits of labyrinthine processes; and who knew that some labyrinths are extricable only when men are free of the limitations of the flesh. But Boethius, writing a philosophical treatise rather than a Christian poem, did not treat the specifically religious process of extrication from the many labyrinths in which man is implicated. By including theological and even revelatory perspectives, Dante sees more, and from more vantage points, than his predecessors. If Aeneas travels through Hades and Boethius through philosophical terrain, Dante's voyage is far more extensive and almost completely otherworldly. The *Comedy* deals only obliquely with the labyrinth of *this* life, the labyrinth Aeneas and Boethius's narrator never really transcend, and it emphasizes instead the anagogical labyrinths that reward and punish the choices made in the multicursal labyrinth of the living.

Other paths may have led Dante to the idea of the labyrinth as a continuous theme in his *Comedy*, however, and I mention a few of them, partly to show how he might have arrived at a motif that is one among many guiding threads in the poem and partly—perhaps more important—to indicate some resonances that motif should have for us as read-

9. "High-level reception"—the reading that exceptional writers give to the great predecessors who inspire them—is, of course, Jauss's useful term. High-level reception, unlike the middle-level reception of the formal commentarial tradition, is often idiosyncratic,

ers trying to adopt a medieval horizon of expectations. These paths have been brilliantly charted for other purposes by great *Dantiste*, but their cross-relations with the labyrinth have gone unnoticed. John Freccero has repeatedly and persuasively argued the importance of the *Timaeus*, with its images of circularity and its view of *paideia*, for an informed reading of the *Comedy*.[10] But the *Timaeus* also, quite unwittingly, provides a striking if inexplicit commentary on the characteristic form of medieval labyrinths and an evocative description of movement within a labyrinth. According to Plato, the Demiurge created the ordered circular cosmos out of chaos, using a perfect and unchangeable pattern; thus the universe consists of two circles—the "same" and the "other," the latter containing seven unequal circles (planetary orbits)—whose intersection forms a *chi*, a cross. The microcosmic human soul, too, contains these circles of the same and the other. But when the soul enters the body and experiences physical sensation, there is a great disruption: the balanced "circles were broken and disordered in every possible manner, so that when they moved they were tumbling to pieces and moved irrationally, at one time in a reverse direction, and then again obliquely, and then upside down."[11] This image of broken circles, of disorder and disorientation, is highly suggestive: what better visual representation of *broken* circles and erratic movement within could there be than a medieval labyrinth, its concentric circles "broken" by radii, so that the perfect circles and breaks combine to form a series of enforced turns that disorient the wanderer and make him move irrationally, in reverse, obliquely? What simpler, more familiar visual model could a medieval person imagine to portray the distortion of order Plato describes? Incarnation, then, enforces the intrinsic convertibility of the labyrinth by landing the soul in a labyrinth and imposing labyrinthine confusion, disorientation, bewilderment. "The whole animal was moved and progressed, irregularly however and irrationally and anyhow, in all the six directions of motion, wandering backward and forward, to the right and left, and up and

involving a creative rewriting and free imitation of antecedent texts. Although it may, and in the Middle Ages generally does, draw on commentarial tradition, it goes far beyond, as, say, the *Corbaccio* ransacks, modifies, and recreates the same text that Boccaccio, writing as commentator, simply glosses, analyzes, and explicates. Most commentaries fill in gaps; high-level imitation of texts creates entirely new constructs. Dante is drawing upon his own high-level reception of Virgil in the *Comedy*, as Hollander notes in "Dante's Use of *Aeneid* I in *Inferno* I and II," p. 156.

10. Cf. Freccero, "Pilgrim in a Gyre"; "The Dance of the Stars: *Paradiso* X," *Dante: The Poetics of Conversion*, pp. 221–244 (reprinted from *Dante Studies*, 86 [1968], 85–111); "The Final Image: *Paradiso* XXXIII, 144," *Dante: The Poetics of Conversion*, pp. 245–257 (reprinted from *MLN*, 79 [1964], 14–27); and "Infernal Inversion and Christian Conversion: *Inferno* XXXIV," *Dante: The Poetics of Conversion*, pp. 180–185 (reprinted from *Italica*, 42 [1965], 35–41).

11. *Timaeus* 43d-e, in *Plato*.

down, and in all the six directions" (*Timaeus* 43b). This passage aptly describes the pilgrim Dante's movements through hell, as Freccero has shown;[12] but it also describes characteristic movement within a three-dimensional maze. If Dante knew these passages, either directly or through works they influenced, and if he shaped his pilgrim's progress to this Platonic pattern, could he not also have experienced a sudden intuitive recognition that this pattern, this path, is best represented by a maze—the very maze his literary fathers Virgil and Boethius explored?[13] For Plato, man rights himself and rebalances the circles (again, the idea of labyrinthine convertibility) through *paideia*, proper education; for a Christian the action of Christ is necessary: the disordered circles must be stamped with the cross. The Christ who harrows hell and redeems mankind, who converts the individual and leads him from the maze, is often figured as Christ-Theseus, who plays a major role in the *Comedy*. We will return to these ideas in due course: for the moment, I want merely to establish that if the *Timaeus* influenced the *Comedy* in obvious ways—obvious, that is, once Freccero has pointed them out—then it might also have suggested, or at least reinforced, the symbolic potential of the labyrinth for what the *Comedy* has to say.

Another generally accepted pattern in the *Comedy* is the Exodus story, as Dante himself implied in the Letter to Can Grande and as Charles S. Singleton has amply demonstrated.[14] Without detracting in any way from the definitive importance of Exodus as a shaping influence, I would suggest that Theseus's liberation of his people from the threat of the labyrinth constitutes a related, if subsidiary, recurrent pattern. Dantean allegory frequently links Old Testament, New Testament, and classical mythology, as the exempla in the terraces of purgatory show. The myth of the labyrinth is a classical analogue to the story of Exodus: in both, a nation is rescued from oppression and exile by their leader and his guide. In both, there is a necessarily circuitous passage before the goal is reached: where the children of Israel wander for forty years in punishment for their grumblings and backslidings, the labyrinth itself

12. See Freccero, "Pilgrim in a Gyre."

13. In Dante's Christian cosmos, man's erratic movement is caused more by erring choice than by the material nature of things: losing the way in God's mundane labyrinth is one's own fault, not the maze-maker's. Admittedly the physical body creates obstacles to virtue quite apart from its appetites: see *Purgatorio* 9.16–18, arguing that the soul often sees more truly in dreams, when it is distant from the body. We will consider such impediments later.

14. See Singleton, "In Exitu," which uses Dante's *Letter to Can Grande*, with its exegetical association of Exodus, the redemption, individual conversion, and "the departure of the sanctified soul from the bondage to the corruption of this world into the freedom of eternal glory," as the basis for a cogent exploration of the Exodus pattern in the *Comedy* (see *Letter to Can Grande* 7, in *The Letters of Dante*, ed. Paget Toynbee, 2d ed. Colin Hardie [Oxford: Clarendon Press, 1966], pp. 173 and 199). I join most scholars in assuming that the *Letter to Can Grande* either is Dante's or reflects his intentions.

prescribes a roundabout path. In both—although this is not stressed in analyses of the Exodus pattern—a woman's aid is critical; Ariadne's in the Cretan legend and Rahab's in Jericho, a highly significant parallel that intimately links Exodus with the labyrinth legend, as we shall see. Moreover, the labyrinth story is often interpreted as a type of the redemption and, particularly, of the harrowing of hell.[15] If Exodus and the redemption are Old and New Testament counterparts to the spiritual action of the *Comedy*, as Dante implies, might not the story of the labyrinth be a singularly appropriate mythological counterpart to that action and hence figure continuously in this Eastertide poem, both as a classical variation on biblical themes and as a model for certain aspects of the pilgrim's situation, conversion, and progress?[16]

There is one other a priori reason why the idea of the labyrinth might have appealed to Dante and in any case should strike modern readers as a singularly useful visual analogue to the *Comedy* and other complex literature. In "Dante's Ulysses," Freccero discusses differences between the classical view of time as endlessly cyclical—where departure and return constitute a common narrative pattern—and the Christian insistence on linear time, with beginning and end, in which context narratives question whether the protagonist will ever reach his final goal. Freccero finds the *Comedy* both circular and linear: Dante *does* return, but he is permanently transformed. Freccero concludes, "Dante's poem could be characterized by neither figure because it partook of both. . . . Representing that synthesis of linearity and circularity is as out of reach, however, as is the squaring of the circle."[17] Not quite: the labyrinth, circular in design and linear in path, depicting both the linear process of attaining a goal and the circular pattern of beginning where it ends and

15. Robert Hollander argues that Dante's decision to follow the "allegory of the theologians" rather than the "allegory of the poets" entails treating all characters and events in the poem as literally true and thus "charged with figural connotations." Thus even Virgilian and Ovidian characters are "true," "historical" people who exist in the afterlife and who, in this life, might prefigure other historical characters; later I argue that, for example, Beatrice and Mary are prefigured by Ariadne. See Hollander, "Dante Theologus-Poeta," *Dante Studies*, 94 (1976), 91–136, and *Studies in Dante*, pp. 39–89; also, *Allegory in Dante's Commedia* (Princeton: Princeton University Press, 1969).

16. The importance of the redemption, with Beatrice and Mary serving as vehicles for Christ, is discussed by Amilcare Iannucci ("Beatrice in Limbo: A Metaphoric Harrowing of Hell," *Dante Studies*, 97 [1979], 23–45) and James I. Wimsatt ("Beatrice as a Figure for Mary," *Traditio*, 33 [1977], 402–417).

Dante's descent into hell takes place precisely at that point of the liturgical year when Christ descended to harrow hell—when Christ acted most like Theseus. For the temporal sequence of the poem, see Singleton, "In Exitu," *Dante*, p. 111, and, for modifications, Iannucci, pp. 37–38 and n. 30. Iannucci's persuasive argument that Beatrice's appearance in Limbo is a figure for Christ's harrowing of hell intensifies the importance of the idea of the harrowing in the *Inferno* and thus also heightens the implicit role of Christ-Theseus.

17. Freccero, "Dante's Ulysses: From Epic to Novel," in *Dante: Poetics of Conversion*, pp. 136–151 (reprinted from *Concepts of the Hero in the Middle Ages and the Renaissance*, ed. Norman T. Burns and Christopher J. Reagan [Albany: SUNY Press, 1975], pp. 101–119); here, p. 150.

ending where it begins, offers precisely the synthesis Freccero is seeking.[18] Most structurally labyrinthine literature, including the *Comedy*, is characterized by just such a narrative pattern: one achieves transcendent understanding *and* returns to the place from which one started, in some sense at least knowing that place for the first time. Labyrinthine narrative expands the experience crystallized in Boethius's epiphany in the *Consolation* (3p12), where labyrinthine ways lead to order—and to further labyrinths.[19] Whether or not it was so for Dante, for us the labyrinth is the best visual model for the narrative structure of the poem.

In this chapter, I consider the *Comedy*'s labyrinthine qualities under three general headings: first, the labyrinthine landscape and, in particular, structural analogies between the poem's physical geography and the maze; second, the labyrinthine journey, both literal and spiritual, of the pilgrim through the pattern of the maze. These sections, which provide first an overview and then a subjective internal tracing of Dante's labyrinths, set the stage for the third, and arguably most important, discussion: the *Comedy*'s transformation of characters and motifs from the Cretan myth into vehicles for a Christian message. We shall see a gradual development of traditional labyrinth lore throughout, as Dante first presents the confusing, multicursal labyrinth of this world, where proper choice at repeated *bivia* is critical,[20] and then describes the world-maze's two competing goals: the inextricable labyrinth of hell, with its many paths but (normally) no exit, and the unicursal maze of purgatory, whose circuitous passages lead eventually to the bliss of paradise, where dynamic, wheeling concentric circles reveal the grand pattern of a cosmos labyrinthine in its artistry and final impenetrability.

· The Labyrinthine Landscape ·

It is not surprising that the landscape of the *Comedy* should include a series of labyrinthine places: the organizing principle of Dante's otherworldly topography is the pattern of concentric circles that characterizes

18. One might even suggest that, as a construct of angles and lines and superimposed crosses and circles, the labyrinth is as close as one comes to a squared circle. The labyrinth also combines the dual motions of circling and forward progress that Freccero identifies at the poem's conclusion: "The Final Image."

19. Cf., inter alia, "circular" Ricardian poems: *Sir Gawain and the Green Knight*, which overlays narrative linearity and formal circularity with the cycles of the seasons and the liturgical year; *Pearl*; *Piers Plowman* (perhaps the most frustrating sequence of linear progressions that return one to the same confusion); the *Canterbury Tales*, whose conflict between an announced circular plan and its linear reality rings fascinating changes on the idea of labyrinth. Dream vision poetry is usually labyrinthine in part because it necessarily fuses circular (from waking to sleep to waking) with linear movement.

20. On *bivia* in the *Comedy*, see Phillip Damon, "Geryon, Cacciaguida, and the Y of Pythagoras," *Dante Studies*, 85 (1967), 15–32.

most medieval labyrinths.[21] Hell is a cone of nine ever-diminishing and deeper circles of increasing complexity: the seventh circle contains three sharply differentiated *gironi*, and the eighth, Malebolge, contains ten concentric circles spanned by an unspecified number of radial bridges.[22] Viewed from above, the whole Inferno, like its eighth circle, would resemble an inward-sloping turf-maze or pavement labyrinth with ridges separating each circular channel. But hell is sharply distinguished from labyrinths of the visual arts in one significant way: although hell has many circles, many paths, no defined path leads through these circles to the center. The whole point of hell, the feature that makes it an arch-labyrinth, is its inextricability, as so many mythographers had warned. The damned soul's only, inevitable, and eternal goal is a strictly delimited circle in the terminal labyrinth of hell. Movement *around* a circle is possible and may even be required: the lustful are blown on an unceasing wind, the avaricious and prodigal move in opposing circles, the sodomites course along the burning sands, panderers circle one way and seducers the other, soothsayers walk backward, hypocrites drag their leaden capes interminably. But there is no end—no cessation, no goal—to this motion, which becomes a futile parody of earthly and purgatorial progress *through* a maze. The damned have nowhere to go in the inescapable dwelling determined by the false paths they chose on earth. While its circles and complexity suggest the diagrammatic mazes of art, then, functionally hell is closer to the Cretan labyrinth of literature: it is an inescapable prison.[23]

Hell and its *loci* physically resemble traditional labyrinths in other ways as well. Sculpted out of earth's innards, the Inferno is a vast, elaborate cave, as Boccaccio, commenting on *Inferno* 5, thought the Cretan labyrinth had been.[24] The seven-walled castle in Limbo and the initially impenetrable City of Dis have labyrinthine aspects, as some illuminators noticed, and the disordered, tangled, pathless wood of the suicides—a recapitulation of the *selva oscura* of the opening canto—is, like the desert

21. See Brieger, *Illuminated Manuscripts*, pls. 22–24a, 27, 33, 35b, 144b, 148b, 205c, 209a,b, and examples in n. 29 below.

22. See Singleton's diagrams, *Inferno: 2. Commentary*, pp. 44 and 312. Possibly Dante's Malebolge, like medieval labyrinths, is stamped with the cross. We will return to the question of the "ruins" in hell.

23. It has a center, even if it has no goal: the bat-winged Satan, arch-minotaur of this maze.

24. Boccaccio's unusual view of the Cretan maze as a series of caves (*Comento*, 2, 108) suggests that he saw Dante's subterranean hell as labyrinthine, an hypothesis borne out by the geographical and narrative parallels between the *Comedy* and the *Corbaccio*, where the dreamer is explicitly in a labyrinth, albeit an earthly one still permitting free choice and escape. Others, like Buti and Benvenuto, follow Boccaccio and describe the Cretan labyrinth as a cave: Francesco da Buti, *Commento sopra la Divina Comedia*, ed. Crescentino Giannini, 3 vols. (Pisa: Fratelli Nistri, 1858–1862), 1, 323–324, and Benvenuto, *Comentum*, 1, 385.

of the sodomites, an image sometimes linked with the labyrinth.[25] Whether or not Dante had the labyrinth in mind as he designed his complex circular hell, it is a chilling elaboration of that metaphorical cliché, the labyrinth of hell.

Purgatory too consists of a series of concentric circles diminishing in size as they ascend the mountain of the southern hemisphere; yet here there are steep, narrow, sometimes winding (cf. *Purg.* 10.8) pathways leading to the next level. But unlike hell, purgatory has a goal, the earthly paradise, and everyone who enters purgatory will reach that goal sooner or later.[26] Thus purgatory resembles the unicursal maze of the visual arts. Like other unicursal mazes, purgatory requires not intelligent choice but persistence in suffering the seemingly interminable circlings of terraces, for purgatorial circuitousness cures the soul and unwinds the binding knots of sin (*Purg.* 16.24; 23.15). From this benign unicursal maze of purgatory, trodden according to infinite individual timetables, the soul frees itself gradually through its circuits of suffering.[27] Although it contains torments and delays, this labyrinth is not a prison; designed to be extricable, purgatory is a spiritual labyrinth whose difficult circuities prove the elect and make them worthy. Here too Dante seems to have rung changes on the labyrinth tradition. Medieval literary labyrinths of life are often multicursal (cf. the *Corbaccio*, *Piers Plowman*, the *Queste*), but this labyrinth of the afterlife is appropriately unicursal because souls in purgatory have already chosen the true path on earth, however belatedly; this choice of the right path in the maze of the world gives them entry to the otherworldly maze, while the time spent on bad paths on earth determines the schedule to be followed here—the more bad paths, the longer the circuits and delays. If the

25. Since the ancient Cretan-type maze has seven circuits (see plate 1), the castle's seven walls may suggest a labyrinth, in particular the labyrinth of pagan thought. (Seven-walled Jericho, as we have seen, is also often depicted as a maze, and later we will see evidence that Dante may have known this tradition.) For the argument that the castle's seven walls and gates represent pagan insufficiency—a lack of faith in the resurrection, whose number is traditionally eight—see John Guzzardo, "The Noble Castle and the Eighth Gate," *MLN*, 94 (1979), 137–145. For somewhat labyrinth-like illuminations of the *castello*, see Brieger, *Illuminated Manuscripts*, pls. 67c, 69b&c, 70a, 72b, 74b, 76, 77b, and esp. 75b.

Although he does not explore the image of the labyrinth in the *Inferno*, Richard H. Lansing falls back on the metaphor to describe hell's complex structure: it is "a labyrinth of sin for the damned," and the seventh circle in particular is an "infernal maze"—in more ways than he suspects: see "Dante's Concept of Violence and the Chain of Being," *Dante Studies*, 99 (1981), 67–87.

See chaps. 3 and 6 above for identifications of wildernesses, deserts, and forests as labyrinths.

26. The language of pilgrimage, which implies a goal, enters the *Comedy* only in the *Purgatorio*, as Singleton notes: "In Exitu," p. 113. Getting into purgatory in the first place is the difficult task, though getting out involves pain. Getting into hell is easy, in contrast, and getting out impossible.

27. Cf. *Purgatorio* 21.61–66. The prayers of the living may diminish delays in purgatory, providing external aid to speedy passage: see *Purg.* 6.25–45; 8.71–72; 23.76–90.

unicursal maze of life illustrated in medieval art bends back and forth, toward and away from the goal, such fluctuations have no role in purgatory: treading its circles inevitably takes one closer to God in space as well as in time. Nor does purgatory instill confusion like earthly mazes, for even as they are entangled in its processes the maze-walkers here understand the pattern and know that its circuitousness is productive and that its perfect order (*Purg.* 21.40-42) prescribes an unerring path to transcendence.

Purgatory resembles unicursal earthly mazes; in paradise the labyrinth is fully converted to the perfection of its underlying principle, the cosmic circles of divine order.[28] As in the *Consolation*, labyrinths give way to circles of divine simplicity. Imagery of wheels and circles pervades the *Paradiso*, as no reader or illuminator can miss.[29] But these dynamic circles are very different from the static circuits of hell and purgatory, with their punitive or purifying torture. Heavenly revolutions are blissful, perfectly in accord with the divine artistry of the God who shaped the world with a compass (*Para.* 19.40-42). These spheres and circles are art (8.108), and if the physical cosmos reveals minor deviations from perfection in that the planets course in an "oblique circle" with their "pathway . . . aslant" (*Para.* 10.14, 16), that in itself is part of the order of "that Master's art" (10.10-11). Dante gives us privileged comprehensive overviews of the cosmos to ensure that we perceive that art: twice we see it naturally, with earth at the center (22.128-138; 27.77-87), and once spiritually, inverted, with God as the brilliant focal point of all things (28.13-39). As earthly and infernal labyrinths are deliberately imperfect copies of cosmic order, so that physical order itself must be inverted to reflect spiritual reality. Viewed from above, all is art, all is order, although for Dante the revolutions of the angels around God are the most perfect manifestation of an order that is increasingly less symmetrical and perfect as one declines toward earth. Paradise may be labyrinthine in its circularity, its sublime artistry, and the perspective-dependent convertibility it expresses, but it is itself no labyrinth unless it is a labyrinth of divine art.[30]

As in hell there were physical images of prison-labyrinths, so in para-

28. Just as the *rota* of fortune becomes the concentric *rosa* of the cathedral window when the viewer changes perspective. John Leyerle argues that the *rota-rosa* window at San Zeno, Verona, may very well have inspired Dante's synthesis of rose and wheels in the *Paradiso*: "The Rose-Wheel Design," p. 301.

29. See Brieger, *Illuminated Manuscripts*, pls. 488a, 491a, 492b, 510b, 519.

30. While souls in hell have a fixed circle and souls in purgatory a prescribed course and timetable, souls in heaven have perfect freedom of movement: presumably most of them contemplate God from their assigned seats in the heavenly amphitheater, but they may circle in every sphere and even descend to purgatory and Limbo, like Beatrice and Lucy. One would not wish extrication from paradise, but it is possible.

dise there are spiritual images of labyrinthine artistry quite apart from the dominant structure of wheeling concentric circles. One of these is the amphitheater of the elect in *Paradiso* 30. The Roman amphitheater in Verona was considered a labyrinth in the Middle Ages, and some illuminators of Raban Maur juxtapose the drawing of an amphitheater and the labyrinth text (see Chapter 5 and plate 9). Might Dante have known the Veronese amphitheater and the tradition that it was a maze, or had he seen a manuscript relating and accidentally equating the diagrammatic pattern and the amphitheater? If so, the celestial amphitheater might represent the transformation of a disordered and inextricable pagan monument to an edifice of perfect order and contented inclusion: an artistic labyrinthine structure as a reward for the sure treading of the labyrinths of life and purgatory, and a counterimage to the dark and painfully tiered labyrinth of hell, a ruin in which everyone also has a place according to merit. A much more important labyrinthine image in paradise, however, is the round dance, the carol, which for Marius Victorinus was associated with both the varied motions of the planets and stars and Theseus's celebratory labyrinth dance on Delos— the dance that may also inform the humanly ordered but unsustainable Trojan Ride of Ascanius. The dance *in bono* first appears in the earthly paradise, where the theological virtues form a knot and perform a round dance (*Purg.* 29.133, 121-122). Purified in Lethe, Dante joins the dance (also knot-like and labyrinthine?) of the cardinal virtues (*Purg.* 31.104). This, perhaps, is Dante's personal dance of liberation from the labyrinth of sin. The dances in heaven, recalling the round dance on Delos and Marius Victorinus's interpretation, correct Virgil by depicting an eternal vision of measured order, a natural expression of perfect harmony as opposed to the rehearsed and ephemeral order of the *lusus Troiae*. The celestial dance, like the Auxerre ritual discussed in Chapter 5, reveals the truth adumbrated on Delos and celebrates the redemption and eternal liberation from hell made possible by the actions of Christ-Theseus.[31]

Structurally, then, the *Comedy* offers three variations on the labyrinth: the inextricable prison-labyrinth of hell, the probative unicursal laby-

31. For the dance, see *Paradiso* 7.7, 8.26, 9.65, 10.79, 12.22, 13.1–20, 14.19–24, 18.135, 24.16–18, 25.99, 28.124. The dance terms used are *carola, rota, ballata,* and *tripudium*; the first three are recognizable as carols, and the fourth—the term used to describe the Auxerre Easter ritual—may also involve carol-like patterns of rotating first one way, then the other, then standing still. As the pattern of the Auxerre ritual is "garland-like," so the round dance in the Circle of the Sun forms a garland around Beatrice's head (10.91–92). Of course, there is a great deal more to be said on the subject of the cosmic dance in the *Comedy*, but I happily leave the topic to James L. Miller, who will no doubt provide a definitive reading in a planned sequel to *Measures of Wisdom*. See also Freccero, "The Dance of the Stars: *Paradiso* X."

rinth of purgatory, and the circling spheres and souls of paradise, which enact divine artistry and liberating goodness in a dance. Those whose wise choices on earth allow them to avoid the endless labyrinth of hell must labor through the teleological maze of purgatory, their circlings unwinding them from earthly error, until they are free to weave endless carols on high.

If the cosmos is thus in some sense a series of labyrinths, as Virgil intimated in the *Aeneid*, for Dante those labyrinths have a celestial architect and constitute a kind of hierarchy, for they increasingly manifest divine artistry the closer they approach to God. The circles of hell, farthest from God, are most unlike divine circles and as far from artistry: they are ruins, disrupted by the crucifixion and the harrowing of hell (*Inf.* 12.31-45; 21.106-114). As we have seen, the idea of the broken circle goes back to the *Timaeus*, where it describes the intellectual and moral confusion of the newly incarnate soul and incidentally evokes the pattern of the circular labyrinth, its characteristically roundabout paths created by the breaking up of perfect concentric circuits. Hell, with its tumbled rocks and disordered inhabitants, is therefore in some senses the most labyrinthine place in the *Comedy* and fitly is where those who failed to order their own broken souls are inextricably locked. Ironically, the coming of Christ-Theseus to this labyrinth liberates the just who had been bound eternally, making hell extricable on this one occasion; his harrowing breaks hell's circles further, making it still more labyrinthine (it is now eternally inextricable for its denizens, except—this once—for Virgil) and providing a path for one traveler, Dante, to pass through into deepest hell and beyond.[32] The ordered circles of purgatory, closer to God, are far from being ruined, but they too are visually "broken" by physical paths from one to the other; these circles contain, but also correct and purge, human disorder within their unicursal pattern. They are also less than perfect in that they are circular but static: they do not participate in the rhapsodic spinning of celestial spheres and spirits. The cosmic circles are not broken in Plato's sense; they participate most obviously in divine order and are the least like earthly and infernal mazes, even though they share the same organizing principle. But the planetary orbits, however fitly ordained, are oblique. Only in the region of the fixed stars and the Empyrean is the fullness of divine art perfectly imaged. Structurally speaking, the art of heaven corrects the comparative disorder of earth and hell and perfects the circles of purgatory, revealing the principles of perfect circularity that underlie all creation, all labyrinths.

32. If hell is Egypt, in accordance with the Exodus pattern, how appropriate that it should be a *ruined* labyrinth!

· The Labyrinthine Journey ·

We turn now from pattern to path, from an overview of the *Comedy*'s labyrinthine landscapes to the pilgrim Dante's labyrinthine progress, which begins in the labyrinth of the world, where meaningful choice among paths is still possible. As the living Dante moves through world, hell, purgatory, and paradise, he, like Aeneas and the prisoner Boethius, undergoes labyrinthine experiences that define human life as a journey through a maze wherein perfect understanding is finally impossible, but where circuitous process is epistemologically essential.[33]

As the *Comedy* begins, Dante is disoriented in something very like a labyrinth: a dark, pathless forest bordering on a desert. Halfway through life's course he has lost—or worse, abandoned—the "diritta via" (*Inf.* 1.3, 12). The adjective "diritta" (straight, direct, right) is fruitfully ambiguous: "direct" access to the light Dante sees atop a mountain is barred by three wild beasts of sin; nor would the path up the mountain have been "right" (correct), for Virgil must guide him "another way" (1.91) through circuitous paths if Dante is to be saved.[34] As in a labyrinth, he is exhausted by wandering (1.28); nevertheless, he must take the long way round (4.22) to learn the right way and prove himself, in part by overcoming obstacles and deflections like those represented by the beasts. The circuitous route *is* the right route, the only way to reach the goal; as in Book 3 of the *Consolation*, we learn what is right only by seeing what is wrong. Although Dante tries to turn back (1.36), in that first dark valley he is like most maze-walkers: he cannot remember how he entered the forest (1.10), and without guidance he could never find the right path again.[35] He is effectively in a multicursal maze: one path is blocked, another is forgotten, and only the third road promises success.

Much later we learn how Dante arrived in that trackless wood: when Beatrice was alive, she "led him with [her] turned toward the right goal," but after her death "he turned his steps along a way not true, following

33. For extensive comparisons between Aeneas's situation and Dante's in the Prologue, see Hollander, "Dante's Use of *Aeneid* I." Hollander finds these parallels complementary to the Exodus patterns noted by Singleton ("In Exitu"), as I do; but I would go still further to note that as Dante is here confronted with many aspects of the labyrinth, so too is Aeneas in Book I: driven off course by labyrinthine storms, shipwrecked in the Libyan desert wilderness, he speaks to his goddess-mother like one in a maze: see chap. 8, n. 8.

34. Cf. Beatrice's statement that Dante must be led through the "lost people"—*Purg.* 30.138. Dante gives Brunetto Latini a similar account of how he lost his way and needed redirection: *Inf.* 15.49–54.

The necessary circuitousness of Dante's path is one of the features that makes the labyrinth a particularly appropriate setting for the spiritual action.

35. The only retracing of steps for Dante will be the constructive retracing "unerring memory" (*Inf.* 2.6) takes later in writing the poem, which will then guide other maze-walkers' return to God.

false images of good, which pay no promise in full" (*Purg.* 30.123, 130-132). Without a guide, he swerved aside from the true course, as men with free will and terrestrial perspective tend to do (cf. *Para.* 1.127-135). The first canto, then, is set in a version of the traditional world-maze of error and sin, in which, as in the *Consolation* and Seneca's Epistle 44, most men pursue multicursal dead-ended paths of false felicity without having any idea where they lead. Dante's own maze-walking will teach him what lies at the center.

Once Dante accepts Virgil's guidance and leaves this world, he is on the right path, but it is not straight, nor is Dante free of mazes. Although he has free passage through hell, which for him alone affords a transcendent goal, his subjective experience therein is labyrinthine. The place is dark, noisy, terrifying, and his head is "circled with error" (*Inf.* 3.31). Alternative paths are possible (cf. 4.149; 7.105) and alarming impediments must be overcome: not merely the hybrid demons that guard each circle (most labyrinths *in malo* contain minotaurs), the truculent devils of Dis, and the conniving Malebranche, but also the increasing roughness of the landscape. Physically and emotionally, the journey is exhausting. Often Dante swoons or fears to continue, and once at least he wishes to retrace his steps (8.102). The travelers' direction is generally downward and to the left,[36] but it is important to remember that the reader, sharing Dante's disorientation, detects no consistent pattern until Virgil has described it (14.126), and in fact the trip through hell involves a good deal of wandering to and fro, backward and forward, up and down, left and right: by Virgil before the gates of Dis (8.109, 117), within the sixth circle (9.132; 10.4-5, 133), when meeting Geryon and visiting the usurers (17.31, 43-45, 78), and in Malebolge, where Virgil and Dante often cross one ditch only to turn back and go down into it before retracing their steps out again (cf. 19.40-41, 126; 24.79-81; 26.13-15). Thus progress is not direct, regular, and consistent, but instead emulates hesitant movement within a maze.[37] Circuitous, disordered,

36. But "rightward" from God's perspective, as Freccero argues ("Pilgrim in a Gyre"). Freccero analyzes the pilgrim Dante's physical orientation and direction of movement throughout the *Comedy*, showing how and why, according to Aristotelian and Platonic cosmology, Dante always moves toward God and in the "rightward" direction, along the path of the sun, even when he seems to be going "down" and "leftward" in hell. For a different explanation of Dante's progress, see Damon, "Geryon, Cacciaguida, and the Y of Pythagoras."

37. Or the movement of Plato's disordered material world.
Freccero argues that the right-hand turns along the circumference of the circles amid the heretics and to meet the usurers reflect the perversion of speculative and practical reason committed by those sinners ("Pilgrim in a Gyre," pp. 87–89), but I do not see why *Dante* should turn to the right to counter these sins. The traditional association of labyrinths with heresy, and of ancient labyrinths with tombs, might explain why there is *a* turn in the sixth circle: along with the heretics' coffins—arranged in a very disorderly fashion in some illuminations (see Brieger, *Illuminated Manuscripts*, pls. 136, 139b, 140a, 141a&b,

disorienting, arduous, dark, full of hybrid monsters, hell is labyrinthine even to one with a guide and the promise of escape.

We come to *know* what the map of hell would look like, but significantly we do not *see* it. Virgil offers a belated verbal description of its structure (Canto 11), and Dante is granted a parodic celestial voyage on Geryon's back in Canto 17. But Dante actually sees very little during this terrible flight: "I saw that I was in air on every side, and saw extinguished every sight, save of the beast" (112-114); "I saw fires and heard laments" (122); "I saw then—for I had not seen it before—the descending and the circling, by the great evils which were drawing near" (124-126). He sees only enough to make him suspect that, like Icarus, he is following a "mala via" (111). In the following canto Dante describes the structure of Malebolge—the concentric circles, the radial bridges, the central pit— but it is not clear whether he has seen this landscape in his flight. If Dante has a physical overview of any part of hell, then, he sees only a fragment of the whole, and indeed the fragment that looks most like a labyrinth; but the center is invisible. The lack of a complete overview corresponds to the lack of moral perspective the damned had on earth.

Dante passes through the prison-labyrinth of hell unscathed, though not without confusion and effort, because he is not and will not be bound by it. Instead, his instructively circuitous tour shows where the disordered paths of unrepented sin inevitably lead. The labyrinth he finds in purgatory touches him more closely, for he needs to be purified: he shares the progress of these saved souls, whose final earthly choices were for good, as he does not share the situation of the damned.[38] Dante's

142a&b, 149a&b)—and the emphasis on the travelers' severely constricted passage between the walls of Dis and the tombs (*Inf.* 10.1), the emphasis on turning suggests the landscape and process of a labyrinth: in this case, the labyrinth of heresy. But why this turn should be to the right I cannot guess. However, the fact that Dante's movements through hell are not regular—not simply the spiral that Freccero sees—makes the journey labyrinthine; to create the feeling of a labyrinth, of course, turns to the right as well as to the left should be involved, and it may simply be coincidental that they occur with heretics and usurers, both of whom abuse human arts.

38. Hollander ("Dante's Use of *Aeneid* I," p. 154, n. 16) wonders whether, as the Exodus pattern initiated in *Inferno* 1 is completed in *Purgatorio* 1, so too Dante again draws on the *Aeneid* as the pilgrim arrives in the promised land. He cites Edward Moore's suggested parallels with Book 6 (the golden bough is analogous to the girdle of reed; both reed and bough are renewed when plucked; and both heroes bathe their faces with dew) and concludes that Dante is comparing his own "invention" and description of purgatory with Virgil's alleged "invention" and description of Hades.

Certainly the parallels adduced by Moore (*Studies in Dante: Series 1*, p. 170) are significant, but perhaps they tell another story. When Aeneas seeks the golden bough, he has just emerged from the Sibyl's labyrinthine cave; in *Purgatorio* 1, Dante has also emerged from a labyrinth by the dark, winding, difficult path from hell to purgatory (*Inf.* 34.95, 129-134); the description of the path suggests the cavernous corridors of a maze. Like Aeneas, he needs a talisman to enter the next labyrinth: Hades for Aeneas, purgatory for Dante. For each hero, this next journey is crucial; hence, as the Sibyl rebukes Aeneas for lingering over the sculptured labyrinth on the Cumaean gates, for resting rather than doing, so Cato

movement through purgatory is less complex than his passage through hell: girded with the reed of humility, he has refound his way (*Purg.* 1.118-120), and while he and Virgil often ask directions (e.g., 3.76-77; 6.60; 11.40-41; 16.44; 19.78), assistance is always available and the sun is a reliable guide (1.107-108; 13.13-18). The journey is difficult (e.g., 4.19-30; 10.7-16), but it becomes easier the higher they go (4.88-94; 12.92-93) as Dante's own tendencies toward sin, symbolized by the seven Ps placed on his forehead, are erased by his partial circling of each terrace. The path itself is clearer, for Dante and Virgil move in the light of day. The gracious ladies who made his otherworldly travels possible— Lucy, Beatrice—are there to help and instruct at crucial junctures (9.49-63; 19.26; 30.32ff.).

Yet if purgatory feels less physically labyrinthine than hell, it shows Dante's passage through a spiritual labyrinth: the labyrinth of the sinful heart, of the tainted will in need of cleansing. We saw analogous moral labyrinths in Chapter 6: the mazes of wrongful desires in Boccaccio's *De genealogia* and in Bersuire, of earthly love in Petrarch's *Canzoniere*, of sensual pleasure in *Les Echecs amoureux*. The *Corbaccio* embroils its narrator in a labyrinth of love from which he can escape only with the careful questioning of a guide-confessor who helps him see the error of his ways and determine to reform. The forest-labyrinths of the *Queste*, too, represent the spiritual landscape of the sinner entangled in error and liberated only through penance and grace. For the English friar Robert Holkot, conscience is a labyrinth almost impenetrable for the confessor and nearly inextricable for the sinner; it can be entered and unraveled only by a priest whose searching questions become a spiritual thread of Ariadne: "Morally speaking, when the devil sees someone commit a monstrous sin, the devil makes the sinner's conscience resemble the house of Daedalus . . . and there he hides that sin [from the sinner himself as well as the confessor] so well that no confessor can enter unless with a ball of thread. The confessor must unwind the sinner's conscience with searching questions before the guilty man can admit what he has done."[39] It is in just such a labyrinth of sin that Dante finds himself. The theme is announced at the locked gate to purgatory, where Dante contritely beats his breast (*Purg.* 9.111): the benefits within are inaccessible without true penitence. Marked with the Ps of *peccato*, allegorically Dante is himself a labyrinth, the "knot" that must be "disen-

rebukes Dante and the other pilgrims for yielding to the seductions of Casella's song— again, for resting rather than resuming the "iter durum." Virgil will later play the Sibyl's role in urging Dante to move on from his dangerous absorption in the artistry of pavement images in the first terrace—*Purg.* 12.77-78.

39. *In librum Sapientiae regis Salomonis praelectiones CCXIII*, ed. Jacob Ryter (Basle, 1586), lectio 115, p. 387.

tangled" by the angelic gatekeeper's double keys, one the power of absolution and the other, requiring more "skill and wisdom" to wield it, the confessor's sense of whether penitence is genuine enough for absolution.[40] Warned not to look back (9.132), Dante is admitted through this gate "which the souls' wrong love disuses, making the crooked [*torta*] way seem straight [*dritta*]" (10.2-3). The path Dante follows is morally direct—it is the shortest legitimate route to the earthly paradise—but it is also crooked (though not wrong): the cleft leading to the first terrace bends back and forth, demanding skill (10.7-10), and Dante's route involves constant turning to the right (along the terraces) and left (to rise to the next terrace). His journey is as paradoxical as many labyrinths: while bad love makes the morally crooked paths of the labyrinth *in malo* look like a straight path to true felicity, Dante's good love takes a tortuous, roundabout road to unwind his sins just as purgatory's residents unknot theirs to attain the true good as directly as possible. In one sense, the pilgrim is on a road to the center, beginning to penetrate the divine mysteries of paradise; in another sense, he is weaving his way out of the labyrinth of sin. Center and circumference converge mystically, as they do later in paradise; the idea of the labyrinth suggests yet another of the astonishing inversions in the *Comedy* (cf. *Inf.* 34.76-117; *Para.* 28.13-139). The labyrinth of purgatory, like the labyrinth of the sinful heart, entails difficulty in both penetration and extrication.

The theme of the heart's labyrinth is restated in the earthly paradise, where Beatrice herself plays the role of Holkot's Ariadne-confessor.[41] Chastising Dante for his folly, she tries to bring him to full awareness of his sin, "so that fault and grief may be of one measure" (*Purg.* 30.108). Using imagery of path and goal, she describes how he turned from true happiness and from her love, falling so low that her intervention was his only hope. This Ariadne may have been abandoned, but her love, like Lady Philosophy's for Boethius, is constant. For preferring false love to Beatrice's love, Dante owes debts of penitence and confession (30.145; 31.6). Her pointed questions guide him, confused and almost speechless, through this confession. She makes him recognize the obstacles that caused him to swerve aside, delivers a trenchant homily, and imposes penance for his error so that he is truly converted (31.22-90). Freed from his spiritual labyrinth by this retracing of his sinful steps, guided by the thread of Beatrice-Ariadne's questions, he crosses Lethe and dances

40. See Singleton, *Purgatorio 2: Commentary*, p. 192, citing Porena. The keys are described in *Purg.* 9.121–129.

41. This role complements Beatrice's other functions here: e.g., her acting as Christ the Judge in the Second Coming (Singleton, *Elements of Structure*, pp. 45–60) and as Mary in the incarnation (Wimsatt, "Beatrice as a Figure for Mary"). Christopher Ryan also discusses Dante's need for a full and difficult confession in the earthly paradise: "Virgil's Wisdom," 9–10.

with the Virtues. Christian Ariadnes, unlike pagan ones, rescue their lovers from as many mazes as necessary and participate in Delian dances of liberation. We will return to Beatrice's role as Ariadne shortly.

Dante's progress through paradise seems direct and straightforward, ever upward and toward God; the metaphors of flight anticipated in the *Purgatorio* (cf. 3.52-54; 4.27-29; 9.19-30) dominate the *Paradiso*, and Dante moves effortlessly between spheres. But if he experiences none of the physical difficulties of traditional mazes, if he seems to have flown like Daedalus above them all, that impression is misleading. Paradise embodies the perfect circular art of the divine architect and clarifies the principle of the labyrinth, but still Dante cannot achieve perfect understanding. God's ways are not so divinely simple as Lady Philosophy would have them, and although Dante is free of malignant mazes, he cannot penetrate the final labyrinth of divine mystery heralded by Jerome, Vegetius, Gregory of Nazianzus, and the *Queste*. Like Boethius, Dante is limited by perceptual and intellectual labyrinths that make divinity finally impenetrable. No creature can take an overview of God.

Dante's powers of vision increase dramatically as the *Comedy* progresses, but these very changes remind us how much vision on earth—where all the critical choices must be made—is restricted, not merely by point of view but also by inherent physical limitations. In purgatory, the dazzling angels and the still more brilliant Beatrice are blinding (e.g., *Purg.* 9.81-84; 15.22-33; 17.44-57; 32.10-12). In paradise, where "much is granted to our faculties that is not granted here [on earth]" (*Para.* 1.55-56), Dante repeatedly confronts impenetrable brightness, and only special dispensation allows him finally to see as the blessed see (30.59-60). Yet if the perceptual labyrinths that handicap most living creatures can be transcended in the poem, certain mental ones cannot. Dante is granted an extraordinary vision of the Trinity, of "the universal form of this knot" (33.91), of how "the image [of humanity] conformed to the circle [of divinity]" (33.138). But human language and memory lag behind privileged vision and flounder: "Thenceforward my vision was greater than speech can show, which fails at such a sight, and at such excess memory fails" (33.55-57). Or, as Dante puts it in *Paradiso* 1.7-9, "as it draws near to its desire, our intellect enters so deep that memory cannot go back upon the track."[42] As Dante cannot remember how he left the *diritta via* in the *selva oscura* or where he entered the earthly paradise (28.23-24), so he cannot retrace in memory or words what he

42. Cf. also *Paradiso* 18.8-12 and 23.61-63, in which, evoking labyrinthine metaphor, "depicting paradise, the sacred poem must needs make a leap, even as one who finds his way cut off." On the inadequacy of language for the most difficult concepts (cf. Hugh of Saint Victor, chap. 7 above), see also *Para.* 11.22-24 and 15.38-43, 44-45, and Rossi, "'A l'ultimo suo,'" 70-72.

saw of the impenetrable labyrinth of God. If the *Comedy* is a text whose thread, like Ariadne's, guides humanity through the divine labyrinth, at some point the thread snaps and the labyrinth, while glimpsed, remains unmapped.

The final labyrinth of divine mystery remains impenetrable and unchartable to other faculties as well. As with memory, so with intellect, which is doubly handicapped in that its "short wings" normally depend on perception (see *Para.* 2.52-57; 4.40-42). True, Dante's knowledge increases as the poem progresses, and many of the mental doubts, errors, knots, and perplexities that increase in frequency as he advances are unraveled, dissolved, and explicated (if Beatrice is an Ariadne, her methods are often like Philosophy's despite the poem's pejorative comments on human reasoning).[43] But the greatest mysteries remain inexplicable: even Virgil knows that God "wills not that the way of Its working be revealed to us. Foolish is he who hopes that our reason may compass the infinite course [*trascorrer la infinita via*] taken by One Substance in Three Persons" (*Purg.* 3.34-36).[44] Most notably, Dante's urgent questions about predestination and divine justice go unanswered, for "He that turned His compass round the limit of the world . . . within it marked out so much *hidden* and revealed" (*Para.* 19.40-42; my italics). God traced a labyrinth parts of which must be secret. Therefore, as Peter Damian declares, "that soul in heaven which is most enlightened, that Seraph who has his eye most fixed on God, could not satisfy your question: for that which you ask lies so deep within the abyss of the eternal statute that it is cut off from every created vision. And when you return to the mortal world, carry this back, so that it [mankind] may no longer presume to move its feet toward so great a goal [*segno*]" (21.91-99). God "endows with grace diversely—and here let the fact suffice," Saint Bernard states bluntly (32.66). The workings of divine justice which Philosophy explained to Boethius become for Dante an unanswerable question, the impenetrable conceptual labyrinth at the center of all things. Dante may *see* "the universal form of this knot," but it can never be explicated. Like Aeneas, Dante traverses many labyrinths and is finally left in one— indeed, he returns to the labyrinth of the world where he began. But for the Christian poet, all labyrinths *in malo* can be overcome; the grace-given view from above and the partial view of what is above clarify mundane and infernal mazes even while asserting the impenetrability, the final oblivion, of the labyrinth that is God.

43. For a few examples of mental knots, entanglements, etc., see *Inf.* 10.95–96, 10.113–114; *Purg.* 15.60, 18.39–45; *Para.* 1.94–96, 4.17–18, 7.52–53, 19.33, 32.49–51.
For cynical views of human reasoning, see, e.g., *Purg.* 33.79–90; *Para.* 2.52–57, 11.1–3, 15.38–42, 29.85–87.
44. Cf. Simplicius's discussion of the labyrinth as infinite, chap. 3 above.

· The Myth Transformed and Reenacted ·

The structural and subjective labyrinths of the *Comedy* set the stage for Dante's most striking, and most explicit, transmutation of the labyrinth tradition: his development of the Cretan myth's characters and plot. Most of the Cretan characters are named in the poem, where their quasi-historical roles are modified, extended, transformed, and often assumed by other characters, as we have begun to see with Beatrice as an Ariadne figure. Like many medieval mythographers, Dante finds in the legend "shadowy prefaces of . . . truth," motifs and roles that receive their best fulfillment in a purely Christian allegorical context;[45] yet his treatment of these characters and motifs, whereby some, like Minos and the Minotaur, appear literally whereas others, like Ariadne, function by analogy, is so rich and extensive that most mythography seems banal in comparison. The rest of this chapter explores Dante's manipulation and redefinition of the myth of the labyrinth.

Presumably Minos is chief custodian of hell because he was a judge in Virgil's Hades, but Dante expands Minos's role and authority, transforms his person, and assimilates him into the *Comedy*'s labyrinthine patterns. In the *Aeneid*, Minos assigns places to those condemned on false charges (6.430), although, empowered to hear "men's lives and misdeeds" (6.433), he may have somewhat broader jurisdiction. But he also works by lot (6.431-432), and chance affects his justice. In contrast, Dante's Minos has unquestioned and virtually absolute power over the damned. The "discerner of sins" (*Inf.* 5.9) "who seizes everyone" (20.36), a magistrate "to whom it is not permitted to err" (29.120), Minos judges souls according to their confessions, and his dreaded name echoes throughout the Inferno.[46] He is gatekeeper and ruler, embodying "the severity of divine judgment."[47] Dante's Minos, unlike Virgil's, is locally omnipotent and infallible, powers demanded by his new role as minister of a Christian God's justice. Thus far, Dante's Minos might have been depicted in at least as dignified a manner as Virgil's.

But Dante is at once too traditional—in a Christian sense—and too original for that. In paradise, he shows that divine justice is impenetrable, thereby partaking of labyrinthine qualities, and this conclusion is foreshadowed in hell. Infernal justice, a subdivision of labyrinthine divine justice, is fitly implemented by the law-giver king who ordained the Cretan maze: the celestial labyrinth-maker works through an earthly

45. The quotation comes from *Paradiso* 30.78. On Dante's figural use of pagan myth seen as "true," see Hollander, "Dante Theologus-Poeta," and n. 15 above.

46. See also *Inferno* 13.96 and 27.124. In *Purgatorio* 1.77, Minos stands for hell in Virgil's metonymy. On the possible conflation of Rhadamanthus and Minos, see Moore, *Studies in Dante*, pp. 183–184.

47. Boccaccio, *Comento*, 2, 147.

commissioner of mazes. But Dante's Minos is not anagogically a founder of labyrinths: instead, with poetic justice, the murderer of innocents becomes a creature, as well as lord, of the labyrinth, as befits someone who is a devil in the Christian scheme of things. Dante's Minos dispatches the damned to the appropriate circle not by word but by gesture: he winds his tail around his body as many circuits as the sinner must descend. In the inextricable prison-labyrinth of hell, he himself becomes a physical *signum sequendi*, an ironic parody of Ariadne's guiding thread, showing exactly what path the soul must follow to reach its goal. His sinuous appearance reflects hell's mazy architecture and also the twisted coils of the prison he had constructed on earth.

An emblem of the labyrinth, he also becomes an emblem of what hell and maze alike contain. Once a man, Minos is now a demon with a tail that marks him as a hybrid. His characteristic emotion is wrath: he bites his tail in rage as he sends sinners off to torment (5.4; 27.126). The justice he enforces is the justice of an angry God. In his newly hybrid appearance and his fury, Minos has come to resemble the hybrid Minotaur: the nominal father's single nature and anger undergo metamorphosis into the titular son's dual nature and "bestial wrath" (12.33) in an infernal parody of the incarnation.[48] Unlike Cretan king or monster, however, Dante's Minos has no power over innocents; God's justice, however inscrutable, is demonstrably fairer than that once meted out in the labyrinth by the Minos of pseudo-history, whose own sins are punished by his deformation.

The Minotaur, too, is one of hell's arch-wardens, and perhaps the archetype of all hell's inhabitants thanks to the terrible man-beast duality that, physically or morally, characterizes sinners and demons alike. Implicitly half man and half beast, he resembles other double-natured hybrids in the Inferno: Geryon, centaurs, harpies, furies, many sinners.[49] Inarticulate, communicating only by outraged gesture, biting

48. For illuminations of Minos as hybrid demon, see Brieger, *Illuminated Manuscripts*, pls. 80a, 82a, 83a, 84a, 85a&b, 87a&b, 88a, 89a, 90b. On parody of celestial truths in the *Inferno*, see Barolini, *Dante's Poets*, pp. 223–224; Anthony K. Cassell, *Dante's Fearful Art of Justice* (Toronto: University of Toronto Press, 1984), pp. 23–24; Singleton, *Elements of Structure*, pp. 34–44.

On the general theme of metamorphosis, see Kenneth Gross, "Infernal Metamorphoses: An Interpretation of Dante's 'Counterpass,'" *MLN*, 100 (1985), 42–71.

49. For a discussion of which half was man and which beast, see Steven Botterill, "The Form of Dante's Minotaur," *Forum Italicum*, 22 (1988), 60–76. After reviewing descriptions of the Minotaur in literature before Dante as well as in trecento commentaries and illuminations, most of which either rely on the "half man, half bull" formula or, in the visual arts, show a centaur-like creature, Botterill goes against most twentieth-century opinion to opt for a bull-headed man. On the other hand, one might argue that because most hellish hybrids in the *Inferno* have human faces, so too would the Minotaur. My own interpretation of the evidence is that Dante, like most predecessors and followers, deliberately avoids precise description of the Minotaur's composition, which was, after all, a matter of considerable doubt in the Middle Ages. For Dante, as for most writers who develop the myth,

himself, the Minotaur mirrors the irrationality, futility, and self-destructiveness of all sin. In the circumstances of his conception—through shameful lust, consummated in the tricky "falsa vacca"—and in his anger and monstrosity he specifically embodies the generic sins of the lower circles of hell: fraud, malice, bestiality. Unable in life to find his way out of the now-vanished Cretan labyrinth, he stands guard in the ruined, and now eternally inextricable, labyrinth of hell over those who did not follow a true path on earth. Product of Pasiphae's unnatural lust, he and his ilk supervise the tortures of those who never repented their love for fallacious goods. The "infamy of Crete" (12.12), he signifies those, named and anonymous, who even in hell seek earthly fame but earn infamy instead through their immortalization in the *Comedy*. As with Minos, so with the Minotaur Dante draws on traditional material but shapes it to fit his own grand design. There is, however, a significant difference between "father" and "son": Minos rages at sinners and consigns them to the labyrinth, but the Minotaur, true to his mythological circumstances, rages most violently at the notion that anyone can *escape* the labyrinth he inhabits forever. Thus when Virgil taunts him with a reminder of Theseus's triumph and Ariadne's loving ingenuity, he dances ("saltella") back and forth in futile anger; his grotesque leaps simultaneously mimic uncertain movements within a maze and parody more elegant dances that celebrate freedom from the labyrinth: the dance on Delos, the dances of paradise, perhaps even cathedral labyrinth-dances, like the Auxerre ritual, that were performed at Eastertide. His rage may be heightened by a dim understanding that Dante too will be freed from the labyrinth of hell: after all, the Minotaur episode is significantly framed by allusions to the "ruins" of hell—the tokens of its historical extricability—wrought by Christ-Theseus (12.4–11, 32–45). In any case, the mere facts that hell is Minos's prison and under his control (as was not true of Hades in the *Aeneid*) and that the Minotaur and other terrible hybrids stand guard within, convincingly define Dante's hell as a labyrinth.

Unlike Minos and the Minotaur, Daedalus, master of sundry arts, is not assigned a place in Dante's otherworldly labyrinths, but he flits through the narrative by name, work, and role in an oddly ambivalent way, as if Dante could not decide whether the greatest mortal artisan, or indeed human art itself, could or should be pinned down *in bono* or *in malo*.[50] Certainly Daedalus emerges as a more complex and ambiguous

the Minotaur's double nature, its perverted blend of humanity and bestiality, dictates its most important moral significance: cf. Benvenuto, *Comentum*, 1, 386, and Buti, *Commento*, 1, 325. In other physical respects, the denizen of ambiguity fitly remains ambiguous.

50. This ambivalence is not surprising, for Daedalus's mythical actions were usually fairly shady, and his mythographical significance is ambiguous as well. See Flahiff, "Labyrinth: Some Notes on the Crafty Art of Daedalus."

character than either of the mythical characters so far discussed, and it is always his artistry that is at issue. Daedalus's most unsavory creation, the wooden cow in which Pasiphae satisfied her lust, is twice mentioned in the *Comedy* (*Inf.* 12.13; *Purg.* 26.87), but he is never identified as its artificer. Does Dante want us to remember, and condemn, Daedalus's perverse misuse of his talents here—the abuse that, in many versions of the myth, leads to his own imprisonment in the maze? Or is Dante sparing Daedalus deserved infamy by permitting us to ignore the inventor, think of the work itself as "falsa," and damn only Pasiphae's abuse of the cow in her frenzied passion? Perhaps there is a clue in Dante's description of the Sicilian Bull commissioned by the tyrant Phalaris (*Inf.* 27.4–15). Like Pasiphae's wooden cow, the bronze bull was a work of art counterfeiting nature; as the cow encased Pasiphae and echoed with her moans, so the bull, placed on the fire, resounded horribly with the cries of men enclosed within. Its first victim—"and that was right," Dante notes tersely—was its own inventor, Perillus, like Daedalus an Athenian craftsman. Perhaps Dante's point is that the artist ought to suffer every ill his creations can possibly cause, so that Daedalus gets off lightly by a stint of imprisonment in the labyrinth and the loss of Icarus.[51]

The same ambivalence toward the art of Daedalus, and by extension toward all human arts, is found in relation to the Athenian's mastery of flight, perhaps his more significant achievement in that Daedalus is alluded to in the poem most often, and specifically identified only, as wing-maker. Daedalus is named by the seedy Griffolino, who fraudulently offered to teach one Albero to fly like Daedalus (29.112–117); yet Griffolino is damned for another art, alchemy.[52] Elsewhere in the *Inferno* (17.111) Daedalus appears in a nobler light as a stern father warning his son, "You go an ill way," a reference evoking traditional moralizations of Daedalus as an admirable contemplative whose rash son falls from the sin of pride (see Chapter 6), and in paradise (*Para.* 8.126) he is seen as a tragic genius whose amazing arts lose him his own son. The context of this last reference is suggestive: Charles Martel is explaining God's astrological use of the heavens to influence human potential, and he immediately follows the allusion to Daedalus by noting that "circling nature, which is a seal on the mortal wax, performs its art well" (8.127–128). The wax metaphor and the juxtaposition imply an analogy: as providence

51. Dante's view is not much clarified by the presence of Ulysses and Diomedes in the *bolgia* of evil counselors, and of Sinon in the *bolgia* of the falsifiers, for having used the Wooden Horse—another analogue to the cow and bull—to deceive the Trojans. Is the fault in the builder, the abuser, or both? On the other hand, if Daedalus's works are analogous to *verbal* artistry, Francesca's succinct comment may be pertinent: "Galeotto fu 'l libro e chi lo scrisse" (*Inf.* 5.137, my italics). Or does the lady too easily blame others for her own failure?

52. Griffolino notes that he was condemned by "Minos, to whom it is not allowed to err"; does this comment, immediately following the mention of Daedalus, suggest that Daedalus too ought properly to have stayed in prison in the maze where Minos put him and, by extension, belongs in hell?

(acting through the medium of the stars) is to the wax of human nature, so Daedalus is to the wax that binds wings; both God and Daedalus are artists working with tricky materials, and both lose beloved children whose wax melts when their "track is off the road" (8.148). Surely another analogy between the human architect and the divine creator, both of whom crafted circular complexities as if with compasses, lies latent here and, perhaps, elsewhere in the *Comedy*, as in medieval cathedrals or the mythography of Bersuire and the *Ovide moralisé*, even though Daedalus is never explicitly described in the *Comedy* as inventor of the labyrinth. Perhaps the only labyrinths that really matter are God's.

But does the *Comedy* present Daedalus as type or antitype of divine artistry? Although a quick look at the motif of flight in the *Comedy* gives no firm answer, it does suggest the complexities of Dante's attitude to Daedalian artistry. Flight is, after all, one of two traditional means of escape from the labyrinth, the only means that provides a full overview by direct vision, and a route followed by Boethius with Philosophy's feathers. Dante emphasizes, as Boethius does not, the difference between flights of human reason or philosophy and flights empowered by grace. Infernal flights are terrifying (Dante's flight downward on Geryon's back) or tragic (the flights of Icarus and Phaeton—*Inf.* 17.106–111) or simply ridiculous (Griffolino's cynical instruction of Albero). Ulysses' "mad flight" (*Inf.* 26.125), however, has the most serious implications of all. Like Virgil's Daedalus, he makes his oars wings ("de' remi facemmo ali al folle volo" [26.125]—cf. *Aeneid* 6.19) in his forbidden voyage past the Pillars of Hercules to seek "virtue and knowledge" (26.120), doing in the wrong spirit, and literally, what moral mythographers interpret Daedalus as doing rightly and metaphorically.[53] But where the good Daedalus, like Lady Philosophy of the *Consolation*, traditionally seeks contemplation by legitimate wings, avoiding the too lofty flight of pride and the sea-skimming flight of desire for things of this world, Ulysses' wing-

53. Others commenting on the flight of Ulysses include Giorgio Padoan, "Ulisse 'fandi fictor' e le vie della sapienza: Momenti di una tradizione (da Virgilio a Dante)," in *Il pio Enea, l'empio Ulisse: Tradizione classica e intendimento medievale in Dante* (Ravenna: Longo, 1977), pp. 170–199, reprinted from *Studi Danteschi*, 37 (1960), 21–61; Freccero, "The Prologue Scene," pp. 15–24; David Thompson, *Dante's Epic Journeys* (Baltimore: Johns Hopkins University Press, 1974), pp. 63–73; Pierre Courcelle, "Quelques symboles funéraires du néo-platonisme latin: Le vol de Dédale—Ulysse et les sirènes," *Revue des Études Anciennes*, 46 (1944), 65–93; and John A. Scott, "Inferno XXVI: Dante's Ulysses," *Lettere Italiane*, 23 (1971), 145–186, who sees Ulysses as "guilty of transgressing the laws of nature and society"—as one who delights in leaping over the rails of rightful labyrinths, as it were. For parallels between Dante the pilgrim and Aeneas, in contrast to Ulysses, see Lawrence W. Ryan, "Ulysses, Guido, and the Betrayal of Community," *Italica*, 54 (1977), 227–249, and Thompson, *Dante's Epic Journeys*. For a full treatment of the themes of Canto 26 and intriguing reference to the lessons Dante learns from Ulysses, see Giuseppe Mazzotta, *Dante, Poet of the Desert: History and Allegory in the Divine Comedy* (Princeton: Princeton University Press, 1979), chap. 2, esp. pp. 93 and 105.

ed sea-voyage, like Icarus's soaring, stems from just such intellectual arrogance as Dante himself may have felt in *Inferno* 1 when thinking to climb the mountain by his own strength. Ulysses' daring, like that of Icarus, leads to drowning: human mechanical aids like wings, winged sails, and natural reason fail like Griffolino's arts when no grace or angel-pilot (*Purg.* 2.31–36) attends them. In contrast, flying on wings of grace, Dante later sees the traces of Ulysses' "mad track" just as the pilgrim is about to leave linear time itself (*Para.* 27.82). Men who try to fly usually end up like Icarus—too high *and* too low—unlike the moderate, respectful Daedalus of medieval mythography, for they are seeking by ignoble means to penetrate the labyrinth of divinity.

For Dante, Philosophy's wings will not go far either: "Reason's wings are short," Beatrice tells Dante (*Para.* 2.57), and "defective syllogisms make you beat your wings in downward flight" (11.2–3, my trans.). The two wings available to humankind, will ("voglia") and reason ("argomento"), have feathers of different strength (15.79–81), and the reformed will's feathers, strengthened by grace, outstrip the wing of reason. Dante's wings, which carry him almost to his supreme moment of illumination (33.139–140), are supplied not by the natural or even contemplative ingenuity of a Daedalus, nor by the reasons of Lady Philosophy, but by Beatrice and Mary (15.53–54, 72; 25.49–51; 33.15), whose grace and art far transcend Daedalus's noblest endeavors. Nevertheless, Daedalian art is not to be scorned: when it involves a properly directed will, as in many mythographers' interpretation, it can take you a long way (see *Para.* 10.74–75).

Thus the arts of Daedalus, sketchily surveyed here, seem to be neither good nor bad in themselves; they are, like labyrinths in the abstract and metaphorical labyrinths of life in particular, simply a means to an end. How the user directs them, and with what empowering grace or shortsighted vice, determines what the end will be. Perhaps the Daedalus of the wooden cow panders to lust and belongs in hell; perhaps the Daedalus who would safely direct the flight of Icarus along a moderate course is a guide to virtue and belongs, metaphorically at least, with the just. If Dante knows, he does not tell us, leaving the ingenious old creator of ambiguities—feigned cow, many-folded labyrinth, double wings—a complex ambiguity himself. All that is certain is that there is a greater architect, guide, and master of flight.

The mythical Daedalus knew how to escape the labyrinth and follow the right track, and the good flight he espouses is sanctioned in the *Comedy* as part of an answer to liberation from its mazes. Two other solvers of the Cretan labyrinth, however, are far more important in Dante's theological mythography: Theseus and Ariadne. Virgil's Theseus is firmly lodged in Hades as an infamous sinner, but in the *Comedy* Theseus plays a continuously noble part. The slayer of the double Minotaur is invoked

in purgatory as slayer of the double-breasted Centaurs who would have raped Hippodamia (*Purg.* 24.121-123), reminding us that Theseus can conquer bestial vice; and he is remembered with fear and anger in hell for his penetration of labyrinth and Hades alike. For Dante, Theseus is clearly and unambiguously a figure of Christ, as so many writers from Jerome and Gregory of Nyssa to Bersuire, the master of the Auxerre ritual, and Dante's own commentators knew.[54] Examination of events surrounding the poem's allusions to Theseus bears out this conclusion. Christ-Theseus is first evoked implicitly in *Inferno* 8, when the demons of the City of Dis take alarm at the presence of a living man and suggest he had better retrace his steps as fast as possible (82-92): is this another deceitful Christ pretending to be merely human?[55] Is it Theseus or Hercules, who also retraced their steps through the labyrinth of Hades, they seem to wonder? In any case, they intend to keep the nether labyrinth of Dis impenetrable lest it become extricable to these potential rescuers of souls. Delayed by diabolical recalcitrance, Virgil recalls the harrowing of hell, which left the gates of Limbo open (8.124-126). This reminiscence guides the reader's interpretation of the Furies' ensuing cry: "Poorly did we avenge the assault of Theseus!" (9.54).[56] Since the classical Theseus's living descent into hell was by most accounts disastrous—he had to be rescued by Hercules—the Furies must be thinking of Christ-Theseus here. The crisis is averted by another messenger from heaven who opens the way to the terrible city (9.79-100). As Christ-Theseus came to save the just in Limbo, so his messenger now ensures Dante's rather different passage to salvation through lower hell; without Christ's first trip, of course, neither one exit nor the other would be possible.

The idea of the labyrinth with its narrow paths, turnings, circles, bewilderment, retracings, and deceitful arts provides a kind of ground bass

54. See, e.g., Guido da Pisa, *Expositiones et glose super Comediam Dantis*, ed. Vincenzo Cioffari (Albany: SUNY Press, 1974), pp. 222-223. See also Giorgio Padoan, "Teseo 'figura Redemptoris' e il cristianesimo di Stazio," in *Pio Enea*, pp. 125-150, reprinted from *Lettere Italiane*, 11 (1959), 432-457, which considers other roots of the Christ-Theseus tradition (most notably, a commentary on Statius's *Thebaid* attributed to Fulgentius) and covers the same territory in the *Inferno* as I do from a complementary point of view (pp. 147-150). Musa, *Advent at the Gates*, pp. 65-84, discusses the Messo's coming as almost a dumb-show of the advent of Christ, in parallel to Christ's coming to the hearts of the elect in *Purgatorio* 8; and Iannucci comments on the originality of Dante's treatment of the harrowing throughout the *Inferno* in "Beatrice in Limbo."

For a complementary analysis of Hercules as a pagan Christ-figure in the Inferno, see Clarence H. Miller, "Hercules and His Labors as Allegories of Christ and His Victory over Sin in Dante's *Inferno*," *Quaderni d'italianistica*, 5 (1984), 1-17. Just as Hercules and Theseus are seen as liberators in the *Aeneid*, so too they are figures of Christ in the *Comedy*.

55. According to some theories of the atonement Christ was able to harrow hell because, in terms of the Cretan myth, he carried a ball of pitch (humanity, which allowed him into hell) and a ball of thread (divinity, which let him escape). See chaps. 5 and 6 above.

56. On variant readings of this line, see Musa, *Advent*, p. 150, n. 9.

to the next two cantos, which touch on heresy (traditionally linked with the labyrinth) and the circular groundplan of hell, mapped verbally by Virgil's description.[57] Then Theseus is mentioned again: to enrage and distract the Minotaur, Virgil cries, "Perhaps you believe that here is the Duke of Athens, who dealt you your death up in the world. Get you gone, beast, for this man does not come tutored by your sister" (12.16-20). The title "Duke of Athens" properly belongs to Theseus after his destruction of the Minotaur and solution of the labyrinth; it connotes the wise, just ruler come into his kingdom, like Christ after the resurrection. Moreover, pseudo-Bernard Silvester's interpretation of Theseus, which Dante may have known, points the parallels between Christ and Theseus: the name derives from *theos*, or God, and *eu*, good, and Theseus himself is "partly human, partly divine."[58] Presumably, then, we are again to see through Theseus to Christ, who overcame the Minotaur of hell with the pitch of humanity and the thread of divinity supplied by another guiding lady, Mary. Double-natured good—the Christ who later will appear in the earthly paradise as the double Griffin, "the animal that is one person in two natures" (*Purg.* 31.81)—defeats double-natured evil, the beastly hybrids who run hell. As if to underline the christological overtones, Dante frames the episode with references to the ruins of hell, as we have seen, and Virgil immediately explains that the "ruins" offering "some passage to anyone above," through which he and Dante now pass, were caused by the earthquake at Christ's death, when "the deep valley trembled so on all sides that I thought the universe felt love, whereby, as some believe, the world has many times been turned to chaos" (*Inf.* 12.4, 9, 40-43). As Theseus destroyed the power of the labyrinth, so Christ ruined hell's power to hold the just; as Pasiphae's perverse passion for the bull, symbolizing the misdirected love of the unrepentant who end in hell, occasioned the building of the confused labyrinth, so the good love of Christ was the confusion of hell and opened many ways to paradise (cf. *Para.* 7.103-110).[59] Christ-Theseus

57. See 10.1-3, 4-5, 31, 51, 58-59, 95-96, 113-114, 121-122, 125, 133; 11.1-3, 9, 17, 28-30, 76-78, 93-96, 109. In *Inferno* 10, the setting is among tombs, and one recalls that ancient labyrinths were also tombs.

58. J&J, pp. 56 and 88. Dante's reading of the *Aeneid* in the *Convivio* may have been influenced by pseudo-Bernard's, directly or indirectly: see Giorgio Padoan, "Tradizione e fortuna del commento all'*Eneide* di Bernardo Silvestre," *Pio Enea*, pp. 207-222, reprinted from *Italia Medioevale e Umanistica*, 3 (1960), 227-240 (here, pp. 221-222 and n. 60, giving bibliography on the subject). However, I agree with Hollander that Dante's extraordinarily perceptive reading of the *Aeneid* as reflected in the *Comedy* was not seriously dependent on medieval interpretations: see Hollander, "Dante Theologus-Poeta," p. 131 n. 69, and "Dante's Use of Virgil," p. 156 and n. 17.

59. It is presumably part of the same christological parallel that the breaking down of hell is followed by a description of "the river of blood . . . in which boils everyone who by violence injures others" (*Inf.* 12.47-48): as the Minotaur is a perverse parody of the dual Christ, so this infernal river parodies the redeeming river of Christ's blood on the cross.

thus makes it possible for men to help themselves achieve salvation by choosing one of these right paths: for Dante, it will be a path that first leads through hell.

If Christ-Theseus made salvation possible historically, however, Dante pays more attention to the Minotaur's sister Ariadne, without whom the Athenian Theseus could never have escaped the maze. The mythical Ariadne is a pitiable creature who loves and saves a handsome visitor only to be jilted by the cad, and in such guise Ariadne appears in most classical and medieval literature, thanks, no doubt, to Ovid's sentimental *Heroides* 10.[60] Dante reads and adapts the myth in a far nobler light: Ariadne's role is played chiefly by Beatrice, whose loving cords, footsteps, and counsel lead Dante from all threatening labyrinths. Direct references to Ariadne in the poem stress her wisdom (*Inf.* 12.20) and her transcendence: the dance of the wise men in the Heaven of the Sun echoes the form of her celestial *corona* (*Para.* 13.1-30) and sings "not Bacchus," like the classical Ariadne on Naxos, "but Three Persons in the divine nature, and it and the human nature in one Person," the essential Christian paradoxes. Invaluable in teaching Theseus how to slay the double Minotaur in Crete (*Inf.* 12), Ariadne now is linked with the double Christ, and the ordered heavenly dance—labyrinthine in its double circlings, like the choral labyrinth-dance of Victorinus—is in striking contrast to the aimless leapings of the Minotaur in his clumsy *saltarello*. The glorious dance in paradise, circling the head of Beatrice-Sapientia,[61] makes clear just what kind of Ariadne errant men really need to guide them from the maze: loving wisdom.

We have already seen how, in the earthly paradise, Beatrice unravels the labyrinth of Dante's conscience with the thread of insightful questioning just as she guided his steps in the earthly labyrinth until he abandoned her for other ladies. Beatrice's good love, like Ariadne's the antithesis of Pasiphae's perverse lust, exceeds the Cretan princess' love because it is eternal and unchanging, however fickle Dante, like the *Heroides'* treacherous Theseus, may prove. Even after his desertion, Beatrice deigns "to leave in hell [her] footprints" (*Para.* 31.81): this Christian

Guido da Pisa comments on the parallels between Theseus's "ruin" of the Minotaur and liberation of the Athenians and Simeon's prophecy that Christ will ruin some and resurrect others in Israel (Luke 2:34): *Expositiones*, pp. 222-223.

As early as *Inferno* 1.18, in which the sun "leads men aright by every path," the idea that Christ reveals *many* ways to salvation is expressed; the image suggests a multicursal labyrinth.

60. Boccaccio takes a very different view of Ariadne in the *De genealogia*: see chap. 6 above. Botterill argues that Dante relied heavily on *Heroides* 10 in the Minotaur episode: "The Form of Dante's Minotaur," 64-65.

61. *Paradiso* 10.92-93 shows that the dance circles Beatrice as well as Dante. Jefferson B. Fletcher's chapter on Ariadne's crown (*The Symbolism of the Divine Comedy* [1921; repr. New York: AMS Press, 1966], pp. 1-113) emphasizes the importance of the image but says almost nothing about Ariadne.

Ariadne enters the maze that the Cretan princess merely described.[62] To lead Dante the better, she provides a thread of good counsel in the form of the guiding Virgil, and presumably it is she who influences his other helpers and guides, from the compliant monsters of hell— Geryon, Antaeus—to the angelic *messo* and Lucy herself; as Dante acknowledges, "It is you who have drawn me from bondage into liberty by all those paths" (*Para.* 31.85-86). Christ-Theseus may open the paths, but Beatrice-Ariadne sees to it that they are followed. Although many cords incline Dante to God, those that have most truly captured him are Beatrice's eyes (26.49-51; 28.11-12). Her discourse in the earthly paradise and in heaven provides the thread that guides him to knowledge of himself and God; she and her assistants chart many labyrinths and untie most of the intellectual knots that beset the poet.[63] To ensure his escape from sin and worldliness, she augments Ariadne's guidance with Daedalian wings, accompanying Dante on his flight through paradise and guiding his wings (25.49-50). Whatever Beatrice may signify— revelation, sanctifying grace, good love, wisdom—she *acts* as Ariadne, the force that frees the individual soul from labyrinths *in malo* once the work of Christ-Theseus has opened the way in principle.[64]

The importance of the Ariadne theme in the poem finds surprising support in one of Dante's strangest fancies: that Rahab was the first person Christ rescued in the harrowing of hell. Rahab, a harlot justified by faith, is the closest biblical analogue to Ariadne: just after the death of Moses, when Joshua was leading his people from the Exodus into the promised land, Rahab helped Joshua's spies escape the hostile city of Jericho by means of a cord—the very cord that, later, helps her escape the city's destruction.[65] If Rahab is a kind of Ariadne, so her city is perhaps the closest thing to a labyrinth in the Old Testament: impenetrable and inextricable (Joshua 6:1), Jericho had to be encircled seven

62. In this respect, Beatrice also serves as a kind of Theseus: see Iannucci, "Beatrice in Limbo."

63. Other important cords or threads in the poem include Dante's cord that, knotted and coiled, attracts Geryon (*Inf.* 16.106–111); its counterpart, the reed-girdle of humility that permits entry to purgatory (*Purg.* 1.94–95; cf. *Para.* 11.87); and the cord of love that whips envy (*Purg.* 13.39). All these cords provide safe passage through difficulty and contribute to the labyrinthine patterns of the *Comedy*. Singleton sees the cord of *Inferno* 16, with which Dante had hoped to capture the *lonza*, as self-reliance, whose casting away is a step towards humility ("In Exitu," p. 121). This interpretation accords with a labyrinthine reading in that a self-made guiding thread through an unknown maze is necessarily inferior to the thread offered by a guide like Beatrice. See also Damon, "Geryon, Cacciaguida, and the Y of Pythagoras," which links the cords with safe passage.

64. Saint Peter, too, may have played Ariadne's role: in *Paradiso* 24.63, Dante addresses him as one who, with Paul, "mise teco Roma nel buon filo." Singleton translates this as "put Rome on the good path," or "brought Rome into the right line," but might it not also be read "led Rome along the good thread"? If so, Peter and Paul, by their writings and guidance, were Ariadnes to a church and people that later, as Petrarch complains, fell into other labyrinths.

65. See Joshua 2:1–21 and 6: passim; Hebrews 11:31; James 2:25.

times (the number of circuits of the most ancient labyrinths) by the children of Israel, after which its walls fell down. Presumably it is for these reasons that the city was often depicted as a seven-walled labyrinth in medieval manuscript illuminations, and its name given to the occasional labyrinth (see Chapter 5). According to Dante, this Old Testament Ariadne was the first soul Christ-Theseus freed—presumably from Limbo with its seven-walled castle (*Para.* 9.115-120). Dante's surprising alteration of the established tradition that Adam was the first person liberated from hell[66] points to the prominence of the Ariadne motif in the *Comedy*: those who save others from labyrinths are, in the Christian scheme of things, the first to be rescued themselves by Christ-Theseus in a benevolent variation on the *contrapasso* principle. It is probably significant that as Theseus and the *messo* appear in *Inferno* 9, with echoes of the harrowing, and as Lucy and the guardian angel facilitate Dante's entry into purgatory proper in *Purgatorio* 9, so Rahab's escape from Limbo is described in *Paradiso* 9; as so often happens in the *Comedy*, Dante creates structural parallels, alluding to similar events in like-numbered cantos. It is presumably significant that these "escapes" leading ultimately to Heaven appear in cantos numbered *nine*, the number of Beatrice-Ariadne.[67]

If Rahab was the first Ariadne, Beatrice is not the ultimate Ariadne: her work as agent of Dante's redemption was initiated by Mary's compassion for Dante and mediated by Lucy (*Inf.* 2.94-120). Even in the *Purgatorio* Mary extends a guiding thread that is none of Beatrice's doing: the references on each terrace to Mary as incarnation of each virtue that remedies sin. She is both a continuing guide to right conduct and the means that historically "opened the roads between Heaven and earth" (*Para.* 23.38); as mother of Christ-Theseus, she supplied the ball of pitch that helped conquer the Minotaur; she made it possible for that "good way," and all other good ways, to be taken (23.75).[68] Beatrice cannot carry Dante all the way, nor can Saint Bernard, and finally it is Mary who prepares Dante for the vision of God (32.85-87), who gives the best wings (33.15), and who can keep him on the right path once he returns to the labyrinth of this world (33.34-37).

Thus the Cretan cast provides characters to inhabit the *Comedy*'s labyrinths and, more significantly, roles to be played and transfigured:

66. See Iannucci, "Beatrice in Limbo," p. 27.

67. On Beatrice as a nine, see the *Vita nuova*, chap. 29. For other instances of parallelism in the *Comedy*, see L. Ryan, "Ulysses," 238 and 242; Musa, *Advent*, chaps. 4 and 5; and Rossi, "'A l'ultimo suo,'" 64–65. On Cantos 9–10, see also Kenelm Foster, "The Celebration of Order: *Paradiso* X," *Dante Studies*, 90 (1972), 109–124.

68. If Mary and Ariadne are related in function as guides through labyrinths, Pasiphae and Mary are antitypes: both participated in unnatural matings and produced double-natured offspring, but Mary's good love generated Christ, who rules in heaven, whereas Pasiphae's perverted love produced the Minotaur, a ruler of hell: cf. *Purgatorio* 17.91–105 on erring love for the wrong object as the root of all evil.

Christian mazes and their makers, treaders, guides, and residents are necessarily unlike pagan ones. Dante splits Virgil's Minos of Crete in two: the infernal Minos administers justice in the prison-labyrinth of hell and resembles the monster for whom he ordered the Cretan labyrinth built, and the truly omnipotent judge in heaven, foreshadowed by the Cretan law-giver, himself maintains an impenetrable labyrinth of justice. The dual Minotaur, prisoner and guard, aptly tends the inextricable maze of hell that was once raided by the double-natured Christ. Daedalus's wings and arts bear men into labyrinths as well as out of them, and his compasses, wielded by God, describe the circles of all creation. Theseus and Ariadne, purged of unattractive traits, are reenacted, even fulfilled, by paradisal players who rescue others from spiritual prisons with whatever guiding threads are most sorely needed.

The story and cast of the Cretan myth, important in the *Aeneid* and implicit in Boethius's *Consolation*, may well have served Dante as suggestive analogues to the psychodrama of damnation, conversion, and salvation that constitutes his subject. Even the poet himself, as pilgrim or as author, plays virtually every role in the legend at some point. Like Minos, Dante the poet assigns real people to places in hell, thereby partaking of the wrath of Minos and the Minotaur. The crafter of a poem as brilliantly articulated and as full of structural complexity and symmetry as the greatest ancient labyrinth, Dante the writer mimics Daedalian artistry.[69] Dante the pilgrim flies with Daedalian wings through paradise, yet comes perilously close to a fall like Icarus's (*Purg.* 31.58-60). Like the mythical Theseus, the pilgrim treads and escapes labyrinths, dances to celebrate his escape, and abandons his best guide. In simile, he even becomes Theseus's son Hippolytus (*Para.* 17.46-48). But as poet his most important role, finally, is Ariadne's: his text, recounting how one exemplary pilgrim is led through the labyrinths of this world and the next, is itself a thread to guide those who otherwise "would remain astray" (*Para.* 2.6), like the pilgrim himself at the start. As in the *Consolation*, poetry can sometimes fly higher and offer sweeter incentive than human reason.

As Freccero so aptly puts it, Dante did indeed specialize in "the poetics

69. On cyclical and repeated structures, see, inter alia, Singleton, *Dante's Commedia: Elements of Structure* (Baltimore: Johns Hopkins Press, 1977), originally published as *Dante Studies I: "Commedia": Elements of Structure*" (Cambridge: Harvard University Press, 1954), pp. 3–5 and 34–44; and, on numerical and concentric structures, Singleton, "The Poet's Number at the Center," *MLN*, 80 (1965), 1–10.

For an excellent discussion of concentric structure in the *Paradiso*, see Victor Castellani, "Heliocentricity in the Structure of Dante's *Paradise*," *SP*, 78 (1981), 211–223. Much more could be said about concentric and bracketed structures in the *Commedia* as a whole.

For the *Comedy* as "an analogue to God's way of building," see Singleton, *Elements of Structure*, p. 48.

The *Comedy* is also labyrinthine in that it follows a kind of artificial order, at least in regard to Dante's own life.

of conversion." As I have tried to demonstrate, the poetics of conversion coincides with the poetics of the convertible labyrinth, whose structure, implications, and myth significantly inform the *Comedy* and its assumptions, providing a continuing mythical pattern that supplements and supports the dominant Exodus pattern. If "ascending and circling this mountain . . . makes you straight whom the world made crooked," it is precisely the circuitousness of the labyrinth's path to a goal that provides the best model for Dante's fictional pilgrimage: there is no straight path up the mountain, although, as Boethius shows, Daedalian wings may eventually supplant the laborious tracing of roundabout mazes and offer a privileged, though not perfect, perspective on the labyrinths of this world. In the *Comedy*, the path to that grand, if still limited, overview runs sequentially through the labyrinths of the next world, which permit increasing vision and freedom of movement along the way. Dante shows just what labyrinths lie at the end of the varied paths through the probationary multicursal labyrinth of this world: the inextricable prison-labyrinth of hell, the purifying unicursal labyrinth of purgatory, and their perfect pattern, the celebratory wheelings and carolings of the cosmos and the elect, where the universe turns inside out in a moment of transcendent vision, revealing God as center, circumference, and, in some respects at least, impenetrable maze. The labyrinth's inherent convertibility would naturally have appealed to the poet of conversion whose heaven is mystically expressed in astonishing shape-shifting images: the dance of the wise that is also a crown and a garland; the souls like a flock of birds in the heaven of Jupiter who shape various letters, a phrase, an *M*, a lily, and an eagle woven of soul-gems that are also like flowers; the amphitheater of the elect that is also a yellow rose, a city, and a white rose; the book that is three circles somehow containing the human image. This last shifting image of the Trinity is also an image of Dante's book itself—a labyrinth of words and a guiding text, its three spiritual worlds filled with men, its words and the images they evoke serving as a thread to lead Everyman through painful labyrinths to the highest, most joyous, and most aesthetically pleasing labyrinth of all.

Chaucer's *House of Fame*

Tho saugh y stonde in a valeye,
Under the castel, faste by,
An hous, that Domus Dedaly,
That Laboryntus cleped ys,
Nas mad so wonderlych, ywis,
Ne half so queyntelych ywrought.
And ever mo, as swyft as thought,
This queynte hous aboute wente,
That never mo hyt stille stente.

Chaucer, *The House of Fame*, 1918–1926

THIS book has examined many examples of labyrinthine lit-
erature: works that discuss labyrinths, explore their meta-
phorical potential, use them as central images, or entail a
labyrinthine experience by hero, narrator, and reader. We have seen
how three masterpieces—Virgil's *Aeneid*, Boethius's *Consolation of Philoso-
phy*, and Dante's *Divine Comedy*—represent a self-consciously continuous
expression of the idea of the labyrinth in western literature. Chaucer's
House of Fame is slighter than its three self-avowed labyrinthine models,
but this sparkling tour de force may be the most comprehensive (if not
comprehensible) and creative culmination imaginable of the medieval
labyrinth tradition, and hence a fitting conclusion to this book.[1]

1. I continue to cite the Riverside Chaucer; *The House of Fame* (*HF*) is edited by John M.
Fyler, whose notes list most studies that have appeared in the past twenty or so years, when
the work has finally been taken as seriously as it deserves, although it still remains a kind of
cult classic. There are also numerous useful Chaucer bibliographies, two recent selective
examples being John Leyerle and Anne Quick, *Chaucer: A Bibliographical Introduction*,
Toronto Medieval Bibliographies 10 (Toronto: University of Toronto Press, 1986), and
Mark Allen and John H. Fisher, *The Essential Chaucer: An Annotated Bibliography of Major
Modern Studies* (Boston: G. K. Hall, 1987).
Since these bibliographies and others are easily available, and since my own labyrinthine
reading of the poem, first conceived in 1969, has developed independently of other sec-
ondary studies, my bibliographical notes generally mention works that provide useful
background or important alternative views on specific topics, works actually quoted, stud-

Chaucer probably knew both visual and verbal labyrinth traditions well. Even before he wrote *The House of Fame* (ca. 1378–1380), he had had many opportunities to become familiar not only with the unicursal diagrammatic labyrinth design but also with its extensive metaphorical significance. He seems to have known medieval English turf-mazes: glossing the Cretan labyrinth in the *Legend of Ariadne*, he notes, "For it is shapen as the mase is wrought" (*LGW* 2014), apparently assuming that his audience would be familiar with these indigenous secular labyrinths so often linked with Troy and Julian. His interest in Gothic architecture is reflected in *The House of Fame* and in his eventual appointment as Clerk of the Works at Westminster; a man of such sensibilities would have seized the chance to visit French cathedrals and their labyrinths, and when he did he might well have learned about their associations with the art and fame of the architect (at Reims, for instance) or with the *rota-rosa* of fortune and providence and the guiding footsteps of Christ-Theseus (at Chartres). Chaucer traveled to northern Italy two or three times, and the translator of Boethius's *Consolation* would surely have made a pilgrimage to Pavia, where Boethius died and where San Michele Maggiore boasts a pavement maze. Nearby is Piacenza, with another labyrinth whose moralistic inscription identifies the Cretan maze as the world, in which sinners return to true doctrine with the greatest difficulty. And on the way from Genoa to Florence, Chaucer might have visited the cathedral at Lucca, with its labyrinth relief and its purely explanatory gloss ("This is the Cretan labyrinth, built by Daedalus, which no one who entered could leave except for Theseus, aided by Ariadne's thread").[2]

He had studied important literary labyrinth texts, too, some of them possibly illustrated with illuminations of the maze. He knew the *Aeneid* and the *Consolation*, as well as some commentaries;[3] perhaps his readings

ies to which I am specifically indebted, and important parallel studies. With a few exceptions, I do not note incidental agreement or disagreement with other scholars, lest this chapter grow as alarmingly as Fame herself.

2. See Kern, plates 239–241, p. 243, and plates 233–244. Unlike most French labyrinths, these Italian examples include Theseus and the Minotaur and explanatory texts.

For Chaucer's career and travels, see *The Riverside Chaucer*, Martin M. Crow and Virginia E. Leland, "Chaucer's Life" (pp. xv–xxvi); and Donald R. Howard, *Chaucer: His Life, His Works, His World* (New York: E. P. Dutton, 1987). Chaucer might have seen Reims and Chartres as early as 1360 (*Riverside Chaucer*, p. xvii); he was probably in Pavia as well as Milan in 1368 and 1378 and might have gone to Lucca in 1373 (Howard, pp. 118, 179–180, 226–229).

3. For Chaucer's knowledge of Boethian commentaries, see chap. 7, n. 49, above; for his probable knowledge of Virgil commentaries, see Baswell, "Figures of Olde Werk," chaps. 4 and 5. Baswell's learned and perceptive study of *HF* is one of the highlights of scholarship on the poem, and I do not say that merely because Baswell's study and mine come independently to similar and mutually supportive conclusions, namely, that *HF* leans heavily on the parodic recapitulation of Virgilian and Boethian (and, I would add, Dantean) patterns, making the point that Geoffrey (and, I would add, Everyman) cannot achieve transcendent wisdom. My own study differs from Baswell's in my emphasis on

of these works, and of the *Divine Comedy*, corresponded in some degree to the labyrinthine readings I have just offered. Ovid's *Metamorphoses*, another treasury of labyrinth lore, is called Geoffrey's "oune bok" in *The House of Fame* (712), and Chaucer based his *Legend of Good Women* on the *Heroides*, with its complaint of Ariadne. Chaucer's direct knowledge of the historical-geographical tradition of Pliny is less certain, but Pliny was well-known in England, and it seems likely that the *Natural History* reinforced Chaucer's association of labyrinths with fame, elaborate architectural artistry, noisiness, and inexplicability; it may also have alerted Chaucer to the discrepancy between diagrammatic and three-dimensional labyrinths, a discrepancy that may inform *The House of Fame*. Among mythographical works, Chaucer was familiar at least with Bersuire and the *Ovide moralisé*; and what is intriguing in this context is the secularity of his use of the labyrinth, his avoidance of traditional moralistic interpretations.[4] The Song of Troilus (*Troilus and Criseyde* I.400–420) translates Petrarch's Sonnet 88; did Chaucer also know the labyrinths of Sonnets 211 and 224? or the *Liber sine nomine*'s identification of Avignon, so like the meretricious world of Fame, as the fifth labyrinth of the world? Did he know the *Corbaccio*? Or the many works linking labyrinths with literature, with complex language, with logic? Did he ponder the labyrinth's ambiguous etymology, *labor intus*? Even if he did not, Chaucer could have gleaned enough about the medieval idea of the labyrinth from works he mentions in *The House of Fame* alone to weave his own elaborate variations on the theme, ingeniously blending literary, intellectual, metaphorical, visual, and popular labyrinth traditions.

Many readers have sensed the poem's labyrinthine qualities: for instance, A. C. Spearing notes its "bewildering uncertainty of direction," Alfred David its "planned chaos" (a perfect definition of a maze), B. G. Koonce its "air of deliberate obscurity," and Robert Burlin that "the poem is all process, and we can only speculate on the ultimate goal."[5] Such comments reflect the labyrinth's intentional confusion and complexity, its disorienting turnings back and forth, its paradoxical in-

particularly *labyrinthine* patterns and images, in and out of Virgil, Boethius, and Dante; in a greater stress on the poem's epistemological implications; and in a greater focus on the work's enunciation of a labyrinthine poetic. Nevertheless, I have learned more from Baswell's work on the poem than from all other studies combined.

4. For Chaucer's knowledge of Bersuire's *Ovidius moralizatus* and of the *Ovide moralisé*, see the many references cited in Lynn King Morris, *Chaucer Source and Analogue Criticism* (New York: Garland, 1985).

5. A. C. Spearing, *Medieval Dream Poetry* (Cambridge: Cambridge University Press, 1976), p. 76; Alfred David, "Literary Satire in *The House of Fame*," *PMLA*, 75 (1960), 333–339 (here, 333); B. G. Koonce, *Chaucer and the Tradition of Fame*, p. 3; and Robert B. Burlin, *Chaucerian Fiction* (Princeton: Princeton University Press, 1977), p. 52. These examples could be greatly augmented from recent scholarship.

corporation of order and disorder, its emphasis on process rather than product, on path rather than pattern. A few readers—Donald R. Howard and, most recently, Piero Boitani—have noticed the particular importance of the House of Rumor as "Domus Dedaly."[6] But the full extent of Chaucer's use of the idea of the labyrinth remains unexplored.

It is generally agreed that *The House of Fame* is an eclectic, complicated, thoroughly engaging dream vision featuring a comic authorial self-portrait and a bizarre cosmic journey. But to what end, and with what coherence? Is it "Daunte in Inglissh," a rewriting of the *Divine Comedy*, as Chaucer's follower Lydgate seems to imply? Is it a thoughtful yet light-hearted commentary on the *Aeneid* and the *Consolation*, as Christopher Baswell argues? Is it a serious philosophical expression of "skeptical fideism," as Sheila Delany proposes? Or, despite its disavowal of "art poetical," is it an art of poetry, a book about literature and language and the writer's relationship to his authoritative predecessors and his craft?[7] I believe that the poem contains all these elements in varying degrees and that they, and other themes, are explored, expressed, and unified through the controlling image of the labyrinth, which becomes the

6. Howard, *The Idea of the Canterbury Tales*, pp. 330–332, and "Chaucer's Idea of an Idea," *Essays and Studies 1976*, n.s. 29, 39–55; Piero Boitani, *Chaucer and the Imaginary World of Fame*, Chaucer Studies 10 (Cambridge: D. S. Brewer, and Totowa, N.J.: Barnes & Noble, 1984), chap. 6. There are inevitably a few parallels between Boitani's and my development of the idea of the labyrinth: e.g., we agree that the confusion of *signa sequendi* is an important theme, that the labyrinthine nature of the House of Rumor is crucial, and that Daedalus is in some ways a figure for the poet; but we treat these topics in different ways. In general I see a far greater importance for the labyrinth as image, structure, and theme throughout the whole poem, and finally there is little overlap between our discussions: Boitani, after all, is focusing on Fame, and I on labyrinths.

7. See Lydgate, *The Fall of Princes*, Prologue, 303; Baswell, "Figures of Olde Werk," chap. 5; Sheila Delany, *Chaucer's House of Fame: The Poetics of Skeptical Fideism* (Chicago: University of Chicago Press, 1972). Most recent studies see *HF* as in some way an art of poetry and/or treatise on language: see, e.g., J. A. W. Bennett, *Chaucer's Book of Fame: An Exposition of "The House of Fame"* (Oxford: Clarendon Press, 1968); Boitani, *Imaginary World of Fame*, chaps. 5 and 6; Joseph A. Dane, "Chaucer's *House of Fame* and the *Rota Virgilii*," *Classical and Modern Literature*, 1 (1980), 57–75; Joerg D. Fichte, *Chaucer's "Art Poetical": A Study in Chaucerian Poetics* (Tübingen: Gunter Narr Verlag, 1980), chap. 4; Jesse M. Gellrich, *The Idea of the Book in the Middle Ages*, chap. 5; Martin Irvine, "Medieval Grammatical Theory and Chaucer's *House of Fame*," *Speculum*, 60 (1985), 850–876; Robert M. Jordan, *Chaucer's Poetics and the Modern Reader* (Berkeley: University of California Press, 1987), pp. 22–50; P. M. Kean, *Chaucer and the Making of English Poetry: Love Vision and Debate* (London: Routledge & Kegan Paul, 1972), pp. 86–111; Jacqueline T. Miller, *Poetic License: Authority and Authorship in Medieval and Renaissance Contexts* (New York: Oxford University Press, 1986), chap. 2; Geoffrey T. Shepherd, "Make Believe: Chaucer's Rationale of Story-telling in *The House of Fame*," in *J. R. R. Tolkien, Scholar and Storyteller: Essays in Memoriam*, ed. Mary Salu and Robert T. Farrell (Ithaca: Cornell University Press, 1979), pp. 204–220; Laurence K. Shook, "*The House of Fame*," in *Companion to Chaucer Studies*, ed. Beryl Rowland, rev. ed. (New York: Oxford University Press, 1979), pp. 414–427; Spearing, *Medieval Dream Poetry*, pp. 73–89; David Wallace, *Chaucer and the Early Writings of Boccaccio*, Chaucer Studies 12 (Woodbridge, Suffolk: D. S. Brewer, 1985), chap. 1; James Winny, *Chaucer's Dream Poems* (London: Chatto & Windus, 1973), pp. 76–112.

work's iconographic center and a *signum sequendi* through the poem's complexities. Labyrinthine characters, though far less important than in the *Comedy*, are mentioned throughout *The House of Fame* as a teasing clue: Theseus and Ariadne in Book 1, Daedalus and Icarus in Book 2, and Daedalus and Perdix in Book 3. Labyrinthine places and images recur continually: Geoffrey goes nowhere that is *not* in some way labyrinthine. Authors of labyrinthine works—Virgil, Ovid, Boethius, Dante—are named, quoted, and imitated. And the subjective labyrinthine experience, the frustrating and disorienting path of ignorance, consistently afflicts both the reader and the dreamer-narrator Geoffrey.

Certainly *The House of Fame* is a commentary on its labyrinthine models, the *Aeneid*, the *Consolation*, and the *Comedy*.[8] It shares with them its general story line: the protagonist's attempt to pass safely through the *errores* and *labores* of a bewildering series of metaphorical labyrinths in order to transcend confusion and doubt by attaining the privileged perspective that brings certain and stable understanding of the divine plan and its justice. Chaucer also develops traditional labyrinthine themes found in his predecessors, from the significance of fame to the epistemological limitations imposed jointly by the human mind in its comparative incapacity and by the *ambages* and deceptive *signa sequendi* of the worldly labyrinth. But *The House of Fame* involves imitation with differences so great that they amount to a radical shift in perspective, and Chaucer's poem becomes a serious parody, if not a perversion, of its predecessors: it humorously and lovingly retraces some of the paths they defined in order to show that these paths break down and finally become impassable, at least for Geoffrey.[9] One major difference is the tone of *The House*

8. For mention by name, see, e.g., 378–379 (Virgil and Ovid), 449–450 (Virgil and Dante), 972 (Boethius). Ovid and Virgil reappear in the House of Fame, but Boethius and Dante do not.

Quotations, allusions, and imitations of the works of these authors in *HF* are too numerous to list here. For Chaucer's use of these authors in *HF*, and different interpretations of the allusions, see, e.g., Baswell, "Figures of Olde Werk," chap. 5 (Baswell discounts Dantean parallels—see esp. pp. 312–313); Bennett, *Chaucer's Book of Fame*; Boitani, *The Imaginary World of Fame*, and "What Dante Meant to Chaucer," pp. 115–139 in *Chaucer and the Italian Trecento*, ed. Boitani (Cambridge: Cambridge University Press, 1983); John M. Fyler, *Chaucer and Ovid* (New Haven: Yale University Press, 1979), chap. 2; Gellrich, *The Idea of the Book*, chap. 5; Louis Brewer Hall, "Chaucer and the Dido-and-Aeneas Story," *MS*, 25 (1963), 148–159; William Joyner, "Parallel Journeys in Chaucer's *House of Fame*," *Papers on Language and Literature*, 12 (1976), 3–19; Koonce, *Chaucer and the Tradition of Fame* (which argues that *HF* is a close and serious imitation of Dante and which interprets parallels in a fashion I find often unconvincing); A. C. Spearing, *Medieval to Renaissance in English Poetry* (Cambridge: Cambridge University Press, 1985), pp. 22–29; John M. Steadman, "Chaucer's 'Desert of Libye,' Venus, and Jove," *MLN*, 76 (1961), 196–201; and Charles P. R. Tisdale, "*The House of Fame*: Virgilian Reason and Boethian Philosophy," *Comparative Literature*, 25 (1973), 247–261.

9. One could argue that each of Chaucer's models dominates one of the poem's books: Virgil and the *Aeneid* provide the labyrinthine story, and the labyrinths of love and of ambiguous texts, for Book 1; Boethius and the *Consolation* suggest the labyrinthine argu-

of Fame: its models treat metaphorical labyrinths with high seriousness and somber respect, but Chaucer's deceptively facetious poem veils its profound *sentence*—and it has a great deal of that—with the most playful *solas*. In keeping with this bright, comic approach to grave matters, *The House of Fame* shifts levels by turning its primary focus away from the moral tradition stressed by its models—the labyrinth is the world, in which choosing the right path is a matter of life and death—and highlighting instead the issues raised by labyrinths of *words*, of texts, of complex and sometimes misleading artistry: the labyrinth every writer and reader necessarily inhabits *as* writer and reader. Labyrinthine errors in *The House of Fame* are not moral but epistemological; they may ultimately have profound spiritual consequences, but Chaucer does not let us see them. This focus on a superficially unthreatening labyrinthine microcosm, however, should not blind us to the broader implications of Chaucer's errand into the maze: the poem speaks seriously, if obliquely, to denizens of the mundane maze, for the epistemological problems that beset the poet/reader as crafter/interpreter of labyrinths of words equally beset Everyman as treader of the world-labyrinth. Thus Chaucer covertly addresses some of the grand philosophical issues that preoccupied Virgil, Boethius, and Dante, but his focus on labyrinths of words means that *The House of Fame* overtly plays with the *Aeneid*, the *Consolation*, and the *Comedy* as texts, *auctorites*, and literary models. However deft its touch, then, *The House of Fame* means business, and it differs from its models in being far more pessimistic about the possibility of escaping any kind of labyrinth.

This pessimism emerges when the narrative patterns of Chaucer's models are compared with that of *The House of Fame*. The *Consolation* and the *Comedy* trace their protagonists' difficult passage through a variety of multicursal mazes: the confusions and choices and limited vision of a morally labyrinthine world, the ambiguities of prophecy, the bewildering complexity of labyrinths of words, the labyrinths of dialectic—Aristotle's labyrinth. But the heroes have careful guidance in these seemingly inextricable mazes of the literary tradition: they have the thread of good counsel and instructive argument and philosophical or spiritual wings for Daedalian flight. With these aids, they transcend many confining labyrinths, though not all of them; and they achieve a privileged—*and an accurate*—overview of the world, whose random confusion is revealed as

ments, the Daedalian flight, and the epistemological mazes of Book 2; and Dante and the *Comedy* figure more prominently in Book 3, whose hierarchy of writers in the House of Fame loosely resembles Dante's amphitheatrical hierarchy of the blessed and whose spinning House of Rumor parodies the wheels and rhapsodic spinning of the *Paradiso*. In each case, the point of the allusions is that his predecessors' path through and flight above the labyrinth, however limited, is no longer available. But since aspects of each work figure in each of Chaucer's books, one would not wish to place too much emphasis on such a schema.

the perfect physical and moral order of a divine architect. These heroes' perceptual framework shifts, with labyrinthine convertibility: what seemed inextricable when experienced from inside becomes a symmetrical, beautiful, teleological arrangement of concentric circles when seen from above, laid out like a diagrammatic cathedral maze. It is as if the three-dimensional literary model is supplanted and corrected by the two-dimensional visual model, which lets us see as God sees. Aeneas is less favored than Dante's and Boethius's narrators, and in this regard a closer model for Chaucer's alter ego Geoffrey: Aeneas's moments of accurate vision are few—the show of heroes in Hades, the future of Rome empaneled on his shield—and his understanding is imperfect. But even he is luckier than Geoffrey, for Geoffrey, though repeatedly promised a goal, new knowledge, and reward for his labors, escapes one maze only to land in another, with nary a moment of transcendent vision. The clarity implied by the diagrammatic visual model of the labyrinth is never achieved; there are no conversions from chaos to order, only the reverse. He may imitate his labyrinth-conquering predecessors all he likes, but all flights above the maze are aborted, and there is no access to transcendence—at least, not for Geoffrey, who will never know whether there is a pattern or, for that matter, an architect. More knowledge than this is impossible because we live—as people, as poets—in a world of ambiguity, duality, multiplicity, where there are no clear *signa sequendi* because texts, words, and perceptions are all made of "fals and soth compouned" (1029, 2108). And the best emblem of this sort of world with its inextricable mix of truth and falsehood? It is the inextricable three-dimensional multicursal labyrinth, which is also compounded of true and false paths. If we could rise above them to experience the change in perspective represented by the diagrammatic visual maze, then we could see a pattern and tell which path was true and which false. But although Chaucer's labyrinthine masters believe in the possibility of achieving that vision, however fleetingly, Chaucer does not: in this world there is only confusion and doubt. The functional inseparability of truth and falsehood caused by our imperfect perspective and perceptions is the central epistemological theme of *The House of Fame*, and it is explored through the vehicle of the labyrinth, which becomes an emblem of the limitations of knowledge in this world, where all we can finally do is meditate on *labor intus*. If this sounds profoundly depressing, oddly enough it is not; so let us follow Geoffrey, who is neither Boethius nor Dante, on his bewildering peregrinations through one disorienting labyrinth after another until he reaches the chaotic "domus Dedaly" (1920) in which the poem ends so anticlimactically.

Boethius's baffled narrator thought that verbal mazes, like visual ones, were places where "thow . . . entrist ther thow issist, and . . . issist ther

thow entrest." *The House of Fame* emulates this labyrinthine structure, for it begins and ends in labyrinths of words. The Proem is an intellectual maze inaugurated by a prayer—"God turne us every dreem to goode!" (1). That line hints at the labyrinths to come, for it suggests the endless turnings of mazes and indicates the need for supernatural guidance if one is to escape: if God can't turn things to good, no one can. After this cheerful yet faintly ominous beginning, the Proem plunges headlong into a minimaze of dream lore and terminology (2-52). I quote just a little to give the flavor:

> hyt is wonder, be the roode [cross],
> To my wyt, what causeth swevenes [dreams]
> Eyther on morwes [mornings] or on evenes [evenings],
> And why th'effect folweth of somme,
> And of somme hit shal never come;
> Why that is an avision
> And why this a revelacion,
> Why this a drem, why that a sweven,
> And noght to every man lyche even [the same];
> Why this a fantome, why these oracles,
> I not [don't know] (2-12)

The causes and kinds of dreams are catalogued in an extended *dubitatio* mimicking the repeated choices of a multicursal labyrinth as the reader is offered a series of randomly ordered options marked by "why . . . and" and "or . . . or." This turning back and forth from one alternative to another—is it this or that? this or that?—is the essence of the multicursal maze and induces labyrinthine confusion. Transcendent understanding of dream theory is anticipated but never delivered; Chaucer the poet enumerates the important options of medieval dream lore, but the narrator Geoffrey refuses to choose, leaving resolution of these dark questions to absent guides, "grete clerkys" (53), and he exits the maze of questions where he came in: may "the holy roode / Turne us every drem to goode!" (57-58). With these repeated lines, he returns us to the beginning of the maze without penetrating its mystery or tracing a true path among false alternatives.[10] Thus *The House of Fame* begins with a multicursal intellectual labyrinth leading nowhere.[11] The experience of the

10. Joyner ("Parallel Journeys") also notes the first two sets of echoing lines in the Proem and Invocation and suggests they delay Geoffrey's accomplishment of his mission just as Aeneas was delayed; however, he does not link this delay with the labyrinth, nor does he see how the pattern of repetition—of entering and leaving at the same point—continues throughout the poem.

11. And reminiscent of Boncompagno da Signa's labyrinths of prolixity and of definitions, Ralph Higden's paralyzingly labyrinthine profusion of data, and Aristotle's Labyrinth: see chap. 7 above.

Proem reflects in little the experience of the whole poem: wildly eclectic, its random order creating chaos, offering choices whose merit is impossible to determine. There are no reliable guides, for if "grete clerkys" created ambiguous and conflicting dream categories in the first place, they can hardly be trusted to resolve them. Thus the Proem exits where it entered and anticipates the whole poem's eventual closure—with another exit at point of entry—in a garrulous House of Daedalus as full of unreliable opinions as the Proem.

We move from dreams to two of their possible divine causes. The Invocation rings further changes on labyrinthine themes as the narrator who refused to choose in the intellectual maze of dream lore now selects two guides who evoke respectively Daedalus the crafter of lifelike moving statues and Daedalus the architect. Preoccupied with his own poetic making, Geoffrey calls first on the God of Sleep (he really means Morpheus, God of Dreams) to help him tell his dream properly, something this Daedalian artificer of deceptive fictions may not be best qualified to do if "properly" means "truly."[12] In any case, Geoffrey backtracks quickly: he has only read about this god (77) and suddenly wonders "*Yf* every drem stonde in his myght" (80, my italics). The reader's doubts, if not Geoffrey's, increase as the narrator appeals to God "that mover ys of al" (81). Although this cosmic *artifex* no doubt has the power to reward everyone who likes Geoffrey's dream and punish anyone who spitefully misinterprets it, as requested, Geoffrey has unwittingly raised a dangerous issue: if the interpretation of dreams is as dicey as the Proem suggests, so is the interpretation of dream poetry, and there are more serious modes of misinterpretation than those arising from hate, scorn, and envy. The Invocation thus carries us further into the realm of ambiguity; texts are as multiplicitous in meaning as dreams, and just as unreliable. The theme of erroneous interpretation, of misreading textual or visual *signa sequendi*, continues in Book 1, but structurally the Invocation, like the Proem, is neatly end-stopped, for it too is framed by a set of echoing lines giving the enigmatic date of the dream (63, 111). Again, the reader exits where he or she entered, as if a digression has been completed or as if two paths have circled back to the same point, raising new doubts but progressing no closer toward a center.

The narrative continues with another allusion to the need for escape: just before his dream, Geoffrey has made a pilgrimage to Saint Leonard, patron saint of prisoners, asking him to make "lythe" (easy) what is "hard" (118). It matters little what particular metaphorical prison Geof-

12. Ironically, despite his association with sleep, as shaper of indiscriminately true and false dreams Morpheus may well be the right tutelary spirit for this poem with its theme of the indistinguishability of truth and falsehood. On the relationship between Morpheus and Daedalus as artificers, and a structural implication for the poem, see Boitani, *Imaginary World of Fame*, p. 206.

frey has in mind: the point is that he, like Boethius, wants relief from difficult confinement, and therefore his waking world is a kind of prison, a labyrinth. If the dream is in fact Leonard's answer to Geoffrey's prayer, the reward for enduring a waking prison-labyrinth is yet more mazes, a frustrating pattern that recurs throughout the poem.

As the dream proper begins, Geoffrey is disoriented (128-129) inside a splendidly ornate temple of Venus whose walls are decorated with the story of the *Aeneid*. He has moved from a personal prison-maze to a labyrinth-text, though it doesn't seem like one at first. The presentation starts with deceptive simplicity: a reasonably literal translation of Virgil's opening lines (143-148), beginning "I wol now synge, yif I kan, / The armes and also the man." The content—a summary of Aeneas's history—gives a clear overview of the complicated story, and the verbatim citation sets up expectations that Virgil's text will be Geoffrey's guiding thread just as Virgil himself guided Dante in the *Comedy*. Moreover, the story is narrated succinctly and directly: Aeneas's circuitous *errores* are straightened out from Virgil's well-known artificial order to natural chronological order.[13] But as Dante's Virgil proved fallible in the long run, so too here with Virgil's text: simplicity becomes complexity, and the security of translation deteriorates into a serious questioning of Virgilian authority. Even the format of the story seems to shape-shift: what was written (142) turns into pictures (151, 162, 174) and speeches (189, 300).

If the murals start off straightforwardly, in apparent harmony with Aeneas's desire to head for Italy "as streight as that they myghte goo" (197), they—or at least Geoffrey's reception of them—wander off into turbulent and delaying digression just as Aeneas's course deviates into *errores*. Indeed, Geoffrey's passage through the story reenacts Aeneas's labyrinthine course in important ways—not least in his own disorientation, his tendency to be sidetracked by beautiful women, and his interest in poring over artistic recreations of history.[14] Like Aeneas, Geoffrey

13. Since most medieval retellings of the *Aeneid* likewise follow natural order, perhaps one should not make too much of it here; nevertheless, opting for natural order reinforces the movement from initial simplicity to great complexity in the narrative as presented by Chaucer. On artificial vs. natural order, see Baswell, "Figures of Olde Werk," pp. 231–232; Hall, "Chaucer and the Dido-and-Aeneas Story"; and Dane, "Chaucer's *House of Fame* and the *Rota Virgilii*," pp. 63–64.

14. Geoffrey's reenactment of Aeneas (and, for that matter, of Boethius) is discussed at length by Tisdale, Joyner, and especially Baswell. Tisdale ("Virgilian Reason") finds the poem's unity in Geoffrey's reenactment of "the moment of conscience that he has just seen Aeneas experience on Libyan shores" (p. 249): as Mercury goads Aeneas into performing his moral duty, so the Eagle, a Boethian stand-in for Mercury, carries Geoffrey off from his "moral lethargy" (p. 248), his misery in a "sterile life" (p. 256), to "a clear understanding of truth" (260). Joyner ("Parallel Journeys") suggests that the murals remind us of crucial events in Aeneas's life so we will recognize that Geoffrey's course from the desert until the end of the poem runs parallel to that of Aeneas: both men pursue "a divinely guided journey that goes temporarily astray" but eventually achieve "a successful conclusion" (p.

dallies and delays in Carthaginian labyrinths of love: luxuriating in sympa-
thy for Dido, he endorses—and partly invents (314)—her tirade against
the tricky amatory arts of men. The biased Geoffrey switches guides
in mid-poem as his sentimental amplification of Dido's woes leads
him down another passage of the textual maze of Roman quasi-history,
namely, Ovid's *Heroides* 7. He moves from the single track of his redac-
tion of Virgil into a multicursal textual conflation admitted openly in the
injunction to "rede Virgile in Eneydos / Or the Epistle of Ovyde" (378-
379). Thus Dido's labyrinth of love begets a labyrinth of conflicting texts
for Geoffrey, whose preference for Ovid's version with its maligning of
Aeneas the traitor leads to further piteous amplifications on the theme
of artful male deceit. The motif of difficult choice—in interpreting and
following texts, in deciding which is right and which wrong, Virgil's or
Ovid's version, this dream theory or that, this reading of Geoffrey's
dream or that—is extended into the practical moral realm: whose words
or deeds can a poor woman believe in the labyrinth of this world? Are
there reliable verbal and visual *signa sequendi* in art and in life, or are they
all as confused and misleading as the *signa* in Virgil's labyrinth?

Geoffrey's poem seems doomed to circle endlessly on its digressive,
repetitive path—to become an inextricable textual labyrinth—as one
deceitful lover after another is named. But finally the circling path is
shortcircuited by the poem's first explicit allusion to the labyrinth myth:
Theseus's betrayal of Ariadne (405-426), the longest encapsulated narra-
tive in these Ovidian digressions. The stories of ill-fated love and ama-
tory arts naturally culminate in the artful labyrinth built to conceal lust
and conquered through a deluded maiden's love. Geoffrey's Theseus,
like Dido's Aeneas, may be a cad, but as a solver of labyrinths he heralds
the narrative's escape from its Ovidian maze: as if following Theseus's
lead, Geoffrey abandons the miserable ladies of Ovid's book (425) to
return to Virgil's (429), marking this change in authorities, this exit at
point of entry, by the repetition of "book." Theseus has been a catalyst

4)—in Geoffrey's case, the hearing of love-tidings; thus "the parallelism between the jux-
taposed narratives is the key to the meaning of the poem" (p. 17), "the poet's journey from
ignorance to wisdom" (p. 18).

I find these readings unconvincing, largely because they completely ignore the humor—
indeed, the parodic spirit—of many of the imitations of Aeneas and Boethius. Moreover,
they assume that Geoffrey succeeds in imitating his predecessors, attaining wisdom and
virtue, whereas I would argue that the point of the parallels is precisely that Geoffrey—
and perhaps fourteenth-century Everyman—*cannot* follow where they lead: he can ex-
plore the same labyrinths, but he cannot transcend them and achieve wisdom. Baswell
agrees that the point of the numerous parallels he analyzes is parodic and suggests that
"witty and cynical doubt" is directed not at Virgil and Boethius but at Chaucer himself
("Figures of Olde Werk," p. 267), who via Geoffrey becomes an "inadequate contemporary
Aeneas . . . [and] Boethius" (p. 313) who finally "has learned nothing," leaving us where
we began, yearning for "truth and transcendence," with only "a model of search" (p.
324)—a *labyrinthine* model, I would add.

for Geoffrey, just as Mercury was in freeing Aeneas from Dido and Carthage—and it is with Mercury's intervention, his shortcircuiting of the labyrinth of love, that we rejoin the *Aeneid*.[15] Virgil is once again a unicursal guide and Aeneas a noble hero who reaches his goal, but their authority, their *truth*, have been undermined: the conflicting attitudes toward Aeneas have shown that interpretation depends on point of view, that there is no reliable guide to truth in history or in human relations. There are only competing paths and irresolvable choices in a multicursal maze.[16]

Having surveyed the doubtful story of Aeneas, Geoffrey remains puzzled and disoriented: he has seen marvels, "But not wot I whoo did hem wirche, / Ne where I am" (474-475). Dazzled, he wonders who crafted such artistry, but although he invokes the "Lord . . . that madest us" (470), the artificer God, he gets no response. If an answer exists, it must be multiple: Aeneas who performed these acts, Juno with her sleights and compassing (462) and Jupiter who shaped his course, Virgil and Ovid who recorded it, Geoffrey himself, the unknown temple architect, whatever caused Geoffrey's dream. . . . The making of art becomes an infinite labyrinthine regression.

Geoffrey leaves these labyrinths only to find himself in another one, at least by medieval standards: he enters a trackless desert with no landmarks or paths or guide (486-491), the labyrinthine desert of Ambrose, Gregory Thaumaturgus, the Arabs, and Boccaccio. He is reminded of Libya (488), where Aeneas was first cast ashore near Carthage: once again, Geoffrey follows in the steps of the Trojan hero (and once again *The House of Fame* traces a labyrinthine course by arriving where the *Aeneid* began just as it abandons the *Aeneid* as a subject). We pass from the confusing order of Venus's temple and Virgil's and Ovid's texts to the intolerable blankness of the silent desert—the desert in which Dante too found himself alone and helpless (*Inf.* 1).[17] Geoffrey is

15. Here too there is a parallel of sorts between Geoffrey and Aeneas: Aeneas gazed at the Cumaean panel of Theseus and the labyrinth until the Sibyl shamed him into constructive action; Geoffrey is similarly detained by myth, but he manages to extract himself from his reverie to finish his own job: telling the story that Aeneas enacted. Geoffrey can escape some labyrinths on his own, but when he does, as here, he is likely to find himself right back where he came in.

16. Geoffrey's précis of the *Aeneid* ends with a cluster of references evoking some labyrinthine Virgilian themes relevant to his own dream: the gods' "mervelous signals," their ambiguous omens and oracles (even gods do not speak the truth clearly); Juno's "sleight" and "compas," the trickery and contriving that create most of the labyrinths Aeneas must suffer (even gods play false, weaving deceit with compasses); Aeneas's subjection to "aventure" and Jupiter's "cure"—a *rota-rosa*-like pairing of chance and providence that is later associated with the construction of Fame's gate (1297–1298)—reflecting the difficulty of distinguishing between chance and fate from an earthly perspective. Chaucer's Fame, the closest thing to God that Chaucer lets us see in this poem, also has her ambiguous signs, her sleights and contrivances. *The Knight's Tale*, Chaucer's other highly labyrinthine poem, reflects a similar view of the gods.

17. Note that Geoffrey has reversed Dante's course: Dante meets Virgil in the desert,

right back where Aeneas and Dante began, and he must suffer yet another series of mazes with yet another guide. First, however, he prays to Christ to save him from "fantome and illusion" (493), from deceptive dreams and magic; and this prayer to Christ carries us back to the poem's beginning, where God and Christ were invoked to deal with dreams, and where Morpheus crafted dreams both true and false. Thus Book 1, like the labyrinth, "issist ther thow entrist" and penetrates no mysteries. Instead, it establishes a pattern that will persist in the poem: artistic and intellectual order collapse into chaos, and Geoffrey advances only to find himself more or less back where he started, little the wiser.[18] One version of the labyrinth is replaced by another, and the center is endlessly deferred.

In the tradition of labyrinthine narrative developed from the Cretan myth, escape from the labyrinth requires either a guide or wings. Aeneas had the Sibyl to guide him through the mazes of Book 6; Dante had many guides, including Virgil and several eagles;[19] and Boethius had Philosophy's labyrinthine arguments and swift wings. To free Geoffrey from the desert, Chaucer characteristically takes all these alternatives at once by creating an avuncular golden-feathered philosopher-eagle who turns out to be as determined as the Sibyl, as terrifying and benevolent as Dante's eagles, and a literal manifestation of Boethius's metaphorical wings.[20] When the Eagle seizes Geoffrey, we expect him to transcend earthly mazes, to see the pattern of the universe as if it were laid out at his feet like the concentric circles of a diagrammatic maze, as other cosmic travelers do.[21]

but Geoffrey has just left him behind. And, if we focus on the wicket through which Geoffrey has just emerged, we notice that where Dante entered Purgatory by a gate to pursue the path of good love, Geoffrey leaves the temple of Love by a wicket to find himself in the desert. Geoffrey is then seized by an eagle derived in part from the eagle that carried Dante to that very gate of purgatory. When Geoffrey follows in his great predecessors' footsteps, he often gets everything backward—unless, perhaps, his sources lied.

18. Fyler also notes a general pattern of "expansion and collapse" in the poem: *Chaucer and Ovid*, p. 58.

19. See *Purgatorio* 9 (where the eagle provides transportation within a dream), and *Paradiso* 18 and 26.

20. The identification of the Eagle with Philosophy's wings, Dante's eagles, and even Beatrice has become a critical commonplace; however, John Leyerle ("Chaucer's Windy Eagle," *UTQ*, 40 [1971], 247–265—here, 253) and Baswell ("Figures of Olde Werk," pp. 286, 311–312) usefully emphasize Chaucer's tendency to reify what is metaphorical in his sources: thus the feathers of philosophy become a palpable eagle. Similarly, Philosophy's labyrinthine argument becomes a series of real labyrinths, most notably the *domus Dedaly* of Rumor.

21. Geoffrey wonders queasily whether he is a new Ganymede (589–592), a reaction that may call to mind the reward given to Cloanthus in *Aeneid* 5 after he has won the labyrinthine boat race: a woven cloak with a double meander border and a depiction of Ganymede and the eagle. If Geoffrey's Eagle is the reification of Boethius's metaphor, perhaps his flight is the living enactment of Cloanthus's cloak: a Jovial ride surrounded by mazes.

But again we are thwarted: the Eagle's soaring spirals are circuitous, his digressive discourse even more so. Disoriented in the temple and the desert, Geoffrey remains disoriented (547-553) in a flight that will carry him into more mazes. Claiming to be Geoffrey's friend, the Eagle announces that this educational celestial tour is Jupiter's idea of a reward for Geoffrey's thankless poetic labors (666) in Venus's honor and will free Geoffrey from the constraints of his waking life: his indoor labors (652) in the Customs House and the headaches of reading and writing poetry in his study, perhaps the very prisons from which Geoffrey asked Saint Leonard to liberate him. Geoffrey may be promised relief from his *labores intus*, his waking labyrinths of words, but he faces yet another verbal maze as the Eagle lists the kinds of tidings Geoffrey will hear (674-699) in a catalogue whose profusion, speed, random order, and cumulative rhetorical patterning ("moo . . . moo . . . moo") recalls the Proem's chaotic dream catalogue. When Geoffrey is told he will hear of more deceptions "then greynes be of sondes" (691), we may wonder whether we are to end up back in the desert again. The beginning of the flight, then, recapitulates the settings of Book 1—the labyrinthine catalogue, Geoffrey's personal prisons, the love-deceptions of Venus's temple, the desert. Has Geoffrey actually left those labyrinths at all? And if so, is he any better off?

As if to still such fears, the Eagle announces that Geoffrey, like Dante and Boethius and other respectable cosmic voyagers, is going to the center of things, or at least to the center of all speech: the House of Fame, placed "evene in myddes of the weye / Betwixen hevene and erthe and see" (714-715). This journey to the center may sound like a real penetration of the cosmic labyrinth, but it is already an anticlimax: Dante and Boethius flew into a clear realm of cosmic order, complete with a vision of the concentric cosmic circles that God-Daedalus drew with his compasses. Geoffrey will never fly above the moon, let alone into the region of celestial spheres, and his flight will take him through more intellectual mazes. On this quasi-Boethian journey, he will suffer Boethian labyrinthine arguments: the Eagle's multiple proof of the laws of sound is just the kind of complex syllogistic argument medieval texts refer to as labyrinths (see Chapter 7). In this prolix disquisition on sound, two images—both of them traditional in this context[22] —play an important role. First, the Eagle repeats three times that sound is really broken air (765, 770, 779); second, he compares soundwaves to concentric circles caused by a rock thrown in a pool (788-815). So Geoffrey *does* encounter the concentric circles one expects on celestial voyages, and they are even associated with compasses (798) and with the wheels (794) that characterize the grandeur and perfection of the heavens in the

22. See Irvine, "Medieval Grammatical Theories," pp. 862–867.

Divine Comedy. But these Chaucerian circles have little in common with the cosmic artistry of a divine Daedalus: they are at best the ephemeral product of fallible human speech and at worst the consequence of breaking air (or wind).[23] Put together the two visual images in the Eagle's discourse, moreover, and the result is the *broken circles* characteristic of mundane medieval labyrinths.[24] No cosmic circles these, and no music of the spheres in the Eagle's gabble or Fame's cacophony! Thus Geoffrey's escape from the desert-labyrinth lands him in the Eagle's labyrinths of prolixity and logic, which evoke not merely Boethius's textual labyrinth but also the visual image of the maze: in ironic contrast, Lady Philosophy's labyrinthine argument led Boethius to a perception of the circles of divine simplicity. If the Eagle sees himself as a latter-day Lady Philosophy, then, he is wrong: true, he *does* incorporate both means of escape from the labyrinth: he is a pair of wings uttering labyrinthine argument. But he is ineffective: he doesn't fly high enough for Geoffrey to have a true cosmic vision, and his argument is no guiding thread. Geoffrey's Jovian reward for unceasing labor is nothing more than free passage through *laborinti*, not least the Macrobian difficulty of "coping with this labyrinth of words"—first from the Eagle, then in the houses of Fame and Rumor.[25]

Failing to achieve a Boethian or Dantean cosmic vision, Geoffrey sees little else.[26] His downward glances, understandably brief in such tenuous

23. On the reductionist equation of breaking air with breaking wind, and the inevitable connections with farting, see Charlotte C. Morse, "William Dunbar: His Vision Poetry and the Medieval Poetic Tradition" (diss., Stanford University, 1970), pp. 236–241, and Leyerle, "Chaucer's Windy Eagle," pp. 254–255. In this context, Geoffrey's experience of concentric circles is deflated all the more: he merely *hears* about them, he doesn't actually *see* them.

Irvine's tracing of the Eagle's disquisition on sound to the commonplaces of medieval grammatical treatises does not diminish the humor of equating speech with farting, especially for an author like Chaucer; indeed, one wonders how many generations of school children were caned for giggling when their grammar lessons touched on the subject of *vox* and broken air.

24. The broken circles also suggest the spiritual and epistemological disruption caused when the soul enters the body in the *Timaeus*, as we saw in chap. 10. Later we will return to epistemological themes in *HF*. For a fascinating argument that the *Timaeus* and Chalcidius's commentary continuously underlie *HF*, see Joseph E. Grennen, "Chaucer and Chalcidius: The Platonic Origins of the *Hous of Fame*," *Viator*, 15 (1984), 237–262. Grennen does not relate broken circles to labyrinths, however.

25. Comically enough, the Eagle thinks his speech has been neither prolix nor artistic but rather plain and simple, that—as Hugh of Saint Victor or Robert of Basevorn would say—he has not created labyrinths for his listener, who could not be expected to comprehend "hard langage and hard matere" at once: see 853–863. For Hugh, Robert, Macrobius, and Boncompagno, see chaps. 3 and 7 above.

26. Geoffrey's flight reveals as little as Dante's flight on Geryon in *Inferno* 17–18 (see chap. 10). Both Dante and Geoffrey are terrified in these flights and fear the fate of Phaeton or Icarus; both see horrible sights below and hear the deafening rush of water— Geoffrey as he nears the noisy House of Fame, Dante from a great whirlpool; both

circumstances, show him nothing of any import, and soon the earth is a mere pinpoint (895-909). For Boethius (2m7) the vision of earth's insignificance occasions meditation on the negligibility of earthly fame, but all the Eagle wants to discuss is whether Geoffrey can recognize any city (911-913). As for looking up bravely like Dante and Boethius, Geoffrey fears for his eyesight and prefers to learn astronomy from books. His flight on "fetheres of Philosophye" (972), then, teaches him only the physics of sound, which he could have learned just as well from grammatical treatises or indeed from Boethius's *De musica*;[27] he stubbornly avoids any cosmic vision, any transcendence of the worldly labyrinths of life and texts. The heavens, or what he sees of them, merely confirm his beloved authors (985-990, 1012-1013). His mental and imaginative limitations create an epistemological labyrinth that would remain inextricable even if the Eagle were as effective a guide to cosmic realms of glory as Lady Philosophy or Beatrice.[28]

Book 1 described a pattern of movement from intellectual uncertainty (the dream-maze) to an ordered building (the Temple of Venus) to a place of disorder (the desert), and Book 2 initiates a repetition of that pattern: rescuing Geoffrey from the desert, the Eagle carries him through intellectual mazes to a new destination, another textual palace of apparent order that, like the Temple of Venus and the multicursal maze, is "of fals and soth compouned" (1029). There is an end to flight, if not to labyrinths, as the Eagle announces their impending arrival: "Seynt Julyan, loo, bon hostel! / Se here the Hous of Fame, lo!" (1022-1023), he cries as they approach their goal, that house at the center of sound but of nothing else. Julian is normally invoked as the patron of hospitality, but Chaucer may have another aspect of Julian's responsibilities in mind: a common name for English turf-mazes was "Julian's Bower," and near Lincoln were examples Chaucer might have known.[29]

encounter broken circles, for Dante the circles of Malebolge. In a poem that privileges vision, Dante flies on a human-*faced* monster; in a poem about words and sound, Geoffrey is in the claws of an eagle with a human *voice*. The point of this parallel, as usual, is that Geoffrey is a comically failed Dante and operates in a very different world: the best illuminating upward flight Geoffrey can manage is no better than Dante's infernal downward flight. Both flights end in mazes.

Carolyn Chiapelli notes a different set of parallels between the Eagle and Geryon: "Fals Apparences: Satan and Chaucer's *House of Fame*," *Proceedings of the Patristic, Medieval, and Renaissance Conference*, 4 (1979), 107–114 (here, 111–112).

27. See Irvine, "Medieval Grammatical Theory," p. 866; Boethius is particularly responsible for the image of sound-circles.

28. Contrast Dante's constant willingness to transcend the perceptual and intellectual labyrinths that bind him in Paradise.

29. Chaucer's wife Philippa was closely associated with Lincoln, where her sister Katherine Swynford lived: see *Chaucer Life-Records*, ed. Martin M. Crow and Clair C. Olson (Oxford: Clarendon Press, 1966), pp. 80–88, 91–93. *The Assembly of Ladies* uses Julian in a like context: see chap. 6.

If Julian is the unofficial patron saint of English mazes, the Eagle may be pulling Geoffrey's leg in more ways than one, for rest, certain knowledge, and the transcendence of mazy labors and errors are hardly in prospect, and both the House of Fame and the House of Rumor turn out to be labyrinths.

Although modern readers may not recognize the maziness of the House of Fame, the resemblance would have been clear to many medieval readers. Elaborate and complex as any Daedalian construction or Gothic cathedral, the House of Fame is most obviously a memorial building as described by Frances A. Yates[30] —a niched, statued, decorated establishment in which those who preserve the poetic memory of the famous are themselves preserved in some semblance of mnemonic order: outside those who sound off with instruments and spells decorate the building in organized groups, and inside great authors of the various poetic "matters" stand on pillars whose metallic composition reflects this subject matter. As a memorial building, the House of Fame is theoretically a place of order and a splendid work of complex artistry. But precisely because of its dazzling complexity and its commemoration of great art, the House of Fame resembles the admirable but confusing labyrinths described by Pliny and others in the historical-geographical tradition (see Chapter 1). Those ancient labyrinths were vast, intricate, galleried stone buildings, and among their more prominent internal features were pillars and statues. Their complexities induced inextricable and inexplicable error;[31] but they were meant to function as ornate monuments to the glory of architect and sponsor. The first labyrinths, then, were ambiguous houses of fame, simultaneously memorial and mazy. They were also, like Chaucer's, very noisy—a detail in Pliny found as late as John Mirk (ca. 1450), who complained that in his day the church had become "an hous of dadull, and of whisperyng and rownyng, and of spekynge of vanyte and of oþer fylthe."[32] The deceptively realistic speaking images of supplicants in Chaucer's palace of fame (1074-1082) also express a labyrinthine connection: they recall the life-

30. See Yates, *The Art of Memory*. Beryl Rowland notes the resemblance of the House of Fame to a memorial image—"Bishop Bradwardine, the Artificial Memory, and the House of Fame," in *Chaucer at Albany*, ed. Rossell Hope Robbins (New York: Burt Franklin, 1975), pp. 42–61.

31. Pliny uses both terms (*Natural History* 36.19.88, 91). Inex*pli*cability, with its hermeneutic implications, is particularly suggestive of mental labyrinths, just as inex*tric*ability connotes physical ones.

32. Pliny mentions that the Egyptian labyrinth produced "a terrifying rumble of thunder"; the Etruscan labyrinth made noise when the wind blew. Chaucer picks up both images: see 1041–1042 and the trumpeting forth of fame by "Eolus the god of wynde" (1571). For Mirk, see the *Festial*, ed. Th. Erbe, EETS, e.s. 96 (1905), p. 279; partially cited in Bennett, *Chaucer's Book of Fame*, p. 167. If the House of Rumor specializes in whispers, the House of Fame is more interested in vanity. One wonders whether Mirk had been reading Chaucer.

like moving statues created by Daedalus, that artist extraordinary "with his playes slye" (*Book of the Duchess* 570), who, like the "smale harpers" outside the palace, tried with craft to imitate nature (1209-1213).[33] The House of Fame, then, is a magnificent *multiplex domus* that is also, by medieval standards, a kind of labyrinth. "So wonderlych ywrought" (1173), built to commemorate artists, it shares both the purpose and the perverse effect of the ancient mazes: with typically labyrinthine convertibility, its very artistry (and certainly the artistry of its writers-in-residence) begets confusion even as it compels admiration.

Initially Fame herself resembles Virgil's Sibyl and Boethius's Lady Philosophy: like them, she varies in size from the length of a cubit to an immensity spanning the distance from earth to heaven (1368-1376). We might hope she would be as useful a guide to labyrinths as these literary ancestors. But as usual we are disappointed: a shifting size is itself an ambiguous *signum sequendi*, and although it might point to the Sibyl and Philosophy, here it points rather to Virgil's Fama (*Aeneid* 4.173-197) and reflects her guiding principle, amplification—the very principle that informs medieval poetry, the expansion of sound-circles, and the reduplicated circles of the labyrinth.[34] Like Virgil's, Chaucer's Fame specializes in *multiplex sermo* (4.189), in mingled truth and falsehood (4.188, 190), and she is as monstrous as the Minotaur: part woman, part beast, with as many ears, eyes, and tongues as there are hairs and feathers on animals and birds.[35] She transcends duality to incarnate labyrinthine multiplicity. On her feet, in an apt mistranslation of Virgil's "swift wings," are the partridges' wings that link her subtly with Daedalus and Perdix, inventor of compasses he never lived to use but which, usurped, enabled Daedalus to construct the labyrinth.[36] So too Fame's magnificent palace with its "compasses" (1302), its beauty that no mortal men have skill to "compace" (1170),[37] is parasitically built on the works of others,

33. Daedalus is thus an appropriate archetype for poets: his labyrinth is a prototype for the grand structure of their verbal compositions, his moving statues a prototype for the characters they create.

34. Were we in any doubt on the point, this Fame welcomes fawning muses (1399–1406), whereas Philosophy banishes them (1p1), and this Fame welcomes poets and fiction, whereas the Sibyl tears Aeneas away from his perusal of Daedalus's poetic fictions (as pseudo-Bernard Silvester interprets them) at the Cumaean gates (J&J, p. 37).

35. Chaucer makes Fame more womanly—and thus more dual-natured—than Virgil's Fama: Fama is purely monstrous, covered with feathers, eyes, tongues, mouths, and ears, but Chaucer's is a "femynyne creature" with golden hair, her numerous eyes, tongues, etc., compared to beasts' feathers, hairs, and so on.

36. See Francis X. Newman, "Partriches Winges: A Note on the *Hous of Fame*, 1391–92," *Medievalia*, 6 (1980), 231–238. Following medieval commentaries, Newman sees the reference as suggesting "the vanity and fraudulence of art"; I see it as part of a pattern of labyrinthine imagery, linking Fame to Daedalus, and as a reference to medieval practices of plundering other writers' work for one's own creations. For other references to the partridge, see Fyler's notes, *Riverside Chaucer*, ad 1392.

37. On possible readings of "compace" in 1170, see Fyler's notes, *Riverside Chaucer*.

the artists of word and sound. But unlike Daedalus's construction, the gates (and presumably the house) of Fame are erected haphazardly by "aventure" as well as "cure" (1297-1298): there is no single architect of this palace, then, no brilliant shaping consciousness to make order dominate chaos.[38]

The association of the House of Fame with labyrinthine chaos is strengthened when Fame randomly assigns praise, blame, or no fame at all to her petitioners. Her judicial process is orderly, but her bewildering illogic in ruling on people's eventual fame creates an experiential maze of dialectic with its intermittent and inextricable error, leaving Geoffrey clawing his head in amazement.[39] In its Chaucerian context, Fame's inscrutability is comic; but at the same time—and who can say how seriously?—she is a parody of that finally impenetrable labyrinth in the *Divine Comedy*, the mystery of God's justice. With Fame's judgments, then, order once again deteriorates into chaos and incomprehensibility.[40]

Like mistress, like dwelling place: the House of Fame as a whole does not necessarily reflect the true merits of its components. If some medieval cathedral mazes witness the glory of their builders, this maze of memory confirms Geoffrey's pragmatic judgment of its icy foundations:

> This were a feble fundament
> To bilden on a place hye.
> He ought him litel glorifye
> That hereon bilt, God so me save! (1132–1135)

These lines might have been a Boethian or Dantean statement on the flimsiness of worldly fame, but to Geoffrey they describe a literal architectural fact. The House of Fame may be a valid memorial building, but it is deeply flawed: like Pliny's mazes, it is built to commemorate, but its effect is to confuse. As ancient writers disagreed about who was memorialized in the labyrinths, so here the stuff of the palace is dubious: how can Homer, Dares, and Dictys with their strongly divergent biases coexist on the same pillar of the Matter of Troy (cf. 1475–1480)? And what about Fame's efficacy to promulgate her peremptory judgments if she

38. As with men's reputations and writings, so with their fates: in Book 1, Aeneas's career is based on Juno's compassing, "aventure," and Jupiter's cure. Again, a dilemma emerges: who's in charge? Is there an architect of men's fates?

39. Fyler, *Riverside Chaucer*, ad 1702, notes that this is "Chaucer's only use of the strong preterite of *clawen*, 'claw, rub'; elsewhere he uses *clawed*." Might this aberrant preterite, "clew," be an in-joke, suggesting Geoffrey's need for a *clue* to escape this maze of illogic? In the "Legend of Ariadne," he repeatedly uses the noun "clewe": 2016, 2140, 2148.

40. Although our modern fascination with an Ockhamist God whose absolute power permits him to reward anything and everything as he wills was not matched by similar interest among medieval poets, I remain struck by how accurate a portrait Chaucer's Fame, with her random disbursement of prizes, might be of such a God.

grants the unnamed villain who burned the Athenian temple of Isis true fame, but that "true fame," as it is known in the real world outside Chaucer's poem, identifies him as Herostratus, who burned Diana's temple at Ephesus?[41] The textual quarrels of Venus's Temple, which is recognizable in retrospect as another memorial building/maze, resurface in the House of Fame, whose collection of literary texts, orderly in their categorical division by pillars, become "a ful confus matere" (1517) when taken as a whole.

Thus Fame's palace initially represents magnificent (if occasionally unjust and certainly ill-founded) order; but as author attacks author and company after interminable company begs a boon, and as each is dealt with arbitrarily by Fame, order dissolves into chaos. Just as in the digression on wronged ladies in Book 1, we go round in circles in need of extrication, abandoned in the continuing confusion of which the maze is the best emblem. As in the desert, so too here a "frend" who speaks "goodly" to Geoffrey appears (cf. 582 and 565 with 1870–1871). Another guide, another potential instructor for the bewildered Geoffrey who once again has learned nothing of value, another misleading if well-intentioned promise of escape from the labyrinth, another repetition of lines and of established patterns that go nowhere, mocking transcendence.

In the valley below the castle Geoffrey sees the poem's final maze: the chaotic House of Rumor, more wonderfully intricate and "queyntelych ywrought" than "Domus Dedaly, / That Laboryntus cleped ys" (1918–1985).[42] It is probably highly significant that Chaucer uses both Domus Dedaly, with its connotations of artistry, and Laboryntus, with its polysemous implications of toil, struggle, and artistry, to describe this maze of words. The pairing—found also in Higden (see below) is extremely rare: even in translating Boethius's *laborintus*, presumably for an audience rather more learned than that of *The House of Fame*, Chaucer relies only on "the hous of Didalus" (*Boece* 3p12.156). His use of *laboryntus* in *The House of Fame* suggests he had its ambiguous etymology very

41. For medieval references to Herostratus, see Fyler, *Riverside Chaucer*, ad 1844. I assume that the temple-burner is telling the truth—none of the postulants seems to lie—and that history's pronouncement that a different temple in a different place was burned would cast doubt even on "true" fame, at least for people in on the joke; cf. Bennett, *Chaucer's Book of Fame*, pp. 162–163. Boitani believes the supplicant is Herostratus and that he lies to Fame: *Imaginary World of Fame*, p. 188.

42. In describing the houses of Fame and Rumor, Chaucer draws on Ovid's House of Rumor (*Metamorphoses* 12.39–63). Chaucer's House of Rumor shares several labyrinthine attributes with Ovid's, notably its noisiness, its complex structure with many apertures, and its blending of truth and falsehood; but only Chaucer compares his house to the labyrinth, and he adds other labyrinthine features to his edifice.

much in mind, as one would expect if he were consciously developing the idea of the labyrinth throughout the poem.

There is a great deal to be said about this complicated labyrinthine place.[43] It spins perpetually, emitting a deafening noise: ironically, Geoffrey has at last found a *visible* circle of sound, but it is hardly a Dantean or Boethian cosmic circle contributing to the perfect harmony of the spheres; it remains a labyrinth, a perverse parody of cosmic circles, just as the broken circles of the labyrinth parody the perfect circles of the cosmos.[44] The house spins "as swyft as thought" (1924): presumably it is as dizzying and disorienting as a maze. Through this simile, the House of Rumor becomes a composite image of the poem's physical and mental labyrinths: it is both an architectural maze, like the temple and the palace of Fame, and an intellectual one, like the labyrinths of dream lore or Fame's logic. The intense energy evident outside is also present within: "Ne never rest is in that place" (1956), we are told, recalling Hugh of Saint Victor's opposition of "requies" and "labor intus"; this is no ark of divine tranquillity.

Nor is there any semblance of order. Its disreputable inhabitants appear in considerable disarray. Innumerable low-life types—pilgrims, shipmen, pardoners—are so crowded together inside and out that there is hardly any room for them to rush, as they do incessantly, from one place to another, their unruly gossip magnifying the chaos within so that this house is even noisier than ancient mazes. The tidings themselves are disordered: in a recapitulation of the Eagle's dismaying catalogue in Book 2, they are jumbled together in categories linked by "of . . . of . . .

43. For complementary meditations on the House of Rumor, see Boitani, *Imaginary World of Fame*, pp. 208–216; for a radically different Marxist interpretation, see Stephen Knight, *Geoffrey Chaucer* (Oxford: Basil Blackwell, 1986), pp. 4–5 and 22–23. Grennen ("Chaucer and Chalcidius," pp. 247–250) proposes the winnowing baskets of the *Timaeus* as a source for the wicker cage.

44. Parodic allusion to Dante here is in fact quite extensive: at the end of the *Paradiso*, Dante has a vision of the Trinity from within the tightly and hierarchically organized amphitheater; in a totally disorganized crowd, Geoffrey sees, but does not hear, a *man* who merely *seems* to be authoritative. Dante's poem ends with the pilgrim whirling "like a wheel that is equally moved by the Love which moves the sun and the other stars" (*Para.* 33.144–145), in perfect accord with cosmic principles. Geoffrey too ends up spinning in a building, that, like Dante and the stars, probably moves like a wheel: revolving on its own axis as it moves in orbit around the earth (see Freccero, "The Final Image," for Dante's motion). But once Geoffrey enters the House of Rumor, he is unaware of its whirling (2031–2032) and deprived of ecstatic union with the cosmos; he remains very much in a terrestrial maze, a failed visionary.

Bennett's interpretation of Geoffrey's lack of a whirling sensation is very different: "The poet, that is, when divinely guided, can reach the still centre of this turning world"—*Chaucer's Book of Fame*, p. 178. Cf. Koonce, *Tradition of Fame*, for whom Geoffrey saw the world for what it was—a confused maze—while outside but loses that visionary perspective when he enters it (p. 258). I would not grant Geoffrey even that much vision.

of" (1960–1976); although the list is often structured by opposition (war and peace, death and life, labor and rest), there are many unpaired elements (marriages, travel, buildings), and nothing is ranked by importance.

This uproarious building has other labyrinthine features. It is likened to a cage (1938, 1985), but if, like the Cretan labyrinth, it is a prison, it is singularly permeable, with as many entries as there are leaves on trees and more than a thousand holes in the roof (1945–1950). Yet these holes are so small that escaping tidings have to squeeze together to fit through (2088–2109), so the house, though extricable, is very difficult to leave. Similarly, it is partly, but not entirely, impenetrable—Geoffrey must be flown in (2002–2006), but shipmen apparently have no problems with access. Like ancient mazes, too, it is vast—sixty miles long (1979). Most peculiar of all—and perhaps most imaginatively labyrinthine—it is woven of multicolored twigs: it is literally *textus*, like Virgil's labyrinth and like literature.[45] We have met the image of cacophonous interwoven twigs before, in the House of Fame:

> The halle was al ful, ywys,
> Of hem that writen olde gestes [stories]
> As ben on trees rokes nestes;
> But hit a ful confus matere
> Were alle the gestes [deeds] for to here
> That they of write, or how they highte [were named]. (1514–1519)

Poets are as numerous as crows' nests: they speak, one assumes, in as many and as raucous voices as a crow, and their texts are interwoven words. And although Geoffrey does not say that their poetic products are confused in themselves, or that the poets are all speaking as he watches, the juxtaposition of nests, confusion, and polyphony anticipates the wicker House of Rumor and explains just what Rumor's twigs, colored perhaps with the colors of rhetoric, might be.

Explicitly compared to the labyrinth and *domus Dedaly*, sharing many features with labyrinths encountered in this study and this poem, this alarming place is surely a maze, though not quite like any we have met before. It resembles some labyrinths in literature—the Sibyl's cave in the *Aeneid*, for instance, with its hundred doors and voices. But it more

45. See *Aeneid* 5.589 and 593. From this detail, and the mention of interlace in the *Boece*, James Winny concludes that Chaucer thought the labyrinth "had an interwoven structure rather than an intricate ground-plan"—*Chaucer's Dream Poems*, p. 102. I assume that Chaucer was not confused on this point—cf. *LGW* 2012–2014—but rather appreciated the possibilities of both structures, rightly emphasizing *textus* when dealing with labyrinths of words.

strikingly resembles some unusual labyrinths in the visual arts. The vast majority of illustrations of the labyrinth in the Middle Ages show a diagrammatic, unicursal, two-dimensional pattern, usually based on concentric circles; these illustrations highlight the maze's artistic design, its symmetry, and its teleology—the fact that its path leads inevitably to a center—and they imply that one can (and should?) rise above the labyrinth to see it whole and thereby comprehend it (see Chapters 2 and 5). In contrast, there are very few surviving illustrations of the Cretan maze as a three-dimensional architectural construction, a mode of representation that encourages the viewer to imagine being within a multicursal building so complex that it is totally disorienting. But these illustrations are fascinating analogues to Chaucer's House. Two illuminations from the *Histoire ancienne* (see plate 18 and Appendix, MSS. 4 and 5) show a huge spherical building full of doors and windows, inside which must be many passages; this is a *multiplex domus* very like Chaucer's House of Rumor. Two other universal histories show the labyrinth as a cage with interwoven bars.[46] There is no evidence that Chaucer knew these manuscripts, but that is not really the point: the illuminations confirm that individual artists imagined the labyrinth as a cage, or as something *textus* and interwoven, or as a disorienting sphere full of multicursal passages and confusing repeated details. It is probably typical of Chaucer that he should assemble *all* these divergent images into something as off-beat as the House of Rumor, whose parts come from various labyrinth traditions (as well as from Ovid's House of Rumor) but whose whole is completely novel and thoroughly chaotic. It remains tempting to think that Chaucer knew some *Histoire ancienne* manuscript with a three-dimensional labyrinth and that such an illumination supported his own inclination to reject the clarity of the circular two-dimensional unicursal maze, endorsed by Boethius and Dante, and to visualize—and make his readers visualize—the three-dimensional multicursal building in which there can be no perception of order, only enduring confusion.

Whatever its sources and inspiration, Chaucer's chaotic House of Rumor is preeminently multicursal. It may not contain *physically* winding and competing passages through which its inhabitants can walk, like the ancient labyrinths, but then it is not really concerned with physical disorientation. Instead, it is interwoven of textual twigs, and it encloses countless competing *audible* passages to bewilder the wandering mind, as the rabble of tale-tellers bewilders the eye; in short, the House of Rumor is an ingeniously appropriate and thoroughly original model of an intellectual or epistemological maze, a perfectly imagined transformation of

46. See Kern, plates 171 (Italian MS., ca. 1350–60) and 172 (French, ca. 1400). These illuminations suggest no path at all; they are neither unicursal nor multicursal.

the traditional physical labyrinth into a mental one, a metamorphosis of the structure that amazes into the psychological experience of amazement.[47]

Within this labyrinth, rumors spread from one man to another, amplified in content and in decibel level; and as these tidings seek an exit, they intertwine inextricably: "Thus saugh I fals and soth compouned / Togeder fle for oo tydynge" (2108–2109). Like multicursal labyrinths, tidings combine true and false passages. The different versions and voices in the Temple of Venus, the speaking Eagle, the poets thick as crows' nests, the clamor in the twiggy House of Rumor with its dual-natured minotaurish tidings—all are competing and finally unreliable versions of truth, and all are summed up in the labyrinth of Rumor, the nest of poetry. The center of literature, this nest of language and knowledge, is a chaotic labyrinth of words, full of indistinguishable truth and falsehood.

Geoffrey's marvelous dream begins in a quiet temple with the text of a single poem—a would-be authoritative version of historical truth, a unicursal text. That text splits into two versions, two paths, as Ovid and Virgil each challenge the other's veracity; and these choices between true and false proliferate throughout the poem until they end not at any true center, and not with any transcendent vision of ordered circles, but inside a spinning labyrinth where the cacophony of truth and falsehood are mingled into institutionalized error—into labyrinths of words. This is truly a labyrinth of over-abundant and unreliable material like that to which Ralph Higden alluded as "laborintus, Dedalus hous, [that] haþ many halkes and hurnes, wonderful weies, wyndynges and wrynkelynges, that will nouȝt be unwarled [unraveled]."[48] Whatever else one finds in the House of Rumor, it will not be the path to transcendence, and it will not be truth or stability: even true tidings (could they be recognized) risk inextricable entanglement with false ones. So much for the "o sentence" (1100) Geoffrey had wanted for his book, whether that phrase means "one meaning" or "only meaning." The mazes of Book 3 are framed—both in poetic structure and in literal substance—with half-truths, half-lies, in yet another of the poem's echoing lines: "fals and soth compouned" (1029, 2108).

Geoffrey ought to have known better than to invoke Apollo, god of

47. Thus Chaucer reverses the historical development of "maze" in English (see chap. 4), which progressed from signifying mental confusion to the physical structure that best creates that state.

48. Higden, *Polychronicon* 1.7, Trevisa's trans. The context of Higden's reference to the labyrinth shares features with *HF*: he is defending "historia" by describing how books preserve the fame and exemplary deeds of great men, which would otherwise pass out of feeble human memory. Oddly, the one great man Higden names in this context is Lucilius, whom Seneca accused of being too immersed in the mundane labyrinth (1.3).

oracular *ambages*, labyrinths, and poetry, to guide his little last book, in which he encounters not one labyrinth but two.[49] In neither place can he find reliable guidance, clear choices between alternatives, an elevated perspective to reveal whatever pattern there may be. There is a momentary glimmer of hope when he finally spies someone who "semed for to be / A man of gret auctorite" (2157-2158): after all, Boethius's journey through labyrinths to perfect order began with the appearance of Philosophy, a "woman of imperious authority" (1p1.13). Yet this significantly nameless man, who merely *seems* a likely guide, never says a word; and had he spoken, what authority could he have had in such a place, in such a poem? In Chaucer's labyrinthine world, the great guides to labyrinths (Ariadne, Daedalus) and to labyrinthine poetry (Virgil, the Eagle who resembles Philosophy and Beatrice, Fame with her Sibylline stature) all fail; transcendence and true authority alike are unthinkable. Order collapses into disorder, simplicity into multiplicity, dazzling artistry into dazed confusion, one statement into its opposite: the only world we know is a labyrinth without a center and perhaps without an end. The poem breaks off abruptly with that ironic word "auctorite," and probably Chaucer meant it to end so: the multicursal labyrinths he describes *are* endless when one cannot escape them, as Geoffrey cannot, trapped in his dream of recurrent mazes. Even Daedalus's exquisite Cretan panels at Cumae are unfinished, and the last completed panel seems to show Theseus *trying* to escape the maze with Ariadne's aid. If Daedalus could not finish his labyrinthine sculptures, if Virgil left his great epic incomplete, would it not be presumptuous of Geoffrey to end his labyrinthine poem?[50]

We have seen how *The House of Fame* adopts the labyrinth as a dominant image and how the text repeatedly evokes and denies the narrative pattern of its labyrinthine poetic models: the pattern of escape from

49. Aeneas, deceived by Apollonian ambiguities at Delos, nevertheless calls for Apollo's guidance at Cumae, where Apollo's Sibyl is in the habit of writing her *ambages* on leaves for the wind to scatter; Aeneas therefore wants her to speak, not write (*Aeneid* 6.56–76). Chaucer may have these events as well as Dantean precedent in mind when he has Geoffrey invoke Apollo before entering the labyrinths of Book 3, one of which issues forth ambiguities from doors as numerous as the leaves on trees (1945–1946). If so, Chaucer is as usual both more lighthearted and even more pessimistic than Virgil, and certainly more conscious of the problems of transmitting information by sound.

50. An ever-increasing number of critics agree that *HF* is *intentionally* incomplete: see, e.g., Baswell, "Figures of Olde Werk," p. 324; Bennett, *Chaucer's Book of Fame*, p. 185; Robert Boenig, "Chaucer's *House of Fame*, the Apocalypse, and Bede," *American Benedictine Review*, 36 (1985), 263–277; Donald K. Fry, "The Ending of the House of Fame," in *Chaucer at Albany*, pp. 27–40; and Kay Stevenson, "The Endings of Chaucer's *House of Fame*," *English Studies*, 59 (1978), 10–26. Moreover, the Eagle implies that there is no end to Geoffrey's labors (652–658); hence it is fitting that there be no end to this poetic *labor*.

subjective confusion within the maze to a privileged overview of clarity and symmetry, analogous to the vision provided by diagrammatic labyrinths. Aeneas, Boethius, and Dante all attain such a vision, if only briefly, but Geoffrey, following in their footsteps, cannot. The question remains: *why* is the labyrinth the most appropriate controlling image for this poem, and the one thing that gives it coherence and unity?

Throughout the Middle Ages, as we have seen, the maze is a common metaphor for difficult, confusing, artful processes or experiences: life, love, fortune, epistemology, the creation and interpretation of texts, rhetoric, dialectic (all of them, incidentally, topics raised in *The House of Fame*). Most of these analogies are based on two essential features of the labyrinth:

(1) *labor intus*: the idea that there is toil—moral, physical, artistic— within, especially when one lacks a privileged overview. Success is problematic in a labyrinth—especially a multicursal one—because *vision* is limited. Only from outside and above the labyrinthine process can one understand the pattern and meaning of a maze.

(2) *error*: labyrinths entail many kinds of error: wandering, mistakes, circuitous paths. Error may be simply a structural feature—an elegant circumlocution or physical circuity—but often, error has pejorative overtones. Multicursal mazes involve a special kind of error in that "fals and soth" paths are "compouned" into an artistic whole whose admirably ornate pattern is defined equally by these true and false paths. In this kind of maze, error has excellent uses.

If labyrinths are about inevitable error and ambiguous *labor intus*, so too is *The House of Fame*, which focuses on these general problems as they affect the writer and reader of literary texts.

As a poet, Chaucer was at least intermittently concerned with both *solaas* and *sentence*, with "fals and soth compouned." But where can a poet find *sentence* and *soth* to write about?[51] Some of Chaucer's favorite books—the *Aeneid*, the *Consolation*, the *Comedy*—suggested where and how truth could be found. In these works, the labyrinth signifies the tortuous, convoluted, necessarily circuitous journey to knowledge; by patience and application, with the right guides, labyrinthine error and confusion can be converted to an epiphany of order, just as the mazy complexities of Philosophy's speech finally express the circles of divine simplicity. All one needs is good guidance and a perspective above the maze—the perspective assumed by diagrammatic cathedral mazes, or that philosophical wings can give the mind. In Chaucer's poem, however, there is no way to rise above the multicursal labyrinth, no way to see whether sublime order informs it; every tantalizing flight above the maze lands Geoffrey in another one.

51. G. T. Shepherd's "Make Believe" is a particularly thoughtful discussion of the complexity of the search for *soth* in this poem and the importance of truth in literature.

This is to be expected in a poem written after Ockham, after Holkot, when, as Delany notes, skeptical fideism became a reasonable response to an uncertain world.[52] Unlike Delany, I find no fideism in *The House of Fame*, but I *do* think the poem is deeply skeptical in ways that have been appreciated and in ways that have not. The quest for *soth* in Chaucer's labyrinthine world is fruitless as it was not for Dante and Boethius, who were granted divine illumination merely parodied by Geoffrey's dream and Eagle. The impossibility of differentiating between truth and error within the mundane maze is considered thoroughly as all sources of knowledge and of poetry—books, logic, perception, experience, perhaps even revelation—are challenged and found wanting. If the labyrinth serves in part to represent the epistemological limitations of human understanding in the *Aeneid*, the *Consolation*, and the *Comedy*, it does so even more forcefully in *The House of Fame*, where such limitations cannot really be transcended at all.

The Proem demolishes the credibility of dreams: how can you tell a true dream from a false one even if your dream happens to be true, perhaps divinely inspired? Even if the source were reliable—and who could tell?— the interpreter might err. Literature, too, is unreliable. The story of Aeneas has conflicting interpretations and versions— Virgil's versus Ovid's, for a start.[53] Oral literature is even trickier: the House of Rumor shows why most tales are lies. Moreover, oral literature (and poetry was often given oral *delivery*) consists of sound—of broken air, as the Eagle delights in repeating. For all its craft, the best poetry may be physically indistinguishable from a fart,[54] with no greater intrinsic claim to truth. How, then, can one decide what poetry or speech is true and what is false? Every poet is in a labyrinth of uncertainty vis-à-vis his sources, be they visionary, oral, or written.

One can avoid written and spoken *auctorite* if Homer lies (1477) and if poetry and farts are scientifically indistinguishable. Are experience and observation more reliable? Chaucer thinks not, in ways not yet suffi-

52. See Delany, *The Poetics of Skeptical Fideism*, which remains the fullest exploration of skepticism in *The House of Fame*. Another important study is Laurence Eldredge's "Chaucer's *Hous of Fame* and the *Via Moderna*," *Neuphilologische Mitteilungen*, 71 (1970), 105–119, dealing with themes of failed transcendence.
Most recent criticism of *The House of Fame* acknowledges the importance of skepticism in the poem: see, e.g., works already cited by Baswell, Boenig, Burlin, Fry, Kean, Fichte, Fyler, Gellrich, Irvine, Jordan, McCall, Newman, Shepherd, Spearing, and Stevenson; and also A. Inskip Dickerson, "Chaucer's *House of Fame*: A Skeptical Epistemology of Love," *Texas Studies in Language and Literature*, 18 (1976–77), 171–183, and Larry Sklute, *Virtue of Necessity: Inconclusiveness and Narrative Form in Chaucer's Poetry* (Columbus: Ohio State University Press, 1984), pp. 35–47. Boitani (*The Imaginary World of Fame*, pp. 211–216) approaches the idea of skepticism via discussion of the ambiguity of signs.
53. Moreover, many medieval writers knew that the Dido episode on which Geoffrey places such weight was completely unhistorical: see Fyler, *Chaucer and Ovid*, p. 34.
54. Cf. Fyler: "the *Aeneid* and flatus are essentially the same thing," *Chaucer and Ovid*, p. 54.

ciently noticed despite the proliferation of studies of the poem's skepticism. *The House of Fame* touches on many of the generally accepted hindrances to perception according to medieval philosophy, hindrances that create at worst a mental labyrinth and at least experimental bias.[55] For instance, error may be caused by submitting to faulty *auctorite*, custom, or prejudice—all encountered in *The House of Fame*. As for vision, the noblest and subtlest sense, Book II systematically destroys its credibility as a source of accurate knowledge—at least for Geoffrey, whose own observations are shown to be extremely dubious. Light that is too bright or too dim hinders perception, and Geoffrey's eyes are "daswed" (658); he also worries that the stars would blind him (1015-1016). Faulty organs of perception create problems—and Geoffrey's animal spirits, essential to sight, are "astonyed and asweved," and his vision is further impaired by age (549, 995). Mental disturbance provokes error, and Geoffrey is remarkably fearful (553, 557, 604). Strong drink or a bad diet impair vision, and Geoffrey's "abstynence ys lyte" (660). Eyestrain and headache also affect accurate sight, and Geoffrey writes so much he gets almost nightly headaches (632-633). Looking at objects "in a negligent and indifferent manner,"[56] as Geoffrey does repeatedly on his flight, leads to error. Great distance from an object, the motion of the beholder, and an unclear atmosphere also harm perception: Geoffrey, flying through the skies, thinks the far-distant earth is "a prikke; / Or elles was the air so thikke / That y ne myghte not discerne" (907-909). The eye must confront the visible object if it is to be seen, but Geoffrey refuses to look at the constellations (1011-1017). A moving object may be deceptive: the House of Rumor is spinning faster than thought, and the trickiness of moving objects is all the more obvious when Geoffrey, once inside, notices no motion at all (2031-2032). One could go on, but the point is clear. So much for transcendent vision, or indeed any reasonably accurate vision at all; it can hardly be coincidental that Chaucer runs the gamut of Roger Bacon's comprehensive list of hindrances to sight. Were we tempted to consider sound a possible source of truth, what we learn in the Houses of Fame and Rumor would destroy those illusions. Perception and experience, then, are problematic, just as unreliable as contradictory old books. In addition, as the Invocation to Book 1 reminds us, the wrong mental attitude—hate, fear, scorn—causes error; and personal bias, that common hindrance to accurate judgment, fascinates

55. In what follows, I draw on two fairly well-known texts: Roger Bacon, *Opus majus*, trans. Robert Belle Burke, 2 vols. (New York: Russell & Russell, 1962), Part 1: Causes of Error (1, 3–35), and Part 5: Optical Science (2, 419–582); see esp. sections 1.1.1, 5.1.8 and 5.1.9 (the nine external conditions for accurate vision), and 5.2 (the effects of age, diet, and emotion on vision); and Bartholomeus Anglicus, *On the Properties of Things* 3.17, trans. John Trevisa, ed. Gabriel Liegey, gen. ed. M. C. Seymour, 2 vols. (Oxford: Clarendon Press, 1975), 1, 108–113 (a briefer and less inclusive summary of errors in vision).

56. Bacon, 2, 575.

Chaucer throughout his career, as the links in the *Canterbury Tales* illustrate time and again. If perception, experience, old books, and *auctorite* fail, what about logic? The Eagle's logical discourse, thinks Geoffrey, is merely "*lyk* to be / Ryght" (873-874, my italics), whatever Plato and Aristotle (759), those old purveyors of labyrinthine arguments, might say.

Books, dreams, perception, and dialectic are thus excluded as reliable sources of truth and knowledge; however neatly shaped, all are as full of error mixed with truth as the multicursal labyrinth. Thus we labor in the labyrinth of this world, unable even to see it properly, let alone to orient ourselves or find a sure way out. Chaucer does not actually claim that Christian religious literature is equally error-prone: such literature is conspicuous by its absence in the House of Fame, despite the influence of the *Comedy* and sporadic references to the Bible, and exclusion may mean exception. Nor does Chaucer explicitly deny the validity of divine revelation.[57] But the closest thing to revelation in the poem is the Eagle, vehicle of divine illumination in one medieval text after another, including the *Comedy*, and that illustrious bird turns out to be far less authoritative than he thinks, even if he does embody both the labyrinthine argument and the feathers of philosophy that carried Boethius to a clear understanding of world and epistemology alike. But even if the Eagle were a totally competent instructor, he proves quite incapable of extracting Geoffrey from epistemological labyrinths. Instead, he flies his reluctant tutee through labyrinths of speech into mazes of stone and wicker. One may deduce, from the unreliability of reception, that Chaucer has his doubts about revelation (especially in dreams) and didactic instruction as efficient vehicles for certain truth.

Thus there are no secure *signa sequendi* in the world of *The House of Fame*; everything is, or is indistinguishable from, error, at least from our perspective. Whether error would delineate the perfection of divine artistry if only it could be seen from a sufficiently privileged perspective is anybody's guess.[58] Error, "fals and soth compouned," the multicursal labyrinth—these define the limits of the poet's, and Everyman's, epistemological *labor intus*.

Given its available sources, poetry—an artistic *labor* shaped by *error*—must necessarily be a labyrinth, however "wonderlych ywroughte" in imitation of Daedalus. Its validity is dubious, its meaning ambiguous, its reception unpredictable. For a poem that discusses these issues, what

57. For the possible parody of apocalyptic imagery in the poem, see Boenig, "Chaucer's *House of Fame*, the Apocalypse, and Bede."

58. If Chaucer's poem implies anything at all about divine order, it is that that order is labyrinthine in the Vegetian sense: secret, incomprehensible, impenetrable (see chap. 3). The fact that Chaucer gives Theseus the emblem of the Minotaur in *The Knight's Tale*, where the incomprehensibility of the gods is a central theme, suggests he may have known this tradition.

more appropriate controlling image could there be than the labyrinth, on one hand the most elaborate of artistic creations, on the other a prison of error for anyone trapped within and deprived of philosophical wings? Even Aeneas penetrated the maze of Hades to achieve a clear vision of his people's destiny, however imperfectly understood; Dante and Boethius had sufficient faith and guidance to transcend the earthly maze, to see its confusing multiplicity condense into a perfect pattern of divine order, even though some parts of that order might never be comprehended. But in Chaucer's poem, clear memorial images consistently dissolve into labyrinths of chaos, for mazy convertibility is a one-way (and, transcendentally speaking, a wrong-way) street. All sources of knowledge are undercut. Even the man of (seeming) authority would probably have been as duplicitous as the Minotaur. Meaning and truth are always deferred; the quest for freedom from error—for a clear vision of the pattern in which we play a part—is as endless as the poem. The only pattern we are shown is the pattern of the labyrinth, for the poem is so structured that all progress is illusory: we may think we are getting somewhere new, but really we are retreading old patterns, circling and turning and retracing our steps until suddenly we exit right where we entered, with an echoing line or repeated pattern, and not once only but time and again.[59]

The House of Fame, then, is about the labyrinths of life and literature: grand, but ultimately futile, works of complex art and artifice that all too easily degenerate into chaos unless the viewer is granted a privileged, stable, transcendent vision; inescapable prisons for body and mind, where all guides, however friendly, prove fallible; tricky, ambiguous creations of architects, divine or human, who may or may not play fair, and who will never *tell* whether they play fair (if all Cretans are liars, according to a favorite medieval *insolubilium*, then all Cretan architects may be liars too); places of confusion where we cannot, or will not, gaze at the stars that end each book of Dante's *Comedy*. This is the world in which we all live, or so says *The House of Fame*; this is also the world of texts, in which the poet lives. The only hope, a slim one, is that God will turn everything to good.

But however pessimistic this vision sounds, *The House of Fame* is not finally a pessimistic poem. It asks what a person, a poet, can *do* when forced to live in a labyrinth. He might reduce chaos to order by an act of faith and poetic affirmation, as Dante and Boethius did, believing that special guidance leads us above *labor* and *error* to see the true pattern of the universe laid out as clearly as the maze on a cathedral floor. Like those authors, a poet might even believe that his complex text, his wit-

59. Boitani suggests some additional patterns—a cave/labyrinth and Morpheus/Daedalus pairing: *Imaginary World of Fame*, pp. 178, 189–191, and 206.

ness to transcendence, could serve as Ariadne's thread to less visionary mortals. But however greatly Chaucer admired Boethius and Dante, his alter ego Geoffrey can follow them only so far, and Chaucer himself refused to fly by faith above a labyrinth he found inescapably multicursal, built from inseparable truth and falsehood. Perhaps he felt that his masters' order, their transcendence of the labyrinth, would be for him a false clarity, a poetic oversimplification, faith masquerading as fact: in short, no real answer at all. There *is* no overview of the labyrinth, at least not in this life, and nothing is clear but the uncertainties of the ambiguous maze above whose constraints we cannot rise.

Believing all this, some men might despair, but that response would never occur to Geoffrey, whose dream, after all, is wonderful: if these be labyrinths, they are enchanting ones, as full of delight as of frustration. The House of Rumor, nightmarish as it may be, is colorful, energetic, chock-full of magnificent diversity, far more beguiling than cosmic spheres. It cries out for the shaping mind and voice of the poet to give order and perspective where none exists. If that shaping is no more reliable than its material, so be it: perhaps a well-wrought poem in such a world is all the more admirable, and much more fun. The confusions and errors of the maze may be as attractive as the transcendent view. And if truth is always deferred, redefined by another twist, a fresh perspective, a different viewer, so what? Multiple voices, multiple perspectives, multicursal labyrinths, are Chaucer's stock in trade as a poet, most particularly in the *Canterbury Tales*. One must adapt to a labyrinth where transcendent vision is the exception and, like the miracles in Chaucer's religious poems (*The Prioress' Tale, The Man of Law's Tale, The Second Nun's Tale*), usually happens long ago or far away.

If Chaucer rejects the ordered overview that converts confusion to clarity, he substitutes something as valuable: the vibrant, chaotic, fertile, ambiguous, multiplicitous poetry of the labyrinth, poetry susceptible to an infinite variety of (mis)interpretations, poetry written *within* the labyrinth of the House of Rumor, with all its inescapable limitations.[60] *The House of Fame* may well be Chaucer's most confusing poem, weaving the labyrinths of words and concepts that medieval rhetoricians warn against and bewildering generations of readers; but it is also a poem that brilliantly satisfies what Morse Peckham describes as "man's rage for chaos."[61] Here Chaucer declares and celebrates a labyrinthine poetic of

60. Thus the House of Rumor, with its pilgrims, pardoners, and shipmen, may well herald the unreliable but thoroughly entertaining poetry of the *Canterbury Tales*: see Bennett, *Chaucer's Book of Fame*, pp. 180–183, and Leyerle, "Chaucer's Windy Eagle," pp. 259–260. And, I would add, the House of Rumor is the very best place to announce a labyrinthine aesthetic as well.

61. Peckham, *Man's Rage for Chaos: Biology, Behavior and the Arts* (New York: Schocken, 1967). Peckham argues that the best art, far from confirming the existence of order in the

Daedalian artistry. He shuns the authoritative voice of the infallible guide; and indeed most of his writings argue that there *are* no such guides—at least, none we are likely to encounter. The guides he offers— the narrator of the *Troilus*, say, or Harry Bailly—are as fallible as Virgil, the Eagle, and Geoffrey himself. Chaucer is not averse to the obviously Daedalian crafting of ornate poetry: *The House of Fame*, with its repeating patterns, echoing lines, and retracings of its model texts, is far more structured than it seems, and its somber labyrinthine companion piece, *The Knight's Tale*, bears witness to Chaucer's fascination with rhetorical and structural complexities, with how the careful symmetrical art of the diagrammatic labyrinth-maker attempts to control chaos. But that well-wrought tale of Theseus never fully transcends the labyrinths it describes, and it too questions the adequacy of any overview achieved by faith.[62] Moreover, it initiates a multicursal and multivocal work with many perspectives and many internal interpretations and reinterpretations, not least the divergent alternative paths charted by the Miller and the Man of Law in their direct responses to the Knight. Even the Parson, who concludes the *Tales* with what he thinks is a privileged and true perspective, knows there are many ways to salvation, though some are better than others.[63] In the absence of transcendent vision and truths so palpable one can shake them by the bills (867–869), Chaucer rejoices in confusion and complexity; like Alice of (biside) Bath, he relishes "wandrynge by the weye" (*General Prologue* 467) in labyrinths, and his characteristic artistic *labores* describe such *errores*. Perhaps he is simply following the advice of Theseus in *The Knight's Tale*, who had escaped at least one labyrinth (though not, for Chaucer, all of them):

> Thanne is it wysdom, as it thynketh me,
> To maken vertu of necessitee,
> And take it weel that we may not eschue. (3041–3043)

Chaucer's need to accept the inextricability of the maze was both philosophical and artistic, if we are to believe *The House of Fame*, and he converted that necessity into a great virtue. His writings reflect typically

world, disrupts normal perceptions of order so that perceivers must readjust their *idées fixes* to a closer approximation of reality.

62. If *The House of Fame* ends in a labyrinth, it can be argued that the *Canterbury Tales* begins with one: see Margaret F. Nims, "Translatio: 'Difficult Statement' in Medieval Poetic Theory," *UTQ*, 43 (1974), 215–230 (here, 227), and F. J. Flahiff, "The Crafty Art of Daedalus." I intend to expand on the insights of Nims and Flahiff and discuss some of the labyrinths of the *Tales*, and particularly the Knight's and Franklin's tales, in a later study.

63. "Stondeth upon the weyes, and seeth and axeth of the olde pathes (that is to seyn, of olde sentences) which is the good wey. . . . Manye ben the weyes espirituels that leden folk to oure Lord Jhesu Crist and to the regne of glorie. Of whiche weyes, ther is a ful noble wey" (*ParsT* 77–80).

Daedalian arts: the creation of astonishingly life-like statues and the making of multicursal labyrinths of words whose artistry depends on ambiguity, multiple perspective, and the systematic "elusion of clarity,"[64] even if, every now and then, that artistry (or at least our understanding of it) becomes "a ful confus mateere." This labyrinthine aesthetic is fully if circuitously enunciated in *The House of Fame* with its mazed narrator, settings, and structure; here Chaucer reconstructs, rather than transcends, the complexity of the many labyrinths in which we live and write—labyrinths we cannot, and perhaps do not even wish to, escape.

64. Surely the finest characterization of Chaucer's art in three words or less, the phrase is E. Talbot Donaldson's: "Chaucer and the Elusion of Clarity," *Essays and Studies 1972*, n.s. 25, 23–44. The structural basis of the multicursal labyrinth, of course, is precisely the systematic elusion of clarity.

For a different view of Chaucer and Daedalus, see Boitani, *Imaginary World of Fame*, p. 216.

Labyrinths in Manuscripts

The following labyrinths in medieval manuscripts are not included in either Kern's or Batschelet-Massini's catalogues.

1. Oxford MS. Bodley Auct. F. 6. 4 (S.C. 2150), consisting of an early thirteenth-century manuscript of Boethius's *Consolation of Philosophy* and a fourteenth-century manuscript of Nicholas Trevet's commentary on Boethius. Circular labyrinths, each in a different hand, appear on fols. 61av and 61bv, at the end of the *Consolation* and before the commentary, which seems to have been added later. The labyrinths seem to date from the thirteenth century.

A. A maze with thirteen circuits and a center medallion labeled *domus dedali*. Latin verses on the signs of the zodiac precede the maze. See plate 22.

B. A clumsily drawn maze with nine circuits and a center medallion labeled *domus dedali*, followed by a hymn in a late thirteenth-century hand whose text reads, "In terram Christus expuit / Saliuam terre miscuit / Et serui formam induit / Dei sapientia. // Illa mundans hec mundata / Illa creans hec creata / Unde lutum fit ex sputu / Sed non sputum fit ex luto / Assignant misteria. // Christus tamen sic providet / Quod non statim cecus vidit / Numquam videt cecus natus / Nisi prius baptizatus / In aquas misterii." A rough translation: "Christ spat on the earth / And mixed his saliva with earth / And clothed the features of the [his] servant / With [by] the Wisdom of God. // That purifying, this purified / That creating, this created, / Whence mud is made from spit / But spit is not made from mud. / They call such things mysteries [miracles?]. // Christ however thus foresees / What the blind man did not see at once. / The man born blind will never see / Unless he is first baptized / In the waters of the sacrament."

2. Florence MS. Bibl. Laur. Plut. 78.16, a fourteenth-century copy of Boethius's *Consolation of Philosophy*. At the end (fol. 58r) appears a circular maze with eleven circuits and a central medallion in which a man and a woman grip the hilt of a sword. See plate 23.

3. Paris BN. lat. 1745, containing miscellaneous MSS. of the ninth and eleventh centuries, including St. Ambrose, *De fide*; St. Augustine, *De haeresibus*; Agobard, *De correctione antiphonarii*; Heribertus, *De haereticis*; excerpts from the Old Testament; a notice of an act of Eudes, abbot of Saint-Germain, Auxerre.

A. Fol. 30v, after Agobard's text and before Heribertus's, illustrates a labyrinth, possibly in connection with Agobard's reference to the labyrinth, mentioned in Chapter 7. See plate 5.

B. Fol. 40r, a labyrinth after the Act of Eudes and preceding a table of contents.

Both labyrinths contain eleven circuits and a center medallion.

4. Dijon MS. Bibliothèque communale 562, 1250-1275; *Histoire ancienne jusqu'à César* from Acre, probably based on French originals. Fol. 115r shows a spherical building with countless doors and windows, before which stands the Minotaur. One of three illuminations of the story of the *Aeneid*. The legend reads, "Coment cil dathenes estoient sugiet a cil de crete." See Hugo Buchthal, *Miniature Painting in the Latin Kingdom of Jerusalem*, pl. 113b. See my plate 18.

5. Paris, MS. BN fr. 9682, ca. 1300; *Histoire ancienne jusqu'à César*. Fol. 142r shows the labyrinth as a three-dimensional building and the Minotaur, as above. See Buchthal, plate 151c.

6. Paris, MS. BN fr. 20125, thirteenth century; *Histoire universelle (Histoire ancienne jusqu'à César)*, French provenance. Fol. 158r shows a quadripartite diagram, apparently with eight circuits and no central medallion, as if projected onto a sphere; the paths seem to wrap around the sphere, passing beyond our line of vision. See my plate 19.

Index

Many aspects of the labyrinth—choice, artistry, inextricability, and so on—appear so frequently throughout this book that I often give only major page references. Some ubiquitous topics—such as ambiguity, guidance, and confusion—are indexed not at all. Bibliographical information is normally given in the first reference to the author or work.

Abbo of Fleury, 164
Abbreviation, 210–212
Abelard, Peter, 164, 190, 193, 200
Aegidius Romanus, 90
Aelian, 66–68, 80
Aeneas, 26–27, 30–33, 116, 135, 149, 169, 227–246, 248–253, 255, 258, 268, 277, 287, 289, 293, 298, 311, 313–319, 324–325, 331–333, 336
Aeneid. See Virgil
Aesthetic, labyrinthine, 95–96, 161–162, 192–221; and Boethius, 255, 258, 267–268; and Chaucer, 337–339; and Dante, 305–306; and Virgil, 232, 234–236, 246–247
Agobard of Lyons, 217, 342
Ahl, Frederick, 231, 235
Alan of Lille, 148; *Anticlaudianus*, 36
Alba longa, 27, 236, 245, 253
Alexander of Hales, 214
Allegory, 215, 219–220; and Cretan myth, 147–155; Dantean, 279–280
Allen, Judson Boyce: "Contemporary Theory," 9; *Ethical Poetic*, 90, 148, 195, 198, 202, 220; *Friar as Critic*, 149
Allen, Mark, 307
Ambages, 21, 24, 31, 34, 36–37, 53–56, 58, 66, 75–77, 82, 151–153, 212, 331; in *Aeneid*, 230–231, 239, 245; as literary term, 207; and literary text, 192–193, 217, 219

Ambrose, Saint, 73, 75–76, 79, 150, 177, 179, 182, 185, 239, 257, 318, 342
Amé, Emile, 117
Amiens, 118, 121–123, 127, 138, 162
Amphitheater, and labyrinth, 103–105, 284–285, 306, 327
Amplification, as rhetorical technique, 193, 210–214; in *HF*, 317, 324, 330
Anchises, 26, 28, 31, 229–230, 233–237, 240, 246, 248, 251
Ancient labyrinths, 20–25, 40, 66, 70, 102–104, 122–123, 288, 301, 304, 323, 325, 327–328; in *Liber sine nomine*, 158–161
Ancrene Riwle, 98
Anderson, William S., 227, 229, 241, 252
Androgeos, 11–12, 30, 34, 206, 233, 245
Anonymous of Erfurtensis Q. 5, 263
Anselm of Laon, 147
Ants, labyrinth of, 66–67, 80
Apollo, 13, 30, 32, 123; in *Aeneid*, 229, 234, 236–239, 251–252; in *HF*, 330–331
Apollodorus, 21
Aporia, 9, 62, 189
Apostrophe, 212
Aquinas, Saint Thomas, 67, 202–203, 263
Architect, of labyrinth, 21, 23, 50, 54, 56, 58, 61, 72–73, 102, 106; celebrated in church mazes, 121–123; and fame, 36, 121–123, 323; of House of Fame, 313,

Architect (*cont.*)
318, 325, 336–339; Louis of Bour-
bourg, 106–107, 112; poet as, 176,
188–189, 247, 249–250, 337–339; re-
sponsibility of, 47–48; sinner as, 73,
150, 169; as teacher, 56, 83, 85–91,
197. *See also* Daedalus; God as architect
Argument, labyrinthine, 51, 79, 86–90,
199–200; and Boethius, 255, 262–264;
and heresy, 164; in *HF*, 311–312, 320,
335
Ariadne, 12, 18, 31, 33, 35, 37, 47, 67–
68, 72, 77, 97, 116, 128, 134, 147, 150–
154, 159, 165, 172, 189, 224, 225; and
Aeneid, 230, 231, 238, 239, 245;
Chaucer's Legend of, 147; and *Comedy*,
280, 290–296, 301–305; and *Consola-
tion*, 255, 259, 265, 269, 270; Dido and,
234, 237; and *HF*, 308, 309, 311, 317,
325, 331, 337; Mary as, 161, 166–167,
299, 301, 304
Ariadne's thread, 47, 72, 77, 97, 134, 189,
224, 225, 239, 269, 270, 308, 337;
Christian dogma as, 77; confessor's
questions as, 290; *contemptus mundi* as,
159; cords as, 302–303; gold as, 159;
law of god as, 166; and Lucca maze,
308; Minos' tail as parody of, 295; sac-
raments as, 166; Saint Peter and, 303.
See also Ball of thread; Text as thread
Aristocratic tradition of labyrinths, 106–112
Aristotle, 198–201, 203, 205, 214, 216,
258, 277, 335; as pagan, 76, 78. Works:
Historia animalium, 199; *Perihermeneias*,
200; *Physics*, 82; *Posterior Analytics*, 199–
200; *Rhetoric*, 201, 214, 216; *De sophis-
ticis elenchis*, 199; *Topica*, 199
Aristotle's labyrinth, 76, 87, 198–201, 205,
262, 312, 314
Arnulf of Milan, 200–201, 205
Arnulf of Orléans, 149
Arthur, Ross G., 8
Artificial order, 69–71, 202–208, 211–
212, 214, 216–217, 246, 305; avoided
in Chaucer's *Aeneid*, 316
Artistry, labyrinth as sign of, 66–72, 101–
103; in church labyrinths, 121–123; in
manuscripts, 138–139, 142–144
Artistry, labyrinthine, of texts, 192–221
Artistry of labyrinth, 46, 52, 57–58, 66–
72, 97–100, 101–112, 309; in *Aeneid*,
28–29, 31–33; in *Comedy*, 274; in *Con-
solation*, 270; in *HF*, 312, 323–324, 332,
336–339; in historical-geographical tra-
dition, 20–22, 24, 26; overshadowed in
classical poetic tradition, 26, 31, 37; in
Ovid, 35–36; reflected in etymology,
97–99, 144; in visual arts, 101–103. *See
also* Divine artistry

Ascanius, 26–28, 33, 115, 234–236, 242,
245, 248, 250, 285
Ascensius, Jodocus Badius, 96–97
Assembly of Ladies, 23, 110–111, 116, 165,
171–175, 186, 322
Atkinson, J. Keith, 264
Augustine: *Confessions*, 272; *Contra academ-
icos*, 88, 164; *De civitate Dei*, 37, 81–82,
97, 103; *De doctrina christiana*, 8–9, 60,
71, 75, 197–198, 213–215; *De magistro*,
88–90, 187, 204, 224; theory of learn-
ing, 88–90, 213–215, 257–258
Ausonius, 33
Authority, in *HF*, 310–312; 316–319, 322,
323–326, 330–331, 333–337
Auxerre, 118, 129, 130, 185; heresy MS.,
49 (pl. 5), 139, 342; labyrinth ritual, 68,
123–127, 156, 285, 296
Avarice and labyrinth, 159
Avignon as labyrinth, 117, 158–162, 309

Babylon as labyrinth, 116–117, 158
Backman, E. L., 123, 125
Bacon, Roger, 334
Badel, Pierre-Yves, 162
Baldwin, R. F., 96
Ball, Robert, 272
Ballgames and labyrinths, 123–127
Ball of pitch, 12, 126, 151, 153–154, 166,
301, 304
Ball of thread, 12, 23–24, 32, 104, 126,
151, 153–154, 166, 301
Baltzell, Jane, 202
Baptism and labyrinths, 73–74, 120 (pl.
15), 166
Barolini, Teodolinda, 272, 295
Barricelli, J.-P., 169
Bartholomeus Anglicus, 334
Barzizza, Giovanni, 104
Baswell, Christopher C., 147, 149, 228,
257, 308–311, 316–317, 319, 331
Batschelet-Massini, Werner, xvii, 4, 40, 69,
76, 116–117, 123–125, 131–132, 134,
138–139, 142, 341
Beatrice, as Ariadne, 291–294, 302–
304
Beginning and ending, coincidence of,
204, 218–219, 263–264, 281; in *HF*,
313–315, 317–319, 336
Beleth, John, 123
Bennett, J. A. W., 310–311, 323, 326, 327,
331, 337
Benvenuto da Imola, 10, 36, 282, 296
Berengar of Tours, 164
Bergin, Thomas G., 167, 169
Bernard of Clairvaux, 190–191
Bernard of Gordon, 170–171
Bernard Silvester, 97, 148; Pseudo-
Bernard (*Commentary on the Aeneid*),

Bernard Silvester (*cont.*)
 xviii, 10, 33, 206, 229, 235, 239, 246,
 250, 301, 324
Bersuire, Pierre, 35, 126, 150–155, 159,
 165, 167, 290, 298, 300, 309
Bivium, 46, 51, 76–77; in *Aeneid*, 239–240,
 242; aesthetic choice and, 205–207; in
 Comedy, 281; in *Queste*, 178–186
Blindness and vision, 27, 30–31, 34, 54,
 64, 70, 71, 75–77, 82, 133, 142, 159,
 161; in *Aeneid*, 229–231, 233–234, 240–
 243, 245; in *Comedy*, 271, 292, 298, 304,
 306; in *Consolation*, 257–268; in *Corbac-
 cio*, 168–171; in *HF*, 313, 321, 322, 327,
 332, 334; in *Queste*, 187–188. *See also*
 Darkness
Bloom, Harold, 248
Bloomfield, M. W., 9, 187–188
Bober, Harry, 197
Boccaccio, Giovanni, 177, 226, 278, 302,
 318; on mazes, 41, 43–44, 104, 107,
 282. Works: *Comento*, 41, 104, 294; *Cor-
 baccio*, 150, 160, 165, 167–172, 239,
 273; *De genealogia*, 149–150, 154–155,
 167, 169, 170, 193–195, 209, 214–217,
 290, 302
Boenig, Robert, 331, 333, 335
Boethius, 39, 53, 168, 204, 223–226; and
 Chaucer, 307–309, 311–313, 316, 317,
 319, 320–322, 324, 326, 329, 331–333,
 335–337; *Consolation*, translation of,
 190, 209–210; *Consolation* and MS. il-
 luminations, 139, 142–144 (pl. 22),
 255–256 (pl. 23), 341; and Dante, 272–
 273, 277, 287, 291–293, 298, 305–306.
 Works: *Consolation of Philosophy*, 74, 87–
 88, 198, 200, 254–270, 281; *In Isagogen
 Porphyrii commenta*, 264; *In topica
 Ciceronis*, 264
Boitani, Piero, 310–311, 315, 326–327,
 333, 336, 339
Bolton, Diane, 255
Bonaventure, Saint, 214
Boncompagno da Signa, 170, 200, 217,
 314, 321
Bond, Francis, 74
Bonnin, M., 11
Bord, Janet, 3, 107
Borgeaud, Philippe, 3, 25, 47, 55, 239
Botterill, Steven, 295, 302
Bovo of Corvey, 262
Boyle, A. J., 227, 230, 233, 237, 240, 246–
 247, 252
Brain as labyrinth, 84–85
Branca, Vittore, 150
Brieger, Peter, 274, 282–284, 288, 295
Brind'Amour, Lucie, 8
Brooks, Robert A., 228
Bruyne, Edgar de, 202

Buchthal, Hugo, 43, 342
Building, labyrinth as, 18–26, 29, 97–98,
 103–112, 147, 203–204; in *HF*, 323–
 331; in MSS., 135
Burlin, Robert B., 309, 333
Burns, E. Jane, 189, 194, 208, 212
Business, labyrinths of, 79
Buti, Francesco da, 282, 296

Cage, labyrinth as, 135, 153, 327–329
Calin, William, 214
Calvino, Italo, 220
Canterbury, 118
Cassell, Anthony K., 167–169, 295
Cassiodorus, 86
Castellani, Victor, 305
Catacombs, as labyrinth, 80
Catullus, 20, 228, 247
Caumont, Seigneur de, 115–116
Cave, labyrinth as, 21, 25, 48, 76, 80–81,
 104, 106, 336; in *Aeneid*, 238–239, 241;
 in *Comedy*, 282, 289
Center, importance of, 40, 46–47, 54–56,
 58
Chadwick, Henry, 254
Chambers, E. K., 123, 125
Chance, Jane, 239
Charageat, Marguerite, 107
Charland, Th.-M., xvii, 96, 203–204, 213,
 218–219
Chartres, 118, 121, 129, 131–133 (pl. 17),
 308; and dance, 123
Chartres-type labyrinth, 49 (pl. 5), 134–
 135
Chaucer, Geoffrey, xvii, 18, 98, 114, 165,
 201, 223–226, 268, 270, 307–339;
 knowledge of labyrinth tradition, 308–
 311, 332; pessimism about escape from
 labyrinth, 312–315, 319, 326–327, 330–
 339; secular use of labyrinth, 309, 312;
 skepticism, 333–336. Works: *Book of the
 Duchess*, 46, 324; *Canterbury Tales*, 198,
 209, 219, 281, 310, 335, 337–338; *Gen-
 eral Prologue*, 338; *HF*, 10, 23, 25, 116,
 273, 307–339; *Knight's Tale*, 80, 318,
 335, 338; *Legend of Good Women*, 98,
 147, 308–309, 328; *Man of Law's Tale*,
 337–338; *Parson's Tale*, 338; *Prioress's
 Tale*, 337; *Second Nun's Tale*, 337; trans-
 lation of Boethius, 209–210, 262;
 Troilus and Criseyde, 201, 210, 309, 338
Chiapelli, Carolyn, 322
Chiarenza, Marguerite, 272
Choice, 40–41, 46–51, 58, 62, and pas-
 sim; in *Aeneid*, 250; and central texts,
 224–225; in *Comedy*, 277, 279, 281–283,
 287, 289, 292, 302; in early Christian
 writers, 72, 76–78; in labyrinthine nar-
 rative, 176; and moral mazes, 146;

Choice (cont.)
Pythagorean, 46, 50; and *Queste*, 177–189
Christ-Theseus, 53, 64, 70–71, 73–74, 77, 100–101, 261; in Auxerre ritual, 124–128; in church mazes, 130–133, 135; in *Comedy*, 279–280, 285–286, 296, 299–304; in MSS., 139–144; in mythographers, 151–154, 159; in *Queste*, 183–185
Church labyrinths, 53, 70, 72, 114, 117–133, 161, 313, 325; Amiens, 121–123, 127, 138; Auxerre, 118, 123–127, 129, 185; Chartres, 121, 123, 129, 131–133 (and pl. 17), 157, 185; Cologne, 130; in England, 118; Lewannick, 118, 120 (pl. 15); Lucca, 127–128, 308; Pavia, 117, 308; Piacenza, 308; Poitiers, 40, 112, 118; Ravenna, 128; Reims, 121–123 (and pl. 16), 127, 138, 308; Saint Mary Redcliffe, Bristol, 118–119 (and pl. 14), 123; San Reparatus, 81, 121; Sens, 118, 123, 129; and cosmic order, 125–133; and harrowing of hell, 123–128; liturgical uses of, 123–128; and *rota-rosa*, 128–133, 157; as sign of artistry, 121–123, 138, 204; substitute pilgrimage theory, 119–121; symbolism of, 118–133
Cipolla, Gaetano, 3, 46, 158, 160
Circe, 32, 240, 250, 258, 265, 266, 268
Circles, broken, and labyrinth, 103; and sound, 320–321; and *Timaeus*, 278–279
Circles, concentric, and labyrinth, 49, 103–104, 128–134, 142–144, 197, 319–322; and *Comedy*, 274–276, 281–286, 305; and *Consolation*, 258–266, 270; in eye, 84–85
Circling movement, as labyrinthine, 204
Circuitio, 212
Circuitousness, 48, 54, 58–59, 82–83, 87–91, 150, 176, 183, 186–187, 195–197, 200, 204, 224; in *Aeneid*, 229–231, 245; and amplification, 212–213; in *Comedy*, 283–284, 287, 289–291, 306; in *Consolation*, 256, 259, 269; in etymology, 98; in *HF*, 316–317, 320, 326, 332
Circular reasoning, 262–264
Circulatio (circuitous development), 218–219
Circumlocution, as trope, 212
Cities, and labyrinths, 43, 115–117, 138, 141 (pl. 21), 143, 158–162, 234, 236, 245–246. *See also* Alba longa; Avignon as labyrinth; Dis; Jericho; Troy
Clark, Raymond J., 3, 20, 25
Clarke, Edwin, 83–84
Claudian, 25
Clausen, Wendell, 237, 252

Cloanthus's cloak, 235, 319
Colish, Marcia, 8
Commager, Steele, 228
Compasses, labyrinth and, 13, 49, 103, 130, 203–204, 284, 293, 298, 305, 318, 320, 324–325
Complexio, 213
Complexity, as labyrinthine characteristic, 22–24, 28–29, 36, 52, and passim; and labyrinthine aesthetic, 192–221
Concentric circles. *See* Circles, concentric
Concentric panels, 232, 239, 242, 246–247
Conscience, labyrinth of, 290
Consolation of Philosophy. See Boethius
Constantinople, as maze, 138
Conte, Gian Biagio, 248–249
Convertibility, labyrinthine, 24, 33, 36, 52–53, 58, 61, 70–72, 79, 81, 156–158; and Chaucer, 311–313, 319–322, 324, 326, 329, 332, 335–337; in *Comedy*, 278–279, 284, 305–306; in *Consolation*, 254–255, 258, 262–266, 269–270; in labyrinths of learning, 87–90; and *rota-rosa*, 129–133; and texts, 193–197, 224
Convivio. See Dante
Corbaccio. *See* Boccaccio, Giovanni
Corbin, Henry, 156
Corrupt art, labyrinth as, 150, 170–171
Corruption, labyrinth as, 158–160
Cosmic labyrinth, 68–69, 86–87, 125–138, 142–144, 153–155, 158, 187; in *Aeneid*, 231, 233, 248–253; in *Comedy*, 281, 284–286, 292–293; in *Consolation*, 255, 266–268; in *HF*, 320–321; and Round Table, 183
Courcelle, Jeanne, 228
Courcelle, Pierre, 228, 254, 255, 263, 298
Cowen, Painton, 133
Crabbe, Anna, 247, 269
Cretan labyrinth, 21–25, 32, and passim
Cretan myth, summary, 11–13
Cretan-type labyrinth, 40, 134–135
Crisp, Frank, 107
Critchlow, Keith, 131
Crooke, Helkiah, 84
Cross, superimposed on Chartres-type labyrinth, 103, 130–131, 134–135
Crow, Martin M., 308, 322
Cruttwell, Robert W., 227, 237, 242
Cryphia, and difficulty, 86
Culler, Jonathan, 4
Cumae, labyrinths at, 13, 30–33, 123, 229, 236–239, 242, 251–252, 258, 318, 331
Curtius, E. R., 205

Daedalus, 11–13, 21, 23, 26, 29–38, 67–70, 76, 88, 97–100, 106–107, 112, 116,

Daedalus (*cont.*)
147, 150–154, 159–161, 163, 203, 308; Aeneas as, 229, 234, 237; in *Aeneid*, 227–229, 231, 232, 234, 235, 237–239, 245, 247, 250–253; and Ariadne's dancing floor, 18, 67; as Christ, 154; in *Comedy*, 290, 292, 296–299, 305; in *Consolation*, 255, 258, 259, 265, 266; as figure for God, 153–154; as figure for poet, 161–162, 204, 310, 324, 338–339; forgetting design of maze, 32, 36, 52; God as, 67, 69, 72, 128–133, 142, 320–321; in *HF*, 310–311, 315, 325, 331, 335, 336, 338–339; reputation, 35–36; Socrates as offspring, 35, 87; and statues, 35, 315, 323–324, 339. *See also* God as architect

Daedalus, as adjective, 32–33
Damon, Phillip, 281, 288, 303
Dance, labyrinth, 18, 25, 27, 67, 68, 123–127, 133; of Ariadne, 302; and Dante, 285; at Delos, 12, 68, 125, 127, 234, 236, 252, 285, 292, 296; of Minotaur, 296, 302
Dancing-floor, Ariadne's, 18, 67
Dane, Joseph A., 310, 316
Dante, 10, 18, 53, 118, 157, 223–226, 271–307, 309, 311–313, 316, 318–322, 327, 329, 332, 333, 336, 337; and *Consolation*, 258, 262, 266, 268, 270, 272, 287–288, 293, 298–299, 305; illuminations of *Comedy*, 136, 274–278 (pls. 24–25). Works: *Convivio*, 272–273, 301; *Divine Comedy*, 10, 23, 41, 82, 148, 168–169, 206, 232, 271–307; *Letter to Can Grande*, 279
Daremberg, Charles, 25
Darkness, associated with labyrinth, 21, 25, 36, 76, 82, 104, 133, 142, 153, 159, 161, 168, 170–171, 176, 206; in *Aeneid*, 230–231, 234, 240–243, 245; in *Comedy*, 285, 287, 288, 289. *See also* Blindness and vision
Data, labyrinth of, 48, 86, 156–157, 201, 314
David, Alfred, 2, 309
David and Goliath, 127
Death, labyrinth and, 31, 37, 50, 73–74, 76, 139, 151, 189
Deconstruction of maze, 62
Dedalus as synonym of *labyrinth*, 97–98
Deedes, C. N., 3
Definitions, labyrinths of, 217, 314
Deguilleville, Guillaume de, 157
Delany, Sheila, 310, 333
Delay, 49, 263; in *Aeneid*, 31–32, 230, 234, 238, 241, 244–245, 248, 252–253; and amplification, 212; in *Assembly of Ladies*, 172–174; in *HF*, 314, 316–318, 337; in

Purg., 283, 289–290; in *Queste*, 183, 186–187
Delos. *See* Dance, at Delos
Demaray, John G., 119, 123, 133, 272
Denis the Carthusian, 200, 263
Derrida, Jacques, 55
Deschamps des Pas, L., 117
Desert as labyrinth, 48, 79, 287, 318
Dialectic and labyrinth, 87–90, 199–201, 257–258, 268–270, 312, 320, 325–326, 332
Di Cesare, Mario, 227, 229, 232, 235, 237, 242
Dickerson, A. Inskip, 333
Dido, 230–238, 245, 251, 253, 311, 316–318, 333
Diehl, Huston, 60, 119, 200
Difficult process, labyrinth and, 36, 56–57, 82–91, 102, 193–221
Difficulty: educational value of, 88–90, 213–221, 225; joy of labyrinthine, 86; labyrinth and, 36, 46, 86, 152, 154, 213–221, and passim
Digression: in *HF*, 315–317, 320, 326; as trope, 212–213
Dimock, George E., 252
Diodorus of Sicily, 17, 20, 23, 35
Dis, city of, in Dante, 282, 288–289, 300–301
Disposition (rhetorical): labyrinth as composite model for, 201–211; labyrinths of, 197, 201–211
Dispute, labyrinth of, 79
Distinctio and labyrinth, 196
Divine artistry, labyrinth and, 142–144, 153, 166–167, 188, 254–270, 284–286, 297–298. *See also* Cosmic labyrinth; Daedalus; God as architect
Divine Comedy. See Dante
Divine mystery, labyrinth and, 67–71, 80–82, 86–87, 177–178, 187–189; in *Aeneid*, 261–262; Chaucer's Fame and parody of, 325–326; in *Comedy*, 292–295, 299, 305–306; in *Consolation*, 263–264, 270
Dolphins, and labyrinth patterns, 27, 29, 241–242
Domus daedali, as synonym of *labyrinth*, 97–100
Donaldson, E. Talbot, 156, 339
Doob, Penelope B. R., 3, 124, 160
Double nature of Christ, 126, 153–154, 301–302, 304–305
Duality of labyrinth, 52, 57, 77–78, 82, 117, 129–133; in labyrinthine narrative, 176; as model for texts, 197; and Petrarch, 162; reflected in etymology, 96–100
Dubitatio, 213; in *HF*, 314

duBois, Page, 227–228, 237, 246, 251
Du Cange, Charles, 86, 123
Duckworth, George E., 246
Durand, Julien, 117
Durand, William, 118, 127–128
Durand of Troarn, 164
Dwyer, Richard A., 254

Easter and labyrinth, 123–128, 132, 138, 142–143, 280, 285, 296. *See also* Christ-Theseus
Easter computus, 132, 138, 142–143
Eberhard of Germany, 97, 138, 156, 194, 213
Echecs amoureux, Les, 110, 162–163, 290
Eckhardt, Caroline, 254–255
Eclogue of Theodulus, 149
Educational, labyrinth as, 56–57, 82–90, 225, and passim
Egyptian maze. *See* Ancient labyrinths
Eichholz, D. E., 227
Elbow, Peter, 44, 254–255
Eldredge, Laurence, 333
Eliot, T. S., 56–57
Elocutio, labyrinths of, 197–198, 211–213
Enk, P. J., 227–228, 237, 239
Ennodius, 68–70, 86, 202, 205
Enthymeme, 199
Epistemology, labyrinths of, 56–57, 82–91, 156–157, 201; in *Comedy,* 292–293; in *Consolation,* 255–257, 260, 264–265, 268–270; in *HF,* 311–313, 321–322, 329, 332–339
Erasistratus, 84
Erasmus, 200
Error, 30, 48, 50, 58, 72–73, 75–76, 176–177, 188–190, and passim; in *Aeneid,* 229–230, 233, 235, 237–238, 241, 245, 252; as circular, 76; and digression, 209, 211, 316–318; and heresy, 76–78, 163–164; in *HF,* 332–336; and madness, 160; medieval connotations of, 145, 190, 332; reflected in etymology and synonyms, 98–100
Essential characteristics of labyrinth, 45, 51–58, 96, 153, 332; reflected in etymology and synonyms, 96–100
Esslin, Martin, 195
Etrurian labyrinth. *See* Ancient labyrinths
Etymology, of *labyrinth,* 8, 80, 95–100, 147, 326; of *Corbaccio,* 168; of Theseus, 301
Evans, Arthur John, 25
Explanations, labyrinth of, 86
Explication, 70–71, 88, 151, 178–188, 262–264; and labyrinthine narrative, 176, 220
Expolitio, 212
Eye, labyrinthine diagrams of, 84–85 (pls. 7–8); and rose window, 133
Ezekiel. See Jerome, Saint

Failed artistry, labyrinth and, 32, 237–238, 247, 253
"Fals and soth compouned," 313, 322, 324–326, 330, 332, 335
Fama (in *Aeneid*), 324
Fame: as character in *HF,* 318, 324–326, 331; and church labyrinths, 121–123, 308; as concept in *HF,* 309, 311, 323–324, 330; and labyrinth, 23, 25, 28, 31, 68–69, 161–162, 246, 296
Faral, Edmond, xvii
Fein, Susanna Greer, 175–176, 181, 207–208, 210
Festus, 33, 80
Fichte, Joerg D., 310, 333
Fitzgerald, William, 227, 235, 237–239
Flahiff, F. T., 36, 296, 338
Fletcher, Jefferson B., 302
Flight, Daedalian, 12–13, 30, 152; in *Aeneid,* 235, 238; in *Comedy,* 289, 292, 297–299, 303; in *Consolation,* 258–259, 265, 269; in *HF,* 312, 319–322, 332, 334
Florentius, 121
Forest as maze, 48, 78–79, 177–178, 181, 209, 216; in *Aeneid,* 239; in *Comedy,* 274, 287
Forgetting path in maze, 32, 36, 47, 52, 216
Forma tractatus and *forma tractandi,* 198, 202
Form of labyrinth: changes over time, 134–135; Chartres-type, 49 (pl. 5), 134–135; of church mazes, 118, 125; circular, implications of, 103, 117, 128–135, 272, 278–279, 286; Cretan-type, 19 (pl. 1), 40, 116, 134, 253; diagrammatic, implications of, 61, 102–103, 112–144, 313; diagrammatic, and Trojan Ride, 29; hierarchy of forms, 56, 96; nearing center and deviating outward, 49 (pl. 5), 179–180; number of circuits, 130–131, 134; octagonal, 127; Otfrid-type, 105 (pl. 9), 134; significance of, 39–63, 102–103, 134, 146; unicursal vs. multicursal, 3, 18–19, 39–63. *See also* Multicursal model; Three-dimensional mazes; Two-dimensional mazes; Unicursal model
Formulaire de Tréguier, Le, 36, 201
Fortune and labyrinth, 74–75, 129–131, 157–158, 179–190, 332; in *Consolation,* 257, 259–261, 265–268
Foster, Kenelm, 304
Fournival, Richard de, 162
France, four labyrinths of, 164, 190–191, 200
Fraud, labyrinth of, 164
Freccero, John, 271–272, 278–281, 285, 288–289, 298, 305, 327

Free will and determinism, 47–51, 62, 249, 267, 293. *See also* Choice; *Rota-rosa*
Friedman, John Block, 130
Fry, Donald K., 331, 333
Fulgentius, 149, 151, 240, 300
Function: of ancient labyrinths, 22–23, 31, 35; of church labyrinths, 118–133
Fyler, John M., 307, 311, 319, 324–326, 333

Gadamer, Hans-Georg, 195
Gailhabaud, Jules, 117, 121
Galen, 83–84
Gallo, Ernest, 203
Galpin, S. L., 162
Ganymede, 235–237, 319
Garden mazes, 106–113 (and pl. 11), 163, 165–167, 172–173, 209
Gellrich, Jesse M., 54, 102, 310–311, 333
Genitalia, labyrinth as female, 170–171
Geoffrey of Vinsauf, 71, 193–195, 216; *Documentum*, 198, 211–214; *Poetria nova*, 202–207, 211–214
Gérusez, J. B. F., 119
Geryon, 288–289, 321–322
Gesta Romanorum, 165–167, 175, 193–194, 219
Ghisalberti, Fausto, 35, 149, 151
Gibaldi, Joseph, 232
Gibson, Margaret, 209, 254
Giglioli, G. Q., 27
Gilabertus, 121
Gilbert of Poitiers, 164, 190–191
Giovanni del Virgilio, 149
Giraut de Bornelh, 217–218
Gislebertus, 121
Gleason, Mark J., 210
Glossa ordinaria, 127–128
God as architect, 62, 67–69, 72, 87, 100, 135, 142, 153–155, 188–189, 261–266, 284–286, 297–298, 305, 320
Godefroy, Frédéric, 145, 190
God's justice as labyrinth. *See* Divine mystery
Golden bough, and labyrinths, 239
Gombrich, E. H., 43, 59
Gothein, Marie Louise, 107
Gougaud, Louis, 123
Gower, John, 98, 101, 114, 147, 165
Graphia Aureae Urbis Romanae, 80
Graves, Robert, 20
Greene, Richard Leighton, 124
Gregory of Nazianzus, 67–68, 70–71, 80, 86–87, 133, 164, 177, 257, 292
Gregory of Nyssa, 73–74, 125, 127, 154, 177, 257, 300
Gregory Thaumaturgus, 73, 78–79, 82, 86, 117, 239, 257–258, 318
Grennen, Joseph E., 321, 327
Gross, Kenneth, 295

Guibert de Nogent, 67, 218
Guido da Pisa, 300, 302
Guzzardo, John, 283

Hades as labyrinth, 159, 169, 239–240
Hadot, Pierre, 68
Hall, Louis Brewer, 311
Hardships, labyrinth as, 151
Harrowing of hell, 101, 124–128, 132–133, 142, 153–154, 157, 184, 280, 285–286, 300–304. *See also* Christ-Theseus
Harvey, John, 106–107
Hearing as labyrinth, 83
Hedge-maze. *See* Garden mazes
Hell, labyrinth as, 35, 50, 125–127, 130, 139, 151, 153, 158–160; in *Comedy*, 281–283, 288–289, 294–296, 300–305. *See also* Harrowing of hell
Heller, John L., 27–28
Heltzel, Virgil B., 107
Henry of Clairvaux, 164
Hercules, 46, 59–60, 229, 238–239, 241–242, 244, 250–251, 266, 298, 300
Hereford Mappa Mundi, 136
Heresy, labyrinth of, 49, 76–81, 139, 160, 163–164, 193, 217, 288–289, 301
Herodotus, 17, 20–21, 23, 25
Herostratus, 326
Higden, Ralph, 67, 104, 107, 201, 314, 326, 330
Hildburgh, W. L., 116
Hippolytus of Rome, 76, 80–81, 83
Histoire ancienne jusqu'à César, 106, 135–137 (and pls. 18–19), 228, 329, 342
Historian-geographers, on labyrinth, 17–26, 30, 37–38, 102–103
Historicity of Cretan myth doubted, 37, 147
Holkot, Robert, 290–291, 333
Hollander, Robert, 272, 278, 280, 287, 289, 294, 301
Holt, Philip, 247–248
Homer, 18, 325, 333
Hopper, Vincent Foster, 127
House of Fame. See Chaucer, Geoffrey
House of Fame as labyrinth, 323–326
House of Rumour as labyrinth, 326–330
Hoveden, Roger, 164
Howard, Donald R., 119, 209, 308, 310
Hugh of St. Victor, 97, 193, 195–197; *De arca noe morali*, 195; *Didascalicon*, 196, 201, 204, 216–217, 292, 321, 327
Huguccio of Pisa, 97
Hunt, J. William, 235, 245–247, 252
Hybrid monsters, in *Aeneid*, 230–232, 235, 237–238, 240–241, 250–251; in *Comedy*, 288–289, 295–296, 300–301; in *Consolation*, 256, 266; in *HF*, 324
Hyginus, 149

Iannucci, Amilcare, 280, 300, 303–304

Icarus, 12–13, 32–33, 117, 152–153; in
 Aeneid, 235, 238, 245, 250; in *Comedy*,
 289, 297–299, 305; in *Consolation*, 258;
 in *HF*, 311, 321
Ihle, Sandra Ness, 175–176, 178, 184,
 187–188, 212
Illuminations, in MSS.: in *Aeneid*, 139; in
 Comedy, 274–276 (and pls. 24–25); in
 Consolation, 139–144 (and pl. 22), 255,
 256 (pl. 23), 270; context of, 135–144;
 initial and terminal labyrinths, 138–139,
 270; as marginal marker of difficulty,
 86; types, 134–145
Impenetrability of maze, 1, 23, 25, 55–56,
 58, 66, 72, 80–82, 96–97, 106, 177–
 178, 224, 281, 293, 328. *See also* Divine
 mystery
Inexplicability of maze, 21, 24, 55, 187–
 188, 193, 219, 224, 309, 323
Inextricability of maze, 1, 12, 21–25, 30–
 32, 37, 46–47, 50–51, 55–56, 58–59,
 65–67, 69, 72–83, 86–88, 96, 100, 104,
 106, 125–128, 130, 139, 146, and
 passim
Infinity, labyrinth as, 81–82, 177
Intellectual mazes, 46, 53, 78–79, 82–90,
 100, 156–157, 192–221, 292–293, 303,
 314, 323, 327, 329, 333–335
Interlace, 48, 84, 96, 121, 191, 206–211
Interpretatio, 212
Interpretation, as labyrinthine process,
 70–71, 75, 193, 225, 314–315
Invention, labyrinths of, 197–201
Iopas' song, 252–253
Irrweg, 98–99
Irvine, Martin, 310, 320–322
Iser, Wolfgang, 216
Isidore of Seville, xvii, 8, 86, 95–96, 102–
 104, 112, 117, 136, 138, 142, 203

Jacobson, Howard, 20
Jauss, Hans Robert, 4, 8–9, 223, 277
Jean de Meun, 125, 190, 209, 262
Jeauneau, Edouard, 148
Jeffery, V. M., 168, 170
Jericho, and labyrinths, 106, 116, 138,
 141 (pl. 21), 280, 283, 303–304
Jerome, Saint, 79–80, 205, 292; *Contra
 Iohannem*, 79; *Ezekiel*, 69–71; *Zachariah*,
 64
John of Garland, 149, 197–198
John of Salisbury, 199–200
Johnson, W. R., 249, 252
Jones, F. J., 161
Jordan, Robert M., 96, 310, 333
Joyner, William, 311, 314, 316
Judgment and labyrinth, 23, 35
Judgment Day II, 98
Julian, Saint, 28, 115–116, 173, 308, 322–
 323

Julian's Bower, 28, 115–116 (pl. 13), 322
Juvenal, 17, 147

Kardon, Janet, 216
Katzenellenbogen, Adolf, 118
Kean, P. M., 310, 333
Kelly, Douglas, 198, 202, 206–208, 212
Kern, Hermann, xvii, 3–4, 9, 18, 21, 25,
 27, 40, 43, 60, 80, 106, 113–117, 119–
 121, 123, 125, 128, 130, 134–136, 138–
 139, 142, 170, 308, 329
Key pattern, 40, 51 (pl. 6)
King, Cynthia, 227
Knapp, Bruce, 129
Knight, Stephen, 327
Knight, W. F. Jackson, 3, 227, 237
Knossos, 25, 40
Knox, Bernard M. W., 230, 235, 247
Kolve, V. A., 148, 182, 224
Koonce, B. G., 309, 311, 327
Kraft, Christine, 162

Laberinto d'amore. See Boccaccio, Giovanni:
 Corbaccio
Laberinto de Fortuna. See Mena, Juan de
Labor: as theme in *Aeneid*, 229–230, 233,
 235, 237–238, 240, 245, 252; as word,
 32, 97–100, 144
Labor intus, 44, 80, 97–100, 147, 192, 196,
 332, 335
Labriolle, Pierre de, 68
Labyrinth: as model for literary creation,
 interpretation, and reception, 7, 48, 51,
 62, 176, 192–221, and passim; as pe-
 jorative term, 7, 86, 100, 139, 160, 190–
 191, 193–197, 202, 220–221; sculptor's,
 199
Lambert of Ardres, 106
Langland, William (*Piers Plowman*), 156–
 157, 198, 204, 218–219
Language, labyrinths of, 83, 86–90, 192–
 221, 320–331, 333–339. *See also* Proph-
 ecy, labyrinth as; Text: as labyrinth
Lansing, Richard H., 283
Laocoon, 230–232, 234, 238, 244–245
Latham, R. E., 145
Latini, Brunetto, 117, 287
Law, and labyrinth, 23, 35, 174
Lawler, Lillian B., 18
Lawler, Traugott, 198
Lay of the Lecher, 170
Learning process, labyrinth and, 56–57,
 77–79, 82–90, 199–200, 213–220, and
 Part Three, passim
Lemnos, labyrinth of. *See* Ancient
 labyrinths
Leo, Ulrich, 272
Leonard, Saint, 315–316, 320
Lerer, Seth, 89–90, 254, 261, 263, 268–
 270

Letter labyrinth, 81, 121

Lewis, C. S., 172, 210

Lewis, Charlton T., and Charles Short, xvii

Lexis of labyrinth, 30–32, 36, 97–100

Leyerle, John, 207–209, 211, 307; "Interlace," 96, 207, 209; "Rose-Wheel Design," 118, 129–133, 284; "Windy Eagle," 319, 321, 337

Liber floridus, 138

Life, labyrinth of, 51, 62, 73–75, 129–133, 139, 155–157, 161, 166–167, 277, 332, and passim

Linear and cyclical, labyrinthine fusion of, 1, 81–82, 103, 128–130, 225; in *Aeneid*, 246–247; in *Comedy*, 280–281; and learning, 89–90; in literary composition, 204–207, 211

Literary structure, labyrinthine, 157, 161, 172–191, 196, 198, 206–211; in *Aeneid*, 227–253, esp. 246–247; in *Comedy*, 271, 287–293; in *Consolation*, 254–270, esp. 268–270; in *HF*, 309–339

Literary theory, medieval, 192–221, 310

Literature, labyrinthine, 165–339; characteristics of, 176, 195, 223–226

Logic, labyrinths of. *See* Argument; Aristotle's labyrinth; Dialectic and labyrinth

Love, labyrinth of, 160–164, 311, 332

Lowes, John Livingston, 160

Lucian, 86

Lucretius, 32–33

Lust, labyrinth of, 31, 34–35, 37, 107, 150, 158–160, 167–171, 180, 183, 189, 234

Lusus Troiae. *See* Trojan Ride

Lydgate, John, 104, 106, 155, 157, 163, 310

MacDougall, Elisabeth Blair, 106

Machaut, Guillaume de, 214

MacKay, L. A., 240

Macrobius, 257; *Commentary on the Dream of Scipio*, 131; *Saturnalia*, 86

Magi, labyrinth and, 139

Mâle, Émile, 118, 127

Manuscripts mentioned: Berlin Staatsbibliothek Preussicher Kulturbesitz lat. fol. 930, 105 (pl. 9); Cambridge Trinity Hall 12, 139; Dijon Bibliothèque municipale 562, 106, 135–136 (pl. 18), 228, 329, 342; Florence Bibl. Laur. Plut. 78.16, 138–139, 256 (pl. 23), 342; Florence Bibl. Laur. Plut. 89, infer., cod. 41, 80; Ghent University Library 1273, 85 (pl. 8); London BL Add. 27304, 149; London BL Add. 33220, 147; London BL Burney 131, 97; London BL Harley 3095, 262; London BL Royal 15 B 3, 106, 264; London BL Sloane 981, 84 (pl. 7); Munich Bayerische Staatsbibliothek Clm 800, 139; Munich Bayerische Staatsbibliothek Clm 14731, 138–141 (pls. 20–21); Oxford Bodley 376, 97; Oxford Bodley Auct. F. 6. 4, 138–139, 142–143 (pl. 22), 341; Oxford Bodley Douce 298, 190, 263; Oxford Bodley Douce 352, 190; Paris BN fr. 9152, 122 (pl. 16); Paris BN fr. 9682, 106, 135–136, 228, 329, 342; Paris BN fr. 20125, 106, 135–137 (pl. 19), 228, 342; Paris BN lat. 1745, 49 (pl. 5), 138–139, 342; Paris BN lat. 13013, 136, 138; Paris BN nouv. acq. lat. 2169, 138; Saint Gall 825, 139; Vatican Bibl. Apost. Barb. lat. 274–276 (pls. 24–25); Vatican Bibl. Apost. lat. 1960, 138; Zwettl Cod. 255, 97

Marius Mercator, 86

Marius Victorinus, 68, 124–127, 285

Martianus Capella, 36, 142

Mase, as word, 98–99, 114, 330

Matthews, W. H., xviii, 4, 102, 113, 115–118, 120

Mazzotta, Giuseppe, 161, 298

Meander, 25, 34, 41, 51 (and pl. 6), 235–236, 319

Mehl, Erwin, 123–125

Mela, Pomponius, 18, 21–22

Mena, Juan de, 157, 226, 273

Mental labyrinths, 83–90, 156–157, 160, 164, 334–335. *See also* Brain as labyrinth; Epistemology; Intellectual mazes

Metaphor: and essential qualities of labyrinth, 65–66, 90–91; and inextricability, 82; and learning, 83

Metaphorical uses of labyrinth, basis of: in classical literature, 18, 24–26, 30–31, 35–36; in form, 46–53

Meursius, Johannes, 20, 86

Meyer, Wilhelm, 40

Miller, Clarence H., 300

Miller, J. Hillis, 8, 97

Miller, Jacqueline T., 310

Miller, James, 18, 67, 87, 125, 285

Milton, John, 79, 200

Minnis, A. J.: "Aspects of . . . *De consolatione*," 209; *Medieval Boethius*, 210; *Medieval Theory of Authorship*, 9, 62, 70, 147, 198, 202–203, 214

Minos, 11–13, 21, 23, 25, 33–37, 138, 147, 150–152, 159, 166, 171, 174, 206, 237, 240, 245, 274, 294–297, 305

Minotaur, 12, 30–31, 33–35, 37, 40–41, 50–51, 55, 73, 80, 101, 126–127, 134–136, 138–139, 147, 150–153, 156, 158–160, 164, 166–167, 169, 171, 342; in *Aeneid*, 228, 230–233, 235, 238, 241–245, 250–253; in *Comedy*, 274, 282,

Minotaur (cont.)
294–296, 299, 301–305; in *Consolation*, 254–255, 265; in *HF*, 308, 324, 335–336
Mirk, John, 323
Models of labyrinth: conflict between literary/multicursal and visual/unicursal, 4–6, 21–22, 39–63, 101–102, 133–144, 282; conflict recognized, 21–22, 41–42; simultaneous affirmation of contradictory, 22, 62. *See also* Multicursal model; Unicursal model
Mode of presentation of labyrinth, three-dimensional/architectural vs. two dimensional/diagrammatic, 21–22, 29–30, 40–43, 55, 102–106, 112, 134–135, 144; Chaucer's, 309, 313, 329
Monfrin, Jacques, 136, 228
Monsters, in ancient labyrinths, 21, 24–25
Moore, Edward, 272, 289
Moral labyrinths, 72–82, 145–191, and Part Three, passim
Morris, Lynn King, 309
Morse, Charlotte C., 175, 183, 188, 321
Multicursal model, 3, 40–43, 46–48 (and pl. 4), 58–61, 77–79, 90, 135, and passim; in *Aeneid*, 249–250; and artificial order, 205–207; in *Queste*, 177–178, 182–186. *See also* Form of labyrinth; Models of labyrinth
Multiplex narrative, 206–207, 210, 214
Murdoch, John E., 43, 103
Murphy, James J., 198, 203–204
Musa, Mark, 272, 300, 304
Muscatine, Charles, 247
Mystery. *See* Divine mystery; Impenetrability of maze; Secrecy
Mythography of labyrinth, 146–155, 165–167, and passim

Names, of labyrinths and turf-mazes, 98–99, 107, 114–117, 120
Narrative, labyrinthine: 176, 187, 196, 201–211, 219–220, and Part Three
Nepaulsingh, Colbert I., 96, 157
Newman, Francis X., 324, 333
Nims, Margaret F., 198, 203, 338
Nisus and Euryalus, 242–243
Noisiness of labyrinth, 21, 25, 104, 238, 309, 323, 326–327
Nonius Marcellus, 41, 209

Oblivion, labyrinth of, 200, 293
Obscurity, dangers of, 199, 213, 216–219; as valuable, 194, 206, 214–221
Occupatio, 213
Ocean as maze, 48, 69, 182
Ockham, William of, 325, 333
Odo Picardus, 149
Olson, Glending, 112

Oppenheim, Dennis, 216
Ordinaire chartrain, 123
Ordinatio, 202
Origen, 78–79
Original sin, labyrinth and, 75, 157
Otfrid of Weissenburg, 142
Otfrid-type labyrinth, 105 (pl. 9), 134–135
Otis, Brooks, 33–34, 227, 229–230, 235, 237, 240, 246–249, 252
Ovid, 10, 17–18, 20, 25–26, 31–38, 76, 150, 158, 194, 280, 311, 317–318, 330, 333. Works: *Heroides*, 20, 25, 33, 37, 147, 302, 309, 317; *Metamorphoses*, 17, 20, 25, 33–38, 91, 95, 149, 153, 295, 309, 326, 329
Ovide moralisé: poetic version, 125–126, 151, 153–154, 163, 298, 309; prose version, 35, 126, 154, 298
Ovidius moralizatus. *See* Bersuire, Pierre

Padoan, Giorgio, 298, 300–301
Pagan thought, labyrinth of, 69, 76–79, 81–82, 139, 258, 262, 277, 283. *See also* Heresy
Palace, labyrinth as, 21–23, 25
Palaephaetus, 36, 149
Panofsky, Erwin: *Gothic Architecture and Scholasticism*, 96, 102, 118, 128–129; *Hercules am Scheidewege*, 46, 60
Paradise as labyrinthine, 284–286, 306
Paradox, maze and, 1–2, 9, 17–18, 24–25, 38–39, 52–53, 62, 128–133, and passim
Parker, Patricia, 209
Parmenides, 264
Parody: in *Comedy*, 282, 289, 295–296, 301; in *HF*, 308, 311–312, 317, 325, 327, 335
Parry, Adam, 245, 252
Pasiphae, 11–12, 30–34, 37, 138, 147, 150–153, 158, 171; in *Aeneid*, 230, 233–234, 238, 240, 245, 250; in *Comedy*, 296–297, 301–302, 304
Paterson, Linda M., 208
Path, as metaphor for literary composition, 68–69, 204–207
Pauly, A. F. von, 27
Pausanias, 21
Pavement labyrinths. *See* Church labyrinths
Payne, F. Anne, 254, 268
Pearl, 204, 214, 219, 281
Peck, Russell A., 255
Peckham, Morse, 337
Perception: hindrances to, 292–293, 334; as labyrinthine process, 75, 83–85
Perdix, 12–13, 152, 130; and partridge's wings, 324
Periphrasis, 212
Persistence: necessary in labyrinths, 49–

Persistence (*cont.*)
50, 58, 173–175, 183, 230, 250, 283; and textual labyrinths, 193, 214–217, 220

Personification, 212

Perspective, 1–2, 18, 24, 29, 37, 45–46, 52, 57, 73–75, 79, 142–143, 146, 156–158, 176, 185–189; in *Comedy*, 277, 284, 289, 293, 298, 306; in *Consolation*, 254–270; and diagrammatic labyrinth, 102–103; and Fate/Providence, 129–133, 157–158; in *HF*, 311–313, 319–322, 329, 332, 335–339; and labyrinthine learning, 83, 87–91; reflected in philology, 96–100; and taxonomy of metaphor, 65; and texts, 192–194

Peter Lombard, 164

Peter of Cornwall, 204

Peter Pictaviensis, 164

Petrarch, 151, 215, 303, 309. Works: *Canzoniere*, 160–162, 290; *Liber sine nomine*, 116–117, 158–162, 169, 239, 309

Philosophy, Lady, 259, 265

Philosophy and labyrinth, 78–79. *See also* Aristotle's labyrinth; Pagan thought

Piers Plowman. See Langland, William

Pilgrimage, and labyrinth, 119–121

Pilota ritual. *See* Auxerre

Plato, xviii, 76, 78, 257. Works: *Apology*, 35; *Euthydemus*, 87; *Euthyphro*, 35; *Gorgias*, 35; *Hippias Major*, 36; *Laws*, 35; *Meno*, 35; *Timaeus*, 261, 268, 278–279, 286, 321, 327

Play, labyrinth and, 28, 110–111, 114, 123–127, 234–236

Pliny the Elder, 17–18, 20–23, 25–26, 29–31, 35–36, 41, 112, 122, 158, 160–161, 225, 228, 246, 309, 323, 325

Plots, labyrinths of, 152

Plutarch, 20, 228

Poetry, as labyrinth, 32–33, 68–69, 192–221

Popular culture, labyrinth in, 10, 48, 113–117

Pöschl, Victor, 227

Prehistoric mazes, 18–19 (pl. 1), 27–28

Premierfait, Laurent de, 104

Priscianus, Theodorus, 170

Prison, labyrinth and, 24–26, 32, 35–36, 47, 51, 55, 82; in *Comedy*, 282; in *Consolation*, 258–260, 265; in *HF*, 315–316, 328. *See also* Inextricability of maze

Prolixity, labyrinths of, 216, 314, 321

Propaganda, labyrinth as, 23, 106

Prophecy, labyrinth as, 69–71

Prosper of Aquitaine (*Carmen de ingratis*), 75, 83, 257

Protection, labyrinth as, 23, 25, 66, 80–82, 177, 187, 215, 220

Prudentius, 32, 51, 53, 73, 90, 150, 169, 178, 185, 194, 199, 257–258; *Apotheosis*, 76–77; *Contra Symmachum*, 77–78; *Hamartigenia*, 77; *Peristephanon*, 80–81

Purce, Jill, 3, 85

Purgatory as labyrinth, 283–284, 289–291, 306

Putnam, Michael C. J., 227, 229–230, 235, 241–242, 247, 252

Quest, labyrinth and, 176

Queste del Saint Graal, 7, 11, 53, 79, 146, 165, 175–191, 193–194, 202, 205–208, 212, 216, 219, 283, 290, 292

Quick, Anne, 307

Quinn, Kenneth, 229, 239, 246, 248–249, 252–253

Raban Maur, 104–105, 136

Rahab, 116, 280, 303–304

Rashdall, Hastings, 126

Rationale divinorum officiorum. See Durand, William

Reason and Sensuality. See Echecs amoureux

Reception of literary texts, 8–10, 223–226, 273–277; concern for, 86–90, 192–195, 216–221; as labyrinthine process, 192–193, 214–221

Recreation, mazes and, 106–116

Regan, Mariann S., 161

Reinhardt, Hans, 36, 117, 121

Relativity: of perception of maze, 24, 29, 144, and passim; of textual mazes, 193–194, 197, 216–221

Remigius of Auxerre, 142

Repetition, as trope, 212

Rete mirabile, 84

Revising text, as labyrinthine process, 157, 213

Rhetoric, and labyrinth, 32, 53, 192–221, 320, 332

Richard of Fournival, 162

Ridewall, John, 149, 151

Ridley, Florence, 9

Robbins, Rossell Hope, 323

Robert of Basevorn, 193, 204, 213, 218, 321

Robertson, D. W., 8, 119

Roche, Thomas P., 161

Rokseth, Yvonne, 123

Romance of the Rose, 163

Roman mosaic labyrinths, 21–22, 29, 40, 42–43 (pl. 3), 81, 104, 113

Roman robes, labyrinth on, 80, 177, 220

Roof bosses, labyrinths on, 118–119, 123

Rosamund's bower, 106–107

Rose, Donald M., 9

Rossi, Albert L., 272

Rota-rosa, 128–133, 157, 197, 284, 308

Rowland, Beryl, 310, 323

Rudolf of Saint Trond, 193, 204

Rufus of Ephesus, 84
Ruins, in *Comedy*, 285–286, 296, 301–302
Rutledge, Harry C., 228
Ryan, Christopher J., 272, 291
Ryan, Lawrence W., 298, 304

Santarcangeli, Paolo, xviii, 3–4, 25, 81, 102, 116–117, 170
Scarry, Elaine, 254, 264, 268, 269
Schnapp, Jeffrey T., 272
Schnapper, Edith B., 123, 125
Schoder, Raymond V., 239
Scholastic method as labyrinth, 200
Scott, John A., 298
Scripture, labyrinths of, 193, 204, 216–217
Seay, Albert, 214
Secrecy, labyrinth as sign of, 80. *See also* Divine mystery; Impenetrability of maze
Sedulius, Caelius, 76, 139, 258
Seneca, 74–75, 145, 257, 273, 288, 330
Sequence of labyrinths: in *Aeneid*, 228–252, 277, 286; in *Comedy*, 293; in *HF*, 311–313, 316, 318–323, 331, 336–339
Sermons, and labyrinthine techniques, 204, 218–219
Servius Grammaticus, 26, 37, 136, 139, 147, 225, 228, 232, 239
Seven Liberal Arts: as guide to complex texts, 216–217; as labyrinth, 201
Shakespeare, William, 114
Shepherd, Geoffrey T., 310, 332, 333
Shook, Laurence K., 310
Shortcuts, danger of, 75, 89–90, 179, 229
Sibyl: and ambages, 77, 331; and cavern, 238–239, 289; and Fame, 324; and Lady Philosophy, 255–256
Sidonius Apollinaris, 69, 72, 79, 86, 202, 209, 257
Sieper, Ernst, 162
Silk, Edmund Taite, 97, 258, 261, 263, 264
Simplicius, 82, 199, 293
Sin, labyrinth of, 31, 75–78, 150, 152, 158–160, 169, 189, 287–288, 290–291
Singleton, Charles S., 271, 274, 279–280, 282–283, 287, 291, 295, 303, 305
Sir Gawain and the Green Knight, 7, 79, 198, 204, 206, 219, 281
Sklute, Larry, 333
Smalley, Beryl, 149, 151
Socrates, as descendent of Daedalus, 35, 87
Solomon and labyrinth, 69, 139
Sophocles, 21
Sources of writer as labyrinth, 198–199, 201, 316–318, 333
Spearing, A. C., 204, 309–311, 333
Speech, as labyrinth, 86
Spenser, Edmund, 208

Spillenger, Paul W., 272
Statues in mazes, 21, 104, 323
Steadman, John M., 311
Stephens, John, 172–174
Stepping out of maze, 110–111, 250, 298
Stevenson, Kay, 331, 333
Stewart, Douglas J., 252
Stock, Brian, 11, 30, 148, 209
Stone-mazes, 112–116
Strabo, 5, 17, 21, 23–24, 29, 35, 52
Suetonius, 27
Syllogisms, labyrinth of, 199

Talos. *See* Perdix
Taurus, 37, 147
Teleology, labyrinth and, 56, 82
Temple, labyrinth as, 23, 25
Temple of Jerusalem, labyrinth and, 69–70, 139
Texere, 28, 30, 69, 76, 80, 203, 209, 262, 328–329
Text: as labyrinth, 7–8, 51, 54, 68–72, 86, 138–139, 161–162, 172–221, 311–312, 332, 336–339; as thread, 72, 161, 171, 225, 259, 264, 269–270, 287, 293, 303, 305–306, 316–319, 337
Theodore Prodromos, 199
Theseus, 12, 25, 31, 33, 35, 37, 40, 68, 76, 80, 108, 125–128, 134–135, 138–140, 142, 147, 150–156, 159, 162, 165–166, 171, 184–185, 189; in *Aeneid*, 229, 231–232, 234, 237–241, 245, 248, 251; in *Comedy*, 279–280, 285, 296, 299–305; in *HF*, 308, 311, 317–318, 331, 335; in *Knight's Tale*, 338. *See also* Christ-Theseus
Thompson, David, 298
Thomson, H. J., 76, 97
Thought as labyrinthine process, 83–85
Three-dimensional mazes, 20–25, 41–43, 55, 103–112, 135, 313, 329. *See also* Building; Form of labyrinth; Models of presentation; Mode of presentation of labyrinth
Time, labyrinth of, 81, 152
Tisdale, Charles P. R., 311, 316
Todorov, Tzvetan, 175–176, 184, 186–187, 189
Tomb, labyrinth as, 20, 23, 25, 73, 80–81, 301
Tower, labyrinth as, 104, 135
Tragliatella labyrinth, 27–28 (pl. 2), 40, 115, 232
Treading the maze, 110–111, 113–116, 172–173
Tree diagram, labyrinth and, 199
Trevet, Nicholas, 95, 97, 142, 209–210, 261–264
Trojan Horse and labyrinth, 230–232, 297

Trojan Ride, 21–22, 26–30, 71, 115–116, 233–237, 241–246, 251–253, 258, 285
Trollope, Edward, 113, 123
Tropes, rhetorical, 211–213
Troubadours, 214–218
Troy, 27–28, 115–116, 135, 232–233
Truth and falsehood, as theme in Chaucer's work, 313–318, 324–326, 330–339
Turf-mazes, 112–118 (pls. 12–13)
Two-dimensional mazes, 21–22, 40, 55, 102–103, 112–144, 313, 329. *See also* Form of labyrinth; Models of presentation; Mode of presentation of labyrinth

Ulysses, 231, 280, 297–299, 304
Unfinished art, labyrinth and, 210, 237–238, 253, 331
Unicursal model, 3, 19, 22, 48–51, 283–284, and passim. *See also* Form of labyrinth; Models of labyrinth
Unicursal pattern superimposed on multicursal design, 53, 72–73, 75–78, 125, 177–178, 184–185

Valdés, Mario, 9
Vance, Eugene, 8
Varro, 20, 23, 228
Vegetius, 80, 177, 292, 335
Verrall, Margaret de G., 227, 239
Versus de Verona, 104, 284–285
Victimae paschali laudes, 124
Vinaver, Eugène, 96, 175–176, 207–211
Vindicianus, 170
Virgil, 5, 17–18, 25–37, 76, 96, 147, 149–150, 157–158, 227–253, 269, 272–274, 277–279, 294, 299, 307–309, 311–312, 330, 331, 333, 338; as character in *Comedy*, 272, 277, 285–293, 296, 300–301, 303, 305; Works: *Aeneid*, 17, 25–37, 53, 69–70, 116, 139, 147, 149, 155, 159, 169, 227–253, 342; *Georgics*, 32; and *Comedy*, 272–273, 277, 286–287, 289, 294, 296, 301, 305; and *Consolation*, 254–257, 268; in *HF*, 307–308, 310–312, 316–319, 324, 328, 331–333
Visual arts, labyrinth in, 6, 18–21, 39–44, 48–51, 101–144, 308, 313, 329

Waleys, Thomas, 96, 218, 263
Wallace, David, 310
Walsingham, Thomas, 149
Walter of St. Victor, 164, 193, 200
Warfare as labyrinth, in *Aeneid*, 233, 235–236, 240–246
Wayland, and mazes, 116
Weaving, 230–231, 241, 244; of argument, 263, 265; of words, 69, 328–329. *See also Texere*
Webb, N. C., 248
Wetherbee, Winthrop, 254, 261, 268–269
Wilderness, labyrinth and, 48, 75–76, 168, 177, 283, 318. *See also* Forest as maze
Wiligelmo, 121
William of Conches, 37, 106, 147–148, 264
Williams, Gordon, 247–249
Williams, John, 121
Wimsatt, James I., 280, 291
Winny, James, 310, 328
Wipo, 124
Witt, Ronald G., 217
Wood, Chauncey, 9
Woodman, Francis, 118
Woods, Marjorie Curry, 202, 213
Woodstock, labyrinth at, 106–107
World, as labyrinth, 74–75, 81, 129–133, 139, 145–146, 151–160, 165–167, 171–191, 308; in *Aeneid*, 248–252; in *Comedy*, 281, 287–288, 304, 306; in *Consolation*, 257–270; in *HF*, 312, 327, 336–339; in maps, 138
Worldliness, labyrinth of, 152, 162
Worldly goods, labyrinth of, 152
Writing as labyrinthine, 192–193
Wyatt, Sir Thomas, 1–2

Yates, Frances, 197, 323
Yeats, W. B., 216
Young, Karl, 125
Yvain, 206

Zacher, Christian K., 96
Zarker, John W., 228, 237
Zarnecki, George, 121
Zodiac, labyrinth and, 130, 142
Zumthor, Paul, 8

Library of Congress Cataloging-in-Publication Data

Doob, Penelope Reed.
 The idea of the labyrinth from classical antiquity through the Middle Ages
/ Penelope Reed Doob.
 p. cm.
 Includes bibliographical references.
 ISBN 0-8014-2393-7 (alk. paper)
 1. Labyrinths in literature. 2. Classical literature—History and
criticism. 3. Literature, Medieval—History and criticism. 4. Labyrinths in
art. I. Title.
PN56.L223D6 1990
700—dc20 89-23993